Revenge of the Domestic

Revenge of the Domestic

WOMEN, THE FAMILY, AND COMMUNISM IN
THE GERMAN DEMOCRATIC REPUBLIC

Donna Harsch

PRINCETON UNIVERSITY PRESS

PRINCETON AND OXFORD

Copyright © 2007 by Princeton University Press
Published by Princeton University Press, 41 William Street,
Princeton, New Jersey 08540
In the United Kingdom: Princeton University Press, 3 Market Place,
Woodstock, Oxfordshire OX20 1SY

All Rights Reserved

Library of Congress Cataloging-in-Publication Data

Harsch, Donna.
Revenge of the domestic : women, the family, and communism in the
German Democratic Republic / Donna Harsch.
p. cm.
Includes bibliographical references and index.
ISBN-13: 978-0-691-05929-7 (hardcover : alk. paper)
ISBN-10: 0-691-05929-2 (hardcover : alk. paper)
1. Women—Germany (East)—Social conditions. 2. Family—Germany (East)
3. Socialism—Germany (East) I. Title.
HQ1630.5.H37 2007
306.850943′109045—dc22
2006014747

British Library Cataloging-in-Publication Data is available

This book has been composed in Sabon

Printed on acid-free paper. ∞

pup.princeton.edu

Printed in the United States of America

10 9 8 7 6 5 4 3 2 1

For Martina Dietrich

Contents

Illustrations

Tables

Acknowledgments

I have enjoyed every stage of this project (perhaps that explains why it took so long to complete). The satisfactions lay in the fascination of the archival materials. The pleasures came from a different source: the human contacts that accompanied the research and writing. Numerous people (and institutions) provided me with useful and informative assistance and, often, enlightenment and entertainment. This statement holds especially true for the people I interviewed. I deeply appreciate them for recounting stories that communicated a real, if necessarily partial, sense of life and work in East Germany.

I would like to thank the Fulbright Program for supporting research in Germany in 1994–95. Beyond its financial benefits, the Fulbright Senior Research Fellowship facilitates scholarly exchange. Fulbright requires every fellow to have a mentor. Professor Karin Hausen of the Technical University–Berlin filled this role for me, asking hard questions and providing invaluable advice. Along with Karen Hagemann, she led a superb colloquium on interdisciplinary women and gender research in spring 1995. I thank Professor Hausen for her input into my work and for the opportunity to participate in the colloquium. Fulbright also sponsored contact with other German universities. In particular, I benefited from the discussion following a presentation to graduate students at the Technical University–Chemnitz. I thank Professor Rudolf Boch and his students for a lovely visit and for directing me to the Oral History Collection at the Industriemuseum Chemnitz. I am grateful to Fulbright for promoting fruitful scholarly experiences for fellows.

The Institute for Research on Women and Gender at Stanford University accepted me as a fellow in 1997–98, providing an intellectual home while I did research at Stanford's libraries and Hoover Institution. Discussion with other fellows and the Institute's senior scholars introduced me to gender research in diverse fields.

A much-appreciated grant from the National Endowment for the Humanities allowed me to devote the academic year 1998–99 to writing. I acknowledge as well research funds and the liberal leave policy of the History Department at Carnegie Mellon University. Thanks, in particular, to successive department heads Steve Schlossman and Joe Trotter for supporting faculty research and writing.

The bulk of archival research for the project took place at the *Stiftung der Arbeiterparteien und Massenorganisationen der DDR* (now part of the

Bundesarchiv). SAPMO's able librarians and archivists made working there productive and pleasant. I would like especially to recognize the indispensable, good-natured help of Carola Aehlich, Volker Lange, Annemarie Müller, and Jana Pautsch. In the photo archive of the East German *Konsumverband*, Marianne Fischer went out of her way to assist me.

At Princeton University Press, I would like to thank my editor Brigitta van Rheinberg for taking on this project, for patience when it ran years over schedule, and for excellent suggestions about how to improve the manuscript. She sent it out to two anonymous readers who wrote extremely useful critical reviews. I acknowledge their contributions and those of Princeton's amiable and skilled production staff.

Friends and colleagues have arranged interviews, contacts, and talks; shared references, data, and ideas; read parts of the manuscript; and helped with translations into or from German. My thanks to Werner Angress, Anna-Sabine Ernst, Kornelia Freitag, Curt Garner, Elizabeth Heineman, Jennifer Hosek, Katherine Lynch, Gerda Neyer, Christine von Oertzen, Katherine Pence, Cathy Potter, Annette Timm, Heike Trappe, Eric Weitz, and Karin Zachmann. With affection, I recognize all I have learned about social history from colleagues in the Pittsburgh Working-Class History Seminar, including Wendy Goldman, Maurine Greenwald, Michael Jimenez, Richard Oestreicher, Marcus Rediker, Steve Sapolsky, and Joe White. I especially want to acknowledge hours of conversation about every aspect of gender relations with Wendy Goldman. As a Soviet historian, she has taught me much about women and the family under socialism. Equally edifying and fun is my friendship with Mary Lindemann, whose knowledge of early-modern Germany inspires awe.

My husband, George Loewenstein, and children, Max and Rosa Loewenstein, have put up with this project for many years. I thank them from the bottom of my heart for their patience and support, and love them for the (mainly) wonderful distractions they created along the way.

I want, finally, to acknowledge the extraordinary assistance of Dr. Martina Dietrich. The first time I talked to Martina at a session of the TU-Berlin's gender colloquium, I thought to myself, "I have to get to know this woman." I was right. From her I have learned about East German daily life and politics, German history as a whole, and the tribulations of the post-1990 "transition." Among many kinds of help with the research, Martina arranged most of the interviews and conducted many with me and several on her own. I treasure memories of our travels around Brandenburg and Saxony to meet interviewees. I have also enjoyed great times with her witty, erudite husband, Andreas, and their charming children, Juliana and Christoph. For her contributions to the project and for the amazing person she is, I dedicate the book to this dear friend.

Abbreviations

Abt	Abteilung
Abt Ghw	Abteilung Gesundheitswesen
Abt MuK	Abteilung Mutter und Kind
AfS	*Archiv für Sozialgeschichte*
AGL	Abteilungsgewerkschaftsleitung
AHR	*American Historical Review*
Arbqr. Fr	Arbeitsgrappe Frauen
BFA	Betriebsfrauenausschuss
BGL	Betriebsgewerkschaftsleitung
BLHA	Brandenburgisches Landeshauptarchiv
BPO	Betriebsparteiorganisation
BVS	Bundesvorstand
DEFA	Deutsche Film-Aktiengesellschaft
DFD	Demokratischer Frauenbund Deutschlands
FA	Frauenausschuss
FDGB	Freie Deutsche Gewerkschaftsbund
Frauenabt.	Frauenabteilung
Fvh	*Die Frau von heute*
G&G	*Geschichte und Gesellschaft*
HA MuK	Hauptabteilung Mutter und Kind
HAT	Hausarbeitstag
HO	Handelsorganisation
IMC	Industriemuseum Chemnitz, oral history project
LAB	Landesarchiv Berlin
LAM	Landesarchiv Merseburg
LStA	Leipzig Stadtsarchiv
LVS	Landesvorstand
MfA	Ministerium für Arbeit
MfAuG	Ministerium für Arbeit und Gesundheitswesen
MfAuS	Ministerium für Arbeit und Sozialpolitik
MfG	Ministerium für Gesundheitswesen
MfI	Ministerium für Industrie
MdJ	Ministerium der Justiz
MfS	Ministerium für Staatssicherheit (also see Stasi)
MfV	Ministerium für Volksbildung
ND	*Neues Deutschland*

NJ	*Neue Justiz*
NW	*Neuer Weg*
RIAS	Radio in the American Sector
SAPMO-BArch	Stiftung der Arbeiterparteien und Massenorganisationen der DDR Bundesarchiv
SBZ	Sowjetische Besatzungszone
SHSA	Sächsisches Hauptstaatsarchiv
SMAD	Sowjetische Militäradministration Deutschlands
Stasi	Ministerium für Staatssicherheit
StJB	Statistisches Jahrbuch DDR
VEB	Volkseigener Betrieb
ZS	Zentralsekretariat

Revenge of the Domestic

THE SHATTERED STATE of their country in 1945 sobered German Communists but did not debilitate them. Communists, a small but determined minority, planned to use class struggle, production, and Marxist ideology to drive Germany toward the socialist future. Contemplating the labor before them, they barely registered the grave concerns of compatriots: divided families, destroyed homes, scarcity of food. As people, Communists loved their families and had to eat and sleep. As Communists, they rated private concerns as diversions, even obstacles, to the realization of socialism. For them, family, household, and consumption formed the backdrop to the drama of class, politics, and production. While Communists studied the wide road ahead, German women stared gloomily at the rut in front of them. Women, a substantial but diffuse majority, looked at their devastated world through the Communist lens inverted: they were sick of struggle; uninterested in production; suspicious of ideology, but ready to sacrifice for family; anxious for a home of their own; and desperate for food, clothing, and any nice thing. Many women worked for wages and participated in political life as it emerged in occupied Germany. Yet most women predicated employment on their family situation and spoke in public about domestic issues.

This book reconstructs the encounter between Communists and ordinary women in eastern Germany, from the era of occupation through the first two decades of the German Democratic Republic (GDR). The narrative addresses the problem of continuity and change in the relationship between women and the family, on one side, and the Socialist Unity Party (SED) and the state it constructed, on the other. The gap between a production-oriented party-state and family-oriented women citizens, the book contends, never disappeared. The SED clung to its Marxist-Leninist ideology and propagated the primacy of socialized production. Women remained deeply interested in their domestic situation and notably family-oriented in career choice, opting for occupations that would allow them to harmonize family and employment.[1] The gulf narrowed, however, and from both directions: women and the SED adapted to one another's position and worldview. At first glance, ordinary women appear to have made all the adjustments. The GDR, as did most state-socialist lands, drew women of every marital and maternal status into wage labor and, hence,

[1] Thaa et al., 154–55, 157, 161, 167–68; Diemer, " 'neue Frau,' " 119, 122.

"socialized" them. East German women came to rate employment as integral to their sense of self.[2] The party-state appeared stationary relative to the women it moved but, in fact, it shifted its productivist stance. State adaptation occurred incrementally, by tweaking "woman policy" in an "affirmative-action" direction; recognizing the family as a determinant of the "socialist personality"; spending much money on services; channeling funds toward consumption and housing; and financing a generous welfare package. Many measures emerged as permanent policies and major leaps in expenditures only after 1971, but they originated in the 1950s and 1960s. Between 1945 and 1970, the book concludes, there unfolded a confrontation between unorganized women, with their domestic concerns, and the dictatorial party-state, with its productivist agenda, that vitally shaped the lives and self-perception of East German women and the policies and discourse of the SED—and contributed significantly to the fall of Communism in the GDR.

The pattern of continuity and change emerged out of a dynamic interaction between structures and agents, on the one hand, and a manipulative party-state and maneuvering women, on the other. The GDR was a dictatorship, and the SED set the terms of the encounter. Women reacted to state actions within structures created, supported, or condoned by the SED. I define "structure" as economic, political *and* domestic arrangements, as well as ideological convictions *and* cultural attachments. The fundamental tension between the SED state and women, the book posits, arose from the party-state's contradictory relationship to these structures. Tension was generated, above all, by subordination of all things domestic to a production-based understanding of political economy and social transformation. The "classical socialist system" had an "ambivalent" relationship to the family, notes János Kornai.[3] This ambivalence arose from Stalinist ideology's indifference to domestic needs and desires, combined with the Stalinist economy's dependence on the material and emotional labors performed by the nuclear family.[4] Orthodox Stalinists, including the SED, squeezed consumption and exploited unpaid domestic labor to accumulate capital for investment in production.[5] The SED aimed also to mobilize the wage labor of mothers of young children, while promoting high fertility and trying to keep access to birth control from women.

The domestic structure that the Communist state exploited was, basically, the family it inherited in 1945, a family forged by cultural tradi-

[2] Thaa et al., 173–74.

[3] Kornai, 106–7. Also see Thaa et al., 25–27, 49.

[4] Thaa et al.; Heitlinger, *Sex Inequality*, 194.

[5] Capitalist societies exploit the unpaid domestic labor of women; market theorists, too, denigrate its economic significance. See Boydston; Hauser, e.g., 24.

tions, capitalism, the Third Reich, and war. The SED did not attempt to transform domestic arrangements, whether understood as family labor (the totality of work and care performed in the family) or gender relations (the division of domestic labors). The neglect of the domestic was not just pragmatic, but also philosophical, resting on the assumption that the family was of secondary social significance. Communists recognized, certainly, that women's oppression was grounded in the patriarchal family. They supported civic and social equality for women and, in power, eliminated the legal privileges of husbands and fathers. They believed, however, that female emancipation and familial change depended fundamentally on woman's participation in wage labor. Herbert Warnke, the head of the East German trade union federation (FDGB), summarized this viewpoint in 1952: "The equality of women is rooted in her place in production. In those places that woman is kept away from production or where she seeks to realize an ideal that keeps her out of production, there she remains dependent on man, her so-called provider."[6] As wage workers, women would gain autonomy, cast off their parochial concerns, and become class-conscious. Communists, in sum, approached the "woman question" from a progressive standpoint. They were, however, antifeminist, for feminism attributed women's oppression to men, not to class society.[7]

Early Marxists recognized that woman could not realize her productive potential unless she was freed from domestic drudgery. A socialized economy, exclaimed Friedrich Engels, August Bebel, and V.I. Lenin, would liberate her by transferring most consumption, child care, and housework out of the home and into the socialized sector.[8] Three points require emphasis here. First, Communists denied social meaning to domestic work. Housework contained no emancipatory potential because it was unwaged, private, individualized, unproductive, and, by their definition, unskilled; it did not function as real *labor*. Nor did they attribute much significance to the emotional work of the family in developing character.[9] Second, they premised the socialization of housework and consumption on the prior transformation of the relations of production. Socialized wage labor, production, and workers would, over time, mechanistically and independently transcend private unwaged labor, consumption, and housewives. Third, they did not see a redistribution of

[6] SAPMO-BArch, DY34/21507, IG Bergbau, Konferenz zur Verbesserung der Gewerkschaftsarbeit unter den Frauen . . . 2.11.52, Protokoll, 7.

[7] See Buehler, 14–16, 30; Diemer, " 'neue Frau' "; Hauser, 24, 142–43: Nickel, "Mitgestalterinnen," 234–35.

[8] Heitlinger, "Marxism," 10–11.

[9] Dölling, "Bewusstsein," 26; Heitlinger, "Marxism," 11, 15.

labor within the family as an interim, much less a long-term, solution, for reapportionment would not decrease the total claim of the household on members' time, effort, and attention.[10] Redistribution would, instead, constitute a step backward, burdening men with the repetitive everydayness of the home's routines and the petty, even frivolous, concerns of consumption. After the Russian Revolution, several Soviet Communists had envisioned communalization of the household or socialization of the family, not just displacement of its work to socialized services.[11] By the 1940s, however, influential German Communists, like their Russian and Eastern European comrades, had abandoned this revolutionary impulse.[12] The SED never officially questioned the nuclear family as the form of domestic life under socialism.

The ideological justification for ignoring family structures was linked to political interest. A program of private transformation might have alienated male proletarians, the social base of Communism. The German Communist party (KPD) consistently advocated women's rights in the 1920s. Yet the KPD remained a predominantly male organization that celebrated the ideal Communist worker as brawny, tough, and devoted to "masculine" organized activities such as soccer, strikes, and street-fighting.[13] The KPD's commitment to political struggle, self-abnegation, and disciplined cooperation was more than an abstract worldview. German Communists had battled the rise of National Socialism, resisted the Third Reich, fought alongside the Spanish Loyalists, suffered in Nazi concentration camps, and contributed to the Soviet cause in World War II.[14] They *lived* their politics and believed that everyone else—rescued from capitalism and correctly educated—would live Communist politics as well.

The neglect of the family rested, finally, on the psychological bedrock of self-serving bias.[15] Virtually every leading Communist in the GDR and elsewhere was a man, and most were husbands and fathers. As they set out to build socialism after the turmoil of fascism and war, they benefited from the conventional, gendered division of domestic labor and were personally invested in the status quo, although they were oblivious to this conflict of interest. Steeped in the rationalistic assumptions of Marxism,

[10] For a late statement of this position by a GDR academic who was critical of its failings on the "woman question," see Dölling, *Individuum*, 147–48.

[11] Goldman, *Women*, 43–57; Heitlinger, *Sex Inequality*, 80–84.

[12] Madison, 46–47; Heitlinger, *Sex Inequality*, 136; Haney, 62.

[13] Weitz; Epstein, 32.

[14] See short biographies in Epstein; Weitz; Grieder, *Leadership*; Leonhard; Landsman, *Demand*, e.g., 24–25, 49, 121.

[15] Babcock and Loewenstein.

Communists profoundly underestimated the power of private desires—including their own—to resist "reform."

However grounded, the effect of Communist denial of the independent significance of domestic relations was the same: the SED proceeded to socialize production and upend class relations, while leaving the organization of individual consumption and private gender relations basically as it was.[16] The contradiction between brave new world and familiar home, and between dynamic production and stagnant consumption, generated ironic effects. The Plan's initial starvation of consumption, and its later inability to satisfy consumer wishes, enhanced the material and affective importance of the family for its members. East Germans depended on a family unit that worked hard to compensate for scarce provisions, crummy clothing, crumbling housing, low wages and pensions, inadequate services, and the paucity of public welfare.[17] The state's exploitation of family labor and private networks of support impinged on women more directly and in more ways than on men: women organized consumption, a task that demanded much time, exertion, and ingenuity; women did the bulk of labor in a household that required much work; women bore and nurtured children; and women performed much of the care for infirm and aged relatives. A second set of ironic consequences was, thus, the continual reproduction of woman's domestic role, the reinforcement of her orientation toward consumption, the home, children, and marriage, and the fortification of men's assumption of the naturalness of women's orientation. Men and women were, obviously, both immersed in the family and its survival. Both contested state policies that restricted consumption and their ability to raise their children. Male workers' sense of themselves as breadwinners who should earn a "family wage" fueled their opposition to wage cuts and antagonism to the integration of women workers into better-paid occupations. Many husbands told wives how to run the household and rear the children. Men had much invested in the family. Nevertheless, they, women, and the SED treated consumption, reproduction, and the home as women's affairs.

The interaction between private domesticity and socialized production produced a third ironic effect: the family generated needs and desires that the socialist economy could not satisfy. In contrast, the "social market" economies of West Germany and other Western countries could meet consumer desires, a capacity that surprised Communists, who had, after all, cut their political teeth on depression-era, pre-Keynesian assumptions about capitalism.[18] In sum, the intermeshing of public upheaval and pri-

[16] On the "ideological neglect" of consumption, see Landsman, *Demand*, esp. 86.

[17] Kornai, 106–8; Thaa et al., 97–98.

[18] Landsman, *Demand*, 9–10.

vate continuity paradoxically strengthened popular interest in the nuclear family, in individual consumption, in conventional gendered personas, and in things "over there."

The Stalinist economy, of course, did modify private lives. The family and public gender norms changed as married mothers entered the labor force in large numbers and became less willing to perform hard labor at home. The structures of wage labor altered the family but, mediated through women's decisions, mainly in ways the SED did not like, such as a rising divorce rate, declining fertility, and growing demands for time-saving household technologies. Party and state officials began to fret about such unexpected tendencies in the late 1950s, as the GDR was plagued by a vexing scarcity of labor, owing to the inefficiencies of every command economy and the hemorrhaging of workers to the West that affected only the GDR. Like every Stalinist economy, the GDR depended on the mobilization of new sources of labor to maintain rapid growth.[19] The SED became eager to improve the productivity of *current* workers by raising skill levels. Looking ahead, the party leadership saw the need for more and better-educated children who would become the *next generation* of workers. The insatiable appetite of state-socialist structures for more and higher-quality labor, now and in the future, concentrated attention on women: housewives constituted the only remaining pool of non-employed labor; women workers composed by far the larger pool of un-skilled labor; women bore all the babies; mothers did the lion's share of child rearing; and wives performed most housework. The party became more alert to the significance of domestic matters as the weight they loaded onto women began to drag against its production and reproduction goals.[20]

The operation of structures, even Communist structures, is always at-tenuated by the behavior of human agents. The SED, of course, might be seen as a single-minded agent and the GDR as its monolithic extension. As First Secretary of the Politburo, the ultra-Stalinist Walter Ulbricht held the Politburo in a tight grip; the Politburo, in turn, controlled the SED, the state, and the economy. Ulbricht's extraordinary power notwithstand-ing, the party-state did not act as a unified ego. Cleavages ran between the Plan and its implementation. Inside "the" state, each ministry pursued its particular priorities and pressed for more resources.[21] Inside "the"

[19] Kornai, 204, 211, 214–15.
[20] For a similar point, see Hockerts, "Grundlinien," 519; Helwig, "Einleitung," 15; Laatz, 182.
[21] Landsman, *Demand*; Stitziel, *Fashioning*. Also see Hoffmann, *Aufbau*, esp. 545; Hock-erts, "Grundlinien," 521. For this argument applied to state-socialism in general, see Kor-nai, 419–20.

party, leading members did not always agree about which line to toe in any one political or economic crisis.[22] Officials in the "mass organizations," such as trade unions and the women's league, did not smoothly transmit the program to members. At the lower rungs of the state, SED, and mass organizations, officials had considerable contact with ordinary citizens. Functionaries relayed up to higher authorities what they heard, acting not only as spies, but as intermediaries. They were susceptible to pressure because they lived in East German society and shared many of its cultural norms. Officials also instrumentalized the opinions of "workers," "the people," or "women" in order to gain resources for their particular projects. Last but not least, individual East Germans navigated and, indeed, negotiated among institutional interests, trying to play this state bureaucrat against that political functionary, that economic manager against this trade union official.[23]

Ordinary women struggled as earnestly as men to locate small levers of influence. Female workers opposed production and wage policies, although they did so less adroitly than men, for women were less experienced on the shop floor, had few patrons in shop floor organizations, and were, therefore, more easily intimidated by pressure from above. In matters of reproduction, consumption, and the family, in contrast, women looked back on eons of experience and knew how to cull information and garner support from private networks. When it came to everyday life, they knew what had to be done and did not shy from speaking out or acting on this conviction. East German women articulated, in the main, "female consciousness," a perspective arising from women's shared sense of a special obligation to sustain life and from their acceptance of gendered responsibilities. Such consciousness, the historian Temma Kaplan has suggested, draws upon women's determination to do right by their families, but it can motivate participation in riots, protests, and industrial unrest.[24]

Without the right to challenge the SED in public, much less to organize, East German women resisted its plans through daily and individual behaviors. Between 1945 and 1948, when the political situation was fluid, women protested postwar dearth at every meeting they attended. In the 1950s, mothers complained about teachers, schools, and infant health care. Women, especially farmers' wives, attended church and supported church-affiliated women's groups. Wives resisted pressures to enter wage labor. Employed mothers missed work, changed jobs, and lamented insufficient and poor-quality institutional child care. Mothers protested

[22] See Epstein; Grieder, *Leadership*, esp. 211–12.
[23] For similar interpretations of state-society relations, see cites in footnote 41.
[24] Kaplan, "Female Consciousness."

the quantity and quality of housing, food, and children's clothing. Housewives clamored for household appliances. Young women snubbed GDR-made fabrics and fashions. Older wives contested the liberalization of divorce law. Unmarried women questioned their exclusion from a paid monthly housework day for women workers. Women workers laid down their tools to protest wage cuts. In the 1960s, as the majority of married mothers entered employment, new strategies emerged: full-time employed wife-mothers retreated into part-time work and refused to train for skilled work. Working women complained about gender inequality in the workplace. They demanded that managers and the SED address the household burdens that held women back. Women reduced their fertility rate. Pregnant women wrote letters demanding an abortion and protesting their lack of reproductive rights. Wives led a rise in the divorce rate. Throwing SED rhetoric about women's emancipation back at the state, women charged that they could not realize their productive potential. Whether they pulled against change or pushed to speed it up, women contested the official disdain for private matters. Although they almost always acted as individuals, the barrage of atomized words and deeds effectively demonstrated that domestic situations, family worries, consumer needs, and individual desires mattered and, indeed, deeply affected women's ability to hold a full-time job, willingness to qualify for skilled work, and readiness to bear another child.

Female functionaries in the SED, trade unions, women's league, and state bureaucracy arbitrated between ordinary women and the party-state. Women Communists typically toed the line but, especially in the late 1940s and again in the 1960s, they sometimes represented women's point of view with brio. They identified with women, intimately understood their structural disadvantages vis-à-vis men, and were appalled by the blatant misogyny they witnessed in the countryside, on the shop floor, and among male SED functionaries. They also used women's issues and complaints to gain some leverage within the patriarchal hierarchies of factories, unions, and party. Ordinary women found another sometime ally, sometime adversary in ordinary men. As workers, consumers, husbands, and fathers, men frequently supported women's complaints about consumption and reproductive policies. Simultaneously, though, men protested the state's efforts to introduce women into "male" occupations. Husbands often opposed their wives taking a job or pressured them to work part-time. The typical husband did not alter private habits to accommodate an employed wife. Workplace tensions eased as men grew accustomed to women's presence in industry and as they realized that women would rarely rise to high positions in the workplace. Private gender tensions did not relax over time, although, to paraphrase Tolstoy, the unhappy family became unhappy in a different way.

From early on, the contradictions within state policies and the popular maneuvering around those policies combined to force incremental adjustments to production goals. In 1948 the SED opened a state-run department store that sold more, better, and higher-priced goods as an enticement to higher productivity. State policy pitched in a consumerist direction after the workers' uprising of June 1953, although investment soon veered back toward production. In the later 1950s and the 1960s, the compromises became bigger, though they remained fragmentary and subject to retraction. The state adjusted hours of employment and modified training programs so women could qualify for skilled labor. It increased production of household appliances to rationalize the private home. Consumer industries tried to produce clothes and household goods that women would buy. Issues that had been utterly marginal, indeed, alien to the class-struggle worldview of the German, or any, Communist party swam into the consciousness of the party elite: consumer desires, marital conflict, domestic violence, the household division of labor, sexual satisfaction, birth control, the difficulties of large families, child development, adolescent angst, all the allegedly petty problems of everyday life that Communists had believed would evaporate after production was socialized. Social scientists and medical experts began to deliberate about reproductive issues, the family's psychological and physical health, and social reform.[25] The party tolerated a normalization and even humanization of public discourse and symbolism. Films, novels, and party slogans began fitfully to downplay political narratives and revolutionary struggle in favor of personal dramas and daily conflicts. Discourse deemphasized the heroic future relative to a comfortable here-and-now. In sum, policy and rhetoric were incrementally and unintentionally, but demonstrably, domesticated.[26]

None of these adjustments righted the wrongs of Stalinist productionism: inability to satisfy consumers' needs and desires; economic inefficiencies; and labor shortages. There never occurred a rethinking of gender relations or their subordinate place in the real and ideal hierarchy of social relations in the GDR. In 1971, nonetheless, a combination of faltering productivity, falling fertility, and flack over consumption prompted a change of leadership and a change of course. Erich Honecker replaced Ulbricht as First Secretary of the Politburo. Under Honecker, the Politburo greatly accelerated the redistribution of resources toward consumption and welfare. Ulbricht had lunged in that direction in the 1960s, only to retreat back into productivist orthodoxy. Honecker made the turn and did not look back. His new course reordered Stalinist priorities without

[25] Winkler, "Forschung."
[26] Feinstein, 6–8, 135, 175, 217.

acknowledging the significance of the reversal; rather than insist that a better standard of living would follow from increased productivity, the media now argued that an improved style of life would generate higher production and reproduction. In typically grandiose language, Honecker dubbed this program the "unity of social and economic policy."[27] The slogan was not just empty rhetoric. The "social" emerged as a key category of state policy in the form of much higher levels of state expenditure on consumer goods, housing, pensions, marriage credits, universal child care, and benefits for employed mothers. In addition, women gained reproductive rights, despite the state's desperate desire for higher fertility.

The climb in consumption and welfare expenditures did not produce the wished-for ascent in production. Rather, productive investment declined relatively and, eventually, absolutely. The "unity of social and economic policy" could be held together only with ever bigger loans from the Federal Republic of Germany (FRG), sending the GDR into heavy debt. The original productivist worldview was as eviscerated as the coffers of the state. "*Soziale Sicherheit und Geborgenheit*" (social welfare and security), the main legitimating claim of the Honecker era, was a homey justification of socialism that the First Secretary incessantly invoked, even after he fell from power.[28] The message contrasted sharply with the class-struggle vision and revolutionary language of the KPD and the young SED.[29]

Women's domestic orientation also seeped into the perspective of ordinary men. By the 1980s, for men as well as women, "private reproductive interests stood at the middle of the [popular] organization of life." In surveys, women *and* men ranked "a harmonious family life" as their primary life goal, rated the satisfaction of private consumer desires as a central concern of daily life, and demonstrated a "notable home-centeredness in defining their lives."[30] The SED's contradictory policies and structures simultaneously reinforced and thwarted people's consumer desires and domestic orientation. Initially, compromise helped stabilize relations between state and society. Over time, however, economic and ideological bankruptcy from above, and private dissatisfactions from below, eroded the foundations of Communism and contributed mightily to its collapse.

The domestic had taken its revenge. This reckoning did not signify a victory for egalitarian gender relations. It did demonstrate, however, that domestic structures—the family's material and emotional labors, gender relations, consumption needs, and private desires—shape society and eco-

[27] Steiner, "Frustration 25; Bouvier, 68, 70–71; Stitziel, "Fashioning," 509; Thaa et al., 53–55.

[28] Bouvier, 295–96.

[29] Thaa et al., 64; Maier, 28–29, 57.

[30] Thaa et al., 154–55, 167–69.

nomic relations as fundamentally as vice versa. The power of the domestic was communicated to the SED state gradually but persistently, and to overwhelming cumulative effect, by the everyday actions, family decisions, consumer choices, arguments, complaints, and occasional open protest of, above all, East German women.

. . .

Since the fall of Communism, scholars of the GDR have debated how to characterize the SED state. Among proposed terms, prominent candidates (and their sponsors) include: modern dictatorship (Jürgen Kocka), educational state (Dorothea Wierling), commodious dictatorship (Günter Grass), tutelary state (Rolf Henrich), provisioning dictatorship (Beatrix Bouvier), and welfare dictatorship (Konrad Jarausch).[31] Each pair says something true about the GDR of the Honecker era, although "welfare dictatorship" best encapsulates, I would argue, its social content and authoritarian form. Every characterization, however, is inadequate, for the GDR was an elaborate institutional entity that existed for four decades. The noun in each pair describes the GDR's state-form, which did not alter between 1949 and 1989, whereas the qualifying adjective refers to state policy, which did change. The GDR was always a dictatorship, but it *became* a welfare dictatorship.[32] No term indicates when or why that occurred. No single modifying adjective can convey, either, the complexity of state policy or its special features at any one time. No description, with the possible exception of Bouvier's, communicates the catering to individual consumption that accompanied welfare measures. None notes the heavily maternalist content of the welfare package.

I offer no alternative terminology. I hope, rather, to illuminate the process by which a superideological, production-obsessed, future-oriented, male-dominated Communist dictatorship came to implement a welfare policy with a maternalist core and notable consumerist features, framed in a "secularized" and domesticated language of "real-existing socialism."[33] My argument emphasizes the domestic causes of this transition in a triple sense: it privileges internal GDR structures and processes, private gender relations, and home-based labor and consumption. These interrelated factors, it posits, are necessary components of any convincing interpretation of the history of the GDR. They are not sufficient causes, but they justify a study that concentrates on them. The analysis proceeds from

[31] Pollack, "Modernization," 56; Jarausch, "Welfare Dictatorship," 60; Bouvier, 329, 335.

[32] Andrew Port makes a similar point. See Port, "Conflict," 614. Also see Thaa et al., 5.

[33] Thaa et al., 54.

several additional assumptions. The mechanism of change was a dynamic, if unequal, relationship between state and society. The basic framework of this relationship emerged between 1945 and 1970 and was decisively shaped by the interaction between socialized production and family-based reproduction. Women carried much of the burden of this interaction from the side of society. Hence, women's relationship to the state is the focus of the book.

The book rests on evidence I gathered in GDR archives, but it also synthesizes the insights, methods, and evidence of social science and historical literature on the GDR, on post-1945 Communism, and on gender relations in industrial societies and welfare states. Within the scholarship on the GDR, a small but substantial subfield is feminist work on the "woman question." The feminist literature characterizes the GDR as a patriarchal state marked by a wide gap between emancipatory rhetoric and discriminatory practice. Feminist scholars have pointed out the contradictions within an ideology that advocated women's equality through employment, while leaving her to perform the bulk of unpaid labor in the home.[34] Communist policies, most studies acknowledge, did improve women's educational, financial, and professional situation relative to 1945.[35] Written largely by political scientists, sociologists, and demographers, feminist research has focused on state decisions and their impact on trends in marriage, divorce, and fertility, on the one hand, and on educational patterns, workforce participation, and SED membership, on the other.[36] I hope to enrich this literature with a history of gender relations between 1945 and 1970 that touches on every major aspect of state policy vis-à-vis adult women as well as on the main facets of their lives, and relates these categories to each other. The book corrects several biases in the feminist literature: a schematic periodization of woman's policy; segregation of woman's policy from general policy; assignment of causal power almost exclusively to structures and the SED; and neglect of the lived experience of women at home, on the job, and in stores.

Most work on the "woman question" puts forward a two-stage model of woman's policy that hinges neatly at the changing of the guard from Ulbricht to Honecker. Ulbricht followed, the scholarship argues, a "woman's production policy," whereas Honecker deemphasized women's integration into production in favor of maternalist measures intended to

[34] See, e.g., Dölling, "Bewusstsein."

[35] A positive assessment can be found in Rosenberg, 136–38, 148–49.

[36] See, e.g., Külke, "Berufstätigkeit"; Gast, *Rolle der Frau*; Helwig, *Familie und Beruf*; Obertreis; Roesler, "Industry,"; Helwig and Nickel; Bütow and Stecker; Trappe; Gerhard; Zachmann, *Mobilisierung*.

make it easier for women to combine employment and family.[37] Feminist analyses, then, see 1971 as the watershed year. They focus not on the origins, but on the consequences of Honecker's maternalist turn. Although broadly convincing, this periodization collapses the contradictory and evolving policies of the Ulbricht years into an intentional and linear trajectory from which Honecker suddenly diverged. This dichotomous chronology ignores the pronounced (negative) pronatalism of the 1950s that tempered Ulbricht's production policy. Authors overlook the origins of the transition to positive natalism and reproductive rights in the 1960s. This perspective tends to downplay the significance of rising state interest in the family under Ulbricht. The literature is also state fixated, assuming that the impetus for change came from above and was structurally motivated. It tends to treat women as passive victims or recipients of state policy, rather than as (constrained) agents.

The feminist literature tends to isolate the "woman question," rather than explore the dynamic interaction between gender relations and social and economic development. It fails to tie changes in "woman's policy" to the question of consumption. Honecker's maternalism appears unrelated even to his broader social policy. These objections do not apply to all authors. In a book published two decades ago and based on printed sources, Gesine Obertreis astutely analyzed the emergence of family policy in the 1960s. The policy historian Horst Laatz attributes the revival of state interest in social science research to concern about women and the family.[38] Above all, social historians of women have begun to redress the structural bias in the literature on gender relations.[39] Social histories have focused largely on women as wage workers. In her superb comparative history of the "housework day" in East and West Germany, however, Carola Sachse tightly links employment and domesticity, showing that women workers struggled around wages and benefits but related them to their domestic role.[40]

Social historians of women have joined a strong current of state-society studies that has invigorated the historiography of the GDR since the opening of its archives in 1990. Social historians reject the classic version of the totalitarian thesis and assume that society was differentiated, active, and even effective, despite being atomized, repressed, and oppressed.[41]

[37] See, e.g., Buehler, 28; Bouvier, 250–52; Schulz, 126; Koch and Knoebel, 94–95. For a "softer" version of this thesis, see Hampele, 287.

[38] Obertreis; Laatz. Also see Helwig, *Familie und Beruf*; Trappe, 63; Schmidt, "Grundzüge," 274, 277, 284.

[39] See, e.g., essays in Budde, ed., *Frauen arbeiten*; Ansorg, "Leitungskader"; Ansorg, "Strukturwandel"; Schüle, "*Spinne*"; Budde, *Intelligenz*.

[40] Sachse, *Hausarbeitstag*. Also see Heineman, *Difference*.

[41] For an overview of recent debates about totalitarianism and *Alltagsgeschichte* in the GDR, see Faulenbach, esp. 19, 21–23. For works that incorporate social history, see Bessel

Using Alf Lüdtke's concept of *Eigensinn* (self-constructed meaning), they define popular resistance and human agency more broadly than have political historians of the GDR. East Germans, social histories have shown, contested state policy in numerous ways: passive resistance, letters of complaint, flight to the FRG, individual sabotage, work stoppages, small protests, and a massive strike wave. These resistances, they argue, made a difference, causing the state to modify its policies at the point of production, attend to consumption, and revise the Plan. They point, above all, to the workers' rebellion of June 1953, which forced policy changes at the time and haunted the SED hierarchy ever after. Thus, they challenge a periodization of the history of the GDR that overemphasizes the Ulbricht-Honecker divide.[42]

This book, too, recognizes the effects on state policy of the massive popular unrest in 1953. It places, however, as much emphasis on the corrosive effect of everyday evasions and resistances, including decisions about consumption, marriage, reproduction, the care of children, job training, and hours of work.[43] It sets these choices in gendered context. Apart from the historians of women among them, social historians generally analyze society from one angle: social class. They do not consider how class interest interacted with gender roles.[44] They presume, as did the SED, the primacy of employment and production over domestic structures and consumption as motivations of popular behavior. When the SED socialized productive relations, they argue, it "remodeled" society and "radically reshaped the social structure." The failure to transform the private sphere goes unmentioned. The family barely registers in social histories.[45] Social historians of the GDR rarely ask how private gender relations or the organization of the family may have influenced workers' demands and actions. In sum, social historians incorporate agency into a model of change over time but define identity in class terms, see agents as workers (not consumers, spouses, parents, or women), treat

and Jessen; Fulbrook; Hübner, *Konsens*; Humm; Jarausch, *Dictatorship*; Kaelble, Kocka, and Zwahr; Lindenberger, *Herrschaft*; Major and Osmond; Naimark; Niethammer, von Plato, and Wierling; Port, "Conflict"; Ross; Weitz.

[42] Kopstein, 11; Ross, 57–59; Hübner, *Konsens*; Merl, 182; Schmidt, "Grundzüge," 284.

[43] For a similar perspective, see Budde, *Intelligenz*, 15.

[44] This neglect continues despite Kathleen Canning's powerful plea for the significance of gender in German labor history. See Canning, "Gender." A minority of general social histories of the SBZ or the GDR do incorporate women and gender: Fulbrook; Naimark; Niethammer, von Plato, and Wierling; Port, "Conflict"; Weitz.

[45] See, e.g., Jarausch, "Gegengesellschaft.,"15; Martin Sabrow, "Konsensdiktatur," 89–90. Quotes are from Pollack, "Modernization," 33, 37. Pollack mentions "the power of persistence and the inherent dynamism of individual social sub-systems" (39) but does not identify the "sub-systems."

industrial relations as the stimulus of resistance, and privilege the shop floor as its site.

Recent consumer studies have pioneered a multidimensional approach to the history of social and policy change in the GDR. Scholars in this new field of research assume an interactive model of state-society relations, treat consumption as a basic constituent of culture and economy, and offer a gendered analysis of consumption and SED discourse about consumption. Recognizing that women were the main shoppers and shapers of taste, historians of consumption argue that women contributed centrally to the partial "consumerization" of the state-socialist economy.[46] I integrate this perspective into the story told here.

Historians tend to see the place and time we study as unique. East Germany, political historians point out, was an atypical industrial country because it was a Communist dictatorship. It was exceptional among Communist lands, they add, because it was a "half-country" and had an especially abject relationship with the Soviet Union. Social and economic historians also resort readily to explanations of SED policies that highlight its slavish imitation of the USSR, its anxious monitoring of events in fellow satellite countries, and its doomed competition with the Federal Republic of Germany.[47] Rather than investigate the structural similarities that may have motivated comparable policies, historians often assume that the SED always willfully copied the policies of some other, more autonomous, state. Comparative studies of East and West Germany have begun to correct this bias. In the case of gender relations, the German-German comparison has produced illuminating studies of marital motivations, consumer culture, youth culture, and the housework day.[48] Seldom, though, have historians (as opposed to social scientists) considered the GDR in comparative Communist context or, alternatively, as one among other industrialized societies.[49]

This book is not a comparative study, but its argument has been inspired by both theoretical and empirical analyses of postwar Stalinism. The interpretive argument that has most influenced mine is Kornai's. The

[46] Kaminsky, *Kaufrausch*; Merkel, *Utopie*; Pence, "You"; Stitziel, *Fashioning*; Crew, "Introduction." Literary critics and historians of culture, too, incorporate a gendered analysis into a dynamic interpretation of state/society relations. See, e.g., Feinstein; Hosek. Authors of several economic histories recognize the significance of consumption to the changing policies of the party elite but do not discuss gender or the family. See Kopstein; Landsman, *Demand*; Steiner, *Plan*.

[47] Steiner, "Frustration," 25; Merl, 183; Wettig, 383–4; Bouvier, 79; Kaiser, "Einfluss," 133.

[48] Heinemann, *Difference*; Pence, "Rations"; Poigert; Wierling, "Generations"; Sachse, *Hausarbeitstag*.

[49] Comparative "parallel" studies have begun to appear. See Brenner and Heumos.

interaction between the private family and socialized production contrib-
uted significantly, he contends, to the gradual deviation from classic Sta-
linism in every Eastern European land. A partial socialization of the fam-
ily occurred over time, but its effects, he suggests, differed less in kind
than in degree from the commercialization of consumption, housework,
and child rearing that has transpired in advanced market economies since
the 1950s.[50] Empirical studies of gender policies and domestic relations
in postwar Eastern Europe and the USSR reveal similar contradictions as
those in the GDR. The same studies, conducted mainly by feminist schol-
ars, trace comparable consumerist dilutions of hard-line productivist poli-
cies after 1960. Every state-socialist land also implemented social and
family policies with a maternalist core in the 1970s.[51] Moscow did not
always set the pace in these changes.[52] In some policies, East Berlin led
the way and, certainly, Honecker put together a more generous welfare
package than did Brezhnev or Gorbachev.

Many scholars would attribute the size of the welfare package in the
GDR to rivalry with the FRG, a developed welfare state by 1970. The
GDR's evolution toward welfare policies paralleled, in fact, similar trends
in most European states, though the timing and form of its welfare policy
reflected state-socialist structures and Stalinist ideology. To make sense of
these comparable tendencies across the Iron Curtain, I have turned to
feminist interpretations of the Western welfare state. Mainstream expla-
nations attribute the rise of welfare states to a political imperative within
democratic countries to temper the class inequalities of classical capital-
ism. As does the typical state-society study of the GDR, this interpretation
of the welfare state treats "class" as the "only relevant social division and
only possible basis for a politics of 'interest.'"[53] Susan Pedersen and others
have challenged this assumption, contending that, as the traditional pro-
vider of welfare, nurture, and unpaid labor, the family "warrants consid-
eration as an independent variable." Changes inside the family, suggests
Jane Lewis, influenced state policy, not only vice versa. The wife-mother,
she adds, typically initiated familial change. Hence, women's private deci-
sions indirectly produced political consequences.[54] Feminist studies of the
modern welfare state extend the insights of a rich historical scholarship

[50] Kornai, 106–8. I have been influenced, as well, by Katherine Verdery's argument
that struggles around consumption profoundly affected the evolution of state-socialism. See
Verdery.

[51] Heitlinger, *Sex Inequality*; Lapidus; Haney; Ingham, Domański, and Ingham.

[52] See, e.g., Reid, "Cold War."

[53] Pedersen, 5–7, 12, 20; Lewis, 160, 167. Also Gordon; Koven and Michel.

[54] Quote is from Lewis, 161–62. Also see Pedersen, 12.

that explores the intricate push-pulls among the family economy, domestic work, consumption, industrialization, and state decisions from the seventeeth to the twentieth centuries in Europe and North America.[55] The theories and findings of this sophisticated body of feminist research have shaped my conceptualization of the dynamic evolution of everyday lives, women's labors, and state policy in the GDR.

. . .

The book's organization is chronological as a whole and thematic within each period. A chapter on 1945–49 and a chapter on 1961–71 bracket five chapters that cover 1949–61, the period from the formation of the GDR in October 1949 to the construction of the Berlin Wall in August 1961. The first chapter discusses the many-sided confrontation between Communists and women under the relatively free, if also chaotic, conditions of the postwar era. Each chapter on the 1950s treats a major area of policy that affected women. These areas are presented in order of state priority: politics, production, reproduction, consumption, and family. The book's focus on the "long" 1950s is motivated, first, by that decade's character. Between 1949 and 1961, the SED created the basic structures and set the fundamental lines of development of the GDR's economy and society. These transformations provoked considerable resistance. The quality of the documentary record is the second reason for the focus on the 1950s. In abundant reports, (predominantly female) party, state, and union officials wrote about women's views and actions, the activities of SED women, male behavior, and tensions within state-party policy. The documentation is specific, descriptive, and revealing. Like other students of East German history, I was struck by the "honesty" and "richness" of reports from the 1950s, in contrast to their formulaic and "ritualistic" tenor in the 1960s.[56] However revealing, most documents were generated by officials and must be used critically. Surprisingly, their partiality does not always lean toward the "rose-colored" picture. Memoranda and reports by women functionaries often emphasize misogyny, negative incidents, failures of SED or trade union policy, and women's disgust with conditions. Whatever the bias, I try to balance conclusions by drawing on other sources, such as statistics, citizens' letters of complaint, and interviews.

[55] Representative of a vast literature on Germany, France, and Great Britain: Quataert; Canning, "Gender"; Sachße, "Mothers"; Coffin; Finn.

[56] Allinson, 9; Ross, 184.

The final chapter focuses on what changed from the 1950s to the 1960s. Its weight tips more toward state policy than popular behavior. This shift reflects the decline in the quality of local reports. More positively, state policy gains attention because it became less heavy-handed, ideological, and single-minded, and more motivated by real social problems and even characterized by lively discussion among "experts" and experimental implementations of their recommendations.

The Trying Time

SURVIVAL CRISES AND POLITICAL DILEMMAS

UNDER SOVIET OCCUPATION

MOVEMENT. Months before the end of the Second World War, German civilians were on the move. Hundreds of thousands of Germans from East Prussia, Silesia, and Poland loaded themselves and their possessions onto trucks, wagons, horses, and human backs and set off westward, fleeing the Red Army as it closed in from the east and southeast. In the region that would become the Soviet zone of occupation (SBZ), people not only bolted westward from the Russians, but also outward from cities pounded by American and British bombers. Eventually, the Americans and the British appeared on the ground, massed in tanks that lumbered relentlessly eastward. To all this motion add the maneuvers of *Wehrmacht* divisions as they retreated into Germany, made occasional, desperate stabs at the advancing Soviets, and became entangled with civilian caravans. At the end, soldiers and Nazi officials ran alongside the civilians, indeed, left them in the dust, having snatched their bicycles and clogged the roads with the ballast of war. After the Third Reich finally capitulated, thousands of forced laborers from Poland and the Soviet Union, as well as an international array of prisoners of war, took off homeward or toward a victorious army. Also stumbling forth into freedom were thousands of inmates of concentration camps.

These vast crisscrossing motions of victors and vanquished, civilians and soldiers, Germans and everyone else were only the most obvious movements to blur the landscape. Desperate to hide their past, members of the National Socialist German Workers Party (NSDAP) ripped off party insignia, burned uniforms, and smashed photographs of the *Führer*. Consider the reverse motions of Communists, Social Democrats, and other anti-Nazis as they returned from exile, exited camps and prisons, or stepped out of "inner emigration." The leaders of the German Communist party (KPD) arrived from Moscow, maneuvered to control and expand their movement, and cogitated about how to build a new social order.[1] The victory of the Red Army also stirred up movement from below.

[1] Hermann Weber, *Geschichte*, 57–58.

Workers' committees reopened abandoned factories. Landless laborers seized rural estates. These popular actions compounded a wave of downward mobility that swept over middle-class Germans who lost assets in war and flight, witnessed the devaluation of their money by postwar inflation, and abandoned professions that possessed no currency in the ruined economy.

If we can break down these retreating and advancing, rising and falling movements along military, ethnic, political, and class lines, we can also look at them in gendered terms. Most obviously, the civilian and military movements offered a contrasting sexual picture. Armies and their staffs were virtually all male, the civilian masses lopsidedly female. Emerging political parties were predominantly male. Emergency work crews that cleared the cities of rubble were famously female. The majority of "antifascist factory committees" were male, but "antifascist women's committees" helped refugees. The millions of refugees and expellees pouring in from the Eastern territories and Sudetenland were even more predominantly female than the native civilian population. In 1946, an East German population of nineteen million was composed of three million more women than men, whereas a West German population of forty-six million was made up of two million more women than men. It might be said, then, women in the SBZ had an ""hour"" that was even more exclusively theirs than women in the western zones had.[2]

From another perspective, one could question whether any woman had even an hour for herself, a caveat that, again, applies all the more to East German women. Because there were proportionately more of them, they had to perform more of the work of survival. And, because more women in the SBZ were refugees, they had fewer resources with which to negotiate the scarcity, black market, and chaos. In addition, the eastern zone was occupied by an exhausted army from a country devastated by German legions. In contrast to American or British forces, the Red Army had few surplus military stocks to share with conquered civilians. Much worse, its vengeful, exhausted, and impoverished soldiers visited their wrath on women in a violent swell of rape.

Despite all this, East German women cannot be dubbed innocent victims of the timeless misogyny of war or the particular horrors of World War II. Women did not deserve the violence that descended on them in 1945. The label "victim" will not, however, stick. German women had not ruled the Third Reich, operated the SS, or manned ravaging troops or murdering police units, but they had benefited from, collaborated in, and, in some cases, perpetrated the crimes carried out under the aegis of

[2] On the "hour of the women," see Freier and Kuhn; Möding; Kuhn; Moeller, *Motherhood*; Heineman, "Hour."

the racist hierarchy Hitler imposed on Europe.[3] In both public and domestic roles, women in eastern Germany were implicated in the state and society that Soviet tanks rolled over in 1945. In the countryside, for example, women had joined the Nazi *Frauenschaft* in high numbers. As farmers who ran farms in the absence of men and who relied almost exclusively on forced labor, rural women could be very nasty in their attitudes and actions toward, especially, Polish farm workers. Not just women's behavior during the war, but also their activity afterward subvert their victimhood. Women did not passively accept what befell them in 1945; rather, they maneuvered around disaster, negotiating a path that neither they nor the more prominent historical agents had traversed before. They improvised and strategized, at first, to make it through one day at time and, later, to carve out a life for themselves and their families. Many historians now recognize that the Soviet military command (SMAD) initially followed no grand plan, but several, sometimes inconsistent, agendas.[4] Women, hence, interacted with administrative and economic institutions that were in formation, not set in stone.

Neither the Soviets nor the German Communists could simply impose plans, for they initially required popular participation for their realization. Women exercised power in no political organization or party, yet their very numbers as potential voters and workers alerted the Russians, the German Communists, and, in fact, every party to women's situation. The Communists (who in 1946 joined with many Social Democrats to form the SED) had little experience organizing women and proceeded cautiously in their bid to win them to the antifascist transformation of Germany.[5] SED leaders such as Walter Ulbricht, Wilhelm Pieck, Anton Ackermann, and Otto Grotewohl held forth about secularization, expropriation of Nazi property, and women's equality. Women did not heed this radical (though not revolutionary) message. Instead, they listened to moderate and, especially, religious candidates. Seeing the impasse, Soviet occupiers and German Communist *women* persuaded the SED leadership to adopt moderate strategies such as focusing on the food question and forming a nonpartisan organization for women. Experimentation opened a space that allowed political women to represent ordinary women in protofeminist terms. Trial and error dominated politics in the years of

[3] On women in the Third Reich, see Stephenson; Dörte Winkler; Bridenthal, Grossmann, and Kaplan; Bock, *Zwangssterilisation*; Koonz, *Mothers*; Czarnowski, *Paar*; Heineman, *Difference*. On the debate about judging women as victims, beneficiaries, collaborators, or perpetrators of Nazi crimes, see Koonz, *Mothers*; Bock, "Frauen"; Grossmann, "Debates"; Ann Taylor Allen, "Holocaust."

[4] See Naimark; Weitz; Meuschel, *Legitimation*, 41; Loth; Hermann Weber, *DDR*.

[5] Genth, "Frauen," 116.

intense social crisis and fluid politics from 1945 to 1947. In that year, the accelerating Cold War and the SED's methodical accumulation of power began to constrict the ability of women activists to cooperate in nonpartisan women's groups or promote a woman's agenda. Everyone had to take sides, especially after the Allies split decisively over how to govern Berlin in 1948 and sanctioned the creation of two hostile German states in October 1949. By then, the SED leadership had lost interest in women as a political factor and quashed any tendency toward feminist autonomy.

CROSSING THE BOUNDARY BETWEEN PAST AND PRESENT

It is striking how often tales of flight in 1945 revolve around a mother/daughter duo. These stories share so many of the same features that, together, they build a collective legend. Separately, each narrative presents a particular intergenerational drama of the transition from war to peace, from Nazism to military occupation and social upheaval. Frau R., for example, grew up in Mecklenburg on a large farm, not, she is careful to point out, an estate. As a fourteen-year-old, she set off during the last days of war with her mother, father, older sister, older female cousin, and two male Polish forced laborers in a car heading—where else?—toward the west. They had reason to flee: her father had been mayor of their village and, albeit unwillingly, a member of the NSDAP. Frau R. saw the flight as a "great adventure." They made it to Schwerin, in American hands, but they and thousands of others were kicked out because of the danger of typhus. All sense of adventure dissipated and was replaced by fear. On the way back home, the Poles, though free to go, protected the German family from Russians. They arrived at the home of acquaintances who, they discovered, had committed group suicide. Frau R.'s parents wanted to follow suit, but she refused. They returned home to discover Soviet troops in the farmhouse. Her family, still accompanied by the Polish workers, moved into the village home for the indigent. As long as the Poles remained in the village, Frau R. claims, life was bearable: they brought food to the family and protected her father. At the end of September, the Poles left for Poland, and conditions deteriorated. The family's prewar day laborers confiscated the farm, although its fewer than 100 hectares exempted it from the 1945 land reform (Frau R. insists that the KPD played no role in this expropriation). The laborers informed the Russians about her father's past. The Soviets sent him to a camp, where he died.

In early November, Frau R., her mother, and her sister were evicted from the county. After trekking around, they stole into Berlin and lived with relatives. Without papers, they received no ration cards. She scrounged in the rubble for plates, cups, and spoons, which helped to get

her mother and sickly sister through the emergency. Finally, they snuck back into their home county and lived with an aunt on her homestead. Frau R.'s sister returned to Berlin to become a seamstress. After Frau R. and her mother got a residence permit, the fifteen-year-old found a job in the local savings bank. She applied to attend her old gymnasium but was turned down because of her social and political background. One day, a former laborer espied her at the bank, and mother and daughter were expelled again. In Berlin once more, Frau R. supported the shrunken family with a factory job.[6] The enterprising daughter had become the emotional and financial mainstay of a depressed mother in a world gone topsy-turvy. Their story forms one piece of the mosaic that was women's postwar experience.

THE SOCIAL CAULDRON

No woman was raped in the family of Frau R., yet each feared she might be and took precautions against it. Dread of the Russian hordes was pervasive, bred by racism and stoked by Josef Goebbels's propaganda machine. Unfortunately, dread became reality. Soviet forces did not rape only German women, nor did only Red Army soldiers rape them. Still, Soviet forces raped many more Germans than they raped other women, or than other soldiers raped Germans. One can only conclude that soldiers (with no orders from above) used sexual violence as a weapon of revenge for *Wehrmacht* ruination of the USSR. The first wave of mass rape swept over East Prussia from January to March 1945. As the troops entered a village, they often raped every female over twelve, killing many, then looted stores and homes for food and alcohol before torching the community. The second wave occurred in what became the SBZ, especially in Berlin during and immediately after the fierce fighting of the Battle of Berlin, which killed 500,000 people and infuriated Soviet soldiers. Eighty percent of the women raped in Berlin were attacked between 24 April and 3 May, the first day of peace.[7]

The violence did not end in May 1945. Rapes occurred wherever troops were billeted. Drinking increased the incidence of rape and pillage. The situation improved as Soviet administrators replaced field commanders.

[6] Interview Frau AR. On the land reform in Mecklenburg, see Naimark, 152–53. For women's stories of the transition from war to peace, see, e.g., Stolten; Krockow.

[7] Naimark, 68–70, 72–74, 78–80, 83, 85, 75, 26, 109, 81–82, 91–93; Anonyma; Genth and Schmidt-Harzbach, "Kriegsende," 32; Schmidt-Harzbach, "Woche"; Kirsten Poutrus, "Massenvergewaltigungen," 176; Grossmann, "Question"; Hoover Institution Archives, William Sander Collection, Box 1, Folder Special Reports 1945–49: Bericht . . . Mecklenburg . . . Mai 1945–Nov. 1946, 4; Bericht . . . Königsberg/Preussen . . . April 1945, 2.3.46 (written by a Communist), 2; Abschrift: (written by a Social Democrat), 4.

They cracked down on undisciplined troops, but they did not punish those who had already raped, much less did they acknowledge the extent and intensity of the brutality. Communist authorities often claimed that deserters, displaced persons, forced laborers, or Germans in Russian uniforms perpetrated the banditry and violence attributed to regular Soviet troops. Women did not feel secure until Soviet troops moved into in encampments in late 1947 and early 1948. We do not know how many women were raped. Most likely the number reached into the hundreds of thousands, though Helke Sander and Barbara Johr have estimated that it topped two million, including 1.4 million raped in the former eastern territories and on the trek, 100,000 in Berlin, and 500,000 in the rest of the SBZ.[8]

The mass rape was followed by mass recourse to abortion. Most of the thousands of women who were impregnated wanted to terminate the pregnancy, and many did. Assisted by sisters, mothers, and friends, women performed abortions on themselves. Or they turned to midwives. Although Germany's antiabortion law, Paragraph 218, was still in effect, physicians, too, performed thousands of procedures in what Atina Grossmann has termed "a fast assembly line" of terminations. Doctors seem to have operated out of sympathy with the raped women and hatred of their Slavic rapists.[9] Among applicants for an abortion were many pregnant women who had not been raped but did not want to have a baby in the midst of scarcity. Estimates put the number of abortions in all Germany at two million per year from 1945 to 1949.[10] Outside Berlin, it remained difficult to get doctors to perform an abortion. Church, especially Catholic, organizations urged women to carry to term and promised to take in the baby. Many a woman gave birth to a "*Russenkind*" against her wishes, but then decided to raise the child. In October 1946, there were 3,000 children with Russian fathers in Mecklenburg, just under 900 of whom were in foster care or an orphanage. The Russian children appear not to have suffered ostracism as they grew up.[11]

The massive influx of refugees created a second serious social problem in East Germany. By summer 1945, tens of thousands of refugees and "expellees" were arriving every day in the SBZ. Villages and small towns in Mecklenburg and Brandenburg reported five times their normal popu-

[8] Naimark, 117, 104–5, 133; Genth and Schmidt-Harzbach, "Kriegsende," 31.

[9] Kirsten Poutrus, "Massenvergewaltigungen,"178–85; Grossmann, *Sex*, 193; Schmidt-Harzbach, "Woche," 65–66.

[10] Naimark, 123. Also see Heineman, *Difference*, 127; BArch, DQ1/323, Bl. 128–37, Deutsche Zentralverwaltung für Volksbildung, Abteilung Frauenausschüsse, Protokoll 3.9.46.

[11] Hall, 146–151; SAPMO-BArch, NY4145/50, Bl. 34, Protokoll über die Sitzung des Rechts- und Verfassungsausschusses 12.6.47 . . . Halle (S-A); Naimark, 124.

lation and had no supplies, no water, no medicine or medical personnel, and no place for the extra bodies to sleep. Thousands of people piled up at the borders to the American and British zones. By November 1945, 4.59 million refugees were in the SBZ. Hundreds of thousands moved further west, but by 1949 around a million more had arrived from Czechoslovakia and Poland.[12] In 1946, refugees composed twenty-one percent of the population of the SBZ. The gender ratio was 142 women to 100 men (natives: 133 to 100). Among people aged twenty to forty, there were more than two women to every man. Until prisoners of war began to return, the imbalance became ever greater, for young refugee men were more likely than young women to move to the western zones. The refugees arrived with larger families than the natives, but their birth rate soon plummeted. The refugees and their babies were in poor health. They were not only more likely to be exposed to typhus, but more likely to die from it than were members of the native population.[13] By 1949, many refugees had moved further westward, but almost four million refugees and expellees remained in the SBZ/GDR, a massive number in a total population of 19 million.[14]

SMAD directed refugees into rural areas. Native farmers appreciated extra hands for the harvest but then wanted the refugees gone. Refugees and natives accused each other of enthusiastic support of National Socialism. In fact, neither side showed much sense of the "national community" so vaunted by the Nazis. Natives believed that Poles and Czechs had justifiably driven out Germans, whereas refugees believed that they should, and would, soon return home.[15] Of course, church, humanitarian, and women's groups provided aid; the refugees also formed self-help committees.[16] Initially, they were housed in hundreds of former army barracks that were short of beds, blankets, chairs, heat, just about everything. By 1947, ninety percent of the refugees had been moved into apartments, mainly cramped subleases. Thousands lived in cellars, attics, and livestock stalls. Generally, the housing situation was a disaster. Several million more people needed housing than before the war, but the housing stock had declined by twenty percent.[17] The situation was the worst in cities pulver-

[12] Hall, 34; Wille, Hoffmann, and Meinicke, "Flüchtlinge," 12–13, 16–17; Wille, "Zentralverwaltung ," 28, 36–37; Naimark, 148.

[13] Pape, 123; Seraphim, 55, 15, 64; Wille, "Zentralverwaltung," 38–39; Hall, 40, 83, note 38.

[14] The SED did not collect census information on refugees and expellees. It estimated that there were 4.3 million in 1949; Seraphim's estimate: 3.85 million (Seraphim, 62, 63, 65).

[15] Christopeit, 99, 50, 102, 105.

[16] Seraphim, 24, 27; Pape, 128–29.

[17] Seraphim, 42; Wille, Hoffmann, and Meinicke, "Flüchtlinge," 19, 21; SAPMO-BArch, DY30/IV2/17/56, Bl. 97, Maria Krick. Bericht . . . Quarantänelagers Quenz in Brandenburg, 24.5.47.

ized by Allied bombs. Magdeburg, for example, had lost fifty percent of its apartments, and Dresden and Berlin had lost sixty-five percent each.[18]

Urban dwellers worried less about where they would sleep, however, than how to get their next meal.[19] The territory of the SBZ included Germany's rye and potato baskets; also, the Nazi rationing system remained more or less intact.[20] Inhabitants of the SBZ fared less badly than people in western Germany in the postwar food crisis. Nonetheless, they ate exceedingly poorly. In May 1945, crop production stood at fifteen percent of the level of 1939; by December it had risen to only twenty-five percent.[21] Crops could not be harvested, because tractors had no fuel. In addition, female workers were harassed in the fields. According to a report, "soldiers steal supplies, cattle, and other provisions. Sometimes the commander intervenes, but it is too late." Sequestration of bank deposits meant employers could not pay workers who, short of cash, skipped work to search for food. The two biggest cities, Dresden and Berlin, were accorded top priority in provisioning, but that did not initially make much difference. Dresden experienced severe shortages in summer 1945, after the Red Army stopped protecting its deliveries. Long lines snaked out of every bakery. Vegetable oil, oatmeal, and even potatoes were in short supply. City residents plowed rubble lots into vegetable plots. By 1946, one million Berliners scratched extra food from 250,000 gardens.[22] Still, ninety percent of the women who visited health clinics in Berlin were underweight, and eighty percent had stopped menstruating. In early 1946, eleven of every hundred infants born in the city died. Women lamented, "Why should we bear children just to bury them?" Not many of them did bear children, whether because of lack of sex, abortion, contraception, or infertility caused by malnutrition. By 1948, fertility in the SBZ had fallen to 54.2 births per one thousand women fifteen to forty years old.[23]

After improving in 1946, the food crisis worsened in 1947, owing to a cold winter followed by a dry summer. People lived off potatoes. They skipped work to scrounge for food, shoes, fuel, and soap, and to play the black market. Women workers joined housewives in the desperate search for sustenance for their families. Firms enticed employees into the factory

[18] Barthel.

[19] Quoted in Genth and Schmidt-Harzbach, "Kriegsende," 29.

[20] Naimark, 88; Peter Hübner, Konsens, 131.

[21] Meinicke, "Bodenreform," 55.

[22] LStA. Versorgung 1945–46. Bestand: Kreisverwaltung Leipzig-Land, 1070 Bl. 42, Besprechung . . . 23.8.45.

[23] SAPMO-BArch, DY30/IV2/17/55, Bl. 12, Bericht über die Sitzung der Zentralen Frauenausschuss am 9.2.46; ibid., Bl. 15–16, 15.2.46; ibid., Bl. 22–24, 18.2.46.

or office by offering food that they had obtained by bartering production goods such as gasoline and grease.[24]

The family crisis was as much psychological as physical.[25] The divorce rate rose rapidly, with most suits filed by husbands. The annual number of divorces in the SBZ increased from 29,494 in 1947 to 49,860 in 1950. Urban couples could receive marriage and sex counseling at centers hastily set up in every zone. According to physicians and social workers, the "psychological causes" of sexual dysfunction and marital discord made it difficult to treat clients. Wives often rejected the sexual advances of unsightly husbands, and husbands refused to live with violated wives.[26] It was not, however, as if no one had sex. Fleeting affairs occurred more frequently than earlier. In 1946, three times as many babies were born out of wedlock as in 1939.[27]

Women preferred sex with a man who had more to offer than love. Favored candidates were cigarettes, food, money, or goods that could be traded for these items. Thousands of women moved in and out of prostitution. Others walked the streets full-time. Around 100,000 prostitutes were active in Berlin. Rape, prostitution, and sexual promiscuity produced an epidemic of sexually transmitted diseases (STD). In 1946, of every 10,000 people, one hundred had contracted an STD. Every occupying army ordered the German police to raid bars, round up anyone suspected of carrying syphilis or gonorrhea, and have them examined by a physician. These measures focused almost exclusively on women. Physicians and women activists complained about the violation of women's civil rights and the hands-off policy toward "johns," most of whom were soldiers. Military authorities ignored the objections. SMAD was especially energetic in forcibly treating, fining, and, in 1948, imprisoning anyone who knowingly infected a Soviet soldier. It required doctors to name infected patients. These decrees were accompanied by public hygiene measures. Every big city opened treatment centers. Posters and press articles alerted people to the danger of venereal diseases and tried to convince them that open treatment was better than silent suffering. The police measures were unfair and obtrusive but, in combination with public hygiene, they worked. By 1947, the rate of infection in East Berlin had fallen below that of 1934.[28]

[24] Hübner, *Konsens*, 20, 131, 138–39.

[25] On the postwar family crisis in Germany, see, e.g., Thurnwald; Willenbacher; Heineman, *Difference*, 108–27; Meyer and Schulze.

[26] SAPMO-BArch, DY30/IV2/17/51, Bl.162, 1.2.47. Richtlinien für Eheberatungsstellen; Bl. 216, 19.5.47.

[27] Naimark, 126–28; Kirsten Poutrus, "Massenvergewaltigungen," 175.

[28] BArch, DQ1/323, Bl. 115. Abt. Frauenausschuss ... Gesundheitskommission, 15.10.46; Bl. 117, Entschliessung . . . 1946; Bl. 69–79, Protokoll . . . 15.7.47, S. 1–2; DQ1/137, Bl.12, Richtlinien . . . Arbeitskolonne Schönebeck; Bl. 11, Landesregierung Sachsen-

Life had its entertaining, educational, and uplifting moments. Indeed, in the cities, especially Berlin, culture and leisure activities sprang forth to fend off misery (*Figure 2*). The Soviet command quickly licensed a broad array of activity. Theaters performed classical and modern plays. Movie houses ran Soviet and American films. Orchestras played. Writers and intellectuals held forth, and artists exhibited. Attendance was excellent, and women were well represented.[29] By February 1946, twenty-five adult education centers, many with several branches, offered hundreds of courses to 40,000 Berliners. Another 10,000 city residents attended the centers' special lectures. Three-fifths of participants were female. Women were overrepresented in courses in language, literature, and the practical arts. They crowded into courses on psychology and religion.[30]

Germans, especially women and refugees, seem to have hungered for spiritual guidance of every sort. The established churches and dozens of sects worked feverishly to meet this desire. In the poorest pockets of the SBZ, women cottage laborers and factory workers flocked to hear preachers. Among established groups, Catholic Youth was especially active, for one-third of the refugees were Catholic (in contrast to few natives of the SBZ). Among the sects, the Jehovah's Witnesses, persecuted by the Nazis, were the most energetic. The meetings and Bible readings of this pacifist, antipolitical, American-based sect consistently drew hundreds of listeners. Communists worried that the religious revival threatened their efforts to engage women in the politics of the new era.[31]

POLITICAL CONUNDRUMS

As women crept out of bunkers and Communists staggered out of concentration camps, they eyed each other across a wide political divide. The relationship between women and the KPD, indeed, the entire organized

Anhalt, Mf AuS . . . 16.9.49: Bl. 5, Dr. Fräser an Landesgesundheitsamt des Lands Sachsen-Anhalt, 10.10.49. Also see Timm, "*Bevölkerungspolitik*," 185, 188–89, 193, 194; Falck, 24–25, 27, 32.

[29] Genth and Schmidt-Harzbach, "Kriegsende," 36; Clarke; Huchthausen.

[30] SAPMO-BArch, DY30/IV2/17/55, Bl.38, Bericht . . . Zentralen Frauenausschusses, 7.3.46.

[31] SAPMO-BArch, DY30/IV2/17/54, Bl. 219, 221, Bericht . . . Sachsen vom 6–10.10.47; Sonderinformation aus Dresden: 15.1.48, Bl. 231; DY30/IV2/17/117, Bl. 7, 29.4.48, SED Zentralsekretariat Abteilung Werbung, Presse, Rundfunk. Allgemeine Information über die Tätigkeit und Verbreitung der Kirchen und Sekten in SBZ; Bl.19, Frauensekretariat/ Zentralsekretariat der SED an LVS der SED Sachsen-Anhalt Abteilung Frauen, 27.8.48; Bl. 24–25, Bericht . . . 3.10.49; Bl. 27, Abschrift, SED Kreisvorstand Brbg/Havel [4.5.49]; Bl. 28, Stefan Heymann, "Zeugen der Wall Street," *ND*, 16.9.49; DY30/IV2/17/51, Bl. 517, 26.8.49, Bericht . . . Zeugen Jehovah an einer DFD Versammlung.

workers' movement, was historically weak. Before 1933, the KPD was never more than seventeen percent female and drew fewer women's votes than any other major Weimar party.[32] On the left, women had preferred the moderate SPD. On the right, women had remained loyal to the established bourgeois parties, especially the (Catholic) Center.[33] Twelve years of Nazi diatribes against Marxism, Social Democracy, Communism, and the Soviet Union had not improved the average woman's opinion of the Left. The actions of the Red Army hardened alienation into antagonism. The typical Communist male activist resented female immunity to the Marxist message. As did bourgeois patriarchs, Communist and Social Democratic husbands associated femininity with an apolitical, family-oriented worldview. In addition, left-wing men saw women as religious, retrograde, and antisocialist.[34] Just as Nazi propaganda had whipped up anti-Marxism, so it had reinforced the gender biases that were bundled together in "proletarian antifeminism."[35] Nazi propaganda about women's place and men's roles, not to speak of the masculine world of the battlefront, had surely nourished the patriarchal tendencies of the thousands of Communists and Social Democrats and millions of workers who fought in the *Wehrmacht*. Left-wing workers claimed, nonetheless, that women, more than men, had succumbed to Hitler's irrational appeal. In fact, before 1933, women voted for the NSDAP initially at a lower rate than did men, and never at a higher rate. But who listens to facts?

In 1945, the KPD leadership and its superiors, the Soviet authorities, wanted to close its gender gap, if only because women composed sixty percent of the electorate in the SBZ. The SMAD aimed several decrees, such as its famous declaration of equal pay for equal work, squarely at women's sympathies. Yet men at the top of the KPD and the Soviet hierarchy were reluctant to revise policies that alienated women. They were unwilling, above all, to censure the actions of the Red Army. Communist women had to chart a political path between their movement's suspicion of women and women's anti-Communism. They disdained the misogyny of Communist men and criticized the inconsistent gender policies of the party leadership and the SMAD. Still, they felt that women, like all Germans, required a political reeducation.

In contrast to the American and British occupiers, SMAD quickly sanctioned the formation of democratic political parties. In summer 1945, the Communist party, the Social Democratic Party (SPD), the Christian Democratic Union (CDU), and the Liberal Democratic Party (LDPD)

[32] On the KPD and women in the Weimar republic, see Weitz, 188–232; Kontos.

[33] On voting in the Weimar republic, see Falter; Sneeringer.

[34] Knapp, 293–94. Also see Hagemann.

[35] Werner Thönnessen coined the phrase "proletarian antifeminism." See Thönnessen.

were licensed to hold meetings and publish newspapers in preparation for the first election, to be held in fall 1946. The KPD enjoyed clear advantages, owing to its strong ties to the Russian occupiers. Leading German Communists who had been in exile in the Soviet Union landed in Germany on 30 April 1945 and worked closely with Soviet commanders and Russian military and party administrators. Communists soon came to predominate among German bureaucrats, mayors, and police appointed by the Soviets. The KPD propagated a gradual "German road to socialism" and presented itself as a mass socialist organization, not a Leninist vanguard party. It called for a populist, egalitarian, antifascist transformation, not a proletarian, anticapitalist revolution.[36] SMAD backed up this position with a land reform that expropriated aristocratic and Nazi-held estates and distributed them to landless natives and refugees to work as individual, not collectivized, plots.

KPD propaganda addressed women in a language that ignored class and political divisions. Party speakers called on all women to join in the construction of a new Germany.[37] The other parties also targeted women. The Woman's Secretariat of the SPD noted, "Interest in women is the trend."[38] Women's preference for moderate and religiously affiliated parties reasserted itself, and the LDPD and the CDU drew in more women than the KPD or SPD. Christian Democracy faired particularly well. It emphasized its Christian worldview as much as its democratic one and took advantage of the fact that many women were members of the Catholic charitable organization *Caritas* or the Lutheran Women's Aid.[39]

Women stepped into civic society as soon as it began to reconstitute itself in the summer of 1945. Religious groups and "antifascist women's committees" (AFA) provided aid to women and children, especially in the cities and in the refugee camps. They cajoled the authorities to provide food and shoes for children, ran soup kitchens, set up sewing rooms, and opened kindergartens, children's homes, and women's shelters. They counseled women on legal matters, helped them locate lost children and husbands, and offered cultural programs.[40] The most successful action of

[36] Hermann Weber, *Geschichte*, 70–71, 53–55, 81, 96; Hermann Weber, *Einheitspartei*, 11; Naimark, 10.

[37] Genth and Schmidt-Harzbach, "Frauenausschüsse," 115. Also see Gast, 51, 46; Elli Schmidt, "Frauen und Gemeindewahl," *NW* (Aug 1946), 3.

[38] SAPMO-BArch, DY30/IV2/17/10, Bl.13, January 1946, Frauensekretariat SPD.

[39] SAPMO-BArch, DY30/IV2/17/80, Bl. 21–24, Zur Frage der Schaffung einer Frauenorganisation, 1.9.46; DY30/IV2/17/54, Bl. 219, Bericht von der Instrukteurfahrt nach Land Sachsen vom 6–10. Okt. 1947; Nr. 20. Stenogramm des politischen Lageberichts von S. Tjul'panov vor der Kommission des ZK der KPdSU (B) . . ., 16/17.9.1946, in Bonwetsch, Bordjugov, Naimark, 81.

[40] SAPMO-BArch, DY30/IV2/17/55, Bl. 12, Bericht über die Sitzung des Zentralen Frauenausschusses am 9.2.46; Bl.22–24, 18.2.46, Die Lage der Frauen in Berlin; DY30/IV2/17/52, Bl. 47–50, Bericht . . . Sachsen [Dec.] 1946; Bl. 69, SED Frauenbericht Jan 1947; DY30/

the Berlin AFA was its "Save the Children" campaign that collected toys, food, and clothes, organized Christmas parties, and found homes for orphans. By September 1946, the AFAs included, a leading Communist claimed, 300,000 women in 6,000 committees throughout the SBZ.[41] These women spanned the social spectrum: housewives, farmers, factory workers, office workers, and teachers.[42] According to Elli Schmidt, the most prominent female Communist at the time, the AFA bubbled up from below.[43] It is true that the initial spark to the AFA came from former camp and prison inmates, not a political party.[44] Yet Schmidt's claim was somewhat disingenuous. The Berlin Magistrate, controlled by SMAD, ordered the formation of these committees from above, even as they were cohering from below. In November, SMAD licensed them as social organizations and prohibited any political party from organizing its own women's movement.[45] Thus, the nonpartisan, welfare-oriented women's movement was politicized from the beginning. Initially, Social Democrats and "bourgeois" parties held aloof from the AFA and organized their own women's activities—but soon SPD women flooded into the AFA.[46] In early 1946, Christian Democrats and Liberal Democrats also joined in.[47] The "Central Women's Committee" included representatives of every party, as well as prominent advocates of women's rights, such as the physician Anne-Marie Durand-Wever. Communists were overrepresented. They elected a member of the KPD/SED, Magda Sendhoff, as chairwoman of the Central Committee.[48] They were instructed from above to accept the

IV2/17/51, Bl. 35, Bericht . . . Kreis Niederbarnim am 21.3.46; BArch, DQ1/3445, Kurzer Bericht . . . Thüringen 1946.

[41] Genth and Schmidt-Harzbach, "Frauenausschüsse," 56–57; SAPMO-BArch, DY30/IV2/17/80, Bl.21–24, Zur Frage der Schaffung einer Frauenorganisation, 1.9.46. An anonymous article in *Neuer Weg* reckoned 200,000 women (*NW* Jan 1947, 28).

[42] SAPMO-BArch, DY30/IV2/17/51 Bl. 57–58, Kreis Frauendelegierte Konferenz 16.3.46.

[43] SAPMO-BArch, NY4106/4, Schmidt Rede. On Elli Schmidt, see Gast, 51; Renate Genth, "Frauen," 119.

[44] On AFAs and ex-camp prisoners in Berlin, see SAPMO-BArch, DY30/IV2/17/55, Bl. 43–47, Bericht des Hauptfrauenausssschusses, 30.4.46; DY30/IV2/17/78, Bl.0024, Abteilung Frauenausschuss 25.9.46; Bl.0010, Frauensekretariat, Berlin, 17.6.46.

[45] Genth and Schmidt-Harzbach, "Frauenausschüsse," 51, 73–74: BArch, DQ1/323, Bl.103–112, Deutsche Verwaltung für Volksbildung in der SBZ, Abt. Frauenausschüsse, Pressedienst, November 1946.

[46] SAPMO-BArch, DY30/IV2/17/10: Bl. 29, SPD Bezirkvorstand Leipzig an den Zentralausschuss der SPD, Frauensekretariat, Berlin, 24.1.46. This report claims that Communists pressured, even threatened, Social Democrats to hold joint women's meetings with them.

[47] SAPMO-BArch, DY30/IV2/17/6: Bl. 0001–7, Referat Elli Schmidt an die Funktionärinnenkonferenz am 16./17.5.46; DY30/IV2/17/80: Bl. 21–24, Zur Frage der Schaffung einer Frauenorganisation, 1.9.46.

[48] BArch, DQ1/323, Bl. 167, Presse Notiz, 1.8.46; SAPMO-BArch, DY30/IV2/17/51, Bl. 57–58, Kreis Frauendelegiertenkonferenz, Kyritz, 16.3.46; Bl.62–63, Bericht . . . Langerwisch, 21.3.46; DY30/IV2/17/10: Bl.44, SPD Leipzig an Frauensekretariat, 3.46.

welfare orientation and nonpartisan character of the AFA—and, initially, the AFA spanned the old gulf between the proletarian and bourgeois women's movements.[49] The AFA drew women into every aspect of public activity. It organized mothers' convalescent homes and children's camps. It coordinated the cooperation between women physicians and the health administration to prevent STDs and educate people about public hygiene to avert TB and typhus epidemics. At counseling centers, physicians, nurses, and volunteers taught perinatal care and contraceptive techniques. Health professionals taught women about democracy and encouraged them to name Nazi doctors before denazification commissions.[50] Leading members of the AFA brought a feminist perspective into public discussion, arguing that housework should be paid and that boys should learn all domestic chores so they could share housework with their future wives.[51]

The AFA gave Communists access to a wide range of women, first and foremost to women Social Democrats. In November 1945, the KPD began to push hard for consolidation of the two working-class parties. In March 1946, the merger occurred, except in Berlin, and the Socialist Unity Party was born. A covert supporter of the push for unity was Käthe Kern, chairwoman of the Women's Secretariat of the SPD. Her communications with SPD women reveal that she exploited their high regard for her to overcome their suspicions of the AFA and antipathy toward the KPD.[52] The KPD saw the AFA, second, as a vehicle to reach women who had been members of the Nazi *Frauenschaft*. In rural areas, the KPD welcomed these women, and even minor members of the NSDAP, into the AFA. When Communist women expressed doubts about this practice, Elli Schmidt reminded them, "we have to work with these women . . . [so they] find their way into the [SED]." She told them, though, to do so quietly.[53]

Clearly, the KPD/SED took a pragmatic approach to women. It broadcast its program for women's equality, reminding them that before 1933 it had fought for women's rights. The leadership created a Central Woman's

[49] SHSA, IV BV/15, Bl.88, SED Sitzung des Kreisvorstandes am 2.7.46. Also see SAPMO-BArch, DY30/IV2/17/78, Bl.39–42, Vom Kommunalen zum Zentralen Frauenausschuss, 5.6.46.

[50] BArch, DQ1/323, Bl. 63–79, Abt. Frauenausschusse, Protokoll . . . 15.7.47, Protokoll . . . 2.9.47.

[51] Genth and Schmidt-Harzbach, 54, 51.

[52] SAPMO-BArch, DY30/IV2/17/10, Bl. 29, SPD Bezirkvorstand Leipzig, an den Zentralausschuss der SPD, Frauensekretariat, 24.1.46; Bl. 34, 20.1.46; Bl. 43, Kern an SPD Leipzig, 6.2.46; Bl. 44, SPD Leipzig an Frauensekretariat, 1.3.46.

[53] SAPMO-BArch, DY30/IV2/17/51, Bl. 62–63, Bericht . . . Langerwisch, 21.3.46; DY30/IV2/1/16, Tagung des Parteivorstandes.14.2.47, 78–79; DY30/IV2/1/18, 26/27.3. 47, 181.

Section and attached it to the SED's highest body, the Central Secretariat [ZS]. Two capable, experienced, and high-profile women, Käthe Kern from the SPD and Elli Schmidt from the KPD, were appointed its co-chairwomen. The ZS introduced an "affirmative action" statute that guaranteed women "an appropriate number" of seats on all leading party committees.[54] These moves modestly boosted the SED's appeal. At its founding, 21.5 percent of SED members were female; a year later, women made up almost 24 percent of the party. Compared to the Weimar KPD (or to *any* West German party of the 1940s), the SED's accomplishment was impressive. Its point of reference was, however, the East German CDU, which was forty-four percent female in 1946.[55] Women activists focused not on their absolute success, but on their relative failure.

PROLETARIAN ANTIFEMINISM AND FEMALE ANTI-COMMUNISM

The desire to win popular support did not stop Communists from bluntly telling fellow Germans that they had no one but themselves to blame for Germany's debacle.[56] This line was directed at all Germans, but it had a misogynistic twist. The KPD press and agitators censured men as aristo-crats, bourgeois, or Germans. Women were criticized *as women*. The stan-dard Communist lecture to a female audience began: "Isn't it true that Hitler came to power only because a large proportion of women suc-cumbed to the poison of Nazi propaganda?" Women activists assailed the political stupidity of this approach, noting dryly that, after all, men were the ones who fought for Hitler to the bitter end. Elli Schmidt, in particular, chastised male comrades.[57] Yet she, too, worried about the "continuing hold of Nazi ideology on women's minds."[58] She contrasted women's Nazi-era fervor to their postwar malaise: "We remember how much ideal-ism, how much fervor, the masses of women summoned for Hitler. They were enthusiastic about everything. . . . we see virtually no acclamation

[54] Gast, 98–99. The KPD central committee had 80 members (13.7 percent female); the SED party executive had sixty members in 1947 (16.7 percent female).

[55] Weitz, 328–29; Naimark, 131; L. Schmidt, "Gibt den Frauen in der Partei Entwick-lungsmöglichkeiten!" *NW* (May 1947), 27; Gast, 54, 56, 42.

[56] Weitz, 319–20; Epstein, 102.

[57] The quote was cited by Irene Gärtner (aka Elli Schmidt) in *Deutsche Volkszeitung*, 6.7.45, and is reprinted in Stössel, 83–84. Also see Elli Schmidt, "Frauen und Gemeindewah-len," *NW* (Aug. 1946), 3; n.a.,"Frauen und Politisches Denkvermögen," *NW* (May 1947), 30; W. Barth, "Frauenarbeit—Sache der Gesamtpartei," *NW* (October, 1946), 12; Gertrud Heutsch, "Frauen gewinnen heisst Mehrheit des Volkes gewinnen," *NW* (Aug 1946), 24–25; SAPMO-BArch, DY30/IV2/1.01/3, Funktionärinnen-Konferenz am 16. u. 17. Mai 1946.

[58] SAPMO-BArch, DY30/IV2/17/51, Bl. 117, SED Ortsgruppe O . . . 11.6. 46.

for the democratic reconstruction of Germany, for the new, for the peaceful Germany."[59]

Schmidt saw women not as fanatics, but as beholden to the Nazi belief in female political passivity. Women, she argued, liked to help the needy or to lose themselves in romance novels, but engaged little in political debate or high culture. Käthe Kern claimed that women were "fleeing into religion and the churches."[60]

Many women (and men) *were* disgusted with politics, yet the malaise was far from universal. In the winter of 1945–46, reports by Social Democrats and Communists noted that, actually, their women's meetings were well attended, and that "[w]omen are interested in everything, but especially in politics . . ." The problem was not women's disdain for politics but, as Schmidt well knew, their strong interest in issues made awkward for the KPD/SED by its ties to the Soviet occupiers. Even worse was the fact that the Christian Democrats could, and did, exploit the issues that engaged women.

Women were engrossed, above all, by the *Ernährungsfrage* (provisioning issue). In Brandenburg, women professed to "understand nothing about politics . . . socialism or communism," yet they showed up in substantial numbers for "robust discussions" of provisioning. In spring 1946, the SED in Saxony campaigned hard for a referendum on the expropriation of the property of war criminals and active Nazis. Women seemed indifferent, even hostile, to the campaign. At meetings about the referendum, they sat silent and morose, until someone raised the *Ernährungsfrage*, and they began to argue excitedly. Men, too, talked about food, but women addressed it more exclusively, protesting, in particular, its incompetent, inequitable distribution.[61] In the winter of 1946–47, a dozen hunger protests occurred throughout the SBZ, all led by women and attracting hundreds of women and children as participants.[62] Kern and Schmidt knew that hunger could provide rich fodder to Communist organizers. Kern reminded her comrades: "The crucial foundation of any agitation among women is visible success in the provision of food." She told them to call for "equal distribution of cigarettes among men and women"

[59] SAPMO-BArch, DY30/IV2/17/6, Bl. 0001–7 - Funktionärinnenkonferenz am 16./17.5.46, Referat Elli Schmidt, 16./17.5.46; Genth, 119.

[60] SAPMO-BArch, DY30/IV2/17/6: Bl. 0001–7 Funktionärinnenkonferenz am 16.–17.5.46.

[61] Quotes in: SAPMO-BArch, DY30/IV2/17/51, Bl. 20, öffentliche Frauenversammlung, March 1946; Bl. 21, Bericht der Frauenleiterin; Bl. 28, Stimmungsbericht zum Volksentscheid im Kr. O, 13.6.46. Also see SHSA, IV BV/15, Bl. 32, SED Kreisvorstand, Zusammenfassender Stimmungsbericht in der Zeit vom 6.–13.6.46; DY30/IV2/17/56, Bl.1–3 Lisa Ulrich, Verammlungsbericht aus Mecklenburg vom 2 bis 6.9.46; DY30/IV2/5/202, Bl. 16–26, K. Kern, Bericht über meine Reise nach Mecklenburg, 4.–6.4.1949; Schotte, 117.

[62] Naimark, 385. On women's hunger protests in Berlin during World War I, see Davis.

(not a trivial matter, given the epidemic craving for nicotine and cigarettes' function as an ersatz currency).[63] In summer 1946, the *Leipziger Volkszeitung* trumpeted improvements in rations for expectant and nursing mothers as the latest achievement of the SED.[64] Schmidt, too, insisted that the party must attend to women's "everyday worries," not because they were political concerns, but because, "[a]s a rule, women are much more emotional than men."[65] Blindness to the social significance of women's demands was, in part, ideological. Marxists did not see demands that revolved around "the labors of consumption" as central to the class struggle.[66] Circumstance reinforced doctrine. German Communists in 1946, unlike the Russian Bolsheviks in 1917, could not emblazon their banners with "Bread!" Indeed, they had to approach the hunger question gingerly. Lenin's heirs, after all, controlled the levers of food distribution.

SMAD's rationing system was based, first, on the size of the locale (the larger the locale, the more rations) and, second, on the kind of work one did. "Normal consumers" were divided into six (or in big cities, five) categories: I (and II). "workers in heavy industry"; III. workers; IV. white-collar employees (including cleaning and washer women); V. children; and VI. "others," including factory owners, ex-Nazis, and "nonworking housewives." The ration cards allotted the majority of urban women the same "starvation rations" (fewer than 1200 calories a day) assigned the outcasts of the new Germany. SED functionaries longed to ditch this political albatross. In Leipzig, the party called publicly for revision of the rationing system.[67] SED leaders in Berlin refused to back up this demand. Internal dissent over this issue ran, in fact, into the top leadership, where it surfaced as a gender divide. At an executive meeting in November 1946, Elli Schmidt censured the system, whereas Wilhelm Pieck, co-chairman of the SED, defended it:

Schmidt: The cursed 'V and VI' cards cripple our work at every turn. Couldn't we make it three [categories] and change the rationing norms? Under Hitler, there was one card . . . and women constantly confront us with that. [Three categories] are also what they have in the Western zones.

Pieck: Hitler could do that because of plunder.

[63] SAPMO-BArch, NY4145/49, Bl. 1–8 Frsek. 31.5.46.

[64] Gries, 122.

[65] Elli Schmidt, "Frauen und Gemeindewahlen," *NW* (Aug 1946). Some Communists did want women's consumption concerns treated as a central and political issue. See, e.g., SAPMO-BArch, DY30/IV2/17/8, Bl. 103–5, Ruth Becker, Betr. DFD, 16.2.47.

[66] Pence, "Consumption."

[67] Gries, 93–98, 127–29. Card I/II holders were entitled to 2,186 calories a day, while Card V/VI holders received only 1,171. The rations allotted Cards V/VI were raised slightly in summer, 1946.

Schmidt: We tell women that.

Pieck: Anyway, the rationing system is an incentive to employment.

Schmidt: Comrade, there is already a decree that requires women to work.[68]

In public, Schmidt berated women for "lacking idealism." *In camerâ*, however, she looked at their plight from the standpoint of political agitation. Pieck, in contrast, addressed it from the perspective of political power. In this transitional phase, Schmidt's vantage point won the day. On 1 February 1947, with much fanfare, SMAD eliminated Cards V and VI. The Communist press attributed the revision to SED intervention in women's favor.[69]

The *Ernährungsfrage* affected more women than any other political issue, but rationing was not the most *fraught* Soviet policy to damage women's opinion of the SED. Their political antennae shot up at the mention of the "prisoner of war question." The Soviet Union held its 3.2 million POWs much longer, on average, than did the British or the Americans. Communist allusions to German pillage of the USSR could not make women understand why their husbands came home so late, or why they could not correspond with them regularly. Even women sympathetic to Communist politics hounded the SED about POWs.[70] In closed sessions and private communications, women Communists argued that the ZS must convince the USSR to accelerate the process of releasing POWs.[71] When a (female) Russian lieutenant asked Martha Arendsee, a member of the SED's executive committee, to explain the SED's insufficient progress among women, Arendsee replied frankly, "The POW question plays a big part."[72]

Other charged issues were the forced labor of Germans deported to the Soviet Union, mass imprisonment of Germans in the SBZ, and the wholesale deportation of "specialists" to the USSR to work on Stalin's atomic and other scientific projects. As the Soviet army swept through East Prussia and Silesia, it captured hundreds of thousands of German civilians, mainly young women, and deported them to work in the Soviet Union, where thousands of them died from hunger and overwork. Re-

[68] SAPMO-BArch, DY30/IV2/1/6, 8.Tagung des Parteivorstandes, 18.–19.11.46.

[69] Gries, 99–100; Hübner, *Konsens*, 20.

[70] SAPMO-BArch, DY30/IV2/17/55, Bl. 22–24, 18.2.46, Die Lage der Frauen in Berlin; DY30/IV2/17/51, Bl. 427–428, Klara Zetkin Spinnerei, 14.10.48. Also see Naimark,130.

[71] SAPMO-BArch, DY30/IV2/5/220, Bl. 45–50, Instrukteur Josef König, Arbeitsbericht,12.–20.6.46; NY4145/49, Bl. 1–8, Frauensekretariat, 31.5.46.

[72] SAPMO-BArch, DY30/IV2/1/4, PVS Sitzung, 18. bis 20.6.46, p. 44. On the Russian frustration with the SED's poor record on women, see Naimark, 131.

leased "abductees" streamed into the SBZ in 1947–48, and SED women were sent to inspect their transit camps. They found that in several camps women were receiving aid from the Protestant Inner Mission. The danger that the camps could be turned into another anti-Communist exhibit was all too real. Many returnees were, it seems, in "fairly good shape," but others looked "like concentration-camp survivors." The occasional *Verschleppten* told an interviewer that she had been treated "better than the Russians themselves," but more common was the tendency to "see only what happened to them (*was sie selbst betrifft*), see themselves as the poor, innocent victims who had to work hard in a foreign land that they believe is guilty of driving them out of their homeland."[73] After the war ended, detentions and deportations affected women, largely, as the wives, mothers, and daughters of deported men. The Soviet internal affairs secretariat interned 150,000 to 240,000 people, mainly male, in Soviet-run camps in the SBZ. Some of these men were influential Nazis, but many were Social Democrats, bourgeois politicians, property owners, or adolescent delinquents. The wives of detainees shot off letters to any and every authority as they desperately tried to obtain information about their husbands.[74]

The SED's close association with the occupying power cost it support among refugees. To dispel any hope that the refugees might return to whence they came, the SED gave refugees and expellees a new name: "settlers." It constantly impressed upon them that Hitler was responsible for their plight. The settlers agreed that they were victims—of Stalin. They persistently denounced the "Oder-Neisse line" (the border between Germany and Poland created in 1945 by the Allies' Potsdam treaty). Settlers, most of whom were women, joined the SED at a low rate. The Oder-Neisse question, SED functionaries admitted, "confused" even some Communists, making it, no doubt, difficult for them to convince settlers to join a party that defended this territorial line.[75]

Most sensitive of all was the issue of Soviet soldiers' mistreatment of German women. Rape, Norman Naimark argues, cost the SMAD and KPD/SED more goodwill than any other policy or behavior of the occu-

[73] Heineman, *Difference*, 85; SAPMO-BArch, DY30/IV2/17/56. Bl. 99, Maria Krick. Frauensekretariat Bericht über eine Fahrt nach Fr/Oder. 2.7.47; Bl. 135, Maria Krick. Bericht . . . Quarantänelager Polte-Nord in Magdeburg, 4.8.47.

[74] Naimark, 376–78, 382–90; Hall, 122; Heineman, *Difference*, 113; BArch, DQ2/1589, (Frau) AB an Deutsche Verwaltung für Arbeit und Sozialfürsorge, 5.12.46; (Frau) AB, Eberswalde, an Brack, Amt für Arbeit und Sozialfürsorge, Berlin, 30.4.47; Brack an die SMA - Abteilung Arbeitskraft, 16.12.47.

[75] Mehlhase, "SED," 162; Christopeit, 101; Seraphim, 32. On Communist "confusion," see SAPMO-BArch, DY30/iV2/17/56, Bl. 0009, Maria Krick, Frauensekretariat. Bericht . . . Greifswald, 20.5.48.

pying forces. Renate Genth and Ingrid Schmidt-Harzbach have attributed the stunning defeat of the SED in Berlin's municipal election of October 1946 to the aftereffects of mass rape. Open discussion of Russian violence against women was *absolut verboten*, but women raised it obliquely. At a meeting of some 600 Berlin women in August 1945, a KPD speaker instructed his audience that they should be grateful to the USSR for its aid to Germans. "A roar went up in the hall," he reported, followed by shouts and, finally, derisive laughter. The mood was "almost fascist."[76] Party functionaries protested to SED higher-ups and the Russian authorities about the continuing occurrence of rape and SMAD's refusal to acknowledge the original wave. In January 1947, Lisa Ullrich, a field organizer, informed a Russian lieutenant-colonel, "Even if attacks and harassment occur only occasionally, fear and worry spread among all women and cripple all our work, not only in the women's committees but in the unions and the party."[77] In contrast to her candor, Wilhelm Pieck and Walter Ulbricht argued that in this case, too, German women should blame Hitler for their fate.[78]

The close ties between German Communists and the occupiers damaged the SED's standing among all, not only female, voters. In the first postwar elections in September and October 1946, the SED did less well than it expected. In "Red Saxony," despite police harassment of the bourgeois parties during the campaign, the SED booked only fifty-three percent of the vote (CDU, twenty-one percent; LDPD, twenty-two percent). In Leipzig and Dresden, which prior to 1933 were Social Democratic strongholds, the merged party did not even win a majority. If the general results dissatisfied the SED, the gender gap alarmed it. In Dresden, where polling was segregated by gender, only 44.9 percent of women voted for the SED, as opposed to 54.2 percent of men. Women, who made up sixty-two percent of Dresden's electorate, contributed only fifty-seven percent of the SED's tally, in contrast to sixty-nine percent of the CDU's. The SED could not comfort itself with the fiction that Dresden women were apolitical, for a whopping ninety-four percent of them voted.[79] In the province of Saxony-Anhalt, too, according to an SED organizer, "[w]omen voted very badly."[80] In Berlin (which voted as a unified city),

[76] Naimark,129, 135; Genth and Schmidt-Harzbach, "Kriegsende," 34–35.

[77] SAPMO-BArch, DY30/IV2/17/80, Bl. 75, Vorschläge des Herrn Oberstleutnant Nasarow . . . 7.1.47; DY30/IV2/17/51, Bl. 102 Stimmungsbericht . . . Warmsdorf am 8.6.46; Bl. 28, Stimmungsbericht zum Volksentscheid im Kr. O, 13.6.46; DY30/IV2/17/56, Bl. 1–3 Lisa Ulrich, Versammlungsbericht [Rostock] vom 2 bis 6.9.46.

[78] Naimark, 88, 118–21.

[79] Barth, 12; SAPMO-BArch, NY 4145/49, Bl. 12; Schotte, 150.

[80] SAPMO-BArch, DY30/IV2/17/11, Bl. 84, Elsa Gärtner an K. Kern, Merseburg, den 13.9.46.

1.4 million female voters confronted 900,000 male voters. There, Communists faced the bourgeois parties *and* the SPD, and every party campaigned under freer conditions than in the SBZ. The SPD captured first place; the CDU took second; and the SED came in third, with a paltry 19.8 percent of the vote.[81] Against their better judgment, SED women had allowed the party leadership to convince them to organize nonpartisan "women's electoral tickets" in order to siphon votes from the bourgeois parties. These candidates (members of the antifascist women's committees) fared disastrously, capturing only one percent of the ballots.[82] Women's loyalty to the bourgeois parties and Social Democracy confirmed the scorn of Communist men for "apolitical" women. Even before the polling in Berlin, Elli Schmidt reported, "Many [men] said outloud that women should not vote."[83] Male Communists had, she charged, "sabotaged" the "women's tickets": "Several local chairmen [of the SED]. . . . declared, '*Frauenlisten* are whores' tickets'"[84]

Many lower-level Communists balked at the SED's "democratic, antifascist" stand. They wanted the party to press toward a dictatorship of the proletariat. Their sectarianism made them distrust women for whom, after all, the party was diluting its message. Women Communists, too, expressed "a bad attitude toward women's work" when it involved, for example, organizing a Christmas party. It was, however, men who associated *all* nonpartisan work with women and caused female organizers "immense . . . headaches" with their hostility to the AFA. SED mayors and county councilors in Brandenburg argued, "[W]omen should drop nonpartisan work and do direct party work."[85] SED men often made it hard for women to engage in political work of any kind. Told to prune public outlays, an (SED) county councilor in Mecklenburg eliminated the posts of the only three women (all SED) in his administration.[86] In one hamlet, the local SED executive advised members to run a woman for mayor, only to unleash a "veritable tumult" among male members.[87] After higher-ups

[81] Naimark, 329.

[82] SAPMO-BArch, DY30/IV2/1/6, Bl. 70–75, 4. Tagung des PVS 16.–17.7.46; DY30/IV2/1/6, Bl. 165–66, 8. Tagung des PVS, 18.–19.11.46 (Elli Schmidt); Genth and Schmidt-Harzbach, "Frauen in den Parteien," 117.

[83] SAPMO-BArch, NY4106/4, Bl. 147–50.

[84] SAPMO-BArch, DY30/IV2/1/6, Bl. 165–68, 8. Tagung des PVS, 18.–19.11.46.

[85] SAPMO-BArch, DY30/IV2/17/52, Bl.33. Kreisvorstand SED, Frauenabteilung. Gardelegen [Sachsen-Anhalt], 20.12.46. Bericht für Dezember 1946; DY30/IV2/17/56, Bl. 55, Lisa Ulrich. Bericht über eine Aussprache mit Genossinnen der Frauenabteilung des Provinzvorstandes Brandenburg am 13.1.47.

[86] SAPMO-BArch, DY30/IV2/17/80, Bl. 3–11, Ke[rn]/S(chmidt), Anlage zum Rundschreiben Nr. 1/v, 25.6.46.

[87] Walter Beling, "Freie Bahn den Frauen," *NW* (Sept 1946), 16. Also see SHSA, IV BV/06, Bl. 35, 38, 1. Bezirks-Frauenkonferenz . . . West Sachsen, 23. und 24.7.46.

instituted an "affirmative action" statute for SED local executive commit-
tees, chapters would elect one woman to the board but stipulate that her
only role was to recruit women.[88] Squeezed between the indifference, even
hostility, of female citizens to the SED and the apathy, even contempt,
of male comrades toward women, SED women functionaries deliberated
about what to do. Their disgust with SED men was matched, interestingly,
by the irritation of SMAD. Soviet authorities were disturbed (rather disin-
genuously, one must say) by the SED's failure to win over women and
unwillingness promote them to important positions in the party.[89] In their
desire to overcome the "woman problem," German Communist women
and Russian administrators urged the party elite to address issues that
mattered to women, such as abortion, and to try a political experiment
that was anathema to Communism: a separate organization for women.

WOMEN'S ISSUES, WOMEN'S ORGANIZATION

Abortion reform had been a major slogan of the Weimar KPD, especially
during the depression years of the early 1930s. Yet after the war, the SED-
controlled press did not initially mention this issue. Only after the disas-
trous elections of 1946 did the SED suddenly put itself at the head of the
considerable popular support for revision of Paragraph 218. Meetings
that addressed the abortion question were packed and full of "excited
discussion" that culminated in resolutions demanding decrimininaliza-
tion. Not all women supported this position. CDU members and reli-
giously engaged women, especially Catholics, often spoke against relax-
ation of restrictions. In general, the rhetoric and demands of the postwar
debate were less wide ranging than before 1933. Virtually no prominent
women called for complete legalization. Dr. Anna-Marie Durand-Wever,
who earlier favored a dramatic loosening of restrictions, now approved
only of medically necessary abortions. Women physicians wanted to con-
vince pregnant women to "affirm life" in the wake of mass death and in
the midst of a baby bust (although these doctors also promoted sexual
enlightenment and contraception).[90]

[88] SAPMO-BArch, DY30/IV2/1.01/3, Bl. 132, SED Funktionärinnen-Konferenz. am 16.–
17. Mai 1946; SHSA, IV BV/06, 1. Bezirks-Frauenkonferenz . . . West Sachsen . . . 23. u.
24.7.46, B. 32.

[89] Nr. 18 Bericht . . . Stadt- und Bezirksverordnetenwahlen in Berlin, 2.9.46, in Bon-
wetsch, Bordjugov, Naimark, 66–67.

[90] Grossmann, Sex, 196–99; SAPMO-BArch, DY30/IV2/17/52, Bl. 73–75, SED Frau-
enbericht, Feb. 1947; Bl. 104, July 1947 Bericht. DFD; Bl. 113, Aug. 1947 Bericht. DFD;
Bl. 119, September Bericht. See the protocols of discussions among Durand-Wever and other
women physicians: BArch, DQ1/323, Abt. Frauenausschüsse: Bl. 128–37 Protokoll 3.9.46;
Bl. 69–79, Protokoll, 15.7.47; Bl. 63–66, Protokoll . . . 2.9.47; SAPMO-BArch, DY30/IV2/
17/51, Bl. 162, 1.2.47. Richtlinien für Eheberatungsstellen.

In the SED, too, opinion ran the gamut, from abolitionist to reformist to antiabortion.[91] Most significant was Walter Ulbricht's absolute antagonism to abortion (unless the pregnant woman was infected with VD).[92] Presumably, political exigency temporarily diluted his opposition for, in 1946, the SED came out for an "indications solution" that proposed to legalize abortion on three grounds: social, medical, or ethical (in case of rape or other criminal treatment). Communists did not revive the Weimar KPD's radical call, "Your body belongs to you!" When women trade unionists put forward this motto, State Prosecutor Hilde Benjamin (SED) told them it was a "bad" slogan, given German underpopulation.[93] Käthe Kern proclaimed, "We would never vote for complete legalization of abortion."[94] In 1947, the SED lobbied hard for its reform plans in state and provincial parliaments and, after some alterations, joined with Liberal Democrats against the CDU to enact indication laws in every province of the SBZ. "Social commissions" conferred about each application and, on average, approved more than fifty percent of requests.[95]

In late 1946, the SED took another major step to enhance its standing among the female populace. In December, the Central Women's Committee, led by its chairwoman Durand-Wever (who had no party affiliation), unanimously underwrote a resolution to lay the groundwork for a "permanent women's organization." The SED press claimed that the call for a women's association had sprung spontaneously from below. In fact, Käthe Kern and Elli Schmidt first proposed this idea behind closed doors. They hoped to "bind" women in the AFA to the SED by creating a centralized, formally nonpartisan, exclusively women's organization.[96] The SED elite—men and women—was skeptical. Marxist-Leninists believed that a separate organization for women, especially a nonpartisan one, skirted dangerously close to antiparty factionalism and to bourgeois feminism. Supported by SMAD, Kern and Schmidt mounted an offensive against objectors. A mass organization, they contended, could raise the theme of German national unity and challenge the West German "bourgeois

[91] See, e.g., SAPMO-BArch, DY30/IV2/17/52, Bl. 92, Funktionärinnensitzung ... 16.7.47; Grossmann, *Sex*, 198–99; Kirsten Poutrus, "Massenvergewaltungen," 184–85.

[92] SAPMO-BArch, NY4182/246, Bl. 47, Besprechung Genosse Ulbricht mit je einem Genossen aus jedem Verwaltungsbezirk am 20.5.45.

[93] SAPMO-BArch, DY34/A1670. Bericht ... 23.10.46 ... Steglitz, Bl. 3. On the Weimar republic, see Grossmann, *Sex*; Usborne.

[94] SAPMO-BArch, NY4145/50, Bl. 24–26, Landtag der Provinz Sachsen-Anhalt am 13.5.47.

[95] Kirsten Poutrus, "Massenvergewaltungen," 187; SAPMO-BArch, DY30/IV2/17/56. Die Frauen in der SED (1947), Bl. 337–38.

[96] SAPMO-BArch, DY30/IV2/17/80 Bl. 21–24, Zur Frage ... einer Frauenorganisation, 1.9.46; DY30/IV2/17/80, Bl.0001, K.Kern, Vorlage für der Sitzung des Zentralsekretariats, 14.6.46. For a more detailed discussion of the DFD's origins, see Harsch, "Approach/ Avoidance."

women's movement" on the international stage of women's work for peace and justice.[97] The SED needed, they claimed, an organization to counter Christian Democracy's popularity among women and to prevent them from pouring into the Lutheran Women's Aid.[98] Convinced by their arguments, Wilhelm Pieck declared himself "absolutely" for a separate organization.[99] Yet the proposal remained suspended for months, dangling between the party elite's lack of interest in the woman question and its dislike of this answer.

After the disastrous elections of 1946, SMAD queried the Women's Section about its plan to build a women's league. With proof of Russian support in hand, Kern and Schmidt prodded Pieck and Otto Grotewohl (co-chairmen of the SED) to make a decision—and they did. By November, the two women had drafted a program, chosen a name, and decided when the new organization would be announced.[100] Thus, they set the stage for the spontaneous event. In December, the Central Women's Committee took up its part in the script. Over the next two months, parallel committees prepared the founding convention of the Democratic Women's League of Germany (DFD). A "Preparatory committee for the creation of the DFD," composed of SED and nonpartisan women, worked publicly on the statutes of the DFD and organized the convention, while its shadow—SED leaders Franz Dahlem, Erich Gniffke, and Helmut Lehmann—secretly vetted requests from Kern and Schmidt to allow the official committee to take the next step.[101] Along the way, the process encountered predictable opposition from the CDU.[102] More vexing was hostility to the DFD from within the SED and its affiliated trade unions: sectarians opposed cooperation with bourgeois women; some women did not want to work in an all-female organization; and some men did not think

[97] On the bourgeois women's organizations, see Stöhr.

[98] SAPMO-BArch, DY30/IV2/1/4, Zentralkomitee Sitzung, 18. bis 20.6.46., Bl. 275–81, 283–85, 269–74; DY30/IV2/17/80, Bl. 3–11, Ke[rn]/S[chmidt], Anlage . . . 25.6.46; Hoover Institution Archives, Wm. Sander Collection, Box 1, Folder Letters from 1945–47 Bericht aus der russischen Zone, 8.3.47, 3; Naimark, 132.

[99] SAPMO-BArch, DY30/IV2/1/4, Bl.292, Zentralkomitee Sitzung . . . 18. bis 20.6.46.

[100] SAPMO-BArch, DY30/IV2/17/80, Bl. 25–27, Kern und Schmidt an Pieck und Grotewohl, 14.9.46; Bl. 21–24, Zur Frage . . . einer Frauenorganisation, 1.9.46; Bl. 61, Programmentwurf, 17.9.46; Bl. 37–38 . . . Besprechung über die Schaffung des DFD, 26.10.46; Bl. 39–41,Vorlage an den Zentralsekretariat, 27.10.46; Bl. 51–59, Satzungen des DFD, 7.11.46.

[101] SAPMO-BArch, DY30/IV2/17/78, Bl. 54–55, Dr. Durand-Wever, Zentraler Frauenausschuss Tagung am 7.–8.12.46; Bl. 69–70, Edith Hauser (ohne Namen veröffentlichen), 1l.12.46: Gibt es eine überparteiliche Politik?; Bl. 76, Kern und Schmidt an Dahlem, Gniffke, Lehmann, 15.1.47; Bl. 77–78, Vorbereitende Komitee zur Schaffung DFD, Mitteilung an die demokratischen Frauen und die antifaschistischen Frauengruppen der Amerikanischen, Britischen und Französischen Besatzungszone, 17.1.47. Also see Pawlowski, 77–82.

[102] SAPMO-BArch, DY30/IV2/1/6/14. Bl. 163–66, Tagung des PVS, 22/23.1.47. Käthe Kern: Bericht über die Schaffung des DFD.

women should lead any organization.[103] Once in motion, however, the juggernaut rolled over every bump in the road. The DFD convention took place on International Women's Day, 1947. SMAD granted participants extra rations of money, groceries, and cigarettes.[104] The hundreds of women in attendance heard speeches about benefits for working mothers, women's equality, and women's participation in building an antifascist democracy.[105] At least on paper, the DFD grew at a rapid (if for Communists always inadequate) pace. Its membership reached 242,544 by September 1947, and by January 1950, it had an impressive 484,075 members. Sixty percent of recruits were not in a political party; most of the others were in the SED.[106]

Months of indecision, planning, and competing demands behind them, SED women set out to make the DFD an organization that would win politically unaffiliated women to antifascism and, eventually, the party. SED women moved rapidly to occupy key posts.[107] They guided the DFD to take up the cause of world peace; to engage in social welfare, public hygiene, and cultural activities; and to teach its members the ABCs of the antifascist worldview. The DFD published the women's weekly, *Die Frau von heute*, which, like its West German counterparts of the immediate postwar era, questioned the institution of marriage and touted woman's public role.[108] Just as the DFD got into gear, however, the political winds shifted. Electoral politics lost significance as the SED relied increasingly on undemocratic levers to shoehorn its way into absolute power. SMAD and the SED elite changed focus from parliament to production. Following suit, Communist women turned away from the woman voter and toward the woman industrial worker.

THE ECONOMIC PREDICAMENT

The "woman of the rubble" stands out as a signature image of postwar Germany. Journalists and chroniclers snapped hundreds of photos of the

[103] LAM, IV/L-2/3/2, Bl. 224–25, Sekretariatssitzung (SED), 9.1.47; SAPMO-BArch, DY30/IV2/17/56; Bl. 96, Bericht . . . Provinzleitung Brandenburg am 25.4.47; Bl. 238, Edith Höding: Bericht über die Kreisleitersitzung (Wedding) am 24.2. 47.

[104] Pawlowski, 86.

[105] Gerda Weber, 424–25; SAPMO-BArch, DY30/IV2/17/80, Bl. 188, DFD Kongress, Gründungsversammlung, Referat Paula Hertwig.

[106] Friedrich and Friedrich, 105. For data on political affiliation, see SAPMO-BArch, DY30/IV2/17/82, Bl. 108–29, Referat M. Weiterer . . . am 3.–4.10.47, p. 6.

[107] See, e.g., SAPMO-BArch, DY30/IV2/17/82, Bl. 19, Dahlem an Schmidt und Kern, 8.4.47; Bl. 26–27, Bericht . . . des Landesvorstandes Potsdam, 20.5.47; DY30/IV2/17/82, Bl. 19, Dahlem an Schmidt und Kern, 8.4.47; Bl. 20.

[108] Heineman, *Difference*, 128–29, 132–33.

thousands of women who lived among the ruins and dismantled veritable mountains of debris (*Figure 1*). Women's work in the rubble evoked contradictory associations for Germans. On the one hand, it made visible women's crucial part in postwar reconstruction, suggesting that women did what needed to be done in the emergency—and would continue to do so if given the chance. On the other hand, this image reinforced the postwar sense of a world gone wrong: war had not only ravaged human beings, but it had also rent the social fabric, forcing weakened women into heavy labor under dangerous conditions. However spun, the symbolic significance of the "rubble women" cannot be denied. Memory of women's hard labor reverberated in private relationships and public gender relations in East and West Germany into the 1950s and beyond.[109] Like all myths, this one gets the story wrong. The rubble woman represented neither *the* working woman nor a watershed in the history of women's work in Germany. Only a small minority of *employed* women (and only a minute percentage of all women) labored in the ruins. Difficult, dirty, and dangerous jobs were not new to women. They had long been overrepresented in textile and garment manufacturing and, above all, the backbreaking labor of agricultural production, both of which loomed large in the economy of eastern Germany. Postwar rubble clearing did temporarily breach women's exclusion from the construction trades. Yet women were pushed out of the building trades again as *reconstruction* overtook deconstruction.[110]

Contemporary discourse about "rubble women" was misleading in both the FRG and the GDR, though differently. In the FRG, Christian Democratic politicians and "experts" treated postwar women's hard labor as an unpleasant, unhealthy anomaly. Their rhetoric honored women's retreat into the family in the 1950s as culturally natural, socially beneficial, and personally desired. Historians have dug West German "rubble women" out from under the legends told about them, revealing that many women wanted to work outside the home, and many more had no choice but to do so.[111] The Communist regime, in contrast, celebrated women's rubble work and exalted female employment as necessary for the development of an egalitarian society, a productive economy, and emancipated women. Official discourse presented women's march into production as steady and unproblematic, eased by wise Soviet policies. A tale of women's linear progress into waged labor and "male" jobs has strongly colored our understanding of what distinguished East Germany

[109] Ibid., 90–92; Heineman, "Hour."
[110] Genth and Schmidt-Harzbach, "Kriegsende," 44–46; Merkel, *und Du*, 16, 24–25, 33–42; Merkel, "Leitblider," 362–64.
[111] See, e.g., Ruhl; Moeller, *Motherhood*; Budde, "Einleitung"; Kolinsky, *Women*, 24–37.

from West Germany.[112] Fantasy has distorted reality: not only did men and women resist policies that fostered women's work, but the policies were inconsistent and often contradicted by other economic goals that Soviet and German planners pursued more single mindedly than the mobilization of women's labor.[113]

Economic administrators and planners in the SBZ did, it is true, foresee expansion of female employment, including into some industries dominated by men. They enacted some decrees toward that end. Most well known is Order Nr. 253, decreed on 17 August 1946, which prohibited wage discrimination based on gender (and age). In 1947, Order Nr. 234 and other regulations ordered factories to provide laundry, sewing, medical, and child care services. Some discriminatory "protective" regulations were voided so that women could work in, for example, construction jobs. SMAD, the KPD/SED, and economic planners also intended for women to learn the skilled jobs in high demand in the reconstruction economy. Communists did not, however, attain their goals. Just the opposite happened: in 1950, fewer women worked for wages than in 1939. The female employment *rate* (the percentage of women in wage-dependent labor) also fell. In September 1948, fifty percent of "registered women" worked in "dependent [i.e., waged, nonfamily] labor"; by September 1949, 47.5 percent did. The employment of women in "male" industries rose only in a few industries in isolated labor markets (such as iron foundries in Leipzig).[114] The only category of women who worked at a high rate was refugee women. They labored disproportionately in agricultural labor and overwhelmingly in unskilled jobs associated with domestic work such as cleaning, washing, and cooking.[115]

Rather than march, battalion-wise, into wage labor, women partially stepped *out* of the labor market. Why? Postwar scarcity, low production of all goods, Soviet reparations and labor corvées, industrial labor relations, and misogyny interacted with women's start position to militate against a breakthrough in the rate, much less nature, of women's work. The East German economy was in the throes of a double transition from war to peacetime production, and from private to public ownership. Its

[112] On this widely held conception, see Merkel, *und Du*, 79–82; Heineman, *Difference*, 92; Dölling, "Bewusstsein," 25–28.
[113] A similar point is made by: Hoffmann, *Aufbau*, 226; McAdams, 160–61; Schwartz, 94, 97.
[114] Hoffmann, *Aufbau*, 231; Zank, 43, 84, 107, 137–39, 173; Dr. Elisabeth Obst, 'Förderung der Frauenarbeit,' *Arbeit und Sozialfürsorge*, Nr.1 (1950), 4; LAM, IV/L-2/602/70, Landesregierung Sachsen-Anhalt an Landesvorstand der SED, 21.10.49.
[115] Wille, Hoffmann, Meinicke, "Flüchtlinge," 21–23; Pape, 122, 127. The SED stopped counting settlers as a separate category in later statistics so quantitative estimates are difficult.

pains were compounded by continuing losses in productive power. The "grey economy" of barter, under-the-table work, and black market exchange flourished. If a woman possessed assets to sell or trade, "connections," a garden plot, or a skill such as sewing, she could contribute more to the family economy by *not* taking a job, especially if her husband brought in cash.[116] In addition, the demand for women's labor was not robust. Initially there was a widespread shortage of labor, but soon the industrial labor market tightened, except in certain trades whose skills veterans were more likely to have mastered than were women. At war's end, women's employment was concentrated in "light industries" that were, by decision of the occupiers, disproportionately crippled by shortages in fuel and raw materials. Consumer production slumped, in addition, because demand fell throughout Germany as prices rose following currency reforms in the western Bizone and in the SBZ in 1948. Hence, demand for women workers and salespeople sank, while it remained robust for skilled men. In 1950, East German *men* worked at a higher rate than they had in 1939.[117]

For women workers, as for women in general, the most pressing problem was not earning cash, but the crisis of daily provisions. Schmidt told the ZS, "If we tell women about [our] school reforms, they say, 'So what if our kids don't have shoes?' If we mention equal pay for equal work, [they respond], 'Big deal, if we have to work in rags.'"[118] Distress tipped into despair when the provisioning situation deteriorated in 1947. In clothing mills in Muhlhausen, one-third of the workforce was absent each day, and work morale fell to a "dangerously low point." Only one issue interested garment workers: "How will I feed my family? How will we get through the winter?" Unaware or unconvinced that the food crisis was, in fact, worse in the Western zones, women complained that the Russians ate too much German food. Rumor had it that "[t]he current occupying power will be replaced by the Americans and then things will go badly for the SED."[119] The SED enjoyed less support among women factory workers than among housewives.[120] In mid-1947, in the highly industrialized province of Saxony-Anhalt, the SED had 92,542 female members (22.1 percent of all members), of whom twenty percent were industrial workers and twenty percent were white-collar employees,

[116] See, e.g., interview Frau AB. Also see Zank, 119.
[117] Barthel, 61, 156; Zank, 43, 84, 107, 137–39, 173; Obst, 'Förderung der Frauenarbeit,' *Arbeit und Sozialfürsorge*, Nr.1 (1950), 4; Staritz, *Geschichte der DDR*, 42. On the skill-structure of the female workforce in 1945, see Mühlfriedel and Wiessner, 133.
[118] SAPMO-BArch, DY30/IV2/1/6, 8.Tagung des PVS, 18.–19.11.46.
[119] SAPMO-BArch, DY30/IV2/17/53, Bl. 285, Landesvorstand Thüringen zur Information, Nr. 165, 6.10.47.
[120] Elli Schmidt, "Auf die aktive Mitarbeit der Frauen kommt es an!" *ND* (28.8.47), 2.

whereas forty-seven percent did not work for wages. In October 1948, fifty percent of women in the entire SED were housewives.[121] In many mills with large female workforces, the SED had only a few women members.[122] Even in Berlin, where the SED included absolutely and relatively more women than elsewhere, only five percent of SED factory groups were composed of women.[123]

Not only were provisions scarce, but production was extremely low. In 1946, aggregate production was forty-three percent, and per capita production was twenty-two percent of the level of 1936. The financial means to advance *any* workers were scant. Women's labor was mobilized, therefore, not with carrots but with sticks. The Allied Control Commission (for all Germany) issued Order Nr. 3, requiring all able men, aged fourteen to sixty-five, and all able women, aged fifteen to fifty, to report for work. To give the work order teeth, the Soviet authorities, as we have seen, assigned low rations to housewives. It also eliminated war widows' pensions to women under sixty who were not disabled.[124] In 1946, Order Nr. 65 exempted women with one child under age six or two children under fifteen—or at least in theory it did so. The Saxon textile industry, complained Elli Schmidt, "forced" mothers of young children to work (presumably by denying them welfare benefits).[125]

The original intent to invest in women workers was undercut by decision as well as by circumstance. Stalin was determined to squeeze the SBZ for labor and capital to rebuild the equally devastated and absolutely poorer Soviet economy. By December 1946, the Soviets had dismantled more than a thousand factories and carted off many thousands of railroad ties and machines, including almost eighty percent of machine-tool capacity. In 1947, the Soviets decided to squeeze reparations from current production and took ownership of 200 concerns that produced twenty-five percent of all goods in the SBZ.[126] The amount and scope of war indemnities slowed economic recovery in the SBZ and undermined the political legitimacy of the SED. Especially hated were orders that sent workers to undesirable places to take up dangerous work whose production bene-

[121] SAPMO-BArch, DY30/IV2\17\52, Bl. 86, SED Monatsberichte, SED Frauenmitglieder, May 1947; Lotte Kühn, "Frauenarbeit—Aufgabe der Gesamtpartei,' *ND* (23.12.48), 3.

[122] SAPMO-BArch, DY30/IV2/17/5, Bl. 4–5, Arbeitsplan des Frauensekretariats. 4.bis.6.1948; DY30/IV2/17/51, Bl. 321–26, Protokoll, 28.2.48. Also see Naimark, 131.

[123] SAPMO-BArch, DY30/IV2/17/55, LVS SED Gross Berlin, 12.4.48, Bericht . . . Sept 47 to Mar. 48.

[124] Zank, 112, 133–36.

[125] SAPMO-BArch, DY30/IV2/1/8, 18.–19.11.46, p. 170.

[126] Hermann Weber, *Geschichte*, 93; Landsman, *Demand*, 23. Also see LStA, 10, VEB Kammgarnspinnerei Pfaffendorf. Betriebsratssitzung am 22.5.48; An den Kreisvorstand des FDGD von KG Textil Leipzig, 25.5.48.

fited the USSR. Worst of all were the uranium mines of Wismut where, until conditions were improved in late 1953, thousands of workers labored day after day in knee-deep radioactive slime. In 1947 and 1948, 20,000 women were arrested in the crackdown against STDs and sent to work in Wismut's offices and mines.[127]

We should consider the gap between intent and reality in "women's labor policy," finally, in the context of labor relations and SMAD's general (apparently gender-neutral) labor policy. Initially, factory workers in the SBZ enjoyed considerable autonomy on the shop floor and, indeed, ran many firms. The re-emergent trade unions negotiated advantageous contracts for workers in many industries. In 1947, only twenty-five percent of workers in the SBZ worked for piecework wages, an abrupt slide from eighty percent at the war's end.[128] Initially, the SED and SMAD showed remarkably little interest in these developments. As productivity plummeted, however, the SED and military authorities turned their attention to labor discipline. Recognizing that workers required stronger incentives to come to work and to work harder, SMAD introduced, under Order Nr. 234, steeply graded "achievement" wages in priority industries such as mining, chemicals, and optics. Order 234 placed consumption at the service of production and demanded from workers "a willingness to put the general need ahead of individual need."[129] Its hook was improved quality and quantity of meals for all workers in high-priority enterprises, but it also differentiated within such concerns between privileged (skilled, semiprofessional, and professional) employees who received a free "A" meal of more, superior calories and other workers who received a free "B" meal of fewer, inferior calories (essentially, potatoes). The authorities found it difficult to implement Order 234's antiegalitarian measures. Factory councils, union officials, and even party functionaries pooled food from the "A" and "B" meals and reapportioned it equally.[130] Clearly, the factory councils had to be tamed. The SED and SMAD began to maneuver to transfer shop floor power from them to the trade unions. Yet union functionaries, too, resisted implementation of Order 234. They did not happily relinquish their autonomy in order to function as a transmission belt for labor policies, wages, and production quotas set from above.[131] Industrial output did begin to rise after 1947. Simultaneously, however,

[127] Naimark, 238–45.
[128] Ross, 37.
[129] Landsman, "Dictatorship," 31.
[130] Zank, 122–23; Staritz, *Gründung*, 132–34; Kopstein, 25–29; Hübner, *Konsens*, 21–27; Suckut, 492–500; Bust-Bartels, 49.
[131] Hübner, *Konsens*, 28, 35; Bust-Bartels, 26–28. On resistance to piece rates in Saalfeld, see Port, "Conflict," 28.

real wages increased because union officials and managers ignored wage "guidelines" and, instead, negotiated contracts.[132]

Most members of factory committees and union committees were men; their leaders were virtually all men. Labor historians have argued that "women's labor policy"—the plan to integrate women into production—had less to do with the interests of women workers than the interests of SMAD and the SED. Women's labor policy was, they argue, part of a "divide and conquer" strategy. The policy aimed to introduce workers with little or no experience onto the shop floor to weaken workers' organization and dilute resistance to piece rates, top-down decisions, and breach of contract.[133] Considerable evidence supports this thesis. Order Nr. 234 contained nonwage benefits, such as maternity leave and laundry and child care services, that can be interpreted as an attempt to "buy off" women workers. Moreover, the piecework system was tested in overwhelmingly female textile firms. By late 1947, women workers labored under "incentive plans" at twice the rate of men.[134] It is true, too, that women workers were underrepresented in the factory councils and trade union federation (FDGB). In December 1946, women formed twenty-nine percent of the FDGB's four million members, a higher ratio than ever before in a German union federation, but substantially below women's participation rate in the wage-dependent workforce. Women's active involvement was lower—they accounted for less than twenty percent of the delegates to the FDGB's second congress in June 1947.[135] Their underrepresentation on union factory councils was yet more extreme, even in textile mills with heavily female labor forces.[136]

The "divide and conquer" explanation of women's labor policy is plausible, but its assumption of Machiavellian unity of purpose between political administrators and economic decision makers does not withstand scrutiny. The researcher stumbles, first, across the stubborn refusal of Soviet-owned and -operated enterprises (SAGs) to implement "equal pay for equal work." In January 1947, Lieutenant Colonel P. F. Nasarov asked Lisa Ulrich, an SED functionary, why women did not seem grateful for the gift of Order Nr. 253. Ulrich informed him that women saw no sign of it "in the biggest and most important factories, which are mainly under Russian management. [Their directors] tell us that German regulations

[132] Brunner, 10–11; Hübner, *Konsens*, 16, 19, 41; Barthel, 151.

[133] Stössel makes this argument forcefully (Stössel, 104, 188–90).

[134] Kopstein, 29.

[135] Friedel Malter, "Gewerkschaftswahlen und die Frauen," *NW* (Jan 1947), 13; *NW* (July 1947), 28.

[136] SAPMO-BArch, DY34/A1468, Malter, Übersicht über die gewerkschaftliche Frauenarbeit, 14.8.48, 11. On antiwomen tendencies in German trade unions and Social Democratic women's challenges to these, see Canning, *Languages*, 317; Maynes, 156–58.

such as Order Nr. 253 don't pertain to them."[137] Not just Soviet economic managers resisted equal pay for women. Women's advocates ran into intense opposition to "253" among managers in private and state-run firms, and among factory directors who were apolitical and ones who were Communists.[138] One realizes, second, that, whatever its intent, "253" did *not* undermine labor solidarity. Rather than crumble at the appearance of women workers on the shop floor, (male) unity hardened and expanded. Foremen objected to "253." Union functionaries joined in the resistance. SED functionaries, too, dragged their heels.[139] Antagonism to equal pay for women jumped every political and social division in the factory *except* the gender divide.

Workers' hostility to "253" contained a sensible moment. Male workers and union officials, no doubt, saw the order to raise pay unilaterally as a breach of negotiated wage scales and a blow to union authority. Yet this one-time breach could have led to long-term gains if workers and unions had exploited its implications. By raising the wages of women (and young) workers by twenty-five to thirty percent, "253" broke with the old capitalist ploy of hiring women at low wages in order to depress wages in general—a practice long denounced by unions.[140] For their part, managers insisted that they had no basis of comparison on which to pay women equally. They did not see the long-term economic advantages of winning women workers "for" management. Neither union representatives nor managers behaved like rational actors, because their antagonism to "253" was rooted in emotion. Workers, foremen, directors, and union officials expressed doubts about whether women could work as well as men; a leader of the postal workers union wondered if they were not "physically and mentally inferior." To earn the same pay as women was deeply humiliating, claimed men from both sides of the management/worker divide.[141]

[137] SAPMO-BArch, DY30/IV2/17/80, Bl.69, n.d., Vorschlag des Herrn Oberstleutnant; Bl.72, Aus der Besprechung mit . . . Nasarow. Also see Hoffmann, *Aufbau*, 229; Port, "Conflict,"437.

[138] See cases in: SAPMO-BArch, DY34/A1639, Thüringer -Landesarbeitstagung der Abt. Frauen am 16.9.47, S. 2; Monat Jan. 1948. Monatsbericht . . . IG metall., S.2; Frauenarbeit in Chemnitz. (1947), S. 2; DY34/21674. Protokoll, 3.8.48. On the failure to implement "253" in textiles, clothing, and other industries, see Hans Thalmann, "Grundsätzliche zur Durchführung des Befehls der SMA Nr. 253," *Die Arbeit* (1947/7), 183; Hans Thalmann, "Lohnpolitische Perspektiven," *Die Arbeit* (1947/12), 342.

[139] Frieda Krueger, "Keine Lohn und Tarifkommissionen ohne Frauen!" *NW* (Nov 1946), 31. On the inconsistent stance of the unions, see Luise Krueger, "Zur Gleichberechtigung der Frauen in der Gewerkschaft," *Die Arbeit* (1949/1), 37.

[140] Hübner points out this effect of "253" (Hübner, *Konsens*, 19).

[141] SAPMO-BArch, DY34/A1468, Malter an Jendretzky, 7.8.48. Aktennotiz, 6.8.48; SHSA. Bestand: Spinnereien. VEB Leipziger Wollgarnfabrik. Bl. 5, An den Militär-Zentral-Kommandantur, 5.8.47; Obertreis, 43–45.

Just as intense and widespread was animosity toward women in "male" jobs and to "double earners" (employed wives). This recalcitrance had a self-interested, if not precisely rational, core: job competition from women. Demobilized veterans vanquished women in the job market, in part because they possessed skills valued in the postwar economy, and in part because they enjoyed the sympathy of employers, party functionaries, and the bureaucrats in labor-procurement offices. At metal working plants, party "inspectors" sent in from the outside had to disabuse SED officials of their belief that the party line was to replace women with veterans.[142] Not only men, but also women, held to the cultural ideal of the breadwinner/housewife family. As men returned from POW camps, many wives dropped out of the workforce.[143]

Focused on Order Nr. 253 as a tool to weaken workers' collective bargaining power, labor historians have overlooked the meaning of Order Nr. 234 for *individual* bargaining power. Modeled on Soviet labor policy, "234" was a veritable Swiss army knife of labor instruments. It introduced nonmonetary perks that were supposed to alleviate the burden of domestic labor. It offered these benefits to women workers as *women*. Simultaneously, however, "234" included other features that discriminated against women workers as *workers*. Thus, it provided better benefits, higher wages, and higher-calorie meals to skilled workers, technicians, scientists, managers, and political directors—who were nearly all male. In the economy as a whole, "234" privileged basic industry, in line with Stalin's strong penchant for coal, iron, and steel. It covered some textile and optics firms with female workforces, but it encompassed entire industries that were overwhelmingly male and required skills that male workers were more likely to possess.[144] Thus, SMAD's general labor policy effectively buttressed the real and symbolic value of male over female labor.

The "divide and conquer" thesis obscures, finally, the sincere support for the equality of women workers from women activists in the party, in the unions, and in the DFD. Appalled by the neglect of women workers by party secretaries and union officials, women turned to the Women's Section of the SED and to the DFD's executive board in their struggle to improve women's situation on the shop floor—and to increase their own clout within male-dominated structures of power in the factory. These interlocking women's directorates began a campaign to take the represen-

[142] SHSA, I/3/24, Bl. 128, Bericht über die Frauenarbeit, 20.2.46; Hoffmann, *Aufbau*, 226. On the similar treatment of women after World War One, see Rouette.

[143] A wool spinning factory in Leipzig could not find women to fill empty positions, even after repeatedly raising wages. See SHSA VEB Leipziger Wollgarnfabrik. Bl. 5, 5.8.47.

[144] Gunnar Winkler, *Sozialpolitik*, 1989), 37; Barthel, 151, 156, 159.

tation of women workers away from untrustworthy male functionaries and give it to a new, exclusively women's organization—the DFD "factory group." This intervention into shop floor politics by the DFD and the Women's Section further complicated the implementation of official labor policies.

The story of the DFD factory group can be interpreted as another example of Soviet "divide and conquer" tactics, or as more evidence that misogyny divided the workers' movement. In early to mid-1947, local DFD officials, without approval from above, began to organize factory cells to push for equal pay for women. These efforts provoked the fury of the FDGB, including its Women's Department.[145] Union functionaries perceived these cells as yet another threat to union prerogatives. In addition, *female* FDGB functionaries worried that women workers would transfer allegiance to the DFD and weaken women's presence in the FDGB.[146] Just when it looked as if the SED leadership would back up the *unions* in this dispute, the DFD found an even more powerful ally—the Soviet command. The Russians supported the creation of DFD factory groups at Buna and Leuna, two big chemical plants under Russian management that were hiring women.[147] Significantly, Leuna workers were offering stiff resistance to piece rates and hassling co-workers who accepted higher production norms. Leuna's male workers also opposed the integration of women into "male" jobs in the plant.[148] Clearly, in line with the "divide and conquer" thesis, the Soviets saw the DFD groups as a wedge to weaken solidarity—and union autonomy. They put pressure on the FDGB to recognize DFD factory groups at the chemical plants. It did so reluctantly. Union functionaries in other factories reacted by stepping up their harassment of DFD organizers.[149]

The tug-of-war between the FDGB and DFD over women's separate factory groups suggests strongly that DFD leaders, soon joined by the Women's Secretariat of the SED, saw women's groups as a way to increase female leverage within the emerging hierarchies of power in the SBZ. Leading women in the DFD and SED wanted simultaneously to build a

[145] SAPMO-BArch, DY34/A1678, Rundschreiben Nr. 4/47, 3.5.47. FDGB Landesvorstand Thüringen an alle Kreisvorstände; DY30/IV2/17/82, Bl. 46, Friedel Malter an Schmidt und Kern, 3.6.47; Pawlowski, 102.

[146] SAPMO-BArch, DY34/A1676, An Kollegen Jendretsky . . . 14.7.47; DY34/A1678, Sitzung . . . der Frauenausschüsse am 10.7.47; DY34/A1672, Bericht . . . 13.9.47.

[147] Ibid.; SAPMO-BArch, DY34/A1676, An Kollegen Jendretsky . . . 18.7.47, pp. 1–2. On the DFD at Leuna and Buna, see DY34/A1676, Bericht . . . Sachsen-Anhalt, Juli 1947.

[148] Engelsmann, 151–52.

[149] SAPMO-BArch, DY30/IV2/17/51, Bl. 62, SED Leipzig an PVS der SED, 13.3.48; DY30/IV2/17/82, Bl. 223, Betr: Rücksprache des Gen. Lehmann mit Kern und M. Weiterer am 16.2.48; DY30/IV2/17/51, Bl. 432–43. Frauensekretariat, Potsdam, 20.11.48.

popular base among women workers and prove their worth to Soviet authorities as shop floor disciplinarians.[150] The DFD's quarterly plan for autumn 1947 provides evidence of this dual aim. The "plan" instructed DFD chapters in textile mills to facilitate the implementation of Order Nr. 234 (which included changeovers to piece work) by expanding "contacts with *Arbeiterinnen*" and discussing with them ways to "advance and increase production, improve the work ethic, and struggle against truants (*Bummelanten*)." This sounds sinister, yet the "plan" also urged DFD women to recognize absenteeism and "loafing" as evidence of women's difficult situation at home. DFD members should push managers to open nurseries, kindergartens, school lunch programs, and laundries in every plant. It was hoped "contacts" could provide activists with wage information to pass on to SED factory committees and, thus, improve enforcement of Order Nr. 253 (equal pay for equal work).[151]

The DFD appeared, in fact, to be the only SED-affiliated organization able to channel the "intense discontent" of women workers. As of May 1948, the DFD had registered 156 factory groups; five months later, they counted 539. In the Potsdam area, DFD meetings were better attended than party gatherings.[152] In the predominantly female Olympia (carpet) Works, the DFD groups "carried out stronger work in . . . the improvement of social benefits, [causing] erosion of respect for the factory groups of the SED and union." FDGB functionaries denounced the DFD for encroaching on "trade union tasks," while DFD leaders expressed open contempt for FDGB work among women. "Severe tensions" arose between DFD and FDGB women. The FDGB complained to the party leadership that SED women activists supported the DFD factory groups.[153]

Party women championed the factory groups, because otherwise, they lamented, "We have no toehold in [women's] factories . . . and just turn in circles," not even receiving credit for the modest social services that many mills now offered.[154] The SED's position only worsened after the

[150] SAPMO-BArch, IV2/17/82, Bl. 228–31, 155–57, Richtlinien für die Betriebsarbeit des DFD, 1.4.48; DY30/IV2/17/82, Bl. 150, Protokoll . . . 20.10.47; DY34/A4004, Beschluss-Protokoll Bundesvorstand Sitzung am 25.8.47; A1678, Rundschreiben Nr. 4/47, 3.5.47; DY30/IV2/17/82, Bl. 46, Malter an Schmidt und Kern, 3.6.47.

[151] SAPMO-BArch, DY30/IV2/17/82, Bl. 89–95, DFD, Arbeitsplan für Oktober, November, Dezember, 15.10.47, 2.

[152] SAPMO-BArch, DY30/IV2/17/51, Bl. 321–26, Protokoll Frauenabteilungssitzung 28.2.48 (Potsdam). On the numbers of DFD groups, see Gerda Weber, 427.

[153] SAPMO-BArch, DY30/IV2/17/7, Bl. 75, Gewinnung der Frauen für die Partei; DY30/IV2/17/51, Bl. 69–73, DFD Kreisvorstand Neiderbarnim. 23.7.48, An Rat des Kreis Niederbarnim, 2; DY34/A1468, Vorstand des FDGB an PVS SED, 8.7.48, Betriebsarbeit des DFD—Zusammenarbeit mit dem FDGB; DY34/A1468, Krueger an Jendretzky, 17.7.48; Malter an Jendretzky, 5.8.48, 2.

[154] SAPMO-BArch, DY30/IV2/17/51, Bl.432–43, Frauensekretariat Potsdam, 20.11.48, Bericht über Funktionärinnenkonferenz.

"two-year plan," introduced in 1948, cut consumer investment in favor of heavy industry and raised production quotas. In combination with Soviet occupation policies, its terms "are shaking the class consciousness of many [women] comrades." They "shrink from popularizing the two-year plan" and, like other women workers, "gaze longingly at the Marshall Plan." Separatism seemed the only way to reach women workers with the party's message. Käthe Kern, co-chair of the Women's Secretariat, pressed the ZS to approve separate women's meetings in factories despite FDGB opposition. Kern claimed, "We never see so many women . . . as at the special women's assemblies . . ."[155] Women functionaries organized an all-female version of a gimmick to stimulate workers' production and stanch demoralization inside the SED—the "activist movement."[156] Like the DFD groups, the *Frauenaktivs* took their double role seriously. They endeavored to convince women workers to accept "achievement wages" and the high production norms that accompanied them. They also pressed management for kindergartens, "improvement of wages," and a monthly paid "housework day" for women.[157] Finally, they tried to counter anti-Sovietism, reminding workers that they should be thankful to "the socialist occupation forces [that] have helped us come this far."[158] Like the FDGB women's commissions and DFD factory groups, the *Frauenaktivs* appeared first in the big factories such as Leuna that were central to fulfillment of the plan and in which "pessimism in the ranks of the party" demanded immediate attention.[159]

After the war, most Communist women initially rejected gender separatism and accepted the DFD only as a tactical maneuver. By early 1948, gender segregation was in vogue among women in the SED. They organized conferences and courses that trained women functionaries as organizers and introduced them to Communist theory, the history of the workers' movement, and the history of the German and international women's movement, proletarian *and* bourgeois. Women preferred the "special

[155] SAPMO-BArch, DY34/A1468, Krueger an Jendretzky, 19.7.48.

[156] SAPMO-BArch, DY30/IV2/17/52, Bl.266–71, Frauenaktivleiterinnen in Magdeburg am 5.8.48; Bl. 321–26, Protokoll . . . 28.2.48 (Potsdam).

[157] See, e.g., SAPMO-BArch, DY30/IV2/17/51, Bl. 377–89, Protokoll . . . 25.8.48; DY30/IV2/17/52, Bl.234, Bericht Mai 1948: Arbeit in Betrieben; DY30/IV2/17/51, Bl. 432–43, Frauensekretariat, Potsdam, 20.11.48, p. 3; Käthe Dietz, "Frauenaktivs: Unsere Frauenarbeit in Sachsen-Anhalt erstärkt," NW (March 1948), 29.

[158] Quote from: SAPMO-BArch, DY30/IV2/17/52, Bl. 266–71, Frauenaktivleiterinnen in Magdeburg am 5.8.48; DY30/IV2/17/52, Bl. 330–35, 6.9.48, Bericht . . . Leuna Werk; DY30/IV2/17/51, Bl. 375, Bericht Bauer, Betriebsverssammlung Hauptpostamt Potsdam 24.8.48.

[159] Quote: SAPMO-BArch, DY30/IV2/17/52, Bl. 279, Konferenz der Frauenaktivisten der SED am 11.8.48. Also see Elli Schmidt, "Das wichtigste Glied unserer Frauenarbeit," NW (Jan 1948), 29; Stössel, 333.

courses" to coeducational ones and, according to organizers, spoke at them more freely. SED women angrily rejected the charge from male comrades that they were "building a party within a party."[160]

THE STALINIST VISE

An atmospheric change descended on the SED in autumn 1948 and ended the balmy days of separatism. The chill blew in with a theoretical broadside from Lotte Kühn, who was married to Walter Ulbricht. Writing in the SED flagship daily *Neues Deutschland*, Kühn impugned the *Frauenaktivs* as a "special organization (*Sonderorganisation*)" that prevented women workers from directly joining the "activist movement."[161] Kühn described the DFD as a "preschool" for women, not as central as the FDGB to women's work, and absolutely subordinate to the SED. Recalling Lenin's disdain for the "feminist tendency toward self-organization," she rebuked Elli Schmidt for her alleged exaltation of the DFD as *the* organization for women.[162] Concrete knocks soon followed the ideological slap. *Frauenaktivs* and the FDGB women's commissions were abolished in late 1948. The DFD factory groups were not immediately quashed, presumably because they had SMAD support. In fact, they continued to flourish, reaching a peak number of 1470 in May 1949.[163]

A variety of factors ushered in the icy wind. Most important was a lurch toward class struggle politics amid intensifying Cold War rhetoric. In January 1949, the SED staged a conference that proclaimed its transition to a "Party of New Type," that is, a Leninist party organized on the principles of "democratic centralism." A witch hunt against Social Democratic and bourgeois "deviations" cranked up. Women's separatism was associated in the Communist mind with "Social Democratism" and bourgeois feminism. In addition, the extreme efforts and unorthodox methods required to overcome women's antagonism to Communist politics were provoking ever more distaste among SED men.

The FDGB claimed that it abolished its women's factory commissions and women's department in order to integrate women into cross-gender

[160] Quote is from: L. Schmidt, 27. Also see Elli Schmidt, "Auf die aktive Mitarbeit der Frauen kommt es an!" *ND* (28.8.47), 2; Edith Höding, Sonderlehrgänge für Funktionärinnen' *NW* (Jan 1948), 30; n.a., "Erfahrungen aus Frauensonderlehrgänge," *NW* (Aug 1948), 29–30; Gast, 67.

[161] Lotte Kühn, "Kennen die Hallenser die Beschlüsse des Parteivorstandes?" *ND* (4.11.48), 3.

[162] L. Kühn, "Frauenarbeit—Aufgabe der Gesamtpartei," *ND* (23.12.48), 3; L. Kühn, "Die Frauen in den Massenorganisationen," *ND* (23.12.48), 3.

[163] Gerda Weber, 427.

committees. Yet its decision took leading women unionists by surprise. The move was part of the so-called "Bitterfeld resolutions" of December 1948 that put the official stamp on the Stalinization of the unions, turning them into agents of the SED, rather than representatives of workers' interests. The congress also eradicated the "antifascist factory councils." "Bitterfeld" sealed the process of concentrating shop floor decision making in the hands of the "factory trade union leadership" (BGL) and advanced the centralization of union power. The dismantling of the women's commissions was part of that process, but it was also something more. Unlike the factory councils, the women's commissions existed inside the union structure of command and had never challenged its authority. The silencing of this rather weak female voice was, one suspects, a sop to male officials, who could not be expected to lose traditional functions *and* tolerate this new irritant.[164]

Initially, leading women in the SED pushed back against the onslaught on women's organizations. They denounced the FDGB, which they saw as their main opponent in the rivalry over the representation of women's interests—and the most vulnerable one, given its hesitant accession to the "sovietization" of shop floor labor relations. They attacked the FDGB's decision to dismantle its women's section and impugned its "ambiguous attitude toward the USSR." They continued to defend DFD factory groups.[165]

It was one thing to snipe at the FDGB, but quite another to challenge the party's antifeminist rhetoric in an increasingly frightening political atmosphere. Women in the SED rapidly tailored their language to fit the revival of Leninism and class struggle.[166] In *Neues Deutschland*, Käthe Kern (who as a former Social Democrat had reason to feel worried) defended the DFD's role in "working with women" but added, "[O]nly a class organization can win women for the class struggle."[167] Elli Schmidt, personally named in Kühn's attack, struck an abject position. "The party of a new type," she told delegates at the party conference in January 1949, required that "a whole series of bad habits in women's work must be

[164] Hübner discusses the "crisis of identity" felt by the FDGB functionary corps in 1948 (*Konsens*, 35–38).

[165] SAPMO-BArch, DY34, Krueger an Sekretariat, 18.12.48, Aktennotiz ... 15–16.12.48. For a similar discussion at a lower level, see DY30/IV2/17/50, Bl. 309, Bericht über die Arbeitstagung mit den Spitzenfunktionärinnen aus den Kreisen am 4.1.49 in Schwerin.

[166] Käte Selbmann, "Nochmals: die Frauen und der Zweijahrplan," *NW* (Dec 1948), 29; Ella Sworowski, "Die Aufgaben der Frauenleiterinnen," *ND* (16.12.48), 4. Also see Stössel, 333.

[167] Käthe Kern, "Zur Frauenarbeit unserer Partei," *ND* (13.1.49), 4.

ruthlessly overcome. The SPD had special women's groups. . . . Such sep-
aration can and dare not exist in a Marxist-Leninist party."[168]

The assaults on women's special organization and promotion now
came fast and furious. The party conference downgraded the guarantee
of female representation on leading bodies to a guideline for what
"ought" to be (*Sollbestimmung*). The Third Party Congress (1950) elimi-
nated even that flimsy measure. In 1949, the party leadership abolished
local women's sections and "special courses." Most significantly, it de-
moted the Women's Section of the Central Secretariat (which had been
transformed into a Politburo) to a Women's Department of the Central
Committee (the former party executive). The ZS had included Kern and
Schmidt; the Politburo was all male. The less prominent Käte Selbmann
was appointed to direct the more subordinate Women's Department. In
a memorandum to the Central Committee of the CPSU, Sergej Tjul'panov,
director of Soviet propaganda in Berlin, commented that all this came
"too early" and would weaken the SED's work among women. His supe-
riors did not, however, intervene.[169]

Maria Rentmeister, general secretary of the DFD during its period of
separatist excess, stepped down from that post. Its nonpartisan chair-
woman, Durand-Wever, had resigned in April 1948 "for health reasons,"
that is, because she was sickened by the SED's open domination of the
DFD. Elli Schmidt became its chairwoman, evidence that her public *mea
culpa* sufficed to allow her to lead apolitical women. In May 1949, the
DFD was ordered to dissolve its factory groups, but some chapters defied
the order and the last factory groups did not disappear until mid-1950.
Their abolition truncated DFD contacts with women industrial workers,
on the one hand, and accelerated the SED-ization of the Women's League,
on the other.[170] The SED, like the FDGB earlier, promised to "make wom-
en's work the concern of the entire party" and to end "compartmentaliza-
tion" (*Ressortarbeit*). The promise went unfulfilled.[171] In plants such as
the Zeiss optics factory, female activists dutifully formed "party actives,"
not *Frauenaktivs*, and continued the struggle to convince women workers
to overcome their hatred of the Soviets and increase production norms.

[168] Quoted in Gast, 65.

[169] Nr. 48 Memorandum S. Tjul'panovs . . . vom 20.–21. Juli 1949, 26.7.49, in Bon-
wetsch, Bordjugov, Naimark, 208–9.

[170] Pawlowski, 84; Gerda Weber, 427; Stössel, 332–33; SAPMO-BArch, DY30/IV2/17/
82, Bl. 366; DY30/IV2/17/55, Bl. 242, Arbeitsbericht . . . Juli 1949; SHSA IV2/17/8, Bl. 2–
10, Bericht . . . DFD Arbeitstagung, 9.6.49.

[171] SAPMO-BArch, DY30/IV2/17/8, Bl. 84–98, Bericht der Frauenabteilung über die Ar-
beit seit des 2. Parteitags, 18.8.49, 9–10; DY30/IV2/5/261, Bl. 16, Die Ergebnisse der Wah-
len zu den Parteileitungen (?1949–1950); LAM, IV/L-2/602/70, Arbeit der Gewerkschaften
unter den Frauen. 27.7.49.

They received "little support from [male] comrades in the factory, local, or regional party leadership," and their backing of women's demands for improved working conditions raised the hackles of management.[172] The top leadership of the SED did not completely abandon the attempt to advance women in the party. It pressured local executives to coopt women.[173] In the by-elections to party positions in 1950, however, male functionaries demonstratively voted out the few women (and youth) appointees.[174] The percentage of women in the SED fell, hitting a low of nineteen to twenty percent in 1950. This decline can be attributed to a housecleaning of inactive members, the Leninist drive for "quality over quantity," and the purge of former Social Democrats.[175] Käthe Kern was not expelled, but she was excluded from any significant position in the party apparatus. She felt increasingly isolated on the executive board of the DFD.[176] She remained on the SED Central Committee but played no important role. She moved into the state bureaucracy as Director of the Department of Mother and Child, a division within the Ministry of Health that oversaw the implementation of programs for pregnant women, new mothers, and young children. Kern's shift to an apolitical and "feminine" function symbolized the coincident marginalization of former Social Democrats and political women, two groups that represented autonomous tendencies in the early SED.

Elli Schmidt remained prominent as head of the DFD. In 1950, she advanced to candidate status on the Politburo, but her influence was more apparent than real. True, under her stewardship, the DFD ballooned into a mass organization of one million members, but its huge girth belied its light weight as the party's transmission belt to housewives. The FDGB,

[172] SAPMO-BArch, DY30/IV2/17/8, Bl. 284–87, Auswertung des Berichtes aller Genossinnen des Parteiaktivs "Klara Zetkin" im VEB Zeiss, Jena (n.d.).

[173] See, e.g., SAPMO-BArch, DY30/IV2/17/8, Bl. 293, SED LVS Thüringen, Fraunsekretariat, an Selbmann, Frauenabteilung, Parteiwahlen 1949.

[174] Stössel, 522. For examples of discrimination against women in the provincial SED, see SAPMO-BArch, DY30/IV2/17/7, Bl. 10–13: Abschrift des Briefes einer Genossin und Gewerkschaftsfunktionärin aus Bernau von 11.5.49; Bl. 15, K. Selbmann an M. Fürmann, 9.6.49; Bl. 14, M. Fürmann an K. Selbmann, 14.6.49; Bl. 17–20, "Es ist nicht richtig, Genossen!" (n.d., n.a.); Bl. 21, Maria Neumann an die Redaktion ND, 17.8.49; Bl. 22, Selbmann an Neumann, 5.9.49; DY3IV2/17/51, Bl. 518, 28.9.49, Lisa Ullrich, Bericht über die Fahrt nach Neuruppin.

[175] Gast, 21. The statistics are imprecise (Gast, 42–47). Also see Dowidat. The SED introduced the category of "candidate" in 1949. People who earlier would have joined the party immediately now had to prove their worthiness.

[176] Kern told Franz Dahlem of her "inner bitterness" at her exclusion from the presidium at the DFD's celebration of Stalin's birthday. Dahlem chided Schmidt for this slight (DY30/IV2/17/82, Bl. 365, 18.12.49, Betr: Behandlung der Genossin Käthe Kern, Franz Dahlem an E. Schmidt).

too, lost its function and autonomy as a trade union, but it eventually gained control of the administration of factory-based social policy, including accident, sickness, and vacation provisions. The DFD, in contrast, enjoyed no institutional base of power. It performed the old standby routine, "women's work for peace," at international women's conferences. In the relatively fluid politics of the SBZ, a dynamic, flexible, and outspoken DFD had seemed poised to become a force within the emerging Communist organizational pantheon, a center for the defense of women's interests, on the job and off. In the dictatorial politics of the GDR, it would devolve, instead, into a bloated, brackish backwater to the torrent of economic and social change that now descended on East Germans.

CONCLUSION

In 1945, the world imploded on top of East German women. Its collapse overwhelmed them, but they did not respond passively. They tried actively to define their relationship to the postwar world. They did whatever it took to get them and their families through the crisis of survival. They also engaged in humanitarian efforts, cultural and educational pursuits, elections, and political parties. They were involved, in other words, in every aspect of public life and life in public. For some women, the postwar years were exciting and suffused with possibility; for others, they were exhausting, scary, and just plain hungry; for many, they were all this simultaneously. Both possibility and uncertainty narrowed as soldiers returned to homes and jobs, and as male-dominated political parties, economic structures, and administrations stabilized and solidified.

By 1948, the young Frau R. had put the most obvious marks of the postwar crisis behind her. The director of the little bank in Mecklenburg where she had briefly worked rescued her and her mother from a precarious existence in Berlin. Determined to avail himself of her financial abilities, this man was now able to procure ironclad residence and work permits for the two women. Frau R. returned to the bank, her mother went back to her aunt's farm, and "from then on everything got much better." The experiences of Communist women were more ambiguous. The tasks before them in 1945 were daunting. In the midst of demographic chaos, a health emergency, and a ravaged economy, they confronted, on one side, a female populace that was even more skeptical than the average man of the antifascist message and its ties to the Russians and, on the other, a male population that looked askance at calls for women's equality and integration into the workforce. Yet Communist women enjoyed unusual leverage within their own movement because of the female electoral majority and the bewilderment of the SED male elite about how to address

women. In their efforts to win over ordinary women, Communist women went in directions that the party leadership initially resisted, such as the reform of Paragraph 218 and the formation of the DFD. Occasionally, an SED woman even said that women had to emancipate themselves.[177] Communist women benefited, paradoxically, from the openness of the postwar situation *and* the power of the Soviet occupiers. The Russians offered support to Schmidt and Kern at key moments in their efforts to promote women's politicization and interests. SED women willingly used antidemocratic levers to gain control over the DFD for their party. Their reliance on Stalinist authoritarian tactics came back to haunt them. The consolidation of one-party rule gutted the significance of the female electoral majority. The centralization of power inside the SED cast a suspicious light on the autonomous organization of women. The turn toward productionism and heavy industrial development pushed "women's labor policy" down the ladder of priorities, and the "woman question" dropped off the central agenda.[178]

[177] Genth and Schmidt-Harzbach, "Frauen in den Parteien," 120.
[178] The pattern of events was strikingly similar in the Soviet Union twenty years earlier. See Goldman, "Politics," 46–77.

Constructing Power

WOMEN AND THE POLITICAL PROGRAM
OF THE SOCIALIST UNITY PARTY

THE 1950S WERE A ROCKY ERA in the history of the GDR. By late 1949, the SED proclaimed Marxism-Leninism its guiding ideology and aligned itself with the People's Democracies of Eastern Europe. The new state decreed on 7 October 1949 was, however, neither solidly formed nor genuinely independent. The SED did not instantly become a "party of a new type," despite its Leninist rhetoric and cult of Stalin. Stalinization occurred progressively as it adopted the structures of the Communist party of the Soviet Union (CPSU), and as crises in the 1950s flushed out everyone who even mildly questioned the path of Walter Ulbricht. The difficulties of honing political power were compounded by the ambitiousness of the SED's plan for a grandly conceived, rapidly realized socialist utopia. Under Ulbricht's heavy hand and dour demeanor, the Politburo and Central Committee set out not only to reconstruct damaged infrastructure, factories, fields, and livestock, but also to restructure a mixed industrial base into a heavily industrialized *and* socialized economy. They planned to transform East German society by massively reducing social privilege and elevating the working class with a new educational system. The SED did not, however, start with a cultural *tabula rasa* but attached itself to extant currents in postwar Germany, such as antifascism, fear of war, and the desire for national unity. These associations provided the GDR with a mantle of legitimacy, while also distinguishing it from National Socialism and the Federal Republic of Germany.[1] Hatred of fascism, love of peace, and yearning for a whole Germany did not, however, a democratic people make. To that end, the SED aimed to purge East Germans of individualism, theism, and imperialism, and infuse them with collectivism, Marxism, and loyalty to the Soviet Union.

The SED trumpeted the popularity of its goals, yet it spotted "class enemies" in every nook and cranny. Alien class-consciousness permeated,

[1] On antifascism, see Meuschel, *Legitimation*, 38–40, 54; Steinbach, 48–50. On nationalist discourse, see, Weitz, 370–71. On peace and unity discourse, see Hermann Weber, *Geschichte*, 187–88.

Communists feared, not just urban elites and big farmers, but peasants and workers; not just obvious antagonists, but apparent supporters. Bourgeois sabotage was exposed wherever people opposed or even misunderstood antifascism; it was present whenever a plan went awry. Malevolent agents of U.S. imperialism stood behind every unmet quota. Members of churches, bourgeois parties, and the SED itself felt the brunt of Stalinist paranoia. Operatives of the Ministry of State Security (Stasi), created in 1950, shadowed, interrogated, and interned real and imagined foes.[2] The persecution of former Social Democrats intensified. Show trials condemned them and other political opponents to long prison terms and even death. The show trials ended in 1952, but up to 1955, State Security made about ten thousand political arrests per year.[3]

Society reacted in complex ways to upheaval and oppression. Social leveling and political repression terrified those with the wrong background or incorrect view of the world, while defamation of doubters and slackers weighed on anyone who lacked diligence or collective feeling. Yet antifascist transformation inspired some citizens. The rhetoric of *Aufbau* (construction or reconstruction) appealed to self-improving, patriotic, and/or cooperative impulses. Many workers felt empowered by an ideology that celebrated proletarians and promised them the future.[4] No impermeable barrier separated supporters from opponents. The draconian methods employed in 1952 and 1953 to meet economic goals infuriated even ardent believers. As the political atmosphere lightened and the standard of living rose after 1953, many skeptics became willing to go along.

The bold program of the 1950s relegated the "woman question" to the margins. The only part explicitly directed at women was the call for their equal right to join the production fray. The constitution outlawed discrimination on the basis of sex. A flurry of legislation established women's legal equality in the public sphere, workplace, and family. Whether married or single, a woman became a full-fledged legal person in civil and criminal courts. In September 1950, the Law for the Protection of Mothers and Children and for the Equality of Women guaranteed the same status and rights to single mothers and their children as to married couples and their progeny.[5] The GDR's constitutional guarantee of equality mattered for itself and as a break with the discriminatory laws of earlier Ger-

[2] This overview is constructed from Fulbrook; Hermann Weber, *Geschichte*; Staritz, *Geschichte*; Schroeder; Weitz.

[3] Schroeder, 106; Staritz, *Geschichte*, 60–62; Epstein, 136–42; Gieseke, 45; Müller, Mrotzek, and Köllner, 389–405, 409–11, 416–23, 437–45.

[4] Weitz, 363–64.

[5] Aus dem Gesetz über den Mutter-und Kinderschutz und die Rechte der Frau vom 27. September 1950 (GBl. Nr. 111 S. 1037), in Scholz, 67–71.

man regimes. The SED was proud of its destruction of legal patriarchy. Women's equality remained, nonetheless, peripheral to the utopian vision, for women's rights did not promote class equality or a collective mentality, much less raise productivity.

The central tenets of the political agenda appeared to be gender neutral, but they included gendered subtexts. In a few cases, Communists emphasized the gender component, as in the plan to integrate women into certain areas of production. In others, they at least recognized it, as in the effort to win farmers' wives to collectivization. Typically, however, the gendered significance of a political decision was unintentional, determined by sex differences in economic role, religious commitment, or political engagement, on the one hand, and the unreflected biases of the male SED elite, on the other. With less political experience and less property or status to lose, women participated at a lower rate than men in overtly political struggles. Yet they did take part. This chapter discusses some of the ways the political decisions of the SED provoked or engaged women. It considers the severe crisis of 1953 from a gendered angle. It provides an overview of women's roles in the SED, DFD, and state administration. It surveys women's responses to three planks of the SED program: educational reform, collectivization of agriculture, and dechristianization.

THE CRISIS OF 1953

The years 1948 to 1953, the tensest period of the Cold War, coincided with the era of High Stalinism in Eastern Europe. Socialist productivism was at its height in the GDR, as in the entire Soviet bloc.[6] Production dominated public speech. Newspapers, radio, posters, banners, photographs, poems, novels, and films promoted higher production with appeals to community spirit, national pride, moral duty, and love of children.[7] Production suffused politics, and politics invaded production. In the run-up to the GDR's first legislative election in 1950, an army of agitators descended, for example, on the huge Buna chemical plant. One thousand twenty FDGB activists plus 350 SED operatives circulated through the vast industrial complex and nearby villages, blasting radio programs over loudspeakers, haranguing workers at gates and tram stops, and handing out reams of leaflets. Even in normal times, 348 FDGB func-

[6] Landsman, *Demand*, 102–6.

[7] *Die Frau von heute* quoted a woman lathe-operator who compared her drive to produce with her desire to be efficient in her housework ("Gut haushalten, vor allem im Betrieb," Fvh, Nr. 24, 12.6.53).

tionaries roamed Buna each day, holding forth on people's production, proletarian commitment, and perfidious saboteurs.[8]

The production in question was basic and heavy industry. The First Five-Year Plan (1951–55) projected a doubling of industrial production relative to 1950. Toward that goal, it devoted more than three times as much investment to heavy industry and machine building than to light industry, provisioning, and retail trade.[9] On top of this drastic plan for industrial expansion, the Second Party Conference (July 1952) decided to "build Socialism"—now! *Neues Deutschland* cranked up its offensive against *agents provocateurs* as the drive to socialize business and agriculture rapidly accelerated. The economy's "heights" had already been nationalized: banks, insurance, and big concerns. The party now directed the class struggle at the middle strata of business owners and farmers (landowners with twenty hectares or more). Farmers were pressured to join a "rural production cooperative" (LPG). The state raised property and income taxes.[10] The onslaught on private property provoked a wave of westward flight. In 1952, 180,000 people fled the GDR; in the first six months of 1953, the number leapt to 300,000. Both class-struggle ideology and practical considerations motivated the campaign; industrialization required capital *and* the state had to pay for an expanded military force (disguised as a "People's Police"). To these ends, the "workers' and farmers' state" slashed pensions and welfare payments to the poor and reduced general consumption levels. By autumn 1952, butter, vegetables, meat, sugar, and bread were in short supply. There was an acute shortage of underwear. Shoppers waited in monstrously long lines. Despite all this, in February 1953, the SED announced new austerity measures under the winning slogan, "regime of thrift."[11] The party was turning the entire population into its enemies. Stalin's death in March 1953 sent a tremor of anxiety through the SED leadership, but General Secretary Ulbricht charged ahead. The Central Committee demanded higher produce deliveries from farmers and raised production norms for workers by ten percent. Combined with higher prices, the new quotas would reduce the real wages of many workers by twenty-five to thirty percent.[12]

The simultaneous campaigns to socialize production, property, and trade; to squeeze consumption for investment; and to raise current production unleashed a multifarious and profound crisis. The assault on pri-

[8] VEB Buna, Rep.II-1/375, Zentrale Aufklärungsstelle des FDGB, Tätigkeitsbericht, 31.10.50; Zentrale Aufklärungsgruppe des FDGB, Schkopau, 1.11.50.

[9] Landsman, "Dictatorship," 127.

[10] Staritz, *Geschichte*, 40; Landsman, Demand, 102.

[11] Pence, "You," 227, 230; Landsman, *Demand*, 105.

[12] Fulbrook, 179–81; Schroeder, 110, 119–20; Loth, 147–49; Staritz, *Geschichte*, 77–79.

vate property spurred flight by the propertied and professionals. It disrupted distribution and retail commerce, both of which were predominantly in private hands. It sliced into agricultural output; by April 1953 almost a half-million hectares lay fallow, their owners having fled west.[13] The class-struggle offensive, therefore, compounded a crisis of consumption that was also accelerated by price increases and reductions in wages, pensions, and consumer production. The crisis of consumption spilled into industry, as workers grew agitated about the scarcity of food and clothing for their families. The exodus of population and expansion of the People's Police intensified the need for higher production from every employee and farmer still laboring in factory or field. The multiplying crises provoked desperation among consumers and, finally, a major rebellion by workers that almost brought down the SED regime in June 1953. I will summarize the main events before analyzing the crisis from the intersecting perspectives of consumption and gender.

Stalin's successors in Moscow introduced a change of course that increased production of consumer goods and heralded more relaxed relations with the United States. East Germans learned of these measures from "Radio in the American Sector" (RIAS). The Russians pressured Ulbricht to follow suit. On 9 June, the SED Politburo retracted the more draconian measures against private business and farmers, reached out to the churches, promised greater availability of food and goods, and scaled back collectivization. On 11 June, the Ministerial Council of the GDR decreased prices for groceries.[14] The only sector of the population that received no relief was the proletariat: the June decrees did not retract the ten percent norm increase of 28 May. On 11 and 12 June, angry workers engaged in protests and work stoppages at scattered factories. After the FDGB's newspaper *Tribüne* defended higher norms, construction workers marched on FDGB headquarters in Berlin on 16 June and called a general strike. The Politburo immediately rescinded the norm increase but acted too late. On the 17th, hundreds of demonstrations and strikes unfolded in a wave spread by word of mouth and RIAS. Five hundred thousand workers struck, and 400,000 people demonstrated in Berlin and 250 other towns. Workers, including members of the SED, led the actions and represented the majority of street demonstrators. Workers' committees demanded lowered work norms and prices. Many called for the SED to get out of the factories and for union leaders to resign. Some commit-

[13] Landsman, *Demand*, 101.
[14] Epstein, 160–63; Grieder, *Leadership*, 31, 79; Hermann Weber, *Geschichte*, 234–35; Baring, 20–27; Staritz, *Geschichte*, 79–85; "Beschluss des Politbüros vom 9. Juli 1953," "Ministerrat beschliesst Neuen Kurs," ND, 12.6.53, in Spittmann and Fricke, 181–83.

tees demanded that the government resign.[15] Soviet military commanders initially reacted with caution but, as it became obvious that the *Volkspolizei* could not contain the rebellion, Red Army tanks rolled. Their presence frightened and infuriated the crowds. In Berlin and a few other cities, workers battled police and Soviet troops. Russian tanks smashed the uprising, killing 21 people. The Stasi took over from the Soviets and interned six to ten thousand people.[16]

Soviet intervention rescued Ulbricht. To secure his still shaky position, he purged the Politburo and Central Committee of anyone who had doubted his leadership over the past months. He did not immediately retract the New Course. Indeed, the SED distributed emergency food supplies, reduced the expense of public transportation, and raised pensions. It returned norms to 1952 levels and let up on the pressure to produce. A modest shift of investment to light and consumer industries was accompanied by a slight cultural relaxation. Yet the New Course retained the Five-Year Plan and kept sights closely trained on the socialist goal. The Central Committee pointedly underscored the "connection between living better and producing more." The USSR promised material help, but on the condition that the SED tighten the rein on the party apparatus. A massive turnover brought in a younger crop of functionaries. This generation owed its rise to the Old Communists, who sat atop the "party of the new type." The Central Committee had on its payroll *40,000* "instructors," who were sent out to watch and correct the behavior of party members and functionaries.[17]

Photographs of the June strikers and street demonstrations show women sprinkled among throngs of young men (*Figure 7*). Underrepresentation among activists did not mean that women were disengaged from events. They took part as citizens fleeing the GDR, farmers resisting collectivization, and workers opposing higher quotas and wage cuts. It is hard, though, to hear specifically female voices in the cacophony of protest, in part because most workers, and certainly most property-holders and professionals, were not women. One source that identifies women's views is a bundle of reports from DFD members whom the SED instructed to record women's responses to the announcement of the New Course. DFD members mingled with the crowds that were milling around every

[15] Baring, 32–33, 36–42, 74–75; Ewers and Quest; Allinson, 55, 59. The scholarly debate is ongoing about whether the rebellion was a workers' rebellion or an attempted political revolution. For the social interpretation, see Baring, esp. 25, 45, 52, 76; Fricke, "Arbeiteraufstand," 5–22. For the political interpretation, see Schroeder, 130. On the debate, see Fulbrook, 182–85, 177–79.

[16] Schroeder, 121–25; Fulbrook, 182–85, 34; Baring, 55, 67, 80; Loth, 149.

[17] Staritz, *Geschichte*, 87, 89–90; Landsman, *Demand*, 115, 118, 120 (quote); Hermann Weber, *Geschichte*, 250–51; Baring, 106–7, 98–99; Fricke, "Arbeiteraufstand," 16–17.

town as early as 9–10 June. They eavesdropped while standing in the
interminable queues of largely female customers in front of grocery and
clothing outlets. Women, DFD informants wrote, were pleased by deci-
sions to stop harassing Christians, ease travel between the zones, release
those imprisoned for crimes against "people's property," and recompense
farmers for their land. Some women saw the reforms as evidence of the
Politiburo's goodwill. The reports tended to accentuate the positive. A
few acknowledged, however, that numerous women believed the Polit-
buro would soon retract the reforms. Several informants recorded aggres-
sive remarks or actions. For example, women expressed anger about ear-
lier cuts in welfare benefits and widows' pensions.[18] The regime's
inconsistencies, remarked a woman, "show it is unfit to govern."[19] In a
street-corner discussion, another claimed, "The day is not far off when
[Communists] will have to resign and lawful conditions, like our West
German brothers and sisters have, will return."[20] In one town, the audi-
ence at a DFD meeting sat in hostile silence when asked by a visiting DFD
group to discuss the political situation. Afterward, townspeople stoned
the car of the DFD delegation as it sped out of town. In another place, a
crowd dominated by women harassed any passerby who wore insignia of
the SED or any mass organization, including the DFD.[21]

The best way to gauge women's participation in the crisis of 1953 is to
consider it from the angle of consumption. Scholarship on popular activ-
ity in 1952 and 1953 has emphasized flight from class-struggle policies
or conflict around shopfloor relations. Historians recognize that scarcity
contributed to the exodus and strike movement but have not treated con-
sumer dearth as central to the causes of popular resistance. Social histori-
ans have recently paid more attention to the crisis of consumption.[22] Strik-
ers and demonstrators, they note, denounced not only high work norms,
but also high prices, and they did not only demand higher wages but
also called for "butter instead of cannons." The provisioning crisis, Mark
Landsman argues, stood "at the heart" of an uprising that the SED inter-
preted as "a violent eruption of consumer protest."[23] Katherine Pence
agrees that "consumers' problems threatened to dismantle the regime."
To understand popular responses to scarcity and the regime's reaction to
consumer anger, one must consider the gender of consumerism for, Pence

[18] SAPMO-BArch, DY30/IV2/5/544, Bl. 2–9. For a similar comment on pensions in a
letter from a woman, see Pence, "You," 242.

[19] SAPMO-BArch, DY30/IV2/5/544, Bl. 2–9: DFD Bundessek. an ZK, 15.6.53. Betr:
Kommunique der Sitzung d. PB d ZK vom 9.6.53.

[20] Ibid., Bl. 28–29.

[21] Ibid., Bl. 3–9, 10–13, 17–22, 23–27, 28–29, 38–41, 57–63.

[22] See, e.g., Hübner, *Konsens*, Chapter 3.

[23] Landsman, *Demand*, 101, 115, 118.

reminds us, the overlap between "woman" and "consumer" was virtually complete. Pence's sources, like the DFD reports, suggest that women's participation in the crisis was highly structured by their roles as consumers, housewives, and mothers. As consumers, women were active in the months-long run-up to the explosion more than in the explosion itself. Their main forms of protest were complaints articulated while shopping or in letters to state officials. In their protests, women represented themselves as experts on caretaking and consumption. They filtered their reactions to political decisions through a grid of commodities, retail trade, and distribution.[24] One can be sure that wives bent the ear of worker-husbands and thus contributed to the content and urgency of workers' demands in the rebellion of 16–18 June.

In letters written in winter/spring 1953 to the new (and short-lived) State Commission for Trade and Provisions, headed by Elli Schmidt, consumers criticized the dearth of diapers and the expense of nylons. Referring often to the needs of children, old people, and housewives, petitioners insisted, politely but firmly, that the state's neglect of the supply and distribution of basic goods harmed not only the physical condition of the population, but the political condition of the GDR.[25] As the crisis moved toward its crescendo, women focused, as they had in the survival crisis of 1945–48, on the *Ernährungsfrage*. Were stocks adequate to meet demand? Will prices for clothes and food skyrocket? In one town, female customers smashed the windows of a *Konsum* shop after it sold out of vegetables.[26] Letters to Schmidt and the DFD reports suggest that women were united as shoppers and nurturers but divided along social lines. Some women lambasted discrimination against private retailers or expressed relief that the New Course returned ration cards to the "middle strata." A working-class woman endorsed class bias, however, and sales-clerks and poor farmer-women were dismayed that the New Course would compensate "big farmers" for their land.[27]

The SED elite assigned Elli Schmidt, the only woman on the Politburo, the role of mediating between its productivist agenda and unhappy consumers; thus, like ordinary women, she reprised her role in the postwar survival crisis. Schmidt traversed a knife-edged ridge. In her replies to consumers, she sympathized as a mother who had bought nappies and a woman who wore nylons. Yet she also strove as a Communist to convince complainants of the future rewards of delayed gratification.[28] In the halls

[24] Pence, "You," 218–52, 249.

[25] Ibid., 234–243.

[26] SAPMO-BArch, DY30/ IV2/5/544, DFD Bundessekretariat an ZK, 15.6.53. Betr: Kommunique der Sitzung des Politburos der Zentralkomitee vom 9.6.53, Bl. 23–27, 28–29.

[27] Ibid., Bl. 38–41, 57–63; Pence, 'You', 236–40.

[28] Pence, "You," 218, 231, 244–46.

of power, meanwhile, she accepted the priority of production, but vented her irritation at productivist excesses. In a speech to the Central Committee in May, Schmidt complained that the ministries of industry "manifest criminal negligence in production of mass commodities." Right after the June rebellion, she aligned herself with Ulbricht's open critics, Minister of State Security Wilhelm Zaisser and the editor of *Neues Deutschland*, Rudolf Herrnstadt. At a fraught Politburo session, she criticized Ulbricht at least as forthrightly as did others. She charged "dear Walter" with "lies, dishonesty," and arrogance.[29] At a Central Committee meeting a month later, however, Schmidt distanced herself from Zaisser and Herrnstadt. Ulbricht was not to be mollified. Schmidt paid not just for disloyalty, but for conciliatory comments made at a strike meeting of women textile workers. The press excoriated her as an "antiparty" element. She was expelled from the Politburo, the Central Committee, the SED, and the DFD, though not pushed out of public life. This former seamstress was appointed director of a new Institute for Clothing Culture.[30] This ironic conclusion to Schmidt's ups and downs in the SED leadership from 1945 to 1953 encapsulates, as Pence suggests, the hierarchy's association of consumption with women and its ambivalence about both.[31]

WOMEN AND THE PARTY-STATE

Women's political participation declined relatively in the late 1940s as men flooded back into the established parties and the SED went Leninist. Next, though, women's SED membership rose relative to men's when the party again purged itself in 1951. The percentage of women SED members rose to twenty-three percent, where it stuck for years.[32] As the SED expanded to a party of 1.4 million members, it came to encompass five percent of the female population of the GDR. The party bureaucracy ballooned, too. Women entered the fattened apparatus, but at a much lower rate than their membership. Men at every level of the party hierarchy protected *their* preserve from female interlopers. In wide stretches of the provinces, no "base organization" had a female party secretary (the pinnacle position at every organizational step in the SED). Women also fared badly at higher levels. When the GDR reorganized the five states (exclud-

[29] Ibid., 247–51; SAPMO-BArch, DY30/IV2/1/115, Bl. 155, SED ZK Tagungen des ZK, 13.–14. Mai 1953. Also see Schroeder, 126; Grieder, *Leadership*, 79.

[30] Baring, 101; Fricke, "Aufstand," 71.

[31] Pence, "You," 247–49, 251.

[32] SAPMO-BArch, DY30/IV/2/17/9, Parteistatistik 1953–62, Bl. 21. Even in the CDU, the most feminized party, women's ratio declined to forty percent as the CDU grew from 68,000 to 180,000 members (before falling back to 70,000).

ing Berlin) it inherited from the German past into fifteen districts (including Berlin), the SED did the same to its leadership structure. In 1950, women represented twenty-five percent of members of the fifteen "district leadership committees"; by 1958 their number had slipped to sixteen percent. In 1950, women accounted for almost fifteen percent of the smaller "secretariats" within each district committee (equivalent to the relationship between Politburo and Central Committee); in 1958, they made up only 6.5 percent of secretariats. Not a single woman held the most powerful provincial post of First Secretary. Women's representation on the Central Committee stagnated at roughly thirteen percent (including candidates and voting members; female *membership* declined from 15.7 percent to 9.9 percent during the 1950s). The Politburo was purely male from 1953, when candidate Schmidt fell from grace, to 1958, when Edith Baumann and Luise Ermisch joined as candidates.[33]

Active party membership, not to mention the exercise of a party function, demanded extraordinary commitment. Meetings were numerous and ran late into the night. Canvassing for new members or political campaigns, two major tasks of SED members, was often unpleasant and always time consuming. The majority of women comrades were housewives, for they had more time to do the footwork that was most women's lot in the party.[34] Female factory workers, burdened by forty-eight hours of wage labor and almost as many hours of commuting and domestic work each week, remained underrepresented. The Buna chemical factory, for example, employed 5,907 women in March 1959, of whom only 305 (5.1 percent) were in the SED.[35] Anecdotal evidence, too, suggests the inference that recruitment of women was lackadaisical. Asked about SED activity in her small town, a postal employee thought back, "All that came later, much later, all that with the party always being around." Her memory supports Mary Fulbrook's finding that in the 1950s, "society's penetration by functionaries was precarious, tentative, often unreliable."[36] In individual cases, certainly, a party organization might put considerable pressure on women workers to join. Asked why she joined the SED in the 1950s, a worker answered, "Because they tortured me for two years! 'When you joining, little P . . . , when you joining the party . . . ? After two years, I said, 'OK, I'll join. What else is there

[33] Gast, 80–81, 84–85.

[34] Ibid., 62; SAPMO-BArch, DY30/IV2/17/7, Soziale Zusammensetzung der weiblichen Mitglieder, Bl. 0089.

[35] LAM, IV2/3/519, Beschluss des Büros der Bezirksleitung über die Erfahrungen der Partei in der Arbeit unter den Frauen . . . Halle, 11.3.59. The percentage of workers in the SED declined from 55 percent in 1946 to 39 percent in 1953, while the percentage of employees rose to 32.4 percent (Schroeder, 100, 102).

[36] Herzberg, 132, 262; interview Frau AB; Fulbrook, 63.

for me to do?'"[37] A second worker recalled that she, too, joined after much cajoling, although she had no idea what Marxism-Leninism meant. A third worker joined with greater commitment to SED politics, because she had been exposed to the SPD and KPD as a girl in Silesia. It is surely significant that these women were all recruited in Berlin, which had the highest female ratio in the SED (33.1 percent in 1958) and the highest percentage of women members who were workers (17.6 percent in 1950).

Deeply involved in its campaign to raise productivity, the SED had little energy to devote to women. The Women's League was there to pick up the slack. Tamed of its autonomous tendencies, the DFD settled into an abjectly dependent relationship with the SED. When Elli Schmidt was ousted as chairwoman in 1953, her erstwhile acolytes on the DFD board denounced her. Her successors never even hinted at a critique of the party leadership, only occasionally expressing irritation over the neglect of women by lower-level functionaries or by the FDGB. When it was not beating the drums for women's employment, the DFD concentrated on activities like those performed by the National Socialist *Frauenschaft* and held a similar place in the organizational hierarchy of the dictatorship.[38]

The DFD was huge, with roughly 1.3 million members throughout the 1950s. After 1952, employed women were its majority. Three-fifths of members were politically unorganized, thirty-five percent were in the SED, and five percent were in a Block party (loyal to the GDR, but nominally independent).[39] The DFD demanded considerably less time from members than did the SED but engaged, nonetheless, in myriad activities that connected it to women as parents, students, housewives, consumers, and citizens. The DFD ran seminars that aimed to involve parents in the schools and win them to the SED's view of education. In adult education centers, it organized well-attended courses on sewing, cooking, infant care, and cosmetics. It gathered signatures on petitions that condemned every variety of Western militarism. It organized women's volunteer labor to help agricultural cooperatives bring in the harvest. Its activists convinced 30,000 women to volunteer "five million hours of labor" to arrange for thousands of children to attend summer camps.[40] Its members agitated for the SED during election campaigns and, as we saw, reported on ordinary women's opinions. Its popular weekly, *Die Frau von heute*,

[37] IMC, Interview 024.

[38] On the *Frauenschaft*, see Koonz, *Mothers*; Stephenson. For the DFD's self-representation, see Demokratischer Frauenbund Deutschlands, Geschichte des DFD (Leipzig, 1989).

[39] SAPMO-BArch, DY30/IV2/17/43. Bl.110.

[40] SAPMO-BArch, DY30/IV2/17/18, Folder 317. Z. Prot. Nr. 38. Anlage. Bericht über die Mitarbeit unserer Organisation bei der Einbringung der Getreide . . . im J. 1954, Bl. 158; DY30/IV2/17/87, Bl. 281–83, Abschlussbericht.

represented women as workers *and* mothers and wives, while feeding their appetite for recipes, patterns, and photos of GDR film and theater stars.[41] Despite or perhaps because of this veritable smorgasbord of duties, the DFD gradually slumped into a *kaffeeklatsch* existence in many locales, its philofeminism mutating into philistine femininity, GDR-style.[42]

If women fared poorly in the SED's hierarchy of power and had little political influence through "their" organization, they did benefit from the denazification, "democratization," and party-fication of the state, especially in the administration of justice. Unlike in West Germany, the GDR's justice system was thoroughly denazified. Given the judicial system's heavy entanglement with the NSDAP, denazification meant the Ministry of Justice required all new personnel. Short, intensive, politicized courses trained People's Judges (*Volksrichter*). The pupils were convinced antifascists aged twenty-five to thirty-five. While a majority of men came from proletarian backgrounds, only about one-fifth of women did. Whatever their class origin, women entered the courses in impressive numbers and, thus, broke men's absolute hold on the administration of justice. Though ratios differed widely from province to province, women's attendance averaged around twenty percent in 1946. By 1953, one-third of *Volksrichter* were women, many of whom went on to get a law degree, often in special programs designed to accommodate older, working students. By 1959, 23.3 percent of prosecutors were women, and women accounted for 26.8 percent of judges, and 34.6 percent of lay judges (the German variant of a jury).[43] The feminization of Justice was impressive, but it was also inconsistent. Women judges accumulated at the lower levels of the system. They also disproportionately entered the overburdened family and divorce court system, ruling over domestic conflicts far removed from the political spotlight.[44] Whatever their purview, judges and prosecutors, male and female, joined the SED in large numbers (fifty percent of judges and eighty-five percent of prosecutors were in the party by 1950).

Women did well in Justice, at least in part, argues Gunilla-Friederike Budde, because from 1953 to 1967, Hilde Benjamin headed Justice.[45] A tough Old Communist, "Bloody Hilde" did *not* fit the image of the apolit-

[41] Merkel, *und Du*, 142–53; Heineman, *Difference*, 224–26.

[42] SAPMO-BArch, DY31/554, Fiche 2, Bl. 121, E.D. an DFD Bundessekretärin, 25.1.53; DY30/IV2/17/41, Frauenkonferenz der Partei im Kombinat "Schwarze Pumpe" am 28–29.6.58. Also see Bühler; Hampele, 296–301.

[43] SAPMO-BArch, DY30/IV2/17/9, HA Kader und Schulung, Berlin 26.8.55; Budde, *Intelligenz*, 202–7; Budde, "Paradefrauen," 197–98; DY30/IV2/17/89. Bl. 471, 1959, Justizorganen.

[44] Budde, *Intelligenz*, 219–20.

[45] Ibid., 208–15.

ical, nurturing female jurist. She proved her mettle as vice president of the Supreme Court during the show trials of 1950–52. In the crisis of 1953, she joined Ulbricht's attack on Minister of Justice Max Fechner (a former Social Democrat)—and was rewarded with his job.[46] Else Zaisser, in contrast, lost her ministerial post after the June rebellion. The Minister for People's Education was married to Wilhelm Zaisser and fell from power when her husband did. Meanwhile, women moved into low-level elected positions. In 1953, 821 women were mayors, a showy but insignificant post that the SED saw as especially fit for women. Nonetheless, only about eight percent of mayors were women in the 1950s. Relative to Western legislatures, the *Volkskammer* included a credible percentage of women (twenty-three percent in 1953). That august body wielded, of course, no power.

WOMEN AND THE POLITICS OF CLASS STRUGGLE

Female citizens shared the political mood and opinions of male citizens. Many ordinary people of both sexes, for example, suffered the Russian occupiers with barely veiled loathing. A woman recalls that in her town, "the entire situation was stamped by hatred of the Russians . . . that's the way we were raised."[47] Few women (or men) dared to express openly their anti-Soviet views, though at meetings they sometimes countered the SED claim that Adenauer was a U.S. puppet by pointing out that "our government has to do as Moscow says."[48] The Oder-Neisse border remained the focus of anti-Soviet, anti-Polish, and nationalist sentiment. At many public meetings, refugee women from Silesia and East Prussia lamented the loss of the eastern territories.[49] Women continued to ask about husbands who had disappeared years earlier into Soviet POW, work, and political camps. Women in a shoe factory in Groitzsch/Borna were still upset about the "war prisoner question" in January 1954. A party "instructor" was sent in to set them straight but found herself unable to control an emotional factory meeting about the issue. Not a single "comrade, male or female" was willing to confront the volatile mood, she complained, although "fascists" were certainly present.[50]

Some political questions aroused women's special concern. Remilitarization appears to have roiled ordinary women more than it did men. After

[46] Gast, 218–20; Weber, *Geschichte*, 107–9, 221; Schroeder, 423.
[47] Interview Frau CT.
[48] SAPMO-BArch, DY30/IV2/17/57, Bl. 49.
[49] SAPMO-BArch, DY30/IV2/5/544 . . . 22.6.53, Bl. 38–43.
[50] LStA, IV/2/17/692. Luise B., Sekretariat Bericht über die Frauenversammlung in Bella-Schuhfabrik Groitzsch/Borna am 27.1.54.

the SED announced the formation of the National People's Army (NVA) in 1956, the SED in Plauen reported that women workers in various firms engaged in "strident discussions" about its creation. They feared losing husbands and sons to a new war. In factories, the SED conducted open balloting on the question, intending to intimidate nay-sayers and establish the popularity of the decision. Nevertheless, some plants delivered barely a majority of yes votes. Most "no" voters were women. In several "women's factories," SED functionaries canceled the referendum when its prospects looked dim. In a garment factory, "tumult" convulsed an informational meeting. More women production workers opposed the army than did office workers. The most vehement opposition, according to party instructors, came from members of "religious sects."[51]

Several of the SED's major political initiatives drew in women directly, owing to the structure of women's employment, their role in the family, and/or their stronger ties to the churches. A high priority was the reform of Germany's elitist school system. In 1946, the Law for the Democratization of German Schools began the process of excluding hostile ideologies and teachers, introduced antifascist instruction, and tilted educational opportunities toward proletarian and peasant children. The school reform made the GDR system structurally more like the American one, introducing a unified, eight-grade school attended by all children. The law eliminated religious instruction from schools. It also set the stage for the denazification of teaching staffs. Thousands of NSDAP members lost their jobs, replaced by "New Teachers" with the requisite antifascist credentials. They did not have to earn a college-preparatory diploma (*Abitur*); they instead graduated from a truncated pedagogical program. By 1949, 49,000 *Neulehrer* were in the schools, working alongside 20,000 *Altlehrer*. Over the next five years, another 10,000 old teachers left the schools, some fired, others fleeing to the Federal Republic.[52]

The reforms affected professional women inordinately, for in 1945 the teaching staff of the lower school system was the only feminized profession in Germany (excluding traditionally female vocations such as midwifery and nursing). In 1948, slightly over half of the *Altlehrer* were women. Women's ratio among *Neulehrer* was forty-eight percent. The difference in the female quotients of "old" and "new" teachers was small but indicative of complex interactions between class, politics, and gender in the Communist reform of lower-school personnel. Like female *Volksrichter*, a majority of female *Neulehrer* came from a "higher social

[51] SAPMO-BArch, DY30/IV2/5/968, Bl. 14, SED Plauen, an ZK und Bezirksleitung der SED. 30.1.56; Bl. 6, SED Stadtleitung/Plauen, 19.1.56. Also see Fulbrook, 159.

[52] Fulbrook, 92–94; Schroeder, 117–18.

group." In contrast, eighty-five percent of male *Neulehrer* had grown up in proletarian or peasant families. Daughters of the educated and small-business classes had long composed the main recruitment pool for elementary and, increasingly, secondary schoolteachers. After the war, their parents hoped they would still be allowed to follow that path to a professional career seen as appropriate for women. The SED, however, favored working-class recruits. Given that proletarian and, especially, peasant parents were less likely to encourage a daughter than a son to get an education, fewer daughters of the poor applied for the *Neulehrer* courses than did bourgeois daughters or proletarian sons.[53] Communists, as we have seen, harbored their *own* variety of gender bias: they saw women, including working-class women, as less political and, certainly, less active in the socialist cause than men. This prejudice, the historian Budde argues, caused recruiters for the *Neulehrer* courses to neglect proletarian girls, while rustling up male applicants. This assumption also hurt the woman *Neulehrer*'s chance of promotion into the administration of the new school system. As reform became institutionalized and the politics of schooling less contentious, professional achievement asserted itself as a criterion for teachers, and the earlier feminization of lower education picked up in the mid-1950s, where it had briefly stalled.[54]

Initially, however, the school reform was hotly contested in hundreds of small but intense local struggles. *Neulehrer* often found themselves stymied by "sabotage" from a united front of *Altlehrer*, school directors, and, especially, parents.[55] Many working-class parents endorsed the structural democratization of the East German school system.[56] Yet the exclusion of religion, intrusion of antifascist ideology, and replacement of experienced teachers by hastily educated upstarts alarmed fervent Christians and the middle and rural classes.[57] Just as change from above was not overtly gendered, neither was parental resistance. Again, though, women were disproportionately involved in school conflicts, for mothers typically supervised homework, attended school meetings, talked to teachers during home visits, and were more likely to practice Christianity actively. "Our work with mothers," reported the DFD in 1951, "revealed that wide circles of the populace do not appreciate the great gift of the school

[53] Ibid.; Hohlfeld, 69; Budde, *Intelligenz*, 257–63, 268–70, 272.

[54] Budde, *Intelligenz*, 264–71.

[55] Quote: SAPMO-BArch, DY31/110, Die Arbeit der DFD auf dem Gebiet der Schule und Erziehung. Referat von Erna Lierse. 21.3.51, Bl. 267. Also see Budde, *Intelligenz*, 264–66.

[56] Interview Frau RB.

[57] See the comments of Elli Schmidt in SAPMO-BArch, DY30/IV2/1/24, 20.–21.8.47, Bl. 182. Also see Weber, *Geschichte*, 113.

reform, do not recognize the difference between the old and new school, even that they mourn the loss of the Nazi teachers and incite their children against the new teachers and new school."[58]

The prominent role of women in struggles over school reform led the SED to delegate the problem to the Woman's Secretariat (of the Central Committee), which, in turn, handed it over to the DFD. The Women's League created "parent seminars" to "enlighten" parents about the state's educational goals and "teach them how to fulfill their duty to raise their children in the spirit of peace and democracy." The courses covered basic pedagogy (urging parents, for example, to forego corporal punishment) and pursued ideological goals (recruiting, for example, for secular confirmation, the *Jugendweihe*). The SED, meanwhile, maneuvered to pack local "parents' councils" with party and DFD members. After the rebellion of 1953, apolitical parents were allowed greater voice in the councils, but many parents continued to view the SED's school policies with hostility. Over time, the SED gained a firm upper hand in the schools, causing many teachers to flee the GDR. By the mid-1950s, "flight from the republic" had left many schools seriously understaffed. In an internal document, the Ministry of People's Education cited low salaries and high political pressure as the reasons for the shortage of teachers. Women teachers and, above all, the engaged Christians among them alerted authorities to the zealotry of some school leaders and SED-organized teachers.[59]

Conflicts over lower education, in sum, drew a wide spectrum of women into interaction with state policy as both teachers and parents, yet school reform also divided women along social, political, and religious lines. The reform of *higher* education, too, generated varied responses from women and uneven results for them. The size of the student body at universities and technical colleges expanded impressively in the 1950s. The number of students in "direct study" (on-campus study) rose from 27,822 in 1951 to 69,129 in 1960. Within this expansion, women widened their relative participation. In 1951, they accounted for 23.4 percent of "direct" students and, in 1960, 32 percent.[60] This increase, however, misrepresents women's ratio in the entire student body. A nonnegligible

[58] SAPMO-BArch, DY31/110, Die Arbeit der DFD auf dem Gebiet der Schule und Erziehung. Referat von Erna Lierse. 21.3.51, Bl. 267.

[59] Quotes: SAPMO-BArch, DY30/IV2/905/142, Bl. 330, G.S. an die Abt. VB beim Rat des Kreis Königs Wusterhausen. 24.2.58. Also see SAPMO-BArch, DY30/IV2/905/142, Bericht über den Brigadeeinsatz zur Untersuchung der Republikflucht von Lehrern im Bezirk Erfurt [1958?], Bl. 193–96; Obertreis, 91, 98, 122; Weber, *Geschichte*, 227; Fulbrook, 67.

[60] Budde, *Intelligenz*, 109. I rely here on Budde as the expert on women's education. In archival files, data differ from document to document. See, e.g., SAPMO-BArch, DY30/IV2/17/43. Studierende. Bl. 108; DY30/IV2/17/18; DY30/IV2/1/40, 12.2.48, Elli Schmidt, 227–29.

number of students were enrolled in "distance learning" (correspondence courses). Distance learners were more lopsidedly male in composition than "direct" students. All told, women composed one quarter of students in institutions of higher learning. The percentage was brought down, too, by the *Technische Hochschulen* (TU), at which women's representation was much lower than at university. They composed, for example, less than seven percent of engineering students in every academic year between 1953 and 1959 (in contrast, they constituted one-third of engineering students in the USSR). Alienated by unwelcoming professors and the macho culture of the technical sciences, women avoided these fields. In 1957, women accounted for only 1.3 percent of all workers in the GDR who held a higher degree or vocational diploma in the *technical sciences*, while they made up 22.6 percent of all workers with a degree or diploma (and 14.4 percent of those with degrees in mathematics). Female students were also underrepresented in economics, law, and communications (*Publizistik*). As in the West, women students clustered in the humanities. Yet they also moved into medicine, a profession whose nurturing reputation convinced women to brave unfriendly professors of biology and anatomy. Students were unlikely to encounter women professors, for in 1959 women made up only four percent of the professorate. Humboldt University in Berlin, the GDR's premier university, earned the *best* record on admission, retention, and promotion of women students and faculty.[61]

Not only reactionary cultural hangovers but, Karin Zachmann has pointed out, revolutionary social policies impinged on women's access to higher education. As in the case of *Volksrichter* and *Neulehrer*, the ratio of students from proletarian and peasant families increased impressively. In the late 1940s and early 1950s, reverse quotas were extreme and kept thousands of middle-class children, regardless of sex, out of university or technical college. Again, gender, class, and Communist sexual stereotypes interacted to the disadvantage of proletarian and peasant girls relative to underprivileged boys. In 1947 and 1948, forty-five percent of male students at Dresden's technical college were working-class or peasants, but only fourteen percent of female students were. "Worker and farmer faculties" (ABF) took the most promising and politically committed proletarian youth and carefully prepared them to do well at university. Women were notably less well represented in the ABF than at university.[62]

[61] Zachmann, "Revolution," 132. 125, 130; BArch, DQ3/281. Tabelle 19, Tabelle 5; Schroeder, 147; SAPMO-BArch, DY30/IV2/17/43. Studierende. Bl. 108. Also see Connelly, 267–68.

[62] Zachmann, "Revolution," 130; Schroeder, 117–18; Connelly, 268, note 111; SAPMO-BArch, DY30/IV2/17/43. Weibliche Schüler . . . Bl. 87; DY30/IV2/1/40, Tagung der Parteivorstandes, 12.2.48, Elli Schmidt, 228.

An extraordinarily contentious transformation was the collectivization of agriculture. Collectivization played out as a triangular struggle among the SED, *Altbauer* (pre–1945 farmers who were often wealthier than average), and "new farmers." *Neubauer*, many of whom were refugees from the East, benefited from the land reform but blamed the SED for the loss of their homelands east of the Oder. They resented the better-off *Altbauer*. *Altbauer* saw *Neubauer* as incompetent outsiders and distrusted the SED. All farmers hated the requisitioning of produce.[63] Inconsistent state policies made things worse. Depending on the place, the year, or even the season, the party encouraged or discouraged class struggle, defended *Neubauer*, or protected *Altbauer*. In 1951 and 1952, the SED pushed for the formation of LPGs, but under the New Course it retreated from collectivization. In 1959, family farmers still controlled almost sixty percent of the land. The existing LPGs were composed disproportionately of poor farmers, former farm laborers, and former industrial workers. The LPGs were less productive than the larger private farms, even though the SED tried to improve their viability with marketing cooperatives and loaning livestock, wagons, and tractors through Machine Tractor Stations (MTS). Small, private "new farms" fared even more poorly than the LPG and, as a result, many *Neubauer* gave up farming to join the industrial labor force.[64]

Every twist and turn in agricultural policy affected millions of farmer women. In 1946, native women operated twenty-two percent of all farms (in 1939, they ran only 4.1 percent).[65] For their part, rural refugees and expellees were disproportionately female and young compared to the native population. Many *Neubauer* were women with young children and no husband (though his return was often awaited).[66] Many settlers had grown up on farms in Silesia and the Sudetenland, but the women among them had little experience running a farm. Incomplete data suggest that women *Neubauer* turned in their plots at a higher rate than did men.[67] "New female citizens" were disproportionately represented among landless laborers who were, as a rule, badly housed, exploited, and even abused by private farmers, including the women among them.[68] A refugee

[63] Bauerkämper, 123–35; Seraphim, 46–49, 59–61; Pape, 121; SAPMO-BArch, DY30/IV2/17/56, Bl. 137–38. Bericht über die Kreiskonferenz.in Sangerhausen am 23.10.47.

[64] Osmond, "Kontinuität," 136; Naimark, 150–66.

[65] Kuntsche, 89–90.

[66] In Mecklenburg/Vorpommern, 65 percent of the *Neubauer* were women. See Schotte, "Kampf von KPD/SPD," 141.

[67] Bauerkämper, 124.

[68] See, e.g., SAPMO-BArch, DY30/IV2/7/117, Bl. 85, Abschrift (n.d.—1949?), Bl. 95, FDGB, LVS Thüringen, IG Land u. Forstwesen. 27.10.49. Bericht ... Verhalten der Grossbauern gegenüber ihren Landarbeitern.

from Silesia complained that her female employer spewed forth a running barrage of incoherent slurs, "You lousy pack of Russians, you stole my rye . . . the Polish swine devours and doesn't work, the Hitler swine stole the pigs. . . . You pack of thieves . . . locusts . . . get out of here. The Hitler swine descended on us like locusts."[69]

Altbauer culture was patriarchal. Farmer-wives, daughters, and sons worked for a husband and father who often made unilateral decisions about the "family" farm. Many husbands prohibited their wives from attending meetings of the private farmers' association. Some men voted against enfranchising independent female farmers to participate in decisions of the association. Women also joined the LPG at a lower rate than men, in part because they saw no benefit in doing so, in part because their husbands discouraged their participation.[70] The SED found it as difficult to steer through the murky waters of rural gender relations as through the countryside's turbulent social channels. Women Communists argued back and forth about whether to "distinguish between [female] small, middle, and large farmers" or convince "all farmer women" that life on the "kolchosy" (collective farm) would improve their lot.[71] The SED's woman problem and its farmer problem flowed together to carve a chasm between the party and farmer women.[72] Sent to do party work in Beeskow-Storkow, a representative of the central women's department wrote back to Berlin, "You can't imagine how backward even comrades are" in this "very reactionary, very rural" area. She and her comrades wanted to believe that "peasant women aren't consciously reactionary." SED women admitted that their ignorance of what mattered to peasant women made a bad relationship worse.[73]

SED women hoped that the DFD could overcome the hostility of farmer women to an atheistic, pro-Soviet party by organizing laundries, setting up kindergartens, or preparing seed-potatoes.[74] The DFD, too, did not get far. Every issue was fraught. Even the opening of a kindergarten could

[69] Christopeit, 99.

[70] Osmond, 151; Panzig, 175–76; SAPMO-BArch, DY30/IV2/17/50, Bl. 80, SED LVS MeckVorp. 29.4.47, An Zentralsekretariat der SED, Abt. Frauensekretariat.

[71] SAPMO-BArch, DY30/IV2/17/51, Bl. 321–26, Protokoll der Frauenabteilungssitzung 28.2.48; Frauensekretariat, Potsdam, 20.11.48, Bericht . . . Funktionärinnenkonferenz, Bl. 433–36.

[72] SAPMO-BArch, DY30/IV2/1/8 (14.2.47), Schmidt: 78–79; DY30/IV2/17/53, Bl. 221, 10.–12.4.47.

[73] First quote: SAPMO-BArch, DY30/IV2/17/11: Bl. 1, SED Kreisvorstand Beeskow-Storkow, 20.10.49, An Zentralsekretariat. Frauenabteilung. Second quote: DY30/IV2/17/51, Bl. 321–26, Protokoll . . . 28.2.48.

[74] SAPMO-BArch, DY30/IV2/1/8, 18, 26.–27.3.47, p. 181; DY30/IV2/17/50, Bl. 62, Bericht aus der Arbeit der Abteilung "Für die Landfrau" . . . 28.10.48. Also see Fulbrook, 63–64.

create divisions: married, wealthier *Altbauer* mothers did not want it, but immigrant, poor, especially unmarried, *Neubauer* mothers did. Perhaps, SED women reflected, the DFD should just talk about "mother and child issues," that is, the effort to improve pre- and perinatal care and encourage childbearing. Such a focus would surely help the DFD "develop a mass basis quickly." The DFD did begin to win members among settlers, housewives, and retirees who lived in villages. Most *Altbauer* out on their farms, however, refused even to cooperate with "an arm of the SED," much less join it.[75] The DFD resigned itself to "concentrating on work with LPG members and neglecting work among independent farmer women." The Women's League was, ironically, also underrepresented among the landless workers who worked on private farms. In other words, its influence was limited to those farmer women who already had, by hook or crook, joined the LPG. Moreover, its propaganda tended to occur in bursts, revving up, in the SED's typical way, when a new production slogan or gimmick was introduced from above, and petering out as the campaign did.[76] If the DFD worked unevenly among rural women, it also worked virtually on its own. Whether in 1948 or 1958, men in rural SED organizations snorted that they had "more important things to do than women's work." Like other men in the LPG, Communists disdained "broads' work" (*Weiberwirtschaft*), i.e., the dairy—which was associated with women and children and traditionally shunned by men.[77]

A consistent worry of women in the SED was rural women's loyalty to the Protestant Women's Aid and other Lutheran organizations.[78] Farmer women's religiosity went against a central cultural-political goal of the state: secularization. The GDR never banned the major churches nor placed them under direct control.[79] They operated various diaconal and charitable services (such as hospitals, homes for the disabled and elderly,

[75] SAPMO-BArch, DY30/IV2/17/51, Bl. 321–26, Protokoll . . . 28.2.48; Bl. 433–36, Frauensekretariat, Potsdam, 20.11.48, Bericht über Funktionärinnenkonferenz; Bl. 526, DFD Landesvorstand Brandenburg, Arbeitsgebiets-Konferenzen in 29 Kreisen. 5.12.49; DY30/IV2\17\8, Bl. 36–37, Bericht . . . Instrukteurfahrt . . . Mecklenburg. 31.1.50; DY30/IV2/5/544, Bl. 38–43, DFD Bundessekretariat an ZK . . . 22.6.53.

[76] SAPMO-BArch, DY30/IV2/17/18. Bl. 200–3, Protokoll . . . 8.6.54. Anlage 1. Arbeit auf dem Lande.

[77] SAPMO-BArch, DY30/IV2/17/50, Bl. 262–63, Bericht aus der Arbeit der Abt. "Für die Landfrau" . . . 28.10.48; DY30/IV2/17/61, Bl. 12–15. Notizen über die Bezirksbäuerinnenkonferenz Potsdam am 11.2.59; Bl. 21, Abt. Org./Kader. Auswertung . . . Lage der Frau.

[78] BArch, DO4/346, Betr: Verlagerung in den konfessionalen Verhältnissen der Länder in der DDR, Deutscher Caritasverband, Berlin-Charlottenburg, 17.2.50, Bl. 4; DO4/459 Info. Nr. 4, 1968, Der Prozess des Absterbens von Religion und Kirche in d. DDR S.3.

[79] In 1950, Catholics composed 11 percent of the population, alongside 80.5 percent Lutherans and 7.6 percent "without confession." Catholics fled at a higher rate in the 1950s. The Jewish community was also tolerated but was minuscule in size (under 2,000 in 1955).

orphanages, and day care centers). Up to 1949, SMAD and SED gave
the churches much leeway, in recognition of their useful activities, their
(partial) opposition to Nazism, and their meaning to many East Germans.
The SED did set out to limit clerical influence over youth. The state pushed
clerics out of schools with alacrity. Less handily regulated were leisure
activities. To the anger and humiliation of the Free German Youth (FDJ)
and its chairman, Erich Honecker, the Christian *Junge Gemeinde* (Young
Congregation) continued to draw the active participation of many adoles-
cents. In 1952 and 1953, at the apex of High Stalinism, the state engaged
in a veritable *Kirchenkampf* (confessional war) against the *Junge Ge-
meinde*. The press fulminated against the churches' alleged ties to Ameri-
can Imperialism and West Germany. Members of the Young Congregation
were discriminated against at school and denied admission to institutions
of higher learning.[80]
The onslaught abated during the New Course. The party approached
clerical, especially Lutheran, leaders with the promise of a *modus vivendi*.
In 1954 a new conflict flared, though, over the proposed revision of family
law. The SED also announced the introduction of a *Jugendweihe*, a volun-
tary ceremony of secular confirmation whose preparatory classes empha-
sized loyalty to community and state, antifascist ideals, and secularly
motivated, though conventional, moral values. SED teachers and admin-
istrators pressured parents and pupils to choose the *Jugendweihe* over
confirmation or at least go through both rites of passage. The churches
fought back from the pulpit and through women's and youth groups.[81]
The dechristianization of East German society was, overall, quite suc-
cessful. By the end of the GDR in 1990, seventy percent of all East Ger-
mans had left the church. "Modernization"—urbanization and increasing
levels of education—supported this trend, but state policy accelerated it.
The biggest decline in organized religion occurred in the 1950s, when the
GDR was most anticlerical. The decline reflected, in part, the high levels
of "republic flight" among active Christians. Whatever the cause, the ef-
fects were measurable. In 1950, seventy-seven percent of babies were bap-
tized; in 1970, 23.4 percent were. In 1950, 57.4 percent of all couples
married in the Lutheran Church; in 1970, 16.5 percent did. Dechristiani-
zation was, however, lopsidedly urban. In the 1950s, the village church
remained a popularly rooted and vibrant institution. In 1964, 81.5 per-
cent of the farming population was still in the Lutheran Church.[82]

[80] Fulbrook, 67, 92–97, 101; Klessmann, "Sozialgeschichte," 44–45; Hermann Weber, *Geschichte*, 230–31.
[81] SAPMO-BArch, DY30/IV2/14/162, Bl. 60, Vorläufige Info . . . zur Frage Jugendweihe, Konfirmation am 29.1.56 in Kirchen des Landes Sachsen, 30.1.56; Wentker, 156, 161–64.
[82] BArch, DO4/459. Info. Nr. 4, 1968 . . . S.3; Pollack, "Volkskirche," 271–75, 284; Klessmann, "Sozialgeschichte," 31; Humm, 295–96.

As was the case in Europe since the nineteenth century, active Christianity was a disproportionately female affair. Women accounted for about seventy percent of active adult worshippers, a gendered social fact that the SED definitely noticed. Every state or party report on attendance at church services, parish meetings, or liturgical gatherings mentioned the preponderance of women. Many reports referred derisively to the predominance of "old women" in church pews.[83] When it came to women's parish organizations in villages, however, contempt turned to envy. SED and DFD women remarked often on their size and vitality. In Plauen, fourteen women's groups encompassed 750 members, and eleven "mothers' circles" included 200 women in 1956. A report contrasted their energy with the "merely formal" existence of the DFD. In a small village, "virtually every woman in the parish" attended a woman's circle whose leader "speaks against us." Men, in contrast, took little part in parish life, except to sing in the choir.[84] The churches assiduously tended their ties to women, attracting them with talks such as "How do we create a Happy Marriage?" They learned, however, to modulate their promarriage, prohousewife message by aiming appropriate topics at "working women" and "unmarried women."[85]

The small Christian denominations, too, exerted a stronger pull on women than on men. If anything, the sects were more feminized.[86] The SED associated only one sect consistently with women: Jehovah's Witnesses (ZJ). This was also the group it most abhorred.[87] The Ministry of State Security harassed Mennonites, Seventh Day Adventists, Methodists, and Baptists but did not systematically persecute them, presumably because they did not deny the legitimacy of state power. Jehovah's Witnesses did—*and* they were eschatological pacifists tied to an American headquarters. Despite an internal plea to tolerate them as a tiny, harmless minority

[83] See, among many, SAPMO-BArch, DY30/IV2/17/117, Bl. 7, 29.4.48, SED Zentralsek. Abt.; BArch, DO4/2649. Anleitung der Räte der Bezirke (Bezirksmappen), Fr/O. 1950–56, Bl. 25, Bericht Betr: Einwiehung der Kirchenorgel . . . 26.8.56; DO4/360. Betr.: Probsttei Kirchentag . . . Quedlinburg, 10.9.56; SAPMO-BArch, DY30/IV2/14/162, Bl. 60, 30.1.56. Vorläufige Info . . . zur Frage Jugendweihe, Konfirmation am 29.1.56 in Kirchen d. L. Sachsen; Bl. 66, Dresden. 31.1.56.

[84] SAPMO-BArch, DY30/IV2/5/968, Bl. 14, 19, 22–23, SED Plauen, an ZK . . . 30.1.56; Fulbrook, 102.

[85] SAPMO-BArch, DY30/IV2/14/161, Bl. 79, Bericht . . . aus Berlin-Neukölln. 25.5.51; Bl. 90, Betr: Fluchtlingszusammenkunft in Pfingsgemeinde Potsdam am 12.6.51; DY30/IV2/14/159, Bl. 31, Lage in d. Kirchen, 18.6.52; BArch, DO4/2890. Bl. 24 Der Landesbischof der Ev.-Luth. Landeskirche Sachsens, Dresden, Weihnachten 1955.

[86] BArch, O4/255. Statistisches Material. Religionsgemeinschaften in der DDR, 1955. In 1950, of 100,000 members of tolerated sects, 69,000 were women (StJb, 1955, Table 22, 33).

[87] Hacke, 26–27, 29, 33–36.

whose base in "Brooklyn, USA . . . ought not to be taken as evidence that they are a foreign organization," the GDR outlawed the sect in 1950 and denounced members as agents of American Imperialism.[88] When it came to the ZJ, SED church policy intersected with National Socialist policy. Like the Third Reich, the SED-state hounded Jehovah's Witnesses, though without the murderous intent, much less the deadly consequences. German women may have been attracted to the very qualities that both dictatorships loathed, in particular, the excoriation of militarism. Ironically, Communist discourse probably stoked women's fear of war and, thus, interest in the ZJ by hyping imperialist militarism. In the early 1950s, the police raided hundreds of ZJ homes, confiscated literature, interrogated people, and made many arrests. In 1954, according to a West Berlin newspaper, 1,334 Jehovah's Witnesses were imprisoned in the GDR.[89] It is unclear how many were women, although reports refer to arrests of female "leaders" and literature-distributors.[90] Repression did not immediately produce the desired effect. In 1958, the sect held a four-day revival meeting in West Berlin that attracted 9,000 to 19,000 visitors a day. East German spies claimed that sixty percent of participants were "GDR citizens." Women, they noted, accounted for sixty percent of the 1,100 converts baptized on one evening.[91] As late as 1959, around 18,000 Jehovah's Witnesses lived in the GDR. Twelve thousand were active, especially in the Saxon cities of Dresden, Karl-Marx-Stadt, and Leipzig. By then, persecution had abated. In 1958, 450 Jehovah's Witnesses sat in GDR prisons; in 1963, the number was 242.[92]

The state pursued religious dissent less vigorously over time, both because the SED grew more politically secure and because religious affilia-

[88] Hacke, 19; SAPMO-BArch, DY30/IV2/14/250 Bl. 260–62, Abschrift (written by Kurt Lenz), 10.2.51. Lenz noted that "many women were among [the] victims" of Nazi persecution of Jehovah's Witnesses. The Nazis sent 10,000 Witnesses to concentration camps, where 2,000 died.

[89] BArch, DO4/267. Der Abend, 6.8.54. "8466 Jahre Haft für Zeugen Jehovas." In Mecklenburg, 234 homes were searched in 1950 (SAPMO-BArch, DY30/IV2/14/247. Bl. 23, Landesbehörde d. Volkspolizei Meckl. an MdK, 10.1.51).

[90] Ibid.; SAPMO-BArch, DY30/IV2/14/247, Bl. 16, Land Thüringen, MdI, an ZK, 15.1.51; DY30/IV2/14/250, Bl. 264, Erfurt, 1.4.53; Bl. 272, CDU Bezirk Halle an Parteileitung der CDU Deutschlands, Berlin, 23.12.54. One woman carried a pamphlet that included photographs of Lutheran ministers blessing the Kaiser's troops!

[91] SAPMO-BArch, DY30/IV2/14/250. Bl. 276–79, 282. Betr: ZJ in Westdeutschland und ihre illegale Tätigkeit in DDR, 1.9.56; DY30/IV2/5/968, Bl. 25, SED Plauen, an ZK und Bezirksleitung der SED. 30.1.56; Bl. 55, 24.4.56; DY30/IV2/14/247, Bl. 296, 299, Information, Nr.2, 12.9.58; Bl. 303, 14.9.58; BArch, DO4/360. Bl. 252 Jahresbericht. Ref. Kulturfragen. 30.4.56.

[92] Hacke, 60; SAPMO-BArch, DY30/IV2/14/247. Bl. 310, Der Tag, 2.10.58. "Pankow bekämpft christliche Erziehung"; Der Telegraf Berlin, 4. April 1963. "Religöse Märtyrer."

tion declined. Dechristianization affected women, too. On the one hand, they continued to be members of the established churches at a higher rate than men. In 1965, 63.2 percent of East German men, but 73.3 percent of women were members of an established church.[93] On the other hand, the evidence suggests that women's active participation was abating, and their religious organizations were in decline after 1960.[94] Women maintained *formal* church ties longer, perhaps in consideration of parents and grandparents.[95] The decline in women's religious participation suggests that modernization did contribute to dechristianization, for women moved out of the family circle and into paid labor in large numbers from the mid-fifties into the early sixties.

CONCLUSION

The SED entered the 1950s convinced it could rapidly transform the political structures of East Germany and the beliefs of East Germans. It proceeded to push through its vision of the socialist production society with a combination of force, terror, shaming, and cajolery. It ran into resistance at every turn. Opposition took many forms, ranging from the private and individual to the public and collective. Motivations ran the gamut, from self-interest to ideology to religion. Dissidence reached into the SED itself. Did resistance, discord, and dissidence make a difference? Clearly, the popular will did not impose itself on the SED leadership. Political structures that were shells in 1949 became solid. Except in June 1953, resistance was too diverse, scattered, narrowly oriented, and inchoate to brake a party whose core cadres believed deeply in its historic mission and inherent "rightness," if not in every method used to construct Socialism.[96]

Resistance did force the SED to retreat from its terrifying tactics of the early 1950s and to make adjustments, concessions, and corrections. A new, though minor, wave of disquiet rolled over the GDR after Khrushchev's secret speech in 1956. Many SED members were shaken to discover that Western smears of Comrade Stalin were true. A few Politburo members tepidly challenged Ulbricht's meager destalinization, dictatorial methods, and high-handed style. He promptly expelled the "revisionists" and operated free of even mild criticism from fellow leaders until his fall

[93] BArch, DO4/459. Infor. Nr. 4, 1968, S. 3.

[94] Humm, 300.

[95] Interview Frau AB; Interview Frau RA; SAPMO-BArch, DY30/IV2/17/41, Bl. 47, Frauenkonferenz . . . "Schwarze Pumpe" am 28.–29.6.58.

[96] Catherine Epstein strongly makes the point about the significance of cadre commitment to the cause (Epstein, 9, 115, 178–79, 253).

from power in 1971.[97] Despite the cult of Ulbricht, the popular mood generally improved. After all, the SED's harshest detractors fled and, in doing so, left those who stayed to divide the pie. From 1949 to 1961, more than 3.5 million people moved west, freeing up thousands of jobs, university places, and—very significant in a state that built little housing—apartments.[98]

The number of women who fled was absolutely greater, but relatively smaller, than the number of men. *Young* men fled at an especially high rate. Younger women's lesser propensity to "republic flight" was grounded in their lower rates of job training and their greater attachment to parents and extended families. They may also have had positive reasons to stay. Anecdotal evidence suggests that even young women from the "wrong" class background sometimes believed they would have a better chance to progress professionally in the GDR than in the FRG. Liselot Huchthausen and her mother suffered years of harassment and discrimination because her mother owned a candy shop in Rostock. Nonetheless, the daughter, who turned eighteen in 1945, was grateful that the new state allowed her to become a "new teacher" and finally sent her to university from whence she emerged a professor. She and her mother lived in increasing harmony with the state, though neither joined the SED.[99] For her part, Frau R., whom we left as she settled into a career in banking, had a job in the GDR's central bank in Berlin by the mid-1950s. She remained in the East, despite having lost father, farm, and social status. Asked why, she tells the following story: hoping to entice his career-oriented niece to "republic flight," an uncle in West Berlin arranged an interview for her with a banker there. The bank director, she recalls, showed no interest in her but fawned over her uncle. Having asked little about her competencies, he offered her a good, though not comparable, position to what she had. Put off by his snobbish, unprofessional manner, she abruptly declined the offer and would not be dissuaded from this decision by her dismayed uncle. She returned to East Berlin. At the time, as far as she remembers, she did not identify the banker's disinterest in her skills as sexism but as enthrallment with her family. She was proud of having triumphed over class bias in the GDR and did not want to benefit from reverse discrimination in the FRG. Retrospectively, she wonders if she was unconsciously sensitive to gender bias. In her bank, she was used to being valued for what she did, not judged by her sex or class. Frau R. was lucky. Gender discrimination was not alien to the East German work-

[97] Klessmann, *Zwei Staaten*, 303–4, 306–7; Hermann Weber, *Geschichte*, 276–79, 283–92, 309; Staritz, *Geschichte*, 103–5; Allinson, 69–71; Grieder, *Leadership*, 114–19, 24.

[98] Hermann Weber, *Geschichte*, 48–49; Major, "Going west," 191.

[99] See Huchthausen.

place. Yet everything is relative. The changing balance between class and gender policies in the GDR, on the one hand, and between women's relative prospects in the GDR and in the FRG, on the other, seems to have begun to make a difference in the attitudes of some younger women. The consequence was not necessarily identification with the party-state. Huchthausen disliked the SED, and Frau R. hated it, but they appreciated the opportunities its state afforded them.

CHAPTER THREE

Forging the Female Proletarian

WOMEN WORKERS, PRODUCTION, AND THE CULTURE

OF THE SHOP FLOOR

IN 1950, A REPORTER from *Die Frau von heute* observed a young tractor operator as she plowed a field. From afar, Agnes resembled a man. Up close, however, "her brown, earthy face with dancing eyes" made it clear: she was a woman in love with her job. She worked harder and longer (and certainly more gleefully) than anyone else in her Machine Tractor Station. Liked and respected by male colleagues, she drove "night and day, through ice and snow" toward the Socialist future (*Figure 5*).[1] Agnes was just one of thousands of women drawn into the labor market as it geared up for the rapid (re)industrialization of East Germany. The doubling of production projected by the First Five-Year Plan (1951–55) would, the State Planning Commission predicted, create demand for 890,000 new workers, many of whom would have to be women; hence, it projected the employment of women over eighteen years old would increase from thirty-seven percent to forty-two percent.[2] Three demographic factors reinforced the ideological and economic motivations for mobilizing women's wage labor. The GDR's adult population declined from 1949 to 1961 because of massive emigration to the Federal Republic (Table 3.1). It was an aging population because of war, a postwar baby bust, and the disproportionate emigration of working-age people. The working-age population was lopsidedly female. In 1950, 5,185,000 men (aged 15–65) faced 6,461,000 women of working age (15–60). Three and a half million of those women were not in the workforce.[3]

Features such as "Everyone calls her Agnes" aimed to pull those women into paid employment by transforming society's understanding of women's productive labor. Newspapers ran dozens of such profiles, accompanied by photographs of smiling women and their faithful machines. Fiction writers were instructed to address the subject of women in production. Documentary films shown at DFD meetings depicted the ex-

[1] Scheel, 17; Tagung zum Stand der DDR-Forschung, 68.
[2] Obertreis, 33, 57–58; Külke, "Berufstätigkeit," 60–61; Roesler, "Industry."
[3] Zank, 35. Also see SAPMO-BArch, DY30/IV2/17/30, Bl. 1, Bevölkerung, 30.6.49.

TABLE 3.1
GDR Population, Five-year Intervals,
1950–1970

1950	18,360,000
1955	17,832,000
1960	17,188,000
1965	17,040,000
1970	17,068,000

Source: StJB (1974), 3.

citement, demands, and rewards of productive labor.[4] In wartime, earlier German regimes had propagated the patriotic duty of women to work. In time of peace, however, German states' discourse about female waged labor had ranged from ambivalent to hostile. Adenauer's regime in West Germany continued this tradition.[5] In contrast, the chorus in the GDR sang steadily, voluminously, and harmoniously of the benefits and significance of productive labor for all women. The SED knew that it had a lot of minds to change. In 1949, a memorandum acknowledged that the regime had to persuade the average married woman that employment would "make her independent, allow her to develop all her capabilities, and give her life meaning and content." Persuasion would require, the report went on, training her for a skilled position *and* providing social services to reduce her domestic load.[6] Just as daunting was the anticipated hostility of men who believed a woman "belonged at home" and who feared they would "lose their hard-won right" to a comfortable job and be moved into heavy labor.[7]

Having recognized and cataloged these obstacles to the mobilization of women's labor, the SED proceeded largely to ignore them for some years. Propaganda, force of law, and negative incentives made up women's labor policy, not massive and sustained investment in training, services, child care, and consumer production. The SED "forgot" the lessons of the 1940s for several reasons. On a practical level, its labor policy toward married women was undermined by its wish for them to reproduce plentifully. More fundamentally, the party acted from an instrumentalist view

[4] SAPMO-BArch, DY30/IV2/17/30, Bl. 226, Aktennotiz über die Aussprache . . . bezug. Herstellung eines Kurzfilms, 18.7.52.

[5] On the FRG, see Ruhl; Moeller, *Motherhood*; Heineman, *Difference*. On earlier German states, see Orthmann, 170–74, 211–13; Franzoi, 66–69, 71–74; Canning, *Languages*, 93–95, 106–8, 100, 110–111, 121, 149–51, 153–54, 158, 161–62. On World War I, see Daniel. On World War II, see Sachse, "Hausarbeit," 260, 271.

[6] SAPMO-BArch, DY30/IV2/17/30, Bl. 1, Bevölkerung, 30.6.49.

[7] LAM, IV/L-2/602/70, Abteilung Arbeit und Sozialfürsorge, 24.10.49, Halle: Überprüfung einiger Betriebe um Einsatzmöglichkeiten für Frauen zu schaffen.

TABLE 3.2
Percent Increase in Employment in All Industry and
Selected Industrial Branches, 1950–1958

All Industry	24.4
Heavy Metal Industry	35.4
Basic Industry	29.0
Light Industry	11.4
Textiles	9.8

Source: Storbeck, Arbeitskraft, 94.

of the world. The campaign was about labor, not about women or men. At a meeting to discuss the propaganda offensive for women's labor, a female FDGB representative complained, "Nothing's being said about the social position of women, everything's single mindedly concentrated on the necessity that women work because there are not enough men."[8] She saw correctly that women were not just a tool, but a *secondary* tool.

The central goal of the First Five-Year Plan was the construction of an industrial base in concrete, coal, iron, steel, and metallurgy that required the heavy physical labor and extant skills of male workers. Workers in these industries, and especially in 200 "large concerns," would earn higher wages in order to attract them from other industries.[9] This Stalinist plan was imposed on a land with, on the one hand, few deposits of high-grade coal and iron and, on the other, a well-trained labor force and good capacity in industries such as chemicals, electronics, precision mechanics, and textiles. It was implemented in a world economy very different from the prewar one.[10] Last but not least, East Germany's adult human capital was disproportionately female. In textiles, a developed (if aging) infrastructure, a female workforce, and a ready market overlapped. East German textile and garment manufacturing employed a huge workforce of 325,000 workers, mainly women. After the war, they were the main producers of fabrics for all four zones of occupation. Yet SMAD and the SED starved light industry, with its inter-German *and* international connections, of investment and funneled it, instead, toward the chimera of a heavy-industrial autarchy (Table 3.2).

The biggest construction project of the early 1950s epitomized the First Five-Year Plan's "heavy metal" bent: a gigantic iron and steel conglomerate built from scratch on the border with Poland. This difficult, costly effort was completed swiftly—with a predominantly male labor force.

[8] SAPMO-BArch, DY34/2/a/422. Bericht von der Arbeitsausschusssitzung zur Förderung der Frauen.

[9] Hübner, Konsens, 44; Hoffmann, Aufbau, 548.

[10] Landsman, "Dictatorship," 27.

Women, it was expected, would fill the holes left by male workers sent to the steel mills at *Stalinstadt* (a double entendre: it was named after Stalin whose *nom de guerre* means "man of steel").

The Plan subsumed women's labor policy under the general labor policy of increasing production by a whopping sixty percent. Gripped by a productivist mania, planners shoved training programs, not to mention services, child care, and consumption, to the side. They felt only weakly motivated to implement positive measures to mobilize women's labor. Labor offices could find plenty of workers among widowed, divorced, and never-married women, i.e., women "standing alone." Female unemployment remained high into 1952, owing, above all, to the reduced investment in consumer industries and, especially, in textile and garment making. The Department of Mother and Child, directed by Käthe Kern, had the legal authority to mobilize women's labor but exercised no real clout over regional labor officers or factory directors, who believed men deserved first shot at an open position. As the reserves of "willing and looking" women began to dry up, the SED's interest in female labor perked up. Prodded by women Communists, it re-created women's factory committees in 1952. In 1953, during the heady days of Construction of Socialism, interest in women flagged again. Even the Ministerial Council, the highest body of state, distanced itself from the plan to hire women to fill thirty-seven percent of jobs in industrial production. Only when every man had been assured his position, it now reasoned, should industrial employment of women expand.[11]

The explosion of June 1953 confused and partially reshaped labor policy. The New Course shifted some investment toward provision of more and better food, clothes, and other consumer goods. The first Plan's goals went unmet, although industrial production grew by an impressive forty-seven percent and productivity by fifty-four percent. The Second Five-Year Plan (1956–61) projected another big rise in industrial production (55 percent) and foresaw similarly lopsided increases in basic industry, machine building, and chemicals, relative to light industry. It aimed, though, to "modernize, mechanize, and automate" the economy, rather than rely so heavily on brute and brawn.[12] Its slight consumerist tilt would direct women into textiles, canning, and the like—i.e., traditionally feminized industries.[13] Labor policy moved tentatively toward positive incentives as opposed to a blatant speed-up, wage cuts, and harangues, though they far from disappeared. Not only fear of another rebellion motivated

[11] Hoffmann, *Aufbau*, 405–9, 412.
[12] Staritz, *Geschichte*, 89; Hermann Weber, *Geschichte*, 261, 266–70, 280–81.
[13] Külke, "Berufstätigkeit," 67.

TABLE 3.3
Women in Employment, Five-year Intervals

Year	Total	Workers/ Employees	Independent or Family Helper	LPG/ Other Cooperatives
1950	3,155,598	2,073,820	NA	NA
1955	3,395,600	2,543,500	760,100	92,000
1960	3,456,400	2,840,400	157,500	458,500
1965	3,580,800	2,988,000	131,400	461,400
1970	3,749,700	3,227,900	101,500	420,300

Source: StJb (1955), 118, 33, 117, 119; StJb (1960/61), 192; (1974), 58.

TABLE 3.4
Women's Employment by Percentage in Selected Years

Year	Of Females 15–60 Years Old	Of Total Female Population	Of Total Employed
1949			40.9
1950	55.4	44.1	40.0
1955	54.2	55.4	44.0
1960	52.9	60.2	45.0
1965			46.7
1970			48.3

Sources: Trappe, 71; StJB (1960/61), 193; StJB (1974), 19; Storbeck, *Arbeitskraft*, 93.

little steps toward a less-exploitative labor regime. East German workers enjoyed one big economic advantage. Given the rate of industrial growth, westward flight, and inefficiencies of the command economy, a shortage of labor developed. Workers could not exploit their leverage with collective bargaining or legal strikes, but they could and did win greater leeway on the shop floor. Wages increased, though unevenly across industries, depending on the scarcity of the skills involved.[14]

UP FROM THE FARM: WOMEN'S EMPLOYMENT IN THE 1950S

The broad trends in women's workforce participation are easily sketched. Hundreds of thousands of women moved into wage labor (Tables 3.3 and 3.4). They did so especially rapidly from 1950 to 1955, although that

[14] Port, "Conflict,"195–96.

TABLE 3.5
Women as Percentage of Employment by Sector

Year	Industry	Commerce	Services	Agriculture/ Forestry
1950	32.3	53.1	58.5	49.1
1955	37.7	59.0	59.4	51.3
1960	40.5	64.6	64.2	45.7
1965	39.9	67.2	68.0	47.8
1970	42.5	69.2	70.2	45.8

Source: StJB (1955), 118, 117; (1960/61), 193; (1974), 59.

increase is somewhat deceptive, given that the baseline had dropped after the war. Up to 1954, there were women looking for work who found none.[15] The overall increase, though, is *more* impressive than at first sight for, from 1950 to 1960, almost 950,000 women passed the age of sixty. Of those in the workforce, eighty to ninety percent retired. Women's work lurched toward a more modern structure. Women left family-based work for wage labor and moved out of agricultural production into industry, commerce, and services (Table 3.5). The overall labor market did not become markedly less gender segmented.

Even the original goals did not portend a revolutionary degendering of the labor market. The Mother and Child Protection Law of 1950 listed projections for women that generally fit existing trends in feminization: railroads and other transportation, thirty percent; communications, fifty-five percent; commerce, sixty percent; administration, banking and insurance, sixty-five percent; and textile and garment manufacturing, eight-five percent.[16] These targets were unevenly met. Women flooded into communications, retail commerce, and banking, so these sectors overshot the plan. Transportation, administration, and textiles and garment making did not meet the targets, owing to changing economic priorities, structural obstacles, and willful resistance. On average, women remained underrepresented in industry, especially production. Women entered industrial labor as unskilled workers. By 1959, large numbers had attained some skills and training on the job, but few had become certified skilled workers. Their wages improved modestly both absolutely and relatively to men's, but they still lagged far behind because of structural and intentional wage discrimination.

[15] Zank, 137–39, 173.
[16] Zachmann, "Frauen," 132.

Changes in Women's Employment by Sector

In 1950, about one-third of the female workforce consisted of "assisting family members" (mainly in agriculture) and self-employed women; the other two-thirds were worker-employees. By 1960, worker-employees accounted for three-quarters of the female workforce. Female worker-employees made up 45.8 percent of all worker-employees in 1960, up from 38.4 percent in 1950.[17] Women's movement out of agricultural work, on the one hand, and into wage labor, on the other, continued long-term trends in the eastern part of Germany. Ironically, the decline in female participation in the primary sector contradicted the SED's original plan. State priorities changed over time, but women also negotiated the growing labor shortage to enter preferred areas of work. Even in a command economy, labor bureaus found it hard to keep workers down on the farm.

Women's industrial employment in Germany, as elsewhere in Europe, was an old phenomenon that had concentrated originally in textile and garment manufacturing. From 1900 to 1939, German women's industrial employment had spread beyond textiles to canning and bottling, paper manufacturing, electrical and optics, and chemicals.[18] In the GDR, the trend toward industrial employment sped up. From 1950 to 1955, 305,000 women moved into industry; from 1955 to 1960, an additional 127,000 women followed them.[19] By 1960, the *number* of East German women in industry was higher than in any other branch. They made up, however, a much higher *percentage* of the workforce in commerce, and especially retail (76.7 percent in 1960). In services, too, they began in a strong position and secured it.[20] The feminization of commerce and services paralleled developments in the West. The service economy was, one should keep in mind, much smaller in socialist economies than in postwar market economies and employed less of the total female workforce than in the West.

Women's Industrial Employment

The GDR, it has long been assumed, pushed and pulled women into production and into "male" jobs in the 1950s. Poor data make it hard to assess to what extent that actually happened, yet they suggest that the rate of change was not as impressive as often thought. The baseline of

[17] Storbeck, *Arbeitskraft*, 92. SAPMO-BArch, DY30/IV2/17/43, Bl.82. Arbeiter und Angestellte.

[18] Canning, *Languages*, 25–33; Kolinsky, 20–24; Knapp, 312, 399.

[19] DDR StJB Jg.1, 1955,118, 117, 1960–61,193.

[20] StJB, 1960–61,192–93. If 1950 equals 100, in 1955 the index of female worker-employees had risen to 132.2, index of women in industry to 153.4, and in commerce to 213.6.

TABLE 3.6
Percentage of Women in Workforce in Selected
Occupations (1956?)

Fitter	1.2
Plumber	1.2
Construction Mechanic	1.3
Electric Machine Builder	12.0
Semiskilled Mechanic	28.7
Semiskilled Chemical worker	33.2
Sugar Production Worker	42.3
Cable Production Worker	58.7
Weaver	62.7
Spinner	84.9

Source: Helga Ulbricht, "Zu einigen arbeitsökono-
mischen Problemen," 68.

women's industrial employment was fairly high. In 1950, one-third of "worker-employees" in industry were female. In 1951, twenty-three percent of worker-employees in the metal-working industry, for example, were female. Yet what ratio were *workers*, not employees, and what percentage of the workers worked in production? From a unique table, we know that in 1950, women accounted for 11.7 percent of *workers* in "basic industry" (mining, energy, metallurgy, stone and earth), and 14.2 percent of *workers* in "heavy industry" (iron and metal working, but also including electronics, fine mechanics, and optics).[21] The overall picture is not clear, however, much less how it changed. One can only say that in the 1950s, women moved faster than earlier into the "lighter" areas of heavy industry and continued to penetrate the "heavier" areas of light industry. In production jobs, they still dominated, above all, the manufacturing of textiles and garments (Table 3.6).[22]

An example can illustrate lines of continuity and change. The First Five-Year Plan targeted "heavy chemicals" for feminization. Industrial chemicals, synthetic rubber, fertilizers, etc., were produced at huge plants such as Leuna and Buna (located in the industrial belt of Saxony-Anhalt near Halle and Merseburg). These plants were desperately short of labor as they expanded production under Soviet ownership.[23] In 1951, Leuna's labor force was 16.8 percent female. Many of its women workers did not produce chemicals but cooked in its four kitchens, served in its seventeen canteens, or washed its mountains of laundry. Management faced pres-

[21] StJB, 1955, 32. On women in a steel mill in Saalfeld, see Port, "Conflict," 431.

[22] Roesler, "Industry," 101.

[23] Leuna and Buna were among thirty-three concerns in chemicals, optics, metallurgy, and mining under Russian ownership and direction until 1954.

sure to increase the total female ratio to twenty-five percent by 1952 and to shift women into production. Leuna engineers and chemists "expressed doubts" that the firm could or should reach that goal, given "economic and health" constraints. Whether self-fulfilling or not, the skepticism was borne out: in 1953, twenty percent of Leuna's 22,738 workers were women. The percentage of women at Buna was similar, with similar pressure from outside and reluctance from within to hire women in production.[24] After 1955, the percentage of women in chemicals did rise substantially. In 1959, thirty-one percent of Buna's 18,000 workers were female. Not only did their overall numbers in the chemical industry grow, but women's role in production increased. By 1958, 28.5 percent of production workers in Buna were women. They labored at an especially high rate (fifty-five percent) at the *Filmfabrik* Agfa Wolfen, which with 8,500 women worker-employees in 1959 was the "largest women's plant" in the GDR.[25] Yet even in chemicals, noted a report on Buna, a "male" industry in which women were relatively well represented, "the integration of women into the work process is limited almost exclusively to jobs that were once described as conventional female occupations."[26]

Women at the Bottom: Promotion, Skills, and Wages

Women negotiated the job market from a disadvantaged starting position because they lacked skills. In 1945, even in the "best" industry for women, the garment trades, only 21.3 percent of women were skilled. In the chemical industry, a tiny 1.5 percent of women were skilled in 1945.[27] More women trained after 1950, yet "qualification" consisted mainly of on-the-job training for semiskilled occupations.[28] In 1956, only nine percent of women were skilled in the highly feminized food industry; 77.2 percent were semiskilled.[29] Women's gains were also fragile. A trade union

[24] LAM, A1377, Leuna Werke, Bl. 48, Aktennotiz, Besprechung am 8.2.51 . . . Fraueneinsatzes im Leuna Werke; Leuna Werke, A1372 (1949?). On Buna: VEB Buna, Rep. II-1/120, Arbeitsberichte des Aktivs zur Förderung der Frau, 20.8.51; DDR MfA Abteilung: Arbeitskraftlenkung an die Chem.Werke Buna, 5.2.52; Buna Werksleitung an das MfA, 14.2.52.

[25] VEB Buna, Rep. II-12/954, Unterlage zum Referat f. d. Betriebsfrauenkonferenz des VEB Buna . . . 23.6.59; Die Frau im VEB Chem. Werke Buna . . . 1959; SAPMO-BArch, DY34/A1544, Anlage Nr.4, Ergebnisse . . . Chemiegrossbetrieben [1959]. On Wolfen, see LAM, VEBFAWO, 596, 8.3.53, Frauen im gesellschaftlichen Leben, p. 3.

[26] VEB Buna, Rep. II-12/954, Unterlage . . . 23.6.59.

[27] Mühlfriedel and Wiessner, 133.

[28] Trappe, 115, 170; Obertreis, 88. Also see LAM, A893, Leuna [1953], Anlage 4b, Abgeschlossene Qualifikationsverträge von Frauen.

[29] SAPMO-BArch, DY34/39/94/5571, Analyse über die Lage der Lebensmittelarbeiterinnen in der DDR (1956?).

report concluded that, overall, women experienced a slight *de-skilling* from 1955 to 1959.[30] In 1959, 17.3 percent of women industrial workers were skilled, as compared to sixty-nine percent of men. The ratio of skilled women was higher in textile and garment manufacturing (as was the ratio of skilled men, too).[31]

Girls were underrepresented in the training programs that gradually replaced classic German apprenticeship programs. Of the 8,500 women who worked at Wolfen Film, *none* had a skilled chemical worker's certificate in 1959, and only *nineteen* were in training to get one. Women were also underrepresented in the "factory-schools" that opened in the early 1950s.[32] Women were not uninterested in advancement. They continued to attend adult education centers (*Volkshochschulen*) at a high rate (41.5 percent of students in 1959 and 1960). There, they concentrated in courses in stenography, typing, basic accounting, and medicine, suggesting that women were determined to escape manual labor more than gender-segregated work.[33]

Partly because they were unskilled, women were uncommitted to their jobs. The fluctuation rate of all workers was high, but women's was higher. Heike Trappe has studied the employment paths of a cohort of women born from 1929 to 1931. Ninety-one percent of her sample changed their occupation (*Beruf*) at least once before the age of 30; 43.1 percent changed it three or more times. Seventy-two percent changed their place of work (*Stelle*) at least once; 28.9 percent did so three or more times. Female *manual* workers were especially likely to shift occupations, preferably out of production and into jobs in offices, administration, and pedagogy.[34] The turnover rate among unskilled women workers was especially high.[35]

Women's chances of promotion into supervisory or lead-worker positions were slim. They were terribly underrepresented among "masters,"

[30] SAPMO-BArch, DY34/39/140/6011, Konzeption für die Beratung der Frauenkommission des BVS (n.d.), S.5. Part of the explanation for this decline was the relative youth of women in chemicals in the late 1950s. VEB Buna, Rep. II-12/954, Die Frau im VEB Chem. Werke Buna . . . 1959, p. 10.

[31] SAPMO-BArch, DY34/712. Gegenüberstellung der in den Lohngruppen arbeitenden männlichen und weiblichen Produktionsarbeiter in der volkseigenen Industrie.

[32] Wolfen: LAM SED Bezirksleitung/SA IV2/3/519, Beschluss des Büros der Bezirksleitung über die Erfahrungen der Partei in der Arbeit unter den Frauen . . . Halle, 11.3.59 Leuna: LAM, 10413, Leuna Werke, Technische Betriebsschule, 12.10.58. Also see LAM, A914, Leuna [1953], Bl. 66–68.

[33] SAPMO-BArch, DY30/IV2/9.05/125, Bl. 179, Material über . . . Volkshochschularbeit . . . , 11.10.51; LStA, 2966, Volkshochschule (1953–54), Bl. 9, 24, 50, 67, 124.

[34] Trappe's sample included 1,182 women in four cohorts (1929–31, 1939–41, 1951–53, 1959–61). They filled out detailed questionnaires about their reproductive and productive lives (Trappe, 94–95). On women's job fluctuation, see Trappe, 156–57, 162–64, 170.

[35] LAM, A914, Leuna Werke, Fluktuation und Gründe.

i.e., foremen. In 1956, 4.7 percent of foremen in state-owned industry were women. In 1959, of five hundred masters at Buna, six were women.[36] Women's situation was dramatically better in garment factories, where up to seventy to eighty percent of shop floor supervisors were female.[37] Almost no women participated in the top management of state-owned enterprises. In 1960, a survey of 1570 VEBs found fifteen female factory directors, sixty-eight chief accountants, fifty-one directors of the labor department, and four technical directors.[38]

Women earned less than men owing to compound comparative disadvantages. They were overrepresented in the poorly paid primary sector.[39] They worked disproportionately in the worst-paid branches of services. In industry, women were clustered in the worst-paid subsector—light industry—and the worst-paid industries within that branch. Textile production workers earned the lowest average monthly wage of all production workers in state-owned industry in 1956.[40] Women's position *within* light industry was better than in industry as a whole, for in light industry they earned at Level V of the eight-step wage scale at almost the same rate as men. In machine building, in contrast, thirty-one percent of men but only ten percent of women earned at Level V.[41] The wage gap closed slightly at the end of the decade, but in 1960 women remained highly overrepresented at the lower (unskilled) levels and underrepresented at the higher steps of the wage scale in every sector, industry, and industrial branch (Table 3.7).[42]

Gender bias contributed to structural disadvantages. Administrators classified workers' level of skill, a tricky task because so many workers were trained on the job, not in formal programs. Faced with a murky case, supervisors gave men the benefit of the doubt more often than

[36] LAM, IV2/5/1441, SED Bezirksleitung [1959], Beispiele für das Referat der Frauenkonferenz; LAM, IV2/3/519, Beschluss des Büros der Bezirksleitung über die Erfahrungen der Partei in der Arbeit unter den Frauen . . . Halle, 11.3.59; VEB Buna, Rep. II-12/954, Unterlage zum Referat für die Betriebsfrauenkonferenz . . . 23.6.59.

[37] BArch, DQ3/281, Tabelle 8, Die Verteilung der weiblichen Meister auf die 4M-Gruppen in der VE-Industrie insgesamt, November 1956.

[38] SAPMO-BArch, DY30/IV2/17/43, Bl. 146.

[39] For wages by sector: StJb 1955, 97.

[40] StJb 1956, 265–67; StJb, 1960–61, 357; Storbeck, *Strukturen*, 305; Hübner, *Konsenz*, 60; SAPMO-BArch, DY34/712, Gegenüberstellung der . . . Produktionsarbeiter . . ., 1962.

[41] Helga Ulbricht, "Probleme." At Buna, only fourteen percent of workers paid at Level V were female. VEB Buna, Rep. II-12/954, Die Frau im VEB Chem. Werke Buna . . . 1959, 29.

[42] See Table IV/12, in Storbeck, *Soziale Strukturen*, 305. For the gender gap in the wages of production workers in 1960 and 1965, see SAPMO-BArch, DY34/5471, Entwurf, Thesen. Probleme der komplexsozialistischen Rationalisierung und der weiteren Förderung der Frauen und Mädchen . . . 7.1.67.

TABLE 3.7
Wage Steps, Percentage Female, 1960 and 1965

	Percent Female	
Wage Step	*1960*	*1965*
I	84.3	85.6
II	90.3	92.2
III	72.7	78.0
IV	38.8	41.4
V	15.3	15.8
VI	6.6	6.6
VII	5.1	5.1
VIII	4.1	4.7

Source: LStA, IV/A-2/17/473, 27.

women. The wages of semiskilled women production workers in the food industry, for example, spanned Levels II to IV, while virtually all semiskilled men in that industry earned at Level IV.[43] Another sign of gender bias: women did not receive bonuses or nonwage perks such as "rest and recreation" at nearly the rate that men did.[44]

The Social and Marital Status of Women Workers

The sociology of women's work began to change, though not yet dramatically. Initially, the state expanded the pool of women who *had* to work. In 1947, the SED began to pare the pension rolls by reducing the number of widows living on a husband's pension, a huge category of pensioners. The category of war widow was abolished. After 1948, these widows and their children received (lower) pensions under social-insurance payments. Widows under 60 had to work unless they had a child under three, two children under eight, or were disabled. Even a woman with young children had to prove that her husband had "predominantly" supported her before he died. Pension payments were, anyway, too low to live on. People deeply resented these measures. Local physicians and social workers interpreted the rules liberally or ignored them. After the uprising of 1953, the definition of "principal" support by a husband was relaxed. Despite uneven application and partial revision, these measures forced many wid-

[43] SAPMO-BArch, DY34/39/94/5571, Analyse ... Lebensmittelarbeiterinnen ... (1956?).
[44] SAPMO-BArch, DY46/ 11/310/1890. Frauenabt. Bericht ... VEB Zeiss-Jena. 11.10.55; SAPMO-BArch, DY34/39/120/5865. Hauptverwaltung-Chem-Tech. Erzeugnisse. Auszeichnungen (von Frauen) 1950–55.

ows into waged work.[45] Meanwhile, public assistance was greatly curtailed in 1952. Responsibility for young children no longer exempted a single mother from wage labor. In this case too, doctors, case workers, and local courts resisted strict interpretation, but the new rules dramatically cut the welfare rolls. The amount of aid in dispute was, again, pitifully low. Finally, the gradual abolition of alimony forced an increasing number of divorced women to work. The early and thorough deployment of widowed, unmarried, and divorced women's labor explains the changing slope of the rise in female workforce participation: steep to 1952, moderate until 1955, and much flatter until 1960 as this pool dried up. Single women were still heavily overrepresented in the female workforce in 1959, when, for example, more than 3,000 of Leuna's 6,800 women workers "stood alone."[46]

Refugee women worked at a high rate, in part because many had no husband, and in part because settlers as a whole moved faster than natives into industrial work.[47] In 1949, sixty percent of the women workers in a concrete slab factory in Mecklenburg were immigrants. "Lots of settlers, especially women," noted a report on Buna, "work in the factory, for example, in the kitchens." The GDR stopped collecting separate statistics on settlers in 1950, but scattered accounts suggest that refugee women remained overrepresented among female factory workers far into the 1950s.[48]

It is difficult to say much about *married* women's employment. GDR statistics either do not provide the relevant information or calculate it according to odd categories. We can estimate the base rate and social profile of working wives in *1950* from several angles: about half of all working women were married; among women aged eighteen to fifty, thirty-six percent of married women worked as opposed to sixty-three percent of single women; in nineteen percent of households headed by a married couple, the wife had a job. The wives of workers and employees worked at a below-average rate, while women married to an independently employed man (businessman, shop owner, or farmer) worked at

[45] Leutwein, 59–60, 92; Heineman, *Difference*, 197–200; Obertreis, 72. In 1949, local "departments of work and welfare" were calculating which women on assistance could work. See LAM IV/L-2/602/70, Abschrift, Abt. Arbeit und Sorge, Halle/Saale, 12.11.49.

[46] SAPMO-BArch, DY30/IV2/17/65, Bl. 199–200, 25.2.59, Die Arbeit des Frauenausschusses Leuna.

[47] Seraphim, 47, 49, 98, 123, 50, 95–97; Hoffmann, Wille, Meinicke, "Flüchtlinge," 22–23.

[48] StJb 1955, 170; 1957, 19, 50; SAPMO-BArch, DY30/IV2/5/202, Bl. 16–26, K. Kern, Bericht über meine Reise nach Mecklenburg. 4.–6.4.49. Quote from VEB Buna, Rep. II-1/375, Protokoll . . . 24.11.50.

almost three times the average ratio.[49] The next useful statistic appears only a decade later: in 1960, 56.7 percent of the wives of employed husbands worked for wages—seemingly a big leap from 1950.[50] It is hard to trace what occurred in between. The trend toward "double earning" seems to have sped up after 1955 and jumped after 1958, when the state ended rationing, raised prices, improved consumer production, and lifted the lowest wages, all in order to mobilize married women's labor.

The data on married *mothers'* employment are even worse. In 1956, Hilde Benjamin lamented that only 18.6 percent of married mothers were in the workforce.[51] This number was almost certainly too low. Fifty-two percent of the married mothers in Trappe's 1929–31 cohort of interviewees were employed in 1955. By 1960, when most of their children were old enough to have entered school, sixty-three percent of the cohort had joined the workforce. Yet forty-nine percent of them interrupted employment for at least three years to raise children. Trappe appraises the duration of interruptions as "astoundingly high," given assumptions about married mothers' employment in the GDR. Still, virtually all mothers did return to work. The "housewife model," Trappe concludes, was being marginalized by the norm of sequential combination of work and family.[52] GDR data on the *age* of employed women corroborate Trappe's finding of a moderate rise in married mothers' employment in the late 1950s. In 1956, 50.4 percent of women aged twenty-four to thirty-nine worked for wages, whereas in 1959, 55.3 percent did. A big majority of women in that age span were married and had at least one child.[53] From the perspective of an increasingly labor-hungry state, the expansion of married women's and/or married mothers' work was too slow. In 1958, 2,207,700 women of working age were not employed (in contrast to fewer than 400,000 men). From 1955 to 1960, only 60,000 more women entered the workforce than left it.[54]

WOMEN WORKERS VERSUS MANAGEMENT

Industrial workers suffered under intense pressure to produce. The campaigns to improve labor discipline and raise production norms took many forms: piece rates and "incentive" wages, the activist movement, the bri-

[49] StJb, 1955, p. 23.
[50] StJb 1966, 452.
[51] Hilde Benjamin, "Wer bestimmt in der Familie," ND 1.2.58.
[52] Trappe, 115, 116, 119, 133, 135,141–42.
[53] SAPMO-BArch, DY30/, IV2/17/43, Bl. 83.
[54] Roesler, "Industry," 102.

gade movement, and the TAN movement (a form of Taylorism). The demands to meet and surpass production quotas provoked anger and resentment among workers.[55] They did not, however, oppose every aspect of the production mania. Accustomed to a low hourly wage, the average worker condoned, and even welcomed, the shift to incentive wages. Yet he or she opposed the constant attempts to crank up the base rate of output from which incentive wages were calculated. Denied recourse to organized negotiations, workers engaged in scattered slowdowns, walkouts, and, especially, small-group bargaining. Some won concessions from managers, others did not. Unsystematic wage adjustments eroded proletarian solidarity, such as it was after Nazism and total war. Ironically, the horizontal fragmentation of the working class also undermined any semblance of a unified labor policy. In the Buna chemical plant, for example, ever more workers moved from hourly to incentive wages. Yet in this Soviet-run plant, management arranged a special deal for all workers: Buna's directors convinced SMAD to grant their workforce the level of rations reserved, in theory, for the heaviest mine labor.[56]

The evolution of the production brigade, introduced in 1950 in imitation of the Soviet model, offers a textbook case of the dialectic of state-socialist labor relations. The brigades mimicked defunct grassroots structures of collective cooperation toward the goal of enhancing pride in the group's achievement and encouraging competition for high-productivity premiums. On paper, the scheme appeared to work like a charm. By the end of 1950, 98,000 brigades had 663,000 members; by 1956, 107,396 brigades encompassed 1.4 million members (not including Berlin). In fact, many brigades were more formal than real.[57] The functioning ones often resisted strategies to squeeze more output from each worker, such as "the enterprise-based collective contract (BKV)," which management, the SED, and FDGB tried to impose on workers in 1951. The BKV restricted "negotiations" over norms and wage levels to a single firm, rather than across an industry. An impressively large proportion of the workforce complained that the BKV was a "curtailment of workers' rights" and refused to sign the contracts. Plant officials and visiting party "instructors" had to arrange time-consuming individual meetings, at which they bullied each worker to sign the BKV.[58]

The labor historian Peter Hübner has noted that women's brigades were less likely than their male counterparts to engage in wage disputes.

[55] Port, "Conflict," 385.

[56] VEB Buna, Geschichte der Arbeiterbewegung des Kombinates VEB Chemisches Werks Buna.Bd.1, 81, 83–84. On the erosion of solidarity, see Port, "Conflict," 10; Port, "Workers," 159.

[57] Port, "Conflict," 10, 378.

[58] Hübner, *Konsens* 213, 184–85, 12. Quote from Port, "Conflict," 35.

This observation is no doubt correct. Women workers were historically less likely to participate in class-conscious organizations or protests.[59] The question is why. Hübner points, also plausibly, to women's higher rates of job changing. With little experience of shop floor organization, women workers did not resist speed-up but left to find a better factory job (or hone their office skills). Hübner's ancillary hypothesis is more problematic. He wonders if improvements in the factory's "social infrastructure," such as factory stores and rest rooms, caused "women workers to feel that their interests were being more strongly considered" than did "wage-oriented men workers." Two faulty assumptions are embedded here. Hübner assumes that factory services kept pace with the increase in women's participation in industry. The high rates of job fluctuation signal, in fact, the inadequacy of services. Women interrupted employment so often precisely because the state left the work of social reproduction to the family—that is, to wives and mothers.[60]

Also wrong is Hübner's assumption that women were not "wage-oriented."[61] True, food, clothing, and family survival occupied a central place in women's pantheon of concerns.[62] Women also used their household responsibilities as an excuse to dodge pressure to produce. Nonconfrontational tactics could be quite effective, given that trade union functionaries approached their new role as disciplinarians with some timidity. An attempt to "improve work morale and discipline and meet the goals of the five-year plan" at the Buna plant illustrates the point. In January 1950, union stewards in Buna's kitchens and cafeterias posted this notice:

1. An end to unnecessary overtime.
2. Ration cards stamped only for those in work clothing.
3. Workers have to be on time, unless they come on the train.
4. No shopping during work time. Only in emergencies will one [female] colleague go to the store for everyone.
5. No visits to the kitchen after breakfast and lunch are served. Please take this seriously.[63]

[59] Canning, *Languages*, 315.

[60] See, e.g., a report *from 1961* that attributes high turnover to the need for women to care for small children: SAPMO-BArch, DY30/IV2/17/71, Bl. 136, SED KrLeit Flöha an ZK SED Arbeitsgruppe Frau, Ruth Schreiter, 3.8.61. Annegret Schüle criticizes Hübner for the same reasons that I do. See Schüle, "Spinne," 244–48.

[61] Hübner, *Konsens*, 219–20.

[62] See, e.g., VEB Buna, Rep. II-1/375, Instrukteurbericht, Versammlung in Karbidfabrik, 46 present, 27.11.50); SAPMO-BArch, DY46/11/2400/4476. Bericht über den Einsatz in LEW Hans Baimler Hennigsdorf . . . 19.11.53.

[63] VEB Buna, Rep.II-1/165, Verpflegungsbetriebe [employed virtually only women], Sitzung am 17.1.50 des Vertrauenskörpers.

Of course, many women did not. Amazingly impervious to constraint from above, the tendency of East German women workers to shop during work time became gradually entrenched.[64]

Even as they carved out time on the punch-clock for unpaid household labor, women workers were eager to earn as much as possible. Many shifted readily to incentive wages or took part in speed-up campaigns.[65] Aware that their pay was absolutely and relatively low, women were not shy to complain about wage *discrimination*. Because the gendered wage gap violated the "equal work, equal pay" law, they understood that it constituted a legitimate reason to complain. They did so at women's factory assemblies and in letters (called *Eingaben*, or petitions) to Hermann Warnke, chairman of the FDGB. They were less outspoken about low wages in general, for the authorities did *not* see that as a legitimate cause of dissatisfaction. Nonetheless, like men, women resisted the constant pressure from above for higher norms and lower wages.

Labor disputes in the textile and garment-making industry exemplify the characteristics of working women's protests. Saxony and (East) Berlin were historically the centers of German textile and garment making. Berlin, especially the Jewish quarter in the city's eastern part, had formed the "heart of the German ready-to-wear industry with a reputation for producing good, affordable knock-offs of Parisian haute couture." Although greatly damaged by the war, not to speak of the annihilation of German Jewry, Berlin factories produced forty percent of all clothing sold in the GDR in 1950. Saxon firms, too, marketed fabric and clothes all over Germany after the war. Textile production was a profitable industry whose exports generated capital and hard currency for investment in the GDR's unprofitable producer industries. The Cinderella of the industrial economy declined in the 1950s, robbed of investment by five-year plans and hurt by competition from new mills in West Berlin.[66] Despite its slow growth compared to producer industries, textile manufacturing (excluding garment making) employed more people *than any other industry* throughout the 1950s.

Mill workers labored under deplorable conditions, continuing a lamentable tradition. Mill operatives had joined trade unions and fought major strikes before World War I but won few concessions. Popular opinion

[64] See, e.g., the comments of a male textile engineer: IMC, Interview 04.

[65] For examples, see SAPMO-BArch, DY30/IV2/17/51, Bl. 505–8, 28.6.49, Potsdam Frauenabteilung im Kunstseiden-Werk Premnitz; DY30/IV2/17/53, Bl. 349, Kreisvorstand Rudolstadt, an LVS SED Thüringen, 27.8.49, Lagebericht . . . Zellwolle AG, Schwarza; Bl. 348, Frauensekretariat an Ulbricht, 8.9.49.

[66] Stitziel, "Fashioning," 66, 75–80.

branded mill women "dumb" and immoral because some turned to prostitution to survive.[67] In the GDR, rumor had it that "whoever was left on the labor market" could find a job at the VEB Leipzig Cotton Spinning Mill, which employed 4,000 women.[68] Single mothers, refugees, and widows worked by the thousands in textile mills.[69] In 1961, an SED inspector noted, "the textile industry encompasses an especially strong concentration of women whose happiness was destroyed by the war."[70] Like all GDR workers, textile employees worked a six-day, forty-eight-hour week in the 1950s. Mill workers labored in shops that were unbearably hot in summer and often very cold in winter. They breathed in fibers and dust and, sometimes, noxious fumes. In an elastics department, "poison glue" caused "weight loss of eight to sixteen pounds within three months, serious blackouts of up to four hours, and damage to inner organs." When workers complained to the factory union committee, they received a daily dose of a half-liter of milk, the GDR's universal palliative for unhealthy occupations.[71] The "technology in most textile factories is very outmoded," a report concluded in 1961. "About sixty to seventy percent of the machines are forty to fifty years old. In a few spinning mills, they work with machines built in 1867. . . . [Some] apprentices are trained on eighteenth-century looms." Job fluctuation and absenteeism ran high; productivity stayed low.[72]

Foot dragging, collective resistance, and organized protest occurred throughout the late 1940s and 1950s. Textile workers, in some cases backed by union stewards, ignored pressure to participate in the "Hennecke movement" of 1948–49 ("Hennecke workers" performed supershifts toward the goal of jacking up norms).[73] Women at the Olympia

[67] Canning, *Languages*, 255; Schüle, "Spinne," 52, 57. The focus on textile plants is not meant to imply better conditions in other industries. On Maxhütte, a steel mill, see Port, "Conflict," 208.

[68] Schüle, "*Spinne*," 105–10; Schüle, "Industriearbeit," 114–15; DY30/IV/2/17/37, Bl. 104–11, Einschätzung . . . der Lage der jungen Arbeiterinnen in der Textilindustrie, 5.5.61.

[69] SAPMO-BArch, DY30/IV2/17/51, Bl. 542, 31.1.50, Bericht über die Protestaktion in den Bekleidungswerkstatten in Zehdenick; IMC, Interview 024.

[70] SAPMO-BArch, DY30/IV/2/17/37, Bl. 104–11, Einschätzung . . . Textilindustrie, 5.5.61.

[71] SAPMO-BArch, DY49/16/35/1572 IG, Bericht über . . . VEB Thüringen, Erfurt am 10 u. 11.6.52; DY49/16/45/1577 (no heading) (1957?), 4; DY49/16/35/1572. Bericht über . . . Bekleidungswerk Neugersdorf. 2.2.52; LStA, IV2/3/208. Bericht der BGL der VEB Leip Baumwollspinnerei an d. Büro d. SED Bezirksleitung (August 1956); SAPMO-BArch, DY34/A347, VEBBekleidungsfabrik Bürgel. 10.11.51.

[72] Quote: SAPMO-BArch, DY30/IV2/17/37, Bl. 104–11, 5.5.61, Einschätzung. . . Textilindustrie; DY30/IV2/17/70, Bl. 78–83, 92, Arbeitsgruppe Frau, Einschätzung . . . VEB Leipziger Baumwollspinnerei . . . [1961]; DY34/A347, VEB Bekleidungsfabrik Bürgel, 10.11.51. Also see Stitziel, 66, 75–80.

[73] See, e.g., SAPMO-BArch, DY30/IV2/17/51, Bl. 460, Bericht . . . Agfa-Seide Premnitz.

carpet factory objected vociferously when their pay was docked two hours on 8 March 1949, as a "contribution" to the Greek struggle against U.S. imperialism. Because it was International *Women's* Day, this involuntary gesture of solidarity did not apply to men. An SED observer reported, "Hostile elements in the plant cleverly exploited the situation and organized public protests" at a meeting addressed by Käthe Kern.[74]

Textile workers looked askance at the factory collective agreement (BKV) and its alleged "incentives." The executive board of the Textile, Garment, and Leather Workers Union (IG TeBeLe) had to send out numerous "instructors" to clarify "questions about the new incentive wages." In Forst, a mill town in Brandenburg, "discussion of the BKV caused tumultuous scenes," necessitating an "intervention" by an instructor who called a big meeting of local workers to try to intimidate them into compliance. He received little support from Forst's union officials who, he reported in disgust, "seemed to fear talking about the BKV with their colleagues." The commotion had been kicked up by a group of male skilled garment workers. Prompted by their example, the mass of female workers at twelve of Forst's fourteen mills voted against or abstained on the BKV. Their resistance took crafty forms. Required to make "personal pledges" that showed their commitment to the Collective, every woman at one mill offered this sacrifice: those workers who received a monthly paid housework day would relinquish it once quarterly to women deprived of a housework day by the BKV. This offer, local union officials suggested tentatively to the instructor, would "enhance feelings of solidarity." They shut up after he denounced the pledge's "opportunism and frivolous egalitarianism (*Gleichmacherei*)." Many union functionaries, it seems, reverted to "pure trade unionism" when confronted with the terms of the BKV. Shop floor representatives, like ordinary workers, failed to see the "rational basis" or "political necessity" of the wage reclassifications. They wrote to superiors, "We can't expect our workers to accept it, you come to our factories, you'll fly right back out again." In Chemnitz, textile unionists conceded that the BKV "must" be signed for "it is the law" but said they would not enforce it. "Intensive work" was required to change such attitudes. In a cotton-spinning mill in Flöha, local officials were trained by outsiders to lead scripted discussions with workers and to convince supervisors to publicize their "personal pledges" before asking workers to sign on the dotted line. More typically, union and party officials spent hour upon hour individually berating every worker in a mill about the necessity of the BKV. Not sur-

[74] SAPMO-BArch, DY30/IV2/17/8, Bl. 244–45, Bericht über die Vorgänge in der Olympia, 2.6.49.

prisingly, mills in Chemnitz, Leipzig, Dresden, and Löbau lagged far behind the schedule of implementation.[75]

Far from unconcerned about what they earned, textile workers kept exact accounts of the money due them. Opposition to the BKV in textiles and garments centered on the terms of the paid housework day, supplementary night wages, payment of craft workers, payment of nonproduction workers, payment for time missed for a doctor's appointment, reimbursement of travel expenses, payment during power outages, payment during time out for political meetings.[76] Women in "male" industries also reckoned every penny: "After carefully enumerating her monthly fixed costs, a worker at the steel mill Maxhütte [in Saalfeld] rejected the levels set forth in the proposed contract, arguing that no woman could 'make ends meet' on such wages."[77] Women workers, like men, were especially distressed by the comprehensive "step downs" to lower wage levels that were a prominent feature of the BKVs.[78]

As suggested by events in Forst, women workers often learned how to protest from male skilled workers. At a garment factory in Zittau that employed 737 women and 113 men, a work stoppage occurred in early 1952 in reaction to decisions by "stop-watch toting TAN experts" (Technical Work Norm time-setters). Workers accepted the shorter "time-intervals of production" recommended by the time-setters but balked at the wage cuts that accompanied them. Even if they fulfilled norms by 150 percent, workers complained, they could barely earn a living wage—and so they stopped work, only picking up their scissors again when the mill's SED secretary promised to ask the textile and garment union to investigate. Union instructors arrived, took measure of matters at the mill, and pronounced judgment: they attributed the walkout not to wage cuts per se, but to "mistakes and weaknesses" in management's representation of them (more evidence of Stalinist postmodernism). They blamed "class enemies" and "the irresponsible administration of the former plant director" (an SED member). They faulted "members of the SED and [union]

[75] SAPMO-BArch, DY49/16/35/1572. IG TeBeLe, Bericht über den Instrukteureinsatz im Ortsvorstand Forst am 13. u. 14.8.51; Bericht. Instrukteureinsatz Chemnitz, 13.8.51. On Flöha, see DY49/16/35/1572. Bericht . . . vom 27.6 u. 28.6.51 in Flöha und Leipzig. For another case of resistance, DY49/16/35/1572. Bericht. Betr: Hausschuhfabrik Pegau, 19.10.51.

[76] SAPMO-BArch, DY49/16/35/1572, Bericht über die Überprufung des Gebietsvorstands Chemnitz zum Abschluss der Betriebskollektivverträge am 24.7.51; Bericht über die Arbeit zur Erstellung des BKV, Dresden, 6.6.51; "Opportunismus hemmt Abschluss des Betriebskollektivvertrags," Berlin, 31.8.51.

[77] Port, "Conflict," 34.

[78] SAPMO-BArch, DY49/16/35/1572. IG TeBeLe Bericht über den Instrukteureinsatz vom 27.6 und 28.6.51 in Flöha und Leipzig. For another case, see DY34/39/54/2613. IG TeBeLe Abt. Frauenbericht über den Instrukteureinsatz am 17. und 18.3.53_, 2–3.

functionaries" who made "bad remarks during assemblies." "It's often easier," they complained, ". . . to convince [non-SED members] of the need to cooperate."[79] Some workers wanted to work, but "the others forced them to stop. The majority had not the slightest idea what a work stoppage means. We ascertained that precisely those workers who have a good standard of living led the walkout, while the others shied away." The better-paid workers were probably skilled men, such as a cutter mentioned by the instructors.[80]

Union instructors, as was typical in these disputes, held the authority to resolve the conflict. They had the mill director fired, retracted some wage cuts, stabilized "norm-seesaws," and met with almost every worker. Yet they approved the principle of resetting norms and steeply reduced wages in one department. The pattern of compromise, indoctrination, and selective cuts restored "calm" in Zittau.[81] Textile workers elsewhere continued to resist wage cuts that created "unbearable conditions" as women worked frantically to meet the high norms.[82]

By mid-1953, women workers were as "riled up" as men by speed-up and wage reductions. They did not, however, play a central role on the main stages of the June rebellion: large construction sites, the Leuna works, and the city of Magdeburg.[83] Militant male workers did little to bring women into the struggle. Just the opposite. Workers at the Leuna chemical complex hung a banner on an outside wall that denounced the "plan to promote women."[84] Some male workers obviously associated higher norms and lower wages with the advancement of women on the shop floor and felt, presumably, that all three developments threatened male workers' responsibility for supporting their families.

Not gender divisions, but the peripheral locations and small size of mills militated against textile or garment workers playing a key part in the uprising. Still, tension ran high in Saxon mill towns, in one case requiring

[79] SAPMO-BArch, DY49/16/35/1572. IG TBL. Bekleidungswerke Neugersdorf. 22.1.52; Instrukteurbericht über den Einsatz in Bekleidungswerk Neugersdorf und Mechanischer Weberei, Zittau, . . . 19. bis 23.2.52; Bericht . . . Neugersdorf. 25.1.52; Bericht . . . Neugersdorf. 2.2.52.

[80] SAPMO-BArch, DY49/16/35/1572. Instrukteurbericht . . . Bekleidungswerk Neugersdorf und Mechanischer Weberei, Zittau, . . . 19. bis 23.2.52. For another case of men as inspiration, see DY34/39/54/2613. IG TeBeLe Abt. Frauen, Bericht über den Instrukteureinsatz am 18.11.52 in der Kleidermacher Werk LI Görlitz.

[81] SAPMO-BArch, DY49/16/35/1572 IG TBL Bericht . . . Bekleidungswerk Neugersdorf. 25.1.52; Instrukteurbericht . . . Neugersdorf. 21.1.52; Instrukteurbericht . . . 19. bis 23.2.52.

[82] LStA Bestand: VEB Leipziger Wollgarnfabrik.Nr.94. Bericht zur BGL Sitzung am 3.3.53; SAPMO-BArch, DY30/IV2/5/544, Bl. 2: DFD Bundessekretariat an ZK, 15.6.53.

[83] On Leuna and Magdeburg, see Staritz, *Geschichte*, 131–33.

[84] Zachmann, "Frauen," 132–33.

emergency mediation by Elli Schmidt, whose peace making was soon used against her by Ulbricht. Generally, local officials and plant directors dealt with the unrest. On 17 June, the mood in a mill with 3,000 workers "was extremely dangerous." Its non-SED union leadership and plant administrators managed "to calm the workforce so that it went to work." Union officials warned their superiors that textile workers might appear docile but were very angry. As if to underscore this point, in July at a mill assembly, the workforce loudly articulated its "lacking trust in the party, regime, and trade unions." "The dictatorial norm increases were a major cause of workers' discontent," insisted one worker, provoking another to yell out, "That was the only cause!" When a third complained that the union had "done nothing since 1945," the entire audience began to "cheer, clap, and stomp its feet."[85]

The June uprising sapped the will of the SED to impose draconian speed-ups and wage cuts. The regime, of course, continued to try to increase productivity, but in less exploitative, explicit, or effective ways—such as "Socialist competitions," the "Socialist brigades" introduced in 1958, and "production consultations."[86] Through every change of labor and production policy, women workers continued to focus on what new policies and schemes might mean for their paycheck.[87] As they gained experience on the shop floor, women taught a new generation of colleagues, born and bred under socialism, how to interpret the state's maneuvers. According to a report of 1961, "Young women workers in the textile industry rarely adopt the 'innovation-method' . . . because [if they do] older women workers label them wage-cutters (*Lohndrücker*). [The older women] often give advice that they gleaned from the struggle against [capitalist] exploitation without considering that we live in completely different social relations."[88]

Issues such as sick leave and hours of work also moved women workers to protest. East German workers were not healthy in the early 1950s. Weakened by poor nutrition and life in poorly ventilated, cold, damp, cramped quarters, they suffered in large numbers from diseases of the intestines and lungs, especially TB. Physicians were in short supply, and

[85] SAPMO-BArch, DY34/39/54/2613. Protokoll . . . am 12.6.53 in Glauchau; IG Te-Be-Le Frauenabteilung, Bericht . . . Textilwerk Einheit I, Glauchau am 8.7.53, S. 4. For similar scenes in feminized chemical plants, see IG Chemie Frauenabteilung . . . Aussprache mit den Kolleginnen der zentralen Frauenkommission. 5.10.53. Also see SAPMO-BArch, DY46/11/2400/4476. Bericht über . . . LEW Hans Baimler Hennigsdorf . . . 19.11.53, p. 5.

[86] See, e.g., LStA. IV2/3/208, Baumwollspinnerei, Bericht . . . VEB Leipzig Baumwollspinnerei an das Büro der SED Bezirksleitung (August 1956).

[87] See, e.g., IMC, Interview 024.

[88] SAPMO-BArch, DY30/IV/2/17/37, Bl. 104–111, 5.5.61, Einschätzung . . . Textilindustrie, 10.

penicillin was scarce. Sickness caused male and female absenteeism, but women's maladies lingered longer.[89] Factory supervisors, economic planners, and the SED were determined to reduce lost days. The head of the Department of Mother and Child, Käthe Kern, intoned in classically Stalinist fashion, "We all know that inadequate ideological enlightenment is . . . the main cause for the high rate of sickness."[90] Not just patients, but physicians required enlightenment. Early on, most doctors were in private practice and not averse to prescribing sick leave. A "communal health officer" or "physicians' committee" often overrode authorization of leave by a private doctor.[91] Women workers preferred private physicians and complained about the pressure put on doctors to reject sickness or disability claims.[92]

Night-shift, or three-shift, work was another contested issue, as it had been since the nineteenth century. While some advocates of women workers defended bans on night work as necessary to protect employed mothers or pregnant women, others criticized protective legislation as discriminatory, in part because dangerous occupations and night work brought wage premiums.[93] These disagreements resurfaced after 1945.[94] SMAD orders upheld prohibitions against certain occupations and night work. As the labor market for women turned soft in 1948 and 1949, opposition to protective measures rose. Women who worked in a power plant passed a resolution against the ban on night work because it "contradicted the basic law of equality" and allowed men to take back jobs that women had "conquered."[95] In 1950, as the SED and FDGB ironed out the terms of the Mother and Child Law, the FDGB argued successfully for fewer occupational restrictions and for lifting the ban on night work.[96] Three-

[89] SAPMO-BArch, DY49, Abt. Sozialversicherung . . . Wollkammerei in Leipzig . . . 1.–3.2.56. Krankenstand; DY34/39/94/5571. Protokoll . . . Frauen im Bezirk Halle der IG Chemie. 18.10.56, Krankenstand, 5.

[90] Quote from Kern: SAPMO-BArch, DY30/DY 30/IV2/1/115, Tagung des ZK, 13.–14.3.53 Bl. 134. Second quote: DY49. Abt. Org-Massenarb. an Abt. Sozialversicherung, 25.2.57.

[91] SAPMO-BArch, DY30/IV2/17/61, Bl. 47; SAPMO-BArch, DY34/39/54/2613. IG TBL Frauenabteilung. Glauchauer Damenstoff-Weberei VVB (Z). BGL Vorsitzende an BUVO . . . 20.7.53.

[92] SAPMO-BArch, DY34/39/54/2613. IG TBL Fr. Abt., Bericht über die Belegschaftsversammlung im Textilwerk Einheit I, Glauchau am 8.7.53; Betriebsgwerkschaft Kleiderstoffwerk Zittau, Protokoll . . . 8.11.52; DY49/16/35/1572, Abteilung Arbeit u. Sozialpolitik. Bericht . . . Baumwollspinnerei, Chemnitz, 15.10.52; DY34/39/54/2613.

[93] On this debate in Germany, see Canning, *Languages*.

[94] For disagreements in Saalfeld factories about protective measures, see Port, "Conflict," 220.

[95] SAPMO-BArch, DY30/V2/17/12, Bl. 59, Resolution, am 18.2.49 in Kraftwerk Finkenheerd, Frauenversammlung: Bl. 60, 21.4.49, FrAbt.

[96] SAPMO-BArch, DY34, Zum Gesetz der Frau, 5.4.50.

shift work became increasingly common in textiles and other industries.[97] Women complained about precisely what protectionists predicted: they *had* to work nights. Women at a garment factory in Bernau, according to a report, "reject the night shift and, recently, just go home without informing anyone. They told me that they don't want to work *any* more night shifts. They're fed up and simply can't take it." To avoid night work, many women quit state-owned mills with three shifts for jobs in private mills with two shifts. During a factory assembly, the outspoken workforce at the Glauchau mill raised a banner that read, "Night work must end and the two-shift system reintroduced according to the old rules."[98] In summer 1956, the state ministerial counsel eliminated the "sixth night shift in a few textile mills." "Great relief" greeted this slight concession, although women workers worried that their pay packet would shrink.[99]

Women tied their complaints about sick leave and night work to their domestic responsibilities and, especially, concerns about their children. The labor issue that elicited far and away the most protests was *about* their domestic duties: the "housework day," a monthly, paid day off available to many, but not all, women workers (and no men). The housework day (HAT) began as a National Socialist scheme to draw middle-class women into munitions work. The Nazis granted the "washing day" initially to married women who worked full-time; they soon extended it to single women with children under age fourteen. Women workers immediately incorporated the HAT into their sparse trove of entitlements. Every occupied zone of the 1940s and both postwar states had to deal with this legacy of the Third Reich. The tenacity with which East German women, in particular, clung to or demanded the HAT attests to the failure to address women's domestic labor, women's bitterness about that failure, and their readiness to make their anger known. The HAT became a central site of battles over the comparative rights of different groups of workers, on the one hand, and conflicts over the balance of power in the workplace among workers, the FDGB, management, and the SED, on the other. As

[97] SAPMO-BArch, DY34/39/54/2613. Betriebsgwerkschaft Kleiderstoffwerk Zittau, Protokoll . . . der Gewerkschaftsarbeit unter den Frauen . . . 8.11.52; SAPMO-BArch, DY30/IV2/17/87, Bl. 299–302, Erna Lierse, Die Lage der Frauen in den Braunkohle- und Eisengiessereibetrieben im Geiseltal Kreis Merseburg, 30.6.51.
[98] SAPMO-BArch, DY49/16/35/1572 IG TBL Abt: Arbeit und Sozialpolitik. Bericht über . . . Konsumbekleidung, Bernau, 22.4.52; Abt: Arbeit und Sozialpolitik Bericht über die Tagung der HV Textil mit den Arbeitskräfteplanern und Arbeitskräftelenkern, 22.4.52. On Glauchau, see SAPMO-BArch, DY34/39/54/2613. IG Te-Be-Le Frauenabt., Bericht über die Belegschaftsversammlung im Textilwerk Einheit I, Glauchau, am 8.7.53.
[99] SAPMO-BArch, DY30/IV2/17/35, Bl.1, Bericht von der Tagung der zentralen Frauenkommission mit Arbeiterinnen aus der Produktion der IG Metall am 7.12.56; LStA, IV2/3/208. Betriebsparteiorganisation. VEB Baumwollspinnerei, Leipzig, 3.8.56. Bericht der BGL über die Durchführung der Beschlüsse der 3. Parteikonferenz.

Carola Sachse has observed, this struggle "bundled together social debates about the gendered division of labor, about equal treatment of different groups of women, and about the equality of the sexes—and ignited them."[100]

After 1945, many factory agreements maintained or reintroduced the HAT. Eager to win women's support, the FDGB, SED, and provincial administrations initially pressed SMAD to anchor the HAT in law.[101] SMAD rejected this proposal, except in Berlin. The administration of Saxony-Anhalt adopted, nonetheless, a broad HAT: *all* women workers could claim it. This decree put the first stitch into a crazy-quilt pattern of regulations that fanned workers' constant sense of grievance about the housework day. In 1947, SMAD Order Number 234 tried to stop the proliferation of the wide HAT by trimming it to fit only women with an "independent household" (i.e., a husband). When factories in Saxony-Anhalt tried to apply this rule, "spokeswomen for all the working women of Magdeburg" sent a protest resolution to the FDGB that demanded the union federation confront SMAD. They represented the HAT as an inalienable right won through struggle. According to one delegate, "We women are absolutely unwilling to let something be taken from us that we achieved through our own efforts. The housework day didn't fall into our laps as easily as some gentlemen believe. . . . [T]he opinion of a few backward-thinking men in the regime . . . cannot be allowed to reverse the progress fought for by women."[102]

The SED soon began it own effort to crop the HAT and, if possible, toss it.[103] The FDGB initially defended the housework day, but in 1950 it adopted the party's negative stance. "[T]he housework day," the FDGB realized, "cannot be reconciled with the principles of the five-year plan." It promised to help the SED with the "ideological work of enlightenment" to bring this realization to women. There was much enlightening to be done for, in 1951, virtually every woman worker wore the HAT. Faced with a daunting task of reeducation, the regime decided to forget enlight-

[100] Sachse, "Eisen," 253–55.

[101] SAPMO-BArch, DY34/A1664. Hauptabt. 9, Frauenfragen an . . . Jendretzki, 11.6.46; Sachse, "Eisen," 257, 255; DY34/A1678, FDGB . . . 15.10.47, Betreffend: Haushaltstag.

[102] SAPMO-BArch, DY34/A1664, FDGB VS Magd, Abt. FRsek an BVS, 15.4.48. Also see Sachse, *Hausarbeitstag*, 49–58.

[103] SAPMO-BArch, DY34/A1664. Hildegard Goth, Bitterfeld, an BVS, Herrn Lungwitz, 2.6.48; Hauptabt. Frauen an H. Goth. 5.7.48. Beschluss des Zentralsekretariats von 9.8.48; Landesregierung S-A, MdI, 28.5.48; Aktennotiz. Betr: Anordnung Siewert; An HA IX - Frauen von 2. Vorsitz. 26.6.48; Betr: Hauarbeitstag für Frauen; L. Krüger An Zentralsekretariat SED, Gen. Weck. 21.7.48. Changes in the regulation of HAT played a role in unrest at the Olympia carpet factory: DY30/IV2/17/8, Bl. 244–45, Bericht über die Vorgänge in der Olympia, 2.6.49.

enment. In 1952 it decreed new terms. The HAT would cover women with children younger than sixteen, with sick or disabled family members, *or* with a fully employed husband. It would not cover single women without children or with children older than sixteen; it would not extend to wives with an unemployed or semiemployed husband. The new terms robbed about half of employed women of the HAT.[104] Left uncovered were older single women and mothers who had to work out of dire necessity *and* had no other adult with whom to share housework. Covered were the childless wives of employed husbands. Like the Nazi regime, the SED regime obviously hoped the HAT would help mobilize the labor of women who did not need to work for wages.

This decree provoked an outcry among women workers, and enlightenment had to begin again. FDGB representatives lectured women about "how much money is used each year to pay for the housework day." Male union officials pointed out that if single women got a housework day, "true equality demanded that single men must also." The DFD reversed its earlier support for the HAT. Elli Schmidt disparaged the housework day as "Nazi labor policy." With watertight logic, she argued that Communists must reject the HAT as reactionary within the GDR, but they must fight for its continuation in capitalist, militarist West Germany.[105]

Every argument fell on deaf ears. This "hot iron" did not cool as social services improved, wages rose, and scarcity gave way to relative plenty. Single women did not see these ameliorations as compensation for the HAT. Consonant with the "endowment effect theory" of psychologists Daniel Kahneman and Amos Tversky, they suffered the loss of the HAT more than they appreciated the gains offered in its place.[106] Moreover, the HAT offered real relief for employed women. The issue flared, Sachse notes, at moments of high tension in 1953 and 1956, suggesting that it also acted as a vent for political frustration.[107] Ironically, the housework

[104] Sachse, *Hausarbeitstag*, 92–93, 99–100.

[105] SAPMO-BArch, DY34, Zum Gesetz der Frau, 5.4.50; Verordnung vom 20.5.50; DY34/39/21/2214. An das Sekretariat den Buvo FDGB von Organisations- und Instrukteur-Abteilung, 21.4.51; Protokoll über die Sitzung des Zentralen Aussschusses des FDGB/DFD zur Beratung gemeinsamen Fragen am 20.4.51; DY34/39/64/2615. Frauenabt. Betr: Bericht . . . LEW Hans Beimler Hennigsdorf am 17.6.52, S.2; Sachse, "Eisen," 257, 261–62, 267. Also see "Aktivistin Gudziol und der Frauenausschuss," Fvh, Nr. 26, 25.6.54.

[106] Kahneman, Knetsch, and Thaler.

[107] Sachse, *Hausarbeitstag*, 104; SAPMO-BArch, DY30/IV2/5/273, Bl. 57, Kreisleitung der SED Rathenow. Abt. Partei u. Massenorganisationen an die Bezirksleitung SED, Potsdam, 7.8.53. Stimmungsbericht; SAPMO-BArch, DY30/IV2/17/35, B. l1, Bericht von der Tagung . . . mit Arbeiterinnen aus der Produktion der IG Metall am 7.12.56; DY30/IV2/17/37, Bl. 128–30, (1957?); DY30/IV2/17/32, Bl. 44, 46, 50, 52; DY46/11/559/2105. Zentraler Frauenausschuss VEB Waggonbau Bautzen an BVS, 14.5.56; DY34/39/85/5568. E. König an Grete, 7.9.56, S. 2.

day became more politically fraught in the GDR than the FRG, because the SED regime, unlike West German politicians, could not thrust the blame for trimming the HAT onto private employers or labor courts.[108]

Agitation in favor of a broader HAT percolated throughout the 1950s and culminated in a barrage of 123 resolutions to the FDGB congress of 1959. These came out of meetings in every industry and economic sector and called for extending the HAT to all women workers.[109] The petitions demanded justice. Yet, in contrast to postwar protests, they rarely adopted a feminist tone but advocated equality of rights *among women*— between single and married women. Report after report noted: "Single women began a raucous debate about the housework day."[110] "Women standing alone" were incensed that key to the HAT was an employed husband, while it was denied to mothers (many of them widows) with older (employed) children at home. They felt mistreated by the regime *and* wives.[111] They calculated the HAT's monetary value to wives, suggesting, again, that remuneration mattered to women workers.[112] A widow wrote bitterly, "We have equality of men and women but not yet equality between married and widowed women." She and others pointed to the "hard work that rests on our shoulders alone."[113] A woman who lived in a village with no social services told of her long travel times, queue standing, and schlepping of coal and wood. She concluded: "These are hardships that city women and ones with a husband don't have. . . . Many married women have no interest in reducing the burdens of single women. . . . Yet these women, mostly over forty years old, did much to build the workers and farmers state and today are disadvantaged compared to married women."[114]

Single women wanted not just relief, but recognition. Many married women sympathized with them. Resolutions sent to the FDGB congress in 1959 underscored that wives endorsed extending the HAT to single

[108] Sachse, *Hausarbeitstag*, 101.

[109] SAPMO-BArch, DY34/39/106/5899; DY30/IV2/17/32 Anträge zur Veränderung der Regelung über Hausarbeitstag, 17.11.59.

[110] First quote: SAPMO-BArch, DY34/39/64/2615. Frauenabt. Bericht über die Frauenkonferenz . . . Hennigsdorf am 17.6.52, S.2. Second quote: DY30/IV2/5/273, Bl. 57, Kreisleitung der SED Rathenow. Abt. Partei und Massenorganisationen an die Bezirksleitung SED, Potsdam, 7.8.53.

[111] SAPMO-BArch, DY34/ 39/54/2613. IG TBL Frauenabt. Bericht . . . Textilwerk Einheit I, Glauchau am 8.7.53.

[112] Sachse, *Hausarbeitstag*, 328.

[113] SAPMO-BArch, DY30/IV2/17/32, Bl. 50, 27.11.57; DY34/39/106/5899, FDGB Karl Marx St. an BVS, 1.10.59.

[114] SAPMO-BArch, DY30/IV2/17/32, Bl. 52, VEB Fettchemie, 6.1.58. Also see DY34/ 39/94/5571. VEB Kunstlederfabrik Tannebergsthal/Vogtland an die Kreisleitung der SED Klingenthal/Sachsen . . . 26.11.56; Heineman, *Difference*, 204–6.

women.[115] Female union functionaries and factory women's committees supported the single women's cause. They collected and sent forth the volley of resolutions that landed on the FDGB congress, although "union delegates did not vote for the resolutions because they realized that is not the way to solve the woman question."[116] Women in responsible positions were themselves disproportionately single and older. The activity around the HAT reflected, as well, the growing self-confidence of local unions in the late 1950s. They contended, "We think firms should be able to regulate it for themselves."[117] In practice, firms did. Like the regulation of wages and other benefits, the uniform regulation of the HAT disintegrated. In 1957, a survey of factories showed that variation in how many women enjoyed the HAT was not correlated with the ratio of married to single women workers in the concern. In several entire industries, single women with older children had won the HAT. The SED could find no palatable solution. It did not extend the HAT but also did not retract or restrict it. In 1961, the HAT still covered about half of women workers.[118] The state, Sachse argues, felt secure enough to ignore the complaints of single women but not to anger employed wives or their husbands.[119] The SED's manner of "solving" the problem suggests that, in the mind of the party-state, husbands did make a difference. The state's assumption infuriated single women—and gave their complaints about its unfair consequences a gendered charge, although they did not usually articulate their fury in feminist language.

The dynamics of party, union, and worker interaction in struggles over the housework day typified wider tendencies in labor relations after 1953. A sense of relative deprivation was endemic in the GDR, Andrew Port argues.[120] Conflicts about the HAT's inequities represented this general tendency but also exposed the gendered structure of advantage and disadvantage. The SED's inability to eliminate the housework day backhandedly acknowledged the large amount and variety of domestic labor required to keep the family alive, clean, and clothed, on the one hand, and

[115] SAPMO-BArch, DY30/IV2/17/32, Anträge zur Veränderung . . . HAT. 17.11.59; DY30/IV2/17/32, Bericht . . . VEB Erzgebirgische Flachspinnerei, Wiesenbad, 31.3/3.4.58. On desire for social recognition, see Sachse, *Hausarbeitstag*, 375.

[116] Quote from SAPMO-BArch, DY34/39/137/6010 Entwurf . . . HAT, 23.11.59. Also see Sachse, *Hausarbeitstag*, 24.

[117] Quote from: SAPMO-BArch, DY34/39/137/6010. Abt. Arbeit und Löhne an Bombach, 30.10.57. Also see DY46/11/559/2105. Zentraler FA VEB Waggonbau Bautzen an BVS, 14.5.56; 39/85/5568, König an Grete, 7.9–56, S. 2.

[118] SAPMO-BArch, DY34/39/137/6010 Betr: Hausarbeitstag, 11.12.57; DY30/IV2/17/70, Bl. 125–26 FA d. VEB Fahrzeuggetriebewerkes . . . an E. Baumann, 16.8.59; Bl. 127, Arbeitsgruppe Frau an Baumann, 26.8.59; DY30/IV2/17/37, Bl. 128–30 (1957?).

[119] Külke, "Berufstätigkeit," 65; Sachse, "Eisen," 280.

[120] Port, "Conflict," 114.

the state's and employed husbands' dependence on women to perform domestic work, on the other.

GENDER RELATIONS ON THE SHOP FLOOR

Postwar shop floor tensions between the sexes did not suddenly ease in the new world of the workers' and farmers' state. In fact, focused on the drive for production, the SED challenged workplace sexism less than earlier. Misogyny did not poison every encounter or relationship between men and women at work, but it was ever present. Men held stubbornly to their suspicion of women's employment and to their hostility to women's promotion. Whether in "male," "female," or "feminizing" industries, male managers, foremen, workers, and their political and shop floor representatives sabotaged, often cooperatively, every aspect of the new state's effort to integrate women into the workforce. Intentional wage inequalities remained a widespread practice. In a precision-machine factory whose production workforce was one-third female, an FDGB instructor discovered that workers were "largely satisfied with the achievement wage" but that gender relations were "very tense," because a number of men were paid at Level IV for a job that women performed at Level II wages. The director agreed to abolish these discrepancies after admitting that "violations were related to the difficulty of reforming the consciousness of individual colleagues" and that the "BGL, BPO, and factory directors will have to carry out individual enlightenment from man to man."[121] In a heavy machine building plant, women were paid at lower rates even when performing the same job as men. When women challenged this inequality, supervising men threatened to drop them into an even lower wage category.[122] In an iron foundry, "men shove women aside and divvy up the wage groups among themselves . . . [so that] no women are in the higher wage categories," although the department was majority female. In 1959, the hydration department at Leuna, in another case, hired new women at wage Level II but new men at Level III.[123] In the Buna chemical works in 1960, women worked as excavator drivers as long as this job was paid at Level IV. Reclassified at Level V, the job became "too hard" for a woman

[121] SAPMO-BArch, DY34/A347, An den Landesvorstand Thüringen Bericht . . . Betrieb, Feinmesszeugfabrik, Suhl, 10.11.51; Port, "Conflict," 438. The uneven distribution of "commendations" was often intentional. See, e.g., DY34/A347. Instrukteurauftrag für VEB Harmetall . . . 15.11.51; DY34/39/89/5567. Kollegin Inge Posselt . . . [1955].

[122] LAM, IV/L2/2/10, Bl. 5–6, Protokoll . . . FA . . . 1.7.52.

[123] SAPMO-BArch, DY30/IV2/17/41, Bl. 40, Frauenkonferenz . . . Kombinat "Schwarze Pumpe" am 28/29.6.58; DY30/IV2/17/65, Bl. 199–200, 25.2.59, Die Arbeit des FA in Leuna.

and was assigned to men. A woman declared her willingness to continue at Level IV. Dredging became miraculously easy again and she was allowed to work alongside a higher-paid man.[124]

Men were especially protective of "male" skilled jobs. During the 1953 rebellion, Leuna workers denounced "the plan to promote women" because it intended to train women as drivers and locksmiths. They thought women should work as (lower-paid) cleaners, helpers, or cooks.[125] In Leuna's electronics department, the party organization refused to train a woman who wanted to become a norm-setter, because "a woman can't perform that function." In the "Carl von Ossietzky" plant, managers hired women as low-paid transportation workers under the proviso that they "could not demand qualification."[126] Men wanted, above all, to control job assignments—and women workers. In a charcoal briquette factory, a skilled woman worker told a female SED investigator, "Women might well be pulled into every job [in her plant] but will never get to decide anything."[127] The few women who supervised male workers felt they had to "fight for every little decision."[128] "Economic functionaries"—the keepers of the plan in each concern—acknowledged that supervisory women had it hard. To them, this proved that women were unsuited to lead.[129]

Women experienced the whole range of sexual harassment: ridicule, lewd remarks, mild sexual advances, and violent assaults.[130] In a shocking case documented by Andrew Port, a male worker thrust an iron rod into the vagina of a pregnant co-worker, causing serious injury. His superiors

[124] SAPMO-BArch, DY30/IV2/17/65, Bl. 186, Bericht . . . VEB Chem. Werke Buna, 12.11.60.

[125] Zachmann, "Frauen," 132–33.

[126] See, e.g., SAPMO-BArch, DY30/IV2/17/35, Bl. 1, Bericht von der Tagung der zentralen Frauenkommission mit Arbeiterinnen aus der Produktion der IG Metall am 7.12.56; DY34/39/134/6009. Bericht . . . IG Chemie am 25.10.57, S. 3; Bericht . . . Kunstseidenwerk "Friedrich Engels" Premnitz 14.1.58; Beratung mit zwanzig Produarbeiterinnen . . . 6.5.58: Bericht d. IG TeBeLe über . . . Textilarbeiter . . .; LAM, IV2/3/519, Bl. 128, 192, Beschluss . . . Frauen in den chemischen Grossbetrieben . . . Halle, 11.3.59.; DY30/IV2/17/41, Frauenkonferenz..."Schwarze Pumpe" am 28.–29.6.58. Bl. 20, K. Thiel, Eisenhüttenkombinat Stalinstadt; Schüle, "Die Spinne," 62–63.

[127] SAPMO-BArch, DY30/IV2/17/87, Bl. 299–302, Erna Lierse, Die Lage der Frauen in den Braunkohle und Eisengiessereibetrieben im Geiseltal Kreis. Merseburg, 30.6.51: Brikettfabrik Pfennershall, Braunkohlenkombinat Mücheln und Eisengiesserei Frankleben. On the Leuna protest, see Zachmann, "Frauen," 132–33.

[128] SAPMO-BArch, DY30/IV2/17/41, Bl. 27, Frauenkonferenz . . . Kombinat "Schwarze Pumpe" am 28.–29.6.58; DY30/IV2/17/65, Bl. 186, Bericht . . . VEB Chem. Werke Buna, 12.11.60.

[129] LAM, IV/L2/2/10, Bl. 1, 8, Protokoll . . . FA, 1.7.52; SAPMO-BArch, DY34/A2080. Bericht . . . Frauenarbeit im Bezirk Cottbus [October 1958].

[130] See cites in notes 126 and 127 above.

reproved him but, fearful he would flee to the West, did not fire him. They looked for a position within the same steel mill where he could use his "excessive strength" productively.[131] Any number of tough women did well in male-dominated occupations, though one of them conceded, "It's open season on women in a men's factory."[132]

Male workers undermined women in production for the same reason they cut cables, defaced Ulbricht's picture, and feigned sickness—to protest state policy.[133] That this particular subversion was also about women is suggested by the collusive obstructionism by men at all levels of factory decision making.[134] Not every member of the male cabal thwarted women's advance with equal passion, however. Factory directors and economic managers, protected from direct competition with the interloper, deferred to the active maneuvers of men who exercised power on the shop floor: the factory or departmental union leadership (BGL or AGL), the factory or departmental party organization (BPO or APO), foremen, and brigadiers.

At first glance, women's position in the FDGB does not look bad. Women made up thirty-six percent of union members in 1951. In 1952 and 1953, the average district executive committee of the FDGB was two-fifths female (but one-fourth if only elected women are counted); the average BGL was a third female. These statistics, however, mask wide variations by industry. In the metal-working industry, which was twenty-three percent female in 1951, the average BGL was 16.7 percent female, the average AGL 14.6 percent.[135] Statistics also hide the instances in which a BGL had been forced to take in women. At a telecommunications factory with 6,000 employees, 3,700 of them women, the BGL was one-quarter female in 1952. Outside instructors "suggested" that *women* workers should elect five new members to the BGL. The chairman of the BGL and the factory's party secretary rejected this "affront to union democracy," whereas women in the plant liked the idea. After much debate, a "trade union active," an instrument of the top hierarchies of the FDGB and SED, intervened, and five women were "elected."[136] One can imagine how

[131] Port, "Conflict," 446, 454.

[132] IMC, Interview 024.

[133] Fulbrook, 159; Port, "Conflict," 306; Ross, 96, 100.

[134] Port, "Conflict," 259, 265–66, 268, 277.

[135] SAPMO-BArch, DY30/IV2/611/42 Bl. 9, 5.1.62, Anteil Frauen in FDGB; Bl. 14, 5.1.63; SAPMO-BArch, DY46/11/559/2105. Entwicklung von Förderung der Frauen, 13.5.52; DY34, Bericht über Untersuchung des Zentralvorstandes der IG Metall. im Bezug auf die Entwicklung und Förderung von Frauen in der IG Metall. 13.5.52, 4.

[136] SAPMO-BArch, DY34/A3744. Bericht über die Wahl von Frauen in BGL im Fernmeldewerk HF-Oberschön. am 4.7.52.

much authority they exercised after the "active" dashed off to improve democracy elsewhere.

In many big factories with large female workforces, the BGL included no or one woman.[137] An "overwhelmingly male" BGL was often blatantly unsympathetic to women's situation. Confronted with evidence of wage discrimination against skilled women workers in the Zeiss optics factory (forty percent female), a member of the BGL retorted that he and his colleagues had "more important problems to solve than dealing with women." In such cases, female shop stewards spoke only reluctantly in public arenas about BGL neglect of women, for fear of "catching it" back at work.[138] Women functionaries were also less likely than men to be released to do full-time union work. IG Metall's "district secretaries," who oversaw the BGLs, were virtually all male. Complaints about factory *SED* secretaries were almost as common as ones against BGLs. The BGL and BPO, as one woman put it, were such back-scratching "good old boys" (*verschwägert*) that the concerns of women workers simply never came up.[139]

The recalcitrance of BGLs and BPOs to implement official policy is interesting, because they represented the regime and its goals. The collaborative misogyny of brigadiers and foremen is notable for another reason. The production brigades, as we have seen, slipped out of the control of the FDGB and often turned against foremen on the shop floor. The SED intervened to shore up the foremen's authority, but tensions between brigadiers and foremen undulated throughout the 1950s.[140] Nonetheless, brigadiers and foremen mounted joint resistance to women's qualification and their integration into brigades. In a cement works, "several brigadiers tried to exclude women from the brigades because they apparently don't produce enough. . . . They kicked out a woman who spoke out for women."[141] In the Zeiss optics factory, several foremen refused to hire

[137] See, e.g., LAM, IV/L2/2/10, Bl. 5–6, Protokoll . . . Frauenausschuss am 1.7.52 (Halle); SAPMO-BArch, DY34/A3744. Bericht . . . Förderung von Frauen in der IG Metall, 13.5.52; DY34/A2080. Bericht . . . Frauenarbeit im Bezirk Cottbus (n.d.—Okt. 1958).

[138] First quote: SAPMO-BArch, DY30/IV2/17/7, Bl. 101–4, Protokoll der Sitzung mit den Abteilungsleiterinnen der Frauenabteilungen aus den Landesleitungen vom 8.12.50. Second quote: DY30/IV2/17/35, Bl. 1, Bericht . . . aus d. Produktion . . . 7.12.56, Berlin VEB Wälzlager Ritterstr. Also see DY30/IV2/17/87, Bl. 299–302, Erna Lierse, Die Lage der Frauen in den Braunkohle und Eisengiessereibetrieben . . . Kreis Merseburg, 30.6.51.

[139] SAPMO-BArch, DY46/11/310/1890. Frauenabteilung. Bericht über die Förderung . . . der Frauen im VEB Zeiss-Jena..11.10.55: 9. Also see DY30/IV2/17/57, Bl. 26, 48–50, Bericht über die Kreiskonferenzen . . . im Bezirk Erfurt 1.12.53 bis 12.1.54. For public criticism of a BPO, see "Wo den Frauenausschüssen die Hilfe der Partei fehlt," Fvh, Nr. 13, 27.3.53.

[140] Roesler, "Produktionsbrigaden," 155.

[141] SAPMO-BArch, DY30/IV2/17/41, Bl. 40, Frauenkonferenz"Schwarze Pumpe" am 28/29.6.58.

women in their departments because, as one foreman said, "With no skills, they don't contribute to the brigades." In some cases, foreman and brigadier directly helped each other, as when a foreman refused to allow qualified women to act as brigadiers in the Oil Synthesis Works Schwarzheide. They could function only as "assistant brigadier" to a man. Many brigades had no women members. Most common was a ratio of one or two women among eight or nine men. "Disparaging remarks" often caused the women to drop out.[142]

Certainly, in every industry there were women-friendly trade unionists, party leaders, brigadiers, and foremen, and, more often, men who learned from experience to value women workers. The daily press abounded with just such stories. Not all of these tales can have been fabricated. In fact, archival files contain examples.[143] Still, official discourse of the early 1950s virtually never portrayed a woman as the boss or foreman, even as they depicted many women at work, including, indeed, emphasizing, heavy labor.[144] Even the most gifted GDR novelists could not quite fashion a story in which men and women were real comrades on the shop floor. Erik Neutsch's *Spur der Steine* portrays conflicting loyalties that bound brigade members together, while dividing them from the SED and management at an industrial construction site. A central character is a woman engineer, Käthe, loved by the SED secretary and the apolitical brigadier. Their destructive rivalry at work and over her provides the narrative engine of the sprawling, 900-page tome. Käthe is educated, competent, and dedicated, a paean to the New Socialist Woman. She is not, however, a Worker and needs the protection of the hypermasculine, retrograde, honorable brigadier. In Christa Wolf's tightly constructed *Der geteilte Himmel*, the protagonist Rita works (temporarily) building train cars in Halle. Even as a clumsy novice, she is never mistreated by the men who initiate her into their brigade. She becomes an able worker, yet her respectful, adoring colleagues define her less by what she does than who she is.[145]

In life, women's integration into production threatened many men. Socialism did not instantly undermine the attraction of the breadwinner/housewife ideal, even as jobs proliferated and labor grew scarce. In June

[142] Port, "Conflict," 400; SAPMO-BArch, DY46/11/310/1890. Frauenabteilung. Bericht über die Förderung . . . im VEB Zeiss-Jena . . . 11.10.55; DY34/A2080. Bericht . . . Cottbus (n.d.—Okt. 1958), 3. Also see DY46/11/2400/4476. Bericht über die Förderung der Frau im . . . Maschinenbau [1953].

[143] See, e.g., SAPMO-BArch, DY46/11/310/1890. Frauenabteilung. Bericht über den Einsatz im VEB Kondensatorenwerk Gera.

[144] Merkel, *Und Du*, 80–96, 97; "Sie machten ihrem Herz Luft, in Eisenhüttenkombinat Ost," Fvh, Nr.2, 9.1.53; Scheel, 68.

[145] Merkel notes a similar asymmetry of representation in the pages of *Neue Berliner Illustrierte*.

1953, Leuna workers condemned "double earners," that is, employed wives who had employed husbands.[146] Leuna workers "worr[ied] that [male workers] will be pushed from their position" into a more onerous job or, worse, transferred into hard labor in a different factory or even locale. Assigning women to "lighter" tasks, men charged, violated the equality women demanded.[147] Others believed the mobilization of female labor was crisis driven, a temporary solution to the problems of a transitional economy. This assumption, long dormant, resurfaced, one report noted, as "prosperity increase[d]." In 1959, "many leading functionaries in chemical concerns think . . . women will leave production when socialist reconstruction is complete." According to Jörg Roesler, this view circulated even high in the SED leadership.[148]

Men repackaged in Stalinist wrapping traditional beliefs about women's lesser capabilities. They complained about women's low productivity and inability or unwillingness to work hard. In a construction firm in Weimar, they claimed, "Women make it harder for men to fulfill the norms, women gobble up the percentages, men have to tow the women along."[149] Higher wage steps should be reserved for men, argued foremen in Leuna's pressurization department, because they were more valuable to the factory.[150] Speaking to a women's conference, a party secretary and factory director, both men, explained that few women could become foremen because they were unwilling to undergo the theoretical training.[151] Men claimed that women suffered from inferiority complexes that held them back from training and responsible positions.[152] They did not speculate about the origins of this irrational lack of confidence.

In fact, women's "work discipline" varied. According to a report on the Buna plant, married women performed poorly, but single women without

[146] SAPMO-BArch, DY30/IV2/17/7, Bl. 86 , . . Bericht über die Arbeitskraftslenkung in Sachsen, 5.5.50); Zachmann, "Frauen," 133.

[147] LAM. Leuna Werke, A1170, Gerda Mund, "Wie wird der Frauenausschuss unterstützt?", 26.1.53, 2 ; SAPMO-BArch, DY30/IV2/17/57, Bl. 5–6, Bericht . . . Bezirk Erfurt 1.12.53 biz 12.1.54. Also see Port, "Conflict," 219.

[148] First quote: SAPMO-BArch, DY34/39/140/6011. Beratung mit den Fraueninstrukteurinnen am 24.8.60, 3. Second quote: LAM, IV2/5/1441, [1959], Beispiele für das Referat der Frauenkonferenz . . . 2. See Roesler, "Industry," 110.

[149] SAPMO-BArch, DY30/IV2/17/57, Bl. 2 , Bericht . . . Bez. Erfurt 1.12.53 biz 12.1.54. Also see DY30/IV2/17/7. Bl. 86, Bericht über Arbeitskraftslenkung in Sachsen, 5.5.50.

[150] LAM. SED Bezirksleitung/SA IV2/3/519, Bl. 192 Beschluss . . . über . . . Frauen in den chemischen Grossbetrieben . . . Halle, 11.3.59.

[151] SAPMO-BArch, DY30/IV2/17/57, Bl. 2, Bericht . . . Bezirk Erfurt 1.12.53 bis 12.1.54.

[152] SAPMO-BArch, DY31/A2080. Bericht . . . Bezirk Cottbus (n.d.—Okt. 1958), 4; DY30/IV2/17/6, Bl. 59–63, Bericht . . . VEB Werk für Bauelemente der Nachrichtentechnik Teltow, 4.12.61; DY30/IV2/17/41, Frauenkonferenz . . . "Schwarze Pumpe" am 28.–29.6.58.

dependent children worked well, and young female apprentices showed more discipline than their male counterparts. SED functionaries acknowledged that women were often dedicated workers, yet that characteristic could make them suspect. According to some reports, the women most eager to qualify for skilled labor were those least interested in joining the party.[153] These women, local functionaries argued, must change their ways if they wanted to train. Anecdotes and statistical samples both indicate that women who joined the SED or a Block party were more likely to advance at work or be delegated for a qualification program. The higher echelons of the SED, including Communist women, agreed that woman's liberation should be tied to correct political commitment.[154]

Nevertheless, the "unsatisfactory" progress of women unsettled the hierarchy. SED women officials witnessed the disadvantaged situation of women workers on the shop floor.[155] Regaining some of the confidence they lost in the frightening atmosphere of 1948–49, leaders of SED Women's Departments charged BPOs and BGLs with "neglect of women" and referred wistfully to the DFD factory groups. In 1952 and 1953, disgust with trade union functionaries grew voluble, focusing in particular on their failure to use funds available to them to improve social services and, especially, build kindergartens.[156] Leaders of the FDGB knew that women workers distrusted male union officials. Female union functionaries themselves wrote scathing reports about the BGLs. The FDGB flailed between complacent integrationism and sheepish separatism in trying to address its woman problem. In 1952, the FDGB recreated a central women's department and "recommended" that each industrial union do the same, a suggestion many ignored.[157] In 1956, the FDGB published an impressive program for the "improvement and alleviation of the lives of working women and girls." Workers in many factories never heard of this program; entire unions, such as Printing/Paper and Post/Communications,

[153] On the Buna situation, see VEB Buna, Rep. II-12/954, Die Frau im VEB Buna, 1954. On the association between hard work and "bad" politics, see SAPMO-BArch, DY30/IV2/17/53, Bl. 349, KrVS Rudolstadt, an LVS SED Thür., 27.8.49; Bl. 348, Frauensekretariat an . . . W. Ulbricht, 8.9.48; DY30/IV2/17/51, Bl. 460, Bericht . . . über Agfa-SeidePremnitz; Bl. 542, 31.1.50, Bericht über die Protestaktion in den Bekleidungswerkstatten in Zehdenick.

[154] Zachmann, "Frauen," 132–33; Trappe, 191; IMC, Interview 046; Interview Frau MB; Interview Frau LT; Interview Frau RG.

[155] SAPMO-BArch, DY30/IV2/17/30, Bl. 210, MfA, Abt. Arbeitskräftelenkung, an all Landesregierungen, 30.5.52. "Good" counterexamples in: DY34/A2080.Bericht . . . Bezirk Cottbus (n.d.—Okt. 1958), S. 2; DY34/39/120/5865 Frauensekretariat, Bericht über . . . Fernmeldewesen. 3.3.58.

[156] SAPMO-BArch, DY30/IV2/17/7, Bl. 101–4, Protokoll . . . 8.12.50; Bl. 105–8, Selbmann, 19.10.50. Also see Külke, "Berufstätigkeit," 68.

[157] SAPMO-BArch, DY34/712, Abteilung Frauen, 20.6.62, Entwicklung der . . . Frauenarbeit seit 1945, 5–7.

disregarded it. In 1958, the FDGB *required* that women's commissions be formed in every industrial union at the central and district level. In 1959, each union was instructed to create a Woman's Secretariat. The commissions often existed "only on paper," and the Secretariats were ignored, so both were dismantled.[158] Over the decade, women's representation on union bodies declined relative to women's rising ratio among union members.[159]

Confronted with the rampant resistance to women's integration on the shop floor, the FDGB's inability to overcome it and resurgent pressure from SED women to circumvent the FDGB, the SED took two steps in 1952. It instituted the "women's promotion plan," requiring every concern to produce an annual blueprint for the qualification and promotion of women. To the chagrin of male workers, the plans appeared year after year, in neat pamphlets full of optimistic, correct phrases. Yet it is impossible to know if projections were met, for no plan referred to a previous one. The plans were vague, in part, because plant managers did not want to commit to shifting women to new occupations.[160] In backhanded recognition that this scheme was window-dressing, the SED also created a shop floor organization to represent women's interests and placed it directly under party control. It (re)created the workplace women's committee (BFA).

THE WORKPLACE WOMEN'S COMMITTEES

Modeled on the Soviet women's factory committee, the BFA first appeared on the industrial shop floor but was extended to offices, stores, and agricultural cooperatives. Like the DFD committees of the 1940s, it

[158] SAPMO-BArch, DY34/39/86/5568. Aussprache mit . . . Sekretärinnen für Frauenarbeit . . . am 16. u. 17.10.56; Frauensekretariat. 4.2.57; DY34/39/134/6009. Bericht über die Arbeitsbesprechung der Frauenkommission des Zentralvorstands der IG Chemie am 25.10.57; DY30/IV2/17/71 Bl. 165, Bericht über die Beratung mit der Fraueninstrukteurin . . . Wismut, 26.10.61; DY34/39/140/6011, Berichte/Einschätzungen. 24.10.60.

[159] In 1960, women accounted for forty-four percent of union members, thirty-eight percent of BGLs (1961), thirty-three percent of district executives (1961): SAPMO-BArch, DY30/IV2/611/42, Bl. 9, 5.1.62, Anteil Frauen.

[160] Zachmann, "Frauen," 132–33. For example: LAM A1052, Rechenschaftslegung, Frauenförderungsplan in Leuna, 23.2.54. For women's complaints about promotion plans in Leuna and Buna: ibid., Niederschrift über die Konferenz des Frauenförderungsplanes Leuna, 2.9.53, Bl. 239; VEB Buna, Rep. II-2/929, Abt. Lohn und Arbeit, Frauenfragen, an Abt. Leiter 26.10.54. For an FDGB/IG Metall report that remarks on the meaninglessness of the plans, see SAPMO-BArch, DY46/11/2400/4476. Frauenförderungspläne. "Einige kritische Bemerkungen über die Erarbeitung und den Inhalt der Frauenförderungspläne 1955."

had a dual mission: defend women's interests at work and convince women to get "involved in raising productivity and fulfillment of the plan."[161] Also like the DFD groups, the BFA bespoke pressure from leading SED women on the SED to limit the hegemony of the BPO and BGL over women workers.[162] The local (not factory) party secretary controlled the BFA, both to give it some clout and to keep it in check. Thus, each BFA relied not just on the energy of the women who ran it, but also on the goodwill of a (male) SED secretary. In big cities and in a number of industrial settings, the BFA caught on quickly. By 1955, 10,000 committees had 100,000 members (the BFA was not intended to be a mass organization). In 1961, East Berlin had 900 women's committees. About three-quarters of BFA members were politically unaffiliated.[163]

The BFA entered the ring ready to fight. It used its factory-wall newsletter to denounce male "arrogance and anxiety about losing their positions" and lampoon managers for caring only about revenues. This aggressiveness, Annegret Schüle argues, corresponded to the "militant tone" that rang out from protocols of women's factory meetings in the early 1950s.[164] Some activists used the BFA to press for equal wages and qualification. Private talks with the BFA emboldened timid women to expose wage or job discrimination.[165] The militant committee was not the norm, however. In some firms, the women's committee began as, and remained, a top-down affair, with a chairwoman appointed by the local SED leader.[166] Prodded into life from above, many committees led a shadow existence. Sometimes no one could be convinced to form one, especially out on the LPG.[167] BFAs appear to have had a rough time of it, even in gigantic concerns such as the chemical plants around Halle, situated as they were in the boondocks and with workforces that lived far and wide. Although women at the Leuna works certainly needed the BFA, SED

[161] Clemenz. Also see "Drei Jahre Frauenausschüsse," Fvh, Nr., 7.1.55. Quote from: LAM, A1172, Leuna Werke, Zentraler Frauenausschuss. Arbeitsplan 1.1.53.

[162] See, e.g,, SAPMO-BArch, DY30/IV2/17/65, Bl. 221, Bericht . . . VEB Chem. Werke Buna, 12.11.60.

[163] SAPMO-BArch, DY30/IV2/17/72, Bl. 10 Einschätzung . . . Frauenausschuss . . . Bezirk Berlin, 23.8.61.

[164] Schüle, "Industriearbeit," 102.

[165] See, e.g., SAPMO-BArch, DY46/11/310/1890. Bericht . . . Bezirk Potsdam.11.5.53; LAM, IV/L2/2/10, Bl. 1, 5–6, Protokoll . . . am 1.7.52 (Halle).

[166] See, e.g., LAM, IV2/3/63, Bl. 73. In LPGs, a visiting instructor often set up the women's committee, which then collapsed after she left: SAPMO-BArch, DY30/IV2/17/59, Bl. 4, . . . Bericht über die Zusammensetzung d. FA, Bez. Schwerin, 25.5.59.

[167] See, e.g., LAM, IV2/3/67, Sekretariatsvorlage, Abt. Frauen, 4.6.52, Bl. 52; SAPMO-BArch, DY30/IV2/5/273, Kreisleitung SED Rathenow an Bezleit SED, Potsdam, 22.10.53; DY30/IV2/17/65 SED Kreisleitung Bitterfeld an Halle SED 13.3.58. Also see "Wo den Frauenausschüssen die Hilfe der Partei fehlt," Fvh, Nr. 13, 27.3.53.

women found it difficult to organize an extensive, much less active, network of committees throughout its many buildings. They ascribed disinterest to the fact that the "women's committee doesn't handle important issues." By 1959, when Leuna employed 7,000 women, it did have BFAs, but most existed only formally. The more active ones, a report complained, were headed by nonparty women who "do better work than the comrades."[168]

Active committee members did not always advance the interests of workers. The doldrums of the BFA in Leuna become less mysterious after one discovers that management fired the leader of one of its only vigorous BFAs for "following the provocateurs and demonstrating" on 17 June 1953. A fellow BFA member informed on her.[169] In the months after the uprising, women's committees "expose[d] fascist provocateurs, as in the Torgau glass works where the committee led women in the struggle against . . . those who receive packages [from the West]" or "in the candy factory Markkleeberg where the women's committee called for the dismissal of a colleague who skipped work from 17 to 20 June."[170] In 1958, the BFA at the Wolfen film factory conducted so-called "maternal counseling" sessions. At these, mothers whose sons had joined the still-voluntary People's Army "advised" any mother whose son had not done so to prod him to rethink his decision. The district party secretary would note with pride if BFAs in his district had become "political," that is, constantly reminded workers of the need to increase productivity and join competitions.[171]

Clearly, BFA activities varied. Any number of BFAs focused on women's shop floor interests, using nonconfrontational methods. They joined cries to extend the housework day, led discussions on women's rights in the GDR and USSR, held seminars for men's "enlightenment," produced wall-papers, and organized the celebration of International Women's Day

[168] LAM, A1170, Leuna Werke, Wie wird der FA unterstützt?" 26.1.53, 2; LAM, IV2/5/1441, Einige Feststellen . . . Frauenausschüsse [1957], 3–4; SAPMO-BArch, DY30/IV2/17/65, Bl. 199–200, 25.2.59, Die Arbeit des Frauenausschusses in Leuna. On the "backwardness" of women's committees in the chemical industry, see DY30/IV2/17/41, Bl. 249, Arbeitsgruppe Frau, Einige Probleme . . . Chemieindustrie, 3.10.58. Other industries, too, had troubles: see DY30/IV2/17/69, Bl. 105, Bericht . . . Frauenkonferenz d. Partei in Meissen. 4.7.59.
[169] SAPMO-BArch, DY34/39/49/2610.
[170] LStA, IV/2/17/692 Direktive des Sekretariats der Bezirksleitung über die Arbeit des Frauenausschusses, 24.9.53.
[171] SAPMO-BArch, DY30/IV2/17/65 SED Kreisleitung Bitterfeld an Halle SED 13.3.58; SED Kreisleit. Aschersleben, 13.3.58. For the focus on productivity, see DY30/IV2/17/65, Bl. 224, Bericht . . . VEB Chem. Werke Buna, 12.11.60.

(some BFAs sprang to life in February, only to die again on 9 March).[172] Successful committees often functioned less like an interest group than a (geniune) counseling service. Each member met regularly with "her" women to discuss their "worries and needs."[173] BFAs also promoted culture and enlightenment. Its "dialectical materialism circles" were sadly undersubscribed. "Chiaroscuro in Rembrandt's Art" also fell flat, attracting only a handful of "administrative employees" (asked why she did not attend, a worker replied, "Rembrandt doesn't impress me. He's been dead for so long"). More successful were lectures on "coming to know and love our homeland [*Heimat*]" or on interior decoration. Talks about child-rearing methods and children's health were well attended. The absolute winners were fashion shows, which drew huge crowds.[174] The BFA represented women's need for factory social services: child care, laundry rooms, and sewing centers (where workers could make the designs they had seen modeled). The BFA also convinced women to donate their labor to organize a children's camp or to convert a factory room into a kindergarten.[175] Even the militant committee mellowed over time, evolving into a social club.

The BFA did not solve the problem of BGL/BPO indifference to women's issues, because the typical local party secretary was *equally* apathetic. In 1953, there were calls for the committees to be put under DFD. Complaints of neglect cropped up throughout the decade.[176] In the end, the BFA created a safe venue at which, to the sympathetic applause of fellow sufferers, women could air their frustrations with male workers, the FDGB, and SED factory secretaries. In 1953 began the tradition of an

[172] See, e.g., LAM, A1172, Leuna Werke, Zentraler FA, Arbeitsplan; LAM, 11/310/1890. Beschlussvorlage für Gebietsfrauenkommissionssitzung. 12.5.54.
[173] SAPMO-BArch, DY46/11/2400/4476. Bericht . . . LEW Hans Baimler Hennigsdorf . . . 19.11.53.
[174] SAPMO-BArch, DY30/IV2/17/65, Bl. 199–200, 25.2.59, Die Arbeit der FA in Leuna; DY30/IV2/17/69, Bl. 116–17 Bericht . . . VEB Kunstseidenwerk "Siegfried Rädel" im Kreis Pirna, 17.6.59.
[175] SAPMO-BArch, DY30/IV2/17/72, Abt. Organisation und Kader, Bl. 19–20 Einschätzung . . . Bezirk Berlin, 23.8.61; DY46/11/310/1890. Protokoll über die . . . Bezirksfrauenkommission der IG Metall (Erfurt) . . . 29.1.52; IV2/5/273, Kreisleitung SED Rathenow an Bezirksleitung SED, Pdam, 22.10.53; DY30/IV/2/17/1443. SED Quedlinburg an Bezirksleitung, 13.3.58.
[176] Külke, "Berufstätigkeit," 68; "Aktivistin Gudziol und der Frauenausschuss," Fvh, Nr. 26, 25.6.54; SAPMO-BArch, DY30/IV2/17/65, Bl. 189, 218 Bericht . . . VEB Chem. Werke Buna, 12.11.60; DY30/IV2/17/41, Bl. 19 Frauenkonferenz. . . . "Schwarze Pumpe" am 28/ 29.6.58; DY30/IV2/17/70, Bl. 129, Beratung mit zwei Mitarbeiterinnen d. FA d. Uni Leipzig am 27.8.59; DY30/IV2/17/69, Bl. 32, Zu einigen Fragen der Anleitung der Frauenausschüsse . . . im Bezirk Dresden 6.5.60; DY30/IV2/17/72, Abt. Organisation und Kader, Einschätzung der Statistik über den FA in Bezirk Berlin, 23.8.61, Bl. 21.

annual all-GDR Conference of Working Women, at which hundreds of delegates reported on life in the gendered workplace. Truly angry comments dot early transcripts of deliberations.[177] Over time, the "speakouts" became formulaic, declamatory, and self-congratulatory. Ritual triumphed over substance at these rallies, just as convention routed confrontation in the everyday work of the BFA.

The Self-Perception of Women Workers

In 1955, the SED, FDGB, and Free German Youth sent a team of investigators into a large textile mill, Novatex, with a very young workforce (sixty-five percent of workers were aged fourteen to twenty-one) that was drawn, by and large, from poor proletarian or rural backgrounds. The aim of the intervention was to figure out why young women were not getting "qualified" and, instead, often quit when they turned 19 or so. Inspectors discovered that young women were not interested in learning a trade. The youngest workers just wanted "to have fun," especially dancing, a craze they shared with other East German youths. Slightly older colleagues said they spent their free time preparing for marriage; they hoped to give up employment as soon as they tied the knot. This group was interested in learning all sorts of things: "cooking, baking, sewing, infant care, childrearing, women's illnesses, the [GDR's] new family laws, interior decoration, fashion and cosmetics"—everything, that is, a successful wife and mother needed to know, but nothing that would forge a committed worker.[178]

Six years later, women's situation at Novatex had improved. Female textile workers could now afford "stiletto heels and petticoats"—and wore them to work. Alongside disconcerting fashion trends, the SED saw some evidence of an improved work ethic in textile mills. They now employed a modest number of young women engineers who were often "more socially [i.e., politically] active than the young male intelligentsia."[179] Gratifyingly, three-quarters of Novatex workers joined the "so-

[177] SAPMO-BArch, DY30/IV2/17/57, Bl. 149 Bericht . . . im Bezirk Erfurt 1.12.53 bis 12.1.54. Also see "Sie machten ihrem Herz Luft, in Eisenhüttenkombinat Ost," Fvh, Nr. 2, 9.1.53.

[178] SAPMO-BArch, DY30/IV/2/17/37, Bl.10, Bericht über die Arbeit der FDJ unter den Mädchen und jungen Frauen im Kreis Greiz, 3.9.55. Also see DY46/11/2400/4476. Bericht . . . LEW Hans Baimler Hennigsdorf . . . 19.11.53. The tendency for women to quit upon marriage was also observed among rural workers. See DY30/IV2/17/18, Bl. 200–201, Protokoll Nr. 99 IV d. DFD am 8.6.54. Anlage 1, Arbeit auf dem Lande.

[179] Interviews conducted after 1990 suggest that women of the intelligentsia were committed to their professions from early on: Interview Frau MB; Tobin and Gibson.

cialist production brigades" created in 1958 and competed for the "title" (the best team entered into regional and, finally, national competition). Yet a follow-up investigation found the attitude of production workers toward their jobs had not fundamentally changed. In part *because* of higher wages, mill workers remained uninterested in qualification. In 1961, only twenty-four percent of female textile workers in the GDR had a skilled worker's diploma. Turnover rates in most mills remained extremely high. "The role of work [in their lives] is unclear, especially among young girls," an instructor reported after a discussion with brigade members in a cotton spinning plant. "They say: we want to put something away, so we don't go naked into marriage. . . . [O]nce we're married, we'll see if we want to continue working."[180]

SED instructors were troubled that working-class girls who had grown up entirely in the SBZ/GDR manifested a "bourgeois" understanding of the place of work in a woman's life. They blamed such false consciousness on several sources. They pointed to Western mores propagated by RIAS or seen in West Berlin. They cited the opposition of proletarian parents to their daughters getting trained.[181] Such hostility was certainly not universal. Daughters of widowed and single women remember their mothers telling sons and daughters to learn a trade or profession.[182] On the other hand, such opposition was not confined to parents. Boyfriends and husbands, too, were known to dampen the ambitions of the woman they loved.[183] According to one report, "embittered" and "bourgeois-influenced" older, single women often advised their young colleagues, "Girl, don't be dumb. Get a husband who earns a lot, don't spend your life working. I'd be happy if I didn't have to."[184] It is unclear whether instructors actually heard such remarks or imagined them. It could well be that the presence of so many older, involuntarily single, overworked women

[180] SAPMO-BArch, DY30/IV/2/17/37, Bl. 104–11, 5.5.61, Einschätzung . . . der Lage der jungen Arbeiterinnen in der Textilindustrie; DY30/IV2/17/70, Bl. 99, Bericht . . . Leipziger Baumwollespinnerei vom 28.11–2.12.61. Also see DY30/IV2/17/61, Bl. 59–63, Bericht über die Aussprachen im VEB Werk für Bauelemente der Nachrichtentechnik Teltow, 4.12.61; I DY30/V2/17/36, Bl. 30–34, Analyse zu Problemen der Qualifizierung und Förderung der Frauen im . . . VVB Chemifaser und Fotochemie, Wolfen, 27.4.61, S.4.

[181] SAPMO-BArch, DY34/39/84/5567. Zentralrat der FDJ, 1955. Instrukteurbericht über die Arbeit der FDJ unter den Mädchen und jungen Frauen in Kreis Greiz, S.3; DY46/11/2400/4476, Instrukteurbrigade der Neptunwerft Rostock. 27.1.53; LAM, IV2/5/1441, Beispiele für das Referat der Frauenkonferenze[1959], S. 4. Also see the testimony of Klara L., re: Glühlampwerk in Berlin (Herzberg, 256–66); IMC, Interview 3, Frau GK.

[182] Examples of mothers who encouraged their daughters to get qualified: Interview Frau AR; Interview Frau RB; Interview Frau UN.

[183] SAPMO-BArch, DY30/IV/2/17/37, Bl. 10, Bericht . . . Kreis Greiz, 3.9.55.

[184] SAPMO, IV/2/17/37, Bl. 104–11, 5.5.61, Einschätzung . . . der Lage der jungen Arbeiterinnen in der Textilindustrie.

in factories enhanced the value of a housewife-marriage in the eyes of young women.

Most wives eventually returned to work at Novatex, as was the trend in the GDR in general. When they did, they took their jobs more seriously than they had as teenagers. Not only stage of life, but social change shaped their understanding of work. Whereas women had earlier claimed, "Women only work because they have to," by 1960 they cited the scarcity of labor as a motivation. As one woman exclaimed, "What am I supposed to do at home? Workers are needed, so I work."[185] They now referred to their "wishes for the household," rather than "having" to work. Returning women expressed surprise over how much "fun" it was to work and have a social community after several years of hanging out with infants and toddlers.[186] Wage increases surely fostered this attitude. Constant propaganda about the value of work for women also had an effect. Asked why they worked, women answered in the positive language of the GDR press, just as earlier they had denigrated women's wage labor in the negative phrases of conventional discourse.

Equally important were changes in the culture of work for women. The shortage of labor placed considerable pressure on each worker to produce, but it also changed the psychology of that pressure. Up and down the line of hierarchy, workers were given more responsibility than before. The "socialist production brigades" allowed the brigadier and members greater independence and used modest positive incentives to forge team spirit. These modifications affected all workers, of course, but were more profound for women because the socialist brigades engaged them much more than had the brigades of the early 1950s. Few reports on women workers in the early to mid-1950s highlight their role in a brigade, except to mention discrimination by a male brigadier in a mixed brigade or to portray an all-woman brigade as a regimented work detail. In contrast, investigations of 1961 refer often to "discussions with women in the brigade" and quote respectfully the opinions of *female* brigadiers. Women's role depended on the industry. Of 105 socialist production brigades in the Buna chemical plant in 1958, only three had a woman brigadier.

[185] First quote: SAPMO-BArch, DY34, Frauenabt. Betriebsbesuch in Glasshütte Carlsfeld Kreis Aue (Privatbetrieb) 11.7.52. Second quote: DY30/IV2/17/70, Bl. 99, Bericht . . . Leipziger Baumwollespinnerei, 28.11– 2.12.61.

[186] What follows is based on: SAPMO-BArch, DY30/IV2/17/61, Bl. 59–63, Bericht . . . VEB Werk fur Bauelemente der Nachrichtentechnik Teltow, 4.12.61: DY30/IV2/17/61, Bl. 55–58, Bericht über die Gespräche im VEB Geräte u. Reglerwerk "Carl v. Ossietzky" in Teltow am 29. u. 30 November 1961; DY30/IV2/17/36, Bl. 30–34, Analyse zu Problemen der Qualifizierung . . . im . . . VVB Chemifaser u. Fotochemie, Wolfen, 27.4.61, 4.

The socialist brigades seem to have made a bigger difference in women's relationship to wage labor than did the BFA. The brigade decided cooperatively when to "compete" against other brigades, then worked as a team to meet the goals it had set. The brigadier kept a workbook in which she recorded brigade activities, her observations, and her beliefs about work. The women's brigades should not be overinterpreted: brigade books mentioned parties more than the Party.[187] Nonetheless, in interviews with inspectors in 1959 and 1960, women talked proudly and, apparently, spontaneously about their work "collective." Years later, a female party secretary in a Chemnitz cotton mill recalled,

> . . . what perhaps can't be found in the brigade book is the personal contact. They were together for years in the brigade . . . where they talked things over, now providing support, now courage. . . . Working under the conditions of a spinning mill: very noisy, very dusty, very hot, and personal problems on top of that, that all had to be dealt with. And then the yarn, that never reels out the same way twice. Sometimes you were so sick of it, you could have shot the next person you saw. To get through all that together, that was the real, immediate life of the brigade, that is what made a big difference.[188]

In scattered instances, women's brigades also acted cooperatively to protest a grievance, such as skimpy competition premiums.[189]

The revised brigade system awakened not just a sense of collective purpose, but also hope for individual achievement, a combination that is surely essential to an internalized ethic of waged work. Asked about her aspirations, a worker responded, "I'd really like to become leader of a brigade that's being newly formed. Where things aren't easy, but you see that progress is being made." The movement inspired her, yet she was careful to hedge her bets: "But who knows if that will happen? [Women] still run into lots of resistance." In fact, gender identification was intrinsic to the success of the new brigades. They helped to integrate women into the workforce, but not necessarily to enhance gender integration on the shop floor. All-women's brigades led by women brigadiers became common. Their prominence reflected gender segmentation in the workplace. It seems likely, too, that plant managers, the FDGB, and the SED accepted that women worked well in segregated brigades.

The brigade did not breach the reluctance among production workers to qualify. Women workers were happy to participate in on-the-job train-

[187] Schüle, "Die Spinne," 263. On the socialist brigades, see Port, "Conflict," 10, 378; Ross, 102.

[188] IMC, Interview 006.

[189] See, e.g., Port, "Conflict," 373.

ing but were generally impervious to pressure to get a proper "professional qualification," much less take on supervisory responsibility. To interviewers, some women acknowledged lack of interest in training, even as they also talked about how active they were in their brigade. At the Wolfen film chemical complex, some women pointed to the shortage of labor as an obstacle. "Extreme understaffing" so overtaxed them, they said, that they had no energy to study. Others used the scarcity of workers as a threat when plant supervisors pressed them to get training: "If you don't stop pestering us with your qualification nonsense (*Qualifiziererei*), we'll quit. We can get work anywhere." A woman director of "cadre development" explained to investigators that women production workers did not see employment as a "social necessity for their own development and for society."[190] Lack of intrinsic motivation was class related. In every society, the unskilled or semiskilled worker, male or female, is less likely to identify with work as a career. In addition, male opposition to women's qualification remained a constraint. In the interviews conducted in 1961, women argued that if they did qualify, the men would still "make me sweep." Foremen still insisted that women were "scared of responsibility." Women reported that men *and women* accused them of being "careerist" if they wanted to qualify.[191] Many women said they did not want a fore*woman*. They preferred the shop floor's conventional gender order.[192]

Finally, the interviews exposed the structural drags on women's qualification. Women reported that they were overwhelmed by housework, child care, and long commutes. A woman brigadier relayed her impression that women over the age of 30 were "more open to qualification" than younger workers. This idea is not surprising, for by 30 years of age the majority of East German women had school-aged children. In Heike Trappe's sample of women born between 1929 and 1931, women with no child or with one child in institutional care were twice as likely to "qualify" than mothers of several children who had to arrange private child care. The presence of a husband also dampened a woman's interest in qualification. One woman told an investigator, "When my husband comes home, I have to be there." Single women, in contrast, described the factory as "my life" and participated more than married women in work brigades and "societal activity" (trade union or political work).[193]

[190] SAPMO-BArch, DY30/IV2/17/70, Bl. 99, Bericht . . . Leipziger Baumwollespinnerei, 28.11–2.12.61.

[191] SAPMO-BArch, DY30/IV2/17/33, Bl. 47 Protokoll der Beratung mit den Frauenreferentinnen . . . des FDGB . . . , 5.10.56.

[192] Schüle, "Die Spinne," 188.

[193] Trappe, 188. On single women, see DY30/IV2/17/69, Bl. 111, 113, 116. Bericht . . . VEB Kunstseidenwerk "Siegfried Rädel" im Kr. Pirna, 17.6.59.

CONCLUSION

From 1945 to 1961, the East German proletariat was partially recon-
structed and significantly expanded. The working class changed in many
ways: loss of soldiers and civilians, immigration from Silesia and the Sude-
tenland, flight to the FRG, movement of agricultural laborers into the
industrial workforce, promotion of skilled workers into management,
and, last but not least, the influx of women. If turnover was great in the
working class as a whole, change was more dramatic among women
workers, many of whom were new to waged, and especially industrial,
work. The remaking of the working class shaped its response to the SED's
industrial regime. Old lines of solidarity ran dry or were smashed; new
ones could be only partially reconstituted. Trade union representation
was a sham. Nonetheless, new forms of shop floor negotiation emerged.
Alongside their other forms of resistance to SED labor policy, men collab-
oratively obstructed the integration of women into the production pro-
cess. Antagonism was composed of equal parts self-interest, cultural bias,
and gender identity. Many men felt viscerally that men must support their
families and, anyway, production was gendered male. Trade union preju-
dice against untrustworthy women lingered, even as trade union function-
aries moved into the semimanagement roles. A political culture that
looked suspiciously at apolitical women compounded the difficulties of
women production workers. The majority of women workers were inex-
perienced and marginalized within male-dominated brigades. They were
also divided internally. Women in priority industries or trades had it better
than those in light industry or food production. Every firm harbored ten-
sions between SED-organized and apolitical women, younger and older
women, immigrant and native women, and married and single women.
Despite these divisions, women workers resisted SED labor policy and
shop floor misogyny, both individually and collectively.

 Gender segmentation continued to dominate both the labor market as
a whole and the industrial labor market within it. Women's wages and
the level of their training remained dismally low, both absolutely and rela-
tive to men's. The railroad, for example, employed 70,000 women in
1960, of whom a mere 500 possessed a skilled worker's diploma. In 1961
and 1962, only 1.48 percent of women in the automobile industry had
any sort of formal training or education, although they accounted for
twenty-five percent of its workforce. In contrast, 42.7 percent of the auto-
mobile industry's male worker-employees had a diploma or degree. A
report compiled for the FDGB showed declining numbers of female ap-
prentices in every economic branch except health and "research."[194] Also

[194] Ulbricht, et al., 35; SAPMO-BArch, DY34/9/125/6005. Abteilung Qualifizierung/Be-
rufsausbildung. 13.5.60.

notable is the high percentage of housewives who resisted taking any job. "The reserves are there but the women don't want to work," grumbled Ministry of Labor officials. Only "special measures," they contended, would draw wives into the labor market.[195] In 1958, as the economy's demand for, especially, skilled workers cranked up, the SED found itself at an impasse—and began to look at women with new attention.[196] Women functionaries in the SED expressed dismay that "the labor shortage governs the mobilization of women."[197] The labor shortage was, however, so acute and economically crippling that it began to reshape the terms of "women's policy."[198] It directed serious attention to women's qualification. It led to sustained interest in housewives. These issues, in turn, caused the SED to begin to pay attention to the household and the family.

[195] SAPMO-BArch, DY30/IV2/2.042/20 Bl. 168, MfA, Stellungnahme zur Halbtags-und-Teiltagsarbeit, 18.2.58.
[196] Obertreis, 141.
[197] Quote from LStA, IV/2/17/692 Frauenarbeit Mai 1960.
[198] Bouvier, 257.

Restoring Fertility

REPRODUCTION UNDER THE WINGS OF MOTHER STATE

WHEN THE SED LOOKED AT WOMEN in the early 1950s, they saw (potential) workers. This perception, feminist scholars have argued, proves that production, not reproduction, was the foundation of women's policy in the 1950s. Contrasting Ulbricht's paltry maternalist measures to the lavish expenditures of Honecker, they conclude that pronatalism emerged only after 1970.[1] Certainly, labor mobilization was the preeminent government policy aimed at women. "The promotion of women's work" was named as a central task of even the Department of Mother and Child (subordinated in 1949 to the Ministry of *Labor* and moved later to the new Ministry of Health). The Law for the Protection of Mother and Child and the Rights of Women (1950) described maternal benefits as tools in the battle to increase women's participation in the labor force.[2] Yet, the very name "Mother and Child" suggests that the agency most directly involved with women also saw a (prospective) mother when it looked at women. In fact, reproduction ran a close second to production in policy toward women in the 1950s. Eager to rebuild a population base devastated by war, the state did not place great pressure on wives to work for wages. Pronatalism, thus, contributed to the state's relative lack of success in drawing married mothers into employment.

It is easy to overlook the strong interest in fertility, because official representations of women did not highlight reproduction as insistently as they did production. In contrast to women's productive labor, natalism continued earlier German state traditions and dovetailed with dominant cultural assumptions about women's proper role. The message about maternity did not have to undo twelve years of Nazi propaganda. It did not have to overcome church teachings. Reproduction was natural to women. Production had to be made so. Nonetheless, the illustrated press clearly

[1] Trappe, 38, note 5; Koch and Knöbel, 94–95.

[2] BArch, DQ1/4700, Land Thüringen, Jahresbericht 1950 der Hauptabteilung Gesundheitswesen beim Ministerpräsidenten, 121–34. Also see DQ1/5331, Steidl, MfG, an d. Bundessekretariat des FDGB, 25.5.50; Obertreis, 33, 57–58; Külke, "Berufstätigkeit," 60–61; Roesler, "Industry."

communicated the state's interest in fertility *and* women's employment.
It was full of photos of healthy newborns cradled by well-outfitted nurses
in lovely nurseries, happy children in the crèche, kindergarten, or moth-
er's arms, stories about the joys of combining three, four, or five children
with wage labor.

In the mid-1950s, propaganda for higher fertility became more explicit
as concern rose that employed women's natural urge might not be as
strong as the state wished.[3] The GDR's first (and for many years, only)
advice book for married couples appeared in 1957. In *The New Marriage
Book*, "the well-known social hygienist" Dr. Rudolf Neubert wrote,
"children are the root, the happiness, the most beautiful fulfillment of
every healthy marriage." A childless marriage can be "good," he con-
ceded, though he could not resist a slap at "the childless couple with a
dog" as "the nadir of the false development of human narcissism." In
The Question of Sex. A Book for Young People (1956), Neubert warned
that the "one-child marriage" rests on the "total self-deception" that it
is best to give one's child more than one had. "Even two children can be
worry children (*Sorgenkinder*)," he regretted to inform. He concluded,
"Life only becomes full with three children. With four to six children it
becomes really varied, cheerful, complete. Today, it is best to have three
to six children."[4] The state did not stop at propaganda for more children
but also implemented natalist policies. In their efforts to increase the
population, as in their drive to raise productivity, Ulbricht and the Polit-
buro relied heavily on raising the quantity of children through, on the
one hand, basic improvements in nutrition, control of infectious dis-
eases, and maternal and infantile health and, on the other, restriction of
birth control.

WOMEN AND REPRODUCTIVE SERVICES

The Mother/Child Law (1950) guaranteed pregnant workers or employ-
ees a paid five-week leave before delivery and six weeks afterward (which
was increased to eleven weeks after in 1956). The state paid for all deliver-
ies, whether at home or in the clinic. Every mother was given 50 DM to
buy diapers and other items for each new child. To encourage a "big
family," a woman received an additional one-time payment of 100 DM
for her third, 250 DM for her fourth, and 500 DM for her fifth child. If
employed, a woman received an extra 50 DM at the birth of each of

[3] Timm, "*Bevölkerungspolitik*," 207.
[4] Neubert, *Ehebuch*, 270–71; Neubert, *Geschlechterfrage*, 104. Neubert's *Ehebuch* went
through 21 editions by 1976.

TABLE 4.1
Fertility Rate in the SBZ/GDR, Selected Years,
1947–1971
(Births per 1000 women, 15–45 years old)

Year	SBZ/GDR
1947	55.7
—	—
1950	75.0
1955	77.0
1960	85.3
1961	89.2
1962	89.7
1963	90.0
1964	88.7
1965	85.2
1966	81.5
1967	76.9
1968	74.3
1969	71.9
1970	70.8
1971	69.7

Source: Storbeck, *Strukturen*, 263; StJb (1973), 36.

her first two children, as well. Each mother received a modest monthly allowance (20/25 DM) for a fourth, fifth, etc., child. Single mothers received all the same benefits. Oddly, a pregnant woman who lived in a "wild marriage" (common-law marriage) was delivered at state expense but received neither the one-time nor the monthly child allowance. Better alone than wild, it seems. Adoptive and foster mothers were also ineligible for child allowances, presumably because they had not brought a *new* child into the world.[5] A jump in child allowances took place in 1958, in the same year that the state tried to increase the employment rate of married women by eliminating ration cards and increasing the wages of unskilled workers. Every mother now received 500 DM at the birth of each of her first two children, 700 DM at the birth of the third, 850 DM for the fourth, and 1,000 for the fifth. For every child, a family now received at least 20 DM a month and from 40 to 45 DM for children beyond number three.[6]

Whether owing to these measures or not, the birth rate increased. By 1949, the fertility rate was recovering from its mid-forties plunge. It rose

[5] Leutwein, 50, 93.
[6] Gunnar Winkler, *Sozialpolitik*, Tabelle 5.13, 384.

TABLE 4.2
Average Age of Mother at Birth of

	1st child	2nd child	3rd child
1955	22.8	26.3	28.7
1960	22.2	25.6	28.1
1965	22.7	25.6	27.9
1970	21.9	25.8	28.6

Source: Dagmar Meyer, 35.

until 1951, before it leveled off for the remainder of the 1950s at a rate the regime found acceptable.

Despite having a lower standard of living and a higher rate of employment than women in West Germany, East German women had an equal or higher fertility rate throughout the 1950s. Child allowances probably induced women to bear children at a younger age rather than causing them to produce more babies (Tables 4.2 and 4.3). Almost seventy percent of first marriages produced a child within the first year. And a very high percentage of East German women bore at least one child. Ninety percent of the married women surveyed by Heike Trappe gave birth to at least one child, 65.6 percent percent to at least two.[7]

Given that virtually every young woman gave birth, a huge swath of the female population came into contact with public reproductive services in the 1950s as the state extended the existing network of medical clinics to improve prenatal care, the safety of delivery, and postnatal medicine. It was the job of the Department of Mother and Child, headed by Käthe Kern, to pull pregnant women into this net. As early as 1951, according to the Ministry of Health, the pregnancy counseling system encompassed 67.5 percent of (known) pregnant women; in 1958, it claimed to have examined 100 percent of pregnant women at least once and to have seen 52 percent of them three times before delivery.[8] These impressive figures convey, of course, nothing about the quality of care. In urban areas, clinics were often well staffed, with "a social worker, nurse, woman physician, male physician, and mid-wife," yet these five professionals examined twenty-five to thirty women an hour in very cramped spaces. Patients complained about the abrupt, unfriendly tone and unpleasantness of consultations.[9] Outside the cities, the situation was worse. At the beginning of 1952, many centers did "not correspond to the most minimal stan-

[7] Wagner, 186–87; Trappe, 103.
[8] BArch, DQ1/5331, 29.5.57, Betr: Bericht zum Ministerialratsbeschluss von 8.7.54.
[9] BArch, DQ1/4726, Schulze (Hauptabeilung MuK) an die DDR, MfG, 28.11.51.

TABLE 4.3
Births/Deaths per 1000 Population

	Births	Deaths
1950	16.5	11.9
1955	16.3	11.9
1960	17.0	13.6
1965	16.5	13.5
1970	13.9	14.1

Source: StJb (1973), 35.

dards."[10] In small towns, centers held office hours only once a week or, in rural areas, monthly, so that many women "do not use the services."[11] Not just the paucity of office hours discouraged visits to a clinic. Health officials regretted that many women did not understand "the meaning and importance of pregnancy counseling."[12] In other words, a lot of them did not keep or even make an appointment.

The state offered incentives to overcome women's immunity to its message. It provided pregnant women with special vouchers that entitled them to double the basic rations of milk, bread, and fats. They were also allotted extra "points" on their textile ration certificates. Only at a pregnancy counseling center could a pregnant woman pick up a monthly surplus rations card and have it validated. Cards were distributed to clinics right before the next month began. The clinics were virtually empty for three and half weeks, but a "stream of women" flowed through their doors during the first two to three days of each month. This crush "greatly harms the work of our pregnancy counseling." Pregnant women stood in line for hours, only to get a cursory exam, followed by another wait to get the ration card stamped.[13] A report noted, "Mothers prefer to relinquish the urgently needed supplementary rations than go through the monthly examination."[14] In 1948, the Women's League complained to a health official about this policy.[15] The new state, however, continued to

[10] BArch,DQ1/4726, Auszüge aus dem Brandenburg. Jahresbericht 1951, Berlin, den 21.1.52.

[11] Ibid., Aus den Bericht der Zent. Kontrollkomm, Abschrift: Mütter- u. Saüglingsberatungsstellen (Entbindungsheime) (n.d.).

[12] Ibid., Adamzik an MfG, 26.10.52; 2512, Richtlinien . . . Schwangerschaftsberatungsstellen, 7.9.53.

[13] BArch, DQ1/4616, Halbjahresbericht der SBS, 7.9.54; Dr. Neumann an Dr. Otto Konke, Zeitz Bezirk Halle, 18.12.53.

[14] BArch, DQ1/4726, Aus den Bericht . . . (Entbindungsheime).

[15] BArch, DQ1/1686, Bl. 282, Dr. Neumann an deutsche Wirtschaftskommission, 12.1948.

hitch rations to consultations. In 1952, in response to an article in *Berliner Zeitung*, the Ministry of Trade, which issued the cards, suggested a cut in the required number of visits, only to be rebuffed by the Ministry of Health.[16] Popular resentment against the practice peaked in the crisis year of 1953. At a Leipzig clinic, women "often drastically express their disgust" by pushing and shoving in line.[17] In letters to the Ministry, husbands criticized the many exams endured by a pregnant wife who had to leave her other children at home alone to get a "very modest" amount of extra provisions. Physicians in private practice protested because they were not allowed to validate the ration cards, although women often turned first to "the doctor whom they trust."[18] An official report acknowledged that many women still visited "private physicians" who were not, however, supplied with cards, because the establishment of a state monopoly over health care was as much at stake as women's health.[19] State-employed physicians who operated factory clinics charged the Department of Mother and Child with bureaucratic bungling, because it insisted that pregnant workers be examined at municipal, not factory, clinics.[20] Physicians in the Ministry of Health defended the system as necessary for effective prenatal care.[21] Indeed, they worried about "how [we will] get pregnant women to come in when [the end of rationing means] they no longer need the surplus rations cards."[22]

Health officials not only monitored pregnancies but, aided by the DFD, taught employed pregnant women their rights on the job, the terms of maternity leave, and the kinds of heavy tasks or dangerous materials they must avoid. In general, they reported, "industry" met these legal stipulations, while "agricultural concerns" ignored them.[23] Most pregnant women took advantage of paid leave. Every year, several thousand work-

[16] Ibid., Dr.Bertschy . . . Landesregierung Meckl., MfG, an das MfG, DDR, 19.12.50; Dr. Neumann, Zusatzkarten für werdende u. stillende Mütter, 22.12.51; Zu diesem Schreiben . . . 1.2.52, an HA MuK, Herr Min. Steidle.

[17] BArch, DQ1/4616, Körner, MuK, 27.6.53.

[18] BArch, DQ1/4616, Dr. Grosse-Weischede, Abt. Ghw, an Dr. Med. Anno Dittmer, den 10.1.53: Dittmer an G-W, 24.1.53.

[19] BArch, DQ1/4726, Auszüge aus dem Brand. Jahresbericht 1951, 21.1.52.

[20] Quotes from: BArch, DQ1/4616, S. Hoppe an Frau Dr. Damaschun, 25.8.53. Also see DQ1/4616, Dr. Otto Kionke, Zeitz, An den Ministerpräsident, 30.8.53; Dr. Pohlemann, Chefarzt of Betriebspoliklinik Chemische Werke Buna, an das MfG, 11.12.53.

[21] Quote from BArch, DQ1/4616, Dr. Müller . . . an die MfG, 17.12.53. Also see DQ1/4616, Dr. Damaschun, Kommunale Kreisärztin, Bez. Cottbus, an das MfG, HA MuK, 23.11.53; HA MuK an S. Hoppe, 12.11.53.

[22] BArch, DQ1/4616, Dr. Schmiedel, Kreisarzt, Rat des Landeskreis Leip, an den Rat des Bez. Leip, 12.12.52; Rücksprache . . . Dr. Schmiedel, Dr. Rentzsch, Berlin, den 25.10.52.

[23] BArch, DQ1/ 4726, Adamzik an MfG, 26.10.52; 2512, Richtlinien . . . SBS, 7.9.53; Aus den Bericht . . . (Entbindungsheime).

ing mothers who had suffered a difficult delivery got to stay in recovery homes for the duration of their "nursing leave." Officials dreamed of the day when all employed mothers would spend their entire leave in a state-run "delivery home."[24]

A major stumbling block to a realization of this dream was the common practice of home delivery, mainly by midwives. In Saxony, one of the GDR's most populous states, roughly 1,000 independent midwives were in practice in 1952. In Leipzig, a large city with more and better clinics than the average locale, one-third to one-half of babies were born at home in 1952.[25] The strong position of midwives was historically rooted. Unlike American physicians, German obstetricians had not systematically impugned midwifery as a profession or home delivery as a practice; German states had encouraged cooperation between physicians and midwives. Nonetheless, midwives' position had been eroded by the inroads of obstetricians, and they fought back. In 1938, they had negotiated an agreement with the Third Reich that recognized their independence and licenses.

The GDR adopted a middle tack toward midwifery. The Ministry of Health never planned to destroy the profession, if only because the worsening shortage of physicians made midwives indispensable. Health authorities aimed, however, to bring them completely into state employment. To this end, in 1952 the ministry suddenly annulled the 1938 agreement and (secretly) instructed the health licensing administrator (always a physician) to grant no new permits for private practice. Midwives were presented peremptorily with a contract that, adding injury to insult, slotted them at a low salary level.[26] Not just the drive to socialize health care impelled the state forward. Health officials believed that safer, cleaner clinic deliveries would reduce infant and maternal morbidity and mortality. They also suspected that "free-practicing" midwives performed illegal abortions and sold abortifacients.[27] Last but not least, the state wanted to bring midwives into public clinics so the state could exploit the "great respect" they enjoyed in rural areas to modify "the rustic belief that one should come into the world in the home of one's fathers" and to make people realize the clinic was better.[28]

[24] BArch, DQ1/ 4726, Auszüge aus dem Brandenburgischen Jahresbericht 1951, Berlin, den 21.1.52.

[25] BArch, DQ1/5924. Neumann an MfG, Sachbearbeiter Frau Behrend, 12.2.52.

[26] BLHA, Rep. 601/5928, Bl. 375–76, 16.12.52; Bl. 398, Matern an Frau Staatssekretärin. Malter, MfA, FDGB, BVS, 1.9.52.

[27] Interview Frau J. (a physician who worked in the Department of Mother and Child in the 1960s). Also see Prof. Rudolf Koch's comments in *Zentralblatt für Gynäkologie* 1947 [Heft 7]).

[28] BLHA, Rep. 601, 939, Bl. 18–19, Ref. MuK, Dr. C. an Dr. S., 26.8.56.

Independent midwives were entangled in two overlapping processes: the rapid statification of the East German economy and the gradual medicalization of childbirth in the modern world. Statification also affected physicians, of course. Once in state service, however, doctors enjoyed considerable influence over health policy. Indeed, they helped orchestrate the campaign against independent midwifery and home deliveries. Whether in state or private practice, doctors agreed, "independent midwives performed more deliveries than can be responsibly countenanced." East German midwives rejected the argument that home delivery was more dangerous, pointing out correctly that postnatal breast infections occurred more often in hospital. "Women have delivered at home for thousands of years," they told clients and physicians, "[b]irth is something entirely natural." This argument, a physician retorted, "serves their design to maintain control over the birth process." The "reeducation of midwives," health officials and physicians believed, would advance smoothly only after they entered state service.[29]

East German midwives acted with verve to protect their profession. They enjoyed the advantage of recognized union status in the FDGB. They knew that they had a crucial skill and a loyal clientele. Irma Neumann, leader of the Saxon midwives' union, was their most assertive proponent. Without explicitly criticizing the contract of 1952, she warned the Ministry of Health that midwives would reject the contract unless allowed to meet to discuss its terms. She criticized doctors who, she said, were impeding a cooperative arrangement between the state and independent midwives by robbing midwives in state employ of control over examinations and deliveries and, thus, turning midwives against state employment. Unimpressed, Käthe Kern denied midwives the right to discuss contract terms (though Kern admitted to a colleague that the salary offer was too low).[30] In anticipation of Kern's rebuff, Neumann carried out a letter-writing campaign to bring the cause of hardworking, poorly paid, politically loyal midwives to the attention of higher authorities such as President Pieck and Health Minister Steidl. On a more pragmatic level, she played on the FDGB's *amour propre* by pointing out that the new measures had been decreed without consulting the union federation.[31]

The state prohibited discussion of the contract in order to preempt opposition. Its secrecy had the "opposite effect," reported State Secretary

[29] Ibid.

[30] Ibid., 5928, Hebammenwesen. Neumann an Dr. Hahn, MfG, 16.2.52; Bl. 349, Kern an Zentralverwaltung der Sozialversicherungskasse . . . 5.3.52.

[31] BArch, DQ1/6418, Neumann an MfG, 12.2.52; Neumann an Pieck, 1.2.52; Neumann an Steidl, 16.2.52; Abschrift, Freiprak. Hebammen Klara Steuber; Neumann an Landesvorstand FDGB Gesundheitswesen, 30.1.52; Neumann an Kollegin, 31.1.52; BLHA, Rep. 601/5928, Hebammenwesen, Bl. 403, Aktenvermerk: Frau Wedel.

Jenny Matern. Midwives, presumably alerted by Neumann, refused to sign the contract to enter state service and told expectant mothers that it was safer to deliver at home.[32] Those midwives who were already in state service protested the poor terms of the contract and in 1954 began a movement to "return to independent practice," because of their lack of autonomy in the clinic and the state's "insufficient recognition" of their services. They discussed these matters at their union's annual conference, which union and Health officials also attended. A health administrator complained afterwards that an FDGB officer had "made promises [to the midwives] that cannot be kept."[33] The state eventually won the war. Ever more midwives entered state service; hospital deliveries became the norm and, finally, replaced home births. In 1952, clinic deliveries made up 48.2 percent of all births; by 1955, 71 percent; and by 1959, 86.5 percent.[34] Both processes took longer than projected, however, slowed down not only by a dearth of clinic beds and physicians, but by midwives' organized resistance.

The campaign in favor of hospital birth was motivated primarily by the desire to reduce infant and maternal mortality. The Health ministry anxiously tracked infant mortality, noting its decline with satisfaction and expressing alarm over temporary or regional lapses. By 1949, infant deaths had been reduced from 131.4 to 78 per 1000 live births; they declined steadily from then on (Table 4.4). Babies of single mothers died at a higher than average rate, still 86 per 1000 in 1952. An investigation established that the main reason out-of-wedlock babies died more frequently was that they were more likely to be premature. Thus, Mother and Child set out to reduce premature births and soon closed the gap in the mortality rate. The regime was no less eager to reduce maternal death. In 1950, 20.6 of every 10,000 mothers died in or right after delivery; by 1955, this number had been reduced to 13.7.[35]

Safely delivered, baby was bundled over with mother to "maternal counseling centers." By 1952, *Mutterberatungsstellen* existed in every GDR state and were being opened at a rapid rate in ever more remote places.[36] Again, their actual operation could leave room for improvement. Many centers were "inadequately" outfitted and staffed. In rural areas,

[32] BLHA, Rep. 601/5928, Hebammenwesen, Bl. 396, Matern an die Zentralverwaltung der Sozialversicherung, 12.9.52.

[33] BLHA, Rep. 601/5928, Hebammenwesen, Bl. 398, Matern an Frau Staatssekretärin Malter, 1.9.52; BArch, DQ1/2653, MfG, HA MuK an Ref. MuK. 27.2.54; DQ1/2653, Abt. Gesundheitswesen. 14.5.54.

[34] StJb 1960/61, 64.

[35] Ibid.; BArch, DQ1/2752, Bl. 106, 1.3.57, Bericht des Referats MuK; Gunnar Winkler, *Sozialpolitik*, Tabelle 2.6, 386.

[36] See, e.g., BArch, DQ1/4616, Auszug aus dem Bericht . . . Magdeburg.

TABLE 4.4
Infant Mortality, per 1000 Live
Births (selected years)

1938	55
1949	78
1950	72
1955	49
1960	39
1965	25
1970	18

Source: StJB (1973), 35.

counseling for mothers was often available only one day a month. Even in cities, centers might be open only two or three days per month. Most acute was the dearth of social workers and physicians. When a center could not be staffed, a physician, or, more often, a midwife, nurse, or social worker, made home visits to sick patients.[37] New mothers, unlike pregnant women, wanted a *doctor* to examine their baby and got upset if a midwife or nurse showed up. The medical staff found it difficult to make rounds to widely scattered clinics, because district governments allotted less gasoline to the Department of Mother and Child than to the more esteemed industrial departments.[38] These difficulties had the consequence that mothers tended to avoid the maternal counseling centers.[39] In Brandenburg, private practitioners still cared for the majority of new babies.[40]

In 1951, the Department of Mother and Child added mothers' training courses to its services. Evidently quite popular in some areas, these classes taught hygiene and parenting skills.[41] A major subject, and a primary focus of maternal counseling, was the promotion of breastfeeding to reduce infant mortality. Communist efforts to get proletarian mothers to breastfeed continued a mission of the German health system and bourgeois women activists dating back to the 1890s.[42] In its eagerness to en-

[37] BArch, DQ1/4726, Auszüge aus dem Brand. Jahresbericht 1951, 21.1.52; Brandenburg, Mütterberatungsstellen, 11.11.52; Adamzik an MfG, 26.10.52; DQ1/2512, Richtlinien . . . 7.9.53; LStA, 912, Mutterberatungsstellen, Bl. 71, Döbeln an Leipzig MuK, 22.9.52.

[38] BArch, DQ1/4616, Rat des Bezirks Magdeburg, Ref. MuK, Dr. Lange-Malkwitz . . . 26.3.53.

[39] BArch, DQ1/4616, Dr. Arndt an den Rat des Bez. Mag, Abt. Gsw, 4.2.53; Dr. Schmautz, Bezirksarzt, Bezirk Suhl, an HA MuK, 16.10.52.

[40] BArch, DQ1/4726, Auszüge aus dem Brand. Jahresbericht 1951, 21.1.52; Brandenburg, Mütterberatungsstellen, 11.11.52.

[41] BArch, DQ1/4726, Röhle an MfG.

[42] Frevert, "Tendency."

courage nursing, "Mother and Child" in Brandenburg introduced classic Stalinist productionist methods: it instructed midwives and nurses to hold competitions for the output of the most milk during the lying-in period! At maternal counseling centers, mothers were given "breastfeeding cards" that allotted them extra rations, such as more cow's milk, until their baby was a year old.

Despite such measures, physicians feared a decline in breastfeeding. In cities with higher than average rates of women working *and* infant mortality, such as Potsdam, officials complained about a "lacking will to nurse" but admitted that most mothers stopped breastfeeding when they had to return to work. Physicians recommended the extension of "nursing leave" from six to twelve or fourteen weeks. In lieu of this change, various measures were put in place to ensure that more babies got breast milk for a longer time. Factory managers allowed nursing mothers special breaks during which they either could run home to feed the baby, retire to a special room to which the baby was delivered, or, in concerns that provided infant care, go to the nursery where the baby stayed. "Mother and Child" also arranged for mothers with plenty of milk to express milk for the children of others. Physicians recommended, in addition, that counseling centers be "more generous and less controlling" with the breastfeeding ration cards, despite the fact that poor mothers were known to sell their cards to better-off mothers.[43]

CONTRACEPTION AND ABORTION

GDR natalism took on increasingly "positive" features in the 1950s, but these measures rested on laws and policies that restricted women's control over reproduction. "Negative" pronatalism was less expensive than positive incentives. It also fit the repressive principles and practices of High Stalinism. It was consistent with Ulbricht's mentality and morality. It is not surprising, then, that the state discouraged the use of contraception with a de facto quarantine on public discussion of birth control and uneven availability of condoms, diaphragms, and spermicide. The GDR never prohibited the publication of information about birth control nor banned the sale of contraceptive devices. Indeed, women who had just delivered and couples who requested an abortion were told to visit their doctor to learn about contraception. In practice, however, as elsewhere at the time, available methods did not work well. It was, more-

[43] BArch, DQ1/4726, Auszüge . . . 21.1.52; 2 DQ1/1752, Bl. 108, 1.3.57, Bericht . . . Potsdam; LStA. 912, Bl. 35–36. Protokoll über die Besprechung mit den Ärzten und Fürsorgerinnen . . . 1.12.51; Interview Frau J.

over, difficult to get ahold of them. Pharmacies usually carried condoms, although they were often faulty and, of course, heavily dependent on the man's will to use them. A physician could prescribe spermicide creams and diaphragms. Rigid and uncomfortable, the pessaries were ineffective. Better ones were imported from Czechoslovakia but only sporadically available.[44]

Despite these hindrances, East Germans practiced birth control. The rise in the birth rate was modest compared to historical levels. To cut down on fertility, according to Neubert, couples "probably" relied most commonly on *coitus interruptus*. How eager were East Germans to increase their knowledge about and access to birth control? On the one hand, questions about contraception and abortion motivated about seventy percent of the visits to family or maternal counseling centers. On the other hand, even in a city such as Potsdam, only eight to ten people a week (most of them women) visited a center for any reason.[45] Perhaps the typical couple was embarrassed to consult either a center or a physician about sexual questions, including birth control. Presumably, they also knew that no method was reliable.

Women I have interviewed who were young adults in the 1950s expressed both embarrassment and pessimism about contraception. They articulated a sense of helplessness. One woman remembered, "Then one [child] came after the other . . . as it was at that time. . . . [A social worker said,] 'you don't need to have so many kids if you don't want to.' . . . [W]e couldn't do anything . . . pregnant!"[46] Once the birth rate had been restored to a respectable level, this helplessness among, especially, young workers began to worry the regime or, at least, "social hygienists" such as Neubert. In the later 1950s, concern rose about the strain on young couples of too many babies too soon. Thus, Neubert's books explained methods of contraception. His book for young couples only listed them, but his *Marriage Book* went into some detail, including explanations of the rhythm method, douching, and coitus interruptus, and cautioned readers that none was failsafe.[47]

Abortion was one method of birth control that Neubert absolutely did not recommend and, indeed, referred to repeatedly as "wrong." This view fit with state policy. In 1950, the GDR introduced a restrictive definition

[44] On the poor supply and unreliability of contraception, see SHSA, 5321, Bl. 19, Anleitung zur Durchführung . . . 31.3.65.

[45] BArch, DQ1/4726, Kreisarzt . . . Potsdam, 21.9.51, an die Landesreg. Brandenburg, MfG. 21.9.51; DQ1/5145, Kern an . . . alle 14 Bezirke, 16.11.53; DQ1/5145, Dr. Bunge, 6.11.53. Also see summaries of other reports in DQ1/5145. On marriage counseling centers, see Timm, "*Bevölkerungspolitik*," 205–7.

[46] Interview Frau BP.

[47] Neubert, Ehebuch, 98–99; Neubert, *Geschlechterfrage*, 75–77.

of legal abortion that became the cornerstone of its repressive reproductive policies. Article 11 of the Law for the Protection of Mother and Child authorized termination of a pregnancy under two conditions: if the pregnancy "seriously threatened the life or health of the pregnant woman," or if one parent suffered from a grave inherited condition. Article 11, in other words, recognized medical and eugenic indications, but not a social or ethical one. The law held as criminally liable anyone who performed an unauthorized abortion on herself, performed such an operation on someone else, or underwent an illegal abortion.[48] It, in effect, reintroduced the terms of Germany's long-standing Paragraph 218, thus contradicting German Communists' former opposition to Paragraph 218. Article 11 fit, however, the *ideology* behind the early Bolshevik policy and the abortion-rights campaign of the Weimar KPD: Communists assumed a socialist state had the right to overrule individual control of reproduction. In a letter to the SED executive committee in 1946, the physician Maxim Zetkin (Clara Zetkin's son) wrote, "We do not believe in natural rights; right is a social category. We accede to society the right to determine the fate of the mother and child, though under *one* condition: that the society offers them at least a minimally acceptable standard of living." Also in 1946, Hilde Benjamin criticized the "vulgar" slogan, "My body belongs to me," under which Weimar Communists had fought for the abolition of Paragraph 218 in 1931. The state, she said, had a right to "demand the birth of children," though only "when it assures they can grow up under healthy conditions."[49]

Ten years later, Neubert reinforced this view for a popular audience. His *Marriage Book* never mentioned that German Communists had earlier called for legalization of abortion. He wrote as if Article 11 represented the eternal socialist solution to the practice of abortion. If he veiled the facts, he correctly conveyed the Communist philosophical approach to abortion, although he went further than Zetkin or Benjamin. Neubert argued that *every* state had a legitimate "interest" in reproduction: "Marital fertility is of social . . . and, as long as states exist, state interest."[50]

[48] BArch, DQ1/1843/1, Bl. 309. Up to 1964, abortionists and their clients were criminally liable. The penalties were greater for abortionists who worked for money (three to five years, as opposed to one to three years for a woman who aborted her own pregnancy). Judging by a summary of arrests and sentences from 1960 to 1963, the police did not pursue such cases vigorously, and judges did not treat them severely (SAPMO-BArch, DY30/IV A2/ 17/83, Kriminalität und Abtreibung).

[49] Zetkin an Vorstand der SED, 2.10.46, printed in Thietz, 30; Hilde Benjamin, "Juristische Grundlagen für die Diskussion über Para. 218," Zentraler Frauenausschuss Juristische Mitteilungen, 25.2.47. On the Bolsheviks, see Goldman, *Women*.

[50] Neubert, *Ehebuch*, 27.

Besides this constant "state interest" in fertility, the ban on abortion in 1950 bespoke, no doubt, more immediate interests that, however, remain murky. Oblique references suggest that the Soviet Union, where the abortion ban of 1936 was still in force, pressured the SED to ban abortion sooner than it had intended. Article 11 allowed, one notes, for exactly the same indications as the Soviet law.[51] If the USSR applied pressure, not much was needed, given Ulbricht's moral opposition to abortion. A third factor was, no doubt, the opinion of conservative gynecologists, who dominated East German academic faculties far into the 1950s and advocated a strict definition of "therapeutic abortion."[52] At their meetings in the 1940s, gynecologists expressed strong antagonism to the provisional loosening of 1945–46 and to the social indication included in the laws of 1947–48.[53] In a lecture to social workers and physicians employed by marriage counseling centers, a senior academic gynecologist delivered a ringing call for the sovereignty of medical expertise in abortion decisions and a shrewd critique of the social indication as a slippery slope toward legalization. Gynecologists also voiced doubts about the verifiability of rape as grounds for abortion.[54]

Whatever the exact constellation of forces behind Article 11, it set up an elaborate process that a woman had to negotiate to take the legal route to an abortion. Every request for an abortion was evaluated by a "termination commission" composed of three physicians, a (female) representative of the Department of Mother and Child, and an envoy of the Women's League. If turned down by her local commission, a woman could reapply to a district commission composed similarly to the local one. Its decision was final. Her only (legal) recourse then was to the right of individual petition anchored in the GDR constitution. She (or her husband or mother or some other relative) could write to the Department of Mother and Child or, more rarely, to prominent SED leaders, newspaper editors, or other authorities (who forwarded the letters to the Department of Mother and Child). All this had to occur within the first trimester of a pregnancy, after which no abortion was legal (although some were approved and performed).[55] In practice, the timing did not matter; for not a single petition met with success.

[51] Kirsten Poutrus, "Massenvergewaltigungen," 192.

[52] Interview Dr. Karl-Heinz Mehlan. Also see Ernst, "Prophylaxe"; Ernst, "Profession."

[53] See, e.g., "Berichte aus gynäkologischen Gesellschaften," *Zentralblatt für Gynäkologie* 1947 (Heft 2), 182–94. Also see: An den Kreisvorstand . . . 23.4.48, reprinted in Thietz, 50–51.

[54] Dr. H. Lax, "Die soziale Indikation," *Zentralblatt für Gynäkologie* 1950 (Heft 9), 517–22.

[55] BArch, DQ1/1843/1, Bl. 309.

TABLE 4.5
Authorized Abortions in the GDR

	Per 1000 Inhabitants	Per 10,000 Births
1952	2.7	122
1956	0.9	35
1962	0.7	26

Source: SAPMO-BArch, DY 30/IV 2A/17/83.

The Department of Mother and Child oversaw the machinery of prohibition. Most importantly, it tried to track *every* pregnancy through its counseling centers. Its boss, Käthe Kern, once a vociferous critic of Paragraph 218, now had to try to convince women of the correctness of Article 11. This message, she admitted, did not always go down well.[56] Many women refused to be convinced. Between 1950 and 1955, 70,000 to 100,000 illegal abortions took place annually in the GDR.[57] It was generally assumed that women who lived in or near Berlin (and could afford the fees) visited abortionists in West Berlin, where the Social Democratic regime enforced Paragraph 218 less diligently than the Communist one in East Berlin enforced Article 11.

Physicians, nurses, and social workers remarked on the "terrible plague of illegal abortion" in the GDR. A hospital director claimed that ninety percent of all miscarriages in his semirural district were, in fact, abortions; older women, he said, terminated pregnancies at an especially high rate. An opponent of abortion, he blamed terminations on marital relations "disturbed" by the alleged postwar promiscuity of wives.[58] In contrast, a nurse and a factory social worker, who dealt daily with working-class women, identified economic misery as the main impetus behind abortion.[59] Data on the social circumstances of women who had *legal* abortions in 1949 and 1950 suggest that they were probably right. Almost sixty-four percent of applicants claimed the social indication. Twenty-one percent said they had medical reasons for an abortion. A miniscule 0.9 percent claimed to have been raped, while 0.4 percent based their application on the eugenic indication. The majority of women who cited a social indication were married, and more than twenty-five percent of them had

[56] See, e.g., SAPMO-BArch, NY4145/23, Käthe Kern, "Eine Wende im Leben der Frau. Das neue Frauenrechtgesetz/ Von der formalen zur realen Gleichberechtigung," *Tribüne* 29.9.50. Also see Grossmann, *Sex*, 199.

[57] SAPMO-BArch, DY30/IV2A/19/22, K.-H. Mehlan, "Vortrag gehalten auf der Zentralen Fortbildungstagung der Hebammen . . ." 20.9.63.

[58] BArch, DQ1/1843/1, Bl. 312–17 [1952].

[59] BArch, DQ1/1843/1, Bl. 321, 3.1.52.

TABLE 4.6
Commissioners' Rulings on Requests for Abortion,
Leipzig District

	Total Applications	Approved	Rejected
1953	362	169	183
1955	234	96	138

Source: SHSA, 931, B1.1–14.

four or more children, while almost sixty percent had an infant or toddler to care for. More than half of all applicants were housewives. Sixty-three percent of applicants were married to blue-collar workers, eighteen percent to white-collar workers.[60]

Article 11 inaugurated a drastic decline in *legal* terminations (Table 4.5). In 1950 (Article 11 went into effect only in October), 26,400 legal abortions were performed; in 1951, 5,000; in 1956, 1,000; and in 1961, 800.[61] The number of applications also fell, as suggested by data on Leipzig (Table 4.6). In the 1950s, state officials and influential physicians argued that the decline in applications reflected "the improvement in our economic situation." Looking back from the 1960s, however, a report admitted that the very low rate of approval had discouraged women from undertaking the almost hopeless process of application.[62] This same report insinuated that physicians had applied the terms of Article 11 more strictly than the state intended. Dr. Kurt Winter, a Communist physician of some prominence in the 1940s, claimed, however, that "[d]octors reacted so restrictively because they were scared."[63] The documentary record supports this assertion. In 1953, for example, the physician who headed the Division of Mother and Child in Schwerin queried his superiors in Berlin about the possibility of performing an abortion on an indigent 42-year-old woman impregnated during a rape. The Ministry of Health answered laconically, "There is no ethical indication."[64] Physicians did, however, exercise considerable control over legal abortion. Doctors constituted a majority of the termination boards. Medical superinten-

[60] Kirsten Poutrus, "Massenvergewaltungen," 187.

[61] Mehlan, 183: Table 11.1.

[62] BArch, DQ1/1796, Besprechung über die Schwangerschaftsunterbrechung, Juni 1954; SAPMO-BArch, DY30/ IV A2/19/22, Stellungnahme und Empfehlungen der Kommission zu Problemen der Schwangerschaftsunterbrechung in der DDR [1963], 1.

[63] SAPMO-BArch, DY30/IV A2/19/22, Notizen während der Beratung am 21.4.64 mit führenden Gynäkologen, usw.

[64] BArch, DQ1/1668, 1.7.53. For similar cases, see DQ1/1843/1, Bl. 82–3, Bl. 53, 7.7.53. Also see SHSA, 5321, Bl. 6–7.

dents clearly influenced the boards. Medical academics ruled summarily in ambiguous cases. Nonphysician health officials such as Käthe Kern deferred to the opinions of professionals about which illnesses endangered the life of a pregnant woman. Her correspondence with health officials reveals that she and they accepted an older medical argument that *every* abortion debased the general health of *any* woman and, worst of all, might cause infertility.[65] Thus, the SED and conservative physicians, especially gynecologists, suppressed the pragmatic inclinations of more liberal physicians.

In the early 1950s, very few East Germans protested to higher authorities after a commission turned down a request of an abortion. I have located eighteen petitions from 1951 to 1955 from families (including two single mothers) that had an average of three children, lived in all geographical areas of the GDR, and spanned its social spectrum. The typical husband was a member of the socialist "middle-class," i.e., a teacher, white-collar employee, engineer, manager, etc. Husbands wrote eleven of the sixteen letters from married couples, suggesting that the couple assumed he should mediate between the family and the state about this delicate matter. Every petition justified its claim for reversal on medical grounds.[66] To the untrained eye, the great majority of the delineated diseases do not appear to have been serious.[67] Many letters referred to *social* distress even as they placed medical claims in the foreground. They also conveyed a strong sense of the profound physical and psychic exhaustion of the pregnant woman. Petitioners asserted that the family was already too large, mentioned inadequate housing, claimed financial constraints, and made much of problems attributable to the war and its aftermath. Indeed, as in the applications from the 1940s read by Atina Grossmann, these petitioners tried one argument after the next as they searched for the right key. Pleading the case of her pregnant, unmarried daughter, for example, a mother predicted the misery that every member of the extended families would suffer if an illegitimate baby was born, counted her years of dedicated service to the GDR, and quoted Walter Ulbricht, before ending, "I'd like to add that in principle I'm opposed to abortion."[68]

[65] See, e.g., BArch, DQ1/1668, Bl. 309, Kern an Steidle, 1.3.52; DQ1/1843/1, Bl. 54; DQ1/5145, 30.8.54.

[66] Only one letter added a eugenic claim. Atina Grossmann found, in contrast, that raped women resorted often to eugenic arguments in applications filed in 1945 and 1946 (Grossmann, *Sex*, 194).

[67] Complaints included vague circulation troubles, stomach ailments, headaches, heart problems, and tuberculosis.

[68] BArch, DQ1/6324, Bl. 601–2.

As exaggerated or simulated as they are, the petitions (and the investigations they prompted) reveal much about how husbands and wives made decisions about reproduction. Husbands appear to have tried to exercise considerable control. When a social worker visited a couple in which the husband had written the petition, the wife said she now wanted the baby. He attempted to get her to change her mind, saying, "I can't be expected to have to listen to two kids' screaming when I come home from work."[69] In another case, a social worker believed that the woman would have kept the pregnancy, "if she did not fear that her husband, a psychopath, would fall apart or file for divorce if she carried to term against his will. The father can't stand small children and never forgave his first wife for how she changed after she had a child. . . . [His current wife] lives for him. . . . He cries continually, can no longer do his scientific work, and makes life miserable for his wife. . . . [S]till, she places him and his egoistic wishes first."[70] Several husbands wrote without informing their wives that they were doing so.[71] No petitioner referred to the right of a woman to control her own reproduction. No one mentioned the rights of women at all. A few petitioners did talk about "woman" in general but only to associate her with weakness and children.[72]

No argument convinced Kern to overturn the ruling of a termination board. In her responses, she always insisted that, sooner or later, the couple would look forward to the birth of their baby. On the other hand, she never "shamed" a woman for wanting an abortion. Although the occasional political attack in a petition provoked her to lecture about the superb social provisions of the Workers' and Farmers' state, she did not impugn any couple's cry for help as illegitimate. Her practical responses were several: she sent in social workers to observe and counsel the couple; offered the suicidal or exhausted woman a state-financed "cure" in a rest home; and offered to board the family's existing children temporarily in a children's home at state expense.

As the decade progressed, the social profile of legal abortion changed. In 1956, the gynecologist Hans Mehlan gathered statistics on applications for abortion. Of 2,072 applicants in 1955, two-thirds were over thirty years old, compared to one-half in 1949. As earlier, four-fifths were married and the majority already had at least three children. Three-fifths of them were housewives, thirty-five percent were employed, and five per-

[69] BArch, DQ1/5145, 19.4.54.

[70] BArch, DQ1/2036, Protokoll . . . Beschwerdekommission . . . 20.3.57.

[71] BArch, DQ1/5145, (*Herr*) E. an das MfG, 22.11.54.

[72] BArch, DQ1/5145, (*Herr*) E. an das MfG, 22.11.54; DQ1/5145, 23.8.53; DQ1/1843/1, Bl. 58. Also see DQ1/5145, 20.8.54.

cent were "without profession" (probably adolescents). Abject social misery no longer prompted the typical request. The average family monthly income of applicants was 290 DM, as opposed to 250 DM for the population as a whole. Mehlan acknowledged, though, that twenty-eight percent of applicants lived "very poorly." He also recognized that women from "good social circumstances" were more likely to get a request approved than those from "badly situated families."[73] Better-off women were, one suspects, more likely to live in a larger city with a more liberal termination commission. Moreover, prosperous women were better educated and could, presumably, use language more effectively to convince a physician of the rightness of their plea.

Socialist Population Policy and Eugenics

GDR officials and publicists boldly proclaimed the state's right to pursue "the goals of population policy [bevölkerungspolitische Aufgaben]," even though the SED was fully aware that population policy was identified in the public mind with National Socialist racism, eugenics, and militarism. At trade union meetings, working women denounced the blatant natalism trotted out to justify Article 11, wondering: "Why do they want so many children—that would be like Hitler."[74] In 1949, health officials in Leipzig acknowledged that a difficult, but necessary, task of the marriage and family counseling centers would be "to turn population policy against National Socialist ideology and toward an ethic of healthy and natural maternalism with no militaristic objective."[75] Insensitive to the idea that their language might be interpreted as "Nazi," Communists praised the desire of "healthy" women, "healthy" men, and "healthy" couples to reproduce. It was pernicious to impute "unhealthiness" to people who did not share this yearning. One should not, however, conflate the Communist notion of health with a definition based on racial or hereditary characteristics. In SED discourse, healthiness signified the "natural," universal state of the mind or body uncorrupted by poor nutrition, capitalist decadence, or fascist ideology. Public hygiene, as represented by the Ministry of Health and by experts such as Rudolf Neubert, aimed to excise

[73] SAPMO-BArch, NY4182/246, Bl. 75–77, Betr.: Arbeitstagung der ärztlichen Direktoren und Chefärzte vom 29. bis 30.5.58 in Leipzig. Mehlan Vortrag: "Das Bild der legalen und illegalen Schwangerschaftsunterbrechung."

[74] SAPMO-BArch, DY30/IV2/17/29 SED Brbg, FrAbt. an ZK FrauenAbt., 26.10.50. Also see DY30/IV2/17/29, Bl. 114, Gegnerische Stimmen . . . ; Bl. 127–28, SED Brandenburg, Frauenabt. an ZK FrAbt. 18.10.50. Bl. 129. Also see Grossmann, Sex, 198; Timm, "Bevölkerungspolitik," 205.

[75] LStA, 544, Bl. 39, Abschrift. Richtlinien über Ehe und Sexualberatungsstellen. 31.7.49.

these *environmental* causes of disease and "unhealthiness."[76] More funda-
mental was the distinction between the GDR's strikingly "unselective"
interest in quantity of births and the National Socialist obsession with
racial and genetic "quality."[77]

As the eugenic indication in Article 11 suggests, however, Communist
pronatalism was not free of eugenic assumptions. Applicants rarely
claimed the eugenic indication. A random selection of monthly compila-
tions of abortion requests in the Leipzig area suggests that about five per-
cent of legal abortions were eugenically motivated in the early to mid-
1950s.[78] Except for two or three petitions that used a eugenic argument,
there is no record of why applicants listed the eugenic indication.[79] GDR
doctors knew that eugenic abortion was a "very hot iron" because of its
associations with Nazi population policy.[80] In private consultations
among themselves, physicians occasionally used eugenic arguments. In
one case, a "feeble-minded" twelve-year-old girl, five months pregnant,
had been raped by an "unknown" who "can't have been a worthwhile
man." A eugenically indicated termination was, a gynecologist reflected,
possibly justifiable on these grounds. Several days later, he performed the
abortion. In this case, as in four or five instances found in files of the
Ministry of Health, the pregnant woman was a minor whose parents or
another adult relative pressed for the abortion. In all of these instances,
the pregnancy was advanced and a termination could not be justified on
medical grounds.[81] I have found one case in which an adult woman, an
inmate of a mental institution (as was her sexual partner), was aborted
without her explicit consent. Sterilization was also recommended in her
case, though it is not clear if it was carried out. No doubt other involun-
tary abortions and/or sterilizations took place, though I have seen no evi-
dence that this was a *policy* directed at the mentally ill. Certainly, Commu-
nist health officials, social workers, and citizens used the term "asocial"
to describe people who refused to work, took inadequate care of their
children, or produced many unwanted children. At least officially, how-
ever, "asociality" was not ascribed to heredity, and no one attempted, as
far as I can ascertain, to keep "asocial" people from reproducing.

[76] Annette Timm places Communist policy in a more continuous line with Nazi popula-
tion policy. See Timm, "*Bevölkerungspolitik*," 176, 205, 212–13.
[77] Süss, "Gesundheitspolitik," 59.
[78] See "Statistische Monatszahlen der Bezirke," collected (unsystematically) on districts
including Leipzig, Magdeburg, and Rostock in BArch, DQ1/1668; DQ1/1675; DQ1/4870,
Bl. 445–48; DQ1/4872; DQ1/1677.
[79] See BArch, DQ1/2036, 30.4.53; 5.5.54.
[80] Quote: SAPMO-BArch, DY30/IVA2/19/22. Dr. H. Kraatz an Friedeberger, 20.4.64.
[81] BArch, DQ1/5145, Protokoll . . . 27.3.52.

CONCLUSION

The GDR's maternalist benefits, strict limits on abortion, and discouragement of contraception were comparable to the practices of most European states of the era. They were also in line with the German past. The GDR enacted programs that followed directly from Nazi pronatalist measures, *stripped of their racist features*, but broke with Nazi *anti*natalism which, Gisela Bock argues, was the fundamental and distinguishing characteristic of Nazi reproductive policies.[82] Under each dictatorship, health officials attempted to register all pregnant women, see that they were continually under a doctor's care, teach them basic hygiene, and ensure that nursing mothers and infants were regularly examined. In both dictatorships, the mass women's organization helped the state implement these goals. Only in the GDR centers, however, were women educated about their social and legal rights (as women, workers, and/or wives).[83] Both the Third Reich and the GDR, in turn, expanded the Weimar era's embryonic counseling system for pregnant women, new mothers, and babies, though only in the Third Reich were the counseling centers conducted along racist lines.[84]

Like National Socialists, Weimar and West German Social Democrats, West German Christian Democrats, and, indeed, most political parties even today, German Communists assumed that reproduction was a natural human goal that was differently motivated for women and men. To quote Neubert's *Marriage Book*, procreation "corresponds to the woman's yearning for children and to the man's will to carry on his life and work."[85] One of the SED's most progressive physicians, Dr. Lykke Aresin, who ran an unusually enlightened marriage counseling center in Leipzig, explained her opposition to the full legalization of abortion: "Pregnancy, children, a full family life belong to the full life for women. Something is wrong with a woman who applies for an abortion at the age of thirty. We would allow her life to be robbed of its meaning by [what she wanted done] in one of life's heedless moments."[86] The conviction that a "healthy" woman's desire for children was central to her identity as a woman constituted a real, if transparent, cultural bond between the state

[82] Bock, *Zwangssterilisation*; Bock, "Gleichheit."

[83] See, e.g., BArch, DQ1/4726, Röhle an das MfG (n.d.). On Nazi policies, see Czarnowski, *Paar*, 133–36.

[84] On the Weimar republic, see Grossmann, *Sex*; Usborne; Hong; Hagemann, 207, 210–12, 216–18.

[85] Neubert, *Geschlechterfrage*, 36. On Imperial discourse, see Ann Taylor Allen, Feminism. On Social Democracy, see Canning, Languages, 151; Hagemann, 307.

[86] SAPMO-BArch, DY30/IV A2/19/22. Notizen . . . S.8.

and the majority of the population *and* between the regime and East German churches (which strongly supported Article 11).[87]

The SED's intervention into reproductive matters fit with its refusal to treat the domestic sphere as sacrosanct. Communists believed in the right of a just, socialist state to reach its arm into private affairs in pursuance of "communal" goals. They would not have denied that they were engaged in social engineering, though they did not, of course, see themselves as instrumentalizing women. From an ideological perspective, it is only peculiar that control of women's bodies continued largely within the traditional confines of state intervention in the family and, indeed, pried mostly into matters that both conservatives and National Socialists deemed worthy of state attention. Many East German women and men, however, opposed the meddling of any outside authority into their reproductive lives. Women accepted the state's financial "carrots" to raise fertility, but they resented and circumvented its "sticks." They protested the linking of extra rations for pregnant women to prenatal examinations, remained loyal to midwives and private doctors, and, despite legal and physical dangers, had illegal abortions. Few of them did so in accordance with a philosophical or political understanding of their rights as women. Rather, they acted out of a sense of what seemed right for them and their families. Over time, women's practical challenges to state control and the "big family" began to impress some Communists, especially women functionaries and professionals, as legitimate. Moreover, the tensions between the state's productive and reproductive priorities led to impasses in its ability to mobilize women's labor and develop female skilled labor and led, hence, to an equivocal rethinking of reproductive policies in the 1960s.

[87] On the churches' position, see SAPMO-BArch, DY30/IV A2/19/22, Dr. We/Str. an Hager, 28.6.65.

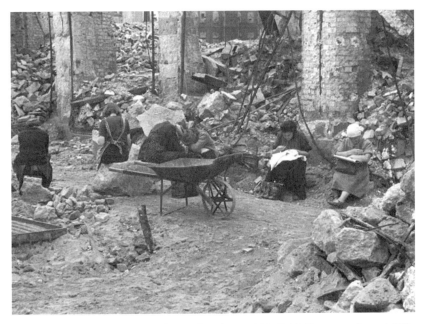

Figure 1. "Rubble Women" taking a break, c. 1946. (LAB Fotosammlung 1 NK, Bestell Nr. 38741, Trümmerfrauen bei der Pause)

Figure 2. Life and Death in Postwar Berlin, c. 1946. (LAB Fotosammlung 1 NK, Bestell Nr. 68670, Soldatengrab an der Havel)

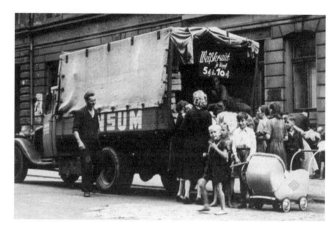

Figure 3. *Konsum* Mobile Market, Special Sales, late 1940s/early 1950s. (Konsumverband eG, Fotoarchiv, Mappe Märkte, FA24)

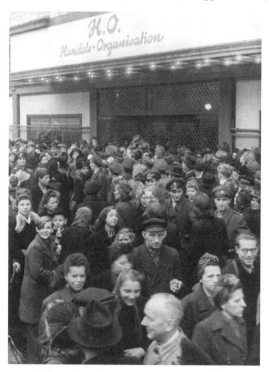

Figure 4. Crowd Gathered for the Grand Opening of a new HO in Berlin, 1949. (Konsumverband eG, Fotoarchiv 3, FA3, R 89 363)

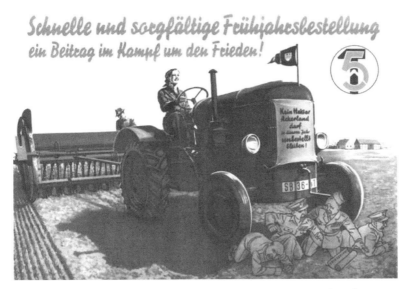

Figure 5. Propaganda for the First Five Year Plan, Agricultural Collectives, and Women's Employment, 1951: "Fast and careful spring planting. A contribution to the struggle for peace!" The banner on the tractor says: No Hectare can be left unplanted. (SAPMO-BArch, PLAK. Y1 VP5/31/1)

Figure 6. Karl Marx, Economic Reconstruction, and Tea: Display Window in *Konsum* store, 1953. (Konsumverband eG, Fotoarchiv, FA10, Werbe-Abtl. Konsum-Genossenschaft Kreis Oelnitz)

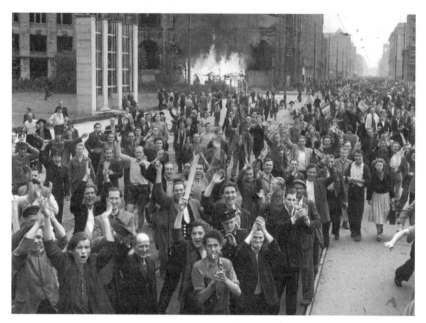

Figure 7. 17 June 1953: Demonstration at Leipziger Platz (Stalinallee). The crowd is optimistic and predominantly young and male. (LAB 57 DDR 31 51, Bestell Nr. 25759)

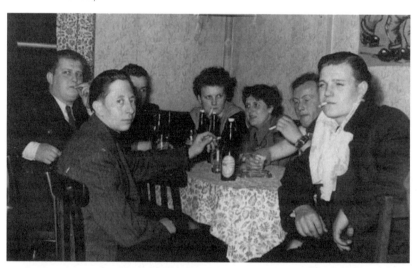

Figure 8. Married couples and friends at their local pub, c. 1953. (Private Collection)

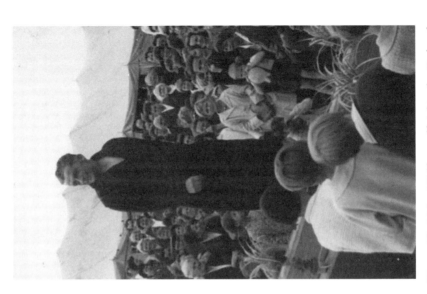

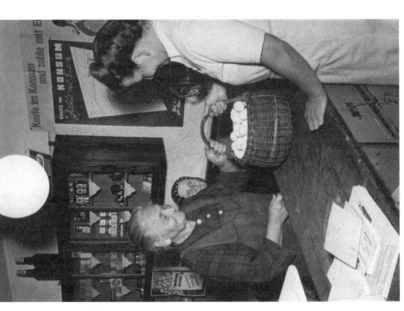

Figure 9. Toward overcoming a shortage of eggs, farmer-women were encouraged to exchange eggs for other goods at *Konsum* (a campaign announced by the poster in the photograph), mid- to late 1950s. (Konsumverband eG, Fotoarchiv, Kap. 2, Dorfkonsum)

Figure 10. Heinz Wolf, an official in the *Verband der Konsumgenossenschaft*, presents. The fashion show was put on by the *Konsum* Department Store Lucka to celebrate the "Day of the Miner," 1965. (Konsumverband eG, Fotoarchiv, FA4)

Figure 12. Babies need fresh air, infant home Adelheitsruhe, 1950s. (Konsumverband eG, Fotoarchiv, FA50, Säuglingsheim Adelheitsruhe)

Figure 11. Propaganda for "Thousand Little Things" and Self-Service, 1959–60. (Konsumverband eG, Fotoarchiv, FA3, 1000 kleine Dinge, 13)

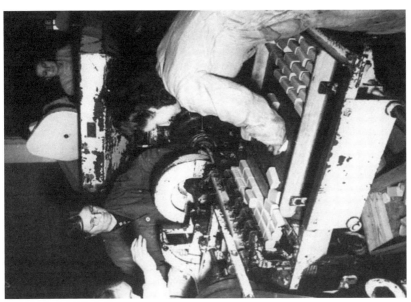

Figure 14. Production in a soap factory, 1950s. (Konsumverband eG, Fotoarchiv, Produktion 6, 1244/21, Seifenfabrik Riesa)

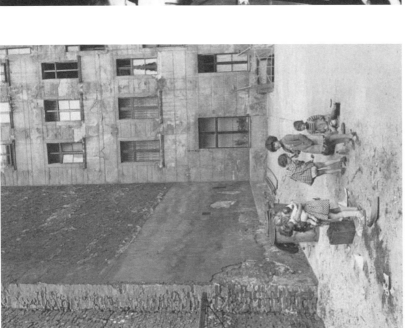

Figure 13. Older children too get their fresh air, if in a more traditional manner, (East) Berlin 1960. (LAB-25 SG, Bestell Nr. 70246. Kinderspiel auf dem Hinterhof, Bezirk Mitte Pflugstrasse, 1960. Photographer: Klaus Lehnartz)

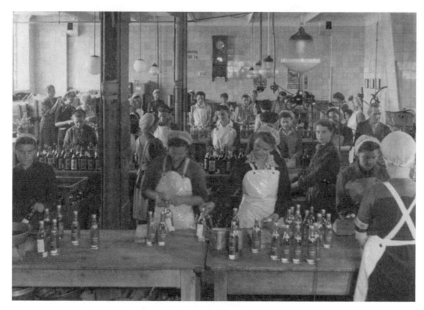

Figure 15. Liquor bottling plant, Cottbus, 1950s. (Konsumverband eG, Foto-archiv, Produktion 19, Spirituosenfabrik "Melde" Cottbus)

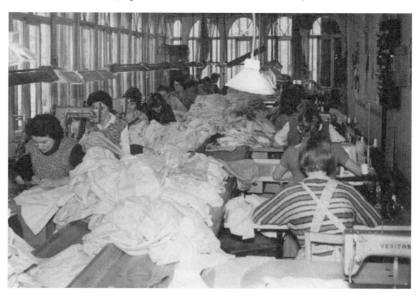

Figure 16. Garment making, Blankenburg, late 1950s/early 1960s. (Konsumver-band eG, Fotoarchiv, Produktion 4)

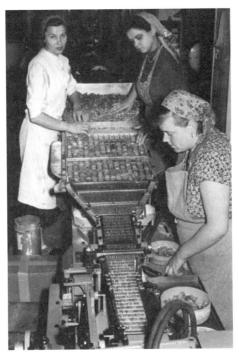

Figure 17. Chocolate factory, Tangermünde, late 1950s/early 1960s. (Konsumverband eG, Fotoarchiv, Produktion 7, Tangetta Tangermünde, Scholadenfabrik "Fedora")

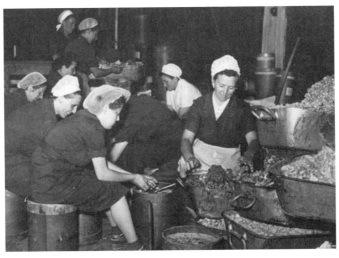

Figure 18. More chocolate making. (Konsumverband eG, Fotoarchiv, Produktion 7, Tangetta Tangermünde, Scholadenfabrik "Fedora")

Figure 20. Under Honecker; propaganda of a "new type," associated youth, sexuality, individualism, and consumption with life in the GDR, 1972. (Private Collection, Photographer: Peter Woelck)

Figure 19. "Counseling Center DFD: Center for Advice, Information, Screenings, regarding questions of daily life, healthy living, modern housework as well as the leisure activities of women, families, and young married couples," 1972. (SAPMO-BArch, PLAK, Y8 60/3)

Reforming Taste

PUBLIC SERVICES, PRIVATE DESIRES, AND DOMESTIC LABOR

THE LEADING CADRES of the Socialist Unity party did not approach consumption and services with the same zeal as they did politics, production, or reproduction. Communists viewed with suspicion the tertiary sector and the desires it evoked. Consumption symbolized, on the one hand, traditional capitalism: an irrational marketplace filled with the gouging and wasteful competition of small businesses and shops. It represented, on the other hand, hypermodern American imperialism: huge conglomerates spewing out useless goods, for which Madison Avenue pumped up spurious demand. Communists were hostile to bourgeois consumerism, frivolity, spending, and personal indulgence, and committed to proletarian production, asceticism, saving, and collective investment. In 1947, Executive Committee member Fred Oelßner wrote in the SED theoretical journal *Einheit*, "The task of the planned socialist economy is, first, to satisfy not the individual need, but rather the social need. . . . It is the capitalist mentality that assumes that the most important task of the planned economy is the satisfaction of individual needs."[1]

This vision of the socialist future accompanied, Mark Landsman has perceptively observed, an understanding of capitalism and economic growth that was rooted in the past. After 1945, the supply-based productionism of the classical capitalist system reemerged in Western Europe, but it was superseded gradually, then ever more rapidly, by demand-driven economies characterized by a synergistic combination of Fordist mass-market production, Keynesian fiscal policies, and Social Democratic redistributive policies. Before 1933, German Communists were part of a wider European intellectual tradition of left-wing *and* right-wing contempt for the vulgarity, extravagance, and emptiness of American consumerism. Unlike Western economists and politicians after 1945, Communists did not recognize the growth-generating potential of individual consumption and, by extension, consumer industries and services. They were genuinely bewildered by the unprecedented prosperity, technological innovations,

[1] Landsman, *Demand*, 4–5, 38–39.

and commercialized services that flowered in the regulated market economies of Western welfare states, including the FRG.[2]

Of course, the SED elite wanted to satisfy the people's legitimate needs and raise workers' standard of living. The party elite did not even disdain middle-class domestic tastes. In the protected, secluded compound at Wandlitz, outside Berlin, where they moved after the Hungarian uprising of 1956, they eventually had respectable and architecturally familiar two-story, single-family houses built for themselves. Although the homes far surpassed the housing of ordinary East Germans, they were not extravagant. Wandlitz bespoke attachment to the blend of cultivation, comfort, and self-control that suffused prewar German bourgeois domestic culture. Only the elite lived out this dream. Its desire to do so, however, colored its vision of mass consumption.[3]

The German Communist leadership's ambivalent relationship to private consumption became downright inconsistent during postwar struggles over production, power, and international politics. Soviet planners had long since realized that productionism could not function without consumption carrots to spur productivity. Thus, SMAD imposed on the SBZ the incentive system of the classic Stalinist labor regime, which included provision perks for certain categories of workers and rewards for superproductive workers.[4] East Germany's uncomfortable position within Cold War enmities alerted the SED elite, meanwhile, to the *political* significance of consumption. The SED observed the allure of the Western market more directly than did Communists elsewhere in Eastern Europe. The confrontation over consumption carried a great symbolic charge in the German case, because systemic rivalry between Socialism and Capitalism was entangled with a race for national legitimacy. The East/West contest over "best provider" opened dramatically in June 1948, when the Western allies introduced a currency reform in their zones of occupation, causing hoarded goods to tumble into stores in West Berlin. East Berliners rushed across the border to buy, or at least oggle, the cornucopia of commodities in shop windows. Their behavior galled SED leaders and contributed centrally to the Soviet blockade of West Berlin in 1948–49. The SBZ, the SED press explained, was taking the prudent, though stony, road of delayed gratification. Yet simultaneously, SMAD and SED spiffed up East Berlin as a showcase of SBZ consumption.[5]

[2] Ibid., 6–9; Mühlberg, "Arbeitsgesellschaft," 191–92; Felski; Poiger, Chapter 1.

[3] Mühlberg, "Überlegungen," 69; Ernst, "Politics," 489–505; Stitziel, "Fashioning," 135–37, 143–45; Merkel, "Arbeiter," 532–33.

[4] Landsman, *Demand*, 38.

[5] Ibid., 38, 40–48; Pence, "Schaufenster," 94–95; Landsman, "Dictatorship," 161, 14, 79, 86; Stitziel, "Fashioning," 36–37.

To economic and political reasons for inconsistent consumption policies, Mark Landsman adds an institutional stimulant. Inside the GDR's Ministry of Trade and Provisioning emerged what he dubs a "consumer supply lobby." From the late 1940s onward, career bureaucrats, economic planners, and political appointees in Trade argued cautiously for improved consumer production, market research, advertising, and a consumer-pleasing retail "culture." The June rebellion of 1953 filled their small sails with wind. They pointed out ever more persistently the political and economic significance of individual consumption.[6]

Economic, political, and institutional factors acted separately and in tandem to force the SED to take account of consumption. All three interacted with the gendered organization of consumption and its cultural consequences. Heavily invested as women were in the labors of consumption, they acted as arbiters of individual taste and as major mediators between the state and the people in matters of consumption. Consumption became a central element of the fraught relationship between women and the SED. Woman as worker, full steam ahead. Woman as mother, naturally. Woman as consumer, how awkward. Yet there she stood, part obstacle, part challenge to Stalinist productivism (*Figures 3* and *4*). Every day, the woman consumer confronted high prices, shortages, poor quality, queues, and distributive inequities. She devoted phenomenal energy and time to obtaining food; making it edible; hauling in fuel; cleaning and decorating decrepit apartments; and buying, sewing, or repairing clothes and linens, and—dreadful job—laundering them. With her yearning for fashionable clothes, cosmetics, and other fanciful stuff, the consuming woman represented a "potentially dangerous and disruptive element" in a reconstruction economy oriented toward producer industries.[7]

Socialism would eventually overcome, it was assumed, the tension between capricious desires and rational moderation by socializing wide swaths of consumption. The future looked grand: people would meet their needs with public transportation, restaurants, canteens, laundries, cleaners, and repair shops. They would satisfy leisure and cultural desires in public parks, camps, resorts, hobby clubs, theaters, libraries, and museums. Unhappily, the present was awful, especially through 1953. After 1953, with more money and less frantic emphasis on heavy industry, a partial socialization of social reproduction began to emerge. Following the Soviet model, trade unions provided services through the workplace:

[6] Landsman, *Demand*, 9–10. Also see Pence, "You." Judd Stitziel ("Fashioning") argues along similar lines that within the Ministry of Light Industry a consumer production lobby promoted investment in textile manufacturing, innovation, and marketing.

[7] Stitziel, "Seam," 57. The fear was peculiar neither to Communists nor to Germans. See Crowley, "Shops"; Reid, "Cold War," 213–14.

social insurance, child care, laundry services, repair services, grocery shopping, leisure activities, and even vegetable gardens and livestock pens. The gradual "factory-fication" of services forged, eventually, a new work culture distinctive to state-socialism.[8] Factory services did not displace the taste for private consumption. They satisfied only some wants and needs. As Kornai points out, Stalinist economies socialized consumer services, from laundries to restaurants to repairs, in fact, less well than Western mass-consumption economies commercialized them.[9] Factory services, moreover, were associated with work, not home, and drew in the family unit only tangentially. Yet it was the family that generated and constantly redefined the "basic" needs of children, housework, and provisioning. New wants, and the competitive yearning to satisfy them, emanated from various domesticated spaces: conjugal life, child rearing, friendship, neighborly contacts, or connections with extended family in West Germany. Immersed in the pleasures and pains of family life, women wanted more household appliances; kitchen wares; cleaning supplies; furniture; curtains; knickknacks; easily prepared foods; items for personal hygiene or beauty; and stylish, good-quality clothes for them, their children, and their husbands. For economic, political, and institutional reasons, the SED found it increasingly difficult to dismiss women's desires.

THE UNEVEN EXPANSION OF SOCIAL CONSUMPTION AND SERVICES

In the early 1950s, the provision of services for women workers was motivated by immediate economic concerns, not social aims. The pragmatic instrumentalism of the era is illustrated well by the expansion of child care for very young children. The absolute increase in numbers of spaces in institutionalized child care for infants and toddlers (aged 0 to three years) was impressive (Table 5.1).

Relative to the needs of young working mothers, the increase was utterly inadequate. In Heike Trappe's sample of women born from 1929 to 1931, only ten percent of women workers enjoyed a full five years of preschool care for a child. The overwhelming bulk of working mothers relied only sporadically on outside care for an infant or toddler and, when they did, they usually arranged it privately, turning to relatives or, more rarely, private or church-run institutions.[10] In Trappe's sample, an additional thirty-five percent of working mothers placed their three- to six-

[8] On GDR work culture, see Kohli, "Arbeitsgesellschaft?"; Roesler, "Produktionsbrigaden."

[9] Kornai, 457–58.

[10] Trappe, 115, 125.

TABLE 5.1
Expansion of Crèche Places (children 0 to 3 years old)

	Number of Places	As Percentage of All Children 0 to 3 years old
1950	4,674	6.3
1955	50,171	5.9
1960	81,495	9.9
1965	116,950	13.8
1970	166,700	23.6
1975	234,941	44.2

Source: Reyer and Kleine, 127. (The crèches were used disproportionately for children older than one year, so a higher percentage of children one to three years old was covered.)

year-olds in a kindergarten. Group facilities for this age range expanded at a rate more commensurate with women's entry into employment. In 1952, municipal, factory, private, and church kindergartens together provided 200,000 places.[11] Yet kindergarten spots, too, were oversubscribed. Reports describe women workers as "anguished" over the lack of child care for preschool children and "very worried" about leaving older children alone after school. Virtually every new facility filled up immediately and had a waiting list.[12] Report after report from the Department of Mother and Child or from women's factory meetings noted the "urgent" need for child care in industrial areas and at universities.[13] Availability was better in priority industries, such as chemical combines, than in small factories, offices, or stores. Yet even at the huge Buna plant, less than a third of mothers (and even fewer of their multiple children) could be accommodated by the 525 places in its several factory nurseries and kindergartens. Overcrowding was often worst in child care facilities at these big, "feminizing" plants because their employment of women was ex-

[11] StJb, 1955, p. 62.
[12] See, e.g., BArch, DQ1/3851, Adamzik an MfG, 18.9.51; DQ1/2245, K. Kern, Betr: Besichtigung der Sozialhielfe in Berlin-Pankow, 12.2.51; DQ1/2245, Warnecke, Aktenvermerk, 22.7.53; BArch- SAPMO, DY30/IV2/17/33. Protokoll . . . 5.10.56, Bl. 5; DY34/39/94/5571. Protokoll . . . IG Chemie. 18.10.56.
[13] See, e.g, LStA. IV/2/17/692. Bericht . . . Bella-Schuhfabrik Groitzsch/Borna am 27.1.54; 924, Land Sachsen. Mutter und Kind an HA MuK; Bl. 82, Rat d. Kr. Eilenburg an Rat d. Bezirk Leipzig Mutter und Kind, 19.9.52; Bl. 42. Rat d. Kreis Borna und Rat d. Bezirk Leip, MuK, 31.8.53: Bl. 96, Kreisrat zu Grimma an Leipzig, MuK, 24.9.53; Bl. 58, Rat d. Kr. Döbeln an Rat d. Bezirk Leipzig MuK, 21.8.54; LStA, 916, Bl. 66–67. 25.2.55, Frau Dr. B.; BArch, DQ1/2245. Naumann an Kern, 12.12.55; DQ1/5331, Kinderkrippen u. Heime. Entwicklung seit 1950 [1954].

panding, and they drew on labor from a huge swath of poor communities with few municipally run child care centers.[14]

Party representatives claimed that women workers gradually grumbled less about "provisions and ever more about housework and child care." The "double burden" of women workers, and especially the child care issue, was a major topic at conferences of women unionists and party activists. Women already in shift work, or who wanted or had to work in production, were desperate for child care.[15] Some women complained to state authorities that they had to bring their children to work with them. The lack of child care prevented many women from taking a job and kept others from assuming "leading functions" or getting qualified.[16] To judge by reports on the communications and chemical industries, the chorus of complaints reached a crescendo in 1959 and 1960.[17]

The crisis was real, and women functionaries in the SED and FDGB milked it for all it was worth. Women's conferences glossed over workers' anger over low wages but vaunted their "despair" over child care. Services, and especially child care, were legitimate topics of discussion. When they berated male authorities for their neglect of services, women officials stood up for female interests and, they hoped, enhanced their own influence within the state, party, and factories. In a blistering account of gender discrimination in a coal-processing plant near Merseburg, a woman instructor contrasted its new club hall, sports center, and other apparently gender-neutral, but largely male-used, facilities to the complete lack of child care facilities for the 300 mothers in its workforce.[18] The New Course of 1953 promised attention to services of all kinds and, thus, women activists and, especially, the BFA demanded all the louder that

[14] VEB Buna, 1954. Die Frau im VEB Buna . . . 1959, 43. On overcrowding, see BArch, DQ1/1890, Dr. Pollack, Gera, an das MfG, HA MuK, 27.7.53; SAPMO-BArch, DY34/39/94/5571. Protokoll . . . IG Chemie. 18.10.56.

[15] See, e.g., LStA. 924, Bl. 82, Rat d. Kreis Eilenburg an Rat der Bezirk Leipzig Mutter und Kind, 19.9.52; Bl. 58. Döbeln an Bezirk Leipzig MuK, 21.8.54; Bl. 96, Kreisrat zu Grimma an Leipzig, MuK, 24.9.53; BArch, DQ1/2166, HAMuK an Rat d. Bez. Dresden, 19.1.53, Kinderkrippen, VEB Jutespinnerei u. Weberei; Deutsche Notenbank an MfG, 13.11.53; SAPMO-BArch, DY30/IV2/17/57, Bl. 23–26, Bericht . . Gera, 21.12.53, Bl. 26; DY30/IV2/17/33. Protokoll . . . 5.10.56, Bl. 45.

[16] See, e.g., LStA 916, Bl. 247, Frau EM an MfV, 9.9.54; FDGB Bezirksvorstand Schwerin, Beratung . . . 14.6.57, S.3, 5; SAPMO-BArch, DY30/IV2/17/41, Bl. 249, Arbeitsgruppe Frau, Einige Probleme der Arbeiterinnen in der Chemieindustrie . . . 3.10.58.

[17] SAPMO-BArch, DY34/39/120/5865. Bericht . . . Fernmeldewesen. 3.3.58, S. 5; A1544. Arbeitskreis der Arbeitskraftsreserven (Chemieprogram), Abschlussbericht . . . Gewinnung von Arbeitskräften im Bezirk Halle . . . 20.4.59, S. 25–6; DY34/39/140/6011. Beratung mit d. Fraueninstrukteurinnen am 24.8.60, S.3.

[18] SAPMO-BArch, DY30/IV2/17/87, Bl. 299–302, Erna Lierse, Die Lage der Frauen in der Braunkohle und Eisengiessereibetrieben im Geiseltal Kreis,Merseburg, 30.6.51.

Table 5.2
Crèche Places by Type of Facility

	Municipal	Factory	Long-term/ Weekly Home	Seasonal (LPG)
1955	37,430	12,626	9,217	7,718
1960	63,731	17,617	10,913	12,373
1965	91,427	25,361	9,431	15,861
1970	129,810	36,602	7,519	9,123

Source: StJb (1960/61), 106; BArch (DQ3/281); StJb (1973), 406.

union "social" funds be spent on facilities useful to women and, most importantly, on child care.[19] They were supported by the petitions of women workers to municipal officials and union representatives asking for more and better services, especially child care and laundries.[20]

Men wondered at this sense of urgency. Many male workers saw child care facilities as the Trojan horse of women's participation in production. At a meeting at the Hennigsdorf steel works, they argued that children needed their mothers at home. If child care were available, one man worried, women would want to work, and husbands' "authority would vanish and a poor relationship between the spouses would develop." Male workers, opined the SED functionary who led this discussion, "understand falsely and underestimate the importance of social facilities."[21] Workers alone did not suffer false consciousness: neither factory trade union leaders, factory managers, district officials, nor municipal authorities wanted to invest in child care. It was an expensive enterprise, for which mothers paid only ten percent of costs (a father's pay was never debited). Every authority dragged its heels, hoping someone else would feed the kitty.[22]

The Department of Mother and Child, under Kern, oversaw the expansion of public child care and supervised all childcare facilities. Kern occupied this domain assertively. In memoranda to other state authorities, she repeatedly pointed out the deplorable failure to meet quotas set by the

[19] Külke, "Berufstätigkeit," 100.

[20] SAPMO-BArch, DY30/IV2/17/37, Bl. 135, Information über den Stand der Produktion von Haushaltgerät, 26.3.57; DY31/250. Protokoll der 4. Prasidium-Sitzung d. BVS d. DFD am 12.9.58, S.3; DY 31, Folder 338, Einschätzung . . . Handelskonferenz . . .

[21] SAPMO-BArch, DY30/IV2/17/51, Bl. 503–4, Bericht im Stahlwerk Hennigsdorf am 20.6.49.

[22] SAPMO-BArch, DY30/IV2/17/7, Bl. 137–43, Bericht von der Besprechung mit den Frauenleiterinnen der Industriegewerkschaften . . . 9.11.48; BArch, DQ1/3851 Adamzik an HAMuK, 7.11.51. Municipal councils took over day care from negligent district authorities: LStA, 924, Bl.42, Kinderkrippen, 31.8.53.

five-year plan. She dispatched members of her staff to inspect factories to see if the building could accommodate children; she leaned on firms to assign monies to child care.[23] Kern exercised more clout over municipal officials than over VEB directors and, thus, municipalities made greater progress than factories in the provision of infant and toddler care (Table 5.2). Municipalities sometimes simply expropriated private and church-run children's institutions, though many of those continued to operate.[24] Looking for excuses to expropriate, inspectors for "Mother and Child" tried to find faults with church facilities but had to concede that parents preferred these well-financed centers to the typically slapdash communal facility.[25] Kern enjoyed the greatest success in cities where the SED was "invested" in the woman question. Berlin—the GDR's showcase city, a district with high female employment, and the SED chapter with the most women members—had the highest percentage of crèche space relative to children aged 0 to three (16.3 percent compared to a national average of 10 percent). Kern's power to pressure factory directors did increase over the decade. Take the case of the film factory Agfa Wolfen, the GDR's biggest "women's factory." In 1959, Wolfen operated crèches with places for 500 infants and toddlers; yet this number barely dented the needs of its 8,500 women workers. The BFA asked Kern to intervene. The threat of her appearance prompted Agfa managers to create space and hire care-takers for an additional 500 infants within two years.[26] Administrators and managers expanded facilities only under duress, and haphazardly. Crèches sometimes lacked plates, cups, play space, hot water, or toilets. Women functionaries angrily attributed such conditions to male indifference and ignorance.[27] In reaction to male neglect, women in the BFA, DFD, or other SED front organizations such as the National Front and People's Solidarity took matters into their own hands. In the manner of

[23] BArch, DQ1/2245 Hauptabteilungsleiterin (Kern), HAMuK, Berlin, den 6.6.52; DQ1/2245 Kern an die 5 Länder, Betr: Betriebliche Kinderkrippen, 1.8.51; DQ1/3851, Bericht: Betriebsbesuche in Zusammenarbeit mit dem MfG, 14.2.51.

[24] BArch, DQ1/1890, Bl. 7, Bericht . . . 21.9.53; DQ1/2245, Schwerpunkte in der Arbeit Mutter und Kind . . . 23. 9.53; DQ1/2245, R. Naumann an K. Kern, 12.12.55; StJb 1960–61, 115. In 1960, roughly 75,000 (of around 356,000 total) children attended *private* kindergartens.

[25] On church facilities, see, e.g., SAPMO-BArch, DY30/IV2/9.05/102, Bl. 21–22, M.Watzlawik an ZK , 8.6.51; Bl.25, Abschrift eines Schreibens des Bischöf Generalvikariat Diozese Fulda . . . 4.5.51; BArch, DQ1/4725, Bl. 201–2, Dr. Fassbinder, Landesregierung Sachsen-Anhalt, MfG, an MfG, 10.1.51. Nursery personnel earned little. See LStA, 916. Bl. 150, Protokoll . . . Kinderheim Tschaikowskistrasse, 2.11.55.

[26] BArch, DQ1/6363, Symalla an Kern, 19.2.60; Kern an Symalla, 1.3.60; Kern an Völkel, Parteisekretar der VEB Filmfabrik, 29.3.60; Betriebszeitung, 6.3.60.

[27] BArch, DQ1/3851. DFD Brandenburg an MfG, HAMuK, 31.2.52: DQ1/1890, Bericht . . . 18.9.52, 5.

pre-1933 bourgeois women's groups and the Nazi *Frauenschaft*, they convinced villagers to build facilities, mobilized the voluntary labor of carpenters to outfit them, and raised money from women workers for children's centers.[28]

The tale of other factory services parallels the saga of child care. Again, the list of services can dazzle the researcher. The big chemical complexes, for example, built "shopping avenues," where workers could purchase basic and luxury food, shoes, cloth, sheets, underwear, and household appliances. They could have their footwear, clothing, and appliances repaired and get their dirty laundry cleaned. Leuna and Buna operated, in addition, shops, laundries, and coal-delivery services in nearby towns, but exclusively for their employees. Grain and hogs were raised on empty acres within the vast confines of these enterprises, so their cooks never lacked supplies for the thousands of meals they prepared each day. These and other giant firms had swimming pools and libraries on the grounds; they ran convalescent homes and children's camps in bucolic locations. Factory social workers watched over pregnant women and taught mothers to care for their babies and prevent the spread of childhood diseases. Leuna's social workers also administered five centers in surrounding towns that helped workers find housing, apply for pensions, or resolve family crises. More ominously, social workers tracked down absent workers and ensured that applicants for the housework day really had the dependents they claimed. In 1951, Leuna's counseling centers booked 30,000 in-office appointments and 8,700 home visits.[29]

Like lists everywhere, these astounding inventories can mislead. Reports admitted that, even in the big "show" plants, the seductively named "shopping avenue" was plagued by long queues, lack of supplies, and poor quality. As the employment of women rose, especially in chemicals, such problems worsened.[30] Smaller plants, such as textile mills with their overwhelmingly female workforces, did not offer a wide range of services and often provided few amenities of any sort. Women workers in village-based mills enjoyed the fewest services, despite their onerous domestic

[28] BArch, DQ1/3851 Frauenausschuss VEB Venus-Werk Lübben Spreewald, an Staatssekretärin für Gesundheitswesen J.Mattern, 19.5.52; DQ1/2369, Bl. 7–20, MfG, Bericht . . . 24.9.52. See also LStA. 924, Bl. 136–37, 19.10.53; Bl. 130–31,18.1.54; Bl. 203, 19.8.54.

[29] BArch, DQ1/6634 (newspaper article: Tägliche Rundschau, 28.3.50); LAM, A1170, Leuna Werke, Frauenförderungsplan [1954]; A 910, Personnalabteilung, Arbeitsangelegenheiten, 26.2.52. Also see VEB Buna, Rep.II-1/319 [1953]; VEB Buna. Rep.II/2 1251, Bericht . . . 1954; Rep. II-12/954, Die Frau im VEB Buna, 1954, 31; II-12/954, Geschichte der Arbeiterbewegung . . . [1954], 83–4.

[30] See, e.g., LAM, IV2/17/1439, SED Betriebsgruppe Filmfabrik Agfa,Wolfen. Betr: Frauenversammlung, 30.1.52; VEB Buna, Rep. II-12/954, Unterlage zum Referat für die Betriebsfrauenkonferenz des VEB Buna 23.6.59, 29.

burdens. Just to *heat the water* for the weekly wash, village women had to schlep coal, wood, and water across considerable distances.[31]

The laundry question was a major one. Doing the wash robbed virtually every employed woman of many hours a week. Hence, a laundry service seemed a particularly smart investment for a "woman's factory." Good intentions did not always pan out. Again, "feminizing" and "priority" chemical factories offer the best-case scenario. By 1954, Buna had a laundry, but its delivery system was "not very good." By 1956, all of the big chemical plants had laundries. Yet workers had often to wait six to eight weeks before retrieving their cleaned sheets, towels, or clothes. In that year, the Buna laundries did manage to clean mountains of wash in eleven days. Unfortunately, by 1958, things had deteriorated. Women had to wait three to four weeks for delivery, a report explained, because "all the big washing machines" produced in the GDR were now exported. Women at Buna had, however, nothing to complain about. The 17,000 women employed by chemical concerns in and around Dessau could get their wash done in a laundry *twice a year.*[32]

If the provision of factory services for women was uneven, it was also not new in Germany. During the First World War, the Imperial regime ordered factories, against managerial and union resistance, to hire social workers to help women find housing and buy groceries. The state also instructed firms to provide child care.[33] This skimpy network of factory services continued to function between the wars. The National Socialists expanded it during the Second World War. The German Workers' Front pushed factory social services into peculiarly Nazi territory: heredity, racial hygiene, and the health of the *Volk*. Yet they also provided amenities for women in firms, watched over their health, ensured that pregnancies of *German* women progressed well, mediated between women "and every possible authority and office," conducted house visits, and even supervised the cleaning of apartments. Social workers tried to reduce women's domestic burden by organizing middle-class members of the *Frauenschaft* to mend their clothes and shop for them. Some factories opened shops

[31] SAPMO-BArch, DY34/A347. An Landesvorstand, Betr: Instrukteurauftrag im VEB Bekleidungsfabrik Bürgel, 10.11.5; DY34/712, Entwicklung der gewerkschaftlichen Frauenarbeit seit 1945, 20.6.62, 5–7; LStA. IV/2/17/692. Bericht . . . Bella-Schuhfabrik Groitzsch/Borna am 27.1.54; SAPMO-BArch, DY30/IV2/17/32, Bl. 52, VEB Fettchemie, 6.1.58.

[32] VEB Buna, Rep. II-12/954, Die Frau im VEB Buna, 1954. S.31; SAPMO-BArch, DY34/39/94/5571. Protokoll . . . IG Chemie,18.10.56; DY30/IV2/17/41, Bl.249, Einige Probleme . . . Chemieindustrie . . . 3.10.58; DY34/A1544, Arbeitskreis der Arbeitskraftsreserven (Chemieprogramm) . . . 20.4.59, S. 28–29; DY34/39/91/5570, Bericht . . . Neustrelitz am 22.1.58.

[33] Daniel, 100–3; Sachse, "Hausarbeit," 210, 213, 227.

that sold groceries and basic items. A few firms ran kindergartens. Like the Imperial regime before it and the antifascist state after it, the Third Reich aimed, above all, to increase women's participation in the labor force and to raise productivity. In some cases, the continuities between Communist and Nazi policy were literal. The counseling centers run by Leuna, for example, had been set up in 1938. Many factory social workers were the same women who had counseled women workers under the Third Reich. Soon, change overtook continuity. By the mid-1950s, the sheer quantity of social services, and especially child care facilities, distinguished East Germany from its predecessors. By 1960, there was no comparison between the range and extent of services available even in many small factories in the GDR and the primitive services offered before 1945. Around the same time, the state's motivation for providing on-the-job services also shifted as it cranked up a campaign for the qualification and promotion of the female labor force.[34]

The Housing Crunch

The five-year plans of the 1950s invested almost nothing in housing. In 1961, fifty-two percent of apartments and single houses in the GDR had one or two rooms; thirty-one percent had three rooms; twelve percent had four rooms; and five percent had five or more rooms. Central heating could be found in 2.5 percent of homes. One-third had a toilet, and twenty-two percent a bath. Only 10.5 percent of housing had been constructed after 1945; 44.4 percent had been built between 1900 and 1945; and 45 percent had been built before 1900. Amazingly, poor housing did not become a political issue, for conditions improved because of the flight of three and a half million people to the West.[35] Nonetheless, the shortage and inadequacy of housing generated social problems. The promise of a separate apartment led young people to marry before some should have. When a couple did not receive the promised apartment, they lived with in-laws, and much conflict ensued. In letters requesting permission for an abortion, petitioners frequently detailed an "unhealthy" or "cramped" living situation as a reason not to bring another child into the world.[36]

[34] SAPMO-BArch, DY30/IV2/17/70, Bl. 78–83, Einschätzung . . . VEB Leipziger Baumwollspinnerei . . . [1961].

[35] Klessmann, *Staaten*, 406–7.

[36] BArch, DQ1/5145, Herr J. an MfG . . . 9.8.54; Frau J. an MfG . . . 27.6.54; Frau W., 13.1.54; Herr F., Gera, 19.4.54; 1843, Bl. 294, Bericht . . . Familie E., 15. und.18.9.53; Bl. 321, Anna Rupf, HVTextil, FrauenausschusWirkerei u. Strickerei an Genossen Glaner, 1.Parteisekretar, 3.1.52.

Individual stories convey a sense of dreadful circumstances (*Figure 13*). A woman and her husband had their first two children while living with her mother, brother, and sister-in-law in a three-room apartment. They managed to move just before their marriage crumbled.[37] A seamstress and her handyman husband, refugees from Silesia, lived with their baby in one room until they had the great "luck" of snaring a second room, separated from the first by a long hall trafficked by other sublessees. They later moved into a shed, with garden, that they transformed piece by piece into the sweet, doll-like house they still inhabited in 1997.[38] After moving three times around bomb-devastated Rostock, a teacher and her mother settled into two rooms, one unheated, in a villa that they shared with three other families. The only kitchen was located in the basement and was very crowded at meal times. She and her mother cooked, instead, in an ironing closet. They could not avoid sharing the basement toilet with everyone else. They lived there until 1968.[39]

Workers in industrial regions often lived in especially poor conditions, as illustrated by examples from Leuna's workforce: four adults in one room, four adults and one child in one room, two adults and three children in one room plus a kitchen. Factory directors resided, in contrast, in "big apartments with few people" but, to the disgust of party officials, refused to sublet rooms.[40] The Buna factory financed the construction of 500 apartments for its workers. Nonetheless, in 1954, 2,000 workers lived with their families in barracks on the grounds. In 1965, the barracks still housed 1,527 people.[41] Some workers in the metal industry lived no better: husbands stayed one place, wives another, and children at a third. The effects of the "extraordinarily tense housing situation" reverberated in the bad moods of women workers, who complained loudly and often at the housing bureau.[42] Because of the shortage of housing near factories, workers lived scattered over wide areas and deep into the countryside. Leuna workers lived in 450 localities and traveled up to two hours to work and two hours back.[43] Housing for single women posed particular problems. In 1958, the women's dormitory at Leuna had no private rooms: mothers and their children bunked alongside women without children. "Unpleasant arguments" were common. This dorm sat amidst the

[37] Interview Frau BP.

[38] Interview Frau AB.

[39] Huchthausen, 30–31.

[40] LAM, A914, Leuna Werke, 1953, Bl. 39.

[41] VEB Buna, Rep.II-2/1251, Bericht . . . 1954; Geschichte der Arbeiterbewegung [1954], 83–84.

[42] SAPMO-BArch, DY46/11/273/1869, Bericht . . . 24.11.53.

[43] SAPMO-BArch, DY34/A1544. Arbeitskraftsreserven (Chemieprogram), 20.4.1959.

men's barracks and "harassment [was] not unusual."[44] In the textile industry, fourteen- to eighteen-year-old millworkers lived in a barracks frequented by "older, married men" until the home's supervisor got herself a big dog.[45]

The GDR's worst living situation could be found in towns near the Wismut uranium mining complex in Thuringia whose production went to the USSR. Wismut's overwhelmingly male miners were billeted with local families, who resented having to put them up and hated the prostitution, drunkenness, fights, and vandalism that accompanied them.[46] After Wismut workers "rumbled" to protest labor and living conditions in 1951, the Women's League was assigned the unenviable task of rustling up "mass accommodations" in neighboring towns.[47] The authorities sent more goods to Wismut's stores, improved working conditions, and organized cultural events, yet pubs remained the main venues of entertainment.[48]

A minority of industrial workers experienced, in contrast, the best housing the new state had to offer: the grandiose *Stalinallee* in Berlin and the equally grandly conceived *Stalinstadt* next to the huge new steel complex near the border with Poland. These showcase developments consisted of elaborately designed apartment blocks in the neo-Baroque style beloved by, of course, Stalin. The buildings were attractive, well constructed, and divided into handsome apartments that included a roomy, though not modernized, kitchen. Each building housed a laundry room, common room, and a well-appointed communal kitchen. Stores and services were incorporated into residential blocks. In the late 1950s, the situation for industrial workers as a whole improved more rapidly than for the general population, because the regime concentrated construction of new apartment blocks in industrial areas.[49]

THE ATTRACTIONS OF PRIVATE CONSUMPTION

Even during the era of High Stalinism, the SED made concessions to individual consumption. Compromises were minor and circumscribed by aggressive rhetoric praising delayed gratification. The rush to build Social-

[44] SAPMO-BArch, DY30/IV2/17/41, Bl. 249, Einige Probleme der Arbeiterinnen in der Chemieindustrie . . . 3.10.58.
[45] SAPMO-BArch, DY30/V/2/17/37, Bl. 104–11, Einschätzung . . . Textilindustrie, 5.5.61, 13.
[46] Port, "Workers,"150–52.
[47] SAPMO-BArch, DY30/IV2 /17/87, Bl. 253–58, Instrukteureinsatz in den Kreisen Saalfeld und Rudolstadt 11.9. bis 15.9.51: Bl. 259–61, Plan des DFD . . . Saalfeld/Saale.
[48] Port, "Conflict," 64.
[49] Hübner, *Konsens*, 158. Also see Nicolaus and Obeth.

ism in 1952 and 1953, moreover, cut deeply into gains made since 1948. Throughout, consumption was framed by the motto, "the best provisioning to the best worker."[50] Stalinist distributive inequities angered consumers, as did every aspect of consumption policy. The New Course of 1953 substantially conciliated consumption needs, if begrudgingly and inconsistently. From 1954 to 1956, productionism reared again, though less brazenly than earlier. In the later 1950s, planners moved back toward consumption. Multiple forces ground down the productivist rampart: the steady drips of consumers' choices and complaints, as well as the one-time explosion of workers' strikes; the advice of women Communists, as well as the arguments of Trade bureaucrats; and socialist economic dilemmas, as well as Cold War political rivalries.[51] By 1959 and 1960, a distinctive organization of consumption was emerging from the interaction between these influences and SED priorities. Although identifiably state-socialist, it neither created a truly alternative world of consumption nor matched Western consumerism (*Figure 9*).[52]

The Downs and Ups of Private Consumption

In 1948, SMAD authorized the opening of a state-run grocery and department store (*Handelsorganisation*, or HO). The HO sold goods at set prices, without the ration tickets required in private shops and state-cooperative outlets (*Konsum*). A media campaign touted the HO's wide selection and quality of food, clothes, and household wares. Their appetites whetted, thousands of "women, girls, and men" gathered hours before the first store opened on 15 November in East Berlin. Customers' most "burning" desires, reported *Neues Deutschland*, were for shoes, stockings, and darning yarn.[53] The HO's tempting, but pricey, goods were intended to entice workers to earn "achievement wages." They might even convince workers to join the Hennecke superproduction movement. The HO also aimed to undercut the black market. It was assigned, finally, a central part in the Cold War contest over consumption. Modeled on Soviet department stores and staffed by personnel instructed to put the consumer first, the HO offered desirable goods within a "socialist retail culture." It was an expensive venture, yet woefully underfunded to meet these many goals. Its high prices appalled even the workers and their

[50] Landsman, *Demand*, 16.

[51] Landsman argues that the "consumer supply lobby" was the only effective agent of consumer interest. He is antagonistic toward incorporating gender relations or women's activism into his interpretation. See Landsman, *Demand*, 91–93.

[52] Similar analyses of the derivative character of state-socialist consumerism can be found in Crew, "Introduction," 3; Stitziel, "Seam," 66–67, 76–77; Landsman, *Demand*, 85–87.

[53] Pence, "Schaufenster," 95; Landsman, "Dictatorship," 93–95, 108.

wives who could afford to shop there. During the June rebellion of 1953, demonstrators yelled, "HO makes us KO," and demanded price reductions of forty percent.[54]

The HO, nonetheless, signaled a normalization of consumption. By 1950, East Germans could purchase a greater amount and variety of food in every type of store in the GDR. Normalization was, of course, relative. Flour and potatoes were the only foods more plentiful than before 1939. Production of meat, butter, fat, eggs, milk, and white sugar was actually lower. The populace faced shortages of fuel, soap, mattresses, chairs, lamps, clocks, and various articles of clothing. The First Five-Year Plan projected that by 1952, the GDR would attain the standard of living of 1936. That pathetic goal went unmet, while industrial production soared.[55] In 1952 and 1953, as we saw, East Germans confronted shortages of many daily goods. Yet—salt in the wounds of women consumers—the HO simultaneously opened new venues, staged fashion shows, and advertised silk panties. Outright inflammatory were ribbon cuttings at specialty HOs located on the *Stalinallee*, the grand avenue in East Berlin that showcased a spanking new Stalinist-Baroque apartment and shopping complex.[56] (*See drawing of Stalinallee inset into Cover Illustration.*)

The message was as contradictory as the policies. In his speech celebrating the HO's first anniversary, Ulbricht lauded "people's consumption" but rejected "unnecessary investments [in consumption] . . . at the cost of investments . . . for iron and steel and mining."[57] *Die Frau von heute*, meanwhile, served up the classic fare of the woman's magazine: recipes and menus, sewing patterns, and tips on health and good looks. Illustrated articles demonstrated how to decorate a home, hang drapes, and dress children. They presented sketches of slim, demure models in respectable fashions for work, play, evening, sport, and maternity.[58] Having titillated readers with glimpses of conventionally domestic and gendered consumption, propagandists trotted out maxims of self-control: waste not, want not; good taste and a clean home conquer all; and beauty shines from within.[59]

At the height of the Cold War, the SED did not just moralize about consumption but politicized it. HO window displays trumpeted political slogans (*Figure 6*).[60] The act of shopping became ideologically charged.

[54] Landsman, *Demand*, 38, 55–58, 61–65; Pence, "You," 221–23; Hagen, 61–62.

[55] Landsman, *Demand*, 77, 88; Pence, "You," 227.

[56] Pence, "You," 225; Landsman, *Demand*, 103–5.

[57] Quoted in Landsman, *Demand*, 70.

[58] See, e.g., "Die Gardine zieht sich nicht," Fvh, 5.11.54.

[59] Tippach, "Nymphenbad"; Pence, "Schaufenster."

[60] Pence, "You," 225.

During a criticism/self-criticism–style session at a canning factory near Berlin, a worker admitted that she traveled to West Berlin to buy affordable margarine. A "comrade" could not let such rational behavior go unchallenged, "I prefer to pay higher prices [here] because I know that the excess goes toward building peace . . . not Imperialism." Focused on their "everyday interests," the women workers, lamented a DFD informant at the meeting, failed to see "the connection between everyday worries and the big political issues."[61] As if in direct response to this critique, a petitioner attributed women's "everyday" obsessions to scarcity. "Empty cooking pots," wrote a Berlin housewife to Elli Schmidt in March 1953, mattered more to housewives than the "greatest political events."[62]

The inequities of Stalinist-style consumption peaked during the frantic push to build Socialism in 1952 and 1953. *Schwerpunktversorgung* (priority provisioning), introduced in January 1953, held out the promise of better provisions as an enticement to hard work by the (mainly male) laborers in "High Priority Industries." *Schwerpunktversorgung* operated along the same lines as Order Number 234 of 1947, but it offered better perks. Workers and engineers in (initially) forty-one large concerns in heavy and basic industry (cement and concrete, mining, foundries, steel, metallurgy, machine building, industrial chemicals) received double rations of meat, fat, and sugar at the canteen *if* they met their norms. In addition, they or their wives could use a factory ID card to purchase food and textiles at the HO or at special in-town stores run by priority firms. *Schwerpunktversorgung* did not just divide privileged workers from other workers but divided their wives from other consumers. Outraged when they saw a neighbor use a "high priority" work pass to shop at the HO, housewives deplored the "injustice" of priority provisioning. In a small town, a pregnant woman was not allowed to buy a single lemon, charged her friends, but a "high priority" housewife purchased ten. The system provoked tensions inside families as the wives of workers in nonpriority industries harassed them to switch to a priority firm.[63] Priority provisioning entered full swing at the very moment when a poor harvest, collectivization, and the offensive against private retailers caused extreme shortages in butter, margarine, vegetables, meat, and sugar.[64] It was, to say the least, exceedingly resented.

[61] SAPMO-BArch, DY30/IV2/17/51, Bl. 613, Bericht. . . Betrieb Lamparski (Konservenfabrik), Werder/Havel, 14.7.50.

[62] Pence, "You," 219.

[63] SAPMO-BArch, DY30/IV2/5/528, Bl. 47, Bezirksleitung der SED Leipzig, Infobericht Nr. 116, 15.6.53; DY31/555, Fiche 1, Bl. 18, DFD Magdeburg an Elli Schmidt, 3.7.53; Bl. 19. DFD Aulda an Bundessekretariat.

[64] Hübner, *Konsens*, 148.

Die Frau von heute had the tricky task of representing *Schwerpunkt-versorgung* as both fair and extraordinary, so that wives would incite husbands to heroic levels of production. An article on *Schwerpunktvers-orgung* featured photos of a "high-priority shop" stocked with the "finest worsted cloth from Czechoslovakia." Titled "As in the Family, so in the Factory," it listed in loving detail the, in fact, moderate amounts of margarine, salad greens, asparagus, and bed linen that a "high-priority" family could buy. The author interviewed the wives of workers in a steel and sheet metal factory that enjoyed *Schwerpunktversorgung*. One housewife declared the system "nothing new! When I was a child . . . my father got the biggest piece of meat because he had to work the hardest and supported us all. . . . [T]he regime has set things up just like in the family."[65]

Patriarchal provisioning did not always function smoothly. As head of the short-lived Commission on Trade and Provisions, Elli Schmidt extolled *Schwerpunktversorgung* to unhappy petitioners but to the Central Committee she excoriated its "bureaucratic problems." A steel plant in Magdeburg, she pointed out, had received 120 *tons* of vegetables. The excess rotted in vast piles outside the plant, near the entrance to a construction site whose workers dared not take the (once) choice overflow.[66] *Die Frau von heute* espied dark forces behind such snafus: "The threads of agents and saboteurs . . . have mangled and tangled our provision system."[67] DFD members were there to help disentangle the strangling threads. They carried out "controls" in the HO and *Konsum* to ensure that women did not engage in "hamstering" when "whisper campaigns" spread fear of shortages.[68]

Women consumers hated the Stalinist consumption system not only for its inequities, but also for its inefficiencies. A ubiquitous grievance of 1952 and 1953 was the cost of nylon stockings, whose price shot up after planners shunted off investment for textile manufacturing to heavy industry. The State Planning Commission considered *Perlon* a luxury. Employed women begged to differ. The exorbitant cost of nylons forced, they complained, "endless darning" of stockings. Women compensated for cuts in textile production with their unpaid labor. "With one stroke of the pen," wrote a working woman, the state "forces our workers to take on once again the trouble of 'stocking darning' and the loss of time connected with it." When Perlon was less expensive, she had "more time for my

[65] "Wie in der Familie, so im Betrieb," Fvh, Nr. 23, 5.6.53.

[66] SAPMO-BArch, DY30/IV2/1/115, Bl. 142, SED ZK Tagungen des ZK, 13.–14.Mai 1953. Also see Landsman, "Dictatorship," 186; Landsman, *Demand*, 57.

[67] "Wie in der Familie, so im Betrieb," Fvh, Nr. 23, 5.6.53..

[68] SAPMO-BArch, DY30/IV2/1/115, Bl. 154, Tagungen des ZK, 13/14.Mai 1953; DY31. 317. Bericht d. Sek. Nr. 12/55 6.4.55, Bl. 302. Arbeit des Klassengegners.

studies."[69] As this petitioner suggested, the forced reallocation of time undermined the program for women's emancipation *and* postponed women's contribution to productivity as educated workers. Instances of such wasteful scrimping abounded. Institutional food, for example, tasted so dreadful that mothers often cooked a midday meal for the family, even when children and husbands received coupons for school and canteen meals.[70] State monies were squandered, family budgets were strapped, and women stayed home to do work that socialized services could have performed well.

The crisis of 1953 forced a turn away from extreme productivism. Under the New Course, investment in consumption rose. Fruit, jams, and hams were imported from the People's Democracies. Farmers could keep profits they earned from selling surplus produce on the market. The state reduced prices on basic foods, shoes, children's clothing, fabric, socks, *nylons*, radios, and bicycles. The regime encouraged, rather than harassed, private shopkeepers whose businesses accounted, after all, for almost a third of retail sales in the 1950s.[71] Trade bureaucrats encouraged designers to study the presentation of consumer wares in West Berlin shop windows.[72] The Ministry of Trade opened a catalog service and stocked its warehouses with the GDR's best clothing and durable goods. In 1956, Trade introduced a few self-service stores, though *Selbstbedienung* remained uncommon before the 1960s. Customers could now buy some goods on credit. *Neues Deutschland* and other dailies played up these consumer trends.[73] *Die Frau von heute*, too, heralded the turn away from austerity. In December 1954, it celebrated a quintessential feast of consumption, Christmas, with photos of gaily decorated trees, mounds of pretty packages, and lovely models in holiday attire.

All this was not just pie in the sky, but sausage in the stomach. East Germans swamped memories of the hunger years in a "wave of gobbling" (*Fresswelle*). The consumption of butter, sausage, and other fats reached prewar levels in 1954 and 1955 and kept climbing into the late 1950s. By 1959, East Germans *expected* foods that had only floated through their dreams five years earlier.[74] According to a GDR study that compared "breadbaskets" in the FRG and GDR in 1960 and 1961, the East German basket contained, predictably, more bread and potatoes, but fewer eggs,

[69] Pence, "You," 238–39, 241.

[70] Landsman, *Demand*, 21. On the place of the home-cooked meal in German culture, see Keith Allen.

[71] Landsman, *Demand*, 116–24; Port, "Conflict," 472.

[72] Pence, "Schaufenster," 102–5.

[73] Landsman, *Demand*, 136–41, 186–87; 125; Kaminsky, *Wohlstand*, 64.

[74] Hübner, *Konsens*, 134, 155; Roesler, "Konsum"; Stitziel, "Fashioning," 40–41, 42, 62.

TABLE 5.3
Percentage of Households Owning Selected Consumer Durables

	1955	1960	1965	1970
Refrigerator	0.4	6.1	25.9	56.4
Washing Machine	0.5	6.2	27.7	53.6
Television	1.2	16.7	48.5	69.1
Passenger Car	0.2	3.2	8.2	15.6

Source: StJB (1973), 336.

less fruit, and much less tropical fruit, chocolate, and coffee. More surprising, East and West Germans ingested equivalent amounts of meat, butter and margarine, and fish, puffed equal numbers of cigarettes, and quaffed similar quantities of beer and brandy.[75] Working-class families supplemented their diets with vegetables grown in leased garden plots. In small towns, industrial workers raised chickens, geese, ducks, pigs, sheep, and cows during their "leisure" time.[76] They sold or traded the surplus and, hence, helped the state overcome its inability to satisfy its citizens' culinary cravings.

The improvement in provisions was patchy across locale and type of commodity. Berlin, other big cities, and heavy industrial centers were better supplied than the average town or village. Progress was most notable in food. Even in that case, intermittent shortages occurred, and in 1957 East Germans still used ration cards to purchase more than half of their fats and proteins. Quantities of shoes and clothing rose, and their prices fell, but their design, materials, and construction remained poor. Still scarce were household wares, tools, and, above all, consumer durables such as refrigerators, washers, vacuum cleaners, televisions, and motorcycles (Table 5.3). Relative to West Berliners, East Germans paid high prices for a narrow range of poor-quality goods and could not find certain goods at all.[77]

The problems arose from continuing structural and political limits on consumer production. Landsman argues that the SED began to drift away from the New Course as early as January 1954 and did so on its own initiative, rather than because of the Soviet revival of heavy industrialism at the end of the year. Ulbricht inched the party away from the New Course as he (re)consolidated his hold on power and as the shock of June 1953 ebbed. The Politburo did not dare return to the draconian policies

[75] BArch, DQ3/290. Statistisches Material . . . S.2, Tabelle 1.
[76] LStA, 684, VEB Mitteldeutsche Kammgarnspinnerei- und Streichgarnspinnereien Gera. Nr. 47. Ergebnisse der Untersuchungen . . . [1954].
[77] Landsman, Demand, 77, 147.

of 1952 and 1953; hence, the Second Five-Year Plan (1955–59) projected a forty-percent increase in consumption. Yet the Plan foresaw considerably bigger increases in energy, mining, chemical, metallurgy, and machine building than in light manufacturing or food processing.[78] Internal documents reveal seesawing between consumption and production from 1953 to 1955. The New Course raised quotas for manufactured consumer goods. The Ministry of Trade advocated "market research" in order to ascertain people's actual needs. In 1954, the Department of Statistics surveyed women textile workers about household durables. Eighty-five percent, it found, possessed a radio, roughly half a sewing machine, two-fifths a bicycle and one-fourth a camera, while a paltry six percent owned a vacuum cleaner and a mere three percent had a motorcycle.[79] This useful information went unheeded, however, as interest in consumption waned again. In 1955, noting that production of "mass-demand goods" was a "low priority," the Planning Commission dramatically reduced the quotas suggested by the Ministry of Light Industry for cotton, silk, shoes, clothing, kitchen wares, and bikes. The Second Plan was, in sum, better on consumption than the First, but less so than proposed by Light Industry and Trade, and far below what people needed.[80]

The resurgence of productivism comes as no surprise. The next twist in the story is perplexing. In May 1958, the GDR finally eliminated rationing. To compensate for higher prices, it raised base wages, although planners feared a surge in demand. More astonishing was Ulbricht's speech to the Fifth Party Congress in July 1958. The "main economic task," he announced, was to "surpass" West German consumption levels by 1961. This prophecy, the party leadership surely knew, was absurd.[81] Having just ended rationing of basic goods, Ulbricht promised speedy delivery of consumer durables, including refrigerators, washing machines, and televisions, that were only just showing up in most West German homes. The pledge was outlandish, but it was more than Cold War grandstanding. The state, ministerial documents show, did plan to improve textiles manufacturing and expand appliance production. In another indication of interest in consumption, the GDR sent a deputation to Sweden in December 1959 to study consumption in a Social Democratic market economy. Stunned by the scale and quality of self-service, awed by the

[78] For analyses that emphasize absolute increases in consumption, rather than its limits relative to industrial investment, see Staritz, *Geschichte*, 89; Hermann Weber, *Geschichte*, 261, 266–70, 280–81.

[79] LStA, 684, VEB Mitteldeutsche Kammgarnspinnerei- und Streichgarnspinnereien Gera. Nr. 47. Ergebnisse der Untersuchungen . . . [1954]. On market research, Landsman, *Demand*, 153–55.

[80] Landsman, *Demand*, 116–17, 125–26, 130, 132.

[81] Ibid., 175–80.

ingenuity of housewares, and enraptured by sparkling communal laun-
dries and livable modern apartments, the Communists returned to Berlin
lugging bags stuffed with hundreds of Swedish products for GDR facto-
ries to copy. A month later, Ulbricht's crystal ball provided East Germans
with another tantalizing vision of consumer nirvana. Socialist industry,
Ulbricht pledged, would produce "a thousand little things," from can
openers, cheese cutters, and egg cups to screwdrivers and replacement
parts, all the many household items that the GDR lacked because it
poured its steel into producer goods.[82]

In 1958, then, the SED eliminated rationing, raised the wages of the
worst-paid workers, executed a sharp, even dizzying, rhetorical spin in
the direction of domestic consumption, and intended to produce results,
if not the extraordinary results forecast by Ulbricht. Historians point to
several reasons the regime may have felt compelled to make these moves:
discontent among the intelligentsia following the revelations in Khrush-
chev's Secret Speech about Stalin's Terror; Khrushchev's interest in im-
proved consumption in the USSR and the GDR; the beckoning of the West
German "economic miracle" to skilled and professional East Germans.[83]
No doubt, these factors, especially the last, helped motivate the turn. Fun-
damental, however, was a set of economic traps that had begun to worry
state bureaucrats, planners, and the SED: losses in revenue from failure
to meet consumer demand; the worsening shortage of labor, especially
skilled labor; and the need to develop products that would decrease de-
pendence on expensive, imported raw materials. Several of these difficul-
ties arose directly or indirectly from women's decisions as consumers and
housewives, i.e., as domestic workers. Women boycotted GDR fashions
and spent lots of money in West Berlin; housewives refused employment,
because the hassles of a job were not worth low wages; and all women
wanted appliances, kitchen gadgets, and other household items—and
seemed ready to work for them.

In 1956 and 1957, Trade officials pointed insistently to the large pile
of marks that East Germans spent in West Berlin. Especially striking were
textile sales. The inferior conditions and ancient machinery in East Ger-
man mills affected not only workers, but also the cloth and clothes they
made. Textile and garment production suffered more than producer in-
dustries from Stalinist *Tonnenideologie* (taking quantity as *the* measure
of success). To meet quotas, designers favored solid colors over patterned
fabrics, smaller sizes over larger, and styles that used less material. Poor-
quality, unfashionable GDR-made fabrics and dresses lay unsold and dis-
integrating.[84] The woes of textile and garment making were not only fi-

[82] Merkel, *Utopie*, 52, 126; Landsman, *Demand*, 179, 195–96.
[83] See, e.g., Landsman, *Demand*, 12–13, 175, 185; Hübner, *Konsens*, 60.
[84] Stitziel, "Fashioning," 62–64, 81, 86, 151, 156, 226, 230.

nancial. Low-quality confection, warned Trade bureaucrats, undermined the state's legitimacy, especially among Berliners, whose mood the SED gauged with special concern. A report observed inelegantly, but astutely: "The population hardly judges the workers' and peasants' state according to what it has created in the way of new factories, such as the iron works in Stalinstadt, but rather according to how it perceives [the state as] improving its living conditions, which, next to the provisioning of food, is reflected above all in the qualitatively better and less expensive provisioning of textiles."[85]

As Trade officials and the SED elite recognized, the "population" in question was largely female. Most complaints concerning fabrics, underwear, or outerwear came from women. Clothes piled up in GDR warehouses because women of all ages and youth of both sexes rejected them in favor of stuff "made in West Germany." Elli Schmidt's Institute for Clothing Culture staged remarkable numbers of fashion shows in the late 1950s to tempt consumers with the finest of East German couture. Shows took place in women's factories, at fairs, and at festivals (*Figure 10*). In backhanded acknowledgement of women's role as taste makers, *Die Frau von heute* tried to shame them away from "wasteful" fads such as wide skirts. Women studied the slim-skirt sketches in *Frau von heute* and flocked to fashion shows, yet they did not buy socialist, in part because GDR stores did not often carry what the models paraded. If women liked a style, they purchased Western fabric and worked it up themselves or hired a private tailor or seamstress.[86] Women's interest in fashion was, of course, neither new nor unique. Postwar deprivation may, however, have whetted the appetite for fashion. Workforce participation seems to have had a similar effect. Young Novatex workers paraded into the mill in spiked heels and flounced skirts, donning work smocks only after wowing everyone with their sartorial splendor. The notably "feminine" representations of women in the illustrated press, argues Ina Merkel, suggest that official culture, too, abhorred a sexless vacuum, even as the SED aimed to corral the fashion mania toward socialist ends.[87]

The family shopper crossed into West Berlin to purchase much else besides clothes. East Germans shopped "west" for shoes, spare parts for bikes, kitchen knives, light bulbs, razor blades, zippers, and toilet paper.

[85] Landsman, "Dictatorship," 243; Stitziel, "Fashioning," 53.

[86] Stitziel, "Seam," 51, 58; Stitziel, "Fashioning," 62–64, 81, 86, 151, 156, 226, 230; Landsman, Demand, 143. For evidence of the popularity of fashion shows among women workers, see SAPMO-BArch, DY30/IV2/17/65, Bl. 199–200, 25.2.59, Die Arbeit des FA in Leuna; DY30/IV2/17/69, Bl. 116–17 Bericht . . . VEB Kunstseidenwerk "Siegfried Rädel" im Kreis Pirna, 17.6.59. On women's creative self-fashioning: interview Frau AB.

[87] Merkel, . . .*und Du*, 43. Also see Stitziel, "Seam," 61.

Women no longer abandoned their work stations to buy bread, but to procure household items, "the 1,000 little things" that Ulbricht pledged in January 1960 would soon, very soon, be for sale in the East (*Figure 11*).[88] They also bought bananas, oranges, chocolate, coffee, toys, and, of course, fashion magazines. In 1954, East Germans made monthly purchases of 200 million marks in West Berlin.[89] Such numbers awoke planners to the "stimulating power of people's consumer needs."[90]

Not all of the losses to East German industry would be made up in the near future. Whole categories could be addressed, however, by modernizing an industry in which, like textiles, eastern Germany was traditionally strong: organic chemistry. From plastics, elastics, nylons, and rayons could be made useful and pleasing table and cook wares, stockings, and easy-care synthetics whose production did not demand iron, cotton, or silk and, indeed, few foreign materials except the subsidized oil beginning to flow out of the USSR. In the mid-1950s, plan projections for the chemical industry leaped upward. Research and development in chemicals was linked to improving the well-being of, especially, female consumers, as is suggested by the slogan "Chemistry Provides Bread, Prosperity, and Beauty." The chemical industry adopted this tag in November 1958, four months after Ulbricht prophesized the rapid overtaking of consumption in the FRG.[91]

The chemical program reflected not only a changing understanding of the economics of consumer spending and raw materials. It was also about the labor shortage. The SED needed to stanch the flow of westward migration and to mobilize the GDR's shrinking labor reserves. By 1957, the reserves consisted, basically, of housewives. In late 1957 and early 1958, the FDGB and the SED became concerned about stagnation in women's rate of employment. The Labor Ministry, we recall, reported, "The reserves are there but the women don't want to work."[92] Chemicals were already a feminizing industry. The shift toward plastics and synthetics—lighter applications of chemical processes—would render more of its jobs

[88] See, e.g., SAPMO-BArch, DY30/IV2/5/968, Bl. 55, SED Plauen, an ZK u. Bezirksleitung der SED, 24.4.56; DY30/IV2/17/35, Bl.1, Bericht . . . IG Metall am 7.12.56; DY30/IV2/17/72, 6.10.62, I. Einige Fragen zum Nationalen Dokument, Bl. 42.

[89] Landsman, "Dictatorship," 243; Kaminsky, *Wohlstand*, 62.

[90] Quote: Mühlberg, "Arbeitsgesellschaft," 195. Mühlberg does not mention family and household as a "source of influence" on "ways of life" (186–89). Sachse, in contrast, ties consumption to housework and household (Sachse, *Hausarbeitstag*, esp. 33–34, 273–91, 303).

[91] Hübner, *Konsens*, 155–56; Pence, "Schaufenster," 95; Tippach, "Nymphenbad," 118, 121–22; Stokes, 65, 70; Rubin, 87–91. Also see Ahlefeld, Molder, and Werner.

[92] SAPMO-BArch, DY30/IV2/2.042/20 Bl. 168, MfA, Stellungnahme z. Halbtags und Teiltagsarbeit, 18.2.58.

"woman-friendly" if, that is, housewives who lived in the chemical belt could be persuaded to take them. The slogan "Chemistry Provides Bread, Prosperity, and Beauty" aimed to attract women into chemical production by cleansing it of dangerous, dirty, and oily associations, while hinting at the nice things they could buy with their wages.

Unfortunately for the SED, women not yet in the workforce were comparatively impervious to small sticks and carrots, either because they had small children at home and/or because they were married to a well-paid worker. Sugarplums were required to attract these wives into paid employment—hence, the promises of "1,000 little things" and, especially, consumer durables. Household appliances targeted several birds with one stone. Worker households would need two incomes to afford them, and they would reduce the burden of domestic labor. For years, engineers, designers, and state officials had shown little interest in how the household "worked."[93] Now, home appliances edged toward the center of consumption policy. The socialization of services was not forgotten and, indeed, would soon expand, but the rationalization of housework took on a new allure for both women and the state.[94]

The Renaissance of the Household

It is impossible to say who dragged the household out of its dim corner and dusted it off. Contenders include state officials, opinion makers, industrial designers, retail clerks, shoppers, DFD activists, housewives, employed women, and the shimmer from "over there." The Ministry of Trade, for example, assigned *Konsum* and HO salesclerks the task of asking customers what they wanted from the GDR's retail world. Clerks relayed the information upward, and the reports eventually landed in the lap of the Planning Commission.[95] DFD activists, for their part, manipulated the appliance issue as a lever of influence within the halls of power. Their grip was made strong by women's requests for vacuum cleaners, ovens, washing machines, floor waxers, mixers, blenders, toasters, bread slicers, and the like.[96] These wishes demonstrate, as Sachse points out, "the direct interaction" between housework and consumption.[97]

[93] See Stokes.
[94] Külke, "Berufstätigkeit," 46–47; Obertreis, 185.
[95] Landsman, *Demand*, 153–58.
[96] "Was unsere Männer für den Haushalt konstruierten," Fvh, 21.5.54; 3.9.54, Praktische Neuheiten für die Frau; 21.9.56, Noch einmal Leipziger Allerlei für die Hausfrau; SAPMO-BArch, DY30/IV2/17/33, Bl. 22, Info. der Arbeitsgruppe Frau über die Probleme der allseitigen Erleichterung der Hausarbeit; DY30/IV2/17/33, Protokoll . . . 5.10.56; 39/120/5865. [1957]; DY34/A2080 Bericht . . . Senftenberg und Finsterwalde [1958], 8. Also see Landsman, *Demand*, 167.
[97] Sachse, *Hausarbeitstag*, 33–34, 303.

Competence in the household was integral to the typical woman's sense of self. Most women saw housework as their "autonomous field of action." Single women, for example, resented the unfair terms of the HAT on symbolic as well as real grounds: having the HAT taken away seemed a snub to their femininity.[98] In interviews conducted in the 1990s, older East German women treated as self-evident the feminine gender of the domestic domain. In correspondence to *Die Frau von heute* in the 1950s, women advocated the redistribution of housework to children (girls *and* boys), but not to husbands "with all their [paid] responsibilities."[99] Husbands had no quarrel with that. Indeed, a husband complainant in a divorce case often justified the break-up of his marriage by describing his wife as "unclean and disorderly," or the home as "improperly managed."[100] Statistical evidence supports anecdotal impressions that domestic work was women's work. Even employed wives performed the overwhelming majority of household tasks, spending an average of six hours more a day on housework than did men.[101]

Some women, of course, invested little physical effort or psychic energy in housework. Other women shared it with a male partner.[102] At women's factory conferences, a worker occasionally called for a "socialist marriage," defined as one in which the husband "every so often takes a dish towel in hand."[103] Even when men pitched in more than nominally, women acted as their supervisors. Dörte Grothaus and her husband, both steel workers, worked different shifts. While one was at work, the other shopped, cleaned, and watched their sons. Frau Grothaus pronounced her husband competent at home but then had second thoughts. He did not oversee the boys' homework well and, she added, "(he was not) as clean as I. Okay, oh God, you have to shut your eyes, right? When the husband does [housework]. The main thing is that it's tidy enough so that anyone can see the place." She concluded, "I had to organize the household very strictly." In the case of the banker Frau R. and her husband (also a banker), he shopped for groceries under her management.[104]

The socialization of services, such as it was, did not satisfy women's desire to be a proper homemaker or men's desire for a proper home.

[98] Ibid., 33–34.
[99] "Erziehung der Kinder zur Ordnung und Sauberkeit," Fvh, 7.8.53, Nr. 32; Merkel, . . . *und Du*, 149.
[100] NJ 1956, 514; NJ 1956; NJ 1956, 287; NJ 1956, 543. Also see NJ, 1954, 247.
[101] Ulbricht et al., 28. On the similar domestic division of labor in the Weimar era, see Knapp, 342.
[102] IMC, Interview 034.
[103] SAPMO-BArch, DY30/V2/17/41, Bl. 30, Frauenkonferenz . . . "Schwarze Pumpe" am 28/29.6.58. Also see DY30/IV2/17/71, Bl. 151, VEB Wolle und Seide, 12.4.61.
[104] Niethammer, von Plato, Wierling, 121–22; interview Frau RA.

Women workers did not take advantage of an "instant purchase" system, although this required only that they submit a grocery list at work in order to have groceries delivered to their doorstep. Long queues notwithstanding, women wanted to see what they bought.[105] No socialist service would sweep, mop, and wax the apartment floor—but a privately-owned machine would. Home appliances were also imbued with intangible qualities. Women could be proud of smart, efficient, modern homes; husbands could burnish cherished notions of the domestic space as a cozy retreat from a hectic new world of antifascist politics, socialist management, and social mobility. The inordinate burdens of domestic labor and scarcities seem to have given women pride in their ability to figure out how to feed a family, clothe it, and run a decent household, *despite everything*. The rise in women's employment did not change the gendered valence of domestic space. Rather, a paradoxical psychology set in. The crossing of gender lines at work seems to have reinforced people's need to reassure themselves that they were women *or* men, easily identifiable as one or the other by the clothes they wore to work and the tasks they performed at home.

Official practice buttressed popular attitudes. By tying the housework day to gender, the state obviously endorsed the conventional division of labor. By linking the HAT to marriage, while partially uncoupling it from motherhood, the state appeared to assume, in addition, that a husband legitimately created extra work for his wife, but adolescent children did not.[106] *Die Frau von heute* and *Neue Berliner Illustrierte*, it is true, carried occasional calls for husbands to take up housework or cooking. These stories were illustrated with photos of an aproned man wielding a mop, peering into a gleaming electric oven or, most commonly, serving coffee to women on International Women's Day.[107] Yet the exaggerated frilliness of the apron, the full-dress suit that poked out from behind, and the knowing smiles all round signaled that such performances were topsy-turvy, a confirmation of the order of things rather than an attempt to subvert it. In general, the domestic division of labor went unreflected or even celebrated in the press and in socialist consumption culture. Conventional discourse about women's role in the home often overwhelmed the unconventional message that women and men were alike in the workplace.[108] *Die Frau von heute* headlined a story on new appliances, "What Our Men Constructed for the Household." An HO staged a living tab-

[105] Ulbricht et al., 29–30.
[106] See comments to this effect in: SAPMO-BArch, DY30/IV2/17/41, Bl. 26, Frauenkonferenz . . . im Kombinat "Schwarze Pumpe" am 28.–29.6.58.
[107] Merkel, . . . *und Du*, 163–66.
[108] Also see Sachse, *Hausarbeitstag*, 265.

leau, "A Day at Home," performed by models in a store window as female shoppers pressed their faces to the glass: a woman saw her husband off to work before lovingly demonstrating the power of a tube vacuum cleaner that lay ready to satisfy her needs while he was away.[109] In a long-running ad for its cleaning solutions, the state company Wittol showed *Dr. Glanz* (Dr. Shine) presenting his scientific concoctions to the Family: Mother performed wonders with his floor and furniture polishes, while Father sat at a lustrous table and spot-cleaned his tie.[110]

One can ascertain, in fact, a revival of both genteel and gendered manners in the mid-1950s.[111] The GDR's first advice books appeared in 1956 and 1957. Although they sold well, their number remained few and their discursive tenor is, thus, easily gleaned: they placed bourgeois etiquette back on the pedestal from which Communists once knocked it. Their male authors bundled together proper deportment, order, domesticity, consumerism, and a gendered division of private roles.[112] Karl Smolka's *Good Behavior from A to Z* taught table manners, public decorum, and forms of dress and address to the proletarian-turned-functionary. "Chapter H" was dedicated to *Häuslichkeit* (domesticity). Smolka scolded men who treated home life as petit bourgeois or dull. He advised husbands to take seriously their wives' household concerns and to hand over the "household money" uncomplainingly. In a single sentence, he reminded them of their duty to help at home. Another sentence cautioned women not to put the home before all else. Having neatly disposed of the patriarchal family, Smolka got down to brooms and pans. He chided equally the "shoddy, dirty woman who cannot keep the household in order" and the "cleanliness devil" (*Sauberkeitsteufelin*) who made her home "unpleasant" with incessant vacuuming and wiping. The "test" of the housewife's ability to find the Golden Mean was the arrival of guests: Was "every room clean and orderly"? Were visitors greeted by a sovereign "lady of the house" (*Hausherrin*), or a harassed scrubber in hair rollers? When it came to daily living, the housewife was to develop a weekly budget and housework schedule to ensure that money and time were well spent. Rather than "work irrationally in the kitchen," she should take care to outfit it "practically and efficiently."[113]

Smolka devoted a chapter to domesticity. Neubert's *Marriage Book* revolved around domestic relations. Like Smolka, Neubert ritually de-

[109] "Was unsere Männer für den Haushalt konstruierten," Fvh, 21.5.54; Pence, "Schaufenster," 109.

[110] Tippach, "Nymphenbad," 127.

[111] Also see Ernst, "Politics," 493.

[112] Also see Merkel, . . . *und Du*, 142–44.

[113] Karl Smolka, *Gutes Benehmen von A-Z* (Berlin, 1957), 114–19, 325.

nounced patriarchy and prized the companionate marriage, whose func-
tional division of labor, he assumed, would continue as it was. Indeed,
perhaps it had already changed too much: "inadequate training of the
young wife" was, he opined, a major cause of marital breakdown. The
passion of a young man for his bride initially blinded him to the gaping
lacunae in her upbringing, but the honeymoon was soon over:

> [the husband] realizes that his wife cannot cook, she has no idea how
> to make the apartment cozy. She cannot arrange flowers. . . . What
> has the girl learned? She has appropriated the tools of her occupation;
> she has learned to go to the movies and to dance, perhaps also to do
> sports. If the young man meets an older woman, who runs a well-
> ordered household, he . . . goes to visit the thirty-year-old ever more
> often. It smells good there and everything is in its right spot . . . [O]n
> the nicely appointed table . . .he finds not just bread, butter, and sau-
> sage, but a potato pancake one time, an omelet the next, and an invit-
> ing vegetable salad the third . . . [I]t comes to divorce and an older
> woman has conquered a man with the help of her apartment and
> housewifely competence.[114]

Small wonder that young women workers at Novatex wanted to learn
to be good and attractive wives. Village girls harbored the same desire,
according to a report written for the "Women's Working Group" of the
Central Committee: "[Y]oung girls not only want to dance regularly and
attend cultural presentations, they also expect special discussions and lec-
tures about fashion, cosmetics, and *Wohnkultur* [the culture of the home].
Young girls who plan to get married demand the creation of a special
advisory service on questions of *Wohnkultur,* etc. Many village clubs cater
to these wishes. They have circles for embroidery, cooking, and infant
care. Hair salons and tailor-shops are demanded."[115]

East German opinion makers did not invent the inflation of standards
of housework.[116] Unlike Western counterparts, however, they assumed
that housewives should also work outside the home. A woman should
"appropriate the tools of her occupation," coordinate colors and fabrics,
cook well, and canvass neighbors to join the Society for Soviet Friendship.
The "to do" list entailed much work, while also feeding women's wishes
for the household appliances that could help them do it.

[114] Neubert, *Ehebuch*, 204.

[115] SAPMO-BArch, DY30/IV2/17/19, Bl. 8–13, Material für die Arbeitsgruppe Fr. beim
ZK der SED zu Fragen der Einbeziehung der jungen Mädchen und Frauen in das geistig-
kulturelle Leben auf dem Lande (n.d.[1960?]). For a similar mix of consumer and cultural
desires among factory workers, see DY 30/IV2/17/33. Protokoll . . . 5.10.56.

[116] On the inflation of housework standards at other times and places, see Knapp, 244–
46; Czarnowski, Familienpolitik, 130; Cowan.

While women's magazines and male advice givers stoked private anxieties and domesticated desires, activists in the factory women's committees, the DFD, and the SED contributed to rising official interest in the household by touting "women's demands for small hand-held devices that are easy to clean and transport."[117] The DFD, in particular, helped to legitimize women's cravings by endorsing two widespread complaints of women consumers: the high price of household appliances and the lack of press attention to appliances. Women activists charged that the mixer "Imme" was outrageously expensive (DM 350!) because it was designed for export to restaurants and, thus, to produce meals for twenty-five to thirty people. Relaying upward complaints about poorly functioning or overly complicated machines, they convinced planners to draw housewives into an advisory group on "household techniques."[118] The DFD put out a recruitment pamphlet entitled "Lovely Shop Windows, Good Wares, Satisfied Women," exploiting, Pence argues, women's fascination with household goods to draw them into the system. Demonstrations of appliances, internal reports noted, attracted crowds of women who engaged in "excited" discussions that focused on "where these things can be bought" and how much they cost.[119] The appliance question was not just manipulated by the DFD but forged a genuine link between activists and ordinary women.

A minicult of domesticity bubbled up all round. It percolated, ironically, alongside a renewed current of utopian futurism. An updated version of Lenin's famous phrase "Soviets plus electrification equals Socialism" might be coined to convey the discourse of the late 1950s: Socialism equals state ownership plus automation. Mechanization, women were told, would remove most housework from the home to central kitchens and laundries. Women would continue to perform occasional household tasks with electric appliances as a "hobby."[120] The mechanization of domestic labor, whether occurring in the home or via socialized services, would allow the masses to devote more time to education and to "culture." "Culture," Anna-Sabine Ernst argues, became the word of the hour, used promiscuously to refer to high culture, "work culture," "cloth-

[117] SAPMO-BArch, DY30/IV2/17/33, Bl. 22 Information . . . der allseitigen Erleichterung der Hausarbeit [1956].

[118] SAPMO-BArch, DY30/IV2/17/41, Frauenkonferenz . . . "Schwarze Pumpe" am 28.–29.6.58, 4; DY34/A2080. Bericht . . . Senftenberg und Finsterwalde [1958], S. 8; DY30/IV2/17/37, Bl. 135, Information . . . Haushaltsgeräte [1957]; Bl. 139–141, Anlage: Auswertung des Besuches der Kölner-Haushaltsmesse, September 1956; Pence, "Miniature," 34–38.

[119] Pence, "Schaufenster," 114; SAPMO-BArch, DY30/IV2/17/33, Bl. 58, Protokoll . . . 5.10.56; DY31/338, Einschätzung . . . Handelskonferenz . . ., 5–6.

[120] Ernst, "Culture," 492–93.

ing culture," "home culture" (*Wohnkultur*), "physical culture," "sales culture," and "shop window culture." With the exception of work culture, the "cultures" were associated with leisure, private consumption, or innovative technologies that would free the people to participate in public "high culture."[121]

Advice books presented a concrete and gendered vision of "the culture of the home." In elementary school, according to our friend Neubert, boys and girls should attend the same courses in home economics. In vocational school, however: ". . . bodily hygiene, *Wohnkultur*, musical culture . . . the art of arranging life . . . should be tailored to each sex, if only so that the young men learn to appreciate what their properly raised and well-educated wives can offer them." To avoid misinterpretation, Neubert added, "Should it occur to the reader that here a 'reversion' is intended, a return to Philistinism (*Biedermeier*), he is wrong: he forgets that automization proceeds apace and that in this century we will experience the forty-two hour work week, indeed, the thirty-six hour work week. What are people supposed to do with their free time? Should they fritter it away? Certainly not! Rather, culture will be there for everyone."[122]

In fact, daily life encompassed more than hard work, deprivation, and repression. It had enriching and amusing moments, of which women took as much advantage as they could. Young women in the village wanted not just batik classes but book circles.[123] Urban women attended lectures at the Culture League, sang in choirs, pirouetted through folk dances, and acted in cabaret.[124] They accounted for, as earlier, an overwhelming majority of participants in *Volkshochschule* courses in art, dance, music, and literature, and they attended all of its courses in large numbers.[125]

Yet, as elsewhere in the industrial world, mass culture continued to erode older pursuits. In Germany, commercialization, standardization, and mechanization had been encroaching on popular culture since at least the 1920s. In the 1950s, young East German women "consumed" more movies than any other form of entertainment (until television became available in the 1960s and cut heavily into attendance). More than half of textile workers at a mill in Gera saw at least one movie per month in 1954; a mere tenth saw at least one play per year. In letters to the press,

[121] Ibid.

[122] Neubert, *Ehebuch*, 204.

[123] Humm, 240, 316.

[124] SAPMO-BArch, DY30/IV2/5/222, Bl. 81–82, Protokoll . . . 25.5.49; DY34/39/120/5865, Bericht . . . Kulturarbeit, 7.2.58, S. 4; LStA, 2966, Bl. 9, Rat der Bezirk Leipzig Kreis-volkshochschule Altenburg. 7.5.54.

[125] See, e.g., LStA, 2967, Bl. 67, Analyse der Arbeit der Volkshochschule Leipzig im Jahre 1953; Bl. 38, Analyse des Kreises Wurzen 10.5.54.

queries to the DEFA film studio, and discussions at work, young women asked to meet East German movie stars for "free and easy conversations."[126] That dream was unlikely to come true, but the SED did not object to it. Unwelcome was the magnetism of *Western* pop culture. Adolescent girls begged to learn the latest dance steps—in cities, that meant "rock n' roll, boogie-woogie, be-bop, and other tasteless USA imports." According to a report on village life, village girls wanted to learn the "Lipzi," Leipzig's socialist alternative. If village youth really did want to dance the Lipzi (generally not a great hit), it was only a matter of time before they, too, caught the craze for Elvis and his intriguing gyrations.[127] Village youth also did not yet manifest the defiant attachment to Western idols shown by women in textile mills who decorated their work stations with photographs of "the so-called romantic heroes, movie stars, singers, and other painted apes of the Western world."[128] The "corruption" of the tastes of young LPG farmers may have lagged behind those of mill workers, but they expressed their preferences with similar self-confidence and apparent lack of concern for what the party thought. They "demanded" what they "wanted" and "expected" to get it, according to reports. Rural women claimed to know nothing about the GDR's laws guaranteeing women's equality. Yet married mothers knew they "want equality in the countryside so they can take part in cultural life," and young women knew they "want to have fun in their leisure time."[129] Forthrightness about their desires for culture, pleasure, and fun things did not emancipate village women, but it had, one suspects, liberating effects.[130]

CONCLUSION

After Khrushchev exposed Stalin's crimes, Stalinstadt fell quietly from its place of honor in SED urban iconography. The press began to tout, instead, the "new socialist cities" that were springing up around gigantic industrial complexes. Most famous was Hoyerswerda, the bedroom com-

[126] Ibid.; LStA, Bestand: VEB Mitteldeutsche Kammgarnspinnerei. Akte Nr. 684. VVB Kammgarn- und Streichgarnspinnereien Gera. Nr. 47. Ergebnisse der Untersuchungen . . .

[127] Ibid. Quote from: Schmolka, 176. On the Lipzi, see Ernst, "Culture," 493. On the Elvis vogue, see Fulbrook, 163; Poiger, 195–96, 199. German contempt for American mass culture was not specifically Communist. Conservative West Germans, too, denounced it. See Poiger.

[128] SAPMO-BArch, DY30/IV/2/17/37, Bl. 104–11, Einschätzung . . . Textilindustrie, 5.5.61.

[129] Ibid.

[130] Victoria de Grazia discusses the gender and generation effects of mass culture and consumption in Fascist Italy (de Grazia, 221–28).

munity of a huge brown-coal mine, *Schwarze Pumpe* (Black Pump). Its population jumped from 7,000 in 1955 to 33,000 in 1966.[131] In contrast to Steel City, the population of Hoyerswerda and other new boomtowns included large numbers of women workers, many of them also mothers of preschool children. Citing Hoyerswerda's high-rise apartment houses, youthful population, employed mothers, and general dynamism, the media declared it the city of the future. Up close and personal, it looked more like an enclave of the past. A member of the SED executive committee at *Schwarze Pumpe* complained about the inadequate political engagement of women workers. This tired refrain provoked a heated rebuttal from a woman on the committee,

> People carp about women's inactivity but, in fact, women are generally much more active than men. Unfortunately, they have to prove themselves in ways that actually shouldn't be necessary today—for example, in the matter of shopping, child care, etc. Go observe the wild hunt for food every evening in Hoyerswerda-New City. Watch how women fight to get their kids into a crèche, after-care program, or kindergarten. Imagine women washing their clothes because the laundries are short of capacity.[132]

Obviously, the organization of social reproduction and consumption changed less in the 1950s than is suggested by photos of sunny crèches, gleaming laundries, and well-stocked "shopping avenues." Socialized services were neither the norm nor optimally functional, especially in the "new socialist cities" that most needed them. The press also deceived when it described these services as innovations. Social facilities for women workers were founded on precedents set in the Second Empire and the Third Reich. They served the same goal: to increase the participation of women in labor-starved industries. The press obscured, too, the struggles that lay behind these accomplishments. Institutionalized child care was no "gift" bestowed by the state on passive women. Five-Year Plans set the parameters of child care expansion, but the pledges went unfulfilled. In reaction, women workers demanded more, better, sooner—and women activists made sure someone heard these demands. This, too, recalled the past: the "organized motherliness" of bourgeois women's groups.[133] GDR photojournalism deceived, finally, when it conveyed singularity of pur-

[131] SAPMO-BArch, DY31/269, DFD Bundesvorstand Bericht über die Entwicklung der Arbeit der Frauenorganisation mit kinderreichen Müttern, 10.1.67, Bl. 7–8.

[132] Protokoll der Kreisleitungssitzung der SED-Kreisleitung Schwarze Pumpe, 7.6.61, quoted in Hübner, *Konsens*, 166–67.

[133] On "organized motherliness" in the Second Empire, see Sachße, *Mütterlichkeit*; Ann Taylor Allen, *Feminism*.

pose in the organization of services and consumption. Torn between a supercilious belief in socialism's ascendancy and a visceral competitive urge, caught between asceticism and triumphalism, the SED could not decide whether to forge a distinctive socialist consumption or beat Western consumerism at its own game. Depending on who was speaking and when, official rhetoric vacillated between the socialization of consumption and its domestication. Communists stepped uncertainly onto the alien territory of social reproduction, whereas women understood intimately the failures and injustices of this "shop floor." Official discourse about consumption in general, and about fashion and household goods in particular, bent in a more consumerist direction as it ran up against women's clear sense of what they did and did not want.

The expansion of women's employment caused the other side to bend, as well: men and women came to accept and then to expect that the public sphere would take over some consumer services, some kinds of housework, and even some parts of nurture. The modification of traditional opinion did not approach, however, a transformation of consciousness about the gendered organization of consumption and social reproduction. Men at every level of power had no interest in such a revolution. Self-interest floated in a brew of culture so "second nature" that most men and women did not perceive it. In the past, various women in the German workers' movement had "seen" domestic relations. In the 1920s, Social Democrats in the "socialist life reform movement" called for a new division of labor in the home. In the 1940s, the Antifascist Women's Committee briefly championed wages for housework. Countercultural urges foundered on the shoals of productivist ideology and political oppression. Only out of the ferment of social experimentation and public debate might have emerged a genuinely new conception and organization of consumption, housework, child rearing, leisure, architecture, design, or fashion. That was something the party could *not* imagine. Instead, a collective mentality, centered on production, arose alongside a conventional and private understanding of domestic space and its many labors. Inside the family, women and men tended to reproduce what felt "right" to them. Women chafed at the burden of work at home, yet without access to a counterdiscourse, they had no standpoint from which to challenge the organization of social reproduction as unjust. Instead, they looked yearningly toward a capitalist world that fulfilled conventional desires more satisfyingly and mechanized the private household more effectively than did the socialist one.

CHAPTER SIX

Reconstituting the Family

DOMESTIC RELATIONS BETWEEN TRADITION AND CHANGE

FROM MARX AND ENGELS, German Communists inherited an historical understanding of the family, which recognized that it assumed changing forms and functions over time. Socialists assumed, though, that class struggle and politics shaped the family, not vice versa.[1] What went on between husbands and wives or parents and children seemed especially peripheral to the "main task" in an era characterized by international rivalry between Communism and Capitalism and in a land in the throes of social transformation and economic construction. Hence, the SED took power without a family policy. The GDR's Constitution (1949) and its Mother and Child Protection Law (1950) contain paragraphs that tell us what kind of family the SED did *not* want: a patriarchal family. The SED's vision of the nonpatriarchal family is, however, difficult to reconstruct, for party leaders rarely mentioned, much less discussed, the social role of the family or its structure. Luckily for the historian, the condition of the family did concern some Communist officials, especially those in the MdJ. Having taken over the court system, they discovered that "family affairs" accounted for the overwhelming bulk of civil cases. They realized family law needed to be revised, conducted a lively discussion in the Justice Ministry journal *Neue Justiz* about how to do so, and in 1954 presented a draft family law (EFGB). From this debate, the draft law, and the rulings of family court judges, we can glean an outline of what kind of family the SED wanted. It aimed to modernize and rationalize marriage by, for example, making it easier to dissolve an unhappy union. It wanted to equalize spousal decision making, both in order to limit the power of husbands and fathers and to give the state the authority to intervene in the case of parental discord about child rearing. It would assure the wife and mother the right to take a paid job.[2]

Looking at these legal pieces, West German conservatives divined a grand plan: the SED aimed to destroy the father-headed family, erode

[1] Landes; Busch, 37–39; Neubert, *Geschlechterfrage*, 5–6.
[2] See, e.g., Gerda Grenz, "Soll Mutter arbeiten?", Fvh, Nr. 38, 21.9.56, 3.

marriage, and socialize child rearing.[3] In truth, the SED never seriously entertained, much less elaborated, a transformative idea of the family. It did not intend for the nuclear family to wither away.[4] It did not consider communal living for adults or children. Although jurists touted the proletarian family, they actually envisioned a tightly knit nuclear unit that fit the living arrangements of the prewar bourgeois family, except that the SED version would have an employed wife.[5] The "optimal" family offered its members love, companionship, and mutual support, and was anchored in heterosexual marriage. Signs of "disorganization" such as high divorce rates, adultery, and unmarried cohabitation disturbed leading Communists. True, the SED hoped eventually to displace labor out of the family into the collective sphere. The aim, though, was not to destroy the nuclear family, but to make it into a nexus of sheer affection by removing its financial insecurities and inequalities.[6] The SED believed that the family revolved around an immutable core: biological reproduction. Children gave marriage meaning. As their bearers, mothers had, Communists assumed, a closer relationship to children than did fathers. The mother was, therefore, the natural nurturer.[7] Indeed, women had a maternal instinct: the "healthy" woman wanted to bear and raise children and felt truly fulfilled in life only if she did so. The Communist version of this belief contained a radical kernel: childbearing defined womanhood more than did marriage. This assumption was, however, never more than latent in official discourse.

Having implemented maternity leaves, pregnancy counseling, and strict regulation of abortion to bring more children into the family, East German Communists did not turn around and take them away from their parents. State homes for orphaned, abandoned, and abused children housed ever fewer children as the postwar crisis waned. The state did remove a small minority of children from their families, typically because social workers considered the parents to be "asocial." Certainly, the state tried to control the socialization of school-age children in its effort to forge a populace that was loyal to the state and collective minded. The state also denied access to higher education to some children whose parents were "bourgeois," Christian, and/or politically recalcitrant. It did none of this, however, to undermine the family as an institution, but to

[3] See, e.g., Storbeck, "Familienpolitik," 90–95.

[4] For similar points, see Obertreis, 134; Helwig, "Einleitung"; Frerich and Frey, 401.

[5] Catherine Epstein notes the conventional domestic arrangements of Old Communists after 1945 (Epstein, 121–22).

[6] See, e.g., Hilde Benjamin, "Einige Bemerkungen zum Entwurf eines Familiengesetzbuches," NJ 8 (1954), 351; "Über die Liebe in unseren Filmen – Bemerkungen zur Filmdiscussion des 'Neuen Deutschlands'," ND 5.6.53.

[7] See, e.g., August Bebel's position, explicated in Bühler, 16.

ensure the political fealty of family members. Like governments on the other side of the Iron Curtain, the SED wanted a stable, conformist, quiescent nuclear family. This common East/West goal was lost in the charged atmosphere of the Cold War. Western discourse turned "the family" into an anti-Communist tool. The Western message was consistent: celebration of marriage and the housewife-family, excoriation of maternal employment and institutionalized child care. Socialist family imagery about the family was neither as ubiquitous nor as uniform. The press depicted children as content with parents and in the crèche, lauded the employed woman and her housewife neighbor, and neither shamed nor acclaimed the unmarried mother.[8] Images of paternity closely echoed Western tropes: Father tosses happy Toddler, Father constructs train set with attentive Son, Father smiles indulgently at radiant Daughter.

The heterogeneity of the discourse suggests the lack of a coherent vision, for the SED was a party that pursued its goals single-mindedly. Family constellations were, of course, *actually* heterogeneous. The misfit between the SED's representation of the family and everyday reality lay not here, but in the low significance assigned the family in Communist discourse versus its revered place in the popular imagination. Although SED leaders occasionally genuflected to the family bond, they obviously did not think a lot about the family's emotional economy or its socializing (as opposed to politicizing) role. What did not interest them, they assumed, did not interest the people. Justice officials were astounded by the passionate debate that erupted when the MdJ presented the draft family law for public discussion in 1954. Five years later, party leaders read with surprise the preliminary findings of a survey of 30,000 East Germans about "socialist ethics." A large majority of interviewees disagreed with the SED that the work collective shaped morality. They ascribed the key role in character development to the family.[9] The family, apparently, was not as secondary as Communists assumed.

Nontraditional Families

The demographic effects of the war had a dramatic short-term impact on the structure of the family. In 1950, 1,484,361 widowed, single, and divorced women between the ages of twenty-five and fifty-five lived in the GDR, as opposed to 504,178 such men; 2,021,094 households were headed by women, while 4,166,123 households were headed by men

[8] Heineman, *Difference*, 224–27; Obertreis, 139.
[9] Zerle, 11,14–18, 19–21. Zerle's team of researchers conducted interviews between 1959 and 1961.

(almost all with a wife).[10] Over the decade, the ratio of unmarried women to unmarried men and the percentage of female-headed households shrank considerably. The war did not leave, Elizabeth Heineman argues, "a whole generation of women" unmarried in either West or East Germany, if only because men in both states married at a higher rate than ever before. The war did, however, negatively affect women's marriage prospects.[11] Older women, in particular, were unlikely to (re)marry and the female-headed household remained much more common than before the war. Marital status was a socially significant indicator for women, because single women worked at a much higher rate than wives and because married women were generally better off. Of course, the category "single women" divided along lines of age, maternity, previous marital status, and social background. Changes in family law and welfare policy in the new state affected each subset differently. On the one hand, the state implemented policies that embittered divorced women and widows. The elimination of war pensions, reduction of other pensions, cuts in welfare, and gradual elimination of alimony forced these women to find a job. These changes reverberated through female-headed households. Immediately after the war, for example, a (grand)mother, daughter, and (grand)daughter lived off the war pension of the daughter-widow and the regular pension of the grandmother-widow. In 1950, when the state cut off the daughter's pension, she went to work as a sales clerk; her mother took care of the granddaughter. Soon, the grandmother's pension, too, was cut, so she had to find a job. A paid nanny looked after the girl.[12] On the job, too, single women felt devalued, owing to the denial of the household day to unmarried women without children at home. New laws, on the other hand, improved the legal and social situation of single mothers. They were now the legal custodians of their children. Neither they nor their children could be discriminated against at work or in public housing. The children had the same paternal inheritance rights as children born inside a marriage. In recognition of the fact that they had to work, single mothers had first claim on places in crèches. Training programs for women workers, such as they were, benefited single women without children, because they could more easily take advantage of them than could wives and/or mothers.[13]

It was not unusual for single women to reside with their parents, children, and/or adult siblings in extended families. In a second example of an all-female household, the adult granddaughter trained for a skilled

[10] StJb, 1955, 19, 22.
[11] Heineman, *Difference*, 211.
[12] Niethammer, von Plato, Wierling, 420.
[13] Heineman, *Difference*, 190; Obertreis, 128.

position while also working to support her mother and grandmother. She could manage to work *and* train because her mother ran the household. She was, Dorothee Wierling points out, at once "husband"-earner, daughter to her doting mother, and "mother" to her less worldly progenitor.[14] In a third example, a textiles saleswoman from a proletarian family lived in a "big family gang . . . a large apartment" that included grown men, though no husband for her. The "gang" encompassed her, her two sons, her parents, and her brother and her sister before they married. The arrangement was ideal for her because, as SED secretary in her mill, she was very busy, and "my mother or father or my siblings could watch after my boys."[15] In a fourth case, Frau G. left her village after the war to live with her older sister in Finow/Eberswalde, near Berlin. She eventually joined the grounds crew at a nearby Pioneer Republic (a camp for selected members of the SED's mass organization for children), a privileged, though unskilled, occupation that she loved and owed, no doubt, to active membership in the SED. Her daughter was cared for in a crèche/kindergarten. Frau G. believes strongly that the SED state fulfilled its duty to her, an uneducated single mother "up from the farm."[16]

Right after the war, the percentage of children born out of wedlock increased dramatically. It declined soon but stabilized at a relatively high thirteen percent throughout the 1950s. Social intolerance of "illegitimate" children lingered. In a letter to the *Leipziger Volkszeitung* in 1956, a young man concluded from personal experience that the "thousands of illegitimate children" in the GDR were "excluded," subject to "every ignominy," and victims of "psychological distress."[17] Yet, retrospectively, children and their mothers recall being treated well. Born in 1946, Frau D. was raised by a single mother in Grossenhain, a small Saxon town. Neither she nor her brother, she reports, felt a hint of discrimination. Instead of social angst, she remembers a loving relationship with her mother.[18] Tolerance of their children did not mean that single mothers had an easy time of it. Aside from orphans' allowances for widows' children and the child support received by divorced mothers, single mothers had to make their own way and headed poorer families than did married couples.[19] It was, Liesbeth Mühle recalled, "very, very hard" to raise five children alone. Even with crèche and kindergarten, she could manage only

[14] Niethammer, von Plato, Wierling, 439.
[15] IMC, Interview 006.
[16] Interview Frau RG.
[17] BArch, DP1/VA/1447, Bd.1, Bl. 132–33. HL an den Chefredakteur der *Leipziger Volkszeitung* 2.11.56. Also see Borneman, 195–96.
[18] Interview Frau LD. Also see IMC, Interview 046.
[19] Heineman, *Difference*, 228–30.

because her mother kept the oldest daughter until she was ten, thereby allowing Mühle to train for skilled work and become active in the SED. Always short of time and energy, she felt emotionally and financially burdened. Yet her children were content with their single parent; neither she nor they felt stigmatized.[20] One cannot know for sure whether the state's guarantee of legal equality conditioned open-mindedness or attitudes became more liberal because the war and postwar turmoil produced so many "blameless" single mothers. Elizabeth Heineman credits the GDR for morally and legally defusing the issue of single motherhood.[21]

In the late 1950s, single motherhood came to be seen as more problematic in official eyes. In his book for young people, Neubert cautioned against having a baby outside of marriage. Single motherhood, he wrote, carried no "moral mark," but "children need a mother and a father," for "as the brain develops it is important for the child to experience a harmonious family." In addition, single motherhood typically meant single childhood and Neubert, like the party-state, abhorred the small family.[22] Rather than recycle conventional moralizing about single motherhood, he combined a psychological argument about individual development, with emphasis on the social value of large families.

If the official view of unmarried maternity grew more ambivalent, discourse about the woman who stood alone was always contradictory. Her *public* persona fit the SED's image of the ideal Socialist Woman. The single woman worked for wages, often qualified for a trade, and participated frequently in social and political activities. Yet single women were also perceived as a *private* threat to marital happiness. In 1954, Minister of Justice Benjamin expressed relief at the decline of "the postwar feeling . . . [that the courts] must be "generous" toward women forced to remain single due to the war." "The problem of the single woman," she asserted, "is not to be solved at the cost of existing marriages."[23] Neubert discussed "the so-called surplus of women" more sympathetically, though still ambivalently: "Robust women, hungry for life, yearn for fulfillment. That has led to terrible chaos. After the First and, even more, the Second World War, marriageable women descended upon men. Thoughtlessly, young women broke into existing marriages, tried to pry married men from their bonds, and win them for themselves. Or at least they attempted to satisfy . . . their craving for life."

Neubert attributed this "craving" to "desire for a child" rather than to loneliness or sexual longing. He told of a woman who asked her best

[20] Interview in Szepansky, 134.
[21] Heineman, *Difference*, 223–24, 227–29.
[22] Neubert, *Geschlechterfrage*,104.
[23] NJ 8/1954, pp. 351.

TABLE 6.1
Average Age at First Marriage, by Gender, Selected Years

Year	1952	1955	1960	1965	1970
Men	27.3	26.8	25.0	25.5	24.5
Women	23.8	23.4	22.5	22.9	21.9

Source: Mertens, 17.

friend if she could borrow her husband in order to conceive a child. Neubert disapproved of this solution but found her maternal urge immanently reasonable: "Men want career and family. Why should women not have both?"[24]

In fact, by the mid-1950s, the vast majority of women in the GDR could do just that. The courts had outgrown their "generosity" toward the single woman, because she had become less of a social phenomenon. In general, according to Benjamin, the signs of "postwar turmoil" in the family had subsided by 1954.[25] As evidence of restabilization, Benjamin cited the sharp decline in divorce. In 1950, 49,860 claims for marital dissolution ended in divorce, as opposed to only 23,167 in 1958.[26] The divorce *rate* also declined. She could have pointed to other signs of reconsolidation. Men *and* women married at a high rate. First-time marriage occurred at an ever younger age (Table 6.1). Given these trends, Benjamin concluded, the family had attained an equilibrium that the state could codify and support with a new family law.

REFORMING FAMILY LAW

In June 1954, the Ministry of Justice made public a draft of a comprehensive Family Law that would regulate the terms of marriage, property division and inheritance, spousal decision making, and marital dissolution. The GDR's Constitution and its Mother and Child Law eliminated patriarchal powers but offered no guidance to the courts in matters of family conflict. In 1950, a leading official in Justice, Hans Nathan, warned the Central Committee, "Every court rules differently on the same questions [in family law]," threatening the justice system with "chaos" and a "crisis of confidence."[27] The EFGB was meant to clear up the muddle. It set the

[24] Neubert, *Ehebuch*, 185–86.
[25] NJ 8/1954, 349–51.
[26] Harri Harrland and Rudolf Hiller, "Familienrechtliche Konflikte im Spiegel der Gerichtsstatistik," NJ 1962, 622.
[27] SAPMO-BArch, DY30/IV2/13/99, Hans Nathan, MfJ an ZK SED, 9.5.50.

age of majority at 18, guaranteed a wife's right to work outside the home, allowed spouses to live in separate domiciles if their jobs made that necessary, and permitted them to take either partner's last name as a family name or to keep different last names. The EFGB abolished adultery as absolute grounds for divorce and replaced the guilt principle with "irreconcilable difference."[28] In the case of parent-child relations, the EFGB eliminated "parental authority" (*Gewalt*) over children and replaced it with "parental care" (*Sorge*), glossed to mean that parents had "rights and duties toward the state, society, and children." Besides caring for and educating their children, parents were to raise "independent and responsible children of the democratic state who love their homeland and stand for peace."[29]

The churches were the only stumbling blocks that Benjamin foresaw to smooth passage of the family code. She did nothing to head off the hostility of the Catholic Church but tried to circumvent opposition from the bigger, less antagonistic Lutheran Church. The Justice ministry explained the terms of the EFGB to Lutheran representatives in March 1954, two months before it was unveiled to the public. To Benjamin's relief, they seemed to accept its basic provisions.[30] Having prepared the way, she opened a six-month controlled discussion of the EFGB in the press, work assemblies, and public meetings. Judges and justice officials addressed the gatherings and entertained questions from the audience. By October 1954, more than 300,000 GDR citizens had attended 6,000 meetings; many hundreds had asked questions and voiced opinions at these sessions or in letters to Justice officials.[31] Public interest in the EFGB ran gratifyingly high, especially among women. Soon, however, the meetings began to veer off script. They became increasingly contentious until, as planned, the Justice ministry shut down the discussion in November. The popular reaction was so extreme, in fact, that the MdJ simply dropped the EFGB from the legislative agenda without another public word. For a *decade*, the reform of family law completely disappeared from the SED's agenda, although not from the MdJ's legal practice.

The EFGB aroused a host of hostile reactions. Most alarming to the state was the intense antagonism of both churches, *especially* the Luther-

[28] The Third Reich introduced breakdown as permissible grounds but also retained the guilt principle.

[29] See the presentation and interpretation of the EFGB in *Frau von heute*: "Zum Entwurf des neuen Familiengesetzbuches," Nr. 29, 16.7.54, Nr. 30, 23.7.54, Nr. 31, 30.7.54, Nr. 32, 6.8.54, Nr. 36, 3.9.54.

[30] SAPMO-BArch, DY30/IV2/14/35, Bl. 46 Benjamin an Anton Plenikowski, ZK, 16.9.54.

[31] BArch, DP1/VA/1, Bericht über die Ergebnisse zur Diskussion zum Entwurf FGB auf die Arbeitstagung des MfJ vom 19.10.54, S. 2.

ans. In a campaign that gathered steam from August on, the churches focused their opposition on the EFGB's assumption that wives could and should work. In a letter of 28 August 1954 to GDR Minister-President Otto Grotewohl, the Catholic Bishop of Berlin regretted that the EFGB showed "no consideration for Christian principles" and, instead, saw "in the family only its economic-social function . . . especially when it comes to the woman and mother." He wrote: "We protest decisively against the notion that the equality of women will be accomplished essentially by her participation in production and in the life of the state and society. Such an assumption shows contempt for the natural order, which assigns married women and mothers their basic place inside the family."[32] Lutheran prelates endorsed the Catholic protest. The language of the Lutheran Synod's statement was more conciliatory, insisting that the Synod favored women's equality and was not so "backward" as to oppose wives' employment. Still, it censured the EFGB's "schematic" interpretation of "equality" as "sameness" and its sanction of "separate living arrangements."[33]

Having taken a stand, the Lutheran church began to mobilize its parish base.[34] Churchgoers heard their pastor or visiting clergymen explain why "as a Christian one cannot endorse this law." Speakers consistently described the law as anti-Christian and as forcing women to work and abandon their children. Otherwise, charges varied. Playing on the desire for national unity, several orators claimed that the EFGB would harden the division of Germany. Others denounced it for assuming that all children would join the Free German Youth. They often ridiculed it for allowing a husband to take his wife's name and for ending minor status at 18 (seen as too young).[35] By early November, the clerical campaign against the FGB was in full swing, directed from above by the Lutheran administration. A memorandum from the Brandenburg diocese explained, "[f]or larger assemblies, we are prepared to send an orator," whatever might be necessary to get "all parishes" involved. At church meetings, the memorandum explained, people were to be "invite[d] into political life" and to send resolutions to state authorities.[36] Parish petitions began to flow upward.

[32] SAPMO-BArch, DY30/IV2/14/35, Bl. 1–5, Wilhelm Weskamm, Bischof von Berlin, an Otto Grotewohl, 28.8.54.

[33] SAPMO-BArch, DY30/IV2/14/35, Bl. 20–22 Stellungnahme der kirchlichen Ostkonferenz zu dem EFGB . . . 1.9.54; DY30/IV2/14/35, Bl. 9, Aufzeichnung 6.9.54.

[34] I found no evidence of Catholics mobilizing their parish base.

[35] BArch, DP1/VA, Bl. 101, Hauptabteilung II, Bericht . . . Dresden am 13. u. 14.10.54; SAPMO-BArch, DY30/IV2/14/35, Bl. 104, Abschrift aus d. Bericht Nr7/54 . . . 13.–14.10.54. On other meetings, see DY30/IV2/14/35, Bl. 51, Bericht, 16.9.54; Bl. 107, Bericht . . . Bautzen am 8.11.54.

[36] SAPMO-BArch, DY30/IV2/14/35, Bl. 112, Abschrift. Evangelisches Konsistorium Berlin-Brandenburg, 8.11.54.

Of the thirty-eight that I have located or seen referred to, all came from small boroughs. The number of signatures on each ranged from 15 to 198 names. Every petition denounced the EFGB's lack of Christian principles, while several also faulted the plan "to free women from maternal and domestic duties," rather than accord them "a place of honor in the family and home."[37] The threat of family law reform galvanized Christians. Church assemblies that initially attracted audiences of 40 to 50 were drawing crowds of 400 to 500 by late fall. At a gathering of 450 in Bautzen, a participant remarked, "[F]or years the house hasn't been so full as today."[38]

The Lutheran hierarchy treated the matter as a "woman's question." The Synod instructed the Brandenburg Women's Aid to invite women's church groups to a teach-in (*Rusttag*) and make sure every parish took advantage of a speaker service that the Women's Aid was requested to provide.[39] As the campaign progressed, the churches aimed their message ever more blatantly at women and made increasingly sensationalist accusations against the EFGB. The largest gathering of the entire movement was announced by a leaflet headed: "Women, it's about your honor and your family." At this meeting, a preacher from West Berlin warned 700 Brandenburgers that the EFGB would allow the state to take children from their mothers and raise them in homes, while permitting husbands to sire more children with other women. Local pastors repeated such claims in their sermons. By late December, according to a police report sent to the Central Committee, everyone in a village near the town of Neubrandenburg believed these charges to be true.[40]

As the church campaign against the EFGB unfolded, Justice bureaucrats continued to propagate its virtues at officially organized discussions. Through July, these meetings ran smoothly, and the public seemed to accept the draft's basic provisions—proof, a report claimed, of a "transformation in the population's consciousness."[41] In August and September,

[37] Fourteen petitions are in BArch, DO4, 1555. See, e.g., Der Gemeindekirchenrat der Evang. . . . Döbern N/L; An den stellvertretenden Ministerpräsident Herrn Otto Nuschke, 24.11.54 (Nuschke was a member of the CDU). Ten petitions can be found in: SAPMO-BArch, DY30/IV2/14/35. Fourteen are listed in: BArch, DP1/VA, Bl.12, 15.4.55.

[38] See overview of the situation by Justice: SAPMO-BArch, DY30/IV2/14/35, Bl. 128, Justizverwaltungstelle . . . Bezirk Dresden an Benjamin, 13.11.54. On the meeting of 500, see DY30/IV2/14/35, Bl.168, Kreisgericht Cottbus, 11.11.54. Quote from: DY30/IV2/14/35, Bericht . . . Bautzen am 8.11.54, Bl. 110.

[39] SAPMO-BArch, DY30/IV2/14/35, Bl. 112, Abschrift. Evangelisches Konsistorium Berlin-Brandenburg, 8.11.54.

[40] SAPMO-BArch, DY30/IV2/14/35 Bl. 203, an Md. J, 21.12.54; Bl. 197, Deutsche Volkspolizei an ZK SED, 24.12.54.

[41] SAPMO-BArch, DY30/IV2/13/99, Bl. 460, Bericht . . . 19.10.54; Gerda Grube, "Zum Entwurf des Familiengesetzbuches. Erste Erfahrungen aus der Diskussion mit den Werktätigen," NJ, 8/1954, 442.

however, complaints about the EFGB began to plague Justice gatherings. Picking up on clerical charges, ever more people contested its liberal naming provision, "overly youthful" age of majority, and recognition of wives' right to work and to equal decision making in family matters. They worried that the EFGB would hinder German unification.[42] No provision provoked as much contention, though, as the revision of divorce law and, especially, the elimination of the guilt principle or any absolute grounds for divorce.

The most vociferous opponents of divorce reform were "older wives." They called for tightening divorce regulations, retention of the guilt principle, and legal punishment of adultery. Some women wanted adulterers to be sentenced to thirty years in prison.[43] As in the case of the monthly housework day, the debate about the EFGB revealed that in 1954, East German women still believed a husband made a difference.[44] Men earned more money, worked in higher status occupations, and enjoyed better political connections than women. They were also in short supply. Although the number of never-married women declined in the 1950s, the perception that men could marry more easily was widespread—and correct. Their rate of marriage (especially second marriage) was higher. This imbalance generated a competitive uneasiness between wives and single women that persisted even as the gender gap in marital chances narrowed. In debates over the HAT, unmarried women expressed resentment against policy makers, plant managers, and wives. In the fanfare about divorce law, married women vented their fears that the courts, single women, and their own husbands were ready to cast them to the wind. The public manifested much sympathy with the virtuous, loyal older wife victimized by a philandering, abandoning husband and a predatory, younger rival.

Justice officials named "Western" propaganda as the source of wild gossip about the EFGB. According to one thriving rumor, the EFGB's abolition of adultery as grounds for divorce meant that "every man can have two women" and "every husband can stay at his girlfriend's house until 10 p.m."[45] In Freiberg, near Karl-Marx-Stadt (Chemnitz), 350 people listened quietly to a Justice functionary explicate the EFGB. Afterwards, a member of the audience wanted to know, however, if the law would allow "single women in the city to keep married men with them for three or four days a week." Next,

[42] See BArch, DP1/VA/243 Betr: Aufstellung über negative Diskussionen in Justizausspracheabenden, 15.9.54; SAPMO-BArch, DY30/IV2/13/99, Bl. 462, 464, Bericht . . . 19.10.54.

[43] SAPMO-BArch, DY30/IV2/13/99, Bl. 467, 469, 471, Bericht . . . 19.10.54. Also see Budde, "Einleitung," 16.

[44] I take this phrase from Heineman, *Difference*.

[45] SAPMO-BArch, DY30/IV2/13/99, Bl. 469, Bericht . . . 19.10.54.

[A]n older participant made himself into the spokesperson for a large part of the audience, when he asked, "Where are the measures for dealing with unscrupulous (*gewissenlose*) husbands?" If the draft had nothing to say about them, he could only say, "Phooey." This won him the enthusiastic applause of part of the audience. The judge of the district court [who was in attendance] explained that a compulsory law against adultery would only hurt those who were calling for it. At that, all hell broke loose.

In Nauen, the "craziest rumors" were afoot about the draft's toleration of polygamy among men *and* women. After a Justice official talked to them about the EFGB, "ninety percent of the staff" at Nauen's HO (almost all of whom would have been women) said they opposed it. At a discussion led by DFD members, women asked whether it was true that the EFGB, on the one hand, gave a single woman a legal right to her married lover during the evening hours and, on the other, banned divorce of marriages of more than twenty-five years duration.[46]

Justice officials sympathized with older wives and saw their opposition to divorce reform as "backward but ethical."[47] They tried unsuccessfully to convince hostile audiences that the law would "sustain and strengthen" marriage.[48] Justice took little comfort in what popular support the divorce regulations did evoke. Many people, administrators claimed, liked "relaxation of divorce" for "bad reasons." In letters, writers hailed the EFGB "because, given the shortage of men, now more young women will be able to get a husband." This attitude showed, a Justice official regretted, that "not all who endorse the new regulations are progressive," although the young women who tended to hold such views were victims of "the profound human problem of the desire for a child."[49]

Whether as "good" opposition or "bad" approval, the intensity of popular feelings astounded the MdJ. Clerical opposition, it was believed, reinforced lay antagonism, yet for several months Justice did little to curtail church meetings.[50] Only after the prescribed period of discussion was over in November did the state turn to repression. When preachers in the district of Dresden compared the EFGB's alleged designs on children to Nazi methods, the police "asked [them] in for a conversation."[51]

[46] BArch, DP1/VA/243, Betr: Aufstellung über negative Diskussionen in Justizausspracheabenden, 15.9.54: DFD Abend in Jena (Land).

[47] SAPMO-BArch, DY30/IV2/13/99, Bl. 471, 469, Bericht . . . 19.10.54.

[48] Grube, NJ, 8/1954, 442.

[49] Quotes from SAPMO-BArch, DY30/IV2/13/99, Bericht . . . 19.10.54, Bl. 47; BArch, DP1/VA/1, 1954–55, 1923, Bericht . . . 19.10.54, S. 16–17. These files contain slightly different versions of the same report.

[50] SAPMO-BArch, DY30/IV2/14/35, Bl. 6, Notiz für Gen. Willi Barth, 17.9.54.

[51] SAPMO-BArch, DY30/IV2/14/35, Bl. 197, Deutsche Volkspolizei an ZK SED, 24.12.54.

True to her draconian reputation, Red Hilde sent all parish petitions to Erich Mielke, Minister of State Security.[52] Repression initially failed. The churches staged their biggest assemblies and aired their most immoderate charges in December. A police report from Cottbus remarked with awe that 300 people showed up to a sermon "despite the fact that the church was not allowed to use posters or other forms of advertisement."[53] No public meetings took place after the New Year, but throughout January, parish petitions still landed in the mailboxes of the powerful. It is hard to ascertain what caused the agitation to peter out: suppression or the vanishing of the EFGB from public discourse? The attention of the churches, one might note, was diverted from divorce reform by a direct threat to organized religion—the *Jugendweihe*, announced in November 1954. Official silence on family law reform after November is even more mysterious. The disappearance of public discourse about family law for a decade suggests that the SED was very wary about stirring up a second popular uproar over divorce law. The state did not allow this worry, though, to stop de facto reform. In 1955, a "marriage and divorce decree" introduced many of the EFGB's provisions through the back door of the family courts.

THE CONVENTIONS OF MARRIAGE

East Germans married at a very solid rate (Table 6.2). Around ninety-five percent of women who came of age in the 1950s became a wife.[54] The stabilization, even resurgence, of marriage in the 1950s did not take place, however, on the terms imagined by Hilde Benjamin. The postwar family had emerged, she assumed, on a *new* foundation: a two-earner couple that liked it that way. Conditions for the EFGB, she admitted retrospectively, were not "mature," because the "normative woman whose rights we wished to establish" was not yet "the employed woman."[55] Up to 1955, the majority of wives worked intermittently for wages. The relatively slow march of housewives into the labor market illuminates opposition to the proposed liberalization of divorce. Antagonism to no-fault divorce outlived, however, the influx of wives into the labor force.

[52] BArch, DP1/VA, Bl.12, 15.4.55, An Mielke, SfS. Betr: Stellungnahme der Kirche zum FGB.
[53] SAPMO-BArch, DY30/IV2/14/35, Bl. 197, Deutsche Volkspolizei an ZK SED, 24.12.54; DY30/IV2/14/35, Bl. 196.Bezirk Cottbus, 8.12.54
[54] Trappe, 103.
[55] Quoted in Heineman, *Difference*, 34.

TABLE 6.2
Marriages per 1000 Inhabitants

Year	Area of SBZ/GDR
1938	9.4
1946	6.9
1950	11.7
1955	8.7
1959	9.4
1965	7.1
1970	7.7

Source: StJb (1960/61), 35; Storbeck, *Strukturen* 259; StJb (1973), 476.

Other cultural attitudes about marriage also did not move in step with economic change. The evidence is strong that couples courted and married with quite conventional notions about gender roles and arrangements. Between 1954 and 1970, *Das Magazin*, the GDR's raciest magazine, repeatedly canvassed its readers about courtship, love, and marriage. Individual letters to Hanna Eisler, its editor, might articulate a modern, egalitarian notion of gender relations, but the magazine's surveys turned up strongly conventional attitudes, especially among men. In the 1950s, the vast majority of respondents believed that men should initiate a love relationship and that couples should marry.[56] Frau T. and her lover followed this pattern. She was the daughter of a couple torn apart by German defeat and postwar change. Her father was a former *Wehrmacht* officer who ranted and raved against all and sundry in the GDR before he left her mother, an overworked, underpaid schoolteacher, for a younger woman, founded a new family, and fled to the West. Frau T. escaped the broken hearth at eighteen, seeking refuge in the arms—and "very decent" apartment—of a boyfriend "who took over the role that my father should have played. He took care of everything."[57] They married soon after conceiving their first child.[58]

Women and men across the social spectrum had internalized norms that, at least since the nineteenth century, assumed the housewife and mother would tend to the family's physical and emotional needs.[59] In 1948, men in training to become functionaries in the Free German Youth said that they expected their future wives *not* to take a job. Men attending

[56] Badstübner, 'Zeig,' 451–56.
[57] Interview Frau CT.
[58] Ibid.
[59] On the emergence of the housewife-ideal, see Hausen. On the ideal's spread among workers and Social Democrats, see Hagemann; Schissler.

a school to train the SED's future elite made remarks such as, "When we get married, we need a wife who is there for us alone."[60] Clerical discourse, muted but not silent, bolstered such attitudes. A pastor informed a rural audience of 500, "Men place less value on a modern wife than on a wife who has time for a loving word and friendly look."[61] Official imagery implicitly conveyed a similar message. A cover of *Neue Berliner Illustrierte* showed Minister President Otto Grotewohl with his (much younger) unnamed "spouse (*Gattin*)" by his side as they helped grateful construction workers move bricks on a frigid January day.[62]

East German couples did as Otto practiced, not as Hilde preached. The typical family subordinated itself to the man's work, education, and political engagement. In *Das Magazin*'s (unscientific) surveys, the majority of women said they did not want to work full-time after marriage.[63] Many families, in fact, could have won a West German medal for Best Breadwinner/Housewife Couple. In Chemnitz, a woman, born in 1930 and married to a textile machine technician, went to work when she was 38, after her children were out of the house. Asked whether she did the housework, she said, "all of it," and added, "Yes, certainly that. Certainly that . . . and I . . . but I don't know if it was right . . . I . . . I always subordinated myself a little and saw what my husband did as important and thought to myself, ' . . . you simply have to stand back'." The marriage was "very good. No problems."[64] Unskilled proletarian couples often arranged their lives similarly. A woman, "from a workers' family" who fled Poland at the war's end, left school in 1949 after the minimum eight years and went to work for farmers. At nineteen, she had her first son, then married his father. After "welfare (*Wohlfahrt*)" found the growing family an apartment of their own in 1956, she did the housework and took care of their children, who soon numbered four. She did not go to work until 1963, because "I was always pregnant."[65]

A controversial feature of the EFGB was its guarantee of the right of either spouse to move to another locale for a job. Although the EFGB disappeared from sight, this provision did not: wives sued resistant husbands in court, and judges supported their complaint.[66] Typically, however, *if* an apartment was available (an important caveat), the family followed the father to the city where he worked; if no apartment could be

[60] SAPMO-BArch, DY30/IV2/1/40, 12.2.48, Tagungen des Parteivorstandes, Elli Schmidt, 229.

[61] BArch, DO4/360, B. 241 Stunde der Frau Marktkirche.

[62] NBI, 1952/2, 2. Januar.

[63] Badstübner, "'Zeig,'" 454–55.

[64] IMC, Interview 007.

[65] Interview Frau BP

[66] H. Töplitz, "Die Vorbereitung des neuen Familienrechts durch die Rechtsprechung," NJ 1954.

found, the children stayed with the mother. This convention reflected the fact that an employed wife had, most likely, an unskilled job, while her husband often had a promising career. Although examples can make no claim to representativeness, they suggest that husbands and wives linked the family's social rise to the man's ability to move up and around. Men in technical occupations, political functions, or the officer corps of the National People's Army were especially mobile, both vertically and geographically, and their wives generally followed them. In petitions requesting permission for an abortion, husbands wrote about *their* studies or career, rarely referring to a wife's employment. A party member who worked for the *Volkspolizei* claimed that a third child would force him to postpone entry into the prestigious College of Finance. The second child, he complained, had already forced him to break off his studies at Humboldt University. He concluded, "If you do not approve this request, the consequence will be the end of my development," adding as an afterthought, "and that of my wife," whose education or job went unmentioned.[67] In some cases, the couple lived apart because the wife continued to work while the husband trained, yet she transferred to the location of his employment once he settled in to work. A secretary, born in 1932 and wed to an intern-physician in 1953, did not want to move to the large city where he studied. She continued to work in her small town, where her mother took care of the couple's infant daughter. After the doctor finished a stint as a military physician, he got an impressive job in the state medical hierarchy in another city. His wife moved, reluctantly. She also dropped out of the labor force and bore two more children, returning to wage labor only in 1978.[68]

When a wife was in training for a profession, she would often relinquish her studies if the demands of young children and her husband's career required it. At age 22 in 1954, Frau J. bore her first child while in her second year of medical school. She managed to muddle through her internship but dropped out when her second child was born in 1955. She and the children followed her officer-husband to his military base. After a third child was born in 1956, she stayed at home until 1959. Then she trained through an extension program to become a medical social worker. She briefly worked full-time. "That was very stressful. I had the three children . . . and then my husband went to the Military Academy in Leningrad for five years and during that time I [worked part-time]." Only after his return did she return to full-time work as a medical social worker. She also gave birth to two more children but managed to balance a large

[67] BArch, DQ1/5145 (Herr) H. Heduschka, Cottbus an d. MfG, 23.4.54; Dr. Neumann an Heduschka, 4.5.54; Dr. Wenzke an d. MfG, 6.7.54.
[68] Interview Frau M.

family and a career, in part because staying at home "was too boring to me," and in part because of changing conditions and mores in the 1960s.[69]

In a couple in which the wife worked continuously as a teacher through the births of four children, it was still the husband who made the career rise. A mechanic, this man studied chemical engineering from 1959 to 1961 while living away from home. After he got his degree and returned to his family, he took on "some responsibility" at home, though not much because the wife's sister jumped into the breach as nanny. In another case, a Communist "son of the proletariat" followed a "steep career" path, ending up as a manager of 300 workers. His wife eventually returned to work, yet never qualified to do skilled work. She barely figured, noted his interviewer, in memories which were laden with the pressures and achievements of his working life. Retrospectively, her lack of training piqued him, though he gave no sign of having earlier encouraged her.[70] In these five cases, every husband and at least two wives were members of the SED. Families of socially mobile Communists often functioned as a breadwinner-housewife pair without, it seems, a second thought on the part of either spouse. Nonetheless, the *political* commitments of a career-ist husband did cause domestic tensions. Apolitical wives blamed the SED for the fact that "the kids and I spend evening after evening alone." In other cases, they suspected that a husband's hyperpoliticizing was an excuse to be away from home, or a cover for an affair.[71]

In these marriages, husbands and wives followed his career but collaborated in arranging conjugal life. There were, of course, exceptions in both authoritarian and egalitarian directions. Again, anecdotal evidence illustrates the point. A husband took his wife's weekly salary from her, returning 50 DM and keeping about 150 DM (and his own salary) for himself. She remembers the marriage as "very good" because he was "competent," and she willingly submitted to his authority.[72] Other women found their little pashas less endearing. A thirty-three-year-old housewife and mother of three young children pleaded for approval of an abortion, because her "vicious" husband beat her and gave her scant household money from a salary whose amount she did not know. Rather than grant her an abortion, health officials asked the managers of the husband's firm and leaders of his SED chapter to hold a "conversation" with him, while the Department of Mother and Child watched over the

[69] Interview Frau J.

[70] Niethammer, von Plato, Wierling, 501, 463, 466.

[71] Quote from: SAPMO-BArch, DY30/IV2/17/29, Bl. 127–28, SED Brandenburg, Frauenabteilung an ZK FrAbt. 18.10.50. Also see Niethammer, vonPlato, Wierling, 463; letter to Fvh, Nr. 1, 2.1.53, 21.

[72] Interview E.S. (by Martina Dietrich).

desperate mother.[73] Readers to *Die Frau von heute* wrote of husbands who beat them, tried to force them *to* work, and were unfaithful. The editors (and other readers) always proposed that the wife get a job to establish independence.[74]

Some couples arranged their married life just as Benjamin thought they should. That did not mean they shared Red Hilde's politics. In three of four egalitarian couples who emerged from interviews with fifteen women who were wives in the 1950s, social or political discrimination against one or both members of the pair drew them together and cemented a mutual determination to advance against all odds in the new society. All of the wives and two of the husbands were barred from finishing or starting university in the late 1940s and early 1950s because her or his father had been a bourgeois, a wealthy farmer, or a military officer before 1945. Two couples maintained their distance from the new state in the 1950s, while both members of the third pair joined the SED and were then admitted to university. In two cases, the spouses shared a profession, and that seemed to enhance their partnership.[75] Working-class couples often forged egalitarian bonds as they struggled jointly to make ends meet in the hard times of the 1950s. When a house painter-husband's work was slow, he helped his seamstress-wife to meet her orders.[76]

In sum, marriages worked in many ways but did not generally function according to the norms assumed by the EFGB. Although ever more wives worked for wages, they shifted jobs, interrupted employment, or took up new careers in order to adjust to a husband's education or career. They did this, as a rule, not because husbands insisted they do so, but because it made sense financially, kept the family together, and was the thing to do. They rarely shared housework or child care, much less evenly divided it, but they consulted each other about important family decisions. Most of all, restabilization of marriage was a sign of the centrality of marriage to the sociocultural world of East Germans, women and men. The revival of domesticity in the later 1950s reflected, clearly, pressure from below. Whatever its source, family images, especially pictures of parents with children but also of couples alone, began to consume more space in the illustrated press.[77] Neubert's advice books about marriage and relationships appeared in 1956 and 1957. In 1958, Walter Ulbricht released the

[73] BArch, DQ1/1843, Bl. 300, 11.9.53, Bl. 298, 11.9.53, Bl. 297, 12.9.53, Ärtze am MfG; Bl. 295, Bericht über Haubesuche bei Familie E. am 15. u.18.9.53.

[74] "Wir wollen darüber offen sprechen,"See Fvh, Nr. 1, 2.1.53; Nr. 6, 13.2.53; Nr. 10, 6.3.53.

[75] Interview Frau CT; interview Frau AR.

[76] Interview Frau AB.

[77] Merkel, . . . *und Du*, 142.

Politburo's "Ten Commandments for Socialist Living." These guidelines propagated the virtues cherished by "dear Walter": cooperation, loyalty, cleanliness, decency, order, diligence, and frugality.[78] They reflected both a revived utopian urge that began to pulse through the leadership in the late 1950s and its desire to tap into conventional moral values. Two commandments referred to family life: Number Eight bode parents to "raise children to love peace and society, to be strong in character and body," while Nine admonished, "You shall live purely (*sauber*) and decently and honor your family."[79] Yet if the regime believed these adages captured the popular morality, it erred. The populace registered the Commandments' silence on marriage and took it as a slight to the institution they saw as the anchor of the family and of morality.[80]

CRISIS IN THE OLDER MARRIAGE?

Long before the EFGB was proposed, GDR courts had been effectively revising divorce law. In 1949, Justice directed judges to assess carefully any request for alimony and to allow financial support only to housewives and for at most two years, during which time the ex-wife was expected to find a job; only in exceptional cases could a court extend support. The MdJ also encouraged judges to phase out the guilt principle and replace it with irreconcilable difference. The Supreme Court urged the courts to disallow any absolute grounds for divorce but, based on the facts of a case, decide if it was in the interest of the spouses, children, and society to end the disputed marriage. By doing away with major battles over property settlement, alimony, and guilt, the MdJ aimed to eliminate the need for lawyers and allow plaintiffs and defendants to represent themselves. The routinization of divorce continued after 1954, despite the failure of the EFGB. The process of modernization, however, took longer and was more fraught than expected. The MdJ not only had to slog through the morass of popular opinion, but also found itself hampered by local judges who approached divorce regulation idiosyncratically and seemed unable to follow the guidelines set by the Supreme Court. The Supreme Court added to the confusion by interpreting its own rulings in contradictory ways. Legal opinion veered between liberalization and restriction, on the one hand, and between sympathy and irritation with the older wife, on the other.

[78] On Ulbricht's stringent moral universe, see Weitz, 372.
[79] Obertreis, 211.
[80] Zerle, 16–17.

TABLE 6.3
Divorce, Absolute and Percentage Wife
Complainant

Year	Total Divorces	Wife Complainant, %
1958	23,167	53.4
1960	24,540	55.1
1962	24,900	56.9
1964	27,486	58.3
1966	27,949	61.1
1968	28,721	62.3
1970	27,407	63.4
1972	34,766	64.3

Source: Mertens, 36.

The ratio of divorce per 10,000 people fell continually from 1950 to 1955, then leveled off before creeping back up (Table 6.3). Eighty-five percent of divorces ended marriages of fewer than twenty years duration.[81] In 1958, over half of divorces affected families with children younger than sixteen years old. Divorce was disproportionately high among couples that included a Protestant, a nonbeliever, and/or a partner raised in an urban area. Class background or education level did not influence the rate of divorce, but marriages in which the wife did not work were less likely to end up in court than those in which she did.[82] Until 1957, the majority of plaintiffs were men. Before 1945, male infidelity was the primary cause of divorce in Germany, and it remained so in the GDR. Other leading causes included adultery by the wife, alcohol abuse (nearly always by the husband), incompatibility, violence against wife or children, and alienation as a result of separate domiciles. Infidelity and job-induced separation often went hand in hand (which no doubt explains some of the popular opposition to the EFGB's authorization of living apart). Drinking and violence often occurred in tandem; they observed neither class nor political boundaries. Incompatibility was often situational, the result of inadequate housing or cohabitation with in-laws.[83]

Popular opposition to divorce reform centered on marriages of considerable duration. Although the breakup of marriages in which both partners were at least forty years old accounted for only five percent of di-

[81] BArch, DP1/VA/1364, Bl. 8 Generalstaatsanwalt an MdJ, 25.6.57.
[82] Wagner, 165, 224–25, 240.
[83] BArch, DP1/VA/1445, Bl. 15; BArch, DQ1/1843, Bl. 309, 12.8.53, Rat Rosslau, an MfGw; NJ 1958, 809; NJ 1956, 739; NJ 1957, 482; NJ 1956, 54; Neubert, *Ehebuch*, 198, 201.

vorces, these divorces carried great symbolic meaning. The EFGB, people felt, permitted a husband who had moved in with a younger girlfriend to end his marriage by yelling, "Breakdown!" and then escape the burden of supporting two households. It did not, however, allow a wife the automatic right to divorce an adulterous husband *or* to demand financial support as the injured party. When opponents of the EFGB claimed that it would force young wives to work, they maligned it, but the new regulation of divorce did assume that *ex-wives* would get a job. The curtailment of alimony created difficulties for most, not only older, ex-wives. In 1954, unhappiness over the regulation of alimony or child support was the most common complaint against the judicial administration. And no wonder, for in 1960, 69.6 percent of divorced wives earned less than their husbands. In 1962, a divorcing husband was much more likely than his wife to be in school or job training, meaning that his prospects for future earnings were better than hers.[84]

The loss of alimony hurt older women the most. They had come of age in the Third Reich, or even the Weimar Republic, and only very rarely had a marketable trade. In the cases discussed in *Neue Justiz* or MdJ files, no defending "older" wife or ex-wife had worked for wages during the marriage, much less had a marketable skill. In every case, the divorced wife became a cleaning woman or boarded with her grown children in return for maintaining their household. The income gap between these women and their ex-husbands was wide. A sixty-year-old woman, for example, kept house for her three grown daughters and two grandchildren. Her ex-husband, now married to a second nonemployed wife, filed to stop payment of 80 DM alimony from his 900 DM monthly salary because he had to support his new family. He argued that his daughters should pay his ex-wife for the work she did for them. He won the case.[85] A woman who had married in 1924 resisted divorce only because she did not want her standard of living to decline. After the divorce went through, she earned 284 DM per month, while her husband earned 600 DM. In an out-of-court settlement, he promised her 80 DM per month but never paid it.[86] A housewife, married for eighteen years and with two children still at home, explained in a petition, "the plaintiff earns 2000 DM [per month] and I earn nothing."[87]

Justice administrators disagreed about whether to protect older women from divorce reform. In *Neue Justiz*, Hans Nathan reproved judges who

[84] "Die allgemeine Beschwerde in der Justizverwaltung," NJ 1955, 113; Harrland/Hiller, NJ 1962, 623. Also see Heineman, *Difference*, 194–95.

[85] NJ 1960, 627–28. Also see NJ 1960, 657–58, 805.

[86] BArch, DP1/VA/1362, Bl.3 15.12.55, R.W. an MfJ; Bl.5 Abschrift of Urteil; Bl. 7, no title; Bl. 9 Hauptabteilung Gesetzgebung 29.1.55.

[87] BArch, DP1/VA/1362, Bl. 39, 17.12.55, SR an MdJ.

denied divorces to men with older wives: "Here in the Eastern zone we see marriage ever less as a welfare institution (*Versorgungseinrichtung*). We do not perceive it as an affront to assume that women between forty and fifty-five years old can work."[88] Hilde Benjamin, still a prosecutor at the time, disagreed: "older women are from an earlier era . . . [and] cannot get good jobs. . . . [W]e should not take from women what little they already have."[89] The Supreme Court, on which she then sat, annulled a decision against a sixty-year-old woman who had sued for alimony. It opined, "the demand [that a woman] take up employment should not be schematically applied. We cannot allow equality of rights to become a burlesque of equality (*Gleichmacherei*)."[90] Yet sympathy with older wives was limited. In 1953, the Court argued, "Divorce, even if entirely the husband's fault, is no excuse for the ex-wife . . . to lead an idle life."[91]

Also fraught was the symbolic meaning of older divorce. Divorced men were not only economically but also emotionally better off, for they could remarry more easily. Older wives felt deeply injured by the injustice of men's good fortune. They shared the sense of victimhood that pervaded Germany, East and West.[92] In divorce proceedings, they itemized all they had sacrificed in the 1940s and pleaded with judges to acknowledge their "innocence" and need for "protection."[93] In virtually every older marriage that ended up in court in the 1950s, the husband confessed to sexual affairs during war or postwar separation from his wife. Wives claimed to have come to terms with wartime liaisons and even to have forgiven them. One wife remembered that she had uncomplainingly "care[d] for [her husband] like [he was] a small child" after he contracted an STD. Everything changed, wives charged, as the crisis of survival subsided. They railed against husband-complainants who wanted a divorce to legalize an affair with a "younger" or "much younger" woman whom he had, typically, met at work. Because the courts treated date of "last marital intercourse" as a major marker of irreconcilable differences, couples battled about when their sex life fell apart The plaintiff-husband set the date of "last contact" as far back as possible and said the wife had refused to

[88] "Article 48 Ehegesetz—Unter welchen Voraussetzungen ist ein Widerspruch nach Artikel 48, Paragraph 2 Ehegesetz zu beachten?" NJ 3/1949, 171–73.

[89] H. Benjamin, "Die Ehe als Versorgungsanstalt," NJ 3/1949, 209–10.

[90] OG ruling of 1.12.50, NJ 5/1951, 128–29.

[91] "Die Rechtsprechung des Obersten Gerichts auf dem Gebiet des Familienrechts," NJ, 7/1953, 537.

[92] On West German "victimhood," see Moeller, *Stories*.

[93] The discussion that follows is based on cases discussed in: NJ 1954: 247; 1956: 284, 514, 543, 736–37; 1958, 139; 1959, 714, 716; BArch, DP1/VA/1362, Bl. 3, 15.12.55, R.W. an MfJ; Bl.5, Abschrift of Urteil; Bl. 11, An Frau W. Pirna von Grube, Abtleiter; Bl. 160, RW an MJ. 24.5.56; Bl. 39, SR an JM der DDR, 17.12.55.

have sex for years, forcing him into the arms of another woman. The wife followed the reverse strategy, interpreting, in one case, a goodbye kiss as proof of affection. Wives insisted they had "thrown him out of the bedroom" only after finding out about the "other woman."

Older wives won the sympathy of women in the DFD and SED who felt that the courts were "making it easy for men."[94] In fact, every third lower-court judge was a woman, and she, too, often sided with the wife. "Irreconcilable breakdown," wrote a woman judge in *Neue Justiz*, was "possibly the most misogynistic stipulation in divorce law" and should be applied with caution.[95] Divorce judges found it difficult to relinquish the guilt principle, often referring to a wife as "innocent." The Supreme Court overturned many a decision against a husband-plaintiff and lectured judges not to moralize but to stick to the facts.[96] A lower court denied a divorce to a "member of the productive intelligentsia" who had lived apart from his family for four years, arguing that a person of the husband's education should be "especially expected to fulfill his duty to his wife and children." The Supreme Court remonstrated, "We do not care about someone's social position in the case of divorce . . . [but about] the state of the marriage."[97] Yet the Supreme Court itself maintained: "an antifascist democratic society condemns frivolous conduct (*leichtfertiges Verhalten*) toward marriage."[98]

The proposed family law was intended to rationalize the regulation of divorce. When the EFGB was scotched, the Marriage and Marital Dissolution Decree of 1955 was meant to perform the same trick. Unfortunately, it was an ambiguous document that reflected the ambivalence of the Ministry of Justice, and especially Benjamin, about how to treat marital breakdown. As jurists debated whether the ordinance was "divorce-friendly" or "divorce-hostile," judges interpreted it in widely different ways. The only trend was that "big city courts" granted divorces more easily than small-town ones.[99] In 1957, the High Court added a "guideline" to the Marriage Decree that turned divorce law *back* in a less-liberal direction. In the case of "old marriages," the courts were to apply a "strict stan-

[94] O. Eggers-Lorenz, "Zur Frage des Widerspruches nach Artikel 48 Ehegesetz bei leichtfertigem Verhalten zur Ehe," NJ 8/1954, 136–37. Also see "Zum Entwurf des neuen Familiengesetzbuches," Fvh Nr. 35, 27.8.54, Nr. 37, 10.9.54.

[95] Friederike Kluge, "Gedanken einer Richterin zu Artikel 48 Familiengesetz," NJ 4/1949, 16–17.

[96] See, e.g., NJ 7/1953, 57; BArch, DP1/VA/387, Bl. 130, Landesregierung Mecklenburg an das MdJ, Schwerin 13.10.50.

[97] NJ 7/1954, OG ruling of 7.11.53, 141–42.

[98] OG ruling of 14.2.51, referred to in NJ 7/1951, 57.

[99] Schlicht, 62; Helmut Ostmann, Hauptabteilungsleiter der MdJ, "Zur Richtlinie des Obersten Gerichts über die Voraussetzungen der Ehescheidung," NJ 1957, 459.

dard" to determine if "serious grounds" were at hand. In "exceptional cases," a "long marriage" could be ended, but only after "every cause" of its breakdown had been "carefully weighed." In considering whether the divorce would inflict "unreasonable hardship," the court should not only look at financial need but also apply "a moral evaluation."[100] If an older woman lost her case, courts were directed to consider seriously her request for extended financial support.[101] By 1959, it had become more difficult for any couple to get a divorce. Young couples complained that the courts rejected even joint requests for divorce.[102] The more hostile attitude toward divorce reflected, in part, an increase in divorce among young couples. Jurists now worried about the "crisis of young marriage."[103] At this very time, interestingly, women emerged as the majority plaintiff (53.4 percent in 1958; 55.1 percent in 1960).[104]

The Ministry of Justice aimed to rationalize and demoralize divorce and to eliminate alimony. It tried initially to reach these goals via a controlled public discussion and promulgation of a new family law code. When the process fell off track, Justice introduced reforms through the back door. In the case of alimony, this method worked: by 1960, the courts had effectively eliminated it. Fewer than 350 women asked for alimony among more than 25,000 who divorced in 1961.[105] Lower court judges, the Supreme Court, and Justice bureaucrats, however, disagreed about the interpretation and implementation of other divorce regulations. In response both to pressures from older wives and to the changing profile of divorce, the original intent to relax divorce turned into a restrictive tendency at the end of the decade.

THE JOYS OF SEX

East German sexual attitudes, much less practices, are difficult to investigate, for official culture was priggish and most people at least pretended to be, as well. Interviewees do not pour forth stories of earlier sexual exploits. Nonetheless, from archival sources, the less reticent interviewee,

[100] BArch, DP1/VA/1364, Bl.8 Genstanwalt d. DDR an MdJ, 25.6.57, Betr: Ehescheidungsverordnung. The guideline is printed in Schlicht, 63–64.

[101] NJ 1957, 16–17.

[102] Most of these cases appear in NJ because the OG took them on appeal and overturned the lower court decisions. See NJ 1954, 661; NJ 1956, 739; NJ 1957, 482; NJ 1956, 287.

[103] BArch, DP1/VA/1445, Bl.14; SAPMO-BArch, DY30/IV2/13/106, Protokoll . . . 25.5.59; Harrland/Hiller, NJ 1962, 622, 624.

[104] For statistics, see NJ 1962, 623.

[105] In 1960, former husbands paid no alimony in 84.7 percent of cases. See Harrland/Hiller, NJ 1962, 623.

and the loquacious Rudolf Neubert, one can form a picture of popular mores. In cities, public physicality was as free as in other industrialized countries in the 1950s. Raised "very strictly, very puritanically" in Romania, a seventeen-year-old who immigrated with her parents to Dresden in 1953 was shocked to see "people on the street kissing each other."[106] Nudism, long a popular pastime among Germans, revived. The authorities barely tolerated *Freiekörperkultur*, but that did not stop aficionados from baring all along isolated stretches of the Baltic coast. The high number of out-of-wedlock births and divorces as a result of infidelity suggest that kissing and naked bodies were the least of it. Extramarital sex was common, and prenuptial sex was even more widespread. The latter continued an old custom, at least among working-class and peasant couples.[107] Statistics on prenuptial conception were not gathered until the 1960s, but interviews with women who married in the 1950s suggest that many brides were pregnant. To judge by the matter-of-fact way interviewees mention this, women experienced considerably fewer misgivings about sleeping with a "serious" companion than did middle-class American women of the same era. An eighteen-year-old, for example, met her first boyfriend shortly after she left home to work for the railroad. They had sex soon after getting to know each other and, deciding they were in love, got married when she turned up pregnant.[108]

During the 1920s, German discourse about sex had been more open and tolerant than possibly anywhere else in the world. National Socialist attacks on Weimar "decadence" had not completely effaced this cultural legacy.[109] The chaotic freedoms of the immediate postwar era contributed to a further relaxation of sexual mores. A woman recalled with deep regret that she was not "ready for sexual fulfillment" before her first husband was killed in the war. Sexual relations with her second husband were "completely different" because she had changed, a transformation she attributed to postwar experiences. As a social worker, she counseled many clients who had an STD. Working with them, she believes, made her more "tolerant." She also observed her roommates' unconstrained relations with boyfriends and reflected self-critically on her own "inhibitions and inability to find another man."[110]

This is not to suggest that the 1950s were an era of sexual enlightenment. Many women led unsatisfying sex lives or tried to have as little

[106] Interview Frau RN.
[107] Knapp, 208–9.
[108] Interview Frau RB. Also see interview Frau M.
[109] Heineman, *Difference*, 22–23, 31–36.
[110] Niethammer, von Plato, Wierling, 366–69.

sex as a husband would tolerate. Divorce proceedings suggest that the struggle to bring families through the war had extinguished the sexual appetite of many older wives. Among younger women, fear of pregnancy thwarted desire. According to physicians, some women expressed resentment of male partners who were "only out to satisfy themselves."[111] The average East German was badly informed about the physiology of sex (and contraception). As earlier, parents did not routinely explain the "facts of life" to their children; sex was still a taboo subject in the typical proletarian household.[112] An interviewee recalled that her husband managed their birth control. He did not want her to learn about sexual matters, and she made no effort to take things into her own hands.[113] Her passivity was extreme, no doubt. Before most were closed in the 1950s, marriage and sexual counseling centers were visited by women more than men, though by few of either sex. Clients rarely asked "questions about difficulties in marital intercourse and about conjugal life or [made] requests for sexual advice." Outside the big cities, people viewed the centers with great suspicion.[114] As they struggled to make their way in the reconstruction economy, neither women nor men thought much about improving marital sex.[115]

The state, too, placed sexual education low on its list of priorities. The Weimar KPD had denounced the double standard of bourgeois sexuality and advocated sexual reform. Physicians associated with the Communist party had participated in the flowering of a German and German-Jewish tradition of empirical investigation and theoretical debate about sexuality. The National Socialists squashed Weimar sexology and shuttered sexual counseling centers. Sex researchers lost their university positions and fled to the United States.[116] Immediately after the war, signs looked propitious for a return to the Weimar legacy of sex reform. In the 1950s, however, the marriage and sexual counseling centers languished, owing not only to lack of interest from below but also to tight budgets and inadequate staffing.[117] Short of funds, the Ministry of Health decided to inte-

[111] Neubert, *Ehebuch*.

[112] Interview Frau RB.

[113] Interview E.S. (by Martina Dietrich).

[114] In June 1953, the Ministry of Health asked for information on who visited the centers and why. The reports that were returned can be found in BArch, DQ1/5145.

[115] Borneman, 137–40.

[116] Grossman, *Sex*, 145–49.

[117] BArch, DQ1/4726, Abt. MuK an die Landesregierung Brandenburg, MfG, 21.9.51; Templin, Abt. MuK an die Landesregierung Brandenburg, 27.8.51; Angermünde, Abt. MuK, 21.9.51, an die Landesregierung. Brandenburg. Also see Timm, "Guarding," 489–90.

grate the centers' services with those offered by the gynecological section of "polyclinics." The centers continued to exist only in three cities, most notably Leipzig, where the progressive Dr. Lykke Aresin kept her clinic active and functioning under the palatable name "marriage and *family* counseling center."[118]

The SED elite had no interest in reviving Weimar debates about sexuality, sexual pleasure, and birth control. Leading Communists, especially Ulbricht, aimed for high fertility and were, anyway, prudish. They overruled the reforming urges of some party activists and physicians. Only in the mid-1950s did a public discourse on sexuality reemerge, a by-product of the sturdy birth rate, on the one hand, and the partial rehabilitation of personal pleasure, on the other. A rash of young marriages burdened by several births in quick succession highlighted the disadvantages of sexual ignorance. The press occasionally criticized "harmful prudery" and called for sexual education in the schools.[119] A slightly racy monthly, *Das Magazin*, dealt with sexuality, if chastely and conventionally. Every issue featured a (female) nude photograph and mildly salacious stories and cartoons. In a land deprived of such fare, *Das Magazin*'s soft "erotica for the entire family" won a dedicated readership—and an occasional public swipe from Ulbricht.[120]

Neubert's books, meanwhile, guided East Germans through the (pruned) thicket of premarital and conjugal sex.[121] He offered an eclectic mix of physiological data, enlightened opinion, traditional assumptions, silly prescriptions, and sentimentality. Neubert asserted that the sex drive was biological and, therefore, natural. It was also vital to love and marriage. He did not see procreation as the sole purpose of sex. He criticized the Catholic Church's prohibition of sex for its own sake and argued that young couples could and should distinguish their sexual urges from a conscious wish to reproduce.[122] Within marriage, and assuming consent, there was no "abnormal" method or frequency of attaining sexual satisfaction. He praised the Kamasutra for its descriptions of hundreds of sexual positions. Good sexual technique was not, he explained, an inborn but a learned ability. He urged couples to tell each other what they wanted. He assumed that women were equally interested and able to obtain "satisfaction," if not as constantly, owing to female "hormones and nerves."

[118] BArch, DQ1/5145, Dr. Bunge, Hauptreferentin, 6.11.53.
[119] Quote: BArch, DP1/VA/1415, Bl. 42 "Achtung vor dem Leben," S. Eissner (no title of newspaper) (1957?).
[120] Badstübner, "'Zeig,'" 459–60.
[121] On the lack of sexual research or discourse in the 1950s, see articles by three GDR sexologists (who published prolifically from the 1960s to the 1980s) in Hesse, 51, 55; Günther, 65–66; Schnabl, 117.
[122] Neubert, *Geschlechterfrage*, 93, 95–96, 99, 5–6.

Rather than a reason to privilege male desire, woman's variability meant that she should play the seducer to a man who was always potentially ready for sex. He insisted that psychology was as important to good sex as physiology and instructed men that women often required more time to reach climax.

He promised to offer no "prescriptions," but who can resist a little preaching? He denigrated the Kinsey report (which some East Germans would have read, for it appeared in West Germany in 1954) as irrelevant to the more cultured "European situation" and, indeed, pernicious because it "only reports, without giving norms or guidance" and "makes sex too much a topic of salon conversation, as if we were animals." Rather than Kinsey's clinical approach, Neubert spun narratives that read like a masculine dream of domestic paradise: A wife meets her husband at the door in a "pretty dress" with a nice dinner, tidy house, and children tucked in bed, politely waiting for a goodnight peck from father. After dinner, she entices him to take a thirty-minute stroll through the neighborhood during which she "chats not about the children's disobedience, but their funny escapades." Home again, "pleasantly relaxed and yet excited," they turn to a bedroom that is "also somehow festive" and—lights out.[123]

Neubert's perspective on the sexual activity of teenagers also included progressive aspects. He found it delightful for adolescent boys and girls to "hike, cuddle, and swim" together but warned that sexual intercourse could have negative consequences. He admitted that "many fourteen- to eighteen-year-olds have sex these days," but pronounced that "an evil." Sex between older, even unmarried, youth he found acceptable, only warning young couples to take precaution against unwanted pregnancy. Again, he could not resist some moralizing. Worried about the susceptibility of socialist youth to the eroticized style and stories of Western mass culture, Neubert insisted that the "decline of the capitalist West" was evident in its obsession with "sex, sex, sex" and idolization of the "Playgirl and Playboy." Yet his comments on gender, much less on sexual orientation, fit squarely with the West's line at the time. Behavior that was natural for boys was not for girls: "Early sex [before eighteen years of age] hurts young girls, not young boys," because girls, he wrote, become romantically invested in their partner and fall behind in school. Masturbation had even stronger gendered features: "While it is normal for maturing boys occasionally to play with their member, such activity is in general alien to girls. Only if a badly overstimulated girl instructs and seduces her schoolmates, do girls engage in onanism. Healthy girls who

[123] Neubert, *Ehebuch*, 5–7, 144–45, 133,142, 147–149,154–56, 158,163, 165, 170–71.

are properly nourished, get enough exercise, and have been taught by their mothers to empty their bladders and intestines regularly will hardly ever masturbate."

If masturbation was debauched in excess or for girls, homosexuality was always perverted and nearly always caused by "environmental conditions," especially an early homosexual encounter.[124] Neubert's prescriptions corresponded to official practice. The Free German Youth ran coeducational camps and schools at which, a participant remembered, youth were told that sex was natural but should be "clean" and comradely, that is, between a girl and boy with serious intentions toward each other. Homosexual practices were forbidden.[125]

In his book on *marriage*, infidelity was the only shadow-side of sexuality Neubert discussed. He treated male adultery as widespread, associating it, as did the populace, with the postwar "surplus of women." A form of infidelity that Neubert merely hinted at was married men's recourse to prostitutes. He claimed that prostitution proliferates "most disgustingly in dying capitalism," although he did not deny its existence in the GDR.[126] Providing more evidence of a sexual thaw in the mid-1950s, the press, too, occasionally mentioned prostitution. In 1955, *Das Magazin* published a slightly eroticized article on "girls of easy virtue" at the Leipzig Fair, a products convention attended by businessmen from all over the world. The article included droll interviews with male guests about whether they intended to call on the services of a prostitute while away from their wives.[127] The GDR did not outlaw prostitution but tightly controlled it. As earlier under state-regulated prostitution in Germany, prostitutes, but not their clients, had to register with the police and were regularly checked for STDs. The state ignored the complaints of some physicians about the unfairness, and irrationality, of this practice. Even registered prostitutes were often arrested on pretext of having violated laws that prohibited solicitation in public or in the vicinity of a church, school, or minor. Prostitutes were also cleared off major avenues and restricted to dance halls on side streets. Only at the Leipzig Fair did the authorities tolerate prostitution.[128] Laws also circumscribed prostitution with bans on pimping, homosexuality, sex while under treatment for an STD, and vagrancy. Vigilant application of such statutes led to a decline of prostitution.[129]

[124] Neubert, *Geschlechterfrage*, 166, 153–55, 86–89.

[125] Niethammer, von Plato, Wierling, 495.

[126] Neubert, *Ehebuch*, 184–86.

[127] Falck, 51–57.

[128] Falck, 37–40, 51, 60–61; Pence, "Miniature," 40–41. On German states' earlier regulation of prostitution, see Roos.

[129] LAB, Rep. 118/304. Protokoll einer Besprechung zur Koordinierung der Massnahmen zur Bekämpfung der Prostitution. 11.9.50, 1–2.

THE NURTURE OF YOUNG CHILDREN

In his epistle against the EFGB, the Catholic Bishop Weskamm charged that small children "are being taken from their parents" because their mothers were expected to work. Weskamm "feared the catastrophic consequences" of tampering with the mother-child bond.[130] He was not alone. American and British psychologists, and especially, psychoanalysts, argued in the 1950s that the development of a normal personality depended on maternal nurture of very young children. The EFGB's promotion of the two-earner marriage confirmed Western anxiety about a Communist threat to the family. West German commentators denounced the GDR's substitution of the principle of "paternal authority" with that of "parental care" (a change that U.S. law had made earlier). They charged that the state's right to define "care" delivered a blow to family unity and integrity. The state wanted, they claimed, the legal power to interfere, particularly in Christian families.[131]

The state may have intended to use this provision to keep religious and dissident parents in line, but I have found no evidence of a *policy* to remove children from their homes. Records of the Department of Mother and Child show that it took to court parents who allegedly neglected or abused their children and placed their children temporarily in group homes. Such actions typically bespoke social prejudices and economic imperatives, not political ones. Files refer to "asocial" fathers and mothers and to "work-shy" fathers who did not support their families. Some children in long-term homes were there because their parents were incarcerated for refusing to work as the state saw fit. When the imprisoned parent was a mother, the charge in every case I have found was violation of prostitution laws.[132] It was, in fact, highly exceptional for the state to "take children away" from their parents, if only because the SED relied heavily on the nuclear family to perform the work of social reproduction. In 1955, we recall, fewer than one in ten infants and toddlers was in

[130] Quotes from: SAPMO-BArch, DY30/IV2/14/35, Bl. 1–5, Wilhelm Weskamm, Bischof von Berlin, an Otto Grotewohl, 28.8.54.

[131] Storbeck, "Familienpolitik," 98; Schlicht, 41. On conservative views, see Moeller, *Motherhood*; Obertreis, 98.

[132] See, e.g., LStA 916, Bl. 257, Stadtkinderkrankenhaus u. Universitätskinderklinik Leipzig an Rat der Bezirk, 9.2.53; Bl. 232, Rat d. Landkreis Eilenburg an Rat der Bezirk Leipzig, 3.12.53; Bl. 220. MuK an AbteilungVolksbildung, 3.10.55. In other cases, mothers of adolescent delinquents were described as "disorderly and loud and living mainly off welfare," and in need of guidance from DFD members who could "give advice . . . about housekeeping and care of the children." (LStA, Jugendkriminalität. 1723, Bl. 89, An d. Rat d. Bez Lip, Rat d. Landkreis Döbeln. 4.1.55).

a *Kinderkrippe*, and about one in three three- to six-year-olds was in a kindergarten.[133]

Bishop Weskamm sensed correctly, though, that Communists did not share his worry about the mother-child bond. They applauded the "mutual love" that bound parents to their children but saw it as hardy, not fragile. Indeed, the question of nurture engaged them not at all. The neglect is curious, for Marxism is an "environmentalist" philosophy. Moreover, the nurture debate had once engaged German Communists, most significantly Clara Zetkin, a Social Democrat who went over to the KPD in 1918. In the 1880s, she had argued for socialized child care on the grounds that socialist professionals could care for children better than ill-trained, politically immature mothers. Her reading of psychological literature convinced her, however, that no institution could replace the family's contribution to the "unfolding of the child's individuality." By 1900, she was advocating the intense involvement of proletarian parents in child rearing. The mutual engagement of mother and father would equalize the labors of nurture and infuse children with the different "psychological and moral qualities" of men and women.[134] An opposite, but equally radical, stand was taken by Edwin Hörnle, a German Communist impressed by what he saw of Soviet communal rearing of children orphaned during the Russian revolution and civil war. In "socialist children's homes," he maintained, "collective parents" would replace "natural parents" corrupted by capitalist cruelty and ignorance. A third Communist position on nurture was A. S. Makarenko's theory of the "big" or "collective" family, a view that gained currency in Stalinist Russia in the 1930s. The best preparation for collective society and its work values, contended Makarenko, was not communal child rearing, but "the smallest cell of society," a nuclear family with two parents and lots of children.[135]

In the 1940s and early 1950s, German Communists revived neither these nor any other theory of nurture. This failure, the evidence suggests, reflected indifference and distraction. Frantically taken up with solidifying its hold on power and with the Stalinist production project, the SED did not look beyond the conception, birth, survival, and basic care of infants and toddlers. As head of the Mother and Child Department, Käthe Kern received report after report that detailed whether a crèche met standards for nutrition, safety, health, and physical exercise. Observers criticized the size and airiness of rooms as well as overcrowding. Some ac-

[133] Trappe, 115–17, 125.
[134] Hagemann, 211–12.
[135] Makarenko; Busch, 35–36, 24.

counts commented on the number of toys. The agency recognized the
need to reduce the gap between the actual ratio of caretakers to children
(often 12:1 or higher) and the legal one (6:1 for day children and 5:1 for
children in twenty-four-hour care, reduced to 4:1 in 1954). It planned
to improve the education of the poorly paid, often adolescent, usually
religious, and always female nursery attendants.[136] Prior to 1954, how-
ever, reports were virtually silent about the psychological development of
the centers' charges. Older children were objects of the regime's ideologi-
cal zeal, but not little ones who were, well, not very interesting—except
insofar as they kept their mothers out of employment (*Figure 12*).[137]

Most disturbing is the reports' utter disregard of the amount of time
infants and toddlers spent in institutional care. "Mother and Child" as-
sessed the pros and cons of day crèches versus weekly or "long-term"
homes in, essentially, cost-benefit terms.[138] A weekly home cost more to
operate than a crèche, but it was cheaper than investment in public trans-
portation or a reduction of the work week. Weekly care shaved hours
from the often shockingly long travel times of mother and child, and it
freed the mother of the burdens of tending, shopping, and cooking during
her harried work week.[139] Concern for the working mother was in order.
One's heart goes out, however, to the thousands of small children dropped
off at the crack of dawn on Monday and picked up on Saturday afternoon
to spend a paltry thirty-six hours with their parents—or, more likely, their
mothers. Single mothers' children, by law, went to the top of crèche wait-
ing lists, and reports noted that single mothers relied disproportionately
on weekly and long-term homes. Weekly homes were given priority in
areas with high female employment, and that was correlated with dispro-
portionate concentrations of single women. Fortunately, less than five per-
cent of all infants and toddlers were boarded in these homes. They ac-

[136] See, e.g., BArch, DQ1/3851, DFD Brandenburg an MfG, HA MuK, 31.2.52; DQ1/
1890, Bl.7, Bericht . . . (Magdeburg), 21.9.53; DQ1/2245, Christa Müller an K. Kern, usw.
24.7.53; Dr. Friedler, Kreisarzt, an MfG, Dr Neumann, 31.8.53; DQ1/2245, Kern an
C. Müller, 7.8.53; DQ1/2245, Grünhoff an die Gesundheitskommission . . . Karl Marx
Stadt . . . 27.11.55; DQ1/2245, Stellenplan für das Saüglingsdauerheim Markersdorf; Dr.
Bartolomäus an d.MfG, MuK, 26.7.54; DQ1/2245, Kinderkrippe Liselotte Herrmann an
den Rat der Stadt Dessau, 20.7.54; DQ1/2245, Warnecke, HA Mu.K, an den Rat d. Stadt
Dessau, MuK, 7.9.54: Oelsnitz an das MfG, 23.8.54; DQ1/2245, Warnecke an den DFD,
Oelsnitz, 30.9.54; DQ1/2245, Kreisarzt, Rat des Kreises Fürstenwalde an das MfG,
14.9.54.

[137] For a similar conclusion, see Reyer and Kleine, 118–19.

[138] Long-term homes housed some orphans, but their typical resident was a "half-or-
phan" whose surviving parent had to work.

[139] On prioritization of weekly homes, see LStA. 924, B1. 147, 11.2.53; Bl. 140, 17.6.53;
Bl. 138, 8.9.53.

counted, however, for more than a third of all crèche places: of roughly 80,000 children cared for in crèches in 1958, 23,570 were in weekly homes and 9,059 in long-term care.[140]

Disinterest in the emotional life of children coexisted with a gendered understanding of child rearing that dovetailed, ironically, with Bishop Weskamm's. German Communists assumed that ties between children and mothers were especially strong because, in the natural order, mothers nurture children. In one custody decision, for example, the judge recognized that "neither parent is a good parent" but ruled in favor of the mother because she was "naturally" closer to the child. The Supreme Court overturned this decision, arguing that *this* mother was the worse parent. Yet the reversal bespoke the expectation that a mother *should* be the better caretaker. The judges found it unremarkable that she boarded her son in a weekly residence but were appalled that she often forgot to pay for his meal plan there and failed sometimes to feed him at home. When the Department of Mother and Child wanted to help out an unhappily pregnant woman (and keep her from seeking an abortion), it never assumed that the father should step into the breach. An SED couple, for example, applied for the mother to abort a pregnancy, arguing that she was overwhelmed with care for their six children. Käthe Kern rejected the request, as always, and arranged for the possibly suicidal mother to stay in a rest home. She found places for her two toddlers in a children's residence. The middle children, Kern informed the case worker, should stay in the family—cared for by their adolescent siblings. "Mother State" arranged the smallest details to overcome a domestic emergency but did so in order to preserve the family's reproductive function and to protect a politically active father from having to tend his children.[141]

Most East Germans agreed that the mother was the natural nurturer. Letters written at the time and recent interviews are suffused with maternalist assumptions and rarely mention fatherhood. One interviewee recalled her husband as "stricter" than she but as having had little to do with their children.[142] Politically engaged fathers worked long hours and attended so many meetings that they saw even less of their children than

[140] SAPMO-BArch, DY30/IV2/1.01/426, Stenographische Niederschrift . . . Januar 1959; BArch, DQ1/6634, Bl. 267–68. On single mothers' reliance on weekly homes, see LStA, 924. Bl. 75, Rat des Kreis Eilenburg an Rat der Bezirk Leipzig MuK, 19.8.54; 924, Bl. 203, Wurzen, 19.8.54; 916, Bl. 252, Rat der Bezirk Leipzig, 28.6.54; SAPMO-BArch, DY34/39/86/5568, Bericht . . . 28/30.3.57, S. 4.

[141] BArch, DQ1/1843/1, Bl. 305, Kern an Magistrat Berlin, HA MuK, Frau Brückner, 10.9.52; Bl. 304, Kern an Brückner. For other cases, see DQ1 5145, E. an das MfG, 22.11.54; 2245, Aktenvermerk, Hauptabteilungsleiterin (Kern), HAMuK, 6.6.52.

[142] IMC, Interview 034.

the careerist American father of the fifties.[143] Of course, some fathers played an active part in child rearing.[144] Normally, however, the mother changed diapers, salved scrapes, supervised homework, and imposed daily routines. The state made no policy interventions and few discursive forays into this conventional arrangement. In the case of single mothers, the authorities enforced the norm. Ignoring the complaints of unwed fathers, the courts automatically assigned sole custody to the mother and gave single mothers the right to decide if the father could even see the child.[145] Individual mothers escaped the pall of the cultural imperative and candidly described themselves as "not the maternal type."[146] The state's dual discourse about women as workers *and* mothers liberated them from a source of guilt that afflicted working mothers in the United States. No interviewee who had a job when her child was young expressed remorse about having worked. Some mothers believed that institutional care made their children more "social."[147]

Nonetheless, mothers attributed great significance to the mother-child bond. Women who did *not* work when their children were young recall that they stayed at home "for my children."[148] Women professionals who wanted to work occasionally hired a nanny to avoid group care.[149] Proletarian women did not have this option. If married, they moved in and out of the workforce, staying home when children were young and returning to work when their kids reached kindergarten or school age.[150] Some mothers rejected any nonmaternal care.[151] A nonemployed pregnant mother who wanted an abortion brusquely refused Kern's standard offer of a rest-cure, because she believed a separation would harm her two toddlers.[152] Many mothers saw group care as unloving. They worried,

[143] Niethammer, von Plato, Wierling, 122, 345, 466.
[144] Ibid., 501; interview Frau CT; interview Frau MB; IMC, Interview 033.
[145] BArch, DP1/VA/1447, Bl. 140–41. H.D. an den Volkskammer der DDR, 23.1.57; Bl. 145 Hbt. Gesetzgebung an HD, 1.2.57; Bl.164, Oberstes Gericht, VP Ziegler an H. Benjamin, 18.2.57; Bl.175, VP Ziegler an H. Benjamin, 22.1.57; DP1/VA/1447, Bd. 2, Bl. 8, Hauptabteilung Gesetzgebung on Herrn Rechtsanwalt Dr. A.S., 26.3.58.
[146] Interview Frau CT.
[147] IMC, Interview 006.
[148] Interview Frau RN. Knapp discusses the spread of maternalism among proletarian mothers in the late nineteenth century (Knapp, 340, 349, 359–60).
[149] Interview Frau MB.
[150] Trappe, 127. The reliance on relatives as caretakers continued the working-class pattern of the nineteenth century. See Franzoi, 88–89.
[151] SAPMO-BArch, DY34,Frauenabteilung. Betr: Betriebsbesuch in Glasshütte Carlsfeld Kreis Aue, 11.7.52; LAM, A914, Leuna Werke, Bl. 34, 1.10.52; Bl. 108.
[152] BArch, DQ1/5145, E. an das MfG . . . , Wernigrode, 22.11.54; Dr. Rübberdt, Magdeburg, an das MfG, HAMuK, 13.12.54.

too, about institutional safety and infection rates. Unhealthy conditions in a communal facility in Bernau, for example, spread "mistrust among mothers against our child institutions." A mother who operated a kiosk booth preferred to bring her child to work.[153]

Single mothers had the narrowest range of choices. They often abhorred the weekly homes and did what they could to avoid them. A young mother abandoned a factory job after four days because, the authorities relayed, "she cannot live without her children," who had been placed in a weekly facility. In a town near Leipzig with no *day*care facility, mothers were lost to production because "they do not want to be separated from their children all week."[154] The authorities tolerated such attitudes, more evidence of their utilitarian approach to nurture. The assistant director of "Mother and Child" assured a mother, "children experience acute separation anxiety but quickly adjust to their new surroundings." Neither she nor Kern, though, ever insisted that a mother go to a rest home or use a weekly home. Indeed, they greased the squeaky wheel: for the mother who could "not live without her children," "Mother and Child" arranged a job *in* a children's home so she could work and be near them.[155]

Gradually, mothers made Kern and her subordinates sensitive to nurture. Kern had frequently to field questions from mothers of crèche children about slow motor and verbal development.[156] Maternal concerns alerted officials who in 1953 and 1954 began to worry about the overly hospital-like conditions in long-term homes. "Mother and Child" decided "to make long-term homes more like families" by introducing mixed groups of children from one to three years old in a few homes. Local officials near Leipzig wanted "children in our beautifully outfitted infant homes not only to be tended (*gepflegt*) but stimulated to think." "Our neonatal nurses," they concluded, "don't understand how to teach the children to play or to engage them suitably (*fachgemass*) . . ." Stimulation was important, they said, because these infants did not receive "parental attention on the weekend."[157] In another small town, the staff at "Mother

[153] BArch, DQ1/3849, Bl. 37–39. Also see SAPMO-BArch, DY30/IV2/17/53, Bl. 375, Bericht . . . Eisenach. 28.10.48. Maternal worries about the infection rate in day care were not new (Knapp, 251).

[154] Quote from: LStA, 916. Bl. 269. Rat des Landkreis Torgau, Referat MuK an Rat der Bezirk Leipzig, 2.3.53. Also see LStA, 924, Bl. 75, Rat der Kreis Eilenburg an Rat der Bezirk Leipziger MuK, 19.8.54; SAPMO-BArch, DY31/317, Bl. 151, Auswertung der Beratung mit Hortnerinnen und werktätigen Müttern (11.1958).

[155] BArch, DQ1/5145, Dr. Neumann, HA MuK, Berlin an Eilert, 26.11.54.

[156] BArch, DQ1/208, Zumpe, Kontrollfahrt . . . 8.11.50.

[157] BArch, DQ1/5331 Kinderkrippen u. Heime. Entwicklung seit 1950, n.d. [1954]; LStA 924, Bl. 91, Kreisrat zu Grimma an Rat der Bezirk Leipzig, MuK, 20.8.54.

and Child" told administrators in Leipzig, "in the future we will not build new long-term homes, for they do not correspond to the goal of securing the bond between mother and child."[158]

By the end of the 1950s, there emerged a wider, though patchy, interest in the stimulation of infants and toddlers. Faced with "many criticisms from employed mothers" about "inequalities" in the education of children in crèches and kindergartens, the Department of Mother and Child acknowledged in 1959 that "the quality of the personnel has not kept pace" with the "frantic forward-march of the *Kinderkrippen*." The DFD commissioned an investigation, which found the crèche good on basic care, but neglectful of "pedagogical matters." Even children in *day*care, concluded a comparative study of three-year-olds, entered kindergarten "verbally and emotionally behind" those raised solely in the family.[159] Further research established that children in institutional care, and especially those in the long-term homes, were smaller and less coordinated than their peers.[160] At the *first* GDR-wide conference on preschool education in 1957, the keynote speaker regretted that crèche and kindergarten teachers did not "always adjust their pedagogy to each child's age and personal character [*Eigenart*]."[161]

Interest in the young child was, in part, politically motivated. A delegate to the preschool conference clucked disapprovingly about "pacifist" educators who did not encourage children to play with toy soldiers and guns.[162] Clearly, though, interest was stimulated by the acute observation of her children by "the working mother." Professionals such as the physician Eva Schmidt-Kolmer confirmed mothers' sense that something was awry. She conducted a study that revealed developmental gaps among toddlers nurtured in long-term and weekly institutions. Rudolf Neubert, meanwhile, dusted off Makarenko's "big family" theory of child rearing for East German consumption. Children, he wrote, needed two parents at home, and babies needed to be cared for by their mothers. He cited

[158] LStA, 924. Bl. 37. Rat des Kreis Borna an Rat der Bezirk Leipzig, 9.10.53. For evidence that fewer long-term homes were built, see SAPMO-BArch, DY30/IV2/17/9, Bl. 56, Arbeitsgruppe Frauen an die Genossin Lene Berg, 10.2.60.

[159] BArch, DQ1/6363, Liebmann Rat d. Kreis Bitterfeld an Kern, 7.11.58; 2963, Abt. Frauen und Staat, 31.10.60. Einschätzung . . . Verbesserung der Betreuung der Kinder in Kinderkrippe u. Heimen vom 8.1.60, 4; DQ1/2963, Bericht . . . Bezirk Magdeburg am 21.5.59, 3.

[160] Anita Grandke, Zur Entwicklung von Ehe und Familie, 268.

[161] SAPMO-BArch, DY34/39/86/5568 Bericht . . . Vorschulerziehung in Leipzig von 28.–30.3.57.

[162] SAPMO-BArch, DY34/39/86/5568, Bericht . . . von 28.–30.3.57. S.9; Obertreis, 100–1.

Schmidt-Kolmer's findings to prove the "importance of the family for the infant." He pointed out that the USSR was moving children from group homes into day care and had "extended maternal leave to 128 days [77 days in the GDR]." In the late 1950s, there also appeared other bellwethers of rising official interest in the family's social role, including articles in *Frau von heute* that praised family nurture and dissertations in pedagogy based on Makarenko's theory.[163]

CONCLUSION

The party-state interfered in the family from 1949 onward. It legally curbed parental authority. Social workers made surprise visits to the homes of workers who claimed sick leave or disability. They appeared unannounced to ascertain that a woman who applied for a paid housework day ran a proper household.[164] Members of the National Front entered neighbors' homes to request a "donation" toward the fight against imperialist machinations—and to have a look around. Voluntary "porters" in apartment blocks recorded the names of residents' guests. The SED never pretended to leave the private sphere alone, so these interventions may appall but should not astonish us. Rather, it surprises that intervention in the family often resembled that by Western states and was motivated by similar concerns. Given the hyperbolic rhetoric of West German commentators at the time, it surprises, too, that the state interfered in the family as little as it did. Interviewees recall their domestic lives as largely private. A Romanian family that arrived in Dresden in the mid-1950s was ignored by everyone—neighbors, mass organizations, and state officials. They were, recalls the daughter, "four people unto ourselves." In Berlin, the bank accountant Frau R. and her husband withdrew from a state they rejected. No one disturbed their self-imposed isolation. In the countryside, a housewife and her young children spent their days rambling through wood and field and aroused no attention.[165]

Over time, the official mind was alerted to the significance of the family by, on the one hand, popular and expert opinion and, on the other, worrisome social trends such as divorce among couples with young children. The reorientation of discourse and decision making was slight before 1960, but it revealed several contradictory features that emerged more sharply later on. Burgeoning interest in the family was both conse-

[163] Neubert, *Geschlechterfrage*, 104; Neubert, *Ehebuch*, 26; Busch, 24, 43; "In der Familie beginnt die Erziehung . . . " Fvh, Nr. 45, 8.11.57.
[164] Sachse, *Hausarbeitstag*, 431.
[165] Interview Frau RN; Interview Frau AR.; IMC, Interview 030.

quence and cause of several "modern" tendencies: concern about individual development, sensitivity to the plight of older women, and pragmatism about sex and the body. Simultaneously, it encouraged conventional, even regressive, tendencies: reification of marriage and the maternal role in child rearing. Official reevaluation of the family went into high gear only in the 1960s, as the employment rate of mothers and wives leaped upward, and the state had to deal with the unintended consequences of that trend.

Modernization and Its Discontents

STATE, SOCIETY, AND GENDER IN THE 1960s

THE SIXTIES opened inauspiciously for ordinary East Germans. In 1959, the Politburo replaced the Second Five-Year Plan with an ambitious Seven-Year Plan. It sped up nationalization of private retailers and handicraft producers.[1] It completed collectivization, sending 100,000 activists into villages to harass farmers to join LPGs. In 1958 only thirty-seven percent of farmers worked on an LPG; by January 1961, eighty-four percent did.[2] *Republikflucht* crested again. The wave evaporated in the wake of the SED's most infamous act: construction of the Berlin wall during the night of 13 August 1961. When they awoke the next morning, East Berliners were as stunned as the rest of the world to find the city's western part sealed off. To head off unrest, the Ministry of State Security detained 1,500 people for "political" deeds between August and December. The SED launched a "production complement," putting workers under more pressure to produce than since 1952 and 1953.[3] Consumers faced severe scarcities of potatoes, sausage, butter, cheese, eggs, shoes, underwear, and detergents. People wrote thousands of complaints and carried out scattered strikes to protest the dearth.[4]

Many scholars interpret the calm of 1957 to 1959 as the eye of a Communist storm: the SED let the hard line undulate before setting it in cement. The measures of 1960 and 1961 completed the construction of SED power. In 1974, the political scientist Peter Christian Ludz offered a counterinterpretation. The wall, he suggested, constituted a "social-political caesura" in the history of the dictatorship. The shocks surrounding the wall's construction were followed by a gradual relaxation of relations between the regime and the imprisoned population.[5] The ultra-Stalinist Ulbricht came to support a plan to modernize the economy through partial decentralization, market-style incentives for managers, and some con-

[1] Klessmann, *Zwei Staaten*, 310–12.
[2] Humm, 99; Allinson, 81–82; Klessmann, *Zwei Staaten*, 318; Eckert, 366.
[3] Major, "Vor und nach," 344–45; Ross, 161–63, 166; Eckert, 366; Mählert, 102–3.
[4] Steiner, Frustration, 23–25; Hübner, *Konsenz*, 163–64.
[5] Ludz, "Ziele," 1265–66; Ludz, *GDR*, 11–12; Major, "Vor und nach"; Major, "Torschlusspanik," 243.

sumer perks for workers.[6] Educational institutions were expanded. The SED introduced measures to improve communication between the party, professional "experts," and the populace. It tolerated a cultural thaw.[7] Class-struggle language was tempered by a reassuring rhetoric of social inclusion and a galvanizing language of individual improvement.[8] Ordinary people could adapt to all of these changes or retreat into "inner emigration." Most did some of both. They hankered after life in the West but adjusted to life in the East and took advantage of improved opportunities for qualification, consumption, and leisure.[9]

Having no "voice" and no "exit," to use Albert Hirschmann's terms, East Germans had no choice but accommodation.[10] It is less obvious why the regime conciliated social interests after 1961 more than before. Scholars have put forward three main motivations: Soviet policies, fear of a popular explosion, and/or economic exigencies.[11] Each explanation has merit. The Soviets refused to loan the GDR funds to address its latest crisis, were discussing their own reforms in Moscow, and encouraged the SED to loosen up. Yet the CPSU had at earlier moments been stingy, introduced revisions in the USSR, or suggested a slacker grip—with little sustained effect on SED decisions. Memories of June 1953, certainly, hovered over the Politburo. Yet if a rebellion was so dreaded, why did the SED goad people with the hated measures of 1960 and 1961? The economic explanation is most credible, for it draws a unifying line through the zigzag course of "normalization" from 1957 to 1959, radicalism in 1960 and 1961, and reform in 1962 through 1965, without imputing a master plan to the about-turns.

The late 1950s were comparatively good years, but the economy was strained by consumption bottlenecks. Wage increases and the end of rationing combined to spur consumption demands that neither agriculture nor manufacturing could satisfy. East Germans continued to spend thousands of marks on West German clothes and housewares and to face intermittent shortages in basic provisions. Production policy, too, hit bumps: lower returns on investment in heavy and basic industry, smaller increases in productivity, and worsening shortages of, especially, skilled labor.[12]

[6] On mechanisms to increase incentives, see Kornai, 224; Kopstein, 64.

[7] Kaiser, "Reforming Socialism?" 337; Hübner, *Konsens*, 169; Klessmann, *Zwei Staaten*, 337; Kopstein, 46; Wierling, "Jugend," 404.

[8] Thaa et al., 50–51.

[9] Major, "Vor und nach."

[10] See Heldmann, *Anoraks*, 44–45; Ross, 158.

[11] Kaiser emphasizes anxiety about youth (Kaiser, "Reforming Socialism?"). Steiner highlights Soviet influence and economics ("Überholen," 254–57) as do Thaa et al., 49–51. Grieder points to Soviet debates about economic reform (Grieder, "Leadership," 32).

[12] Steiner, "Überholen," 254–57; Ritschl, 22, 27–29.

Rural collectivization and small-business nationalization would allow, it was assumed, the state to control the supply and distribution of provisions.[13] Instead, these acts exacerbated food scarcities and labor shortages. Economic functionaries estimated that the working-age population would shrink by ten percent between 1960 and 1965. Border officials anxiously tallied the numbers of fleeing farmers, skilled workers, engineers, medical personnel, teachers, and academics.[14] The wall stopped the hemorrhage and allowed the SED to ratchet up norms without fear of renewed flight. Yet the "production complement" failed. Foremen implemented it half-heartedly, because workers threatened to quit in favor of work in some other labor-starved factory.[15] With few units of labor to mobilize, the extensive growth of early Stalinism had reached its limits. The GDR had to grow intensively.[16] The goal of "meet[ing] the challenge of rising living standards in the Federal Republic," pontificated Ulbricht in 1963, could be attained only if the GDR joined the "scientific technological revolution."[17] His economic advisors foresaw a "selective great leap forward" that would surpass West German productivity in light chemicals, electronics, and machine building.[18] The aim remained higher productivity, but the obsession with quantity transmuted into a mania for quality. One cannot whip or harangue workers into high-quality labor, especially in a seller's market. One must train them, set them to work on modern machines, and make it worth their while to work well.

Productivity was the central dilemma—and the party leadership saw female labor as a major part of the solution. When it ended rationing, it dangled consumption carrots, raised unskilled wages, and added child care places, all in order to increase the workforce participation of married women with young children. As we will see, it expanded part-time work toward the same end. These measures helped, but many thousands of housewives still ignored the pressure to get a job. The Ministry of Labor urged more, better, different "special measures." The Politburo's gaze shifted to women's paltry level of qualification—which kept their wages low and unattractive, decreased job commitment, and reduced productivity. Moreover, unskilled women accounted for a substantial fraction of the workforce in priority industries of the 1960s: chemicals, optics, and electronics.

The first public sign of concern about women's qualification appeared soon after the wall went up. On 23 December 1961, *Neues Deutschland*

[13] Heldmann, *Anoraks*, 55; Ritschl, 30.

[14] Major, "Going west," 191, 196, 200.

[15] Port, *Conflict*, 195–201.

[16] Steiner, "Überholen," 254–57; Ritschl, 15; Laatz, 176; Frerich and Frey, 399.

[17] Kopstein, 46. Quote from Grieder, "Leadership," 32.

[18] Kopstein, 64.

published a "communiqué" from the Politburo. Entitled "Women, Peace, and Socialism," it addressed women's promotion, technical qualification, and social parity. The communiqué pronounced gender equality an "unconditional principle of Marxism-Leninism" and "a matter of interest for the entire society." It chided men for opposing women's advance. It invited East Germans to engage in a "broad dialogue" about women at work and in society.[19] The communiqué's focus on employment embodied productivist orthodoxy. Never before, however, had the Politburo dedicated a major statement to women's qualification, much less splashed an unflattering discussion of women's situation in the GDR across the front page of *Neues Deutschland*. Also unorthodox were appeals to "the entire society" and "broad dialogue." Amid the Stalinist moves of 1960 and 1961, the Politburo sent an ambiguous message that suggested the usual ends now required unusual means. It is no accident that the first of several "communiqués" targeted women. They remained out of the loops of high politics and the military but sat in the middle of every other ring that was coming to matter: productivity, qualification, consumer preferences, consumer-goods manufacturing, reproduction, and a motivated "society."

By 1964, the SED attained the historic goal of drawing the majority of young, married mothers into wage labor—only to watch unexpected consequences cascade from all sides. Like male workers in the tight labor market, employed women articulated a socialist sense of entitlement.[20] Female workers' choosiness was structured by the central place of domestic responsibilities in their lives.[21] They were exacting consumers who expected ever better services, fashions, and appliances. They were scrupulous mothers who demanded good care for their children. They were conscientious reproducers who reduced fertility and pressed for access to contraception and abortion. They were picky wives who left abusive, deadbeat, or just plain unsatisfying husbands. They were selective trainees who avoided professions seen as unfeminine or unfriendly to women. They were fussy workers who pressed managers for part-time hours. Women's behavior and increasingly self-conscious arguments demonstrated that the spheres of politics, production, reproduction, and consumption were actually spirals that all circled back to everyday life. In the 1950s, private consumption had forced its way onto the regime's

[19] "Die Frauen—der Frieden und der Sozialismus. Kommuniqué des Politbüro des Zentralkomitees der SED," *ND* 23.12.61; Kreutzer, 24. For a similar interpretation as mine of the Frauenkommunique, see Budde, Intelligenz, 55–63.

[20] On workers' sense of entitlement, see Hübner, "Zukunft," 179–81; Hübner, "Balance," 22–23; Heldman, *Anoraks*, 137–38.

[21] Ansorg and Hürtgen, "Myth," 169.

agenda. In the 1960s came a vogue of the newly identified "basic cell of society"—the family.

THE ROLLER COASTER OF STATE POLICY

Postwall political adjustments consisted of efforts to improve "dialogue" between the state and society. The SED conducted a series of "controlled discussions" about sensitive topics. In 1962, the GDR hosted a conference, attended by thousands of West and East Germans, on the national status of the GDR. In 1965, the Ministry of Justice finally unveiled a new draft family code and permitted a wide-ranging conversation about its provisions. In 1968, the SED introduced a revised constitution for discussion (which was cut off by the Soviet invasion of Czechoslovakia). The SED itself felt a breath of change. It lowered the hurdles to membership, while raising the level of education for functionaries. Party statutes reduced the authority of the apparatus and, especially, party secretaries. Committees were created to study social problems. Scientists, economists, physicians, pedagogues, and other experts conducted empirical investigations and made recommendations to the Central Committee.[22]

The Ministry of Justice released thousands of prisoners. It produced a less draconian and politicized penal code.[23] The Ministry of State Security gloved the naked fist and relied increasingly on ubiquitous but inconspicuous surveillance.[24] By 1971, the Stasi employed 45,000 full-time agents plus 100,000 "unofficial co-operatives" (IMs) who recorded people's conversations about every imaginable topic.[25] The police did not, however, crack down on a variety of economic, shop-floor, and social complaints, as long as these involved no group action.[26] In early 1963, normalization spread to the fraught area of youth policy. Youth, enthralled with Western pop culture, truly reviled the wall. The SED felt it had to make gestures toward reconciliation. After months of internal debate, the party hierarchy and FDJ leadership published a "Youth Communiqué," which boldly designated dancing a "legitimate expression of joy and pleasure in life."[27] To demonstrate this controversial point, the FDJ's new chairman did the

[22] Kaiser, "Reforming Socialism?" 330–31; Mählert, 102–3;Klessmann, *Zwei Staaten*, 337; Weber, *DDR* 58; Grieder, "Leadership."

[23] Eckert, 366.

[24] Quote from Mählert, 101–2. Also see Major, "Vor und nach," 353.

[25] Gieseke, 41–58.

[26] Major, "Vor und nach," 353; Weber, *DDR* 58; Mählert, 108; Eckert, 367, 372–73.

[27] Wierling, "Jugend," 407; Feinstein, *Triumph*, 157. Also see Kersten, 106–35.

"twist" at its congress—whether to the delight or dismay of Chubby Checker can only be surmised.[28]

This stiff bend was one move in a cultural swing that "allowed room for individuality and for a critical appreciation of social problems." The regime permitted the publication of psychologically realistic novels, including *Der geteilte Himmel* (The Divided Sky), Christa Wolf's story of a young couple torn apart by the wall.[29] Wolf's personalization of a hot political issue signified, argues Joshua Feinstein, a subtle shift in the "civic imaginary." Cultural imagery became less masculine and more feminine. DEFA films such as *Der geteilte Himmel* and *Das Kaninchen bin ich* (I am the Rabbit) embodied a subjectivist turn. The new genre favored a female lead. She played a protagonist who represented no class but herself and fought not heroic battles, but everyday struggles. She "felt" her way intuitively toward a sense of belonging in the East and to Socialism. The films, like Wolf's novel, drew the viewer into political dilemmas through the dramas of private life.[30]

Economic reform began in 1963. The New Economic System (NES) allowed for some autonomy of decision making within each industrial branch, and even to each factory director. NES introduced more flexible pricing and implicitly recognized the profit principle by measuring the success of an enterprise by how much surplus it generated and by tying bonuses to surplus production. It enhanced the authority of economic experts relative to that of party secretaries. In 1964 and 1965, national income grew by five percent a year, and production was up seven percent in 1964 and six percent in 1965. Workers' and employees' gross income rose by four percent annually, a substantial rise but gratifyingly below productivity growth. Provisioning improved noticeably. The manufacture of consumer durables expanded.[31]

All this only superficially adjusted the system, yet even fine tuning alarmed vested interests and ideologues. District secretaries on the Central Committee balked at the rise of the expert. Theorists in the Politburo espied creeping capitalism and cultural degeneracy. Ulbricht discovered that The Leader could not fight The Party. His minion Erich Honecker led a conservative block that forced retreat.[32] In December 1965, the Eleventh Plenum of the Central Committee refroze the cultural landscape. It banned eleven DEFA movies, including *Das Kaninchen bin ich* and others

[28] Mählert, 88–89; Weber, *DDR* 63.
[29] Kaiser, "Reforming Socialism?" 329.
[30] Feinstein, 117–19, 131.
[31] Klessmann, *Zwei Staaten*, 342; Grieder, Leadership, 161; Kopstein, 46; Steiner, "Dissolution," 173.
[32] Kopstein, 55, 59.

that film historians rank among the studio's best works for innovative style, emotional force, and perceptive analysis of generational, gender, and social tensions.[33] The Plenum recentralized control over monies for research and development. Unluckily for NES reformers, in 1966 wages rose faster than production, alienating the apparatus. Prices had to be raised, alienating the urban populace. LPGs were told to turn a profit, alienating collectivized farmers. Punctured on many sides, economic reform lost steam.[34]

WOMEN'S POLITICAL ROLES AND WOMEN'S POLICY

The ambiguous *Frauenkommuniqué* of 1961 was motivated, first and foremost, by economics. In 1960, in reports on women's factories, "inspectors" detailed the obstacles to qualification. The communiqué opened a press campaign that criticized these hurdles. In January 1962, the Central Committee hosted a "women's conference" to discuss the problems of working women.[35] Women in the party, DFD, trade unions, and other mass organizations convened discussions of the *Frauenkommuniqué* in factories, shops, and offices. Like every SED campaign, this one soon slackened but, unusually, women's qualification remained a media theme.[36] The communiqué was motivated, secondarily, by politics. On 5 December 1961, the Politburo discussed a report by members of the SED's Women's Working Group, a report that painted a dire portrait of women's state of mind and, argues Susanne Kreutzer, alarmed the Politburo.[37] Women, claimed the report, listened regularly to the RIAS, watched Western television, and salivated over the "glitzy facade of the West." Wives of the "intelligentsia" exerted "negative influence" on their husbands and oriented the family's "style of life" to the West. Before the wall, according to the report, women often pushed their husbands to flee. After its construction, women expressed pacifist views and "reservations about socialism." When asked to become politically active, they declined, with the

[33] Mählert, 103; Kaiser, "Reforming Socialism?" 332; Feinstein, 158–62, 174–75, 177–83.

[34] Steiner, "Dissolution," 177–79; Klessmann, *Zwei Staaten*, 344; Kopstein, 61; Allinson, 133.

[35] "Eine neue Etappe im Leben der Frauen der DDR," ND 5.1.62.

[36] Kreutzer, 24; "Walter Ulbricht: Von der Konferenz der Frauen nun zur Volksaussprache," ND 7.1.62. An example of a workplace intervention: SAPMO-BArch, DY30/IV2/17/20, Bl. 301–6, FDGB Bezirkvorstand Dresden, Verwirklichung d. Kommuniques . . . 2.2.62.

[37] Kreutzer, 25.

excuse, "politics is a man's affair."[38] The report acknowledged the political reverberations of women's domestic influence, but it reinforced the assumption that they were apolitical and religious. Rural women remained particularly suspect. Farmer-women allegedly "idolized the West," constituted the "last bulwark of private property," and were loyal to the Lutheran Women's Aid.[39]

The report's gloomy portrayal of female conservatism corresponded to a glum picture of male sexism. It faulted "the deficient activity of many party leaders" that left political work with women to SED women. The report added audaciously, "This is true from the Central Committee on down." It even noted the "decline in the number of female comrades . . . who exercise leading functions in the party."[40] The published communiqué did not mention these last points, much less blame women's social situation on the SED. Rather, it cited men's retrograde attitudes.[41] The communiqué transmitted, nonetheless, a slight political current, for its reproach of men obviously included SED officials. It implied that not just women's professional advancement, but their political promotion now stood on the agenda.[42]

The faint political tinge of the revived "woman question" quickly faded. Women's standing in the SED progressed little. Female membership increased incrementally, to 26.5 percent in 1966 and to 28.7 percent in 1971.[43] Their role in its "district leadership" expanded. In 1962, average female participation on district committees was 20.2 percent; by 1971, it was 24.9 percent. Yet the ratio of women in the powerful district secretariats stagnated at 3.6 percent (1969). No woman became a First Secretary. From the mid-1950s to 1963, the Central Committee grew larger, became younger, and added "experts."[44] Women's participation rose slightly, to 13.3 percent, but, nonetheless, it stood lower in 1971 than in *1950*. The Politburo (all male since 1953) added two women candidates in 1958. One, Edith Baumann, was an Old Communist; the other,

[38] The report was compiled under the title "Die politische Massenarbeit mit allen Frauen und Mädchen" (SAPMO-BArch, DY30/IV2/5/202 Bl. 56–78, [Sept. 1961]) and then recompiled in November (Kreutzer, 25) as a "Bericht an den Politburo über die politische Massenarbeit unter allen Frauen und Mädchen" (DY30/IV2/5/202 Bl.79–111).

[39] SAPMO-BArch, DY30/IV2/17/69, Bl. 53, Protokoll . . . 10.8.62, Bl. 54–56. Also see LAM, IV/A-2/17/23, Beratung mit den Fraueninstrukteurinnen . . . 11.5.62. For counter-evidence to this portrayal of rural women, see Humm, 59–60; Panzig, "Eigenen Beruf," 177.

[40] SAPMO-BArch, DY30/IV2/5/202, Politische Massenarbeit, S. 11–13, 20.

[41] Kreutzer, 27, 29. Also see Obertreis, 191.

[42] Hampele, 291.

[43] Gast, 43. In 1968, the SED had 1.8 million members, or about one in every eight adults in the GDR (Allinson, 3–4).

[44] Klessmann, *Zwei Staaten*, 337; Grieder, *Leadership*, 163.

Luise Ermisch, directed a textile factory. Neither was reelected in 1963. In that year, the Politburo expanded, bringing in younger academics and economists, among them the agronomist Margarete Müller. The enlarged Politburo included, then, one woman candidate, but no female voting member.[45]

Women's role in state administration stagnated. In 1970, women occupied eighteen percent of mayoralties, the most visible local office. No woman ran a district council (*Bezirksrat*).[46] Women headed two ministries in the mid-1960s: Margot Honecker at Education (after 1963), and Hilde Benjamin at Justice (until 1967). Twenty-three percent of the Supreme Court was female, as was twenty percent of "leading" administrators at the Ministry of Culture, and seventeen percent at the Ministry of Health. In contrast, the top administration of the Ministry of Trade was six percent female.[47]

Depoliticization of the DFD continued. Attendance at meetings was often low, and its membership declined slightly.[48] The Working Group on Women praised the DFD's "serious effort to overcome rigidity in its work and to shape life in residential areas in varied and interesting ways." An example of its new approach: "ladies' teas."[49] As novel as the teas no doubt were, someone recognized the necessity of a more fundamental innovation. In 1964, the DFD convened a highly publicized Woman's Congress. The Congress manifesto represented the socialist "community" as a "house" and called on "[female] workers, farmers, employees, intelligentsia, artists, handicraft workers, housewives, mothers, women of different religious beliefs . . . to join together in a big socialist family."[50] *Neues Deutschland*'s coverage did not relay this family image of socialism.[51] Domesticity was reserved for women. Women workers gave this assumption an ironic twist. At workplace meetings, women were invited to submit "wish lists" for congressional discussion. Many lists included "relaxation of the abortion ban." Congress participants, too, raised this taboo topic. *Neues Deutschland* portrayed the congress as a smashing

[45] Gast, 81–82, 85, 100, 126–27.
[46] Gast, 205.
[47] SAPMO-BArch, DY30/IV2/17/9 Bl. 63, 64, Anteil der Frauen in leitenden Funktionen, 7.9.61. On Grete Wittkowski's rise to and fall from Deputy Chairwoman for Commerce, Provisioning, and Agriculture on the Council of State in the 1960s, see Gast, 220–22.
[48] Külke, "Berufstätigkeit," 85.
[49] SAPMO-BArch, DY30/IV2/5/202, Politische Massenarbeit.
[50] *Dokumente vom Frauenkongress der Deutschen Demokratischen Republik Berlin 25.–27. Juni 1964*, published by Demokratischer Frauenbund Deutschlands (no place, no date), 147–49.
[51] See, e.g., "Ein neues, freies Frauengeschlecht ist herangewachsen," ND 27.6.64; "Die Republik braucht alle Frauen—alle Frauen brauchen unsere Republik," ND 26.6.64.

success, but the party elite may have thought otherwise. Although delegates vowed that a second congress would soon convene, that did not happen for five years. The Congress of 1969 was better orchestrated but still fell off-script and, according to Anne Hampele, "cast too glaring a light on the DFD." The era of the woman's congress closed.[52]

The balance sheet of women's political influence was not completely negative. From posts within the party, trade unions, the Ministries of Health and Justice, and academia, SED women "coordinated and institutionalized" research on women, the family, and society. In 1964, a working group entitled "The Woman in Socialist Society" was formed within the German Academy of Sciences. Headed by the family law expert Anita Grandke, the working group became the executive organ of a "Scientific Advisory Council" on the "Woman in Socialist Society" (WB). The WB laid out four areas of research: women in socialist industry; women in science, education, and health; women in socialist agriculture; and "problems in the development of family relationships." As one of the first among many scientific committees spawned by the Academy, the WB, argues Horst Laatz, played a key role in the renaissance of social science and social policy in the GDR.[53]

In 1961, the Central Committee created a Women's Department, headed by Inge Lange. In 1962 came its higher incarnation, the Women's Commission of the Politburo, also headed by Lange. The formation of the Women's Commission revived the 1940s experiment with special representation for women in the party. Unlike then, the call came from above and, unlike Elli Schmidt and Käthe Kern, Lange did not sit on the SED's highest body. In 1964 she entered the Central Committee; not until 1971 did she join the Politburo as a candidate (she was never granted full membership). The FDGB and state ministries also created "working groups" to study issues that impinged on women: employment, education, consumption, leisure, marriage, the family, and reproduction. Composed of union representatives, SED officials, economists, sociologists, social workers, gynecologists, psychologists, and public health experts, the commissions, lopsidedly female in membership, evaluated reams of evidence, including statistics, women's petitions, interviews with women workers, and factory observations. The WB, Women's Commissions, and "working groups" existed to advance Politburo interests. They, however, approached their mission conscientiously and interpreted it broadly. Often shocked by what they learned, they grew more sensitive to the complicated interactions between the family, women's decisions, and producti-

[52] Hampele, 299–300; "Die Frau im entwickelten gesellschaftlichen System des Sozialismus," ND 12.6.69; "Bewusst und charmant die Frau im Jahre 20," ND 13.6.69.
[53] Laatz, 182–84.

vist goals. Their reports aimed to enlarge the official conception of the "woman question." The reports had some practical effect, yet the men in power incorporated the information into a worldview that subordinated the domestic to production and reified it as a female place.

EMPLOYMENT: TWO STEPS FORWARD, ONE STEP BACK, SLIDE TO THE SIDE

In 1959, the Ministry of Labor set out to locate and tap "reserves," i.e., housewives. In Halle district, home of the booming chemical industry, Labor officials visited towns "where the mayor knows everyone . . . " and could identify nonemployed women. A chemical concern then invited them to a forum entitled "Housewives and the Chemical Program" where they learned of a job's benefits to themselves, industry, the GDR, and civilization. At smaller gatherings, members of the DFD or the National Front lectured housewives on the positive correlation between employment and equality.[54] Every appeal fell flat. Clearly, it was time to get serious about "special measures." The measures came to include expansion of services, consumer perks, rationalization of the home, and "affirmative-action"-style initiatives to encourage qualification. In combination, these initiatives paid off: young, married mothers entered the workforce in droves. Women responded strongly to the mantra of the 1960s: *Bildung* (education, cultivation). Many thousands trained for a diploma or studied for a degree. In 1960 and 1961, women accounted for twenty-five percent of students at universities and TUs; in 1969 and 1970, they made up thirty-four percent.[55] Women's behavior reflected not just policy modifications, but also the friendly attitude of younger husbands toward spousal employment. Social mobility became a family affair. Women workers, meanwhile, faced less hostility from men who were also caught up with qualification and felt less threatened by women's competition.

Not every effect of economic reform was gender equalizing. The labor market became more gender segmented as women took up skilled jobs in services, rather than industry. This trend was not "inefficient," so NES reformers accepted it.[56] A second trend of the 1960s did upset them: a huge jump in the number of women who worked part-time. Ironically, NES contributed to this trend by according factory directors more autonomy in hiring decisions. Desperate for workers, they succumbed to pressure from female employees for part-time positions. Women wanted re-

[54] SAPMO-BArch, DY34/A1544 Abschlussbericht . . . Halle, 20.4.1959, 6–7, 22, 24; Ulbricht et al.
[55] Helwig, 68, 78–80: Hampele, 287.
[56] Also see Schüle, "Die Spinne," 70.

TABLE 7.1

Percentage of Married Women's Employment
by Husband's Income (in marks), 1965

Monthly Income, Husband	% with Employed Wife
300–399	73.6
400–499	76.4
700–799	63.7
900–999	61.0
1000 and higher	53.4

Source: LStA, IV/A-2/7/473,66.

duced hours to meet the demands of domestic labor and child care. For the same reasons, they did not qualify at the rate men did. Nor did they enter management, for men drew a line at female supervision. The gender gaps in wages and authority, thus, remained wide.

The Profile of Female Employment

In 1960, 45 percent of all workers were female and 68.4 percent of all women aged 16 to 60 were employed. By 1965, 70 percent of *married* women had a job; 48.3 percent of all workers were women. True, the more children she had at home, the less likely would a wife have a paid job. Nonetheless, in 1967, fifty-five percent of women with *three or more children* worked for wages.[57] Especially striking was the participation of women in their prime reproductive years. In 1965, 79.5 percent of women 18 to 24 years old and 76.2 percent of women 25 to 39 years old held a job. A wife's workforce participation decreased as her husband's income rose, but not dramatically (Table 7.1). Minor continuities do not negate the historic change: wives of every age, child rearing situation, and family income entered the labor force in large numbers.

The increase in married mothers' employment paralleled a rise in all women's qualification levels. Initially, the trade unions attempted to hector women into qualification.[58] A frustrated functionary wrote to her superior in the metal workers' union of the "immense difficulty" of convincing women to qualify. He advised loftily from afar: remind them that qualification "contributes to the further development of women's equal-

[57] Nickel, "Mitgestalterinnen," 237. Also see LStA, SED, IV/A-2/17/473, S. 68. In 1967, pensioners (older than 60) accounted for 10.1 percent of working women.

[58] SAPMO-BArch, DY30/IV2/5/202, Bl. 56–78, Die politische Massenarbeit mit allen Frauen u. Mädchen [Sept. 1961].

ity." She replied wearily, "We have talked ourselves blue in the face."[59] Multiplied by the hundreds, complaints like hers changed policy. In 1959, the GDR introduced the ten-year polytechnical secondary school (*Oberschule*). "Trade-school" students now had to stay in school until the age of sixteen; proletarian parents could no longer pull out daughters after eighth grade. This reform helped level the playing field. Later measures tilted it slightly in women's favor. Training programs were specialized, shortened, and divided into modules, so a worker could interrupt a program without losing credit, return later, retrain, etc. Factories instituted "special women's classes" that allowed them to earn a trade *diploma* during work hours. Firms conducted "satellite" courses in residential areas so women could dash out for an evening class.[60]

Obstacles did not evaporate. In a plant that manufactured book-binding machines, four women and nineteen men were delegated to attend "preparatory classes" in 1963; in this group, *every* man and *no* woman received "financial aid."[61] No matter how many special courses were held, women with multiple children found it hard to attend. Hence, women continued to resist pressure to qualify. In 1965, 47.2 percent of the workforce in a plastics factory in Halle was female. Yet women accounted for only 12.4 percent of the employees with a higher degree and/or a trade diploma. Most of the plant's untrained workers were recently recruited housewives who, with young children and a husband at home, had no time to learn a trade.[62] Nevertheless, the qualification wave swept up large numbers of women. Between 1960 and 1970, almost 500,000 female apprentices took a skilled worker's test; an additional 300,000 women became skilled workers while employed. In 1970, 41.2 percent of all women worker-employees held a professional diploma or degree. By decade's end, women's level of qualification was higher than that of men in rural occupations, health professions, commerce, and administration.[63] Women who came of age in the 1960s became the first generation of *skilled* women worker-employees in German history.[64] Especially heartening to

[59] DY34/ 4427 VEB Stern-Radio Sonneberg. BGL. Herta Krause an Martha Höhne, Frauenreferentin IG-Metall, 14.8.61.

[60] Külke, 96; Trappe, 171–72; SAPMO-BArch, DY34/A1544 20.4.1959. Abschlussbericht . . . Halle; LAM, IV/ 2/5/144, Leuna Werke, Betriebsparteiorganisation der SED, VEB Filmfabrik AGFA Wolfen, 31.10.59; LAM, 10413, Leuna. Technische Betriebsschule, 1959–60.

[61] LStA IV A-2/17/473 Protokoll . . . 12.11.63: Bericht . . . VEB Leipzig Buchbindereimaschinenwerke (Bubima), S. 4.

[62] SAPMO-BArch, DY34/39/134/6009, VVB Plastverarbeitung. Halle, 25.8.65. an Vorsitz. d. ZV S d. IG Chemie, S. 1–2.

[63] Abteilung Frauen, Bericht über die Entwicklung der Beschäftigung der Frauen in der Produktion, 24.11.71, printed in Thiele, 141.

[64] Trappe, 170–72.

TABLE 7.2
Percentage of Women Working by Education Level, 1964

Level of Education	% Employed
No training	59.4
Skilled worker	66.6
Diploma/professional school	75.8
High degree (technical or unversity)	84.0

Source: LStA, IV/A-2/17/473,70.

the regime, the higher the educational level of a woman, the more likely she was to work for pay (Table 7.2).

In industry, women's qualification did not catch up to men's. In 1970, twenty-three percent of women in production jobs had a trade diploma, in contrast to sixty-five percent of men.[65] The difference in levels of industrial qualification helps explain the wage gap. In 1965 the average monthly wage of *fully employed* female workers and employees was 420 marks, in comparison to 600 marks for men.[66] As earlier, women dominated the three lowest wage steps, were slightly underrepresented at Level IV, and were massively underrepresented in the top half of the scale. The qualification gap was not the only reason women earned less than men. Women were much less likely to attain a "skilled" wage level via the route of "political training." In a survey conducted among 2,000 workers at various industrial concerns in 1971, 56.5 percent of women and 68.7 percent of men reported participation in a training program during the previous five years. Disaggregated, the data reveal that women participated in occupational courses at a *higher* rate than men, but men received either political training or a combination of political and occupational training at twice the rate of women.[67] Not just acquired politics, but also inherent maleness, contributed to the wage gap. As earlier, male industrial workers were often classified as skilled when they were unskilled, whereas women sometimes earned at (semiskilled) Level III when they had a trade certificate.[68] Asked by a member of a Women's Commission why he hired every new male worker at Level IV, but most women at Level III, a personnel director explained, "Even when the men did other work before, they have experience in a factory. Anyway, they have to feed their family and

[65] Abteilung Frauen, Bericht über die Entwicklung der Beschäftigung der Frauen in der Produktion, 24.11.71, printed in Thiele, 141.
[66] LStA, SED IV/A-2/17/473, Protokoll . . . Betriebsfrauenkommission am 27.2.64, S.26–27.
[67] SAPMO-BArch, DY34/9158 Buro Margot Müller, Schriftwechsel mit Akademien, 1970–1972. Institut f. Gesellschaftswissenschaften beim ZK d. SED, S. 8.
[68] See, e.g., LStA. IV A-2/17/473 Protokoll . . . 27.2.64, S. 32. Also see Trappe, 191.

you can't insult them by hiring them at Level III. . . . [T]he plant wouldn't attract any male workers."[69] Some women preferred a job below their qualified level if such a position allowed them to work shorter hours, the day shift, or close to home. As women's qualification levels rose, the disjunction between skill and pay level became more common.[70]

Women's low pay reflected the slow pace of promotion. In 1963, women accounted for 7.3 percent of engineers and technicians, 10.5 percent of chief accountants, and 23.9 percent of "budget experts."[71] In 1968, in Leipzig industrial firms, women were 1 percent of directors, 0.7 percent of technical directors, 4.5 percent of economic directors, 7.7 percent of sales directors, 15.5 percent of chief accountants, and 32.3 percent of personnel directors (*Kaderleiter*). Only 5.4 percent of foremen were female.[72] The wages of women in industrial administration were lower than those of men in comparable positions.[73] Women received fewer non-monetary benefits. They enjoyed less vacation time than men, even when they worked the same job, and even when they, not men, performed the stressful three-shift work that was sometimes rewarded with extra vacation days.[74] Women were less likely to take a "cure" at a clinic or health spa. Physicians, it seems, prescribed "R&R" for as many female as male production workers, but few women used the prescription. "Propaganda," a report noted, should "strongly emphasize the responsibility of the spouse" to care for his children so his wife could rest. The more realistic, if also expensive, solution, its author admitted, was to expand temporary children's homes.[75]

A Step Back: The Rise of Part-time Work

Agriculture, commerce, telecommunications, hospitals, and municipal transportation always offered some part-time jobs.[76] When managers in

[69] Quote: SAPMO-BArch, DY34/1503 Bericht . . . VEB mineralölwerke Luetzkendorf vom 28.1. bis 5.2.64, S. 2–3.

[70] Trappe, 191; LStA IV B-2/17/729 Einschätzung . . . 7.7.66., im VEB Bodenbearbeitungsgeräte Leipzig, 1.12.69.

[71] SAPMO-BArch, DY30/IV2/5/202, Bl. 56–78, Massenarbeit mit allen Frauen und Mädchen [Sept. 1961], S. 13; DY34/4307/212, S. 5.

[72] LStA. IV B-2/17/728 Die gesellschaftliche Stellung der Frau in Bezirk Leipzig. 2/1968, 25, 21.

[73] SAPMO-BArch, DY34/4298 Arbeitsgruppe Frau, 28.9.64. Einige Fakten . . . der chemischen Industrie, 2.

[74] SAPMO-BArch, DY34/DY34/4427. Anlage zum Infobericht. 6.6.64; DY 34/4298. Information . . . 28.12.66.

[75] SAPMO-BArch, DY34/5471, Entwurf, Thesen . . . 7.1.67, 5, 13.

[76] Part-time work ranged from ten hours per week to more than thirty (SAPMO-BArch, DY34/2146. Frauensekretariat. Bericht . . . Halbtagskraften. 24.3.61).

these branches requested more such slots, the MfA refused. Confronted, however, with constant requests for part-time hours from the housewives it tried to recruit, the Ministry decided to expand part-time employment where it already existed.[77] In response, many more housewives signed on to wage labor—and the MfA pushed for extending part-time work into *industry*. This proposal unleashed a debate about the pros and cons of part-time labor for women and for the economy. Participants included the Ministry of Industry, economic functionaries, factory managers, SED secretaries, trade unionists, full-time women workers, and medical experts.

The MfA emphasized part-time work's immediate advantage to industry: the mobilization of housewives. This perspective was shared by managers in industries such as light chemicals that already employed many women and wanted to hire more.[78] Supporters also pointed to longer-term benefits for the socialist economy. "Studies showed," claimed some, that part-timers were more productive than full-timers. Part-timers, it was asserted, relied heavily on family members to take care of their children, "which relieves pressure on the still-inadequate crèches and kindergartens." In addition, advocates pointed out, part-timers did not receive the HAT, although they did qualify for other benefits.[79] The Women's Commission of the FDGB unexpectedly took up the bat for part-time work. It should be extended, members argued, into every economic branch so women could "achieve fully equal participation in the social life" of the GDR.[80] While union women promoted part-time employment as a force for social change, others defended it as a bulwark of the status quo. According to Dr. Maxim Zetkin, director of the Leipzig Hygiene Institute, "studies showed" part-timers "take good care of their household, family, and children and understand well how to organize their working time to fit with their husband's."[81]

Opponents of part-time work focused on its long-term drawbacks. Against the claims of the FDGB Women's Commission, other trade unionists contended that part-time work lowered women's commitment to employment and their willingness to train, and thus, reduced productivity.

[77] Ulbricht et al.; SAPMO-BArch, DY34/A1544 Abt Arbeit, 20.4.1959. Abschlussbericht . . . Halle, 6–7, 22, 24.

[78] Ibid., 24; SAPMO-BArch, DY30/IV2/17/65, Bl. 199–200, 25.2.59, Die Arbeit d. Frauenausschusses in Leuna.

[79] SAPMO-BArch, DY34/2146. Gotzche. Stellungnahme zum Vorschlag . . . Prof. Dr. Zetkin . . . , 2; DY30/IV2/2.042/20 MfA und Berufsausbildung, Stellungnahme . . . 18.2.58, Bl. 168–70, 180; Ulbricht et al., 29–30.

[80] SAPMO-BArch, DY34/2146. Stellungnhame der Frauenkommission des Buvo des FDGB . . . 26.4.61; Friedl Lewin an Kate (Bombach), 7.4.61.

[81] SAPMO-BArch, DY34/2146. Gotzche. Stellungnahme . . . Zetkin, 2.

Part-time work, they pointed out, would require investments in child care that would not be offset by the mother's full day of work.[82] The Ministry of Industry warned that part-time employment would wreak havoc with production's schedule and division of labor. Above all, opponents, especially plant managers, argued that *full-time* women workers would "demand that they too be allowed to work part-time," and so the supply of labor would actually decrease.[83]

In early 1961, *Neues Deutschland* ran an article that portrayed part-time work as a magnificent way for housewives to help build socialism.[84] Obviously, advocates had won the debate. The heyday of part-time work dawned. In 1960, 14.9 percent of all women workers and employees worked part-time; in 1964, 24.2 percent did; in 1969, 31 percent worked reduced hours. The percentage of part-timers employed by industry rose, but it remained below average (1969: 22.3 percent).[85] Nearly all part-timers were married. In 1964, forty-six percent of married women with children worked reduced hours, in comparison to six percent of single women with children. In Leipzig, more than fifty percent of women twenty to forty years old worked part-time in 1969.[86] The majority of part-timers were unskilled or semiskilled.[87] They were likely to stay that way: in 1970, 16.9 percent of part-time worker-employees were enrolled in qualification courses, in contrast to 36.7 percent of their full-time counterparts.[88]

Most worrying to the SED was that in 1962, every second woman who took up part-time work had been a full-time employee. In theory, part-time work can function as a "foot in the door" to employment. In West Germany, where the majority of women did not work for wages, part-time labor *did* pave this path in the 1960s.[89] In the GDR, women pushed their whole bodies against the door—from the other direction. Swamping employers with "application after application" for reduced hours, full-

[82] SAPMO-BArch, DY34/2146. Lewin an (Bombach), 7.4.61.

[83] SAPMO-BArch, DY34/39/140/6011 Grete Groh-Kummerlöw, 25.11.58. Fragen . . . an K. Bombach, 2; DY34/A1544 Abt Arbeit, 20.4.1959. Abschlussbericht . . . S. 24.

[84] See, e.g., ND 26.1.61, Nr. 26, S. 3.

[85] SAPMO-BArch, DY34/11873. Einschätzung . . . Betrieben der Elektrotechnik/elektronik und Textilindustrie . . . (Zeitraum 1968 bis 1969), 1–2; DY 30/IV2/2.042/20, Abteilung Frauen, Arbeitsbericht über die Entwicklung der Beschäftigung der Frauen in der Produktion, 24.11.71, Bl. 245, 247–48.

[86] SAPMO-BArch, DY34/5471, Entwurf, Thesen . . . 7.1.67. S. 7; DY30/IV B-2/17/731 Analyse . . . Frauen in Industriebetrieben . . . 30.7.70, S. 6. For reports on the shift to part-time work by industrial workers in 1965: DY34/5192.

[87] SAPMO-BArch, DY34/4298. Arbeitsgruppe Frauen, 14.1.66. Einschätzung . . . S. 2.

[88] SAPMO-BArch, DY34/11873. Einschätzung . . . Betrieben der Elektrotechnik/elektronik und Textilindustrie . . .

[89] See Oertzen.

timers were incensed that nonemployed housewives were offered part-time work, but not they. Every woman, applicants pointed out ad infinitum, shouldered the same burden of housework. Factory directors found it hard to resist this logic, especially given that women adorned it with references to "help wanted" signs posted up and down the road. Desperate managers agreed even to "individual work-time arrangements" that fit a worker's precise hourly requirements.[90]

No wonder the SED switched positions. Having earlier pressed managers and economic functionaries to create more part-time spaces, in 1965 and 1966 the party hierarchy chided them for succumbing to similar pressure from women workers. Equally sobered were FDGB women. They wrote, "[E]xperience proves that part-time work obstructs the development of the socialist personality" and "objectively prevents [women] from achieving equality." It seemed suddenly relevant to emphasize that a minuscule two percent of Soviet women worked part-time.[91] In 1967, the GDR introduced a five-day work week in the hope that it would stanch the flow. No such luck. Each work day became forty-five minutes longer, so *more* women clamored for a part-time job. (Many firms, even entire sectors, already gave their workforce Saturdays off; thus, many workers did not register the five-day week as a gain.) Applications poured in from women in three-shift work, for the longer shift meant the night rotation disturbed home lives even more than before.[92] According to a survey conducted in 1971, fifty-two percent of employed women wanted to work part-time.[93] Investigators for the women's commissions of the SED and FDGB conducted polls to ascertain why so many women wanted to work part-time. Among women older than fifty-one, the primary impetus was "declining health." Given an aging population, that was worrisome. Investigators found more disturbing the reasons of young, married mothers. Mother after mother said "concern about my children" and the necessity to "balance familial, household, and occupational responsibilities" made her apply for reduced hours. Most disconcerting, many women

[90] SAPMO-BArch, DY34/4426. Frauenkomm. 1959–61 Auswertung der Frauenkommissionsitzung . . . 15.11.61, S. 5; DY34/2146, 18.3.61. Frauensekretariat. Kurzarbeit – Heimarbeit – Halbtagsarbeit -Schichtarbeit, S. 3; 2146, Fr. Lewin, Bericht . . . Carl von Ossietsky Werk Teltow, 9.3.61.

[91] SAPMO-BArch, DY34/4298. Arbeitsgruppe Frauen, 14.1.66. Einschätzung. Also see DY34/11873. Einschätzung . . . Betrieben d. Elektrotechnik/elektronik u. Textilindustrie; DY34/9820, Forschungsthema . . . Teilzeitarbeit, 1970.

[92] On the five-day week, see SAPMO-BArch, DY34/11873; DY34/4301, Frauenausschuss in den Betrieben, Section L; Sachse, *Hausarbeitstag*, 269–72; Port, "Conflict," 136; Rietzschel, 176.

[93] SAPMO-BArch, DY30/IV2/2.042/20, Bl. 245, 248, Abt. Frauen, Bericht . . . Anlage 4, Meinungen eines staatlichen Leiters zur Teilbeschäftigung von Frauen, 24.11.71.

said they cut back hours to satisfy spousal expectations about housework, meals, and domestic "peace and quiet."[94] With a sense of historical irony, one report summed up the interviews: "Reasons? Children and kitchen [*Gründe? Kinder und Küche*]."[95]

Slide to the Side: Gender Segmentation

In the 1950s, the GDR's economy became less gender segmented, if less dramatically so than once assumed. In the 1960s, the trend reversed itself, though again not dramatically. Commerce and services became more lopsidedly female, while agriculture and industry remained gender balanced. The increase in women's participation in industry did not keep pace, however, with the overall increase in women's employment. In 1970, when 48.3 percent of all employed people were women, 42.5 percent of industrial workers were women and, as earlier, only 33 percent of production workers.[96] In 1972, 30.4 percent of women in industrial employment worked in a gender-balanced industry. Women born from 1939 to 1941, Trappe established, were more likely to possess qualification than women born from 1929 to 1931 but less likely to work in a "balanced" occupation.[97]

The labor market became more gender segregated, in part because young women entering it had not trained for technical or industrial jobs. School-leavers rejected apprenticeships in "male" trades such as metalworking or electronics and even in "typical women's trades" such as textile manufacturing or canning. At technical colleges, girls accounted for 39.8 percent of participants in "technical" courses in 1959, but 31.4 percent in 1960. They subscribed, instead, to courses in nontechnical "girl trades" (*Mädchenberufe*).[98] If they did study a technical trade, girls clustered in drafting or chemistry, evidently associating them with "feminine" pursuits such as art and cooking. In 1962, girls occupied 2.2 percent of all apprenticeships in electronics and a tiny 0.25 percent in fine mechanics, but more than 90 percent in technical drafting.[99] In technical *professions*, the trend was similar. From 1965 to 1975, the ratio of women in

[94] SAPMO-BArch, DY34/4298. Arbeitsgruppe Frauen, Einschätzung . . . 14.1.66; DY34/11873. Einschätzung . . . Betrieben der Elektrotechnik/elektronik und Textilindustrie.

[95] SAPMO-BArch, DY30/IV2/2.042/20 Bl. 245, Abt. Frauen, Bericht . . . Produktion, 24.11.71.

[96] "Bericht über die Entwicklung der Beschäftigung der Frauen in der Produktion, 24.11.71," in Thiele, 141.

[97] Trappe, 162–64, 170.

[98] SAPMO-BArch, DY34/ 39/125/6005. Abteilung Qualifikation/Berufsausbildung, 13.5.60; DY30/IV2/17/18 Bl. 31–39, Einiges Material . . . 12.7.61.

[99] SAPMO-BArch, DY30/IV2/17/20, Bl. 370, Abschlussbericht . . . Halle, 5.4.62.

engineering programs leaped from six percent to thirty-five percent for two reasons: engineering departments introduced a quota for women, and universities were faced with a scarcity of students relative to available places. Despite the jump, one would have been hard pressed to find a female mechanical or electrical engineer. Women flooded into chemical or architectural engineering and "ergonomics." The ratio of female to male engineering students was much higher in the GDR than in the FRG, but gender occupational preferences *within* engineering were similar.[100]

The majority of girls in qualification programs trained for sales, office work, or health care jobs. Little was done to counter the cultural currents that guided girls toward "people" and "helping" professions. In 1971, women accounted for ninety-nine percent of preschool educators, seventy-one percent of school personnel, and, more surprising, forty-eight percent of university staff and faculties. Fifty-four percent of employees in the film industry were women, but no well-known director and few prominent screen writers held that distinction. Women accounted for eighty-one percent of employees in health services and ninety-three percent of personnel in social services.[101] Women preferred nonindustrial professions because promotion was easier, and the atmosphere was less anti-female. In 1966, women accounted for 47 percent of pharmacists, 34.3 percent of physicians, and 23.8 percent of dentists. Yet in medicine, too, they rarely reached the top: women accounted for 7.4 percent of hospital chief physicians, hospital directors, and "district physicians" (head of the health department).[102]

It is difficult to say much about women in office or administrative employment, for they went unstudied by the Women's Commissions. Saleswomen did excite the sporadic interest of the upper echelons of Trade and the SED, if only because shoppers complained bitterly about discourteous retail clerks. The average retail employee earned less than the average industrial worker, worked longer hours, and received the minimum vacation due a worker or employee (two weeks). More than eighty-five percent of retail salespeople were women, but they occupied six percent of leading positions in Trade. The Politburo charged that Trade failed to promote or qualify its employees, yet the Politburo turned down a request from Trade to lengthen salesclerks' holidays. In most towns, saleswomen worked in tiny, gloomy *Konsum* shops that offered neither a hot meal nor warm camaraderie. The local SED or trade union showed little interest in

[100] Zachmann, "Mobilizing," 1–8.
[101] StJb 1974, 386, 412.
[102] SAPMO-BArch, DY30/IV A2/19/23 Arbeitsgruppe Frau Information . . . 27.5.66, S. 13. On women in medicine and academia, see Budde, *Intelligenz*.

them.[103] The turnover rate of retail personnel was very high, as was the rate of retreat into part-time work.[104]

Girls flocked into retail sales, it would seem, solely because of inherited ideas about the gender of occupations. Yet interviews with two women who worked in a small-town HO suggest that this conclusion is too simple. Each began her apprenticeship in the 1960s. One rose to the position of lower manager, the other to buyer. Each recalls her two decades in socialist retail with great affection. Both found the work demanding and sometimes frustrating, but varied and rewarding. They remember the environment as rich in companionship and recall male bosses as more congenial than women supervisors. Each felt she advanced as far as she wanted. If their delight in retail trade was unusual, their commitment to employment was not. Studies of the early 1970s found that the better educated and skilled a female employee was, the more likely she was to list "idealistic" reasons for why she worked. Unskilled and semiskilled workers, in contrast, cited material motives. Among all women, fifty percent reported that they worked for the social contact, the professional esteem, or the educational opportunities a job provided.[105]

An interview with a nurse of the same generation as the HO employees tapped into this sense of occupational accomplishment but also elicited sardonic stories about low supplies and high stress in her polyclinic. Her negative memories correspond to the findings of a study of Berlin health services in 1965. The investigation focused on nursing, the most common skilled position of women in medicine. Completely feminized, nursing escaped gender tensions but suffered from frictions between nurses and physicians. As in many medical cultures, physicians, both male and female, often condescended to nurses. Their consequent resentment of doctors took on a peculiar German/German slant. *East German physicians* were, nurses believed, treated well, while *West German nurses* had it better. Be that as it may, investigators agreed that GDR nurses were "very, very overworked." They had to care for a heavy load of patients and perform menial work on understaffed wards. The typical nurse was now a young, married mother who found it difficult to arrange child care when she worked nights, Sundays, or holidays. The report concluded, "Nursing must be seen as one of the most strenuous women's occupations."[106]

[103] SAPMO-BArch, DY30/IV2/17/18 Bl. 15–20, Bericht über Erfahrungen in der Frauenarbeit im Handel, 10.7.61.

[104] Merkel, *Utopie*, 190–92. Also see SAPMO-BArch, DY30/IV2/17/20, Bl. 380–86 Abschlussbericht . . . Halle, 5.4.62.

[105] Helwig, *Familie und Beruf*, 94–97.

[106] SAPMO-BArch, DY30/IV A2/19/23, SED Bezleitung Berlin, Frauenkomm, 29.8.65, Einige Probleme der ideologischen politischen Bewusstbildung der Frauen und Mädchen im Bereich Gesundheitswesen; interview Frau LD.

Shop Floor Relations

Most women worked in "nonproductive sectors," yet the SED and FDGB studied women in industry, central as it was to GDR economic activity and SED ideology. Their investigations suggest that women, like men, benefited from managers' desperate need for labor, even as workers still faced considerable pressure to produce. Wary of alienating workers, foremen avoided precipitous announcements and blatantly unilateral decisions about quotas, job changes, or daily schedules. If a technical innovation required unskilled women to learn a new job, a supervisor warned them beforehand, invited discussion, and explained how to avoid wage losses.[107] Supervisors relied heavily on the socialist production brigade to get things done. In 1964, FDGB investigators concluded, "the best development of women's consciousness occurs in the socialist brigades and collectives because they cooperate closely with the party organizer, shop steward, brigadier, foreman, and department head, and all brigade members are well-informed about assignments and problems."[108] Women interviewed in 1996 remember the brigades as centers of shared decision making and sociability.[109]

The shop floor was no nirvana. Even when prepared for retraining, workers resented having to do it.[110] In modern, "technically outfitted" firms, workers and technocrats quarreled about "rationalization" and other issues.[111] For instance, production conditions long remained chaotic in a shirt factory in rural Brandenburg that opened in 1968. Many departments lacked qualified supervisors and, owing to poor coordination, produced the wrong materials in incorrect quantities. The predominantly female workforce and their forewomen had to troubleshoot from below, while being pressed from above to meet norms. The socialist brigades exercised minimal influence on production quotas and social amenities, and only gradually won the affection of brigade members.[112] Older factories endured these and other problems. A union report described the "heat, dust, noise, and smell" in a rubber factory with a female workforce. It noted, "Almost all gains in productivity come from escalating the

[107] SAPMO-BArch, DY34/5471, Entwurf, Thesen, 7.1.67. S. 4–5; 5471, Arbeitsgruppe Frau. 22.12.66. Bericht . . . VEB Karosseriewerk Halle-Stadt.
[108] SAPMO-BArch, DY34/4298 Bericht . . . Filmfabrik Wolfen, 20.7.–20.8.64, S. 9; 1503 Arbeitsgruppe Frauen. Bericht . . . VEB Halbleiterwerk Fr/O, 5.8.68, S. 2.
[109] Interview Frau H.; interview Frau P.; interview Frau B.
[110] Port, "Conflict," 130, 133, 202.
[111] Ross, 191; SAPMO-BArch, DY34/4298. Arbeitsgruppe Frau. Information . . . 28.12.66; DY34/5471, Entwurf, Thesen . . . 7.1.67; Hübner, "Planung," 228–29.
[112] Ansorg, "Fortschritt," 80, 88–90, 91–4, 96. A textile engineer remembered women as working under bad conditions in his mill: IMC, Interview 4.

work tempo and neglecting work conditions to save money."[113] Factory
reports of the 1960s refer often to pressure to fill quotas. In the Wolfen
film factory, women could not leave their stations to talk with a union
steward.[114] In a firm in Leipzig, lack of materials forced days of inactivity,
but at the end of each quarter women worked "extraordinarily much
overtime" and dragged their eleven- and twelve-year-old children into the
factory to help meet quotas.[115]

As earlier, many mothers hated three-shift work for the toll it took on
them, their children, and their relationship to children and husbands,
costs that officials trivialized because the economy so depended on un-
skilled shift work.[116] The regulation of the housework day provoked, if
anything, more anger than in the 1950s.[117] Wherever they went, members
of the Women's Commissions got an earful about the HAT. In dozens of
petitions to the Woman's Congress of 1964, Factory Women's Commit-
tees called for giving the HAT to unmarried women. The SED, meanwhile,
grew more determined to get rid of it. According to Ulbricht, 1.5 million
women enjoyed the HAT, at an annual cost of 300 million marks. In De-
cember 1965, the SED decided to take the bull by (one) horn. As part of
the decree that introduced a five-day workweek (every other week), the
HAT was taken from wives with no children at home (approximately
160,000 women) and given to single women with children aged sixteen
to eighteen years old (approximately 10,000 women). The next morning,
this was *the* topic of workplace chatter among women—and men.[118] A
radio program was scheduled to discuss the five-day week; instead, its
moderator had to field hundreds of calls about the HAT. As the "endow-
ment effect" would predict, the pain of those who had lost the HAT was
greater than the pleasure of those who had gained it. Indeed, amid the
fury of 160,000 wives *plus* their 160,000 husbands, the joy of 10,000
single mothers did not register at all. Beleaguered union officials ex-

[113] SAPMO-BArch, DY34/6535 Arbeitsgruppe Frauen Teilbericht . . . VEB Thüringen
Gummikombinat vom 2. bis 4.8.67, S. 1–2; 9150 Abteilung Frauen. Bericht . . .
1.9.71, S. 5.
[114] SAPMO-BArch, DY34/4298 Bericht . . . Filmfabrik Wolfen, 20.7.–20.8.1964. S. 12.
Also see Ansorg, "Strukturwandel."
[115] LStA, IV A-2/17/474 Information zum VEB Intron Leipzig. 10.11.67.
[116] Helwig, "Frauen im SED-Staat," 1236.
[117] SAPMO-BArch, DY34/5471, Entwurf, Thesen, 7.1.67. S. 8; 5471, Einschätzung . . .
S. 2. For letters on the HAT, see DY34/5192 KB an BVS. 30.1.62; KG an BVS (Wenzel),
22.2.62; VEB Volkswerft Stralsund. Abt. Frauenausschuss an BVS, 26.10.63; ET, Magde-
burg an BVS, 31.3.63; MT an FDGB; I.H. 19.2.64; FDGB Magdeburg am BVS, 21.5.66;
VEB Wasserversorgung. Vorstand des FA an BVS, 15.6.66. Also see DY34/2482 Infobericht
18.12.63. S. 9.
[118] Sachse, *Hausarbeitstag* 110–11, 114–15.

plained: wives without children at home did not need the HAT, because they now owned refrigerators, vacuum cleaners, and (nonautomatic) washing machines.[119] Such justifications only fanned the flames. The Politburo caved in after a month. Citing the "faulty calculations" of economic functionaries, it returned the HAT to all wives, with the face-saving caveat that a firm must fulfill quotas to receive it. Inge Lange objected to the U-turn. The protest wave, she argued, was ebbing. The men who ruled the GDR knew better—especially, argues Carola Sachse, about the danger of alienating husbands. After the reversal, 25,000 *more* women received a housework day than before December 1965. Still, 890,000 single women did not possess it—and the struggle continued.[120]

If agitation about the HAT picked up, complaints about misogyny died down. Male workers still bandied "witty" remarks when a new woman joined a department, but they generally accepted female co-workers who had, after all, become familiar. Moreover, their role in male-dominated areas of industrial production had stopped expanding. Women's "skilling" was not a frightening specter, given high occupational mobility for men. Antagonism toward the female boss remained, however, alive and well. At a machine works in Leipzig, a woman wanted to qualify to become a foreman. The man she was to replace supported her candidacy, but brigade members derided it with "constant snide remarks." Most hostile was the union steward, who warned that he would not cooperate with her. When a Woman's Commissioner told this woman to turn to the SED factory leadership for support, she snorted, "The party leadership!" SED men, commissioners noted, had learned "to engage routinely in philistine self-criticism" about their "work with women" but did little to implement party decisions.[121] The BGL, women workers reported, suddenly remembered women on 1 February, talked incessantly about "work with women" until International Women's Day, and forgot them on 9 March.[122] SED and union functionaries continued to tie merit raises and other financial rewards to their notion of "correct" political activity. The party leadership in a factory in Merseburg decreed a nonparty colleague

[119] SAPMO-BArch, DY34/4307 (subsection 2113), Betr: . . . VEB Messgeräte u. Armaturenbau Karl Marx Magdeburg, 31.3.66; Arbeitsgruppe Agitation. FDGB. Argumentation.10.1.66.
[120] Sachse, *Hausarbeitstag*, 116–18, 149–50.
[121] LStA. IV A-2/17/473 Protokoll . . . 12.11.63; IV A-2/17/473 VEB Leipziger Buchbindereimaschinenwerke (Bubima), S. 4–5.
[122] SAPMO-BArch, DY34/4427, VEB Werk für Bauelement der Nachrichtentechnik Teltow. BGL an Zentralvorstand IG Metall, Kollegen Sommer, 12.8.61; DY34/1503 Stickstoffwerk Piesteritz, Protokoll . . . 3.3.64; DY34/4299 Arbgr.Fr, Einschätzung . . . VEB stickstoffwerk Piesteritz, 23.10.64.

unworthy of a citation because of "insufficient social engagement." Her participation in the Parents' Council and the DFD did not count.[123] Occasionally, men denied financial awards to women they deemed insufficiently committed to . . . women's equality. Having refused premium pay to a highly productive skilled worker who was active in the firm's athletic league, the (predominantly male) factory committee of the (good old) Leuna works explained, "At discussions about the *Frauenkommuniqué*, many women spoke about the profound questions of our time and made valuable suggestions about how to improve our work with women, but this colleague said nothing."[124]

Such shenanigans exasperated Women's Commissioners, but the authority who truly irked them was the "economic functionary"—he who calculated how each firm would meet its quotas and allocate its monies. Even in the dull reports of the 1960s, this (almost always male) figure stands out with Dickensian vibrancy, especially after the NES accorded him greater autonomy in plant decision making. Investigators for the SED and FDGB portrayed these men as maligners of woman's abilities and opponents of her promotion, all in the name of efficiency.[125] According to one report, the typical *Wirtschaftsfunktionär* shrugged, "Women are now in vogue, just as youth and the intelligentsia were before." The fad would pass, he implied, so why bother to promote women?[126] Women of the "young intelligentsia" (presumably technicians, chemists, accountants, etc.) complained that economic functionaries did their best to ensure the "vogue" was short lived. In a synthetic fibers plant, these women claimed, female promotion "proceeds recklessly. . . . [Women who] do good work . . . are placed in responsible positions, but without preparation or support. Then [the economic functionaries] say, 'See, women can't do it.'"[127] Margot Honecker blamed the failure to guide girls into technical occupations on the "prejudices" of economic functionaries. Even West German Social Democrats joined the fray. The "economic hierarchy," the SPD press service claimed, was the major obstacle to "women's rise" in the

123 LAM, VEB FAWO, Bericht . . . Frauenarbeit in VEB FAWO, S. 20–21.

[123] LAM, VEB FAWO, Bericht . . . Frauenarbeit in VEB FAWO, S. 20–21.

[124] SAPMO-BArch, DY34/A2377. VEB Leuna-Werke Walter Ulbricht. BGL Sitzungsprotokolle . . . Bericht der AGL . . . (Feb. 1962).

[125] See, e.g., LAM, IV2/3/464, Bl. 37–38, Bericht . . . ; LAM, IV a-2/17/474 Bericht . . . VEB Druckmaschinenwerke Leipzig, 12.7.63, S. 1; SAPMO-BArch, DY34/1503. Arbeitsgruppe Frauen Bericht_VEB Mineralölwerke Luetzkendorf vom 28.1.–5.2.64; IV A2/6.04/ 368, Maschinenbau und Metallurgie. Einschätzung . . . Stahl, 27.5.64; DY34, 4298 Arbeitsgruppe Frauen 9.12.64. Bericht . . . VEB "Hans Beimler"Hennigsdorf am 30.11.64.

[126] LAM, IV2/3/464, Bl. 37–8, Bericht . . . ; Kaderarbeit. Stand d. Arbeit über d. Realisierung d. Kommuniques . . . 17.4.62, S. 1–2.

[127] SAPMO-BArch, DY34/Tribüne Nachmittage . . . Gera. 7.6.61.

GDR.[128] The *Wirtschaftsfunktionär* skulked through Women's Commission reports throughout the decade, but his demonization peaked in 1964 and 1965 as women's labor policy crested before it waned in the later 1960s.[129]

Representation of Women Workers

FDGB functionaries assured women commissioners that, of course, the BGL wanted to help advance women but could not "because it won't get by the economic functionaries."[130] The excuse was not just cynical. Union and party officials disliked the technocratic, decentralizing economic experts as much as Women's Commissioners did. Neither a common enemy nor mutual party membership, however, bred friendship between commissioners and male functionaries. The *Frauenkommuniqué* authorized commissions to swoop into a plant and call powerful men to the carpet. Protocols of such encounters pulsate with tension. The Leipzig Women's Commission, for example, grilled four male SED officials at the *VEB Bubima*, a machine shop with 2,800 workers, one-fourth female. The issue was characteristic: a preponderance of women earned at Step III but no man earned below Step IV. At the start of the encounter, the male functionaries impugned the honesty of women workers and intimated the naïveté of commissioners. "Things weren't always presented correctly to you," one asserted condescendingly, and then cited examples of well-paid women. To a dollop of criticism, the men added a pinch of self-critique. "Real problems are at issue," they ritually intoned—and promised to renovate the women's coatroom and dole out more citations on International Women's Day. The interrogators refused to be intimidated or fobbed off. The issue was not, Comrade S. remarked curtly, the wages of a few women, but wholesale violations of wage equity. Women, she continued, were tired of token improvements and wanted substantial results. Chastened, Comrade L. tacked, "we aren't aware of many of these issues." Comrade S. shot back, "That shows that functionaries don't bring problems to you," thus, maligning *his* competence. Not wanting the men to get the wrong idea, a more conciliatory commissioner assured them, "We

[128] "Mehr Aufmerksamkeit den Frauen," *SPD-Pressedienst "Ostspiegel,"* 9.2.65.

[129] See, e.g., SAPMO-BArch, DY34/4299. Arbgr. Fr., Bericht . . . VEb Fettchemie KM St am 6.4.65; 5467, Section Buro Margot Müller, Bericht . . . VEB Bergmann-Borsig Berlin . . . am 29.5.68; 5467. Section B. Bericht . . . WSSB, 4.9.68. On hostility to efficiency experts, see Kopstein, 55; Klessmann, *Zwei Staaten*, 308–9, 352.

[130] SAPMO-BArch, DY34/1503 Arbgr. Fr. Bericht . . . VEB Mineralölwerke Luetzkendorf, S. 2–3.

are not women's rightists."[131] The point had been made, however: SED
women at the district level had the authority to challenge SED men at an
equivalent level.

The evidence is mixed on whether such sessions helped women workers
or emboldened them to speak out.[132] The Commissions certainly repre-
sented their interests better than did the factory women's committee
(BFA) which, with a few notable exceptions, had declined into trivial pur-
suits. In 1960, the SED instructed the BFA to drop its fixation on small
amenities and take up women's qualification. The bureaucratized BFA
found it difficult to reorient.[133] In many large factories, the BFA was run
by a professional chairwoman who worked in the plant's Labor, Planning,
or Personnel Department.[134] In smaller firms, the BFA often had a real
base, but only among white-collar employees.[135] The "democratic" cure
for the malaise, the SED decided, was to place the BFA under the BGL, a
body not known for its commitment to women's interests but undeniably
influential on the shop floor.[136] This move established greater control over
the BFA and gave it more authority vis-à-vis managers and economic func-
tionaries.[137] Not every BGL was helpful to the BFA, a few were obstruc-
tionist, but from the party hierarchy's point of view, the BFA became more
effective, i.e., oriented toward women's qualification.[138] The refurbished
BFA did not have to relinquish its beloved duties of visiting sick col-
leagues, making curtains for the canteen, and hosting fashion shows.[139]

[131] SAPMO-BArch, DY30/IV A-2/17/473 Protokoll . . . 27.2.64: Bericht . . . VEB Leip-
ziger Buchbindereimaschinenwerke, 4–7, 8, 12, 14.
[132] Suggesting they made a difference: SAPMO-BArch, DY34/2482 Information . . . Ros-
tock, 23.8.63. Suggesting they did not: DY30/IV2/17/20, Bl. 301–6, FDGB Bezirksvorstand
Dresden, 2.2.62, Verwirklichung des Kommuniques.
[133] LStA, IV/2/17/692 Frauenarbeit Mai 1960.
[134] SAPMO-BArch, DY34/4299 Arbreitsgruppe Frau. Analyse . . . Industrie, 19.11.
64, 5–7.
[135] Hampele, 293.
[136] SAPMO-BArch, DY34/4299 Arbreitsgruppe Frau. Analyse . . . Industrie, 19.11.64,
5–7. See Lotte Ulbricht's criticism of FDGB: SAPMO-BArch, DY30/IV2/17/18, Bl. 269,
Protokoll . . . Frauenkommission beim PB am 4.9.62. Also see DY34/Eingaben an den
FDGB Buvo: A.M.S. an M.M., 23.1.67; I.N. an MM, 7.3.67; R.S. an MM, 29.3.67; U.S.
an MM, 27.1.68.
[137] SAPMO-BArch, DY34/4299 Beschluss . . . 15.12.64; DY34/4299, Arbreitsgruppe
Frau. Information, 3.2.65; "Mehr Aufmerksamkeit den Frauen," SPD-Pressedienst "Ost-
spiegel," 9.2.65.
[138] SAPMO-BArch, DY34/7019 Abteilung Frauen. Bericht . . . VEB Patina-Seifenfabrik
Halle-Stadt, 16.10.69; 7019 Bericht . . . VEB Reifenwerk Fuerstenwalde, 2.2.71.
[139] SAPMO-BArch, DY34/4299 Arbreitsgruppe Frauen, Einschtäzung . . . VEB Stick-
stoffwerk Piesteritz, 23.10.64, S. 4–5; DY34/7019 Frauenausschuss bei den BGL, 1969:
Bericht . . . VEB Weimar-Porzellan Blankenhain Kreis Weimar, 8.10.69; DY34/4301, Frau-
enausschuss in den Betrieben . . . Section K. Arbeitsgruppe Frau, Bericht . . . VEB Vereinigte
Feinstrumpfwerke Thalheim am 19.1.66.

The Women's Commission acted as a high-level partner for women workers in the dance of shop floor relations, but it was no feminist or revolutionary body. It represented a dictatorship interested in women's productivity, not their emancipation. At unprecedented proceedings in Berlin, commissioners interrogated factory directors, factory party secretaries, and factory union leaders from all over the GDR. Yet commissioners nodded approvingly as these men assessed the value of "women's meetings and lectures" according to whether they decreased job fluctuation, raised productivity, and saved the factory money.[140] Neither did the FDGB's "women's working group" necessarily sympathize with ordinary women. Although interviews suggested they wanted part-time work for their family's sake, the working group concluded, "[part-time workers] rank their personal interests above the progress of the larger society."[141] One report proposed cutting the wages of army draftees so their wives would have to work full-time.[142]

Yet some commissioners chafed at the economic parameters of the "woman question" and argued that women's policy should be about social equality and individual development.[143] They connected some of the dots between the personal and the political, as their investigations revealed just how deeply conventional were the private lives of many economic functionaries and SED officials. Local functionaries, commissioners were disturbed to discover, often feared their wives might "develop beyond them." Such men avoided workplace discussion of women's domestic burdens "because the obvious repercussions would reach into their own families." The sins were not just ones of omission: "[C]ertain comrades and economic managers prevent implementation of the communiqué and deny equality to women in their own families."[144] SED women's commissioners did not become "women's rightists," but some of them edged in a protofeminist direction.

[140] SAPMO-BArch, DY30/IV2/17/18, Bl. 269, Protokoll . . . 4.9.62. For similar instrumentalist views expressed by the BGL, see DY34/A2377. VEB Leuna-Werke, AGL Berichte . . . Leuna, 7.2.62; VEB Leuna-Werke . . . Bericht . . . 20.2.62.

[141] SAPMO-BArch, DY30/IV2/2.042/20, Bl. 247, Abt. Frauen, Abschlussbericht . . . Frauen in d. Produktion, 24.11.71; DY34/11873. Einschätzung . . . ; 11873, Meinungen von Frauen . . . 9820. VEB Kombinat Zentronik, Zella-Mahlis an FM, 22.6.70; Analyse . . . Teilzeitbeschäftigung, S. 3.

[142] SAPMO-BArch, DY34/4298. Arbeitsgruppe Frauen, Einschätzung . . . Teilzeitbeschäftigung, 14.1.66, S. 4–7.

[143] Ibid, Bericht . . . Halle-Stadt, 29.12.66, S. 2–3.

[144] BArch, DP1/VA/1445. Bd. 2, Bl.23 Arbeitsgruppe FGB Entwurf, Information . . . Stand: 25.7.65; Bl. 56, Bericht . . . Entwurf FGB, 6.10.65; SAPMO-BArch, DY30/IV2/17/71, Bl. 117, Bericht . . . Karl Marx Stadt vom 28.8.–7.9.62; DY30/IV2/17/20, Bl. 412, Abschlussbericht . . . Halle, 5.4.62; LAM, IV2/3/464, Bl. 34, Bericht . . . [1962].

Toward Family Planning?

The SED perennially wanted to increase the birth rate. Several methods to that end always remained in its repertoire of "population policies."[145] The state instituted and extended prenatal and maternal leave for women workers. The state continually battled infant mortality. By 1963, 10,000 maternal counseling centers ministered to every pregnant woman and newborn. In 1967, monthly child allowances were increased to sixty marks for the fourth child and seventy marks for the fifth or more. In 1969, a mother received fifty marks monthly for her third child.[146] The SED was not only perpetually natalist but constantly convinced that modern institutions knew best how to protect mothers and infants. By the early 1960s, the GDR had made the transition from home birth to clinic delivery.[147] Change occurred, however, within this stable framework. The GDR traversed from a partially negative natalism that restricted contraception and birth control to a completely positive natalism that used incentives to encourage births. Three famous decisions encapsulate the transfer: legalization of first-trimester abortion (1971); free birth-control pills for women sixteen and older (1972); "the baby year" of maternity leave (1976).

Historians see these measures as indicative of Honecker's emphasis on social reform, in contrast to Ulbricht's interest in economic rationalization. The extravagant, socially moderate, prochoice Honecker shoved aside the parsimonious, socially conservative, antiabortion Ulbricht. The legalization of abortion, certainly, heralded the era of the social; Honecker's embrace of maternalism was central to its blossoming. The new reproductive regime did not, however, spring from Honecker's head. Ulbricht had no objection to maternalist policies to raise fertility, except their cost. After 1963, he oversaw, nonetheless, an extension of maternity leave to fourteen weeks and an expansion of child care facilities.[148] Ulbricht *did* oppose contraception and, especially, abortion. Despite his aversion, a family-planning model of birth control began to emerge in the late 1960s. The original intent was to allow a limited and secret relaxation of Article 11. The means taken to reach that modest end and the relaxation itself, however, set in motion a process that triggered unanticipated changes in women's reproductive behavior and opinions. As of 1969 and 1970, the

[145] Also see Timm, "Health," 489–91; Frerich and Frey, 411.

[146] Commandeur and Sterzel, 95; Winkler, *Sozialpolitik*, 147–48.

[147] In1963, 94.2 percent of births in the GDR took place in a clinic. The ratio was much lower in the FRG (Commandeur and Sterzel, 95).

[148] Winkler, *Sozialpolitik*, 146.

Ministry of Health stood poised between a return to repression and relinquishing control over reproduction. Rather than stuff the genie back into the bottle, Honecker released it.

Revising Article 11

The background to the legalization of abortion can be divided into two parts: first, the preparation and introduction of a clandestine relaxation of Article 11, and second, the repercussions of de facto relaxation. The process was a dynamic one that involved several groups with conflicting agendas: the SED, the Ministry of Health, physicians, and women and couples who wanted an abortion. The most powerful player was, as always, the Politburo, which was clearly split on the issue: witness Ulbricht versus Honecker. One can only observe the Politburo's shifting stance on abortion obliquely, however, from the comments of Central Committee members and Health officials. As on many issues, the Politburo did not deliberate in a vacuum, but in the context of economic and demographic circumstances, domestic opinion, and international developments.

In 1963, the Ministry of Health, with the cautious approval of the Central Committee, created a "working group on problems concerning abortion." Composed of health officials, SED emissaries, and preeminent gynecologists, the working group was instructed to gather data on abortion and recommend revisions of Article 11.[149] Its proposals were vetted by a second committee that included Inge Lange, representing the Women's Commission. Lange told the gynecologists that their recommendations could not be publicized and that "public dialogue" must be avoided. The secretive impulse bespoke anxiety that a public discussion would culminate in the legalization of abortion and a substantial decline in fertility.[150] In June 1964, the Politburo adopted the recommendations, and in March 1965 the Ministry of Health sent "Instructions for the Implementation of Article 11" to "termination commissions." In assessing an application for an abortion, a commission could consider, in addition to a medical or eugenic condition: the age of the woman (younger than sixteen or older than forty); her number of children (five children at home); space between pregnancies (fourth child born less than fifteen months after third child); and how she got pregnant (rape, incest, or other criminal mishandling). A woman who obtained an illegal abortion would not be prosecuted, but "condemned or castigated by public shame."[151]

[149] DY 30, IV A2/19/22, "Stellungnahme . . .". Also see DY 30, IV A2/17/83, "Vorschläge . . . Schwangerschaftsunterbrechung in der DDR." See Harsch, "Society."

[150] SAPMO-BArch, DY 30/IV2A/19/22, Notizen 9–10.

[151] DY 30, IV A2/19/22, "Stellungnahme. . . ." ; Dr. H. an *Neues Deutschland* (no date); Arbeitsgruppe Frauen [bei des ZK], Abteilung Gesundheitspolitik, Entwurf eines Briefes an

The Central Committee reopened the issue of abortion regulation for several reasons. The trend in the Socialist Bloc was toward liberalization; indeed, the GDR was behind the curve, for the USSR had liberalized its law in 1955, and other countries quickly followed suit. The frequent pregnancies of young mothers, second, made it difficult for them to remain in the workforce and to get qualified. Last but not least, the SED hierarchy judged the birthrate satisfactory. Women were reproducing at a steady clip. The number of newborns per one thousand population reached its highest level in 1963, pumped up by women's decreasing age at first birth. The working group remarked complacently, "The birthrate is all the more impressive, given that from 1950 to 1961, the number of women of child-bearing age sank by 23.5 percent. . . . With a fertility rate of 90.5 per 1,000 women between 15 and 45, we compare favorably to other European countries."[152] In 1964, fertility in the GDR suddenly began to decline.[153] Nonetheless, in 1965 the Ministry of Health sent out the "instructions" for broadening Article 11.

Why did the Ministry proceed despite falling fertility? The most important reason was the emergence of a medical understanding of abortion that focused on the danger of *illegal* abortion to the pregnant woman. Earlier, the reigning medical view rejected *all* abortion as dangerous to the health of the woman and to her reproductive capacity. By 1960, increasing numbers of East German physicians questioned this older perspective. In 1961, the party secretary of Frankfurt/Oder wrote to Kurt Hager, the Politburo's leading theorist and a "liberal" on abortion, summarizing medical opinion in his district. Most doctors, he explained, wanted to widen, but not repeal, Article 11.[154] Gynecologists remained more committed to it than did general practitioners, perhaps because gynecologists had less contact with women desperate for an abortion.[155] They began to shift their position after attending an international symposium on "abortion, miscarriage, and maternal mortality," held in Rostock in 1960. There, Western experts presented findings on the link between illegal abortion and maternal mortality. Organized by the Institute for Public Hygiene, founded by gynecologist Karl-Heinz Mehlan in the late 1950s, the symposium heralded an era of closer contact between East

den 1. Sekretär der Bezirks- und Kreisleitungen, Erich Honecker, 26.3.65; MfG, Instruktion zu Anwendung des Artikels 11 . . . , 15.3.65; LStA, 5321, Bl. 19, Anleitung zur Durchführung der neuen Instruktionen . . . 31.3.65.

[152] SAPMO-BArch, DY30/IV A2/19/22, Mehlan, Vortrag, 5; "Stellungnahme. . . ," 3; Anlage 1.

[153] Information über den Rückgang der Geborenen in der DDR und seine Auswirkungen auf die Bevölkerungsentwicklung, reprinted in Ende? 119.

[154] SAPMO-BArch, DY30/IV A2/19/22, Götzl an Kurt Hager, Sekretär des ZK, 10.3.61.

[155] Interview Mehlan, II.

German and Western medicine. An advocate of family planning, Mehlan endorsed a more liberal attitude toward sexuality, contraception, and birth control but, at this point, neither he nor most Western researchers called for legalization.[156] The GDR, Mehlan said in 1963, could not legalize abortion or even introduce a "social indication" because of its poor demographic prognosis.[157] Yet he hoped the state would permit more abortions in order to reduce women's resort to illegal abortion.

Estimates of illegal abortion varied widely from 40,000 to 100,000 annually in the early 1960s. Members of the working group stressed three points about illegal abortion: approximately sixty women per year died as a result of botched abortions; such deaths constituted the largest category of maternal mortality, and their number was rising.[158] Rather than criticize women for resorting to self-help or shady abortionists, the medical experts blamed the "rigid methods," "dogmatic viewpoint," and regional inconsistencies of the state's termination commissions. Women's "understandable lack of trust" would be overcome, the working group argued, only if the commissions ruled according to expanded, standardized instructions. The working group sympathized even with popular refusal to cooperate in the prosecution of abortionists: "The population is, of course, aware of illegal activity, but people don't believe that it contradicts society's interests. Women's behavior seems legitimate to them—and to a large extent it is."[159]

The Deputy Minister of Health instructed the working group that it could not consider a social indication. Nonetheless, medical advisors commented on environmental conditions. Large families, they noted, were plagued by high prices, low wages, lack of space and amenities, and the overwhelming demands placed on employed mothers. The working group defined "social" causes broadly, to include marital conflict, family crisis, and "psychological despair." The sensitivity to social misery was fed, ironically, by materials provided the working group by the Ministry of Health. The package contained dozens of petitions to SED and Health officials from women who had been denied an abortion by a termination commission. The petitions attested, experts concluded, to the "desperate situation of women who are forced to endure an unwanted pregnancy."[160] This judgment applied to many women. A survey of pregnant women in

[156] On medical discourse in the West, see Jenson, "Discourse," 77–79; Brookes, 133–34, 149–50, 154–55; (on the U.S.) Luker, 73–87; Condit, 22–23, 43–46, 56–58.

[157] SAPMO-BArch, DY30/IV A2/19/22, Mehlan, Vortrag . . . 29.9.63, 9.

[158] Ibid, S. 6; Stellungnahme . . . , 2.

[159] SAPMO-BArch, DY30/IV2A/19/22, "Stellungnahme . . . ," 1–2; Mehlan Vortrag, 3, 8; "Notizen . . . ," 9, 10; LStA, 5321, Bl. 17.

[160] SAPMO-BArch, DY30/IVA2/19/22, "Notizen . . . ," 9–10.

TABLE 7.3
Legal Abortion Ratio per 1000 Live Births

1962	2.5
1963	2.3
1964	2.7
1965	40.5
1966	81.7
1967	89.0
1968	87.7
1969	**81.9**
1970	85.6
1971	79.5
1972	576.8

Source: David and McIntyre, Table 4.

1963 and 1964 found that 49.8 percent did not want the pregnancy, and for 18.7 percent it came too early.[161]

Gynecologists criticized the scarcity of all, much less reliable, methods of birth control. Dr. Lykke Aresin reported that her marriage and sex clinic in Leipzig most commonly recommended the "traditional pessary and [spermacidal] jelly."[162] Physicians argued, and the petitions suggested, that condoms were used frequently, and frequently failed. Petitioners also mentioned failed reliance on the rhythm method. While East Germans depended on tried-but-untrue contraceptive methods, in 1964 and 1965 the GDR's pharmaceutical industry became the world's fifth to produce the "modern" method: an estrogen-based oral contraceptive. The GDR exported the vast bulk of its "pills," keeping only enough at home to cover three percent of women of childbearing age. A doctor could prescribe *Ovosiston* only if a pregnancy would endanger a woman's health. A Health official noted in a memorandum, "Abortion is not a desirable method of family planning, but currently it remains a necessary one."[163] In 1968, the state allowed much wider prescription of the pill and, in 1972, made *Ovosiston* freely available. Still, abortion remained a major method of birth control after its legalization into, at least, the mid-seventies (Table 7.3).

The new empathy with women seeking an abortion may have represented a generational turnover in the medical profession. Living in a culture that was historically Lutheran and increasingly areligious, East Germans were relatively immune to the absolutist position of the Catholic

[161] Frey and Frerich, 413.
[162] Dr. Lykke Aresin, "Einige medizinische Ursachen für Ehekonflikte," NJ 1965, 322.
[163] LStA, 5321, Bl. 19, Anleitung . . . 31.3.65.

Church.[164] Physicians educated after 1945, moreover, learned to abhor abortion on demographic, not moral, grounds. They may have been, therefore, susceptible to a discourse about women's health. After several women died in his Dresden clinic following a back-street abortion, a horrified young gynecologist, for example, converted to liberalization.[165] Still, younger gynecologists did not generally condone the "instructions" of 1965, but only accepted them.[166] Generational changeover may explain better the new stance at the *top* of the medical establishment. Every gynecologist consulted in 1963 and 1964 was a member of the SED. By then, a core of loyal and "liberal" gynecologists dominated university clinics. One should note, too, the changing gender composition of the profession. In 1946, only 18.2 percent of physicians were female; by 1960, the ratio had increased to 26.2 percent; in 1966, it stood at 34.3 percent.[167] In the 1950s, Käthe Kern consulted male academic gynecologists about abortions. The advisory commissions of the early 1960s included, in contrast, several women gynecologists who looked at the issue unabashedly as working mothers.[168]

The secret deliberations of 1963 may also have reflected pressure from women SED activists. When the district secretary of Frankfurt/Oder queried physicians about Article 11, he asked them to respond to the following formulation: "An abortion can be justified in an individual case on the basis of [a woman's] social-political [*gesellschaftlich*] activity." The Central Committee intended, it seems, to set aside Article 11 for women triply burdened by children and housework, employment, *and* political activities. When doctors rejected the formulation as "neither clear nor workable," the SED initially ignored them.[169] A similar formulation appeared in guidelines given by the Ministry of Health to the working groups of 1963 and 1964. It referred, the Deputy Minister of Health explained, to "women who play an outstanding role in public life." Physicians again ridiculed the "*Gummiparagraph*" as an untenable scheme to introduce a "social indication for the overburdened female functionary."

[164] The churches were not consulted about revising Article 11, but church leaders realized something was up. Speaking through the East German CDU, they expressed "strong" opposition to a relaxation of the ban. When they heard that private hospitals would not have to perform abortions, the churches were largely appeased. See SAPMO-BArch, DY30/IV A2/19/22, Dr. We/Str. an Hager, 28.6.65. After legalization, a physician could refuse to perform an abortion.

[165] Interview Dr. L.

[166] SAPMO-BArch, DY30/IV A2/19/22, Teildokumentation zu Fragen der ungewollten Schwangerschaft . . . [1971], 5.

[167] Ernst, "'Prophylaxe,'" Tables 4.4, 4.5. In 1961, 51.2 percent of medical students were women.

[168] See, e.g., SAPMO-BArch, DY30/IVA2/19/22, "Notizen . . . ," 3, 8.

[169] SAPMO-BArch, DY30/IV A2/19/22, Götzl an Hager, 10.3.61.

The "rubber paragraph" could be stretched, gynecologists worried, to include *doubly* burdened employed mothers. That was a convincing counterargument, and the elastic clause slipped out of the final draft of recommendations.[170] Nonetheless, medical experts acknowledged the need to cater to SED women's opinion. A woman gynecologist urged the working group to support a more substantial reform of Article 11 than it was recommending. If "something doesn't happen" soon, she warned, SED and DFD speakers would criticize Article 11 at the women's congress of 1964—which, indeed, they did.[171]

The impatience of SED women dovetailed with growing skepticism about Article 11 among younger people. Justice officials noted that at discussions of the draft family code in 1965 audience members, "especially those between thirty and forty-five years of age," argued that the Family Code should include abortion reform and other measures for "family planning" in order to decrease the number of "precipitous marriages" and to "unburden women."[172] According to the working group on abortion, after 1960 there occurred an "extraordinarily sharp increase" in the number of petitions for appeal of a negative ruling.[173] The rise occurred after the wall shut off access to West Berlin abortionists, and as the workforce participation of young married mothers expanded. The demographics of petitioners surely impressed SED officials: complainants were young, employed, and likely to have a skilled job or career or be in training for skilled work or studying for a higher degree. They represented precisely those women whose career commitment the regime wanted to encourage.[174]

The petitions of the 1960s repeated arguments of the 1950s and added new ones. As earlier, appellants referred frequently to a medical and/or social reason for wanting an abortion (and rarely mentioned a eugenic indication). The ratio of medical to social arguments reversed, however. The typical story told in the 1950s centered on the woman's bodily woes, while family problems constituted the background. The petitions of the 1960s highlighted social and/or psychological misery; physical complaints formed the backdrop. The social complaints were similar: number of children, spacing of births, and poor housing. An articulate petitioner wrote, "This pregnancy comes too soon after the last one. . . . Physically depleted and psychologically burdened . . . I will have to continue in shift-

[170] SAPMO-BArch, DY30/IV2A/19/22 Stellungnahme, 4; "Notizen . . . ," 2, 8.
[171] "Notizen," S. 1, 10. Newspaper articles critical of Article 11 also appeared around this time. They are mentioned in: SAPMO-BArch, DY30/IV2A/19/22 Benjamin an Genossen Professoren Friedeberger, 26.3.64.
[172] BArch, DP1/VA/1445 Bd. 2, Bl. 66–67 Arbeitsgruppe FGB Entwurf . . . 25.7.65.
[173] SAPMO-BArch, DY30/IV2A/19/22, "Notizen . . . ," 9–10.
[174] On petitions and petitioners, see Harsch, "Society," 71–72.

TABLE 7.4
Number of Applications and Number of Approved Abortions (absolute and percentage change from 1966)

	Applications	% Change	Approved Abortions	% Change
1966	22,031	100	17,558	100
1967	25, 977	104.2	20,595	117.3
1968	28,119	127.5	21,582	122.9
1969	26,904	122.1	20,068	114.3
1970	27,020	122.2	20,226	115.2

Source: SAPMO-BArch, DY 30/IV A2/19/22, 3.

work and find a fourth berth in a weekly children's home."[175] Contraceptive use was never mentioned in the 1950s, but more than ten percent of complainants in the 1960s mentioned, indeed, underlined, contraceptive use. Also new were laments about the destructive effect of fear of pregnancy on the petitioner's sex life and/or marital happiness.

The "Instructions" of March 1965 at first produced the intended effect: termination commissions ruled more liberally, but within acceptable limits. Statistics showed that 2.7 legal abortions occurred for every 1000 live births in 1964. In 1965, the ratio jumped to 40.5 abortions per 1000 births. Soon the situation threatened to spin out of control: the number of applications shot up, thus overburdening the commission system; some commissions denied applications that fit the new instructions; others ruled more loosely than the Ministry of Health wanted, yet still too narrowly to satisfy popular demand.

The new indications did not remain secret. Petitioners often referred to the Instructions and in some cases knew precisely what they included. As knowledge about them seeped out, ever more women applied for an abortion. In the district of Leipzig in 1963, 270 women requested an abortion and in 1964, 436 did; in 1965, the number leaped to 1070 and again in 1968 to 2087.[176] Republic-wide, the numbers of applications for an abortion rose from 1966 to 1968, fell in 1969, and increased in 1970 (Table 7.4).

Precise numbers are not available for 1971, but memoranda indicate that applications continued to rise. The pedantic specificity of the Instructions did not negate the need for lengthy consultations. Hence, the jump

[175] BArch, DQ1/6015, Bl. 27–32, 12.1.65.
[176] LStA, 5321, Bl. 23, Zusammensetzung der neuen Kommissionen, 17.4.65; Bl. 80–91, Monatliche Operativmeldung der Kommissionen . . . April 1965–March 1966; Bl. 143–144, Betr: Anträge auf Schwangerschaftsunterbrechung in den Jahren 1968, 1969, und 1970.

in applications led to extra work for the commissions. In January 1971, a DFD report noted, "Because of the increasing number of applications, communal and city-district commissions do not take the time for a thorough discussion [of each case]."[177] The rise also clogged the pipelines of social welfare that undergirded the system of termination commissions. The Department of Mother and Child, as earlier, counseled rejected applicants, and it watched over those who were suicidal, arranged to send them to a rest home, and set up care for their children. Healthcare personnel were expected to advise both successful and rejected applicants about contraceptive methods. Yet a committee set up by the DFD to review implementation of the Instructions discovered a disturbing increase in applications for a second or third abortion, evidence, it was argued, that physicians and social workers could not provide adequate "postoperative care."[178]

If the rise in applications was predictable, the failure to achieve uniform decision making was not. Rulings still seemed arbitrary. Erratic decisions reflected, in part, differences within and between termination boards. DFD representatives leaned toward a more liberal interpretation of the guidelines, while doctors found it distasteful to approve more abortions. There was, as well, a method behind the madness: a quota system. The tracking reports of the Ministry of Health repeatedly mentioned seventy percent as an acceptable approval rate of applications that fit the Instructions.[179] Many commissions began to rule too loosely for the Ministry of Health's taste. In 1968, the peak year before legalization, the rate had doubled, to 89.0 approved abortions per 1000 births; 21,582 procedures were performed. The Ministry of Health instructed commissioners to rule more restrictively—and the number of approved terminations fell.

Soon, women's disgust with the more liberal rules matched their earlier dismay over the highly restrictive practices. An evaluation noted anxiously that after dipping from 1966 to 1970, the number of complaints against abortion rulings increased in 1971.[180] Rejected applicants were disgusted by capricious decisions. A DFD report referred to "the impression of heartless treatment and disregard."[181] The responses of SED and health officials must have angered appellants even more. Officials always denied the existence of the Instructions, even when the petitioner pre-

[177] See "Bundestand des DFD, Erfahrungen und Problem aus der Beratung mit Vertreterinnen des DFD in den Indikationskommissionen der Bezirke, 31.1.71," in Thietz, 115.

[178] ."Auswertung der Beratung . . . ," in Thietz, 111.

[179] See statistics on applications and rulings in Berlin during December 1971: LAB, Rep. 118, Akte 486.

[180] SAPMO-BArch, DY30/IV A2/19/22, Teildokumentationt . . . , 4. I found only a few petitions from 1971 (in LAB, Rep.118).

[181] "Bundestand des DFD, Erfahrungen," in Thietz, 115.

sented clear knowledge of their terms. Health officials seldom overturned a ruling, even though most complainants fit at least one of the new indications. Party membership no more guaranteed a reversal of a negative ruling than did a medical condition or suicide threat.

The health bureaucracy tried to manage an increasingly chaotic situation. It dutifully relayed statistics to a nervous Politburo.[182] It noted worriedly that fertility collapsed after legalization in other East block countries, a development that led several regimes to repeal liberalization. Yet, rather than annul the GDR's de facto liberalization, the SED and Health formed another commission to investigate the social, psychological, and economic causes of the falling birth rate.[183] When Honecker came to power, he appointed a commission to discuss how to proceed. It recommended legalization of first trimester abortion. Why did he accept this recommendation? Pressures from within provided the catalyst, but two international developments may have convinced the Politburo that a return to repression would not work. Most important was the looming introduction of "free" (no visa) travel between the GDR and Poland, where abortion was legal. Of secondary importance was the rise of the women's movement in the West. Internal reports show that the SED was highly aware of the fledgling West German abortion rights movement. One can surmise that the SED hoped to convince progressive world opinion that the GDR was the woman-friendly German state. If we do not know what moved the Politburo, we do know how interested circles reacted to its decision for, as usual, the SED canvassed them. Gynecologists accepted liberalization, but less with enthusiasm than with pragmatism. "Most women, social workers, and physicians" supported legalization in the belief that illegal abortion would recede and social workers could devote their energy to women who "want children."[184]

SOCIALIST CONSUMERISM? SERVICES AND CONSUMPTION AFTER 1961

Between 1958 and 1960, Ulbricht twice dangled the promise of consumer durables and "1,000 little things" before East Germans. At the beginning of 1961, the Ulbrichtian oracle pronounced once more, this time explicitly associating the consumer dream with women. "For our women," vowed

[182] LAB, Rep. 118, 1043: Wirken der Kommission . . . 1971; Protokoll . . . 2.11.70. Also see: "Information über den Rückgang der Geborenen . . . ," in Thietz, 119.

[183] "Untersuchung der Ursachen für den Rückgang der Anzahl der Geborenen, 1970," in Thietz, 118–27.

[184] LAB, Rep. 118, Akte 552, Information über den Stand der Durchführung des Politburo Beschlusses.

The Leader, the state would invest more in socialized services *and* in the manufacture of domestic housewares. Prominent women in the SED felt which way the wind was blowing and were not sure they liked it. In its report on "work with women and girls" that paved the way for the *Frauenkommuniqué*, the women's working group remarked dryly, "Instead of improving services, we promote the ideology 'each household its washing machine, its own cleaning appliances, etc.'"[185] If SED women found the de-emphasis of services irritating, ordinary women must have found Ulbricht's pronouncement a cruel joke. Hit by the nationalization of retail trade, collectivization, and construction of the wall, retail turnover declined in 1961 for the first time since 1945; supplies of some goods fell below levels of 1952 and 1953.[186] Productivist ideology resurged, promoted by headlines such as "First produce, then shop."[187]

The carrot of consumerism was only temporarily remaindered. The New Economic System of 1963 retooled the productivist mold to include industrial consumption. Reformers hoped to generate revenues for investment by siphoning private spending away from perishables (and the weak agricultural sector) toward products of a modernized manufacturing sector, including synthetic fabrics, TVs, appliances, housewares, and cars.[188] The reform mechanism hinged on the desire of workers and managers to work harder to earn more to spend on more and better consumer goods.[189] The focus on efficiency provided another reason for domestic production: a "rationalized" home was an efficient household. The economist Helga Ulbricht explained: "Despite exemplary services and institutionalized child care, woman's role as housewife and mother still involves chores that society cannot shoulder in the current phase of socialist development." It solved nothing, she added, if husbands shared the "tasks [that] remain in the family," for that "would only push the problem onto another level." Instead, society should "rationalize" housework.[190]

The dream of a mechanized private sphere entered the realm of practice. In 1962 and 1963, production of household durables and synthetic fabrics jumped and, after 1965, leaped upward.[191] Between 1965 and 1969, private consumption rose at twice the rate of 1960 to 1964 and grew faster than income.[192] From vacuum cleaners to refrigerators to televi-

[185] SAPMO-BArch, DY30/IV2/5/202, Bl. 56–78, Massenarbeit mit allen Frauen und Mädchen [Sept. 1961].

[186] Kaminsky, *Wohlstand*, 66, 71.

[187] ND, 10 January 1962.

[188] Hübner, *Konsens*, 169.

[189] Steiner, "Frustration," 26.

[190] Ulbricht et al., 28.

[191] Prokop, 188.

[192] Steiner, "Frustration," 35. (See Table 5.3, p. 183, above.)

sions, earlier luxuries became articles of everyday life. As always, East Germans measured well-being by the West German standard. In contrast, however, to the 1950s or the 1980s, they felt in the 1960s that their situation was improving and would continue to do so.[193] In fact, the gap between consumption in the FRG and GDR did narrow considerably before widening again in the late 1970s. Of course, improvement was uneven. Periodically, the economy was still plagued by shortages in even basic foodstuffs.[194] Nor did the SED overcome its ambivalence about consumerism.

Forward to the Socialist Service Economy!

The new "ideology" of rationalizing the private home did not efface the vision of socialization. As experts and commissions gathered data that showed just how much time household labor demanded, they became more determined to socialize certain tasks. Surveys conducted in 1965 established that housework demanded *six hours a day* in a three-person household and *eight hours a day* in a six-person household. Four tasks, performed overwhelmingly by women, accounted for more than eighty percent of this work: food shopping and preparation (thirty-two percent); cleaning the apartment (twenty-four percent); laundry (fifteen percent); and child care (twelve percent).[195] Socialized services aimed to reduce the time devoted to three of these chores: food and cooking, laundry, and child care. Firms, especially industrial complexes near the "new socialist cities," continued to offer services to employees. In 1964, the Leuna Chemical Works, for example, operated eight kitchens and fifteen cafeterias that served more than 14,000 meals each day, although that huge number fed fewer than half of its 30,000 employees. Factories remained important providers of washing services and child care, although less so than earlier. Factory directors had always resisted the unproductive outlays that services required and, under the NES, were encouraged to shed them. Municipalities took them up. In the case of laundries, municipal participation did not immediately improve a dismal situation. Not until the late 1960s did laundries work much faster, mainly because demand declined with the spread of private washing machines and apartment-building laundry rooms. Improvement was, anyway, relative. In 1971, Berliners, denizens of the GDR's best-served city, could get a TV or radio repaired within five days but had to wait twelve to nineteen days for laundry and eighteen to thirty-five days for dry-cleaning.[196]

[193] Merkel, *Utopie*, 33, 312.

[194] Steiner, "Frustration,"28.

[195] LStA, IV/A-2/17/473, S. 73.

[196] SAPMO-BArch, DY34/9150. Abteilung Frau. Bericht . . . 1.9.71, 3, 5, 7; Sachse, *Hausarbeitstag*, 280.

Child care availability did not suddenly leap upward. Planners hesitated to tie up big investments in child care, for they believed demand would decline as the birthrate fell.[197] Instead, demand rose, for many mothers returned to work as soon their maternity leave ended, and most mothers returned when baby turned one. At factory meetings, women workers complained, as earlier, about insufficient spaces in crèches, kindergartens, and after-care. Crèches, in particular, were often filled to over-capacity.[198] The story of Frau S. illustrates the difficulties faced even by young mothers who followed every bend of the "correct" path. In the early 1960s, Frau S. studied French and Russian at the Institute for Simultaneous Translation at Leipzig University. While a student, she became secretary of her FDJ chapter, joined the Institute's SED executive committee, *and* bore two babies by her "future husband" (who was manfully negotiating his own socially upward track). When her first son was born in 1963, Frau S. lived in a women's dormitory that did not allow children. The only weekly home that could take him was located in her hometown outside Leipzig. For two years, she rode the train there on Friday evening, picked up the baby from his weekly berth on Saturday morning, cared for him at her parents' apartment through Sunday, and handed him over to the facility at the crack of dawn on Monday. In 1965, the university's SED secretary arranged for Frau S. and her sister to move into a two-room apartment. She moved her son to Leipzig (where, presumably, her sister helped care for him). Her second son was born in December 1965 and, to the mortification of his Communist mother, had to be placed in a Catholic long-term care home. Frau S. managed, meanwhile, to graduate with honors and received numerous job offers. When she inquired, however, about child care and an apartment, she got "a big shrug . . . and many regrets." Frau S. ended her petition to the FDGB executive board with a plaintive "who can help me?" Board member Margot Müller accepted the challenge. After several failed attempts, she found Frau S. a position *and* child care at the university in Karl-Marx-Stadt. The paper trail stops at a predictable blockade: as Frau S.'s baby was about to enter a weekly home and his older brother a kindergarten, both facilities were put under quarantine for whooping cough and shut down for an indeterminate number of weeks. Their mother's career remained on hold—as did the state's investment in her education.[199]

[197] SAPMO-BArch, DY30/V2/5/202, Massenarbeit mit allen Frauen . . .

[198] See, e.g., BArch, DQ1/3584, Bl. 490–94, Frau RF, Frau RK, "Die Probleme unserer Frauen—ein Beitrag zum Frauenkongress" (July 1964); SAPMO-BArch, DY34/4298 Arb-gr.Frau, 3.6.64. Bericht . . . KWO Berlin . . . ; DY34/4299, Arbeitsgruppe Frau, Bericht . . . VEB Fettchmie KM Stadt am 6.4.65; DY34/5463, VEB Erdölverarbeitungswerk Schwedt an Margot Müller; Brunhilde Skibinska an Margot Müller 30.3.68.

[199] SAPMO-BArch, DY34/5463, E.S. an BUVO, 15.9.66, 2–3; Müller an E. S., 23.11.66; Müller an E.S., 14.12.66; E.S. an MM, 17.12.66; MM an E.S., 20.12.66.

Such stories notwithstanding, municipalities expanded institutionalized child care impressively, if insufficiently. The biggest factories also expanded child care provision. In 1967, the Leuna works, with its 30,000 workers, operated *seventeen* crèches and kindergartens with places for 1,479 children. By 1970, 23.6 percent of infants and toddlers in the GDR had a place in a crèche, while 61.1 percent of three- to six-year-olds attended kindergarten. Family care and church-run homes continued to take up some slack. In 1970, there were 571 religiously affiliated child care facilities in the GDR.[200]

Midday meals, laundries, and child care were the most important services aimed at employed women. Also worthy of mention are resorts and sleepaway camps operated by the FDGB. In 1964, workers at Leuna, for instance, paid a small fee to send their children (19,000 in all) to summer camps run by the firm's unions.[201] The state also subsidized health care, spas, tours, and cultural activities, not to mention public transportation, rent, and education. The populace liked some services, such as children's camps, resorts, and cultural events. They held others in contempt, including institutional meals and municipal transportation.[202]

Housing emerged as a major consumer issue in the 1960s, generating more petitions to the authorities than any other matter. In 1971, more than sixty percent of the housing stock of the GDR was over a century old. Ninety-two percent of apartments and houses had no central heating, sixty percent no bathroom, twenty-nine percent no running water. The only significant residential construction of the 1960s was the so-called *Plattenbau* developments in the "new socialist towns" such as the mining center Hoyerswerda. Hoping to relieve the housing crunch, reduce women's domestic labor, and create a socialist urban landscape all in one package, New Town planners designed high-rise apartment blocks of prefabricated parts and unified style that were efficiently grouped, technically equipped, and mixed in with shops, green areas, and playgrounds. The modern construction methods and functionalist form of the *Plattenbau* represented a break with the architectural antimodernism of the High Stalinist period. Each apartment was compact but sported wide windows, good lighting, modern heating, and a bathroom with washer hookup. The small kitchen included a built-in counter, modern sink, electric range, and space for a small refrigerator. Each building contained a laundry room. Constructed of cheap materials, the *Plattenbau* was ugly and badly built. Its adornments looked like what they were: cheesy fig-leafs on monotonous grey towers. Rooms were too few and too small for larger families.

[200] LAM, 16551, Leuna Werke.
[201] Ibid.
[202] Merkel, *Utopie*, 312.

The New Towns suffered from poor services and few cultural amenities. Nonetheless, the apartments *were* new, *were* modern, and *were* desired by working-class couples who were typically young and reproductively prolific and often were unskilled migrants from the surrounding country-side. Older members of the socialist "middle-class" stayed put in their crumbling but charming apartments in cities like Berlin, Dresden, and Leipzig.[203]

Up with the Socialist Consumer!

After 1962, the quantity, quality, and variety of fruit, vegetables, dairy products, baked goods, poultry, coffee, and wine rose steadily.[204] People quickly developed an appetite for these goods and complained when they could not get them.[205] The state fed newly refined tastes with *Delikat* stores that sold an assortment of specialty foods at high prices. People could afford these delicacies because state subsidies kept the price of basic foods low. Inexpensive daily sustenance, on the one hand, and the expensive extraordinary meal, on the other, combined to forge a "distinctly GDR gastronomy," argues Ina Merkel. East Germans spent "generously" on groceries, especially for Sunday dinner, meals with guests, holiday dinners, or special occasions—which abounded. At official and private affairs, tables groaned under breads, cheeses, butter, sausages, cold meats, schnapps, and beer.[206] As guests sociably munched and sipped their way through this bounty, the collective mood rose, sometimes shooting past merry toward messy and downright wild. Not surprisingly, consumption of alcohol rose in the 1960s.[207] This munificence, Merkel suggests, had a particular meaning in a society so influenced by peasant and proletarian culinary styles. Yet the delight in galas, gatherings, and inebriation also paralleled party culture in the West's free-handed, free-spirited (and now freely maligned) 1960s. Where West and East diverged was in the kinds of food (and drugs) that symbolized fun, fortune, and fine taste. By the early 1960s, Western Europeans were eating more tropical fruits, vegetables, and seafood, and less butter, cheese, pork, and beef. East Germans, too, consumed more fruits and vegetables, but the increase came later and was less dramatic, in part because supply and variety were not as good, but also because butter and meat would not be dislodged as the icons of

[203] Hübner, *Konsens*, 172–75; Burkhardt and Burkhardt, 116; Schildt, 184–85.

[204] Hübner, *Konsens*, 169.

[205] For complaints expressed at union meetings, see SAPMO-BArch, DY34/4427, Anlage zum Infobericht. 6.6.64; DY34/4299, IG Metall Zentralvorstand an Margot Müller, 8.4.65.

[206] Merkel, *Utopie*, 45, 87.

[207] Interview Frau D. On alcohol consumption, see Prokop, 175.

plenty. Only in the 1970s did tropical fruits—and especially the banana—become the *sine qua non* of desirable edibles that socialism could not deliver.[208]

Fealty to fat came to signify a perverse sort of resistance to the regime. In a speech to the Sixth Party Congress in January 1963, the abstemious Ulbricht criticized East Germans for buying too much food and not enough industrial merchandise. He contrasted their spending habits to those of West Germans—not typically his ideal type. In the FRG, consumers spent forty-five percent of their budget on food and fifty-five percent on other consumer goods; in the GDR the ratio was reversed. Giving new meaning to the term "chutzpah," Ulbricht blamed skewed demand for "difficulties" with grocery supplies from 1960 to 1962. He also bemoaned what East Germans ate. "Science," he preached, "has established that overconsumption of butter only promotes arteriosclerosis." People must eat, he insisted, a "healthier diet."[209]

An economic motivation underpinned Ulbricht's advice. Stalin was right: the socialist saddle did not sit well on cows (or pigs), and hence, the state had to heavily subsidize dairy and pork production.[210] The regime hoped to shift preferences to protein-rich chicken. Commendably communal, chickens grew plump cheaply on factory-style farms. They could then be packed onto trucks and shipped hither and yon. Slaughtered, plucked, and roasted to a golden brown, they could be sold by GDR-style "take-out" vendors. Amazingly, the plan worked. By 1963, many towns hosted cooker-vans that sold fresh grilled chickens. In the later 1960s, *Goldbroiler* restaurants opened in various cities. The sight and smell of twenty to thirty birds rotating on spits made customers' mouths water, and consumption of poultry climbed.[211] Yet, so did consumption of pork and butter. People ate more of everything. It was one thing for an employed mother to serve a *Goldbroiler* for a workday supper, but quite another to substitute it for Sunday's pork roast. Sundays revolved around an elaborate midday dinner, the only meal of the week to which most women could devote time and effort. They and their husbands liked it traditional in every way. Here, as in other areas of domestic life, women's changing public role seems to have prompted men and women to fetishize certain private conventions.

East Germans liked to eat well, but they did not, contra Ulbricht, disdain nonperishables. As production of household appliances and televi-

[208] Merkel, *Utopie*, 87.

[209] Hübner, *Konsens*,168; Kaminsky, *Wohlstand*, 99; Prokop, 174–75; Süss, 71. See also "Iss gesunder! Hab mehr vom Leben," ND 4.1.69.

[210] Merkel, . . . *und Du*, 45.

[211] Patrice Poutrus, "Abriss," 139–40; Patrice Poutrus, "'Politik'."

sions increased, people snapped up these expensive items. The yawning ravine between East and West German ownership of TVs, nonautomatic washing machines, and refrigerators in 1960 shrank to a narrow gully by 1970. The rise in television ownership presents a classic instance of contradiction between intent and consequence. Television production surged, because the party saw TV programming as a promising "ideological weapon" in its competition with the West. East Germans, however, watched West German TV shows, despite the risk of getting caught. They were confronted like never before with the allure of consumerism. Irony on top of irony, no consumer durable contributed to the domestication of leisure more than the TV. Movie attendance and participation in other public entertainments declined as the family hunkered down together in front of the tube.[212]

The increased availability of durables did not win the state applause, because supply did not satisfy demand. Complaints about waiting times skyrocketed. People perceived distribution as unfair, for priority provisioning was now applied to durables. Priority lists still privileged workers in heavy industry—especially miners. Also as earlier, the lists soon lost meaning, because SED functionaries, union officials, and managers intervened vigorously to have "their" factory listed as a priority producer.[213] In 1960, there were forty-six priority concerns. By 1964, priority status had been extended to seventy-nine concerns on the republic-wide list. An additional 140 firms were on district lists, and 400 factories were on local lists.[214] A new, overlapping priority system favored "large families" (four or more children). If the industry-based system privileged male industrial workers, this one advantaged two-earner families, because almost every large family was headed by a married couple, a point driven home in complaint after complaint from unmarried mothers with three children. As earlier, the discriminatory principle alienated the disadvantaged but was often breached in practice. If a single mother managed to aim her petition at an authority with any clout, she usually received a dispensation to buy the coveted appliance, most often a washer.[215]

[212] Feinstein, 157.

[213] See, e.g., SAPMO-BArch, DY34/4298 Arbeitsgruppe Frau, Bericht ... 17.7.64; DY34/ ZV IG Metall. 4427. Anlage zum Infobericht. 6.6.64.; DY34/4299. Arbeitsgruppe, Bericht ... VEB Fettchmie KM St am 6.4.65. Also see Merkel, *Utopie*, 225–26; Hübner, *Konsens*, 169.

[214] Merkel, *Utopie*, 228–30.

[215] See, e.g., SAPMO-BArch, DY34, Eingaben an FDGB, JK an Frauenkommission; Margot Müller an Kreisvorstand FDGB Bad Doberan, 30.10.67; Bad Doberan on MM. 27.1.67; JK an MM, 16.12.67.

The clothes that women laundered in their new machines were made from better and more "modern" fabrics. Even during the crisis years of 1960 to 1962, the state stuck to a new plan to import expensive technologies and high-quality materials from the West in order to modernize textile production and improve cloth made in GDR mills. The new higher-end textile and garment mills learned to produce synthetics and copy Western styles. Yet they could not escape the game of catch-up. At the end of the 1960s, GDR mills finally solved their difficulties with the first generation of synthetic materials, just as Western innovators came out with a new generation of synthetics and with synthetic/natural blends.[216] East German women had at least demonstrated the significance of fashion: the Central Committee now ritually discussed and lamented the lack of "quality" dresses. To meet women's ever more discriminating tastes, the textile industry produced even more expensive fabrics and clothes, which it marketed directly through "boutiques," not the now tawdry HO. In 1957, a fashion magazine, *Sibylle*, began publication, and a *Sibylle* boutique soon followed. *Die Frau von heute* pronounced its "sack dresses" ugly and overpriced, but they flew off the racks. In 1960, the even more exclusive *Exquisit* opened its doors. It, too, elicited populist grumbling but, after the wall shut off access to West Berlin stores, *Exquisit* found a place in women's hearts. Over time, "*Ex*," as it was fondly known, sold less-classy clothes but retained its cachet as an exclusive outlet.[217]

Bulk textile production remained of low quality, and surpluses of cheaper clothes continued to pile up, especially after the Central Committee, prodded by Erich Honecker and Paul Verner (Berlin's first secretary), proclaimed the year-end sale ideologically suspect. End-of-season discounts, Verner claimed, devalued socialist production *and* encouraged wasteful consumption. Edith Baumann complained about an HO advertising campaign, "Clothe yourself anew!" An ad showed a dress burning on an ironing board with the caption, "It doesn't matter—buy yourself a new one!" The campaign, Baumann argued, "cultivate[d] the antithesis of the 'socialist consumer culture'" and fomented discontent by "arous[ing] needs that we cannot . . . satisfy at this time."[218] GDR market research proved Baumann right. As women's income grew and their wardrobes expanded, their desire to own more clothes rose, along with their dissatis-

[216] Stitziel, "Fashioning," 127, 335–39, 341–42, 253–58.
[217] Ibid., 347, 349–50, 128–29, 359, 378, 411, 415–17, 423, 429; Merkel, *Utopie*, 33, 252.
[218] Stitziel, "Fashioning," 356, 357. Also see Kaminsky, *Wohlstand*, 74–75.

faction with what they already owned. Men showed a similar, though less robust, tendency.[219]

Women mixed and matched ready-made clothes to create their own look. They wore "sportier" clothes and, of course, pants. They bought more cosmetics.[220] The combination of informality and artifice, eclecticism and elegance, trousers and painted faces corresponded to trends in the West. The East German synthesis was less disheveled and androgynous but clearly oriented to the occident. Fabrics lagged further behind the fashion curve than the actual clothes women wore, in part because Western relatives sent, for example, jeans. As earlier, women kept up with international styles by sewing their own clothes or having them made by a tailor or friend. In 1963, only *one-third* of women's and girls' outerwear was ready made. Within five years, two-thirds was ready made, yet as late as 1973, one-fifth of all outerwear—male and female—was still individually sewn.[221] The prominence of self- or privately-made clothing stood in stark contrast to ready-made's conquest of couture in the capitalist West. Homemade clothing also constituted an exception to the socialization of labor in the GDR—and contributed to women's unpaid domestic work.

As the textile industry tried to measure up to the West, so did the Ministry of Trade. It once again cleaned up shops, spiffed up its displays, and improved "shop culture." Under contract with the HO, big concerns, such as the Buna chemical complex, renovated and enlarged their "shopping avenues."[222] Self-service expanded considerably, to the delight of customers. Sales clerks were less enamored of this change. They still faced the wrath of customers during every food or clothing crisis. As more things became available, good relations between clerks and customers did *not* blossom. Customers groused about dirty windows, tacky displays, and slow service. Indeed, the saleswoman was everyone's scapegoat for the failures of socialist consumerism. The GDR's satirical magazine, *Eulenspiegel*, caricatured her more than any other worker. Clerks were infamous for rude nonchalance, encapsulated by their allegedly standard retort to any query about an item, "Don't have it (*Habn' wa nich*)." To counter this cheeky (if often accurate) remark, the Ministry of Trade introduced the slogan "My hand for my product." It soon replaced this macabre pledge with the anodyne "Everybody delivers Quality to Every One."[223] Meanwhile, clerks and customers engaged in a tug-of-war over

[219] Stitziel, "Fashioning," 482; Hilgenberg, 50, 67–76.

[220] Merkel, *Utopie*, 322, 353.

[221] Stitziel, "Fashioning," 465–66, 469, 475–77, 494.

[222] LAM, 16551, Leuna Werke, 1964; VEB Buna, Rep. II-2/928, WL 371, 1966.

[223] Merkel, *Utopie*, 183–86, 97.

store hours. SED women sided with the "much larger percentage" of employed women who benefited from a later closing time, rather than with saleswomen who worked the longer hours.[224] In 1966, after the regime introduced the nine-hour day and five-day week, store hours were extended to 8 p.m.—at least in cities. In small towns, weary clerks defiantly shuttered shops at 6 p.m., blithely ignoring the frantic knocks and angry shouts of their equally exhausted sisters.[225]

As daily living improved, change and continuity intertwined in curious ways. The Central Committee excoriated wasteful consumption but also critiqued mediocre fashions. Ordinary couples moved happily into sterile new high-rise complexes but canonized cozy, conventional culinary customs. Consider the truly all-consuming bustle around the celebration of Christmas as a secular feast. Excitement gripped even the *Politburo*. In what became an annual rite, it deliberated the Yuletide question. These veteran Communists wanted to know: did shops have enough raisins and nuts for *Stollen*, enough coffee and *Schlagsahne* for *Kaffee und Kuchen*? These all-powerful men inquired: did beauty salons have the proper supplies for the holiday rush? One year, hair spray ran low—and the Politburo quickly placed a special order with a West German firm.[226] How is one to interpret the Christmas passion? It attests to the might of popular tastes, appetites that the Politburo both shared and feared to disappoint. It reminds us that the consumer economy continued to live from hand to mouth, which is no surprise, given such absurd overcentralization of decision making. The Politburo's careful accounting of ingredients for domestic feasts and paraphernalia for women's holiday rituals can also be read as a sign of the creeping domestication of an assertively masculine, anticonsumerist political culture. Simultaneously, the Christmas mania highlights the paternalism of the party hierarchy. Finally, the hullabaloo surrounding a traditional feast reminds us of the SED's inability to imagine, much less realize, an alternative culture of consumption.

In 1968, as economic reform went sour, Ulbricht remembered the virtues of delayed gratification. He stripped productivism of recently acquired consumerist baubles. From 1969 to 1971, investment in electronics, industrial tools, computing, and industrial petrochemicals leapt, while investment in consumer industries plummeted. This tilt would prove to be the swan song of Old Communist productivism. The plunge in consumer

[224] See, e.g., SAPMO-BArch, DY30/IV2/5/202, Bl. 56–78, Massenarbeit mit allen Frauen; DY30/IV2/17/20, Bl. 380–86, Abschlussbericht . . . Bezirk Halle, 5.4.62.

[225] Merkel, *Utopie*, 203.

[226] Ibid., 47, 95.

spending coincided with two bad winters and a summer drought, resulting in, again, scarcity. Erich Honecker exploited the crisis as he maneuvered to replace Ulbricht as first secretary in early 1971.[227]

The Family in Vogue, Women under Stress

In the 1960s, the East German family soldiered under a heavy load: wives and mothers entered the workforce in large numbers, husbands and fathers adapted little to this development; and the state raised the standard of family socialization. Hostile West German observers saw a family in "serious crisis" as the wife attempted to resolve the "conflict between what the family was expected to achieve and the constraints that her external activities placed on [her] performance in [the family]." A growing number of "incomplete families" showed how difficult she found it to square the circle, argued the sociologist Dietrich Storbeck.[228] SED leaders denied that maternal employment strained the family, but they worried about the rise of divorce among couples with young children. In 1959, at a meeting to discuss a (new) draft family law code, Lotte Ulbricht admonished, "[The code's] preamble [has to make clear that] we support the fortification, the preservation of marriage." In formulating divorce law, she continued, "We must think first about the welfare of children."[229]

Interest in "family stability" sank from view during the crises surrounding collectivization and construction of the wall, but it soon resurfaced. In a first for the SED, the VI Party Congress of 1963 commemorated the family and its values.[230] Celebration of "family nurture" (*Familienerziehung*) went into high gear in 1965, when the Ministry of Justice finally unveiled a new draft Family Code (FGB). The FGB's opening sentence echoed the philosophy of the Soviet pedagogue Makarenko: "The family is the most basic (*kleinste*) cell of society." Praising *Familienerziehung*, the code credited the family with "determining the personality in socialist society."[231] The FGB, wrote Minister Benjamin, communicated "the Yes of socialist society and the socialist state to the family" and demonstrated the GDR's commitment to "marriage as a life-long relationship."[232]

[227] Hübner, *Konsens*, 165–66, 177.

[228] Storbeck, "Familienpolitik," 98, 100, 102, 109.

[229] SAPMO-BArch, DY30/IV2/13/106 Bl.7, Protokoll . . . 25.5.59.

[230] Busch, *Familienerziehung*, 99, 103.

[231] Schlicht, 10.

[232] Dr. Hilde Benjamin, "Die gesellschaftlichen Grundlagen und der Charakter des FGB-Entwurfs," NJ 1965 228. On the FGB, see Obertreis, 251–64. On the family vogue, see Weigandt, 118–20; Helwig, *Familie und Beruf*.

Like the EFGB of 1954, this draft was presented for six months of open discussion. Justice took precautions to prevent a replay of the disaster of 1954. Gone were mass meetings that could morph into rallies against Communist "antifamily" policies. Justice officials met with small groups of fifteen to thirty people. The cumulative effect was still impressive: 750,000 people attended 34,000 meetings. Careful orchestration controlled the tenor of thousands of questions asked at meetings. Almost no one objected to the FGB's assumption of a "dual-earner" family.[233] In press interviews, Benjamin proudly touted popular interest in and approval of the FGB. Even the Christian clergy played along. Lutheran and Catholic prelates challenged specific provisions, such as a clause that stressed the "duty" of parents to raise "architects of socialism." They praised, however, the code's emphasis on the "development and protection of the family as the kernel of the state."[234]

The vogue of the family had an opportunistic edge. It functioned as a preemptive strike against West German clerics and others who saw maternal employment as antifamily. Like the Women's Congress that described socialist society as a "big family" and urged novelists to write "chronicles of families in our time" the FGB aimed, as well, to convince women that a qualified worker and active socialist could be a good mother.[235] The vogue also had an emulative element. It followed a Soviet trend of the late 1950s that revived Makarenko and emphasized the family's central role in bringing up baby.[236] The commemoration of the nuclear family represented, though, more than rhetorical sleight of hand, as is obvious from the family orientation of revivified social science and social policy. Research projects of the new Institute for Social Policy, for example, all looked directly at the family or viewed family life obliquely through the lens of youth, women, reproduction, and consumption.[237] The homegrown nature of the family vogue is evident, meanwhile, in the odd mix of nostrums to stem family dissolution. The two main "solutions" both entailed outside interference in troubled marriages and, hence, compro-

[233] BArch, DP1/VA/2054, Bl. 6, 1.9.65, Bl. 7; DP1/VA/1445, Bd. 2, Bl. 23 Arbeitsgruppe FGB Entwurf . . . 25.7.65.

[234] The churches disapproved of joint parental decision making, the "right to work" accorded mothers, and the FGB's silence on Christianity. See BArch, DO4, 422 Rundschreiben der evangelischen Kirche zum FGB, 15.5.65; 1555: Evangelische-Lutheran Trinitätsgemeinde (Dresden) an die Staatliche Kommission zur Bearbeitung des Entwurfs eines FGB, 31.7.65; Konferenz der evangelischen Kirchenleitungen, Berlin, an den Vorsitz des Ministerrates der DDR Herrn Willi Stoph, 12.7.65, S. 3; Stellungnahme eines Katholischen Geistlichen zum Entwurf des FGB; BArch, DP1/VA/2054, Bl. 26 EE an Staatliche Kommission . . . 30.9.65.

[235] Dokumente vom Frauenkongress, 148–49.

[236] Madison, 31, 33, 67, 69.

[237] Winkler, "Sozialpolitische Forschung," 389–91.

mised family privacy, but the methods and philosophies of each method were antithetical. The Ministry of Justice directed divorce court judges to assign the "work collective" to "help" a struggling couple. When "collective intervention" produced paltry results, the Ministry of Health applied a dose of Western therapy: sexual and marriage counseling.[238] Nonetheless, anxiety about family stability precipitated no radical change in state policy, much less in popular behavior. The Politburo neither reconsidered its drive for the full-time, permanent employment of mothers nor pondered why "the husband still did not feel obligated to share inner familial functions."[239] The divorce rate kept rising. All the talk about "qualitatively new family relationships" seemed, if anything, to heighten marital expectations and, thus, tensions.[240]

THE STATE CONFRONTS MARITAL CONFLICT

The bias of family court judges against divorce persisted. In 1962, for example, a judge ruled against a wife who filed for divorce on the grounds of "irreconcilable breakdown." She had left her husband three years earlier, after he threw "objects" at their sick, sobbing son. Not her story, but the husband's impressed the judge: they had had sex during the last three years, he said, *and* she never stopped cooking and cleaning for him. She sued for divorce, the woman conceded, only after he stalked her to her mother's apartment and beat her up in a jealous rage. To this dramatic testimony, the judge responded blandly, "This event alone cannot justify a divorce. . . . In the interest of the child both partners are obligated to change their behavior and, above all, be more considerate of the other." The wife was assigned court costs.[241]

Friendlier than local judges to divorce, the Supreme Court reversed this ridiculous ruling, as well as similar ones. Yet its decisions became less liberal, for the rising rate of divorce concerned its members. Rather than tighten divorce regulations, Justice instructed the courts to interpret existing statutes more strictly and to encourage a cooling-off period and "reconciliation." The High Court chided judges for "not drawing in social forces to help [the couple] change."[242] Judges were supposed to direct the work collective of one or both spouses to meet with them and support

[238] Also see Timm, "Health," 489–91; Laatz, 184.

[239] Storbeck, "Familienpolitik," 109.

[240] Anita Grandke and Klaus-Peter Orth, "Rechtssoziologische Untersuchungen zur Stabilität von Ehen in der DDR," *Staat und Recht* (1972), 49, 62.

[241] NJ 1963, 697.

[242] Ibid.

them through troubled times.[243] Collective intervention emerged as a tool against divorce in 1958 and 1959, the overdetermined result of several trends: the state's assignment of social responsibilities to the workplace, interest in "socialist morality" and "socialist personality," and creation of the "socialist brigades." In prescribing collective intervention, judges often incorporated phrases from Ulbricht's Ten Socialist Commandments.

The "work collective" responded with bewilderment to the order to interfere in a colleague's private life. In Berlin, a saleswoman with three young children filed for divorce after her husband beat her so badly that she had to spend a week in hospital. To prevent more violence and save the marriage, the judge called on the husband's BGL to intervene. Union functionaries brought together the couple, a representative from their SED chapter, the husband's shop floor committee, and his closest co-workers. At first, the session focused exclusively on the husband's *public* conduct. Co-workers complained that he came to work drunk and fought with them. The party, reported the SED functionary, had terminated his candidacy for membership. Only gradually did participants overcome "initial astonishment that they were supposed to talk about his conduct in his marriage." After his workmates lit into him on that score, too, the "couple reconciled" but the wife (sensibly) did not withdraw her suit.[244] Was this marriage saved? Probably not. A survey of divorce records concluded that collective mediation was typically "unsuccessful."[245]

Advocates of collective intervention attributed its failure to deficient "consciousness."[246] Communal solidarity was, they believed, too uneven to prevent individual missteps or, put bluntly, the husband's stumbles and, indeed, careening. If watched closely by his collective, the logic went, the husband would reform. His collective, however, had no desire to monitor him. A family judge asked a brigadier in a Dresden factory to comment on the behavior of a colleague whose alcoholism and brutality had driven away his wife. The man had stopped drinking at work, the brigadier reported, but the brigadier did "not know what he does outside work since [his colleagues] do not discuss family matters in the brigade."[247] "Colleagues," interventionists argued, *would* discuss family matters once they realized that what looked like a "purely private affair" was actually of "social interest."[248] The realization never came, for the husband's collec-

[243] Also see Markovits, "'Road'"; Markovits, "Handel."

[244] NJ 1960, p. 493.

[245] Wm Heinrich, Elfriede Goeldner, and Horst Schilde, Richter am Obersten Gericht, "Die Rechtsprechung der Instanzgerichte in Familiensachen," NJ 1961, S. 778.

[246] Ibid.

[247] SAPMO-BArch, DY34/4290. Buro Margot Müller, Bl. 134, Untersuchung . . . Dresden und Neubrandenburg, 18.

[248] "Erfahrungen aus einem Gerichtspraktikum in Familiensachen," NJ 1961, 779–80.

tive was typically composed of men who, in the words of Justice, "do not recognize the necessity of confronting outmoded bourgeois views of marriage and family."[249]

The SED wanted to stop male domestic violence.[250] Compared to the profound concern of the brutalized wife, however, its interest in doing so was weak, especially after the Collective placed "family stability" high on its list of priorities. Collective intervention frequently amounted to patching a deeply fractured, imbalanced relationship. Its conservative bias was intensified by the fact that judges in urban districts almost never prescribed this socialist nostrum, while judges in rural districts often did. It was precisely in the countryside that marital conflict arose most often from "an understanding of male/female relations that is still far from socialist. Violence, abuse of alcohol, and the nearly complete burdening of women with housework are characteristic of marriage [in the countryside]."[251]

Experienced family court judges recognized that "deeply distressed" marriages were beyond rescue. Sometimes, though, they used collective intervention to address an acute crisis.[252] In 1959, a husband sued for divorce because his wife constantly berated him for neglecting his family in favor of the LPG on whose board he sat. The Juvenile Assistance Office and the local court instructed the LPG to discuss the case. Hating the LPG as she did, the wife refused to attend the meeting, yet LPG members sympathized with her and relieved the husband of some farming duties. The LPG Women's Committee and DFD chapter (naturally) promised to help out in the family. Appeased, the wife joined the LPG, the husband withdrew his suit, and they lived happily ever after—or, at least, enjoyed a "good marriage" several months later.[253]

Judges were most likely to recommend collective mediation in a special, though not rare, kind of marital quarrel: conflict over an affair between (usually) a husband and his (usually single) female colleague.[254] Illicit romance *within* the work collective, especially when it involved comrades, became a fraught issue around 1960, after Ulbricht threw a spotlight on morality to counter the popular perception that the SED tolerated promis-

[249] Gerhard Haeusler, Aufgaben des Rechtsanwalts im Eheverfahren, NJ 1963, S. 373.

[250] Domestic violence received some press attention. See, e.g., "Wer seine Frau schlägt, schlägt die Genossenschaft. Mittelalter und Neuzeit in Damsdorf. Nur eine Familienangelegenheit?" ND 9.2.62.

[251] SAPMO-BArch, DY34/4290. Bl. 134, Zusammenarbeit mit dem Ministerium der Justiz, 1966/67. Büro Margot Müller, Untersuchung . . . Dresden und Neubrandenburg, 9, 16, 23–25; Heinrich, Goeldner, and Schilde, "Rechtsprechung," NJ 1961, 778.

[252] Barbara Rotter, Über die gesellschaftliche Mitwirkung in Ehesachen. NJ 1963, 685.

[253] NJ 1960, 395.

[254] Barbara Rotter, Über die gesellschaftliche Mitwirkung in Ehesachen. NJ 1963, 685.

cuity among party functionaries.[255] When a case came to light, the (again bemused) BGL or BPO had to form a committee to criticize the adulterous liaison, whether it involved workers, managers, union officials, or even the party secretary.[256] In some instances, the female "defendant" complained that she received a weightier punishment, such as a wage cut or job transfer, than her codefendant. According to one woman, her lover got off lightly because he was *"ein Genosse und keine Genossin* (a male comrade and not a female comrade)."[257] "It makes you wonder," wrote another, "that they treated *my* behavior as a breach of trust. But the man, who was married, had committed no breach of trust. . . . I had to leave the firm because I was only a secretary and a woman."[258] While such complaints were no doubt valid, some men did incur job transfers, and all got an equal dose of public humiliation. In the countryside, adulterous men were shamed with both traditional and "socialist" techniques. In Neubrandenburg, a husband sued for divorce after his wife told the whole village that he was having an affair, although he claimed innocence. In response to his suit, the court "drove to the village and met with the [LPG and Communal Council] to see how they could help save the marriage."[259]

Clearly, the similarly "cooperative" methods of collective intervention and customary controls coexisted comfortably in the Communist mind. When they proved ineffective, the state added an individualistic elixir: marriage counseling. With the exception of Lykke Aresins' clinic in Leipzig, sex and marriage counseling had largely disappeared in the 1950s. With the ascendancy of expert advice in the 1960s, however, the era of professional counseling arrived. Physicians who wanted the GDR to adopt "modern" approaches to sexuality and sexual dysfunction advocated counseling. In 1965, Aresin, recently promoted to Chief of Staff at the Women's Clinic at Leipzig University, wrote an article for jurists on "the medical causes of marital conflicts." In contrast to Neubert, she came not to damn Kinsey, but to praise him and, especially, Masters and Johnson. Their findings, she claimed, fit data on sexual practices gathered at

[255] Port, "Moralizing." The perception of SED moral laxity bubbled up in Zerle's interviews of 30,000 East Germans.
[256] For a case against a union official, see SAPMO-BArch, DY34/2482 Abt. Org. Heuckrodt, 29.7.63. Bericht . . . Rostock . . . 24–27.7.63, Zur Lage in Kreis Ribnitz-Damgarten, 3.
[257] LAM, IV/A-2/17/23, An die Frauenkommission beim Zentralkomitee der SED, 1.2.65.
[258] SAPMO-BArch, DY30/IV A- 2/17/474 Frau I.H. an Frauenkommission des ZK der SED (Berlin), 1.7.66; Waltrud Seidler an I.H. 12.8.66; Seidler an ZK, Genn. Glöckner. 14.9.66; Seidler an Glöckner, 4.4.67.
[259] SAPMO-BArch, DY34/4290. Bl.134 Untersuchung . . . Dresden und Neubrandenburg, 16.

her clinic. "Psychotherapy," she informed jurists, was the best treatment for some sexual disturbances in women, such as "frigidity" caused by childhood abuse.[260] Her clinic's approach to sexual problems almost instantly became the model.[261] The new Family Code mandated the establishment of sex and marriage counseling centers. By 1966, one hundred had already been opened and, by 1969, 210 centers were in operation (*Figure 19*).[262]

A social worker, lawyer, or, more commonly, a physician headed each center. The medical orientation recalled the counseling services of the Weimar and immediate postwar eras. Initially, the Ministry of Health tried to infuse them with a socialist flavor. Counselors were supposed to emphasize "participation in socialist production," "the role of the woman and the family in socialism," and the "necessity of societal influence" on family relations. At some centers, representatives of the Women's League attended counseling sessions.[263] At others, the counselor was instructed to "contact the firms of spouses who do not treat their families well."[264] Experience quickly showed, however, that the number of visitors "dropped immediately" if clients did not receive an "individual" consultation with the relevant "specialist," whether a "gynecologist, psychologist, pedagogue, or jurist." The most popular centers were directly attached to a polyclinic, perhaps because people found it easier to visit a medical clinic than a "sex" center.[265] Over time, East German "healthcare consumers" drove marriage counseling toward greater individualization, professionalization, and specialization than the regime originally envisioned. Though the mix of methods used to "fix" troubled marriages remained more communal, traditional, and state-directed than in the West, the state's understanding of marital conflict became less ideological, moralistic, and social, and more pragmatic, individual, and psychological.

[260] Dr. Lukke Aresin, "Einige medizinische Ursachen für Ehekonflikte," NJ 1965, 322; Lykke Aresin, "Was ist normal und was ist abnormal im Sexualleben?," NJ 1970, 462.

[261] Karl-Heinz Mehlan also promoted sex counseling and research on sexuality. On physicians' role, see Schnabl, 116–41, especially 116–17. In 1973, Schnabl became head of the sex clinic in Karl-Marx-Stadt. Also see LAB, Rep. 118/499. 1964, Gross-Berlin Rat der Stadtbezirk Mitte, an Prof. Dr. Schorr, 16.2.70.

[262] BLHA Rep. 601, Bezirkstag und Rat der Bez. Frankfurt/O, Ehe-und-Familienberatungsstellen, 1955–1966. Rat der Bezirk Frankfurt, 3.9.65, S. 2; IV A2/17/87. Bericht . . . Eheberatungsstellen. n.d. (1969?).

[263] Ibid.

[264] SAPMO-BArch, DY 30/394, 1970–71 Bl. 199, Bericht . . . Ehe und Familienberatungsstellen. 16.4.71.

[265] Ibid, Bl. 198; SAPMO-BArch, DY30/394, 1970–71. Bezirksvorstand des DFD Halle. Bl. 202–4, Bericht . . . Familienberatungstellen, 5.3.71; BLHA Rep. 601, Bezirkstag u. Rat d. Bez. Fr/O, Ehe und Familienberatungstellen, Einschätzung . . . Schwedt (Oder) (Nov. 1965).

Rather than treat divorce as a "vestige" of capitalism, jurists now conceded that socialism had its own sources of marital discord.[266]

The Good(-enough) Marriage

Belying official concern about the state of marriage, East Germans married at a high rate in the sixties. The solid marriage rate reflected, in part, a declining age at first marriage. According to East German experts, their compatriots married young because social benefits, guaranteed employment, child allowances, etc., provided them with economic security. It was also highly probable that the bride was pregnant—in 1962, eighty-five percent of first children born to a married couple had been conceived before the wedding.[267] The high rate of prenuptial conception shows that contraception was not easily available and suggests that the typical couple felt a child needed *married* parents. True, the percentage of children born out of wedlock was on the rise, as was divorce among couples with young children.[268] At public discussions of the FGB, no one objected to the legal equality of children born out of wedlock or to codification of the single mother's right to custody. Legal discrimination did not disappear, however. Single mothers complained vociferously about the inequities of the housework day and about consumer perks for married couples with children. The social norm clearly favored marriage, above all, for women. Women themselves reinforced the norm. Unmarried women complained that at work and in stores, other women called them *Fräulein* (Miss), despite a law that made *Frau* the universal form of address for women.[269] Women saw "marriage" as their collective territory. As in 1954, they attended discussions of the 1965 FGB in disproportionately high numbers and spoke out even more disproportionately. Older women were, as before, opposed to the relaxation of divorce.[270] Younger women, in contrast, composed the majority of complainants in divorce

[266] Kurt Wünsche, Die Aufgaben des Ministers der Justiz auf dem Gebiet der soz. Rechtspflege, NJ 1969, 67–68. For "divorce as vestige of capitalism," see "Erfahrungen aus einem Gerichtspraktikum in Familiensachen," NJ 1961, 779–80. Also see Grandke and Orth, "Stabilität," 57–59.

[267] See, e.g., Anita Grandke und Herta Kuhrig, "Zur Situation und zur Entwicklung der Familien in der DDR," NJ 1965, 231–32.

[268] Meyer, 39.

[269] SAPMO-BArch, DY34, Eingaben an FDGB Buvo, 1966–68. Akte: 5463, TU an Margot Müller, 21.4.67; TU an Frau Freyer, 6.10.66. S. 2, 4; Schubert (*für Dich*) an TU, 27.10.66; Badstübner, "'Zeig'," 446.

[270] BArch, DP1/VA/1445, Bd.2, Bl.51 Arbeitsgruppe FGB Entwurf . . . 25.7.65. Also see DP1/VA/2054, Bl.6, *Wochenpost* interview with Benjamin, 1.9.65; Bl. 109 E.D. an Redaktion des *Neues Deutschland* (n.d.); Bl. 70–71; "Zum bisherigen Verlauf der Diskussion über den FGB Entwurf"; NJ 1965, 416.

suits. What united the two sets of women was a higher standard of marital happiness relative to men's.[271]

Women's expectations did not generally extend to assuming husbands should share housework equally. In 1963, women worked about six hours longer per day on housework and child care than men.[272] Seven years later, women booked ninety percent of the 47.5 weekly hours of housework performed in the average family. The ratio of wives' to husbands' domestic labor was basically the same as in the GDR's ideological confederate, the USSR, and in its national counterpart, the FRG. Indeed, it was equivalent to the ratio in the imperialist United States.[273]

Many women cut back on time for themselves in order to run a *proper* household. In 1965, the new, trendier woman's magazine *für Dich* set out to determine who in the family did what in their free time. It conducted a reader's forum, interviewed workers at factory gates, and, most inventive, asked fifteen families to keep a nine-day "time-budget diary" of each member's day. Every inquiry found that the majority of women spent most of their "leisure" time cleaning, shopping, sewing, cooking, baking from scratch, and canning. For them, these tasks defined the "good" housewife.[274] Many women, of course, did the housework to avoid marital conflict. A worker in a radio and TV factory explained to investigators of part-time labor, "Since I've worked shorter hours, our marriage has improved significantly. We fight much less, I'm not so irritable or tense, and I have the household in order."[275] In 1972, students in the Family Law program at Humboldt University interviewed an "experimental group" of 222 married couples (spouses interviewed separately) and a "control group" of 2,000 married individuals, all under forty-five years old. Their responses, according to the published report, "demonstrated the continuing development of the new type of socialist family." Having made this obligatory claim in her introduction, the author presented contradictory evidence in the article's body. Husbands and wives agreed, for example, that "domestic duties, including child care, are more the task of the wife."[276]

Internal reports did not waste words on an optimistic gloss. One stated bluntly, "the egalitarian socialist marriage has not materialized."[277] Inves-

[271] See Rita Wenzel, "1975 – Internationales Jahr der Frau. Zur Verwirklung der Gleichberechtigung," *Staat und Recht*, 1976.

[272] Ulbricht et al., 28.

[273] SAPMO-BArch, DY34/ 9137. Studie zur Begrundung des langfristigen Planes der Frauenarbeit im Kombinat. 25.6.70, 17.

[274] Irmscher, "Arbeitsfrei," 46.

[275] SAPMO-BArch, DY34/11873. Abschrift! Analyse . . . VEB Schuhkombinat Banner d.Friedens . . . 5.

[276] Wenzel, 947–49, 951–52.

[277] SAPMO-BArch, DY34/4290. Büro Margot Müller. Zusammenarbeit . . . , 23–24.

tigators found that a kind of "companionable paternalism" was the rule. They also stumbled across a modified patriarchal model: the husband allowed his wife to work for wages, but otherwise tried to control her. Many a husband insisted that his wife clean the apartment *before* he returned from work. At a women's conference in 1963, speakers criticized "men who won't let their wives go out after work. In many households, a fight breaks out when the wife doesn't come home from work promptly."[278] Until at least the early 1960s, patriarchal relations were common in the countryside. Some husbands did not allow their wives to attend even LPG meetings.[279] In urban areas, traditional marriages clustered, it seems, at the top and bottom of the social and political scale. *Unskilled* female workers, according to the Women's Commission, were more likely to apply for reduced hours, although they earned less per hour than their skilled colleagues. On the other hand, the women most likely to attribute part-time work to a "husband's wish" were "married to men who have responsible positions or are in qualification courses" for their job, their trade union, or the SED.[280] At discussions of the draft FGB, much to the consternation of Justice officials, functionaries' wives "demanded" that their marriage be exempted from the recommendation that husbands help with housework. The family code should, they contended, "permit men whose time is much taken up by their various duties to have a 'housewife' who would perform alone [the tasks] shared by spouses in other marriages."[281]

The new Family Law did encourage male household labor, breaking with official disdain for this solution to the drag of domestic work on women. In the late 1960s, the press began to devote attention to women's double burden and encouraged men to pitch in by, for example, doing the laundry in the family's new washing machine or performing heavy tasks.[282] Most women wanted someone to take some housework off their backs, but they seemed to assume the responsibility lay with the state more than with their husbands.[283] A minority of women, however, envisioned an egalitarian marriage—and divorced their husbands when they did not get what they expected.

[278] SAPMO-BArch, DY34/4298. Arbeitsgruppe Frauen, 14.1.66. Einschätzung . . . ; DY34/11873, Einschätzung . . . Elektrotechnik/elektronik und Textilind . . . (1968 bis 1969); 717. Frauenkonferenz am 27.6.1963 . . . Suhl, 8.
[279] LStA IV A-2/17/474. Abteilung Landwirtschaft. Bemerkungen . . . Landwirtschaft, 10.1.63. Also see Ansorg, "Strukturwandel," 116.
[280] SAPMO-BArch, DY34/11873. Einschätzung . . . Elektrotechnik/elektronik und Textilind. DY30/IV2/2.042/20, Bl. 247, Abt. Frauen, Abschlussbericht . . . Produktion, 24.11.71.
[281] BArch, DP1/VA/1445, Bd.2, Bl.59 Arbeitsgruppe FGB Entwurf . . . 25.7.65.
[282] Kaminsky, *Wohlstand*, 88, 90; Sachse, *Hausarbeitstag*, 313–15.
[283] BArch, DP1/VA/1445, Bd.2, Bl.59 Arbeitsgruppe FGB Entwurf . . . 25.7.65.

Marital Discontent and Divorce

Between 1958 and 1969, the number of divorce suits rose, *and* it became more likely that a suit would end in divorce (1958: 59.8 percent; 1969: 68.2 percent). Thus, the number of divorces rose—to 28,933 in 1969, an increase of twenty-five percent from 1958. For every 1,000 inhabitants, there were 1.3 divorces in 1958; in 1969 there were 1.7.[284] Divorce declined among couples with no children or with older children, while divorce among couples with minor children increased. Wives propelled the rise. In 1958, women sued in 53.4 percent of finalized divorces; in 1970, they filed suit in 63.4 percent of such cases. One can trace the opposite curve in the gender composition of defendants who filed to *block* a suit (a step taken in ten to thirteen percent of divorce suits in the 1960s). At the end of the 1950s, wives filed six out of ten blocks. Ten years later, the ratio was reversed. It also became likelier that a divorce would involve an employed wife. Between 1959 and 1970, the percentage of divorces in which the wife earned no income fell from 26.3 percent to 13.0 percent.[285]

The financial independence that gave women the means to leave was new, but they left, in the main, for old reasons. In 1970, the GDR's Supreme Court asked analysts in the Justice Ministry to compare the legal grounds for divorces finalized in 1958 to those of 1968.[286] Three of the top five grounds remained the same: infidelity; "abuse of alcohol," and the catchall "ill-considered" marriage (commonly claimed as grounds in "young" marriages) (Table 7.5).[287] Male infidelity remained the number one reason for divorce, while male alcohol abuse became relatively *more* important between 1958 and 1968. A second analysis reinforces the impression of continuity. As of 1968, complainants could cite more than one grounds for divorce. According to Justice officials, the "especially common combinations" included "male violence" as one cause. Just as the "good marriage" functioned conventionally, so was the "bad marriage" conventionally dysfunctional.

Yet further analysis of grounds for divorce suggests that a more modern definition of marital happiness was emerging, one founded less on a spouse's actual misdeeds than on his or her subjective qualities. "Incompatibility" became one of the top five reasons. A brand new legal grounds

[284] BLHA Rep. 601, Bezirkstag u. Rat d. Bez. F/O. Akte: 8294. Ehescheidung; Oberstes Gericht der DDR. Präsidium. 9.9.70. Ursachen und Tendenzen der Ehescheidungen . . . 4.

[285] Mertens, 36, 66, 41–42, 77.

[286] BLHA Rep. 601, Bezirkstag u. Rat d. Bez. F/O. Akte: 8294. Ehescheidung; Oberstes Gericht der DDR. Präsidium. 9.9.70. Ursachen und Tendenzen der Ehescheidungen . . . 4.

[287] Also see "Erfahrungen aus einem Gerichtspraktikum in Familiensachen," NJ 1961, 779–80.

TABLE 7.5
Grounds for Divorce, by Percentage, 1958 and 1968

Grounds	1958	1968
Unfaithful husband	37.0	28.3
Unfaithful wife	10.8	16.0
Unfaithful both	9.3	6.5
Alcohol misuse, husband	15.0	19.6
Incompatibility	—	23.3
Ill-considered marriage	14.5	15.0
Sexual reasons	7.0 (1959)	14.0
Disagreement about children's upbringing and how to run household	—	9.2

Source: BLHA. Bezirk. Frankfurt/Oder. Rep. 601/8294. Ehescheidung. Oberstes Gericht der DDR. Präsidium. 9.9.70. Ursachen und Tendenzen der Ehescheidungen in der DDR und sich daraus ergebende Schlussfolgerungen für eine aktive Durchsetzung der sozialistischen Familienpolitik.

leaped to sixth place: "disagreements about children's upbringing and/or how to run the household." In rural Neubrandenburg, a study of divorce found, virtually every female complainant claimed to have left her husband because he barely lifted a hand to help with housework or child care.[288] Most striking is the doubling of "sexual grounds" between 1958 and 1968. Female adultery also increased relative to male infidelity. It may be that wives only hid their affairs less diligently than earlier, but it seems likely that female infidelity increased as employment afforded wives new opportunities to dally. One can imagine, further, that women's "adultery potential" was positively correlated with a higher standard of sexual contentment in marriage. Another sign of a more liberated female sexuality in the 1960s was the great popularity of *Das Magazin* among women of every situation, but especially the intelligentsia. Its editor Hilde Eisler continued to publish nude photos and erotic cartoons and drawings, but she added stories by prominent East German women writers that treated personal relationships and everyday life from a "modern" feminine sensibility.[289]

Women's rising standard of sexual satisfaction is suggested, as well, by data on the causes of marital discontent. In 1971, the Ministry of Health collected reports on who visited the new sexual and marriage counseling centers, and why. Sixty to eighty percent of their clients were women, most of them between twenty-five and forty years old, i.e., the same gen-

[288] SAPMO-BArch, DY34/4290 Zusammenarbeit . . . , 23–24; Grandke and Orth, 50–51, note 9.
[289] Badstübner, "'Zeig,'" 440–46.

der and age group who tended to file for divorce.[290] From 1964 to 1969, four main motivations sent people to counseling centers in Berlin: twenty-three percent asked for contraception or an abortion; twenty-three percent came about marital violence or alcoholism (often in combination with "financial troubles"); twenty-two percent wanted to talk about their own or their spouse's adultery; and nineteen percent raised sexual matters ("frigidity, impotence, and sexual disorders").[291] A national evaluation of counseling centers named as "main problems" (without providing percentages) the same ones that sent people to Berlin's centers The all-GDR report listed, as well, a category of conflict that counselors dubbed "equality issues": "violation of marital equality by the husband" and "lack of understanding for the wife's professional advancement."[292]

A final indication of changing perceptions of marriage was an increase in the number of people who visited the counseling centers. Initially, they attracted few clients, even in Berlin. In some towns, the only clients were couples ordered by a divorce court to seek counseling. "The majority of [East Germans]," a report concluded, "are still not accustomed to the idea of societal advice in marital questions" and "are very inhibited" about discussing private affairs with a professional.[293] In 1970, however, Berlin's counseling services experienced a sudden surge in demand. According to analysts, "ever more young or youthful couples" came for counseling, suggesting that they expected more from marriage than did their parents and were more likely to believe professional advice could help them meet these expectations (*Figure 20*).[294]

Counselors believed they saw correlations between social class and the *type* of marital problem they treated. Violence by the husband, drinking by the husband, and hasty marriage were, they claimed, typical causes of conflict and divorce among "proletarian" couples, while "members of the intelligentsia" specified male adultery, sexual issues, incompatibility, professional problems, and "disagreements about running the household

[290] SAPMO-BArch, DY30/DY30/394, Bl. 197–98, Bericht . . . 16.4.71.

[291] LAB, Rep. 118, Akte 499. Gross-Berlin Rat d. Stadtbez. Mitte, an Prof. Dr. Schorr. 16.2.70, 5. See SAPMO-BArch, DY30/394, 1970–71.Bl.197–99, Bericht . . . 16.4.71.

[292] SAPMO-BArch, DY30/394, 1970–71.Bl.197–99, Bericht . . . 16.4.71. SAPMO-BArch, DY31/350 Vorlage . . . 10.5.63. Other reasons people visited the centers: overcrowded living conditions, questions about communal property and income, difficulties with children, and infertility.

[293] BLHA Rep. 601, Beztag u. Rat d. Bez. Fr/O, Ehe u.Familienberatungstellen, 1955–1966 Rat des Kreises Eberswalde, 16.11.65. Also see ibid., Abt. Volksbildung, Fr (O), 12.11.1965. An das Sekretariat des Rates . . . ; Bl. 198–99, Einschätzung . . . Schwedt (Oder) (Nov. 1965).

[294] LAB, Rep. 118, Akte 499. Protokoll . . . 25.10.73. Between 1964 and 1969, fewer than 1,500 people per year sought counseling in Berlin; in 1970, counselors booked 3,435 appointments; in 1971, 4,676; in 1972, 5,238.

and raising children." Counselors emphasized that *women* visitors were educated or qualified. This possibly biased observation supports other anecdotal evidence. In petitions for abortion submitted in the late 1960s, educated women assumed not only that partners would support their professional aspirations, but also that they deserved a sexually satisfying life. Men did not always rise to the challenge—and the wife filed for divorce. In the words of one woman: "My husband has absolutely no understanding for my work, much less for my studies. His ignorant carping drives me to the edge of despair. I'm in the first year of a five-year mathematics program that I will only be able complete if I leave my husband and have no more children by him."[295]

Modern expectations did not mean that women stopped yearning for the right man. After being widowed with three young children in 1957, an accomplished, self-confident chemistry instructor (and SED member) did not remarry. She had several relationships with married men, one of whom fathered her fourth child. Speaking with her in 1996, I asked her to reflect on her life. After a pensive drag on her cigarette and a slow, smoky exhalation, she answered, "I have no complaints about my work. My career went really well. I also had wonderful relations with my children. But I'd have to say that, after my husband died, I never had a good relationship with a man."

CHILD DEVELOPMENT AND MATERNAL DUTY

In the late 1950s, Neubert's *Marriage Book* gave public culture in the GDR a maternalist infusion. It argued that maternal care was preferable to institutional care for very young children and bolstered this claim with empirical evidence, a study of the comparative developmental effects of institutional and home care conducted by the psychologist Eva Schmidt-Kolmer. In 1960, *Neues Deutschland* summarized Neubert's iconoclastic position and opened a column for readers, "Who is the better mother to her child?" Over the next several years, the SED flagship paper published many letters from both points of view.[296] In close association with the vogue of the family, the era of the child had arrived. As in the rise of the family, this trend was not unique to the GDR among socialist countries. In tandem with Soviet and Czechoslovak colleagues, East German pedagogues, psychologists, and social hygienists became more aware of the

[295] BArch, DQ1/6324, Bl. 134.
[296] Busch, 75–79; Obertreis, 157–61, 265; "Arbeitet eine Mutter aus purem Egoismus?" ND 17.1.62; "Ich liebe meine Familie und meinen Betrieb," ND 20.1.62.

importance of emotional and cognitive development, on the one hand, and alert to the family's role in shaping "personality," on the other.[297]

Eva Schmidt-Kolmer did not at first join the debate opened by Neubert. She continued her comparative studies of day, weekly, long-term, and family care. In 1963, she finally weighed in. Neubert, she said, had misinterpreted her findings. Her research showed, she argued, that *day*-crèches did contribute to the "optimal development of the child from the earliest age," even compared to maternal care, if the crèche was staffed by well-trained professionals who provided their charges with "enriching experiences" and "physical and psychic stimulation."[298] In the SED journal *Einheit*, she and her husband ridiculed Neubert's "reactionary utopian" romanticism of the "petite bourgeois family" and his "pseudoscientific theories" that supported "psychoanalytic mystification of the mother/child relationship."[299] In her many invited lectures to women's groups, she dropped class smears in favor of the language of individual rights and development. The child, she said, had a "right" to good nurture, but not a "right to exclusive upbringing by its mother" because the mother had her own "right" to personal development and employment. Their rights could be balanced if the GDR "construct[ed] day-crèches and resort[ed] to weekly and, especially, long-term care only when the mother's job or family situation exclude[d] day care."[300]

Schmidt-Kolmer easily convinced audiences of social workers and preschool teachers to reject "Neubert's view that women should not work until their children are three years old."[301] Her prescription to invest in day care was also highly influential.[302] She was swimming with the stream: communities were already converting weekly homes into day-care centers. The trend picked up speed throughout the 1960s.[303] Nonetheless, the shift out of weekly care was gradual. In 1965, weekly homes accounted for 32 percent of all crèche places; in 1970, their proportion stood at 23 percent; in 1988, weekly homes cared for 1.4 percent of children in institutionalized care.[304]

[297] Madison, 32, 47, 67, 68; Heitlinger, *Sex Inequality*, 169; Haney, 95.

[298] SAPMO-BArch, DY34/2925. Protokoll . . . 16.3.63. Also see Reyer and Klein,127.

[299] Eva Schmidt-Kolmer und Heinz Schmidt, "Über Frauenarbeit und Familie,"*Einheit* 1962, H. 12, Jg. 17, 97–8.

[300] SAPMO-BArch, DY34/2925. Protokoll . . . 16.3.63.

[301] Ibid. On official approval of Schmidt-Kolmer's position, see Busch, 75–79.

[302] Reyer and Kleine, 147–49.

[303] For local awareness of the deficits of weekly and permanent homes, see LStA, Kinderkrippen. Bestand: Bezirk und Rat der Bezirk Leipzig. 922, Bl. 98. Entwicklung . . . Bezirk Leipzig, 26.4.62. The trend was similar in Czechoslovakia. See Heitlinger, *Sex Inequality*, 169. On Eastern Europe in general, see Reyer and Kleine, 138.

[304] Reyer and Kleine, 127.

Schmidt-Kolmer appeared to defeat maternalism on every front. The Family Code, court rulings, and all official statements carefully adhered to gender-neutral or gender-balanced language of "family nurture."[305] Indeed, courts and the press repeatedly noted the right and duty of fathers to active parenting. The FGB, for example, allowed fathers to take paid leave to care for a sick child (though there was no "paternal leave" for infants). In deciding custody, judges now considered the relationship to the father of each child in a family. Despite all this, Neubert won the war. The actual gender imbalance in domestic routines and gendered-cultural imperatives meant that "family nurture" could only have maternalist implications. Neubert's typical reader took his paean to the "warm nest" to mean a refuge feathered by the mother. As the decade progressed, moreover, official culture intensified its focus on *Erziehung*, the childhood parallel to *Bildung*. In the "real-existing socialist" family, the responsibility to produce "quality" children fell on the mother. According to an FDGB report, "women shape (*gestalten*) the education of their children ever more consciously and responsibly," worrying not just about the "education of small children," but about the "very complex problems" that arise with older children.[306]

Asked, in interviews conducted between 1968 and 1970, why they shifted to work shorter hours *after* their children entered school, mother after mother explained that school-age children needed "care" after school. A secretary in a shoe factory reported, "No one will take the responsibility for my children from me. . . . [M]any new subjects are added during the year they become too old for the after-school program. It's better when someone is there for them [at home]." That "someone," everyone assumed, was the mother. A production worker in a ceramics factory had applied for short hours, she explained, "when it became clear that the kids weren't catching on at school and needed individual help." An "engineer-economist" in a textile plant would have preferred to work full-time, especially because, she explained, "work in the firm is still [*sic*] rated higher than work at home." Nonetheless, she cut back to six hours a day because her older son needed help with his homework. She continued, "Children want to talk with their parents. When both parents work full-time, you often see the children run into trouble." Asked about support

[305] Also see Helwig, Einleitung, 6–7.

[306] SAPMO-BArch DY34/4293, Zusammenarbeit mit wissenschaftlichen Einrichtungen, 1964. Verbesserung . . . Betreuung der Kinder, 4–6. Women often visited counseling services for advice about "correct education (*Erziehung*) of their children" (DY31/350, Vorlage . . . 10.5.63).

from her husband, she replied brusquely, "He can't help. He's chairman of the BGL [at the factory where they both worked]."[307]

Not every mother jumped to take on the burden of the higher standard of child development. Some had the onus thrust on them by a teacher, a school administrator, the parents' council, an employer, or SED functionaries. A cleaner reported, "I am forced to work part-time for my child's sake. He already failed one grade. . . . The school called my firm. At work they talked to me about my child's behavior." Asked by investigators about her husband, she replied, "Currently, my husband is taking a correspondence course for a skilled worker's diploma. Now I have to be more involved with my child." A white-collar employee in a shoe factory explained,

> Every evening I have to supervise my children's school work. I attended the district party-school and it was said to me in the parents' council [sic] that I should be more involved with my children. It's not easy when something like that is said to you. So I started to work six hours [per day] and that's turned out well for the kids. Still, the school should stop making such a big deal about the good grades of home-children [Hauskinder] {children not enrolled in after-school care}. You have to get reproached about working and the kids not doing well in school. . . . Okay, so maybe I do take better care of the children because they're at home. At least they're more rested in the morning.

A crane driver, married to an SED functionary, worked part-time, although her sons were fourteen and eighteen years old. She reduced her work week after her younger son had "educational difficulties," an interviewer reported, "because as a comrade she couldn't allow her son to be in constant trouble at school."[308]

Conclusion

Ulbricht's last decade in power was an ambiguous era in the history of the GDR. Were the 1960s a time of reform, or when the SED consolidated total control? Did NES economists attempt a "modernization push," or only a technocratic lurch? Did official culture become more tolerant, or

[307] SAPMO-BArch, DY34/11873. Meinungen von Frauen . . . ; Analyse . . . VEB Schuhkombinat Banner d.Friedens . . . , 5; Einschätzung . . . , 1–2; DY30/IV B-2/17/731 Analyse . . . , 30.7.70, 4–6.

[308] Ibid. Also see BArch, DQ3/427 (Frau) M.V. an Vorsitz. des Ministerrates d. DDR, 27.9.67; SAPMO-BArch, DY30/IV2/2.042/20, Bl. 245–47, Abteilung Frauen, Arbeitsbericht . . . Produktion, 24.11.71; DY34/4298. Arbeitsgruppe Frauen, Einschätzung . . . 14.1.66; DY34/9820. Forschungsthema. . . Teilzeitarbeit, 1970; Obertreis, 157, 205.

more manipulative? Were the 1960s the GDR's "happy" and "most optimistic" years, or were they dominated by familiar problems?[309] Scholars can make a cogent case for each position, depending on whether they emphasize the persistence of original structures or highlight the novelty of the tools used to fortify and legitimate the structures. Interpretations differ, as well, according to one's definition of "reform" and "modern."[310] The evidence presented in this chapter supports, in my view, the argument that the SED engaged in a variety of unorthodox experiments in numerous areas of policy between 1961 and 1969. I would characterize these modifications as reforms or semireforms, although they were inconsistent, limited, and tentative owing to the Stalinist productivism that concurrently motivated and undermined them.

Reforms began as an effort to modernize the economy. As several scholars have noted recently, NES was "flanked" by a turn toward a social-political perspective, couched in a discourse of "social security" and "working and living conditions." The rehabilitation of social policy, argues Manfred Schmidt, was part of the shift toward "material" motives to increase productivity, on the one hand, and to enhance the state's reputation, on the other. As do Beatrix Bouvier, Heike Trappe, and Albrecht Ritschl, Schmidt sees (small) increases in spending on social security as connected to efforts to make it easier for mothers to work for wages, while bearing and rearing several children. The discourse about social policy was mostly just that—words—*except* in the case of "promoting the family" through longer maternity leaves, larger child allowances, more child care places, and panaceas for unhappy marriages.[311] Those measures, too, were piecemeal and incremental, but they were concrete and even innovative.

The vogue of the family was stimulated not only by women's qualification and employment, but also by a new appreciation of the family as nurturer of "the socialist personality," i.e., the dedicated, qualified worker-citizen. Serving disparate purposes, family-related concerns took on modern and unmodern features—and resulted in contradictory, often unwanted, consequences. On the "progressive" side was the de facto relaxation of abortion regulation in 1965. Relaxation opened a Pandora's box of problems for the regime that contributed to Honecker's decision

[309] Optimistic accounts: Merkel, *Utopia*; Thaa et al., 51. Sober assessments: Landsman, *Demand*; Heldmann, *Anoraks*.

[310] For the antireform perspective, see Schroeder; Heldmann, *Anoraks*, 56–65, 217; Landsman, *Demand*; Epstein. For the reform or "modernizing push" perspective, see Thaa et al., 51; Allinson; Klessmann, *Zwei Staaten*; Ross; Kaiser, "Reforming Socialism?"; Hübner, *Konsens*; Wierling, "Jugend"; Grieder, *Leadership*; Mählert.

[311] Quotes from Bouvier, 68–69.; Schmidt, "Grundzüge," 274, 283–84; Trappe, 63; Heldmann, *Anoraks*, 149–51, 73.

to liberalize abortion law as one of his first acts in power. Even people hostile to reproductive rights would rate the new law as more "modern" than what preceded it. Arguably unmodern was the effect on women's lives of the new standards of child rearing that accompanied the family vogue. A survey of 2,000 factory workers in 1970 asked them to check the reasons that, in their view, women worked part-time. Among ranked responses, patently old-fashioned reasons took places two through four: 2. "the burden of housework" (checked by 44.1 percent of women and 48.9 percent of men); 3. "time taken by shopping, lacking services" (22.9; 32.1); 4. "the man wants it" (11.7; 13.7). In first place was, however: "devoting more time to children's upbringing" (60.9 percent of women; 58.8 percent of men).[312] This motive was unmodern in form: women performed the task and did not, for example, qualify for skilled employment in order to fulfill this domestic responsibility. It was modern in content: concern with children's quality of life. Did it move popular attitudes closer to Western mores, or further away?

Women's self-perception is similarly difficult to assess. Many indicators point to a rise in their sense of autonomy: participation in qualification programs, fertility trends, and data on who sued for divorce. Anecdotal evidence on divorce and marriage counseling suggests that educated women's mentality, at least, was changing. Women's petitions for reversal of a negative abortion ruling, too, reveal a subjective, "modern" sensibility about sexuality, psychology, and individual motivation. Petitioners dared confront state and party functionaries with the terms of a social contract that the SED had written, reminding authorities of the "democratic foundations . . . of our socialist constitutional state." Whereas petitioners of the 1950s pleaded for exceptional treatment, in the 1960s they complained about the anomalous nature of Article 11 or insisted on its fair implementation, alluding to special favors accorded party members. They criticized the "rigid," "dogmatic" methods, "bureaucratism," and "petit-bourgeois" attitudes of commissions and physicians. They pointed out that abortion was legal in other socialist countries and insisted that the GDR fall in line. At the very end of the decade, a few writers began to invoke the rights of woman and to appeal to self-determination. A pregnant mother of two children wondered, "Why can't women decide for themselves? . . . Even today women are subordinated to men and don't possess equal rights." Another woman complained that she had been "left behind by society," because with four children she could neither work nor study. "So, you see," she concluded, "the question of equal rights remains open and totally unresolved for me."[313] Evidence of a "modern"

[312] SAPMP-BArch, DY34/9820. Forschungsthema. . . Teilzeitarbeit, 1970.
[313] BLHA, 6324, Bl. 294–6, 632–3. Also see Harsch, "Society," 74–9.

idea of rights can be found in letters and petitions about other topics. Complaints about the HAT, for example, articulated a sharpening sense of justice and fairness.[314]

The language of public rights—women's or otherwise—was, and had to be, highly circumscribed. Nor was it accompanied by a gendered sense of *domestic* rights. Readers' letters to *Das Magazin*, for example, assumed that work etiquette should be egalitarian but expressed conventional ideas about dating and courtship.[315] Women learned from experience that the state needed their labor and heard continually that women's emancipation revolved around employment.[316] They had no access to a full-blown language of *private* emancipation. On the one hand, official discourse about domestic arrangements called on men to perform more housework. On the other hand, it assumed that mothers should rear "quality" children and placed moral pressure on wives to "stabilize" authoritarian and even violent marriages.

By 1970, East German women had attained the world's highest rate of employment in an industrialized economy. The workforce was 48.3 percent female. *This* represented an historic change. Nevertheless, this achievement did not satisfy a party-state with a voracious appetite for labor. In 1970, fifty percent of women with one or more children under three years old did not work for wages. Almost twenty percent of wives were not employed. Almost one-third of women worked part-time.[317] The lacunae in women's employment worried state officials. In 1969 and 1970, the GDR entered yet another consumption crisis. In addition, industrial production experienced renewed difficulties. For the first time, reproduction, too, was in crisis. In the midst of this triple emergency, the SED asked 2,000 factory workers to interpret trends in women's part-time work, women's qualification, and fertility.[318] The SED's decision to survey workers in order to make sense of social phenomena illustrates the striking rise of social inquiry in the 1960s. Its focus on these gendered matters as critical issues facing the GDR also says much about official understanding of socialism's predicament at the decade's end.

[314] Sachse, *Hausarbeitstag*, 328, 366–71, 399.

[315] Badstübner, "'Zeig'."

[316] Ansorg, "Leitungskader," 164–65.

[317] Helwig, "Frauen im SED-Staat," 1238; Madarász, *Conflict*, 99.

[318] SAPMO-BArch, DY30 IV A2/17/15 Einschätzung der Umfrage über Probleme der Frau in unserer Gesellschaft (November 1970).

Slouching toward Bethlehem

ON 3 MAY 1971, Erich Honecker replaced Walter Ulbricht as first secretary of the Politburo and implemented major policy changes. The Politburo eliminated the vestiges of economic reform and decentralization. It also reversed Ulbricht's renascent austerity. At the Eighth Party Congress in June 1971, Honecker announced that the "main task" was to "raise the material and cultural standard of living of the people." The Politburo imported foods and textiles and accelerated production of consumer durables. By 1980, every GDR household boasted a refrigerator, television, and washing machine. Every third household owned a car.[1] Prices for children's clothes and other basic goods, energy, and transportation were heavily subsidized. The new Five Year Plan projected 500,000 new residential housing units, including a small number of single-family houses. The construction program met its high quotas.[2] Socialized services improved. Most impressive was the expansion of children's recreational opportunities and institutionalized child care. In 1970, 64.5 percent of children from three to six years old attended kindergarten; in 1980, 92.2 percent did; by 1989, the percentage had risen to 95.1. In 1970, crèche places were available to 29.1 percent of children (infants to three-year-olds); by 1980, there were spots for 61.2 percent, and in 1989, for 80.2 percent.[3]

The state increased the minimum wage, pension, and vacation. It reduced the work week to forty hours for women who worked shifts and had two children younger than seventeen, and for all women with three or more children younger than seventeen. They received full compensation for their shorter work week. Maternity leave was extended to eighteen weeks (from fourteen).[4] Upon first marriage, couples whose members were younger than twenty-six could avail themselves of a 5,000 DM marriage credit that worked basically like a National Socialist marriage loan: at the birth of each child, the couple paid back less money and, after the third child, owed nothing. Families with three or more children received tax benefits and paid lower prices for public transportation.[5] The positive

[1] Ritschl, 33; Merl, 189.

[2] Steiner, "Frustration," 163; Frerich and Frey, 439; Bouvier, 71, 180.

[3] Helwig, "Frauen im SED-Staat," 1265; Bouvier, 71.

[4] Merl, 181; Schmidt, "Grundzüge," 286–87; Bouvier, 71; Helwig, "Frauen im SED-Staat," 1238.

[5] Bouvier, 262; Frerich and Frey, 414.

incentives to higher fertility came in the wake of the legalization of abortion. In 1976 arrived a natalist bonanza: paid maternity leave for a first child was extended to six months, while a second child now brought a mother a paid "baby year." Something grand for the younger woman was matched by something long in demand for her middle-aged colleague: all single women older than forty got the HAT. All women with two children sixteen years old or younger gained the forty-hour week at no reduction in pay.[6] Honecker's program, in sum, channeled funds toward private income, private consumption, and social consumption in the form of higher wages, pensions, financial credits, tax cuts, apartments, consumer goods, price subsidies, crèches, employment leaves, vacations, and reduced hours. This pricey package might almost be said to deserve its pompous billing as "the Unity of Economic and Social Policy."

Ulbricht's fall from power and Honecker's program constitute the most significant change of course in East Germany before "Communism self-destructed" in 1989.[7] The shift combined orthodox and unorthodox features. Honecker reinforced political authority over economic experts, on the one hand. He made big dispensations to current consumption and social provisions, on the other. The concessions, certainly, had precedents. As we have seen, Ulbricht introduced consumer-friendlier measures and widened welfare provisions in the late 1950s and, especially, in the mid-1960s. Honecker's policies, however, were more than just generous versions of Ulbricht's crabbed compromises. They incorporated something new.[8] The questions are: how new, why new, and what difference did it make?

The "unity of economic and social policy" did not signify loss of faith in the future of socialism.[9] Socialized production remained the motor of the SED project. What changed were the tools used to make the machine hum. In the 1950s, politics was the main instrument of productivist goals. In the 1960s, economic rationalization was the innovative gadget. In the 1970s, the new means were private well-being and social security. Also significant was a subtle shift in economic understanding. The Politburo chose to incentivize workers by redistributing national income toward them and away from direct investment in basic industry and technology. This decision implicitly overturned the SED's productivist assumptions: production precedes consumption; the future trumps the present; material incentives corrupt political ideals. Honecker, Peter Hübner concludes,

[6] Trappe, 73; Helwig, "Frauen im SED-Staat," 1238, 1241; Bouvier, 72, 262. In 1977, the HAT was extended to single fathers and husbands with a disabled wife.

[7] Maier, 58.

[8] Skyba, "Sozialpolitik," 54–55; Bouvier, 69; Madarász, "Normalization."

[9] See, e.g., Grieder, *Leadership*, 170; Kopstein, 81.

broke with Ulbricht's economic experimentation and social conservatism in favor of social reform and economic stasis.[10] As a result, the productivist horizon receded ever further—and the social means to economic growth imperceptibly *became* the ends.[11]

Honecker's turn represented a big stride along a long road of Communists coming to terms with "the unexpectedly complex interaction of social and economic issues," to quote the Sovietologist Gail Lapidus.[12] What made Honecker take the step? Recent scholarship interprets his move as a paternalistic response to social pressures and frames it in "social contract" theory.[13] As the economy modernized, society became more differentiated and autonomous. The state had to concede to social needs and wants in order to command political loyalty.[14] Labor and social historians qualify this thesis. Not "society" writ large, they argue, but workers had become more independent, adding economic clout to their ideological significance.[15] The regime responded preemptively to potential activity by workers as (bad) protesters or (good) producers, with an attempt to induce productivity and win legitimacy among the SED's social base. Three kinds of evidence support the workerist interpretation. In one of his first speeches to the Politburo as first secretary, Honecker mentioned the unrest of Polish workers after price hikes in 1970, hinting that they could spread to the GDR.[16] Class rhetoric and the "worker myth" resurged in propaganda of the early 1970s.[17] Wrapped in proletarian images, most social provisions were doled out by FDGB "factory services."[18]

Worries about workers no doubt played a role in Honecker's accession to power and subsequent decisions. Analysis of the content of his social package shows, moreover, that it *was* socially biased. Such scrutiny does not suggest, however, that its addressees were workers per se. The program targeted three social groups that encompassed most, but not all or only, workers: families, especially larger families, regardless of their income status; employed mothers, regardless of their wage level; and the least well-paid workers who were, as we know, disproportionately female. These features indicate that the regime was focused on labor, production, and equality, but now saw the family as a crucial social vehicle to an egalitarian future. They suggest that the Politburo recognized em-

[10] Hübner, *Konsens*, 177.
[11] Steiner, "Konsumversprechen," 163, 170.
[12] Lapidus, 287.
[13] Thaa et al., 61; Skyba, 59.
[14] Maier, 36–37; Thaa et al., 26, 13.
[15] Hübner, "Zukunft," 181; Dennis, 15; Bouvier, 78–79. Also see Cook, 25.
[16] Skyba, 53–55; Bouvier, 79.
[17] Weitz, 375–76; Bouvier, 232; Staritz, *Geschichte*, 171–75; Thaa et al., 52.
[18] Bouvier, 289; Schmidt, "Grundzüge," 289.

ployed women as key mediators between its constant socialist goals and redefined social means. Honecker reckoned, it seems, that incentives in the form of private and social consumption, funneled heavily to families and employed mothers, would lead the way out of the multiple crises of 1969 and 1970.

The maternalist and family bias of Honecker's program became more pronounced over time. Social policy, as a whole, eventually showed "some stagnation." Pensions, especially, lagged again. Yet the regime raised the minimum wage again in the 1970s, and then a third time in the 1980s. In 1979 women received the "baby year" for their first child; in 1986 they received eighteen months of paid leave for their third child. In 1987 came a significant increase in child allowances with the "aim of decreasing the income gap between households with children and those without." The housing program continued to expand.[19]

The language of legitimacy was gradually tailored to fit family policies. Neither the proletariat nor class struggle disappeared from SED rhetoric, but they were deemphasized as the 1970s progressed.[20] Suppressed trends of the mid-1960s reappeared and accelerated. Image and word increasingly privileged the everyday over the heroic future. Swaggering triumphalism and "abstract moralizing" retreated into the (almost) modest corner of "real existing socialism."[21] DEFA films witnessed the complete "triumph of the ordinary" over politicized epics.[22] In the 1960s, the regime beamed domesticated political imagery at women. By the late 1970s, it broadcast homey metaphors to everyone. Celebrating the thirtieth anniversary of the GDR's founding, "a widely distributed poster showed a happy family living in a house drawn as if by a child and reading, 'Here we're at home'." The message was doubly new: it conveyed a regionalist pride, a comfort with the place of the GDR, through a domestic metaphor.[23] The most prominent slogan of the Honecker era was "*Soziale Sicherheit und Geborgenheit.*" Both nouns translate as "security" or "safety." As Dorothee Wierling has pointed out, *Geborgenheit* carries, in addition, "the connotation of home, warmth, and even tenderness for helpless refugees or children."[24]

Women, gender relations, and the family have received little attention in mainstream interpretations of Honecker's course. Political analysis and

[19] Schmidt, "Grundzüge," 289.

[20] Ibid., 276, note 21; Thaa et al., 54, 64–66.

[21] Thaa et al., 53–54 (quote); Meuschel, "Überlegungen"; Staritz, *Geschichte*, 198–214; Bouvier, 234–37.

[22] Feinstein, 12–15; 228–34.

[23] Maier, 28–29.

[24] Wierling, "Gender," 13. Also see Hosek. On domestication also see Diemer, *Patriarchalismus*, 73–81.

social historical research typically overlook the gendered composition of
the Politburo's package, miss its orientation toward the family, and ignore
its maternalist bias. If social historians provide workerist explanations,
political historians favor externalist interpretations. Honecker, they
argue, needed to mend relations with Leonid Brezhnev, whom Ulbricht
had irritated with his overtures to the FRG, economic reform, and return
to austerity. The Politburo brought the GDR into line by adopting the
consumerist approach of Brezhnev (and Gierek in Poland). Policy histori-
ans also attribute "the unity of economic and social policy" to competi-
tion with the FRG.[25]

The international context plausibly influenced Honecker's construction
of a "welfare dictatorship." Yet, again, I would insist that the timing and
content of the welfare package were mediated by gender and family issues.
The point can be illustrated by considering the place of pensions within
Honecker's welfare package. Several of the historians who see rivalry with
the FRG as a key impetus behind Honecker's program critically contrast
the GDR's low pensions with the FRG's excellent retirement provisions.
According to Beatrix Bouvier, the GDR's absolutely and relatively meager
pensions are one among several reasons that Honecker's GDR does not
deserve the label "welfare state."[26] The pensions were certainly shabby,
and they hurt women more than men, for even in the 1980s the average
retired woman, having matured before the qualification wave, received
the minimum pension. Yet this crucial difference between the social pro-
visions of the FRG and the GDR suggests that the SED was not particu-
larly motivated to parry the charm of the West German model. The GDR's
mix of skimpy pensions and generous maternalist benefits resembled, in-
stead, the composition of the French and Swedish welfare packets. Like
theirs, the GDR's package targeted benefits at younger families. To en-
courage female employment, the GDR, like Finland and Sweden, chan-
neled most benefits through workforce participation. To the same end,
the SED dramatically expanded day care, as did Finland (and eventually
Sweden and France).[27]

Indeed, by broadening the comparative palette to include a spectrum
of Western welfare states, one can see that in *every* country, domestic
relations interacted with other influences to shape the welfare packet. In
parliamentary states, feminist historians suggest, the definition of "social
need" cohered out of contentious negotiations among culture, economics,
expert opinion, and social brokers such as trade unions, women's organi-

[25] Bouvier, 78–79, 221; Skyba, 53–55; Wettig, 383–84; Boyer, "Konsumpolitik," 47;
Laatz, 180.

[26] Schmidt, "Grundzüge," 286; Bouvier, 202, 221.

[27] Haney, 14; Lewis, 160; Sainsbury, "Gender," 83, 85, 86, 89, 95.

zations, political parties, and business groups. In every case, "social need" had the family's tracks stamped all over it, though the footprints ranged in size and shape from country to country. Virtually everywhere, high fertility was seen as a social good. In contrast, nations differed about whether to value or discourage maternal employment. The "male breadwinner model" came to dominate policy in the FRG and Great Britain, while Sweden and Finland moved toward a "universal breadwinner model." French policy was so singlemindedly natalist that it treated mothers' employment purely pragmatically.[28] In the GDR, of course, the definition of "social need" did not emerge out of open debate and organized negotiations. Yet there, too, the state's interests interacted with domestic structures, women's decisions, cultural attitudes, economics, and expert opinion in shaping the welfare package. The result was a universal breadwinner model that promoted fertility, maternal employment, and better conditions for young families than for retirees.

The GDR's path intersected with Western ones on important points, but it closely paralleled the roads of its fellow state-socialist lands. The gendered structures, social dynamics, and "women's policies" of Eastern European states closely resembled each other. By 1970, women represented a substantial part, or indeed a majority, of the labor force throughout Eastern Europe, with women in the USSR, Czechoslovakia, and the GDR in the vanguard. Women's training and education advanced, surpassing men's levels in some cases.[29] Meanwhile, the USSR and Eastern European states neglected private consumption, domestic gender relations, and the family. Social reproduction rested on the unpaid work of the family—labor performed in every country by the wife and mother.[30] The dependence on women's paid labor interacted with the disregard of domestic needs and relationships to exact tolls that Communists neither wanted nor predicted. Western consumerism exerted a powerful pull on societies whose private desires were nourished by domestic structures similar to those in the West. As Václav Havel said in 1978, "The post-totalitarian system has been built on the foundations laid by the historical encounter between dictatorship and the consumer society."[31] Most state-socialist lands were also plagued by labor shortages that created more demand for women's wage labor over time.[32] In every Communist coun-

[28] Sainsbury, "Gender," 89, 94–95; Sainsbury, "Introduction," 1–2; Koven and Michel, "Introduction."

[29] Heitlinger, *Sex Inequality*, 97; Lapidus, 312; Boutenko and Razlogov, 52; Ingham, Domañski,and Ingham, 3–4; Adamski, 216–18.

[30] Boutenko and Razlogov, 52, 59; Heitlinger, *Sex Inequality*, 85, 136, 92, 112.

[31] Quoted in Reid, "Cold War," 216.

[32] On the USSR, see Lapidus, 293.

try, women (and men) could communicate their difficulties to the party-state only through "individualized survival strategies," but they exploited this avenue assiduously. Wives reduced their fertility, filed for divorce, and resisted the pressure to qualify.[33] Consumers lamented the scarcity, prices, and quality of household goods, appliances, and services. Women workers complained about child care facilities. They demanded more leisure and better housing. Manipulating the language of the state, they claimed that women were held back by these inadequacies. They argued that the difficulties of everyday life harmed the family, especially children.[34]

Women's decisions and arguments forced Communist responses. Discourse about rationalizing the private household replaced vague notions of replacing housework with socialized services.[35] Every state showed rising concern about stabilizing the family, promoting the psychological development of children, and raising fertility.[36] Most socialist lands rehabilitated social scientists and encouraged them to cogitate about how to bring wives into (skilled) wage labor.[37] Experts in the USSR envisioned "a serious commitment of public resources to activities that were hitherto considered to be largely outside the public domain."[38] More expenditure *was* directed toward the family, children, mothers, and private consumption. Most obvious were natalist measures: extension of maternity leave, increased child allowances, and more and higher quality child care facilities.[39] The production of consumer durables jumped.[40] Basic goods and services were heavily subsidized. By the 1980s, every Eastern European state (though not the USSR) spent more than twenty percent of GDP on social programs and subsidies.[41] Their legitimizing claims shifted toward a language of everyday socialism that reached out to society, rather than simply bullying it.

This brief comparative foray supports the thesis that gender relations and domestic issues were major stimuli of the metamorphosis of the "classic Stalinist system" into the "welfare dictatorship" and "consumer socialism." It misses, however, the differences among "post-totalitarian"

[33] Heitlinger, *Sex Inequality* 118; Boutenko and Razlogov, 59; Lapidus, 286, 292; Haney, 92.

[34] Haney, 64–67, 69, 86, 87. Also see Lapidus 320, 324–25; Heitlinger, *Sex Inequality*, 85.

[35] Heitlinger, *Sex Inequality*, 139; Reid, "Cold War," 228–30.

[36] Madison, 47, 67; Lapidus, 308; Boutenko and Razlogov, 54; Adamski, 213; Heitlinger, *Sex Inequality*, 169; Haney, 99.

[37] Lapidus, 285: Adamski, 213.

[38] Lapidus, 312, 301.

[39] Lapidus, 303, 308; Cook, 51; Heitlinger, *Reproduction*, 68; Haney, 99; Ingham, Ingham, and Domañski, 3–4.

[40] Heitlinger, *Sex Inequality*, 87; Boutenko and Razlogov, 257–58.

[41] Makkai, 189.

states. The GDR never went as far in a consumerist, much less a market, direction, as did several Eastern European lands. It cleaved closer to the Soviet way. The lurch by the GDR toward positive pronatalism occurred later than in Hungary, Czechoslovakia, or Poland. Those regimes legalized abortion within several years of the USSR's (re)liberalization in 1955, causing their birthrates to plummet. Observing this free fall, East German experts advised that legalization be accompanied by expanded materialist measures. The GDR's expansion of child care facilities resembled the approach of Finland more than that of Poland, Hungary, and Czechoslovakia, for those states emphasized maternal care. The GDR's commitment to day care was pragmatic. It could not spare mothers' wage labor. Yet the GDR endured a much higher rate of part-time work than did Czechoslovakia.[42] Clearly, its almost universal provision of day care in the 1980s reflected not just economic need, but the conviction of GDR experts (and especially Eva Schmidt-Kolmer) that good day care stimulated child development better than did mediocre family nurture.

Political trends in the Soviet Union set the context for all of the above. GDR experts had usually to wait for Soviet counterparts to suggest unorthodox approaches to common structural problems before trying their own experiments. Yet in every area of social and consumer policy, East Germans blazed sections of the trail. Soviet studies of women's low levels of qualification began five to ten years later than in East Germany. A Soviet debate about part-time work opened in the early 1970s, after the SED had long turned against part-time employment (if ineffectively). Soviet experts pointed to the GDR as the model for special work-time arrangements and training courses for women.[43] In the case of individual consumption, Khrushchev set a new tone with folksy talk about "throwing a 'piece of bacon and piece of butter'" into the theory of Marxism (no wonder Ulbricht distrusted the fat revisionist). Yet, in practice, the GDR led the way—for example, in the development of synthetic textiles and consumer plastics.[44] The manufacturing curve of appliances headed upward in both countries after 1961, but in the GDR it started from a higher base and rose at a faster pace. Soviet households suffered worse socialized services than East German ones, yet Soviet discussion about the "urgent" need for services began only in the 1970s and produced fewer improvements than in the GDR.[45] The Soviet discovery of family nurture encouraged the East German vogue of the family. USSR discourse produced, again, scantier results. From the mid-1960s onward, its expansion

[42] Ibid.; Haney, 93; Adamski, 213; Heitlinger, *Sex Inequality*, 198, 112, 147.
[43] Lapidus, 314–19.
[44] Reid, "Cold War," 221 (quote), 239; Crowley and Reid, "Style," 7.
[45] Boutenko and Razlogov, 257–58; Lapidus, 321

of child care facilities lagged far behind the GDR's. The CPSU also extended maternity leave more incrementally and less generously than the SED. The same held true of child allowances. The Soviet woman enjoyed, in sum, fewer services, less time, and less money for raising children, yet she also exercised less control over fertility. In 1978, the "pill" was still not available in the USSR. These were pieces of a pattern. According to a recent study, no "great leap forward" occurred in Soviet social policy from 1964 to 1983.[46] Honecker's "unity of social and economic policy" originated in the gendered contradictions of Communist structures and social dynamics. It unfolded only with Soviet approval. In extent and conception, however, it went much further than the provisioning policies of the USSR before the Gorbachev era.

Not all scholars have downplayed Honecker's maternalist measures and family orientation. Research on women and a small current of research on economics, policy, and political culture highlight the maternalism of the Honecker era and ascribe it to the need for women workers and the next generation of workers. The party-state, feminist scholarship recognizes, got itself into a bind by socializing production, while neglecting the organization and infrastructure of domestic relations.[47] Most feminist scholars treat family policy and maternalism, however, as purely paternalist moves, not also as responses to "strategic negotiations" between the party-state and women. Unlike social historians of workers, few scholars of women apply social-contract theory and, indeed, are reluctant to assign their subjects any responsibility for the changing profile of women's employment policy, family policy, family law, or reproductive policies, much less macroeconomic policies. Yet, as this book and others have demonstrated, women did not roll over at state command but ignored, resisted, and/or complained about every social or economic measure that affected them. They took stances that one could label as feminist or antifeminist, modern or antimodern, but not as passive.[48] Women could only follow atomized individual strategies, but their negotiations with the state had, nonetheless, a cumulative impact on its policies.

One can understand the reluctance among feminist scholars to see women as active representatives of personal and family interests. The GDR was a dictatorship *and* a patriarchal state. Its social-political conception privileged historically male over historically female labors. Its personification of power was strikingly, overwhelmingly masculine.[49] The

[46] Cook, 51; Boutenko and Razlogov, 66–67; Mazur, 226; Manning, Shkaratan, and Tikhonova, 10.

[47] Besides the scholarship on women cited below, see Schmidt, "Grundzüge," 285, 287; Ritschl, 15; Heldmann, "Konsumpolitik," 151; Weitz, 376.

[48] For similar arguments, see Sachse, *Hausarbeitstag*, e.g., 382–403; Budde, *Intelligenz.*

[49] Diemer, *Patriarchalismus*, 413; Helwig, "Frauen im SED-Staat," 1259.

tendency of feminist scholarship to see women as mere pawns reflects, second, the focus of feminist scholarship on the consequences of social policy for women, rather than on its origins.[50] The main effect of Honecker's *Muttipolitik* was, everyone agrees, to reinforce the traditional organization of the nuclear family. It not only assumed that the wife and mother performed domestic labor, but it promoted marriage as the fulcrum of the family.[51]

More contentious is the question of whether maternalist policies provided "substantial relief"' for employed mothers.[52] To judge by surveys and petitions, mothers liked their benefits, yet quickly registered them as entitlements and expected more.[53] Their daily lives became somewhat easier, but not enough so to reverse trends in fertility, marriage, and divorce that have accompanied the rise in women's employment in every industrial country since 1945. True, the birthrate rose for several years, but it then declined, prompting more natalist measures. The divorce rate increased. Most interesting, out-of-wedlock births rose, reaching a third of births in 1989. This trend suggests an ironic interaction between single mothers' right to benefits and the traditional domestic roles the benefits fostered. Ever more young women (and men) preferred trial marriages. Many young mothers lived alone with their children, often searching for a partner but unsatisfied with what they found.[54]

The consequences of Honecker's program for women's employment were also ambiguous. The rate of female employment expanded steadily. In 1989, almost ninety-two percent of working-age women were employed or in school, university, or training. Eighty percent of women with children worked for wages. Women accounted for just under half of the workforce. Problems surrounding women's qualification remained a central area of research of the WB at the Academy of Sciences. The effort to improve qualification rates through better "working and living conditions" fostered results. By 1989, more than eighty percent of female worker-employees had completed a qualification program. Women's overall rate of professional and higher education was slightly lower than men's. In age groups up to forty, however, women and men were equally represented in every category of education.[55]

Despite these advances, in 1989 women earned, on average, twenty-five to thirty percent less than men. They were overrepresented at the

[50] See, e.g., Ansorg and Huertgen, 167.

[51] Schmidt, "Grundzüge," 287; Bouvier, 264–71.

[52] Helwig, "Einleitung," 6.

[53] Bouvier, 295.

[54] Ibid., 295, 262; Thaa et al., 181–84; Madarász, *Conflict*, 41.

[55] Bouvier, 244; Diemer, *Patriarchalismus*, 114; Helwig, "Frauen im SED-Staat," 1248, 1253.

unskilled and semiskilled wage steps and underrepresented at the highest wage levels. They worked at jobs below their qualification level. Women avoided careers that would conflict with their family duties. The labor market became more gender segmented. The state did ever less to counter this trend and, indeed, guided girls out of some technical fields after managers complained about women's high rates of job fluctuation.[56] Women eschewed supervisory functions.[57] The state introduced rules to restrict part-time work, but women and supervisors collusively evaded them. The rate of women's part-time employment fell somewhat but still stood at 27.6 percent in 1983. Women in three-shift labor—many of them unskilled—continued to push especially hard for shorter hours.[58]

Women's share in political power remained at null. Their SED membership increased to thirty-five percent, but no woman exercised a district secretaryship; only 5.7 percent of local secretaries were women. Their representation on the Central Committee stagnated. Two women sat on the Politburo as candidates, none as voting members. The only woman minister under Honecker was the Minister of Education—and she was Margot Honecker.[59]

What happened to women's sense of self, understanding of gender, and outlook on the state after 1971? Attitudes are hard to measure, and their meaning is hotly debated, but it seems that the contradictory trends of the 1960s continued. Women avidly read works of the "literary feminism" wave, which daringly detailed the professional, sexual, and emotional frustrations of female protagonists in a man's world.[60] Yet in real life, women often preferred male to female supervisors at work, and deferred to husbands and lovers at home. Women remained oriented toward the family and generally accepted their domestic duties, yet yearned for personal development and self-determination.[61] The signs are unclear, yet they are easily deciphered by employed women everywhere. Socialized for domestic work *and* employment, East German women felt torn between them—as do women the world over.[62]

Women's relationship to the state, like men's, combined a sense of entitlement with dependence in a passive-aggressive dance. In the 1980s, citizens fired off thousands of complaints about work, consumption, and

[56] Nickel, "Mitgestalterinnen," 231; Helwig, "Einleitung," 9; Helwig, "Frauen im SED-Staat," 1249–51; Laatz, 186, 190–91.

[57] Bouvier, 262–63.

[58] Bouvier, 288–89; Madarász, *Conflict*, 99; Rietzschel, 175–77.

[59] Helwig, "Frauen im SED-Staat," 1257–59.

[60] See, e.g., Christa Wolf; Brigitte Reimann; Maxi Wander. See the excellent analysis in Budde, *Intelligenz*, 380–97.

[61] Thaa et al., 172–77; Madarász, *Conflict*, 97.

[62] Irene Dölling, *Individuum*, 140–41; Ansorg and Huertgen, 172–75.

housing. As did abortion petitions in the 1960s, letters highlighted the gaps between promise and reality and hinted quite openly that the state must close them if it wanted to retain political support.[63] The state tried to redress consumer complaints. Yet it also expanded the Stasi's official and "unofficial" spy network. Spies infiltrated church and peace groups in which, one notes, women were as active as men.[64] Informants watched people in daily situations and relationships, including the most intimate—thus bringing the eyes of the state into the family as never before. Nevertheless, ordinary women's acceptance of Communism seems to have risen under "dear Erich." Some surveys suggest that women's loyalty to the GDR was higher than men's in the 1980s. If true, this imbalance reversed the gendered ratios of support for Communists in 1946 and 1947, when the KPD/SED exemplified class-struggle politics.[65]

In assessing the welfare state's impact on gender relations, writes Anne Sassoon, feminist scholars need to give up "the half empty/half full mentality." Progress can occur, she contends, even as "new relations of oppression are constituted."[66] Her point applies to Honecker's maternalism: its gendered outcomes were mixed. It is important to keep in mind that East German women lived under the top-heavy framework of dictatorship and command economy, which pressed down on state-socialist welfare policies, distorting their consequences. Yet the reverse also occurred: Honecker's maternalist and consumerist decisions set off dominos that soon bumped against Communism's narrow, inflexible scaffolding—and bent it irreparably.

While feminist scholars have focused on what Honecker's maternalism meant for women and the family, historians of economics and political culture have considered the consequences of "the unity of social and economic policy" for society, the SED, and the GDR. From this broader perspective, the dynamic effects of the Politburo's welfare and consumer measures look less power-affirming and paternalistic than corrosive and, indeed, radical. Most fundamentally, the present began to gobble up the future. From 1970 to 1988, social consumption increased by sixty to seventy percent, individual consumption rose by forty to fifty percent, and productive investment declined by ninety to ninety-five percent. In 1970, 16.1 percent of national income went into productive investment; in 1988, 9.9 percent did. That percentage is deceptively high, for ever less "investment" went into production and ever more into nonproduction

[63] Bouvier, 295, 268, 317–19, 320; Trappe, 84: Madarász, *Conflict*, 135
[64] On the Stasi, see, e.g., Schmidt, "Grundzüge," 287. On women's semi-oppositional activities, see Madarász, *Conflict*, 135.
[65] Madarász, *Conflict*, 134.
[66] Anne S. Sassoon, "Comment on Jane Lewis," *Social Politics* (Summer 1997) 4/2, 179.

sectors, especially residential construction. Imports exceeded exports, and most imports were consumer goods.[67] Western loans underwrote East German consumption. In 1970, the GDR's debt to the West was two billion valuta marks; in 1989, it stood at 49 billion. By the early 1980s, state bankruptcy loomed. The SED leadership recognized that social security and consumption were undermining, rather than promoting, economic efficiency, but the Politburo felt it dare not change course.[68]

Every state-socialist country stumbled into economic crisis in the 1980s. Without this crisis, Communism would not have fallen, yet financial bankruptcy alone did not seal its fate. As Charles Maier points out, an economy can limp along and government debt can mount for decades without causing a state to collapse.[69] The end of SED rule was determined, most scholars would agree, by an interplay among economic crisis, SED political control, and popular attitudes that unfolded within the international context of Gorbachev's *glasnost* and *perestroika*. How did popular opinion evolve in the Honecker years? His ascent to power opened the "best years" for East Germans and won him notable support, even affection. His policies also heightened expectations, which rose even more rapidly than in the 1960s, stimulated by tangible things at hand and by Technicolor images of West German plenty set in perfect TV households.[70] In the 1980s, individual consumption fell, especially relative to advances in consumer electronics in the West and Japan. Consumer despair expressed itself in a surge of petitions after 1985. Although the letters complained about everyday problems, their tenor became increasingly "aggressive and critical."[71] People's affection for Honecker's policies had fostered, it turned out, a conditional loyalty that crumbled as the standard of living again declined.[72]

The anger of consumers was significant, and its political overtones were even more so. These phenomena had occurred before, however. On their own, they, too, did not provoke the SED's "curious self-abdication of incredible power."[73] This time, the people's lament represented something more profound. Bouvier describes it as a social crisis.[74] Jarausch, Maier, and Pollack see fragments of a civil society in the burgeoning church and peace groups of the late 1980s. These groups suddenly came together with

[67] Kopstein, 2; Maier, 61.

[68] Ritschl, 34–37; Schmidt, "Grundzüge," 290–91; Dennis, 26–29; Wettig, 383–84.

[69] Maier, 36–37. Also see Thaa et al., 7.

[70] Berghoff, "Konsumregulierung," 18; Steiner, 155: Wolle, 198.

[71] Steiner, 165; Maier, 106–7: Bouvier, 306–7, 321–23. Quote from Bouvier, 312.

[72] Jarausch, "Implosion?" 13. Also see Bouvier, 327, 334; Thaa et al., 54; Schmidt, "Grundzüge," 298; Fulbrook, 165–70.

[73] Sabrow, "Konsensdiktatur," 87–88; Thaa et al., 7.

[74] Bouvier, 326.

vigor and élan in the demonstrations of autumn 1989.[75] Wilfried Thaa and his co-authors agree that society began to assert itself but focus on private, especially domestic, manifestations of that tendency. SED policies of the 1970s, they argue, stimulated privatizing trends that began to push against their domestic limits, in the form of widespread and myriad desires for personal freedom.[76]

East German reliance on the family, as we have seen, did not begin under Honecker. From 1945 onward, people turned to the family to help them overcome the Stalinist system's neglect of physical and emotional needs and desires. They always cherished the family as a place of retreat from an aggressive state and its hyperactive, monotonic political productionism. The GDR's famous "niche society"—evocatively named by Günter Gaus—began to emerge as an identifiable *social* phenomenon in the 1960s. The retreat into the private sphere was part of a long-term trend in all "plugged-in" societies, but it was also peculiarly socialist, for in the GDR, People's Democracies, and USSR, the niche signified recoil from collective ideology. The SED, nonetheless, adapted to the trend. It had never prevented private leisure activities, but in the sixties it grew friendlier to gardening, family camping trips, and evenings with friends. In the 1970s, it gave them the green light.[77] Indeed, the party attempted the neat trick of making the entire GDR the "niche"—and the SED the all-observant head of the family. This ruse seemed only to heighten East Germans' inclination to escape official, increasingly ritualistic demands on their time. More than three-fifths of women and men reported in a survey of 1988 that they wanted more time for home and family-related activities. More than half desired more time with friends, for hobbies, in nature, or for qualification, while less than a third felt inclined to spend more time in political or community organizations. The responses suggest a people with "modern," privatized tastes. Yet the socialist "private sphere" was overwhelmed by the demands of domestic chores and repairs that took more time and caused more aggravation than in the West. People had to scramble especially vigorously to obtain "higher value" goods and services. Denied autonomous civic activities, they depended heavily on private networks to satisfy emotional needs, including an expanding desire for "personal identity and authenticity."[78]

The "unity of economic and social policy" encouraged a pluralistic privatization of everyday life without satisfying the material and immaterial desires it stimulated. Men and, above all, women, felt deeply attached to

[75] Maier; Jarausch, "Implosion."
[76] Thaa et al., 5, 431–39, 169.
[77] Ibid., 177–78.
[78] Ibid., 166–68.

the family but also, it seems, resentful of its demands on their energy and time. The rate of marriage declined, divorce rose, and cohabitation increased. There occurred a limited but perceptible diversification of family types, although children remained at the core of the real and ideal home. "Lifestyle" variations spilled into public culture, as people struggled to realize themselves and skirt state-socialist restrictions on their personal quests. Religious belief and church participation increased; secular nonconformity bloomed. The unified worldview propagated by the SED was "gradually hollowed out," diminishing its ability either to inspire or to frighten people.[79]

The "hollowing out" eroded not only popular loyalty and fear, but also the will to power of SED functionaries and state bureaucrats. The SED elite, like other Communist parties, lost faith in its "original political vision."[80] The process began with Honecker's real and rhetorical domestication of the SED program and language. The monolithic foundations of Stalinist productivism were undermined, yet socialized production remained the heart and soul of the Communist worldview, as it had to if the SED was to be Marxist-Leninist. The practice, the sheer expense, of *Soziale Sicherheit und Geborgenheit* constrained the SED's maneuvering room. Confronted with civic demonstrations in autumn 1989, the party elite seemed no longer to know *how* to act on its principles, for the discourse of *Soziale Sicherheit und Geborgenheit* had sapped Marxism-Leninism of its capacity to make sense of the world and to guide action.[81] The Politburo "pensioned" Honecker and, under Egon Krenz, opened the wall. Amid the thunderous celebrations that accompanied this decision occurred the "almost silent implosion" of the SED state.[82]

The muted collapse of such an oppressive party-state is ironic. Yet, in fact, it is not surprising that a gutted structure disintegrated quietly. The hushed breakdown of the once deafening party machinery is also fitting, for an important wrench in the works had operated stealthily. This apparently soft, malleable instrument, this bit-piece in the powerful motor of history, was the domestic: private needs, individual desires, gender relations, and the family. Communism did itself in, this book has argued, with its concrete neglect of all things domestic and its ideological denial of their social and economic significance. The revenge of the domestic was not a foregone conclusion. It was grounded in the nuclear family that continued under socialism. It was structured by culture, ideology, and economics. It occurred, however, only through the actions, decisions, and negotiations

[79] Jarausch,"Implosion," 19.
[80] Maier, 57.
[81] Thaa et al., 54.
[82] Sabrow, "Konsensdiktatur," 87–88.

of East Germans who in one way or another resisted the SED's insistence that productive relations determined private ones, but not vice versa. The actors included people outside and inside the state apparatus, anti-Communists and fellow travelers, producers and consumers, mothers and fathers, husbands and wives, men and women. The daily labors of family life lay inordinately on women; women bore the brunt of the neglect of the family, private consumption, housing, and gender relations. Women acted disproportionately as conscious representatives of the family and, especially, of children. They typically framed their worries and anger in familial terms, whether they spoke in a conservative idiom of domestic responsibilities or a protofeminist language of domestic burdens, whether they wanted more time alone with their children or better public care for them, and whether they critiqued deficient socialized services or pathetic private commodities. Ordinary women, then, were the main agents of the revenge of the domestic. That does not mean they were the special beneficiaries of that revenge. In fact, the consequences of the fall of Communism have been even more mixed for women than for men. The domestic's revenge signifies, rather, that women played a vigorous, indeed, a central role in the "everyday history" of the GDR. They demonstrated that the routines, decisions, pleasures, and pains of the everyday are rooted in domestic relations. They proved that the dull domestic is of great historical consequence.

Bibliography

ARCHIVES

Brandenburgisches Landeshauptarchiv (Potsdam) (BLHA)
 Hebammenwesen, Rep. 601
Bundesarchiv, Berlin (BArch)
 Ministerium für Gesundheitswesen (DQ1)
 Ministerium für Arbeit und Berufsaufbildung (DQ2, DQ3)
 Ministerium der Justiz (DP1)
 Staatssekretär für Kirchenfragen (DO4)
Industriemuseum Chemnitz (IMC)
 Oral History Project
Landesarchiv Berlin (LAB)
 Gesundheits–und Sozialwesen, Rep. 118
Landesarchiv Merseburg (LAM)
 Leuna Werke
 Filmfabrik Afga Wolfen (VEB FAWO)
 SED (IV2, IV/L-2 , IV/A-2)
Leipziger Stadtsarchiv (LStA)
 Bezirk und Rat der Bezirk Leipzig
 Kreisvolkshochschule
 Gesundheitswesen
 Abt. Mutter und Kind (912, 916, 924)
 SED (IV2, IVA-2, IVB-2)
 VEB Kammgarnspinnerei Pfaffendorf
 VEB Leipziger Wollgarnfabrik
 Versorgung, 1945–1946
Sächsisches Hauptstaatsarchiv, Leipzig (SHSA)
 SED (IV BV, I3, IV2)
 Spinnereien
 Gesundheitswesen
Stiftung der Arbeiterparteien und Massenorganisation der DDR Bundesarchiv,
 Berlin (SAPMO-BArch)
 DDR Collections
 DY30 SED
 DY31 DFD
 DY34 FDGB
 DY46 IG Metall
 DY49 IG Textil, Bekleidung, und Leder
 Nachlässe
 NY4106 Elli Schmidt
 NY 4145 Käthe Kern
 NY 4182 Walter Ulbricht

VEB Buna, Schkopau
 Rep.II

INTERVIEWS

Dr. Karl-Heinz Mehlan, I 25.7.95; II (with Anne-Sabine Ernst and Annette Timm),
 1.6.96
Frau RG, 24.5.96
Frau BH, 27.5.96 (with Martina Dietrich)
Frau GP, 27.5.96 (with Martina Dietrich)
Frau RB, 28.5.96 (with Martina Dietrich)
Frau LT, 28.5.96
Frau BP, 28.5.96 (with Martina Dietrich)
Frau CB, 29.5.96
Frau DD, 29.5.1996
Frau MJ, 29.5.96 (with Martina Dietrich)
Frau RN, 29.5.96
Herr Dr. L, 30.5.96 (with Martina Dietrich)
Frau Dr. MB, 30.5.96
Frau AB, 24.7.97
Frau UN, 24.7.97
Frau LD, 27.7.97 (with Martina Dietrich)
Frau CT, 28.7.97 (with Martina Dietrich)
Frau AR, 27.10.97
Frau ES, 8.11.97 (conducted by Martina Dietrich)

WORKS CITED

Adamski, Władysław W. "Women in Contemporary Poland: Their Social and Oc-
 cupational Position and Attitudes Toward Work." In *Women in Eastern Europe
 and the Soviet Union*, edited by Tova Yedlin. New York: Greenwood Publishing
 Group, 1980.
Ahlefeld, Gabriele, Astrid Molder, and Rudolf Werner. *Plaste und Elaste aus
 Schkopau. 60 Jahre Buna-Werke.* Pinneberg: Runkel Verlag, 1996.
Allen, Ann Taylor. "The Holocaust and the Modernization of Gender: A Historio-
 graphical Essay." *Central European History* 30, no. 3 (1997): 349–64.
Allen, Ann Taylor. *Feminism and Motherhood in Germany, 1800–1914.* New
 Brunswick: Rutgers University Press, 1991.
Allen, Keith R. *Hungrige Metropole. Essen, Wohlfahrt und Kommerz in Berlin.*
 Hamburg: Ergebnisse Verlag, 2002.
Allinson, Mark. *Politics and Popular Opinion in East Germany, 1945–1968.*
 Manchester: Manchester University Press, 2000.
Anonyma. *Eine Frau in Berlin. Tagebuch-Aufzeichnungen vom 20. April bis 22.
 Juni 1945.* Munich: btb Verlag, 2005.
Ansorg, Leonore, and Renate Hürtgen, "The Myth of Female Emancipation: Con-
 tradictions in Women's Lives." In *Dictatorship as Experience. Towards a Socio-*

cultural History of the GDR, edited by Konrad Jarausch. New York and Oxford: Berghahn, 1999.

Ansorg, Leonore. " 'Irgendwie war da eben kein System drin.' " Strukturwandel und Frauenerwerbstätigkeit in der Ost-Prignitz (1968–1989)." In *Herrschaft und Eigensinn in der Diktatur. Studien zur Gesellschaftsgeschichte der DDR*, edited by Thomas Lindenberger. Cologne: Böhlau, 1999.

Ansorg, Leonore. " 'Ick hab immer von unten Druck gekriegt und von oben.' Weibliche Leitungskader und Arbeiterinnen in einem DDR-Textilbetrieb. Eine Studie zum Innenleben der DDR." *AfS* 39 (1999): 123–65.

Ansorg, Leonore. "Der Fortschritt kommt aufs Land. Weibliche Erwerbstätigkeit in der Prignitz." In *Frauen arbeiten. Weibliche Erwerbstätigkeit in Ost-und Westdeutschland nach 1945*, edited by Gunilla-Friederike Budde. Göttingen: Vandenhoeck und Ruprecht, 1997.

Babcock, Linda and George Loewenstein. "Explaining Bargaining Impasse: The Role of Self-Serving Biases." *Journal of Economic Perspectives* 11 (1997): 109–26.

Badstübner, Evemarie. " 'Zeig, Wie Das Leben Lacht und Liebt.' Die Unterhaltungszeitschrift *Das Magazin* und Ihre Leser zwischen 1954 und 1970." In *Befremdlich anders. Leben in der DDR*, edited by Evemarie Badstübner. Berlin: Dietz, 2000.

Baring, Arnold. *Uprising in East Germany: June 17, 1953*. Ithaca: Cornell University Press, 1972.

Barthel, Horst. *Die wirtschaftlichen Ausgangsbedingungen der DDR*. Berlin (E): Akademie Verlag, 1979.

Bauerkämper, Arnd. "Von der Bodenreform zur Kollektivierung. Zum Wandel der ländlichen Gesellschaft in der Sowjetischen Besatzungzone Deutschlands und DDR 1945–1952." In *Sozialgeschichte der DDR*, edited by Hartmut Kaelble, Jürgen Kocka and Hartmut Zwahr. Stuttgart: Klett-Cotta, 1994.

Berghoff, Hartmut. "Konsumregulierung im Deutschland des 20. Jahrhunderts." In *Konsumpolitik. Die Regulierung des privaten Verbrauchs im 20. Jahrhundert*, edited by Hartmut Berghoff. Göttingen: Vandenhoeck und Ruprecht, 1999.

Bock, Gisela. "Die Frauen und der Nationalsozialismus: Bemerkungen zu einem Buch von Claudia Koonz." *G&G* 15 (1989): 563–79.

Bock, Gisela. "Gleichheit und Differenz in der nationalsozialistische Rassenpolitik." *G&G* 19 (1993).

Bock, Gisela. *Zwangssterilisation im Nationalsozialismus*. Opladen: Westdeutscher Verlag, 1986.

Bonwetsch, Bernd, Gennadij Bordjugov, and Norman M. Naimark, eds. *Sowjetische Politik in der SBZ, 1945–46. Dokumente zur Tätigkeit der Propaganda-Verwaltung (Informations-Verwaltung) der SMAD unter Sergej Tjul'panov*. Bonn: Dietz, 1998.

Borneman, John. *Belonging in the Two Berlins: Kin, State, Nation*. Cambridge: Cambridge University Press, 1992.

Boutenko, Irene A., and Kiril E. Razlogov. *Recent Social trends in Russia 1960–1995*. Montreal: McGill-Queen's University Press, 1997.

Bouvier, Beatrix. *Die DDR—ein Sozialstaat? Sozialpolitik in der Ära Honecker*. Bonn: Dietz, 2002.

Boydston, Jeanne. *Home and Work: Housework, Wages, and the Ideology of Labor in the Early Republic.* New York/Oxford: Oxford University Press, 1990.

Boyer, Christoph. "Sozial- und Konsumpolitik." In *Repression und Wohlstandsversprechen. Zur Stabilisierung von Parteiherrschaft in der DDR und der CSSR,* edited by Christoph Boyer and Peter Skyba. Dresden: Hannah-Arendt-Institut für Totalitarismusforschung e.V., 1999.

Brenner, Christiane, and Peter Heumos, eds. *Sozialgeschichtliche Kommunismusforschung. Tschechoslovakei, Polen, Ungarn, DDR 1945–1968.* Munich: Oldenbourg, 2005.

Bridenthal, Renata, Atina Grossmann, and Marion Kaplan, eds. *When Biology Became Destiny.* New York: Monthly Review Press, 1984.

Brookes, Barbara. *Abortion in England, 1990–1967.* London: Routledge, 1988.

Brunner, Detlev. *Der Wandel des FDGB zur kommunistischen Massenorganisation. Das Protokoll der Bitterfelder Konferenz des FDGB am 25./26.11.48.* Koblenz: Klartext Verlag, 1996.

Budda, Gunilla-Friederike. "Einleitung: Frauenerwerbstätigkeit im deutsch-deutschen Vergleich." In *Frauen arbeiten. Weibliche Erwerbstätigkeit in Ost- und Westdeutschland nach 1945,* edited by Gunilla-Friederike Budde. Göttingen: Vandenhoeck und Ruprecht, 1997.

Budde, Gunilla-Friederike. *Frauen der Intelligenz. Akademikerinnen in der DDR 1945 bis 1975.* Göttingen: Vandenhoeck und Ruprecht, 2003.

Budde, Gunilla-Friedericke. "Paradefrauen. Akademikerinnen in Ost–und Westdeutschland." In *Frauen arbeiten. Weibliche Erwerbstätigkeit in Ost–und Westdeutschland nach 1945,* edited by Gunilla-Friederike Budde. Göttingen: Vandenhoeck und Ruprecht, 1997.

Buehler, Grit. *Mythos Gleichberechtigung in der DDR. Politische Partizipation von Frauen am Beispiel des Demokratischen Frauenbunds Deutschlands.* Frankfurt and New York: Campus Verlag, 1997.

Burkhardt, Felix, and Lucie Burkhardt. "Betrachtungen zur Binnenwanderung in der DDR." *Jahrbuch für Wirtschaftsgeschichte* 1974/Teil I.

Busch, Friedrich W. *Familienerziehung in der sozialistischen Pädagogik der DDR.* Frankfurt/Berlin/Wien: Ullstein Verlag, 1980 (orig. 1972).

Bust-Bartels, Axel. *Herrschaft und Widerstand in den DDR-Betrieben.* Frankfurt/M: Campus Verlag, 1980.

Bütow, Birgit, and Heidi Stecker, eds. *EigenArtige Ostfrauen. Frauenemancipation in der DDR und den neuen Bundesländern.* Bielefeld: Kleine Verlag, 1994.

Canning, Kathleen. "Gender and the Politics of Class Formation: Rethinking German Labor History." *AHR* 97, no. 3 (June 1992).

Canning, Kathleen. *Languages of Labor and Gender.* Ithaca: Cornell University Press, 1996.

Childs, David, and Richard Popplewell. *The Stasi: The East German Intelligence and Security Service.* New York: New York University Press, 1996.

Christopeit, Gerald. "Die Herkunft und Verteilung der Evakuierten, Flüchtlinge und Vertriebenen in der Provinz Mark Brandenburg und ihr Verhältnis zu der einheimischen Bevölkerung." In *Sie hatten alles verloren. Flüchtlinge und Vertriebene in der sowjetischen Besatzungszone Deutschlands,* edited by Manfred

Wille, Johannes Hoffmann, and Wolfgang Meinicke. Wiesbaden: O. Harrassowitz, 1993.

Clare, George. *Before the Wall: Berlin Days, 1946–1948.* New York: Dutton, 1989.

Clemenz, Petra. "Frauen helfen sich selbst: Die Betriebsfrauenausschüsse der fünfziger Jahre in kulturhistorischer Sicht." *Jahrbuch für volksdeutsche Kulturgeschichte* 30 (1987): 107–42.

Coffin, Judith G. "Gender and the Guild Order: The Garment Trades in Eighteenth-Century Paris." *The Journal of Economic History* 54, no. 4 (December 1994): 768–93.

Commandeur, Werner, and Alfred Sterzel. *Das Wunder drüben sind die Frauen.* Bergisch Gladbach: Lübbe Verlag, 1965.

Condit, Celeste. *Decoding Abortion Rhetoric: Communicating Social Change.* Urbana: University of Illinois Press, 1990.

Connelly, John. *Captive University: The Sovietization of East German, Czech, and Polish Higher Education 1945–1956.* Chapel Hill/London: University of North Carolina Press, 2000.

Cook, Linda J. *The Soviet Social Contract and Why It Failed: Welfare Policy and Workers' Politics from Brezhnev to Yeltsin.* Cambridge: Harvard University Press, 1993.

Cowan, Ruth Schwartz. *More Work for Mother: The Ironies of Household Technology from the Open Hearth to the Microwave.* New York: Basic Books, 1983.

Crew, David. "Introduction." In *Consuming Germany in the Cold War*, edited by David Crew. Oxford and New York: Berg Publishers, 2003.

Crowley, David, and Susan E. Reid. "Style and Socialism: Modernity and Material Culture in Postwar Eastern Europe." In *Getting and Spending: European and American Consumer Societies in the Twentieth Century*, edited by Susan Strasser, Charles McGovern, and Matthias Judt. Cambridge: Cambridge University Press, 1998.

Crowley, David. "Warsaw's Shops, Stalinism and the Thaw." In *Style and Socialism: Modernity and Material Culture in Post-War Eastern Europe*, edited by Susan E. Reid and David Crowley. Oxford and New York: Berg Publishers, 2000.

Czarnowski, Gabriele. *Das kontrollierte Paar. Ehe- und Sexualpolitik im Nationalsozialismus.* Weinheim: Deutscher Studien Verlag, 1991.

Czarnowski, Gabriele. "Familienpolitik als Geschlechterpolitik." In *Soziale Arbeit und Faschismus*, edited by Hans-Uwe Otto und Heinz Sünker. Frankfurt/M: Suhrkamp, 1989.

Daniel, Ute. *Arbeiterfrauen in der Kriegsgesellschaft.* Göttingen: Vandenhoeck und Ruprecht, 1989.

David, Henry P., and Robert D. McIntyre, eds. *Reproductive Behavior. The Central and Eastern European Experience.* New York: Springer Publishing Company, 1981.

Davis, Belinda J. *Home Fires Burning: Food, Politics, and Everyday Life in World War I Berlin.* Chapel Hill/London: University of North Carolina Press, 2000.

de Grazia, Victoria. *How Fascism Ruled Women in Italy, 1922–1945.* Berkeley: University of California Press, 1993.

Dennis, Mike. *Social and Economic Modernization in Eastern Germany from Honecker to Kohl.* London and New York: St. Martin's Press, 1993.

Diemer, Susanne. "Die 'neue Frau', aber der 'alte Mann'? Frauenförderung und Geschlechterverhältnisse in der DDR." In *Politische Kultur in der DDR*, edited by Hans-Georg Wehling. Stuttgart: Verlag W. Kohlhammer, 1989.

Diemer, Susanne. *Patriarchalismus in der DDR. Strukturelle, kulturelle und subjective Dimensionen der Geschlechterpolarisierung.* Opladen: Westdeutscher Verlag, 1994.

Dokumente vom Frauenkongress der Deutschen Demokratischen Republik Berlin 25–27 Juni 1964, published by Demokratischer Frauenbund Deutschlands. [No place, no date].

Dölling, Irene. "Gespaltenes Bewusstsein—Frauen- und Männerbilder in der DDR." In *Frauen in Deutschland 1945–1992*, edited by Gisela Helwig and Hildegard Maria Nickel. Berlin: Akademie Verlag, 1993.

Dölling, Irene. *Individuum und Kultur.* Berlin (O): Verlag Neues Leben, 1986.

Dowidat, Christel. "Zur Veränderung der Mitgliederstrukturen von Parteien und Massenorganisationen in der SBZ/DDR (1945–1952)." In *Parteiensystem zwischen Demokratie und Volksdemokratie*, edited by Hermann Weber. Cologne: Verlag Wissenschaft und Politik, 1982.

Eckert, Rainer. "Opposition und Repression in der DDR vom Mauerbau bis zur Biermann-Ausbürgerung (1961–1976)." *AfS* 39 (1999).

Engelsmann, Kurt. "Der Kampf der SED um die Entstehung und Entwicklung der Aktivistenbewegung im VEB Leuna-Werke 'Walter Ulbricht', VEB Chemische Werke Buna und im VEB Elektrochemisches Kombinat Bitterfeld (Ende 1947 bis Ende 1949)." Dissertation, Institut für Gesellschaftswissenschaften, Central Committee/SED, 1961.

Epstein, Catherine. *The Last Revolutionaries: German Communists and Their Century.* Cambridge: Harvard University Press, 2003.

Ernst, Anna-Sabine. " 'Die beste Prophylaxe ist der Sozialismus.' Ärzte und medizinische Hochschullehrer in der SBZ/DDR 1945–1961." Dissertation, Humboldt University, 1996.

Ernst, Anna-Sabine. "The Politics of Culture and the Culture of Everyday Life in the DDR in the 1950s." In *Between Reform and Revolution: German Socialism and Communism from 1840–1990*, edited by David E. Barclay and Eric D. Weitz. New York and Oxford: Berghahn, 1998.

Ernst, Anne-Sabine. "Von der bürgerlichen zur sozialistischen Profession? Ärzte in der DDR, 1945–1961." In *Die Grenzen der Diktatur. Staat und Gesellschaft in der DDR*, edited by Richard Bessel and Ralph Jessen. Göttingen: Vandenhoeck und Ruprecht, 1996.

Ewers, Klaus, and Thorsten Quest, "Die Kämpfe der Arbeiterschaft in den volkseigenen Betrieben während und nach dem 17. Juni." In *17. Juni 1953. Arbeiteraufstand in der DDR*, edited by Ilse Spittmann and Karl Wilhelm Fricke. Cologne: Verlag Wissenschaft und Politik, 1982.

Falck, Uta. *VEB Bordell. Geschichte der Prostitution in der DDR.* Berlin: Christoph Links Verlag, 1998.

Falter, Jürgen. "Die Wähler der NSDAP 1928–1933: Sozialstruktur und parteipolitische Herkunft." In *Die nationalsozialistische Machtergreifung*, edited by Wolfgang Michalka. Munich: Verlag C.H. Beck, 1984.

Faulenbach, Bernd. "Acht Jahre deutsch-deutsche Vergangenheitsdebatte—Aspekte einer kritischen Bilanz." In *Deutsche Vergangenheiten—eine gemeinsame Herausforderung. Der schwierige Umgang mit der doppelten Nachkriegsgeschichte*, edited by Christoph Klessmann, Hans Misselwitz, and Günter Wichert. Berlin: Ch. Links Verlag, 1999.

Feinstein, Joshua. *The Triumph of the Ordinary: Depictions of Daily Life in the East German Cinema, 1949–1989*. Chapel Hill: University of North Carolina Press, 2002.

Felski, Rita. *The Gender of Modernity*. Cambridge: Harvard University Press, 1995.

Finn, Margot. "Working-Class Women and the Contest for Consumer Control in Victorian County Courts." *Past and Present*, no. 161 (November 1998): 116–54.

Franzoi, Barbara. *At the Very Least She Pays the Rent*. Westport: Greenwood Press, 1985.

Freier, A. E., and Annette Kuhn, eds. *Frauen in der Geschichte V*. Düsseldorf: Patmos Verlag, 1984.

Frerich, Johannes, and Martin Frey. *Handbuch der Geschichte der Sozialpolitik in Deutschland. Bd. 2 Sozialpolitik in der Deutschen Demokratischen Republik*. Munich/Vienna: Oldenbourg, 1993.

Frevert, Ute. "The Civilizing Tendency of Hygiene: Working-Class Women under Medical Control in Imperial Germany." In *German Women in the Nineteenth Century: A Social History*, edited by John C. Fout. New York: Holmes and Meier Publisher, 1984.

Fricke, Karl Wilhelm. "Der Arbeiteraufstand-Vorgeschichte, Verlauf, Folgen." In *17. Juni 1953. Arbeiteraufstand in der DDR*, edited by Ilse Spittmann and Karl Wilhelm Fricke. Cologne: Verlag Wissenschaft und Politik, 1982.

Friedrich, Armin, and Thomas Friedrich, eds. *Politische Parteien und gesellschaftliche Organisationen der Sowjetischen Besatzungszone 1945–1949*. Berlin: Akademie Verlag, 1992.

Fulbrook, Mary. *Anatomy of a Dictatorship: Inside the GDR, 1949–1989*. Oxford: Oxford University Press, 1995.

Gast, Gabriele. *Die politische Rolle der Frau in der DDR*. Düsseldorf: Bertelsmann Universitätsverlag, 1973.

Genth, Renate, and Ingrid Schmidt-Harzbach. "Die Frauenausschüsse: Das halb gewollte, halb verordnete Netz." In *Frauenpolitik und politisches Wirken von Frauen im Berlin der Nachkriegszeit 1945–1949*, edited by Renate Genth et al. Berlin: trafo verlag, 1997.

Genth, Renate, and Ingrid Schmidt-Harzbach. "Kriegsende." In *Frauenpolitik und politisches Wirken von Frauen im Berlin der Nachkriegszeit 1945–1949*, edited by Renate Genth et al. Berlin: trafo verlag, 1997.

Genth, Renate. "Frauen in den Parteien." In *Frauenpolitik und politisches Wirken von Frauen im Berlin der Nachkriegszeit 1945–1949*, edited by Renate Genth et al. Berlin: trafo verlag, 1997.

Gerhard, Ute. "Die staatlich instituionalisierte 'Lösung' der Frauenfrage. Zur Geschichte der Geschlecherverhältnisse in der DDR." In *Sozialgeschichte der DDR*, edited by Hartmut Kaelble, Jürgen Kocka, and Hartmut Zwahr. Stuttgart: Klett-Cotta, 1994.

Gieseke, Jens. "Ulbricht's Secret Police: The Ministry of State Security." In *The Workers' and Peasants' State: Communism and Society in East Germany under Ulbricht 1945–1971*, edited by Patrick Major and Jonathan Osmond. Manchester and New York: Manchester University Press, 2002.

Goldman, Wendy Z. "Industrial Politics, Peasant Rebellion, and the Death of the Proletarian Women's Movement in the USSR." *Slavic Review* 55 no. 1 (Spring 1996): 46–77.

Goldman, Wendy Z. *Women, the State and Revolution: Soviet Family Policy and Social Life, 1917–1936.* Cambridge: Cambridge University Press, 1993.

Gordon, Linda. "Social Insurance and Public Assistance: The Influence of Gender in Welfare Thought in the United States, 1890–1935." *AHR* 97, no. 1 (February 1992): 19–54.

Grieder, Peter. "The Leadership of the Socialist Unity Party of Germany under Ulbricht." In *The Workers' and Peasants' State: Communism and Society in East Germany under Ulbricht 1945–1971*, edited by Patrick Major and Jonathan Osmond. Manchester and New York: Manchester University Press, 2002.

Grieder, Peter. *The East German Leadership, 1946–1973.* Manchester: Manchester University Press, 1999.

Gries, Rainer. *Die Rationengesellschaft.* Münster: Dampfboot Verlag, 1991.

Grossmann, Atina. "A Question of Silence: The Rape of German Women by Occupation Soldiers." *October* 72 (Spring 1995).

Grossmann, Atina. "Feminist Debates about Women and National Socialism." *Gender and History* 3 (1991).

Grossmann, Atina. *Reforming Sex: The German Movement for Birth Control and Abortion Reform, 1920–1950.* Oxford: Oxford University Press, 1995.

Günther, Erwin. "Aspekte der Sexualmedizin in der DDR." In *Sexuologie in der DDR*, edited by Joachim Hohmann. Berlin: Dietz, 1991.

Hacke, Gerald. *Zeugen Jehovas in der DDR. Verfolgung und Verhalten einer Religiösen Minderheit.* Dresden: Hannah-Arendt-Institut für Totalitarismusforschung e.V., 2000.

Hagemann, Karen. *Frauenalltag und Männerpolitik. Alltagsleben und gesellschaftliches Handeln von Arbeiterfrauen in der Weimarer Republik.* Bonn: Dietz, 1990.

Hagen, Manfred. *DDR-Juni '53: Die erste Volkserhebung im Stalinismus.* Stuttgart: Steiner, 1992.

Hall, W. Karin. "Humanity or Hegemony: Orphans, Abandoned Children, and the Sovietization of the Youth Welfare System in Mecklenburg, Germany, 1945–1952." Dissertation. Stanford University, 1998.

Hampele, Anne. "Arbeite mit, plane mit, regiere mit. Zur politischen Partizipation von Frauen in der DDR." In *Frauen in Deutschland 1945–1992*, edited by Gisela Helwig and Hildegard Maria Nickel. Berlin: Akademie Verlag, 1993.

Haney, Lynn. *Inventing the Needy: Gender and the Politics of Welfare in Hungary.* Berkeley: University of California Press, 2002.

Harsch, Donna. "Approach/Avoidance: Communists and women in East Germany, 1945–9." *Social History* 25, no. 2 (May 2000): 156–82.

Harsch, Donna. "Society, the State, and Abortion in East Germany, 1950–1972." *AHR* 102, no. 1 (February 1997): 53–84.

Hausen, Karin. "Frauenerwerbstätigkeit und erwerbstätige Frauen. Anmerkungnen zur historischen Forschung." In *Frauen arbeiten. Weibliche Erwerbstätigkeit in Ost-und Westdeutschland nach 1945*, edited by Gunilla-Friederike Budde. Göttingen: Vandenhoeck und Ruprecht, 1997.

Hauser, Kornelia. *Patriarchat als Sozialismus. Soziologische Studien zu Literatur aus der DDR*. Hamburg: Coyote, 1994.

Heineman, Elizabeth D. "The Hour of the Woman: Memories of Germany's 'Crisis Years' and West German National Identity." *AHR* 101 (1996): 354–95.

Heineman, Elizabeth D. *What Difference Does a Husband Make? Women and Marital Status in Nazi and Postwar Germany*. Berkeley: University of California Press, 1999.

Heitlinger, Alena. "Marxism, Feminism, and Sex Equality." In *Women in Eastern Europe and the Soviet Union*, edited by Tova Yedlin. New York: Greenwood Publishing Group, 1980.

Heitlinger, Alena. *Reproduction, Medicine and the Socialist State*. Basingstoke: Macmillan, 1987.

Heitlinger, Alena. *Women and State Socialism. Sex Inequality in the Soviet Union and Czechoslovakia*. London and Basingstoke: Macmillan, 1979.

Heldmann, Philipp. "Konsumpolitik in der DDR. Jugendmode in den sechziger Jahren." In *Konsumpolitik. Die Regulierung des privaten Verbrauchs im 20. Jahrhundert*, edited by Hartmut Berghoff. Göttingen: Vandenhoeck und Ruprecht, 1999.

Heldmann, Philipp. *Herrschaft, Wirtschaft, Anoraks*. Göttingen: Vandenhoeck und Ruprecht, 2004.

Helwig, Gisela. "Einleitung." In *Frauen in Deutschland 1945–1992*, edited by Gisela Helwig and Hildegard Maria Nickel. Berlin: Akademie Verlag, 1993.

Helwig, Gisela. "Frauen im SED-Staat." In *Materiellen der Enquete-Kommission 'Aufarbeitung von Geschichte und Folgen der SED-Diktatur in Deutschland'. Bd. III/2. Rolle und Bedeutung der Ideologie, integrativer Faktoren und disziplinierender Praktiken in Staat und Gesellschaft der DDR*, edited by Deutscher Bundestag. Frankfurt/M.: Campus Verlag, 1995.

Helwig, Gisela. *Zwischen Familie und Beruf. Die Stellung der Frau in beiden deutschen Staaten*. Cologne: Verlag Wissenschaft und Politik, 1974.

Herzberg, Wolfgang. *Ich bin doch wer: Arbeiter und Arbeiterinnen des VEB Berliner Glühlampenwerk erzählen ihr Leben 1900–1980*. Darmstadt/Neuwied: Luchterhand, 1987.

Hesse, Peter G. "Die Anfänge der Sexuologie in der DDR." In *Sexuologie in der DDR*, edited by Joachim Hohmann. Berlin: Dietz, 1991.

Hilgenberg, Dorothea. *Bedarfs- und Marktforschung in der DDR. Anspruch und Wirklichkeit*. Cologne: Verlag Wissenschaft und Politik, 1979.

Hockerts, Hans Günter. "Grundlinien und soziale Folgen der Sozialpolitik in der DDR." In *Sozialgeschichte der DDR*, edited by Hartmut Kaelble, Jürgen Kocka, and Hartmut Zwahr. Stuttgart: Klett-Cotta, 1994.

Hoffmann, Dierk. *Aufbau und Krise der Planwirtschaft. Die Arbeitskräftelenkung in der SBZ/DDR 1945 bis 1963.* Munich: Oldenbourg, 2002.

Hohlfeld, Brigitte. *Die Neulehrer der SBZ/DDR 1945–1953.* Weinheim: Deutscher Studienverlag, 1993.

Hong, Sun-Young. *Welfare, Modernity, and the Weimar State, 1919–1933.* Princeton: Princeton University Press, 1998.

Hosek, Jennifer Ruth. "Fathers' Apples and Good Socialist Girls: The Political Pedagogy of Reproduction in DEFA's *Für die Liebe noch zu mager?*" Paper delivered at the German Studies Association Conference, New Orleans, Louisiana, 2003.

Hübner, Peter. "Balance des Ungleichgewichtes. Zum Verhältnis von Arbeiterinteressen und SED-Herrschaft." *G&G* 19, no. 1 (1993): 15–28.

Hübner, Peter. "Die Zukunft war gestern: Soziale und mentale Trends in der DDR-Industriearbeiterschaft." In *Sozialgeschichte der DDR*, edited by Hartmut Kaelble, Jürgen Kocka, and Hartmut Zwahr. Stuttgart: Klett-Cotta, 1994.

Hübner, Peter. "Durch Planung zur Improvisation. Zur Geschichte des Leitungspersonals in der staatlichen Industrie der DDR." *AfS* 39 (1999).

Hübner, Peter. *Konsens, Konflikt und Kompromiß. Soziale Arbeiterinteressen und Sozialpolitik in der SBZ/DDR 1945–1970.* Berlin: Akademie Verlag, 1995.

Huchthausen, Liselot. *Alltagsleben in der DDR 1945–1975.* Kückenshagen: Scheunen-Verlag, 1998.

Humm, Antonia Maria. *Auf dem Weg zum sozialistischen Dorf? Zum Wandel der dörflichen Lebenswelt in der DDR und der Bundesrepublik Deutschland 1952–1969.* Göttingen: Vandenhoeck und Ruprecht, 1999.

Ingham M., M. Domañski, and H. Ingham. *Women on the Polish Labour Market.* Budapest and New York: Central European University Press, 2001.

Irmscher, Gerlinde. "'Arbeitsfrei mit Küsschen drauf'." In *Wunderwirtschaft. DDR-Konsumkultur in der 60er Jahren*, edited by Neue Gesellschaft für Bildende Kunst. Cologne, Weimar, and Vienna: Böhlau, 1996.

Jarausch, Konrad. "Care and Coercion: The GDR as Welfare Dictatorship." In *Dictatorship as Experience. Towards a Socio-cultural History of the GDR*, edited by Konrad Jarausch. New York and Oxford: Berghahn, 1999.

Jarausch, Konrad. "Die gescheiterte Gegengesellschaft. Überlegungen zu einer Sozialgeschichte der DDR." *AfS* 39 (1999): 1–17.

Jarausch, Konrad. "Implosion oder Selbstbefreiung? Zur Krise des Kommunismus und Auflösung der DDR." In *Der innere Zerfall der DDR*, edited by Konrad Jarausch and Martin Sabrow. Göttingen: Vandenhoeck und Ruprecht, 1999.

Jenson, Jane. "Changing Discourse, Changing Agendas: Political Rights and Reproductive Policies in France." In *The Women's Movements of the United States and Western Europe: Consciousness, Political Opportunity, and Public Policy*, edited by Mary Fainsod Katzenstein and Carol McClurg Mueller. Philadelphia: Temple University Press, 1987.

Kahneman, Daniel, J. L. Knetsch, and R. H. Thaler. "Experimental Tests of the Endowment Effect and the Coase Theorem." *Journal of Political Economy* 98 (1990): 1325–48.

Kaiser, Monika. "Reforming Socialism? The Changing of the Guard from Ulbricht to Honecker during the 1960s." In *Dictatorship as Experience. Towards a Socio-cultural History of the GDR*, edited by Konrad Jarausch. New York and Oxford: Berghahn, 1999.

Kaiser, Monika. "Sowjetischer Einfluss auf die ostdeutsche Politik und die Verwaltung, 1945–1970." In *Der Weg in den Untergang. Der innere Zerfall der DDR*, edited by Konrad Jarausch and Martin Sabrow. Göttingen: Vandenhoeck und Ruprecht, 1999.

Kaminsky, Annette. *Kaufrausch: Die Geschichte der Konsumkultur in der DDR*. Cologne: Ch. Links Verlag, 1999.

Kaminsky, Annette. *Wohlstand, Schönheit, Glück. Kleine Konsumgeschichte der DDR*. Munich: C.H. Beck Verlag, 2001.

Kaplan, Temma. "Female Consciousness and Collective Action: The Barcelona Case, 1910–1918." *Signs* 7, no. 3 (Spring 1982): 545–66.

Kersten, Heinz. *Das Filmwesen in der Sowjetischen Besatzungszone Deutschlands*. Bonn/Berlin: Deutscher Bundes-Verlag, 1963.

Klessmann, Christoph. "Zur Sozialgeschichte des protestantisches Milieus in der DDR." *G&G* 19 (1993).

Klessmann, Christoph. *Zwei Staaten, eine Nation. Deutsche Geschichte 1955–1970*. Göttingen: Vandenhoeck und Ruprecht, 1988.

Knapp, Ulla. *Frauenarbeit in Deutschland. Bd. 2: Hausarbeit und geschlechtsspezifische Arbeitsmarkt im deutschen Industrialisierungsprozess*. Munich: Minerva, 1984.

Koch, Petra, and Hans Guenther Knoebel. *Familienpolitik der DDR im Spannungsfeld zwischen Familie und Berufstätigkeit von Frauen*. Phaffenweiler: Centaurus Verlag, 1986.

Kohli, Martin. "Die DDR als Arbeitsgesellschaft? Arbeit, Lebenslauf und soziale Differenzierung." In *Sozialgeschichte der DDR*, edited by Hartmut Kaelble, Jürgen Kocka, and Hartmut Zwahr. Stuttgart: Klett-Cotta, 1994.

Kolinsky, Eva. *Women in West Germany: Life, Work and Politics*. Oxford, Providence, and Munich: Palgrave Macmillan, 1989.

Kontos, Silvia. *Die Partei kämpft wie ein Mann*. Basel and Frankfurt M.: Campus Verlag, 1969.

Koonz, Claudia. *Mothers in the Fatherland: Women, the Family, and Nazi Politics*. New York: St. Martin's Press, 1987.

Kopstein, Jeffrey. *The Politics of Economic Decline in East Germany, 1945–1989*. Chapel Hill: University of North Carolina Press, 1997.

Kornai, János. *The Socialist System: The Political Economy of Communism*. Princeton: Princeton University Press, 1992.

Koven, Seth, and Sonya Michel. "Introduction." In *Mothers of a New World: Maternalist Politics and the Origins of Welfare States*, edited by Seth Koven and Sonya Michel. New York: Routledge, 1993.

Kreutzer, Susanne. " 'Sozialismus braucht gebildete Frauen'. Die Kampagne um das Kommuniqué 'Die Frauen—der Frieden und der Sozialismus' in der DDR 1961/62." *Zeitschrift für Geschichtswissenschaft* 47/1999 (1): 23–37.

Krockow, Christian von. *The Hour of the Women*. Based on an oral narrative by Libussa Fritz-Krockow. New York: HarperCollins, 1991.

Kuhn, Annette, ed. *Frauen in der deutschen Nachkriegszeit. Bd. 2: Frauenpolitik 1945–1949. Quellen und Materialien.* Düsseldorf: Patmos Verlag, 1986.

Kuhn, Annette. "Power and Powerlessness: Women after 1945, or the Continuity of the Ideology of Femininity." *German History* 7, no. 1 (1989): 35–46.

Külke, Christine. "Die Berufstätigkeit der Frauen in der industriellen Produktion der DDR. Zur Theorie und Praxis der Frauenarbeitspolitik der SED." Dissertation, Freie Universität, 1967.

Kuntsche, Siegfried. "Das Bauerndorf in der Nachkriegszeit. Lebenslagen und Alltag." In *Befremdlich anders. Leben in der DDR*, edited by Evemarie Badstübner. Berlin: Dietz, 2000.

Laatz, Horst. "Vom Klassenkampf zur individuellen Wertorientierung. Zur Entwicklung der soziologischen Frauenforschung in der DDR von 1960 bis 1980." In *Qualifikationsprozesse und Arbeitssituation von Frauen in der Bundesrepublik Deutschland und in der DDR*, edited by Dieter Voigt. Berlin: Duncker und Humblot, 1989.

Landes, Joan B. "Marxism and the 'Woman and Question'." In *Promissory Notes: Women in the Transition to Socialism*, edited by Sonia Kruks, Rayna Rapp, and Marilyn Young. New York: Monthly Review Press, 1989.

Landsman, Mark. "Dictatorship and Demand: East Germany between Productivism and Consumerism, 1948–1961." Dissertation, Columbia University, 2000.

Landsman, Mark. *Dictatorship and Demand: The Politics of Consumerism in East Germany.* Cambridge: Harvard University Press, 2005.

Lapidus, Gail W. *Women in Soviet Society.* Berkeley: University of California Press, 1978.

Leonhard, Wolfgang. *Die Revolution entlässt ihre Kinder.* Cologne: Reclam-Verlag, 1990.

Leutwein, Alfred. *Die sozialen Leistungen der Sowjetischen Besatzungszone.* Bonn: Bundesministerium der gesamtdeutschen Fragen, 1955.

Lewis, Jane. "Gender and Welfare Regimes: Further Thoughts." *Social Politics* 4, no. 2 (Summer 1997).

Loth, Wilfried. *Stalin's Unwanted Child. The Soviet Union, the German Question and the Founding of the GDR.* Translated by Robert F. Hogg. London and New York: Palgrave Macmillan, 1998.

Ludz, P. C. "The GDR from the 60s to the 70s. A Socio-Political Analysis." *Occasional Papers in International Affairs*, Center for International Affairs, Harvard University, no. 26 (November 1970): 11–12.

Ludz, P. C. "Politische Ziele der SED und gesellschaftlicher Wandel in der DDR." *Deutschland Archiv* 7 (1974).

Luker, Kristin. *Abortion and the Politics of Motherhood.* Berkeley: University of California Press, 1985.

Madarász, Jeannette. *Conflict and Compromise in East Germany, 1971–1989: A Precarious Stability.* Basingstoke and New York: Palgrave Macmillan, 2003.

Madarász, Jeannette. "Normalization in the Context of Enterprise Culture and Economic Politics in the German Democratic Republic, 1961–1979." Paper delivered at the American Historical Association Meeting, January 2005.

Madison, Bernice Q. *Social Welfare in the Soviet Union.* Stanford: Stanford University Press, 1968.

Mählert, Ulricht. *Kleine Geschichte der DDR*. Munich: C.H. Beck Verlag, 1999.

Maier, Charles. *Dissolution: The Crisis of Communism and the End of East Germany*. Princeton: Princeton University Press, 1997.

Major, Patrick. "Going West: The Open Border and the Problem of Republikflucht." In *The Workers' and Peasants' State: Communism and Society in East Germany under Ulbricht 1945–1971*, edited by Patrick Major and Jonathan Osmond. Manchester and New York: Manchester University Press, 2002.

Major, Patrick. "Torschlusspanik und Mauerbau. 'Republikflucht' als Symptom der zweiten Berlinerkrise." In *Sterben für Berlin? Die Berliner Krisen 1948–1958*, edited by Burghard Ciesla, Michael Lemke, and Thomas Lindenberger. Berlin: Metropol Verlag, 2000.

Major, Patrick. "Vor und nach dem 13. August 1961: Reaktionen der DDR-Bevölkerung auf den Bau der Berliner Mauer." *AfS* 39 (1999).

Makarenko, S. *The Collective Family: A Handbook for Parents*. New York: Doubleday, 1967.

Makkai, Toni. "Social Policy and Gender in Eastern Europe." In *Gendering Welfare States*, edited by Diane Sainsbury. London: Sage Publications, 1994.

Malycha, Andreas. *Die SED. Geschichte ihrer Stalinisierung 1946–1953*. Paderborn: Ferdinand Schöningh Verlag, 2000.

Manning, Nick, Ovsey Shkaratan, and Nataliya Tikhonova. *Work and Welfare in the New Russia*. Aldershot/Burlington: Ashgate, 2000.

Markovits, Inga. "The Road from 'I' to 'We': Family Law in the Communitarian State." *Utah Law Review* (1996/2).

Markovits, Inga. "Der Handel mit der sozialistischen Gerechtigkeit. Zum Verhältnis zwischen Bürger und Gericht in der DDR." In *Herrschaft und Eigensinn in der Diktatur. Studien zur Gesellschaftsgeschichte der DDR*, edited by Thomas Lindenberger. Cologne: Böhlau, 1999.

Maynes, Mary Jo. " '*Genossen und Genossinnen*': Depictions of Gender, Militancy, and Organizing in the German Socialist Press." In *Between Reform and Revolution: German Socialism and Communism from 1840–1990*, edited by David E. Barclay and Eric D. Weitz. New York and Oxford: Berghahn, 1998.

Mazur, D. Peter. "Procreation and New Definitions in the Role of Women in a Soviet Bloc Country: The Case of Poland." In *Women in Eastern Europe and the Soviet Union*, edited by Tova Yedlin. New York: Greenwood Publishing Group, 1980.

McAdams, Kay L. " 'Ersatzmänner'. *Trümmerfrauen* und women in 'Men's Work' in Berlin and in the Soviet Zone, 1945–50." In *Arbeiter in der SBZ-DDR*, edited by Peter Hübner and Klaus Tenfelde. Essen: Klartext, 1999.

Mehlan, K. H. "German Democratic Republic." *International Handbook on Abortion*. New York and London: Greenwood Press, 1988.

Mehlhase, Torsten. "Die SED und die Vertriebenen. Versuche der politischen Einflussnahme und der 'Umerziehung' in den ersten Nachkriegsjahren in Sachsen-Anhalt." In *Sie hatten alles verloren. Flüchtlinge und Vertriebene in der sowjetischen Besatzungszone Deutschlands*, edited by Manfred Wille, Johannes Hoffmann, and Wolfgang Meinicke. Wiesbaden: O. Harrassowitz, 1993.

Meinicke, Wolfgang. "Die Bodenreform und die Vertriebenen in der SBZ in den Anfangsjahren der DDR." In *Sie hatten alles verloren. Flüchtlinge und Vertrie-*

bene in der sowjetischen Besatzungszone Deutschlands, edited by Manfred Wille, Johannes Hoffmann, and Wolfgang Meinicke. Wiesbaden: O. Harrassowitz, 1993.

Merkel, Ina. *. . .und Du, Frau an der Werkbank. Die DDR in den 50er Jahren.* Berlin: Elefanten Press, 1990.

Merkel, Ina. "Arbeiter und Konsum im real-existierenden Sozialismus." In *Arbeiter in der SBZ-DDR*, edited by Peter Hübner and Klaus Tenfelde. Essen: Klartext, 1999.

Merkel, Ina. "Leitblider und Lebensweise von Frauen in der DDR." In *Sozialgeschichte der DDR*, edited by Hartmut Kaelble, Jürgen Kocka, and Hartmut Zwahr. Stuttgart: Klett-Cotta, 1994.

Merkel, Ina. *Utopie und Bedürfnis. Die Geschichte der Konsumkultur in der DDR.* Cologne: Böhlau, 1999.

Merl, Stephan. "Sowjetisierung in der Welt des Konsums." In *Amerikanisierung und Sowjetisierung in Deutschland 1945–1970*, edited by Konrad Jarausch and Hannes Siegrist. Frankfurt/Main: Campus Verlag, 1997.

Mertens, Lothar. *Wider die sozialistische Familiennorm. Ehescheidungen in der DDR, 1950–1989.* Opladen: Westdeutscher Verlag, 1998.

Meuschel, Sigrid. "Überlegungen zu einer Herrschafts-und Gesellschaftsgeschichte der DDR." *G&G* 19 (1993).

Meuschel, Sigrid. *Legitimation und Parteiherrschaft. Zum Paradox von Stabilität und Revolution in der DDR, 1945–1989.* Frankfurt/Main: Suhrkamp, 1992.

Meyer, Dagmar. "Ehescheidung in der ehemaligen DDR." *Zeitschrift für Bevölkerungswissenschaft* Jg. 17, no. 1 (1991).

Meyer, Sibylle, and Eva Schulze. *Von Liebe sprach damals keiner. Familienalltag in der Nachkriegszeit.* Munich: C.H. Beck Verlag, 1985.

Möding, Nori. "Die Stunde der Frauen." In *Von Stalingrad zur Währungsreform. Zur Sozialgeschichte des Umbruchs in Deutschland*, edited by Martin Broszat, Klaus-Dietmar Henke, and Hans Woller. Munich: Oldenbourg, 1988.

Moeller, Robert G. *Protecting Motherhood: Women and Family in the Politics of Postwar West Germany.* Berkeley: University of California Press, 1993.

Moeller, Robert G. *War Stories: The Search for a Usable Past in the Federal Republic of Germany.* Berkeley: University of California Press, 2003.

Mühlberg, Dietrich. "Überlegungen zu einer Kulturgeschichte der DDR." In *Sozialgeschichte der DDR*, edited by Hartmut Kaelble, Jürgen Kocka, and Hartmut Zwahr. Stuttgart: Klett-Cotta, 1994.

Mühlberg, Dietrich. "Von der Arbeitsgesellschaft in die Konsum-, Freizeit- und Erlebnisgesellschaft. Kulturgeschichtliche Überlegungen zum Bedürfniswandel in beiden deutschen Gesellschaften." In *Deutsche Vergangenheiten—eine gemeinsame Herausforderung. Der schwierige Umgang mit der doppelten Nachkriegsgeschichte*, edited by Christoph Klessmann, Hans Misselwitz, and Günter Wichert. Berlin: Ch. Links Verlag, 1999.

Mühlfriedel, Wolfgang, and Klaus Wiessner. *Die Geschichte der Industrie in der DDR.* Berlin (E): Akademie Verlag, 1989.

Müller, Werner, Fred Mrotzek, and Johannes Köllner. *Die Geschichte der SPD in Mecklenburg und Vorpommern.* Bonn: Dietz, 2002.

Naimark, Norman M. *The Russians in Germany: A History of the Soviet Zone of Occupation, 1945–1949*. Cambridge: Harvard University Press, 1995.

Neubert, Rudolf. *Das neue Ehebuch. Die Ehe als Aufgabe der Gegenwart und Zukunft*. Rudolstadt: Greifenverlag, 1957.

Neubert, Rudolf. *Die Geschlechterfrage. Ein Buch für junge Menschen*. Rudolstadt: Greifenverlag, 1956.

Nickel, Hildegard Maria. "'Mitgestalterinnen der Sozialismus—Frauenarbeit in der DDR." In *Frauen in Deutschland 1945–1992*, edited by Gisela Helwig and Hildegard Maria Nickel. Berlin: Akademie Verlag, 1993.

Nicolaus, Herbert, and Alexander Obeth. *Die Stalinallee: Geschichte einer deutschen Strasse*. Berlin: Verlag für Bauwesen, 1997.

Niethammer, Lutz, Alexander von Plato, and Dorothee Wierling. *Die volkseigene Erfahrung. Eine Archäologie des Lebens in der Industrieprovinz der DDR*. Berlin: Rowohlt, 1991.

Obertreis, Gesine. *Familienpolitik in der DDR 1945–1980*. Opladen: Westdeutscher Verlag, 1986.

Oertzen, Christine von. *Teilzeitarbeit und die Lust am Zuverdienen: Geschlechterpolitik und gesellschaftlicher Wandel in Westdeutschland 1948–1969*. Göttingen: Vandenhoeck und Ruprecht, 1999.

Orthmann, Rosemary. *Out of Necessity: Women Working in Berlin at the Height of Industrialization, 1874–1913*. New York and London: Garland, 1991.

Osmond, Jonathan. "Kontinuität und Konflikt in der Landwirtschaft der SBZ/DDR zur Zeit der Bodenreform und der Vergenossenschaftlichung, 1945–1961." In *Die Grenzen der Diktatur. Staat und Gesellschaft in der DDR*, edited by Richard Bessel and Ralph Jessen. Göttingen: Vandenhoeck und Ruprecht, 1996.

Panzig, Christel. "Hin zum eigenen Beruf." In *Frauen arbeiten. Weibliche Erwerbstätigkeit in Ost-und Westdeutschland nach 1945*, edited by Gunilla-Friederike Budde. Göttingen: Vandenhoeck und Ruprecht, 1997.

Pape, Petra. "Flüchtlinge und Vertriebene in der Provinz Mark Brandenburg." In *Sie hatten alles verloren. Flüchtlinge und Vertriebene in der sowjetischen Besatzungszone Deutschlands*, edited by Manfred Wille, Johannes Hoffmann, and Wolfgang Meinicke. Wiesbaden: O. Harrassowitz, 1993.

Pawlowski, Rita. "Der Demokratische Frauenbund Deutschlands (DFD)." In *Frauenpolitik und politisches Wirken von Frauen im Berlin der Nachkriegszeit 1945–1949*, edited by Renate Genth et al. Berlin: trafo verlag, 1997.

Pedersen, Susan. *Family, Dependence, and the Origins of the Welfare State. Britain and France, 1914–1945*. Cambridge: Cambridge University Press, 1993.

Pence, Katherine. " 'A world in Miniature': The Leipzig Trade Fairs in the 1950s and East German Consumer Citizenship." In *Consuming Germany in the Cold War*, edited by David Crew. Oxford and New York: Berg Publishers, 2003.

Pence, Katherine. "Schaufenster des sozialistischen Konsums: Texte der ostdeutschen 'consumer culture'?" In *Akten. Eingaben. Schaufenster. Die DDR und ihre Texte*, edited by Alf Lüdtke and Peter Becker. Berlin: Akademie Verlag, 1997.

Pence, Katherine. "Labours of Consumption: Gendered Consumers in Post-War East and West German Reconstruction." In *Gender Relations in German His-*

tory, edited by Lynn Abrams and Elizabeth Harvey. Durham: Duke University Press, 1996.

Pence, Katherine. " 'You as a Woman Will Understand': Consumption, Gender and the Relationship between State and Citizenry in the GDR's Crisis of 17 June 1953." *German History* 19, no. 2 (2001): 218–52.

Pence, Katherine. "From Rations to Fashions: The Gendered Politics of East and West German Consumption, 1945–1961." Dissertation, University of Michigan, 1999.

Poiger, Uta G. *Jazz, Rock and Rebels: Cold War Politics and American Culture in a Divided German*. Berkeley: University of California Press, 2000.

Pollack, Detlef. "Modernization and Modernization Blockages in GDR Society." In *Dictatorship as Experience. Towards a Socio-Cultural History of the GDR*, edited by Konrad Jarausch. New York and Oxford: Berghahn, 1999.

Pollack, Detlef. "Von der Volkskirche zur Minderheitskirche. Zur Entwicklung von Religiosität und Kirchlichkeit in der DDR." In *Sozialgeschichte der DDR*, edited by Hartmut Kaelble, Jürgen Kocka, and Hartmut Zwahr. Stuttgart: Klett-Cotta, 1994.

Port, Andrew Ian. "Conflict and Stability in the German Democratic Republic: A Study in Accommodation and Working-Class Fragmentation, 1945–1971." Dissertation, Harvard University, 2000.

Port, Andrew Ian. "Moralizing 'from Above' and 'from Below': Social Norms, Family Values, and Adultery in the German Democratic Republic." Paper delivered at the German Studies Association Conference, Salt Lake City, Utah, 1998.

Port, Andrew Ian. "When Workers Rumbled. The Wismut Upheaval of August 1951 in East Germany." *Social History* 22, no. 2 (May 1997): 145–73.

Poutrus, Kirsten. "Von den Massenvergewaltigungen zum Mutterschutzgesetz: Abtreibungspolitik und Abtreibungspraxis in Ostdeutschland, 1945–1950." In *Die Grenzen der Diktatur. Staat und Gesellschaft in der DDR*, edited by Richard Bessel and Ralph Jessen. Göttingen: Vandenhoeck und Ruprecht, 1996.

Poutrus, Patrice. " '. . .mit Politik kann ich keine Hühner anziehn.' Das Kombinat Industrielle Mast und die Lebenserinnerungen der Frau Knut." In *Herrschaft und Eigensinn in der Diktatur. Studien zur Gesellschaftsgeschichte der DDR*, edited by Thomas Lindenberger. Cologne: Böhlau, 1999.

Poutrus, Patrice. "Kurzer Abriss der Geschichte des Goldbroilers." In *Wunderwirtschaft. DDR-Konsumkultur in den 60er Jahren*, edited by Neue Gesellschaft für Bildende Kunst. Cologne: Böhlau, 1996.

Prokop, Siegfried. "Zur Entwicklung des Lebensstandards in der DDR (1958–1963/64)." In *Befremdlich anders. Leben in der DDR*, edited by Evemarie Badstübner. Berlin: Dietz, 2000.

Quataert, Jean H. "The Shaping of Women's World in Manufacturing: Guilds, Households, and the State in Central Europe, 1648–1870." *AHR* 90, no. 5 (December 1985): 1122–48.

Reid, Susan E. "Cold War in the Kitchen: Gender and the De-Stalinization of Consumer Taste in the Soviet Union under Khrushchev." *Slavic Review* 61, no. 2 (Summer 2002): 211–52.

Reimann, Brigitte. *Franziska Linkerhand*. Berlin: Verlag Neues Leben, 1974.

Reyer, Jürgen, and Heidrun Kleine. *Die Kinderkrippe in Deutschland. Sozial-geschichte einer umstrittenen Einrichtung.* Freiburg im Breisgau: Lambertus-Verlag, 1997.

Rietzschel, Almut. "Teilzeitarbeit in der Industrie: ein 'Storfaktor' auf dem Weg zur 'Verwirklichung' der Gleichberechtigung?" In *Arbeiter in der SBZ-DDR*, edited by Peter Hübner and Klaus Tenfelde. Essen: Klartext, 1999.

Ritschl, Albrecht. "Aufstieg und Niedergang der Wirtschaft der DDR. Ein Zahlen-bild 1945–1989." *Jahrbuch für Wirtschaftsgeschichte* 2 (1995).

Roesler, Jörg. "East German Industry, 1945 to the Present." In *Women in the Labour Force*, edited by E. Aerts et al. Leuven: Leuven University Press, 1990.

Roesler, Jörg. "Private Konsum in Ostdeutschland 1950–1960." In *Modernisie-rung im Wiederaufbau: die westdeutsche Gesellschaft der 50er Jahre*, edited by Axel Schildt and Arnold Sywottek. Bonn: Dietz, 1993.

Roesler, Jörg. "Die Produktionsbrigaden in der Industrie der DDR. Zentrum der Arbeitswelt?" In *Sozialgeschichte der DDR*, edited by Hartmut Kaelble, Jürgen Kocka, and Hartmut Zwahr. Stuttgart: Klett-Cotta, 1994.

Roos, Julia. "Weimar's Crisis through the Lens of Gender: The Case of Prostitu-tion." Dissertation, Carnegie Mellon University, 2001.

Rosenberg, Dorothy. "Shock Therapy: GDR Women in Transition from a Socialist Welfare State to a Social Market Economy." *Signs* 17, no. 1 (1991).

Ross, Corey. *Constructing Socialism at the Grass-Roots: The Transformation of East Germany, 1945–1965.* London: St. Martin's Press, 2000.

Rouette, Susanne. *Sozialpolitik als Geschlechterpolitik. Die Regulierung der Frauenarbeit nach dem Ersten Weltkrieg.* Frankfurt and New York: Campus Verlag, 1993.

Rubin, Eli. "The Order of Substitutes: Plastic Consumer Goods in the Volks-wirtschaft and Everyday Domestic Life in the GDR." In *Consuming Germany in the Cold War*, edited by David Crew. Oxford and New York: Berg Publishers, 2003.

Ruhl, Klaus-Jörg. *Verordnete Unterordnung. Berufstätige Frauen zwischen Wirtschaftswachstum und konservativer Ideologie in der Nachkriegszeit (1945–1963).* Munich: Oldenbourg, 1994.

Sabrow, Martin. "Der Konkurs der Konsensdiktatur. Überlegungen zum innerern Zerfall der DDR aus kulturgeschichtlicher Perspektive." In *Der Weg in den Untergang. Der innere Zerfall der DDR*, edited by Konrad Jarausch and Martin Sabrow. Göttingen: Vandenhoeck und Ruprecht, 1999.

Sachse, Carola. *Der Hausarbeitstag. Gerechtigkeit und Gleichberechtigung in Ost und West 1939–1994.* Göttingen: Wallstein Verlag, 2002.

Sachse, Carola. "Hausarbeit im Betrieb. Betriebliche Sozialarbeit unter dem Na-tionalsozialismus." In *Angst, Belohnung, Zucht und Ordnung. Herrschafts-mechnismen im Nationalsozialismus*, edited by Carola Sachse et al. Opladen: Westdeutscher Verlag, 1982.

Sachse, Carola. "Ein 'heisses Eisen'. Ost- und westdeutsche Debatten um den Hausarbeitstag." In *Frauen arbeiten. Weibliche Erwerbstätigkeit in Ost-und Westdeutschland nach 1945*, edited by Gunilla-Friederike Budde. Göttingen: Vandenhoeck und Ruprecht, 1997.

Sachße, Christoph. *Mütterlichkeit als Beruf: Sozialarbeit, Sozialreform und Frauenbewegung.* Frankfurt/Main: Campus Verlag, 1985.

Sachße, Christoph. "Social Mothers: The Bourgeois Women's Movement and German Welfare-State Formation, 1890–1929." In *Mothers of a New World: Maternalist Politics and the Origins of Welfare States*, edited by Seth Koven and Sonya Michel. New York: Routledge, 1993.

Sainsbury, Diane. "Gender and Social-Democratic Welfare States." In *Gender and Welfare State Regimes*, edited by Diane Sainsbury. Oxford: Oxford University Press, 1999.

Sainsbury, Diane. "Introduction." In *Gender and Welfare State Regimes*, edited by Diane Sainsbury. Oxford: Oxford University Press, 1999.

Sassoon, Anne S. "Comment on Jane Lewis." *Social Politics* 4, no. 2 (Summer 1997): 172–80.

Scheel, Daniela. "Zeitschriftenstrategien zur Entwicklung des Frauenleitbildes." In *Lebensbedingungen in der DDR. 17. Tagung zum Stand der DDR-Forschung in der BRD 12. bis 15.6.1984*, edited by Ilse Spittmann-Rühle and Gisela Helwig. Cologne: Verlag Wissenschaft und Politik, 1984.

Schildt, Axel. "Wohnungspolitik." In *Drei Wege deutscher Sozialstaatlichkeit. NS-Diktatur, Bundesrepublik und DDR im Vergleich*, edited by Hans Günter Hockerts. Munich: Oldenbourg, 1998.

Schissler, Hanna. "Social Democratic Gender Policies, the Working-Class Milieu and the Culture of Domesticity in West Germany in the 1950s and 1960s." In *Between Reform and Revolution: German Socialism and Communism from 1840–1990*, edited by David E. Barclay and Eric D. Weitz. New York and Oxford: Berghahn, 1998.

Schlicht, Götz, *Das Familien- und Familienverfahrensrecht der DDR*. Tübingen: Horst Erdmann, 1970.

Schmidt, Manfred G. "Grundzüge der Sozialpolitik in der DDR." In *Am Ende des realen Sozialismus. Bd. 4 Die Endzeit der DDR-Wirtschaft—Analysen zur Wirtschafts-, Sozial- und Umweltpolitik*, edited by Eberhard Kuhrt. Opladen: Westdeutscher Verlag, 1999.

Schmidt-Harzbach, Ingrid. "Eine Woche im April, Berlin 1945: Vergewaltigung als Massenschicksal." *Feministische Studien* 2 (1984): 51–65.

Schnabl, Siegfried. "Sexuelle Störungen—Verbreitung, Zusammenhänge, Konsequenzen." In *Sexuologie in der DDR*, edited by Joachim Hohmann. Berlin: Dietz, 1991.

Schotte, Ernst. "Der Kampf von KPD/SPD und der Sozialistischen Einheitspartei Deutschlands um die Befreiung der Frau im Prozess der Herausbildung der Hegemonie der Arbeiterklasse in der damaligen sowjetischen Besatzungszone (1945 bis 1949)." Dissertation, Humboldt University, 1972.

Schüle, Annegret. "Industriearbeit als Emanzipationschance? Arbeiterinnen im Büromaschinenwerk Sömmerda und in der Baumwollspinnerei Leipzig." In *Frauen arbeiten. Weibliche Erwerbstätigkeit in Ost-und Westdeutschland nach 1945*, edited by Gunilla-Friederike Budde. Göttingen: Vandenhoeck und Ruprecht, 1997.

Schüle, Annegret. *'Die Spinne'. Die Erfahrungsgeschichte weiblicher Industriearbeit im VEB Leipziger Baumwollspinnerei*. Leipzig: Leipziger Universitätsverlag, 2001.

Schulz, Günther. "Soziale Sicherung von Frauen und Familien." In *Drei Wege deutscher Sozialstaatlichkeit. NS-Diktatur, Bundesrepublik und DDR im Vergleich*, edited by Hans Günter Hockerts. Munich: Oldenbourg, 1998.

Scholz, Hannelore. *Die DDR-Frau zwischen Mythos und Realität: zum Umgang mit der Frauenfrage in der Sowjetischen Besatzungszone und der DDR von 1945–1989*. Schwerin: Frauen- und Gleichstellungsbeauftragte der Landesregierung Mecklenburg-Vorpommern, 1997.

Schwartz, Michael. "Vertrieben in die Arbeiterschaft. 'Umsiedler' als 'Arbeiter' in der SBZ/DDR 1945–1952." In *Arbeiter in der SBZ-DDR*, edited by Peter Hübner and Klaus Tenfelde. Essen: Klartext, 1999.

Seraphim, Peter-Heinz. *Die Heimatvertriebenen in der Sowjetzone*. Berlin: Duncker und Humblot, 1954.

Skyba, Peter. "Die Sozialpolitik der Ära Honecker aus institutionentheoretischer Perspektive." In *Repression und Wohlstandsversprechen. Zur Stabilisierung von Parteiherrschaft in der DDR und der CSSR*, edited by Christoph Boyer and Peter Skyba. Dresden: Hannah-Arendt-Institut für Totalitarismusforschung e.V., 1999.

Smolka, Karl. *Gutes Benehmen von A-Z*. Berlin: Verlag Neues Leben, 1957.

Sneeringer, Julia. *Winning Women's Votes: Propaganda and Politics in Weimar Germany*. Chapel Hill/London: University of North Carolina Press, 2002.

Staritz, Dieter. *Geschichte der DDR 1949–1985*. Frankfurt/Main: Suhrkamp, 1985.

Staritz, Dieter. *Die Gründung der DDR*. Munich: Oldenbourg, 1984.

Steinbach, Peter. "Im Schatten des Dritten Reichs. Die beiden deutschen Staaten als postnationalsozialistische Systeme im Zugriff historisch-politikwissenschaftlicher Forschung und Deutung." In *Deutsche Vergangenheiten—eine gemeinsame Herausforderung. Der schwierige Umgang mit der doppelten Nachkriegsgeschichte*, edited by Christoph Klessmann, Hans Misselwitz, and Günter Wichert. Berlin: Ch. Links Verlag, 1999.

Steiner, Andre. "Dissolution of the 'Dictatorship Over Needs'? Consumer Behavior and Economic Reform in East Germany in the 1960s." In *Getting and Spending: European and American Consumer Societies in the Twentieth Century*, edited by Susan Strasser, Charles McGovern, and Matthias Judt. Cambridge: Cambridge University Press, 1998.

Steiner, André. "Zwischen Frustration und Verschwendung." In *Wunderwirtschaft. DDR-Konsumkultur in den 60er Jahren*, edited by Neue Gesellschaft für Bildende Kunst. Cologne, Weimar, and Vienna: Böhlau, 1996.

Steiner, André. *Von Plan zu Plan. Eine Wirtschaftsgeschichte der DDR*. München: Deutsche Verlagsanstalt, 2004.

Steiner, André. "Vom Überholen eingeholt. Zur Wirtschaftskrise 1960/61 in der DDR." In *Sterben für Berlin? Die Berliner Krisen 1948–1958*, edited by Burghard Ciesla, Michael Lemke, and Thomas Lindenberger. Berlin: Metropol Verlag, 1999.

Stephenson, Jill. *Women in Nazi Society*. London/New York: C. Helm, 1975.

Stitziel, Judd. *Fashioning Socialism: Clothing, Politics and Consumer Culture in East Germany.* Oxford and New York: Berg Publishers, 2005.

Stitziel, Judd. "Fashioning Socialism: Clothing, Politics and Consumer Culture in East Germany, 1945–1971." Dissertation, Johns Hopkins University, 2001.

Stitziel, Judd. "On the Seam between Socialism and Capitalism: East German Fashion Shows." In *Consuming Germany in the Cold War*, edited by David Crew. Oxford and New York: Berg Publishers, 2003.

Stöhr, Irene. "Friedenspolitik und Kalter Krieg: Frauenverbände im Ost-West Konflikt." In *Frauenpolitik und politisches Wirken von Frauen im Berlin der Nachkriegszeit 1945–1949*, edited by Renate Genth et al. Berlin: trafo verlag, 1997.

Stokes, Raymond G. "Plastics and the New Society: The German Democratic Republic in the 1950s and 1960s." In *Style and Socialism: Modernity and Material Culture in Post-War Eastern Europe*, edited by Susan E. Reid and David Crowley. Oxford and New York: Berg Publishers, 2000.

Stolten, Inge, ed. *Der Hunger nach Erfahrung. Frauen nach 45'.* Bonn: Dietz, 1981.

Storbeck, Dietrich. *Arbeitskraft und Beschäftigung in Mitteldeutschland.* Cologne and Opladen: Westdeutscher Verlag, 1961.

Storbeck, Dietrich. "Familienpolitik und Familienwirklichkeit in der DDR." In *Studien und Materialien zur Soziologie in der DDR*, edited by P. C. Ludz. Opladen: Westdeutscher Verlag, 1971.

Storbeck, Dietrich. *Soziale Strukturen in Mitteldeutschland.* Berlin: Duncker und Humblot, 1964.

Stössel, Frank Thomas. *Positionen und Strömungen in der KPD/SED 1945–1954.* Cologne: Verlag Wissenschaft und Politik, 1985.

Suckut, Siegfried. *Die Betriebsrätebewegung in der Sowjetischen Besatzungszone Deutschlands (1945–1948).* Frankfurt/Main: Campus Verlag, 1982.

Süss, Winifried. "Gesundheitspolitik." In *Drei Wege deutscher Sozialstaatlichkeit. NS-Diktatur, Bundesrepublik und DDR im Vergleich*, edited by Hans Günter Hockerts. Munich: Oldenbourg, 1998.

Szepansky, Gerda. *Die stille Emanzipation. Frauen in der DDR.* Frankfurt/Main: Fischer, 1995.

Thaa, Winfried et al. *Gesellschaftliche Differenzierung und Legitimitätsverfall des DDR-Sozialismus.* Tübingen: Franke Verlag, 1992.

Thietz, Kirsten, ed. *Das Ende der Selbstverständlichkeit? Die Abschaffung des Paragraphen 218 in der DDR: Dokumente.* Berlin: BasisDruck, 1992.

Thönnessen, Werner. *The Emancipation of Women: The Rise and Decline of the Women's Movement in German Social Democracy 1863–1933.* London: Pluto Press, 1973.

Thurnwald, Hilde. *Gegenwartsprobleme Berliner Familien. Eine Untersuchung an 498 Familien.* Berlin: Weidmann'sche Verlagsbuchhandlung, 1948.

Timm, Annette F. "Guarding the Health of Worker Families in the GDR. Socialist Health Care, Bevölkerungspolitik, and Marriage Counseling, 1945–1970." In *Arbeiter in der SBZ-DDR*, edited by Peter Hübner and Klaus Tenfelde. Essen: Klartext, 1999.

Timm, Annette. "The Legacy of *Bevölkerungspolitik*: Venereal Disease Control and Marriage Counseling in Post-WWII Berlin." *Canadian Journal of History/ Annales canadiennes d'histoire* 33 (August 1998): 173–214.

Tippach, Simone. "Nymphenbad oder Wäschetrog? Exkurs zur Werbung in den fünfziger Jahren." In . . .*und Du, Frau an der Werkbank. Die DDR in den 50er Jahren*, by Ina Merkel. Berlin: Elefanten Verlag, 1990.

Trappe, Heike. *Emanzipation oder Zwang? Frauen in der DDR zwischen Beruf, Familie and Sozialpolitik*. Berlin: Akademie Verlag, 1995.

Ulbricht, Helga et al. *Probleme der Frauenarbeit*. Berlin: Verlag Neues Leben, 1963.

Ulbricht, Helga. "Zu einigen arbeitsökonomischen Problemen der Frauenarbeit." In *Probleme der berufstätigen Frau*. Berlin (E): Verlag Neues Leben, 1957.

Usborne, Cornelie. *The Politics of the Body in Weimar Germany. Women's Reproductive Rights and Duties*. Ann Arbor: University of Michigan Press, 1992.

Verdery, Katherine. *What Was Socialism, and What Comes Next?* Princeton: Princeton University Press, 1996.

Wagner, Michael. *Scheidung in Ost-und Westdeutschland. Zum Verhältnis von Ehestabilität und Sozialstrucktur seit den 30er Jahren*. Frankfurt and New York: Campus Verlag, 1997.

Wander, Maxi. *Guten Morgen, du Schöne. Protokolle nach Tonband*. Berlin: Buchverkag der Morgen, 1977.

Weber, Gerda. "Zur Vorgeschichte und Entwicklung des Demokratischen Frauenbundes (DFD) von 1945 bis 1950." In *Parteiensystem zwischen Demokratie und Volksdemokratie*, edited by Hermann Weber. Cologne: Verlag Wissenschaft und Politik, 1982.

Weber, Hermann. *Die DDR 1945–1990*. München: Oldenbourg, 1993.

Weber, Hermann. *Die Sozialistische Einheitspartei Deutschlands 1946–1971*. Hannover: Verlag für Literatur, 1971.

Weber, Hermann. *Geschichte der DDR*. Munich: Oldenbourg, 1986.

Weigandt, Susanne. "Frauen in der DDR: Präsenz ohne Macht." In *Sozialstruktur und Sozialer Wandel in der DDR*, edited by Heiner Timmermann. Saarbrücken-Scheidt: Verlag Rita Dadder, 1988.

Weitz, Eric. *Creating German Communism, 1890–1990*. Princeton: Princeton University Press, 1997.

Wentker, Hermann. "Die Einführung der Jugendweihe in der DDR: Hintergründe, Motive und Probleme." In *Von der SBZ zur DDR*, edited by Hartmut Mehringer. Munich: Oldenbourg, 1995.

Wettig, Gerhard. "Niedergang, Krise und Zusammenbruch der DDR. Ursachen und Vorgänge." In *Am Ende des realen Sozialismus. Bd. 1 Die SED-Herrschaft un dihr Zusammenbruch*, edited by Eberhard Kuhrt. Opladen: Westdeutscher Verlag, 1996.

Wierling Dorothee. "Generations and Generational Conflicts in East and West Germany." In *The Divided Past: Rewriting Postwar German History*, edited by Christoph Kleßmann. Oxford and New York: Berg, 2001.

Wierling, Dorothee. "Die Jugend als innerer Feind. Konflikte in der Erziehungsdiktatur der sechziger Jahre." In *Sozialgeschichte der DDR*, edited by Hartmut Kaelble, Jürgen Kocka, and Hartmut Zwahr. Stuttgart: Klett-Cotta, 1994.

Wierling, Dorothee. "Is Gender a Useful Category for the History of the GDR?" Unpublished paper presented at the German Historical Institute, London, November 2000.

Wille, Manfred, Johannes Hoffmann, and Wolfgang Meinicke. "Flüchtlinge und Vertriebene im Spannungsfeld der SBZ-Nachkriegspolitik." In *Sie hatten alles verloren. Flüchtlinge und Vertriebene in der sowjetischen Besatzungszone Deutschlands*, edited by Manfred Wille, Johannes Hoffmann, and Wolfgang Meinicke. Wiesbaden: O. Harrassowitz, 1993.

Wille, Manfred. "Die Zentralverwaltung für deutsche Umsiedler—Möglichkeiten und Grenzen ihres Wirkens (1945–1948)." In *Sie hatten alles verloren. Flüchtlinge und Vertriebene in der sowjetischen Besatzungszone Deutschlands*, edited by Manfred Wille, Johannes Hoffmann, and Wolfgang Meinicke. Wiesbaden: O. Harrassowitz, 1993.

Willenbacher, Barbara. "Zerrüttung und Bewährung der Nachkriegsfamilie." In *Von Stalingrad zur Währungsreform*, edited by Martin Broszat, Klaus-Dietmar Henke, and Hans Woller. Munich: Oldenbourg, 1990.

Winkler, Dörte. *Frauenarbeit im Dritten Reich*. Hamburg: Hoffmann und Campe, 1977.

Winkler, Gunnar. *Geschichte der Sozialpolitik in der DDR*. Berlin (E): Akademie Verlag, 1989.

Winkler, Gunnar. "Sozialpolitische Forschung in der DDR." In *Sozialpolitik in der DDR. Ziele und Wirklichkeit*, edited by Günter Manz et al. Berlin: trafo verlag, 2001.

Wolf, Christa. *Nachdenken über Christa T.* Halle: Mitteldeutscher Verlag, 1968.

Wolle, Stefan. "Der Traum vom Westen. Wahrnehmungen der bundesdeutschen Gesellschaft in dre DDR." In *Der Weg in den Untergang. Der innere Zerfall der DDR*, edited by Konrad Jarausch and Martin Sabrow. Göttingen: Vandenhoeck und Ruprecht, 1999.

Zachmann, Karin. "Frauen für die technische Revolution. Studentinnen und Absolventinnen Technischer Hochschulen in der SBZ/DDR." In *Frauen arbeiten. Weibliche Erwerbstätigkeit in Ost-und Westdeutschland nach 1945*, edited by Gunilla-Friederike Budde. Göttingen: Vandenhoeck und Ruprecht, 1997.

Zachmann, Karin. "Mobilizing for Marx: Women in the Engineering Professions and the 'Scientific-Technological Revolution' in the GDR during the 1960s." Unpublished manuscript.

Zachmann, Karin. *Mobilisierung der Frauen. Technik, Geschlecht und Kalter Krieg in der DDR*. Frankfurt/Main: Campus Verlag, 2004.

Zank, Wolfgang. *Wirtschaft und Arbeit in Ostdeutschland 1945–1949*. Munich: Oldenbourg, 1987.

Zerle, Herbert. *Sozialistisch Leben*. Berlin: Verlag Volk und Wissen, 1964.

Index

Sendhoff, Magda, 31
services, 3, 88; factory services, 53, 58–59,
102, 125, 168, 173–75, 197, 277, 306;
laundry, 53, 79, 125, 167, 168, 174,
177, 184, 196, 275, 277, 280. *See also*
childcare, institutionalized; consumption; counseling
settlers. *See* refugees
sex/sexuality, 27, 144, 219–20, 221–26,
271, 289–90, 295–97, 302, 314. *See also*
Aresin, Lykke; counseling; divorce; marriage; Neubert, Rudolf; prostitution; reproduction
Social Democrats (SPD, Social Democracy), 19, 21, 28, 29, 31–32, 34, 38–39,
55, 62, 73, 147, 165, 197, 228, 260
social policy, 12, 98–99, 245, 285, 301,
306–7, 308–9, 310–12, 313, 315
social workers, 27, 99, 136, 142, 147, 150,
173–75, 234, 245, 273, 290; gender composition of social service personnel, 255
Soviet Military Command (SMAD), 20,
27, 28, 29–30, 35–36, 81; and AFA, 31–
32; and origins of, DFD, 41–43; and
rape committed by Soviet soldiers, 29,
38; economic policy of, 45–46, 47–49,
50–51, 89, 101, 166; irritation with SED
about "woman question," 40, 57; women's labor policy of, 45, 49, 52, 109, 110
Supreme Court of GDR. *See* divorce; family law; Ministry of Justice
Stalin, Josef, 15, 36, 37, 47, 49, 61, 64, 65,
84, 90, 177, 195
Stalinallee, 177, 179
Stalinstadt, 89–90, 177, 195
Storbeck, Dietrich, 284
Sweden, 184–85, 308–9

textile/garment industry, 192, 195; economic significance of, 89, 185–87, 281,
311; history of, 93, 103; militancy of
workforce, 73, 74, 104–8, 110; promotion in, 97, 260; qualification of workforce, 95, 96, 126–27; services in, 53,
173; size of workforce, 89, 103; women's rejection of GDR textiles, 186–87,
281–82; workforce housing, 177; working conditions in, 103–4, 257
Third Reich. *See* National Socialism
Tjul'panov, Sergej, 57
trade unions. *See* FDGB
Trappe, Heike, 96, 100, 254, 301

Ulbricht, Helga, 274
Ulbricht, Lotte (Lotte Kühn), 55, 284
Ulbricht, Walter, 13, 21, 311; and abortion, 41, 145, 264–65; control of Politburo, 6, 9, 12, 61, 84, 108; and crisis of
1953, 64–69; differences with Honecker,
14, 133, 241–42; economic views of,
179, 183–85, 236, 241, 258, 273–74,
283–84, 300–301, 306; and mass rape
of 1945, 38; and reproduction, 134,
224, 264; and Ten Commandments for
Socialist Living, 215–16, 287, 288. *See
also* economy/economic policy; Politburo; SED
Ulrich, Lisa, 38, 49
USSR (Bolsheviks, Russians, Soviet Union),
15, 16, 23, 66, 145, 228, 237, 253, 285,
297, 317; German women's view of, 36–
38, 73; policies toward Soviet women/
family, 292, 309–12. *See also* Soviet Military Command

war, 19, 20, 101. *See also* Cold War; pacifism/anti-militarism
Warnke, Herbert, 3, 113
Weimar Republic, 28, 222, 223
West Berlin, 83, 85, 103, 127, 147, 166,
180, 182, 183, 185, 207, 270, 281. *See
also* Berlin; Berlin wall
West Germany. *See* Federal Republic of
Germany
Wierling, Dorothea, 11, 202
Wismut, 48, 177
Wolf, Christa, 119, 241
Woman in Socialist Society, Scientific Advisory Council (WB), 245, 313
women: attitudes toward KPD/SED/GDR,
28–29, 67, 85–86, 243, 302–3, 314–15;
sense of self, 1–2, 7, 102, 126–29, 189–
90, 192, 230–31, 239, 291, 314. *See
also* children; consumption; divorce; domestic labor; employment; family; marriage; mothers; reproduction
women, married: employment of, 99–100,
120, 127–28, 130, 205, 206, 210, 212–
14, 247 and HAT, 112, 113–14. *See also*
divorce; employment; mothers
women, single, 90, 176, 201–4, 291; employment of, 98–99, 104, 120–21, 127,
130–31; and HAT, 112–14, 189, 291.
See also divorce; employment; mothers
women Communists, 8, 21, 31–32, 220;